AMERICAN PARADISE

The World of the Hudson River School

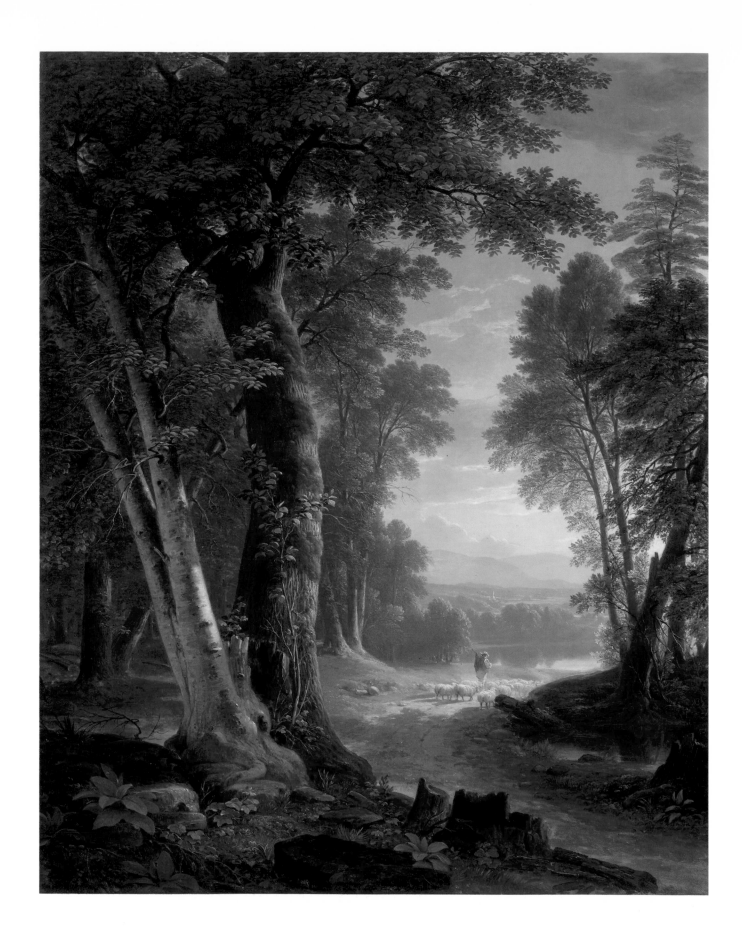

AMERICAN PARADISE

The World of the Hudson River School

INTRODUCTION BY JOHN K. HOWAT

THE METROPOLITAN MUSEUM OF ART

This book has been published in conjunction with the exhibition *American Paradise: The World of the Hudson River School*, held at The Metropolitan Museum of Art, New York, from 4 October 1987 until 3 January 1988.

The exhibition has been made possible through the generosity of the Chrysler Corporation Fund.

Additional support was provided by the National Endowment for the Arts. Grants used toward the publication of the book were provided by the Hudson River Foundation for Science and Environmental Research and The William Cullen Bryant Fellows of The American Wing at The Metropolitan Museum of Art.

Published by The Metropolitan Museum of Art, New York.
John P. O'Neill, *Editor in Chief*
Barbara Burn, *Executive Editor*
Teresa Egan, *Managing Editor*
Mary-Alice Rogers, *Editor, The William Cullen Bryant Fellows Publications, The American Wing*
Roberta Savage, *Designer*
Suzanne Bodden, *Production*

Library of Congress Cataloging-in-Publication Data

American paradise.

 Bibliography: p.
 Includes index.
 1. Hudson River school of landscape painting. 2. Landscape painting, American. 3. Landscape painting—19th century—United States. I. Howat, John K.
II. Metropolitan Museum of Art (New York, N.Y.)
ND1351.5.A49 1987 758'.1'097473 87–15417
ISBN 0–87099–496–4 (MMA)
ISBN 0–87099–497–2 (MMA : pbk.)
ISBN 0–8109–1165–5 (Abrams)

Typeset in Sabon by Meriden-Stinehour Press, Lunenburg, Vermont
Printed and bound by Drukkerij de Lange/van Leer bv, Deventer, The Netherlands

Cover-jacket: *View from Mount Holyoke, Northampton, Massachusetts, after a Thunderstorm (The Oxbow)*, Thomas Cole, 1836, The Metropolitan Museum of Art, Gift of Mrs. Russell Sage, 1908 (08.228)

Frontispiece: *The Beeches*, Asher B. Durand, 1845, The Metropolitan Museum of Art, Bequest of Maria DeWitt Jesup, from the collection of her husband, Morris K. Jesup, 1914 (15.30.59)

CONTENTS

LIST OF PAINTERS AND PAINTINGS

LENDERS TO THE EXHIBITION

Addison Gallery of American Art, Phillips Academy, Andover, Massachusetts
Amon Carter Museum, Fort Worth, Texas
Austin Arts Center, Trinity College, Hartford, Connecticut
The Brooklyn Museum, Brooklyn, New York
The Century Association, New York City
Cincinnati Art Museum, Cincinnati, Ohio
The Cleveland Museum of Art, Cleveland, Ohio
The Corcoran Gallery of Art, Washington, D.C.
Dallas Museum of Art, Dallas, Texas
The Detroit Institute of Arts, Detroit, Michigan
The Downtown Club, Birmingham, Alabama
Henry Melville Fuller
George Walter Vincent Smith Art Museum, Springfield, Massachusetts
The Haggin Museum, Stockton, California
Henry Art Gallery, University of Washington, Seattle, Washington
Hirschl & Adler Galleries, New York City
Lyman Allyn Museum, New London, Connecticut
James Maroney, New York City
Mellon Bank
The Minneapolis Institute of Arts, Minneapolis, Minnesota
Mint Museum, Charlotte, North Carolina
Montclair Art Museum, Montclair, New Jersey
Museum of Art, Rhode Island School of Design, Providence, Rhode Island
Museum of Fine Arts, Boston, Massachusetts
Museum of Fine Arts, Springfield, Massachusetts
National Academy of Design, New York City
National Gallery of Art, Washington, D.C.
National Museum of American Art, Smithsonian Institution, Washington, D.C.
The New Britain Museum of American Art, New Britain, Connecticut
The New-York Historical Society, New York City
The New York Public Library, New York City
The Pennsylvania Academy of the Fine Arts, Philadelphia, Pennsylvania
Dr. Arthur Quart, Riverdale, New York
Reynolda House, Museum of American Art, Winston-Salem, North Carolina
The San Antonio Museum Association, San Antonio, Texas
Terra Museum of American Art, Chicago, Illinois
Toledo Museum of Art, Toledo, Ohio
Vassar College Art Gallery, Poughkeepsie, New York
Robert C. Vose, Jr., Boston, Massachusetts
Wadsworth Atheneum, Hartford, Connecticut
Walker Art Center, Minneapolis, Minnesota
The Warner Collection of Gulf States Paper Corporation, Tuscaloosa, Alabama
The Wellesley College Museum, Wellesley, Massachusetts
Westmoreland Museum of Art, Greensburg, Pennsylvania
Yale University Art Gallery, New Haven, Connecticut
Private collectors (three)

PREFACE

The Chrysler Corporation Fund is proud to be the sponsor of the Metropolitan Museum's *American Paradise: The World of the Hudson River School* exhibition. The works displayed, which represent America's first significant art movement, have been recognized as uniquely American views both here and abroad for more than a century. They go far beyond celebrating the beauty of the American landscape in the 1800s; they are a celebration of America itself.

Lee A. Iacocca
Chairman
Chrysler Corporation

FOREWORD

The Metropolitan Museum's commitment to American art goes back to its origins, when one of the main reasons for creating the Museum was to provide the city and the nation with an institution that would attract and instruct American artists, as well as acquire their works. Leaders in the New York art world of the 1860s and 1870s were principally landscape painters, many of whom were instrumental in founding the Metropolitan. Among them were John F. Kensett and Frederic E. Church, both prominently represented in this exhibition and both on the roster of the Museum's first Board of Trustees, elected on 31 January 1870. Kensett served on the influential Executive Committee until his death three years later; the memorial display in 1874 of thirty-eight of his paintings—referred to as the Last Summer's Work—along with three pictures by Thomas Cole, was the first special exhibition mounted at the Metropolitan. Worthington Whittredge and Sanford Gifford, who are also represented in the exhibition, were among those deeply involved in the early life of this institution. In 1881, when the Museum organized its first monographic retrospective, it was of Gifford's work. Issued concurrently was *A Memorial Catalogue of the Paintings of Sanford Robinson Gifford, N. A.*, the first of a long line of scholarly books and catalogues published by the Metropolitan.

During the 117 years of its existence, the Museum's interest in American art has followed a curve that mirrored the public's taste. That interest reached its nadir in the last decades of the nineteenth century, when Louis Palma di Cesnola, then Director, feuded with local artists and avoided purchasing their works. The fortunes of American art and artists subsequently rose with the acquisition early in this century of the Hearn collection and fund, the latter devoted to the purchase of American painting. With the establishment in 1949 of a separate curatorial department concerned wholly with American art, interest in historical and contemporary American painting assumed added importance at the Metropolitan. More recently, with the opening of the Amer-

ican Wing in 1980 and the Lila Acheson Wallace Wing in 1987, the Metropolitan Museum has wholeheartedly supported the study and acquisition of American art.

American Paradise: The World of the Hudson River School is a large undertaking of the Metropolitan's Departments of American Art, and is an integral part of its program to exhibit and explain the best art of our country. In the past, the Museum has mounted major retrospectives of the work of Thomas Eakins, John Singer Sargent, George Bellows, and Winslow Homer, among others. The current exhibition and its accompanying book were conceived as a presentation of the art of the Hudson River School and a summary of the most up-to-date scholarship on the School itself. The organizers and authors have brought together a number of the finest and most historically important pictures of the School, thereby offering a broad and even-handed survey of thought and critical comment on the artists and their works. Because of the tremendous surge of recent interest in the Hudson River School (traceable in large part to *Paintings of the Hudson River School*, the Museum's small but pioneering exhibition held in 1917; to *The Hudson River School and the Early American Landscape Tradition*, the exhibition organized by the Art Institute of Chicago in 1945; and to the publication in 1949 of *M. and M. Karolik Collection of American Paintings, 1815–1865* by the Museum of Fine Arts, Boston) and the consequent recognition of it as the first pivotal art movement in this nation's history, the time is propitious to present to specialists and the general public alike these indisputable masterpieces.

It is a pleasurable obligation to note the Museum's debt to those staff members who have worked so hard to make this exhibition and book a reality. The project was jointly conceived and proposed by John K. Howat, the Lawrence A. Fleischman Chairman of the Departments of American Art, and Lewis I. Sharp, Administrator of the American Wing and Curator of American Paintings and Sculpture. The members of the American Wing's curatorial staff who selected

the artists and pictures and contributed essays and entries to the book include Doreen Bolger Burke, Associate Curator of American Paintings and Sculpture; Oswaldo Rodriguez Roque, Associate Curator of American Decorative Arts; and Kevin J. Avery and Catherine Hoover Voorsanger, Research Associates. Mary-Alice Rogers, Editor of the William Cullen Bryant Fellows Publications, has seen the publication through to completion with diligence and sensitivity.

We are deeply grateful to the numerous individuals and organizations who have consented to lend to this single-venue presentation; the supreme importance of the works they have agreed to part with temporarily serves only to underscore their generosity.

Exhibitions, related activities, and catalogues are the product of much effort, none of which can come to fruition without liberal financial support. I salute the Hudson River Foundation for Science and Environmental Research and the William Cullen Bryant Fellows of the American Wing for substantial contributions toward the publication of the book. The National Endowment for the Arts provided funds to be used for the exhibition; their gift is greatly appreciated. The Museum is also grateful for the continued support of Lawrence A. Fleischman, president of Kennedy Galleries, whose firm has underwritten a range of educational activities in conjunction with the exhibition.

Our profoundest expression of gratitude must, perforce, be reserved for the Chrysler Corporation Fund, whose handsome support has made *American Paradise: The World of the Hudson River School* possible.

Philippe de Montebello
Director
The Metropolitan Museum of Art

ACKNOWLEDGMENTS

No acknowledgments in a book of this kind can begin without tribute being paid the Metropolitan Museum for offering a safe harbor and temperate climate to those engaged in scholarly endeavors. We therefore honor the institution and thank Director Philippe de Montebello, guardian of art in all its aspects, and Deputy Director James Pilgrim, friend of American art.

Many organizations and individuals have contributed to the final arrangements for this exhibition and the publication of its accompanying book. The authors, much in their debt and grateful for their help, advice, and information, express warm appreciation for the manifold kindnesses and assistance so freely given by the members of the following institutions: Albany Institute of History and Art, Norman Rice, former director; Archives of American Art, Colleen Hennessey; Berkshire Museum, Debra Balken, curator of art; The Brooklyn Museum, Linda S. Ferber, chief curator; The Capitol, Office of the Architect, Florian M. Thayn; The Century Association, Rodger Friedman, librarian; Cincinnati Historical Society, Mrs. Elmer S. Forman, reference librarian; City College of New York, William H. Gerdts, professor of art history; Cleveland Museum of Art, William S. Talbot, assistant director and associate curator, and Linda Jackson, administrative assistant; Cornell University, staff of the Cornell Library; The Detroit Institute of Arts, Nancy Rivard Shaw, curator of American art, and the staff of the institute; Dutchess County Historical Society, Janet E. Nugent, curator; Fashion Institute of Technology, Marcia Briggs Wallace, professor of art history; Fine Arts Museums of San Francisco, Marc Simpson, curator of American paintings; Mint Museum, Martha G. Tonissen, registrar; Montclair Museum, Stephen Edidin, curator; Museum of Fine Arts, Boston, Theodore E. Stebbins, Jr., curator of American paintings, Patricia Loiko, operations coordinator, and Erica E. Hirshler, research assistant; Museum of Fine Arts, Springfield, Richard C. Mühlberger, director; National Academy of Design, Abigail Booth Gerdts, special assistant to the director; National Cowboy Hall of Fame and Western Heritage Center, Donald W. Reeves, curator of collections; National Gallery of Art, John Wilmerding, deputy director, Nicolai Cikovsky, Jr., and Franklin Kelly, curators of American art, and Nancy Anderson; National Museum of American Art, Smithsonian Institution, Andrew Connors, curatorial assistant in the permanent collection, and Merl M. Moore, Jr.; National Park Service, Barbara Barboza and Dean Shenk; Newington-Cropsey Foundation, Florence Levins; The New-York Historical Society, Jean Ashton, librarian, and the library staff; New York State Office of Parks, Recreation and Historic Preservation, Olana State Historic Site, Taconic Region, James Ryan, historic site manager, Robin Eckerle, interpretive programs assistant, Jane Churchill, historic site assistant, and the staff at Olana; The Pennsylvania Academy of the Fine Arts, Kathleen A. Foster, curator; Susquehanna County Historical Society and Free Library Association, Betty Smith, curator; Tennessee River Nature Conservancy, Graham Hawks, Jr., director; Toledo Museum of Art, William Hutton, senior curator; Trinity College, Michael Mahoney, professor of fine arts; The Union Club, Helen M. Allen, librarian; University of Arizona, Ellwood C. Parry III, professor of art history; Washington University Gallery of Art, Joseph Ketner II, curator; Western Reserve Historical Society, Thomas F. Pappas, manuscript assistant; Westmoreland Museum of Art, Paul Chew, director, and Jeffrey P. Rouse, registrar; Wilberforce University, Linda Renner, office of the president; Yale University Art Gallery, Paula B. Freedman, assistant curator of American paintings and sculpture.

The authors are additionally grateful to many gracious individuals for the benefit of their wisdom: Karen Jones Acevedo; Nancy Acevedo; Elizabeth Bartman; Annette Blaugrund; Ann Blair Brownlee; Russell E. Burke III; Gerald L. Carr; Mark Davis; Joyce Edwards; Katherine S. and Eugene D. Emigh; Stuart P. Feld; Lawrence A. Fleischman; Dr. Sanford Gifford; Gary Grimes; Alfred J. Harrison, Jr.; James C. Kelly; Joanne Klein; Jennifer Long; Kenneth W.

Maddox; Elizabeth Milleker; Nancy Dustin Wall Moure; Francis Murphy; Mrs. M. P. Naud; Judith Wilkenson Nielson; Robert S. Olpin; John Peters-Campbell; Jerome Turk; Robert C. Vose, Jr.; Ila S. Weiss; Leslie Yudell; and the late John I. H. Baur, a revered scholar.

The organizers of the exhibition record with gratitude the names of members of the staffs at the lending institutions who deserve special recognition for their assistance in coordinating the loans: Addison Gallery of American Art, Phillips Academy, Nicki Thiras, assistant director; Amon Carter Museum, Jan Keene Muhlert, director; Austin Arts Center, Trinity College, John Wooley, director; The Brooklyn Museum, Linda S. Ferber, chief curator and curator of American paintings and sculpture, and Barbara Dayer Gallati, assistant curator of American paintings and sculpture; The Century Association, Raymond J. Horowitz, chairman of the House Art Committee; Cincinnati Art Museum, Millard F. Rogers, Jr., director; Cleveland Museum of Art, Evan H. Turner, director, and William Talbot, assistant director and associate curator; Corcoran Gallery of Art, Michael Botwinick, former director; Dallas Museum of Art, Rick Stewart, curator for American art, and Maureen A. McKenna, assistant chief curator; The Detroit Institute of Arts, Samuel Sachs II, director, and Nancy Rivard Shaw, curator of American art; The Downtown Club, W. Ralph Cook, president, and, coordinating the loan for the club at the Birmingham Museum of Art, Douglas Hyland, director, and Betty Keen, registrar; George Walter Vincent Smith Art Museum, Richard Mühlberger, director; The Haggin Museum, Setsuko Ryuto, acting director, and Joanne Avant, registrar; Henry Art Gallery, University of Washington, Harvey West, director, and Judy Sourakli, curator of collections; Hirschl & Adler Galleries, Stuart P. Feld, president, and Mrs. M. P. Naud, director of the department of American art; Lyman Allyn Museum, Dr. Edgar deN. Mayhew, director, and Mrs. Arvin Karterud, curator and registrar; James Maroney, Inc., James Maroney, president, and Melissa Bellinelli; Mellon Bank, Jane Richards Lane, arts consultant; The Minneapolis Institute of Arts, Alan Shestack, former director; Mint Museum, Milton Bloch, director, and Martha G. Tonissen, registrar; Montclair Art Museum, Robert J. Koenig, director; Museum of Art, Rhode Island School of Design, Franklin W. Robinson, director, and Maureen Harper, former registrar; Museum of Fine Arts, Boston, Jan Fontein, former director, Theodore E. Stebbins, Jr., curator, and Patricia Loiko, operations coordinator; Museum of Fine Arts, Springfield, Richard C. Mühlberger, director; National Academy of Design, John H. Dobkin, director, and Barbara S. Krulik, assistant director; National Gallery of Art, J. Carter Brown, director, and John Wilmer-

ding, deputy director; National Museum of American Art, Smithsonian Institution, Charles C. Eldredge, director; New Britain Museum of American Art, Daniel DuBois, director, and Lois L. Blomstrann, former registrar; The New-York Historical Society, James B. Bell, director, and Mary Alice MacKay, former registrar; The New York Public Library, Dr. Vartan Gregorian, president; The Pennsylvania Academy of the Fine Arts, Linda Bantel, director of the museum; Reynolda House, Museum of American Art, Nicholas Burton Bragg, executive director, and his assistant, Marge Wagstaff; The San Antonio Museum Association, John A. Mahey, director; Terra Museum of American Art, Michael Sanden, director, and Susan R. Visser, former registrar and coordinator of exhibitions and collections; Toledo Museum of Art, Roger Mandle, director; Vassar College Art Gallery, Jan E. Adlmann, director, and Sandra S. Phillips, curator; Vose Galleries, Robert C. Vose, Jr.; Wadsworth Atheneum, Tracy Atkinson, former director, and Gregory Hedberg, chief curator; Walker Art Center, Martin Friedman, director; The Warner Collection of Gulf States Paper Corporation, Jack W. Warner and Charles E. Hilburn; The Wellesley College Museum, Ann R. Gabhart, former director; Westmoreland Museum of Art, Jeffrey P. Rouse, registrar; Yale University Art Gallery, Professor Anne Hanson, formerly acting director.

The authors have been especially fortunate to receive the constant and excellent services of the interns, volunteers, and staff of the American Wing: interns Mary Raymond Alenstein, Mishoe Brennecke, Henry Duffy, Laura Krebs, Alicia Lay, Jordana Pomeroy, Roberta Schwartz, and Andrew Walker; volunteers Barbara B. Buff, Chantal Hodges, Jo-Nelle Long, Elizabeth Quackenbush, Miriam Stern, and Leslie Symington. Marvels of constant helpfulness were staff members Pamela Hubbard, senior administrative assistant, and Nancy Gillette, administrative assistant and tireless transcriber of manuscript. Merrill-Anne Halkerston, research assistant, not only guided the authors through the archives assembled for the project by the volunteers and interns but was also of great help to the curators who arranged the loan agreements.

All concerned with this endeavor are much indebted to members of the staffs of various departments at the Museum. Useful mines of administrative support and information were: in the Office of Development, Emily K. Rafferty, vice president, and Richard Maxwell, assistant manager; in Public Information, John Ross, manager. In the Department of Paintings Conservation, Dorothy Mahon answered expeditiously inquiries as to the conservation and condition of the works of art; in Academic Affairs, Susan V. Mahoney and

Peter L. Donhauser coordinated the interns who worked on the exhibition. Also acknowledged with gratitude are: in the Office of the Registrar, John Buchanan, registrar, Herbert M. Moskowitz, senior associate registrar, Laura Rutledge Grimes, former associate registrar, and Willa M. Cox, administrative assistant; in Prints and Photographs, Maria Morris Hambourg, associate curator, and Elizabeth Wyckoff, administrative assistant; in the Thomas J. Watson Library, William B. Walker, chief librarian, Doralynn Pines, associate librarian, Katria Czerwoniak, assistant for interlibrary services, and Patrick F. Coman; in the Photograph and Slide Library, Diana Kaplan and Deanna D. Cross, associates for photograph and slide library orders; in the Photograph Studio, Barbara Bridgers, manager. The designer for the exhibition was Roy G. Campbell, of the Design Department.

In undertaking the publication of this book, we have received the able advice and assistance of John P. O'Neill, editor in chief and general manager of publications, and members of his staff: Barbara Burn, executive editor; Teresa Egan, managing editor; Henry von Brachel, former senior production manager; Suzanne Bodden, production associate; Barbara Cavaliere, proofreader; and Susan Bradford, indexer. The felicitous design was provided by Roberta Savage.

It goes without utterance that the book would not have seen the light of day without the creative thought and editorial diligence of Mary-Alice Rogers, editor of the William Cullen Bryant Fellows Publications for the American Wing; it is her book as much as anyone's.

John K. Howat
The Lawrence A. Fleischman Chairman of the Departments of American Art

NOTES TO THE READER

The extracts that appear throughout the book, which have been checked against the primary source wherever possible, are reprinted in their original form. No attempt has been made to correct the sometimes idiosyncratic or archaic spelling, punctuation, and syntax the extracts contain; to do so would have destroyed the immediacy of their nineteenth-century character. As a result, the reader will encounter occasional inconsistencies, particularly where the treatment of place names is concerned: Kaaterskill, Kauterskill, Katterskill, Cauterskill; Catskill, Cattskill, Katskill; Mount Katahdin, Mount Kaatdn come to mind, but there are others.

As far as possible, parenthetic information has been removed so that the flow of the text is not impeded. The repositories of paintings and, in the notes, the books and articles cited are presented in a shortened form. The full references will be found in the Short Titles and Abbreviations section beginning on page 331. Similarly, the life and death dates of persons mentioned in the essays and in the paintings discussions have been moved to the Index. Notes to the essays have been assembled in a separate section beginning on page 91.

Each artist's biography was written by the author of his paintings discussions or the majority of them, as in the case of Asher B. Durand's, the work of Barbara Dayer Gallati. Exceptions are the biographies of William Trost Richards and Alfred Thompson Bricher, which were contributed by Mishoe Brennecke. A bibliography for each artist, also chosen by the author discussing his paintings, is for the use of readers wishing further information and is *not* the source of the short titles and abbreviations previously referred to.

The titles and the information at the head of each painting discussion have been supplied by the private collectors and the lending institutions. The credit lines appear exactly as the lenders requested. The dimensions of the paintings, given in inches and in centimeters, are of the unframed canvas, height followed by width. Every effort has been made to record accurately the artist's signature and its position on the canvas.

The book represents the best efforts of a group of experts in the field of American art, among whom several colleagues from outside the Metropolitan Museum deserve special mention. Their willingness to take time from their busy professional lives to add the results of their research to this body of work is in the finest tradition of scholarly generosity.

The editor acknowledges with much gratitude the invaluable assistance of Merrill-Anne Halkerston, who assumed responsibility for innumerable tasks vital to the preparation of this volume and who accomplished each one with dedication and skill.

Mary-Alice Rogers
Editor of the William Cullen Bryant Fellows Publications
The American Wing

INTRODUCTION

Since the discovery of the North American continent and the beginning of the difficult process of its occupation and settlement by pioneers, the physical and mental possession of the land has been the focus of attention for Americans of whatever stripe. From the earliest years of our written national record, that attention has been the result of a natural and wholly understandable combination of the desires of emigrant newcomers refashioned into Americans: to garner a better existence for themselves in the midst of a mapless and daunting wilderness and to satisfy their endless curiosity about the nature and appearance of the unknown country that lay beyond the horizon. Work and wonder were common companions in such an exploratory situation, but fear and dread of the landscape came to be replaced by loving awe. Though citizens of the United States exercise one of the oldest and stablest governments in the world, now, in the late twentieth century, most Americans still possess the ability to marvel at the nation's immense and dramatically varied landscape and to be astonished by it.

Love and admiration for one's own landscape is hardly unique to Americans. Here, however, the blend of almost naive wonderment and driving curiosity about the land tends to differentiate our perceptions from those of western Europeans. The Europeans, deeply rooted in their ageless ancestral lands, seem to have, to own, or calmly to accept a place in landscape, while we Americans have been, and still are, discovering our heritage and finding a resting place in it. For us, the manifold process of discovery and familiarization has been long and complicated, calling for more than mere geographic expansion, much more than economic growth, infinitely more than the simple, factual recording of the face of the land. Rather, from the beginning, it has been a continuing emotional and spiritual development of the American ethos, deeply interwoven with literary thought and—basic to the concerns of this publication—with subsequently developed attitudes toward landscape art and the artists who paint it.[1]

In that process, landscape painting as a separate, coherent art form is a relative latecomer to American art, rising, in chronological parallel with sculpture, from 1825 through 1875, years during which both art forms attracted and nurtured numerous artists and created substantial patronage where none had existed. In American art-history texts, a familiar and worthy article of faith is that fine architecture, stylish decorative arts, and handsome painted portraiture, because of their obviously greater social utility, long preceded landscape painting onto the American cultural scene. Accordingly, landscape painting is normally perceived as the product of a later phase of cultural development, characterized by greater wealth, increased leisure, and a heightened taste that encouraged the embracement of more contemplative art forms.

The paintings of the Hudson River School, so diverse in their choice of scenery, so varied in their scale of scene and size of canvas, have a valid claim to be hailed as the finest landscape pictures yet produced in this country. They captured center stage in the theater of the American art world at the time of their creation, and today they have reclaimed the keen admiration of those who love American art, a public now immeasurably greater in number than that the artists originally commanded.

This book and the exhibition that it accompanies attempt to discuss and to record the most distinguished works of art produced by the Hudson River School—a school memorable for the aesthetic beauty of its works and for the enthusiastic moral certitude of its many followers—in the hope that a yet wider audience may discover the greatness of its interpreters.

John K. Howat
The Lawrence A. Fleischman Chairman of the Departments of American Art

1. For comprehensive discussions of the subject, see Hans Huth, *Nature and the American: Three Centuries of Changing Attitudes* (Berkeley and Los Angeles, Cal.: University of California Press, 1957), and Roderick Nash, *Wilderness and the American Mind* (New Haven, Conn.: Yale University Press, 1967).

THE ESSAYS

A HISTORIOGRAPHY OF THE HUDSON RIVER SCHOOL

Kevin J. Avery

THE TERM "HUDSON RIVER SCHOOL," applied to the foremost representatives of nineteenth century American landscape painting, was neither self bestowed nor charitably intended. Apparently unknown during the halcyon days of the American landscape movement, which began around 1850 and lasted until the end of the Civil War decade, it seems to have emerged in the 1870s as a direct result of the struggle between the old and the new generations of artists to assert their style as the representative American art. The older painters, most of whom were born before 1835, practiced in a mode often self-taught and monopolized by landscape subject matter, and were securely established in and fostered by the reigning American art organization, the National Academy of Design. The younger men, returning home from training in Europe, worked more with figural subject matter and in a bold and impressionistic technique; their prospects for patronage in their own country were uncertain, and they sought to attract it by attaining academic recognition in New York. One of the results of the conflict between the two factions was that what in previous years had been referred to as the "American," "native," or, occasionally, "New York" school[1] — the most representative school of American art in any genre — had by 1890 become firmly established in the minds of critics and public alike as the "Hudson River School."

The sobriquet was first applied around 1879. While it was not intended as flattering, it was hardly inappropriate. The Academicians at whom it was aimed — Asher B. Durand, Frederic E. Church, Albert Bierstadt, Sanford R. Gifford, T. Worthington Whittredge (then Academy president), and Jasper F. Cropsey, among others — had worked and socialized in New York, the Hudson's port city, and had painted the river and its shores with varying frequency. Most important, perhaps, was that they had all maintained with a certain fidelity a manner of technique and composition consistent with those of America's first popular landscape artist, Thomas Cole, who built a career painting the Catskill Mountain scenery bordering the Hudson River. A possible implication in the term applied to the group of landscapists was that many of them — most notably, Church, Bierstadt, Gifford, and Cropsey — had, like Cole, lived on or near the banks of the Hudson. Further, the river had long served as the principal route to other sketching grounds favored by the Academicians, particularly the Adirondacks and the mountains of Vermont and New Hampshire.

Neither the originator of the term nor its first published use has been fixed with absolute certainty. Whittredge attributed the name to a "savage critic in the *New York Tribune*."[2] He was undoubtedly alluding to Clarence Cook (Fig. 1.1), who from 1864 until the late 1870s wielded formidable

3

the year several young, foreign-trained or foreign-influenced painters, faced with the discriminatory hanging policies adopted by the National Academy in its spring annuals, founded the Society of American Artists to create their own exhibition forum. The open opposition to the Academy exemplified by the Society generated an atmosphere so hostile that, as one critic put it, "Many persons [are] willing to quarrel outright over delicate aesthetic considerations, and to call each other names because they differ about little distinctions of artistic style or nice discriminations of technical theory or practice."[4]

Partisans of the Academicians, particularly outraged by the thought that the foreign-trained artists were attempting to identify themselves as an "American" school, claimed that only the established artists had the right to that distinction

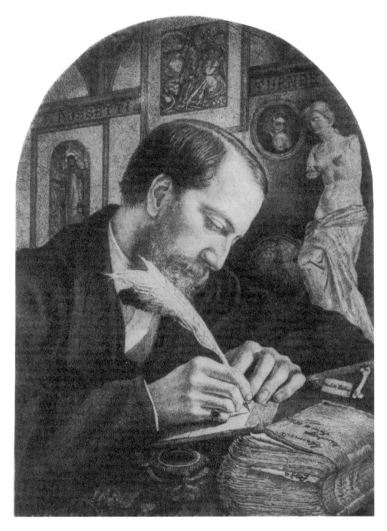

Figure 1.1. Thomas C. Farrer, *Clarence Cook*, 1864, pen-and-ink drawing. Illustrated in Clarence Cook, *Poems* (New York: Privately printed, 1902)

influence at the *Tribune* and who was the bane of the New York art establishment, which suffered his incessant attacks. Cook was the first to use the name in the historical sense, and could also have originated it in private conversation, though it does not appear in his published utterances until 1883.

According to historian Frederick S. Fairchild, another candidate for originator of the term is Homer D. Martin (Fig. 1.2), a landscape painter who converted from a Hudson River School style to one Barbizon in inspiration in the 1870s.[3] It is easy to imagine Martin, an intemperate and unpredictable man, inventing it in a moment of mischief or derision, but neither his letters nor any account of his colorful conversation document that he did.

Whenever it arose and whoever its originator was, the name is not likely to have been used before 1877. That was

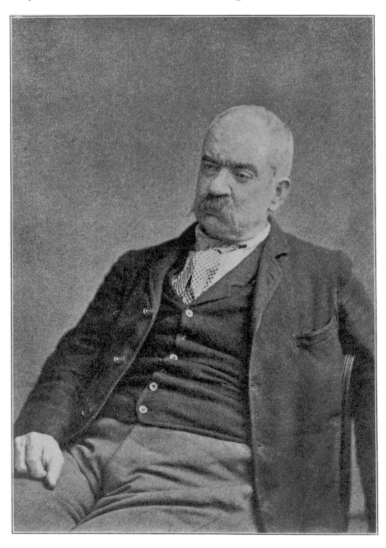

Figure 1.2. *Homer Martin*, 1892. Photograph, taken in England. Illustrated in Elizabeth G. Martin, *Homer Martin: A Reminiscence, October 23, 1836–February 12, 1897* (New York: William Macbeth, 1904)

and scoffed at the younger men, calling them the "American Society of Munich Artists."[5] For their part, those who sympathized with the members of the new generation of artists devised a host of epithets for the traditionalists. "Fogies" was the simplest; references also were made to the "panoramic school"[6] and the "Rocky Mountain period"[7] in American art in the 1870s and to the "Coast of Maine"[8] and "Adirondack" schools in the 1880s.[9] (In 1905, a "White Mountain" designation would be added.)[10] One alert critic, referring to the monopolizing of the eyeline—that is, the hanging space at eye level—at Academy exhibitions by the Academicians, who had previously accorded generous space to works submitted by younger men, dubbed the 1878 exhibition "The Return of the Natives."[11] In that hostile environment the name Hudson River School was fermented. It proved to be the most enduring label.

The first recorded use of the name dates to May 1879, when it appeared in a review of the annual National Academy exhibition, written by Earl Shinn (under the pseudonym Edward Strahan), in the inaugural issue of the monthly *Art Amateur*. Shinn remarked on the startling contrast between the old and the new styles of painting as they were reflected in the pictures on the Academy walls:

> . . . It is striking how quickly the new tendencies, the fogy pictures and the innovating pictures, the Hudson River school and the impression school, separate themselves out and assort their families. Never were the old men with their deeds more completely sent to the wall by the new men and their creeds. The ideas sprouting in the minds of those who have been seeking a fuller education in Paris or Munich, are seen lending their fuller color to the walls that in old years were so dull and conventional. . . .[12]

What is remarkable in Shinn's early use (or, possibly, coining) of the name is that he did not mean it primarily to address the parochialism inherent in such a geographical reference; when he compared "the fogy pictures and the innovating pictures, the Hudson River School and the impression school," he was disparaging the Academicians' works chiefly on stylistic grounds. The word "impression," which he employed to characterize the soft-edged, more spontaneous technique of the foreign-trained painters, had been in current use for several years. In contrast, "Hudson River School" had already come to connote a hard-edged, "finished" technique practiced by a generation in eclipse ("the old men"). However, a reference to "Hudson River methods" later in the article comes close to criticizing the regional limitations with which later generations would mistakenly connect the School. Shinn pointed approvingly to landscape painter Edward Moran, brother of the better-

known Thomas, as an example of several artists "trying to forsake old 'Hudson River' methods" by attempting figure paintings in the manner of French Barbizon genre painters.[13] In short, the critic was anticipating the weakening hold landscape painting had on the American art world it had dominated since the 1840s.

The second known reference to the name makes evident that Academic landscape painting was considered mere topographical description or scenic display. In early June 1879, soon after Shinn's Academy review appeared, an interview

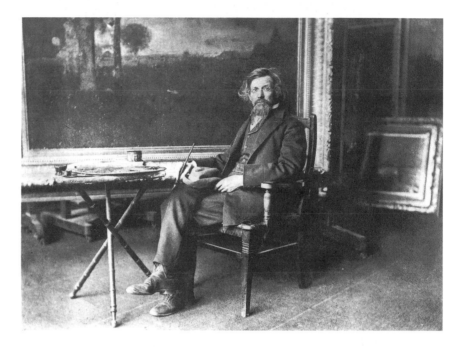

Figure 1.3. *George Inness in his New York City studio*, ca. 1890. Photograph by Edwin S. Bennett, New York City. Macbeth Gallery Papers, Archives of American Art, Smithsonian Institution

with George Inness (Fig. 1.3) was published in the *New York Post*. In response to the anonymous interviewer's observation, "Some of the newspapers sneer at what they call 'the Hudson River school,'" Inness, an Academician since 1868 but also a member of the new Society of American Artists, observed:

> Certain members of the National Academy of Design have been stigmatized, I know, as the Hudson River school. But if they have artistic vitality really sufficient to form a society devoted to the development of scenic landscape, why should there not be such a school? . . . It is true that scenic art can never assume to be a representative of the higher forms of mind. . . . Yet it may become a very beautiful representation of one of the various forms of culture which lead mankind from the lower into the higher types of life.[14]

Inness's defense of the scenic standards of the Hudson River School painters anticipates the many apologists who were to usher the group through the dark ages of public neglect in the late nineteenth and early twentieth centuries. Also to be detected in Inness's comments is that as an Academician himself he was reluctant to condemn the landscape sensibility he had once shared, and that even at that time he anticipated the recognition the School was eventually to achieve.

Aside from the distinctions of style and subject matter it implied, the name Hudson River School was undoubtedly perceived by contemporary critics as bearing a certain irony. The so-called native American school, made up in large part of local landscape painters, was neither representatively American nor a school: until 1869, the "National" Academy that was its aegis excluded from membership artists living outside New York,[15] and could not rival the European academies in the quality of its teaching. Relatively few of its members had ever studied under a recognized (i.e., Continental) master, and many of them were apt to use the Academy primarily to protect and to enhance their own economic security. Those factors, in concert with the generally arrogant disdain the Academy showed to new talents and styles, made the Academicians an easy target for the scorn of more up-to-date critics, who measured them against the students coming from academies in Paris and Munich. Moreover, the name of the School, identified not with a city but a river, denied the Academy landscape painters the international status of a European school. Indeed, as "Hudson River" painters, they were characterized in the most primitive terms. In 1880, a writer in *Art Amateur*, claiming to echo the theory put forth by European critics of American art, so identified American artists:

> [In] America, being an untamed wilderness, nature was the proper study of American art. Destitute of the schools with their masters and models of European critics, without the monuments of an old civilization, the palaces, castles, and cathedrals, the galleries of old masters, the vistas of a long and great history, the American savages in art must show their inspiration . . . as the aborigines show their religion, from the woods and waterfalls, from the great rivers and mountain ranges of the American continent.

The writer rejected that theory: "A generation of artists has arisen in America not content to be simple untutored savages in art."[16]

Despite the aptness of the name and the complexity of meaning inherent in it as early as the 1880s, "Hudson River School" did not become a catch phrase for identifying the older generation of landscapists until the 1890s. Even though critical approbation shifted inexorably to the newer styles in the 1880s, discreet commentators avoided the irreverence of invoking the label, for many Academicians were still very much alive, however dead their styles. Only in 1886, with the death of Asher B. Durand, dean of the older generation of landscapists, did an editor of *Harper's Weekly* refer to his paintings as belonging to "what has of late years been disparagingly called the 'Hudson River School.'" Having used the phrase, he was quick to defend the group for "a power of reproducing poetic impressions with delicacy and grace which the younger and better equipped men by no means always show."[17]

By 1883, the name had gained a foothold of historical currency: that was how Clarence Cook used it in confirming the course of American art he had helped to establish in 1877, when he exhorted the younger painters to form the Society of American Artists. Cook's presumption in evaluating the art of the past and dictating the future fate of academic landscape art is so sweeping, so characteristically arrogant, and, as a consequence, so prophetic of the attitude of the next several decades that his words bear repeating. In 1883, recalling the work of the new generation in the Society's first exhibition five years earlier, Cook wrote:

> Their dash and unexpectedness made the Academy seem tame, and we heard all this tameness summed up in the newly invented stigma, "the Hudson River School," with which our pastoral and chromo-lithographic art, till then firmseated in the popular heart, was now daily pestered by the confident lovers of the new. And, in truth, it was time for the Hudson River School to at least begin to die. It had played its part, and played it well, but it lingered on a stage where Irving and Paulding and Bryant and their disciples had acted a similar part in our springtime literature, and had said Farewell, and now in art also we were ready for a new set of players. It was not possible to regret the change. Nothing more alien to what is recognized as art everywhere, outside of England at least, has ever existed anywhere, than the now defunct or moribund school of landscape once so much delighted in as the American school, but now so slightingly spoken of as the Hudson River School. It has a historical value, and specimens of it deserve to be collected in the museum of the future as characteristic of the pleasant and peaceful if a trifle tame and tedious days "before the war." Nevertheless the hope may be expressed that in the museum of the future it will not be thought necessary to collect these specimens by the gross. . . . Historical value of a certain mild sort it may be allowed these pictures have; but artistic value they never had, nor can any turn in the Wheel of Fashion or of Fortune ever make them seem artistic to a future generation.[18]

With the passing of time, alternate meanings or additional connotations attached themselves to the concept of the Hudson River School in American art. As originally used, the phrase seems to have been aimed specifically at living Academicians. But even in the mid-century heyday of the landscape movement, it was widely acknowledged that the School's standards had originated in the art of Thomas Cole. It was not long before Cole became known as the "father" of the Hudson River School, even though some early historians separated Cole and Durand (along with Thomas Doughty) from true membership in the group.[19] As early as 1880, however, a eulogy to Sanford R. Gifford assigned him to the "Thomas Cole school of American landscape,"[20] while stopping short of identifying that school by the topographical epithet that had been applied to it the previous year.

A final nineteenth-century meaning implicit in the name has to do with the group's tribalism, seen as reactionary in an age of individuality. In the 1880s and 1890s, and more especially as the artistic personalities of Inness, Alexander Wyant, and Homer Martin continued to distinguish themselves in landscape painting, "Hudson River School" began to evoke the specter of coercive Academicism, brutishly opposed to individual poetic expression. That interpretation was voiced as early as 1884, when a review in the *New York Tribune* (possibly written by Clarence Cook) hailed Inness as a "heretic as regards the tenets of the 'Hudson River School.'"[21] In 1898, another commentator declared himself satisfied that Martin, by 1876, was "emancipating himself" from "the influence of the well-termed 'Hudson River School.'"[22] Nevertheless, as Montgomery Schuyler conceded in 1894, "It seems inevitable that [Inness] should have become a member of the 'Hudson River School'" during his early career,[23] while in 1912, Frederick Sherman would assert that Martin had known himself to be "the last and greatest expression of that discredited movement."[24]

During the decade of the 1890s, the critics' concept of the group style took on a firmer, if simplistic, shape. Their new evaluations seem to have been made not on the basis of what few recent Hudson River paintings they were likely to have seen, but from a combination of their distant recollection of past Academy exhibitions and their need for a negative foil to contrast with the qualities they admired in works by Inness, Wyant, and Winslow Homer. Thus, as Schuyler noted in 1894, whereas Inness was devoted to "action—the action of clouds, the action of waves"—in a landscape painting, the Hudson River School had preferred the "scene," the "view," or even the "panorama."[25] In 1900, another critic charged Cole with having ignored the technique of aerial perspective to convey spatial recession, expressing instead

"the retreating of forms by means of perspective diminution of objects and not by color values," whereas in the work of Inness, Wyant, and Homer, he found that "foreground objects are so related to distant objects that they do not clamor for undue attention."[26] It was Schuyler who helped to plant the notion, commonly asserted in early histories of American art, that the engraving practice of several mid-century landscape painters, such as Durand, John F. Kensett, and John W. Casilear, had had an ineluctably deadening effect on their technique, leading to overemphasis on detail.[27] He also perpetuated the myth, common in his day, that the majority of Hudson River painters avoided exposure to European artistic influence. He excepted Kensett from their number, since he had "studied painting in England and exhibited at the Royal Academy before he exhibited at the National Academy."[28]

It was natural, too, that the label "Hudson River School" would by the end of the nineteenth century impute to the mid-century landscapists the narrowest possible geographic range—that is, besides their lack of European training and culture, they had never ventured beyond the eastern United States for subject matter. That misconception seems to have been invoked around 1910 by Theodore Roosevelt, in praising the western genre paintings of Frederic Remington. Roosevelt's remarks were paraphrased in a newspaper account:

> . . . Probably MR. ROOSEVELT spoke without any special desire to condemn the ancient Hudson River school of painters when he declared that our earlier "artists of real ability" had their eyes turned toward Europe and lacked the "robust originality to see where their chance lay to do a great work." Their failure cannot be remedied at this late hour. The conditions of life in the "great divide" and the trails across mountains and plains were not so much as to tempt the artist in those days. Life was perilous, sustenance was hard to get. Most of our earlier artists had hard enough work to live near the Eastern seaboard.[29]

Both the reporter and, if Roosevelt's words and meaning were accurately reflected, the former president spoke as though they were entirely unaware of Thomas Moran's huge painting *The Grand Canyon of the Yellowstone* (Fig. 1.4), which was purchased by Congress in 1872 and which partly inspired the creation of the first national park. Equally forgotten was Albert Bierstadt, who had earlier journeyed West to collect material for the mammoth Rocky Mountain and Sierra Nevada scenes that secured him an international reputation in his own day. How Roosevelt and his companions could have overlooked such formidable achievements of western landscape art by eastern artists is a wonder today.

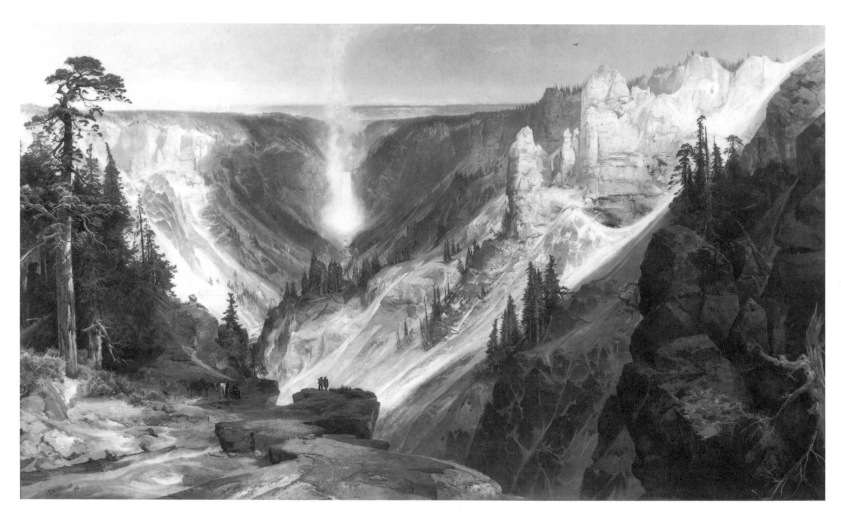

Figure 1.4. Thomas Moran, *The Grand Canyon of the Yellowstone*, 1872, oil on canvas, 84 x 144¼ in. (213.4 x 366.4 cm.). National Museum of American Art, Smithsonian Institution, Lent by the U.S. Department of the Interior, National Park Service

The distorted ideas evolving in the 1890s and early 1900s of the Hudson River School—such as its features of style and technique, its lack of European antecedents, and its restricted range of subject matter—were in some measure the result of the virtual oblivion into which many of the largest paintings of the era had been cast. If "Hudson River School" was a label avidly seized on by contemporary historians attempting to identify an increasingly obscure phase in the history of American art, the aesthetic and commercial value of the works so designated had commensurately declined, in many cases to almost nothing. That fate is manifested in a few notices of private and public collections in the early twentieth century. As long ago as 1884, a writer (again, perhaps Clarence Cook) in *The Studio* revealed that the collection of Kensett's late work, donated to the Metropolitan

Museum by his brother, had been "consigned to the cellar" with no opposition; the writer could not imagine that "the whirligig of time will ever bring about for them a full revenge."[30] Often, such notices are more telling in what they omit than in what they include. In a review of the collection of "Italian, Flemish, Dutch, French, and early American painting" amassed by The New-York Historical Society by 1908, a newspaper reporter described only the European pictures.[31] Not even the splendid American portraits in the society's collection seemed to merit mention, to say nothing of the major canvases by Cole (including his *Course of Empire* series), Durand, and other Hudson River painters that enriched it then, as they do today.

It need hardly be said that during that period there were few, if any, exhibitions devoted to mid-nineteenth-century landscape or even including it. An exception was the retrospective given at the Metropolitan Museum of the work of Frederic E. Church in 1900, the year of his death. That show, however, was mounted perhaps more because of Church's status as a founder and an early trustee of the Museum, and

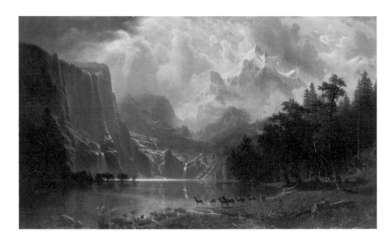

Figure 1.5. Albert Bierstadt, *Among the Sierra Nevada Mountains, California*, 1868, oil on canvas, 72 x 120 in. (182.9 x 304.8 cm.). National Museum of American Art, Smithsonian Institution, Bequest of Helen Huntington Hull (1977.107.1)

namesake—the Hudson River School—went unrepresented in the special exhibition held at the Metropolitan Museum. Instead, Dutch portraits from the Baroque age formed the centerpiece of the exhibition, supplemented by American portraits and furniture from the Colonial and Federal periods.[32]

Sales of private collections that had been formed in the mid-nineteenth century give a fair idea of the decline in commercial value of Hudson River School pictures. The enormous sums commanded by Church and Bierstadt in the 1860s—the highest said to have been $25,000 paid for Bierstadt's *The Rocky Mountains, Lander's Peak* (see p. 285) in 1865—are well known today. Though Bierstadt's paintings continued to sell for respectable prices, one titled *Among the Sierra Nevada Mountains, California* (Fig. 1.5), comparable in size to *The Rocky Mountains*, had by 1892 been sold at auction for $8,000, a third to a half of what it probably would have brought three decades earlier.[33] During the first half of this century, when the market for his large-scale compositions was all but nonexistent, Bierstadt's pictures were

out of respect for a once huge reputation, than for any lasting merit perceived in his art. Even in 1909, on the occasion of the Hudson–Fulton Celebration, when New York hailed the dual anniversaries of Henry Hudson's first exploration of the river that bears his name, in 1609, and Robert Fulton's first commercial steamboat trial two centuries later, the river's

Figure 1.6. Frederic E. Church, *The Icebergs*, 1861, oil on canvas, 64½ x 112⅜ in. (163.8 x 285.4 cm.). Dallas Museum of Fine Arts, Anonymous Gift (1979.28)

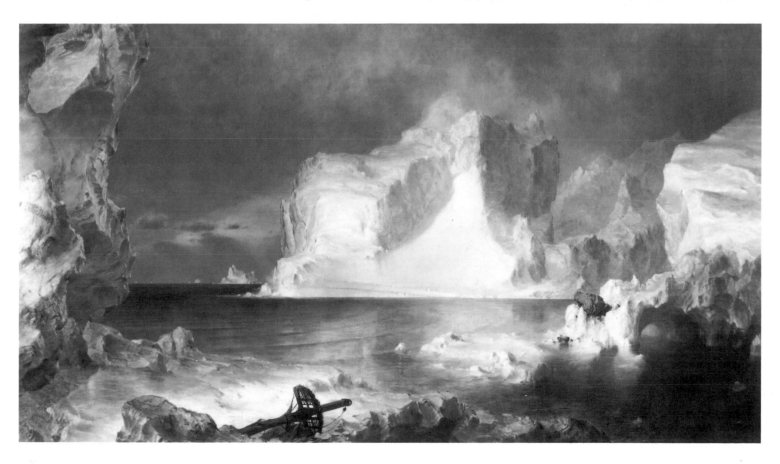

sometimes sold as part of the great houses in which they had originally hung. Or else they were deliberately destroyed, as was the case in 1960 with the largest of three versions of his *Landing of Columbus* (1892), on the order of the director of the museum in whose power plant it had hung unseen for decades.[34] Church's nine-and-a-half-foot-wide *Icebergs* (Fig. 1.6) was sold about 1865 to a railroad magnate from

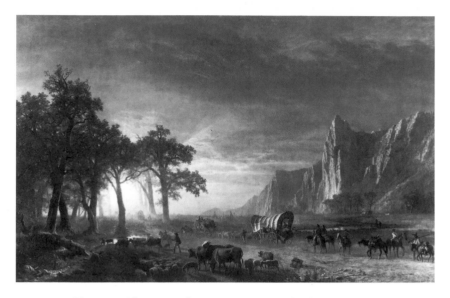

Figure 1.7. Albert Bierstadt, *Emigrants Crossing the Plains*, 1867, oil on canvas, 67 x 102 in. (170.2 x 259.1 cm.). National Cowboy Hall of Fame and Western Heritage Center

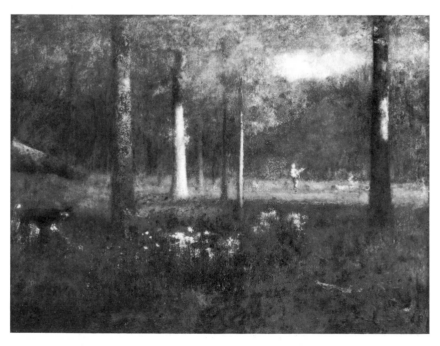

Figure 1.8. George Inness, *Autumn Woodlands*, 1890, oil on canvas, 45 x 36 in. (114.3 x 91.4 cm.). Collection of Mr. and Mrs. Isaac Arnold, Jr., Houston, Texas

Manchester, England, whose residence later became a boys' reformatory. Not until 1979 did anyone suspect that the huge painting, hung in an upstairs hallway, might sell for a few needed pounds. Thus was a renowned "lost" masterpiece brought to light. Bierstadt's *Emigrants Crossing the Plains* (Fig. 1.7) had a similar fate: it turned up in 1969 in the offices of the Cleveland Automobile Club, which had formerly been the home of the daughter of the painting's original owner.[35] Scores of other Hudson River School canvases, big and small, moldered unnoticed in barns, attics, cellars, warehouses, offices, passageways, and parlors for decades. Among them were Bierstadt's *Storm in the Rocky Mountains—Mount Rosalie* (see p. 290), Church's *Twilight in the Wilderness* (see p. 251), Cropsey's *View of Hastings-on-Hudson* (probably after 1884; Union Free School District No. 4, Hastings-on-Hudson, N.Y.), Jerome Thompson's *Belated Party on Mansfield Mountain* (see p. 146), and, perhaps most recently, Gifford's *Mansfield Mountain* (ill., p. 147), rescued in 1985 from the obscurity of a New Jersey basement.[36]

Despite the neglect of the larger pictures, trade in smaller Hudson River School paintings continued in auction sales before and after 1900. Though trends are difficult to measure, official and informal records from those years reveal an only moderate decline in price. That must be measured, however, against the increasing sums being paid for European landscapes and Barbizon-style American paintings. For example, a four-foot-wide landscape by Durand could still fetch as much as $1,000 in 1891, yet one half as large by the Barbizon painter Charles-François Daubigny commanded nearly $7,000 in the same sale.[37] In 1904, small paintings by Cropsey and Gifford sold in the hundred-dollar range, but an Inness of comparable size brought nearly ten times as much.[38] Even allowing for the variable quality within the oeuvre of an individual artist, which always affects the price of a work, the overall disparity in value is inescapable.

The imbalance after 1910 is shocking. Throughout the decade, the paintings of Inness, Wyant, and Martin—none of them monumental in size—excited a frenzy of competitive buying, culminating in the $45,000 paid in 1917 for Inness's *Autumn Woodlands* (Fig. 1.8).[39] Five years earlier, Cole's *The Clove, Catskills* (see p. 123) sold in Philadelphia for $70.[40] Several Kensetts purchased by Daniel Huntington at the auction of Kensett's work in 1873 went in 1916 for roughly a tenth of their original price, one picture fetching as little as $6.[41] At that rate, the entire Kensett collection, numbering six hundred and fifty pictures and selling for $136,312[42] in 1873, would not have come to a fourth of what a single Inness could bring by the time America entered the First World War. Though the wide disparity in value

between Hudson River School works and Inness's paintings lessened in succeeding decades, it persisted through the 1950s.

THE RENAISSANCE OF THE HUDSON RIVER SCHOOL, the first glimmerings of which appeared after 1900, was a measured phenomenon marked by surges and subsidings through the 1960s. The revival took place in three fairly distinct phases, each beginning at a different period. In chronological order, these phases were the scholarly, about 1900; the popular and critical, at the time of the First World War; and the commercial, which began fitfully after the Second World War and fully blossomed only in the 1960s.

The scholarly revival, in its earliest days, is something of a paradox, since it is inseparable from the condescension that marked most critical writings from 1890 through the 1930s. Nonetheless, early-twentieth-century histories of American art, patterned on the hierarchical concept of art development typified in contemporary writings on European art and informed by the dominant, neo-Renaissance aesthetic culture here and abroad, kept the name of the School alive during the period of its worst popular and commercial neglect. The Hudson River School, while it may have represented something of a Dark Age between an American Antiquity (eighteenth-century portraiture) and an American Renaissance (represented by urbane practitioners, such as John La Farge, and by rugged individualists, such as Winslow Homer), remained an indispensable phase of transition that historians could not overlook.

In earlier histories dealing with the subject, the tone was not always abusive: authors frequently assumed the role of apologist and, with individual artists, guarded admirer. In 1902, more than two decades after the Hudson River School name was coined, Sadakichi Hartmann would use it only cautiously, refusing to segregate the School from later developments in mid-nineteenth-century landscape painting. Instead, he preferred to see a continuity between earlier and later styles, warning his contemporaries in the Society of American Artists: "It is ridiculous to be so narrow-minded as to believe only in one school. Why, in a few years, the impressionists will also 'be old fogies,' and lament over the inconsistency of art."[43]

By far the most influential survey during the first third of the twentieth century was Samuel Isham's *History of American Painting*, first published in 1905 and reprinted several times up to 1944. Isham clearly distinguished the Hudson River School, according it a separate chapter, but in so doing sought to define its role as an aesthetic hibernation between rich phases of English and French influence in American art. According to Isham, the School was made up of "the primitives, the men who followed most closely the ideals of Cole and Durand," and who were devoted to the literal transcription of nature to the virtual exclusion of European artistic precepts. They "lacked the indefinable quality of style inseparable from great painting," possessed "as a rule no breath of inspiration, no mastery of noble traditions," and served chiefly as a crude foundation for the achievements of Inness, Wyant, and Martin.[44] What emerges from Isham's history—half its twenty-seven chapters devoted to the last quarter of the nineteenth century—is some idea of the vast shift in values that took place between the 1860s and the 1900s.

A more qualified view was offered by Charles H. Caffin in his *Story of American Painting* (1907). Though he repeats the fashionable opinion that the Hudson River School was "at once too niggling and too comprehensive" in its landscape perception, he maintained that it should be "honoured." Caffin was the first historian to put Cole firmly at the helm of the movement instead of identifying him and Durand as pioneers leading to the School, and had the discernment to recognize strains of European-inspired American historical painting in the landscapes of Church, Bierstadt, and Moran.[45] Caffin's sensitivity to the School reflected to a degree the contemporary reawakening of interest in early-nineteenth-century American literature, particularly in the writings of Washington Irving, James Fenimore Cooper, and William Cullen Bryant, where Caffin found genuine affinities with the native sentiment and subject matter that had inspired the paintings of the Hudson River School.[46]

Ironically, the most severe assessments of the School were written after the group's first major retrospective exhibition, titled *Paintings of the Hudson River School*, was held at the Metropolitan Museum in 1917. In his book *American Painting and Its Tradition* (1919), John Van Dyke declared the School a "failure," following the "success" of American portrait painters who had "grasped the foreign teaching handed down by [Sir Joshua] Reynolds," and preceding landscape painters, such as Inness, who were "influenced by European art" and who "began to see [the native landscape school's] weaknesses."[47] In 1923, Royal Cortissoz, though conceding the sincerity and "glimpses of beauty" that salvaged the School's art from utter obscurity, adhered to the opinion of Isham and Van Dyke in concluding that "the spark of artistic longevity has gone out of their work."[48] By 1929, Suzanne LaFollette, in her book *Art in America*, subsumed the Hudson River School's achievement within three

chapters dealing with the period from 1800 to 1876, which she collectively titled "Material Expansion; Artistic Contraction." She disallowed any concept of painterly technique or composition among the School's representatives; to her, they all possessed "a common ignorance of the meaning of art."[49]

Van Dyke, Cortissoz, LaFollette, and other writers of the 1920s and 1930s not only reflect the persistent prejudice originating in the 1870s against the Hudson River School, but also exemplify a rearguard action against contemporary trends that threatened the cosmopolitan ideals affecting American art for sixty years. As LaFollette observed: "There is a strong tendency in the United States at present to deprecate the foreign influence and the fascination of foreign life for the American artist; to maintain that if American art is to be truly American it must develop on American soil. This prescription seems a bit drastic."[50]

Drastic though the prescription may have seemed to LaFollette, events of the fifteen or more years preceding her comments made it a compelling one, and one that was to have an indirect bearing on the restoration of the Hudson River School to popular and critical favor. The initial outrage and disillusionment of the art establishment caused in 1913 by the New York Armory Show, which introduced Fauvism, Cubism, and other Continental avant-garde styles to the American public; the cynicism and chauvinism engendered by the First World War; and the visceral blow dealt the country's self-esteem by the Great Depression created the environment in which the reputation of the nineteenth-century native school of landscape could regenerate and flourish. For much the same reason that the Hudson River School was originally labeled and castigated—its alleged provincialism—it was eventually to be championed.

The first major exhibition of Hudson River School painting was organized for an ostensibly regional purpose. In 1917, a major section of the Catskill Aqueduct, which channeled water from the old upstate sketching haunts of the Hudson River School to the metropolis that had been its headquarters, was completed. At the request of a mayoral commission, the Metropolitan Museum mounted the *Paintings of the Hudson River School* exhibition to coincide with the city's celebration of the opening of the aqueduct. A single gallery was filled with sixteen pictures culled from the Museum's collection of mid-nineteenth-century American paintings, and a catalogue of the show by Museum curator of paintings Bryson Burroughs was published as a supplement to the Museum *Bulletin* of October 1917. Despite the New York-oriented occasion, the exhibition catalogue emphasized the "national flavor in the Hudson River Painters," decried the "undeserved disrepute" into which the artists had fallen,

and illustrated the variety of subject matter, domestic and foreign, they had essayed. In tune with that reaffirmation of the School's national identity was another factor, probably also a contributing force in mounting the exhibition. Three years earlier, the Museum had received a bequest from Mrs. Morris K. Jesup consisting of paintings that included prime examples of the Hudson River School (see pp. 104; 156; 222; 263); in addition, Mrs. Jesup left $100,000 to establish a permanent fund "for the encouragement of American art." Burroughs featured the Hudson River School paintings prominently in an article he wrote on the Jesup collection in the *Bulletin* of April 1915, and they formed an impressive contribution to the 1917 show. In his exhibition catalogue, Burroughs also outlined the stylistic lineage traceable from Cole and Durand to the School's second generation— Church, Kensett, Cropsey, Bierstadt, Gifford, Whittredge, Wyant, Inness, Casilear, William Hart, Alfred Thompson Bricher, David Johnson—each reflecting aspects of the work of one of the two older men or of one another. Dutifully echoing the critical assessment of the day, he concluded that in Inness the Hudson River School reached "its highest achievement."[51]

The Metropolitan exhibition was the nucleus of a flurry of articles on and small shows of or including the Hudson River School from 1915 through 1925, reflecting and nourishing the increasingly isolationist temper of the contemporary American art establishment.[52] One writer, perhaps alluding to those responsible for the Armory Show, credited the Hudson River School artists with being the first Americans "to realize the great truth in art—or what was a great truth before the contemporary modernists spoke—that the actual study of nature was the purest fount of wisdom."[53] Another, writing in 1915, implicitly invoking a European art culture paralyzed by war, deemed the time "a fortunate moment to bring [the Hudson River School] forward, with America practically the only place left in which art schools may flourish."[54] Yet interest in the School could not be sustained throughout the 1920s, and after 1921 exhibitions devoted to it are hard to find. An article written by Lloyd Goodrich in 1925, to mark the centenary of the "founding" of the School by Thomas Cole, reflects the patronizing attitude of Goodrich's contemporary historians. Though admiring the Hudson River painters for their "simple and unpretending companionship with nature," he found their work "unpleasantly hot in color, thin in texture, and meager in form . . . painfully limited."[55]

The increasing American insularity caused by the Great Depression was manifested in the New York art world by the opening of the Whitney Museum of American Art and

by the rise of American Scene painting and Regionalism. Those events laid the groundwork for a durable and popular resurgence in the 1930s of both the Hudson River School and other genres of mid-nineteenth-century American painting. In 1932, the Macbeth Gallery, well established in New York as a showplace for American Barbizon and Impressionist painters, mounted its first historical exhibition of American art, which was devoted wholly to the School. Robert Macbeth, long a partisan and dealer of the modern art that had displaced in favor the paintings of the old landscape school and wary of the criticism of proponents of American abstraction, offered the exhibition almost apologetically, in the modest hope that it would "prove interesting to those who are willing to give a thought to this now far distant period of 'representational painting.'"[56] That time around, it assuredly did. Some critics not only wondered why the School had been neglected in the preceding decades, but were willing to recognize the "abundant craft" exhibited in the School's pictures; they also found remarkable its members' ability "to communicate the moods of landscape in a manner that truly and sometimes magically evokes praise."[57] After about 1880, only Inness and his followers—the American Barbizon painters—and the Impressionists had exhibited anything the critics considered poetic. Undoubtedly, the newfound sympathy for the Hudson River School was also fostered by the contemporaneous revival of English Romantic landscape painting and by the discovery, noted in a review early in 1932, that "the best landscapes of such men as Thomas Doughty, Asher B. Durand, Thomas Cole and Jasper F. Cropsey are just as fine as the works of all except the most illustrious of their English contemporaries."[58]

Public attention on the epoch dominated by the Hudson River School was maintained by the reemergence of mid-nineteenth-century genre painting in the period immediately following the Macbeth Gallery exhibition,[59] and gained impetus with a major retrospective of the School held in Chicago in 1945. The widely publicized Macbeth show had a measurable ripple effect that lingered through the Second World War. For the first time, museums began to publicize their holdings of mid-nineteenth-century American landscapes and to expand them with new acquisitions.[60] Other cities—Boston in 1933 and 1938 and Albany in 1939—played host to exhibitions devoted to the School and, in 1941, Albany offered a retrospective on Thomas Cole, the first showing in modern times of the works of a Hudson River painter.[61] The School became fixed in the public mind as an integral and major historical factor in American art by such landmark exhibitions as the College Art Association's *Background of American Painting* (1933), the Whitney Museum's *A Century of American Landscape Painting* (1938)—an undertaking unthinkable without the restoration of the Hudson River School to popular favor—and the Museum of Modern Art's *Romantic Painting in America* (1943).[62]

Resistance to the aesthetic validity of the School would persist even in the minds of its supposed advocates, whose attitudes were partly colored by traditional criteria and partly, perhaps, by a negative reaction to the nationalist and representational styles of American painting of the 1930s. In 1938, Whitney Museum curator Lloyd Goodrich, in selecting the eighty-one pictures that made up the museum's American landscape survey that year, included only thirteen by Hudson River painters, compared with twenty-eight representing the Barbizon and Impressionist styles—proportions that some critics of the show found unbalanced.[63] In the essay he wrote for the exhibition catalogue, Goodrich maintained the conventional theory that American landscape art had vastly matured in its evolution from the Hudson River painters to those perceived as antiacademic heroes of the late nineteenth century—Inness, Martin, Homer, and Thomas Eakins.

The Hudson River School and the Early American Landscape Tradition, an exhibition organized by Frederick A. Sweet at the Art Institute of Chicago in February 1945 and traveling to New York's Whitney Museum the following month, seemed to represent the ultimate vindication of the School at a propitious moment in American history. One of the most remarkable features of the exhibition was its size—164 oils, watercolors, and prints. In keeping with the exhibition's title, many works by painters not normally associated with the Hudson River School were included: Washington Allston, Ralph Blakelock, Albertis Browere, George Catlin, and John Neagle, to name a few. For the first time since the nation's Centennial Exposition, in Philadelphia, American landscape painting of the early and middle periods of the nineteenth century received the attention befitting its long duration and influence, with actual School paintings composing about sixty percent of the display. Thomas Cole alone was represented by thirty works. Sweet's catalogue essay broadly traced the School's literary foundations (pictorial influences were for the most part ignored), and he supplied biographies for each of the fifty artists whose work was included.[64] Inness was now interpreted as the "villain of the Hudson River melodrama," who had served mainly to import "a phony Impressionism based on the French."[65] That opinion, however misinformed and exaggerated it may have been, does indicate a shift in focus from the Barbizon and Impressionist schools back to the era of the Hudson River School's greatest authority.

The exhibition, arising partly from the country's postwar nationalism, was far from perfect. Its broad scope tended to obfuscate any idea of the School's true identity. Though it was properly weighted with the paintings of Cole (thirty), Durand (twelve), Church (nineteen), Kensett (eight), Bierstadt (seven), and Whittredge (five), a few major figures were severely underrepresented (Cropsey, by three paintings; Gifford, by only one), and far too much work by predecessors of the School and by its contemporary followers was included. Part of the disproportion could certainly be attributed to the near infant state of scholarship at the time and to the relative paucity of available pictures by some of the artists. Poor curatorial judgment was also a factor: according to one critic, the exhibition was so large and so unfocused that the experience of viewing it was exhausting.[66]

The effect of *The Hudson River School and the Early American Landscape Tradition* was beneficial to the School's reputation for a time. It stirred gallery owners to accelerate their attempts to find and to promote the sale of Hudson River School paintings and, in the late 1940s and early 1950s, it inspired a series of exhibitions in several other cities—Oberlin, Ohio, and Atlanta, Georgia, in 1946; Baltimore, in 1946–47; Oklahoma City, in 1948; Dallas, in 1949; Yonkers, in 1954; Boston, in 1957; as well as minor shows in New York City.[67] The Vose Galleries of Boston held annual exhibitions of Hudson River School paintings from 1944 until 1949, and, during that period, was responsible for several Hudson River School shows exported to public institutions in other states. Prior to the Chicago exhibition, only one painter of the group—Thomas Cole—had been accorded a solo retrospective, and that outside New York City. In New York, the Harry Shaw Newman Gallery earned special credit for mounting several one-man exhibitions: Kensett and Heade, both in 1945, and Cropsey and Durand, both in 1946. In 1949, Cole's work received a second and more thorough retrospective at the Wadsworth Atheneum in Hartford, Connecticut, and at the Whitney Museum in New York.[68] Nonetheless, the new enthusiasm in the United States for Abstract Expressionism and other nonrepresentational painting probably served to retard the interest in premodern native painting traditions that had built up in previous decades. Not until the late 1950s did advanced scholarship in American nineteenth-century art begin to mature; only in the 1960s did Cole's followers in the Hudson River School enjoy major retrospectives; only then did the market for their paintings take fire.

THE POSTWAR PERIOD has witnessed various revisions of the thinking that restored the Hudson River School to the forefront of American nineteenth-century landscape painting. Owing perhaps to several causes—the overinclusiveness of the Chicago show of 1945, the mediocre quality of some publications on the School,[69] the emerging prominence of nonrepresentational painting, and the formation and promotion of the Karolik Collection of American painting, with its deliberate concentration of landscape paintings by nonacademic artists, particularly Fitz Hugh Lane and Martin Johnson Heade—the School's apparent monopoly of the painting of its day, as interpreted by earlier historians, was challenged. After 1945 only a few scholars, including Virgil Barker and James Thomas Flexner, granted the Hudson River School the central place in American landscape painting that it had apparently earned by the time of the Chicago exhibition.[70] For the other historians, a wide range of motives—the lingering prejudice against the academic aspects of Hudson River School painting, the discovery of nonacademic landscapists of unarguable appeal, the rejection of developmental patterns of American painting that had been established in earlier accounts, the modernist tendency to endow certain mid-nineteenth-century landscape paintings with more relevance—led to questioning of the School as a stylistic entity.

In *American Landscape Painting: An Interpretation* (1948), the first serious modern book on the subject, author Wolfgang Born included the Hudson River School within the framework of a "panoramic style" that expressed a unique "space feeling" by American painters toward their native environment. To Born, the style had originated in the popular art form of the panorama and was the most original and indigenous mode of American expression.[71] In *American Painting; the Story of 450 Years* (1956), E. P. Richardson, ignoring the School altogether, discussed the Cole–Durand tradition within the international tide of Romanticism, and categorized the Hudson River painters of the second generation as either romantic naturalists or "luminists."[72]

By far the most influential, provocative, and controversial reexamination of the status and validity of the Hudson River School has been that brought about by the concept of American Luminism. Whether Luminism is to be regarded as "an alternative tradition" to that of the Hudson River School or, more generously, as the School's "culminating" or "closing phase," it has clearly supplanted the School historically as the primary representative of native expression in American nineteenth-century painting.

Luminism was first identified by John I. H. Baur in 1954, was strengthened and codified as a historical concept by Barbara Novak in 1969, and was consecrated (much as

the Chicago show had done in 1945 for the Hudson River School) in the exhibition *American Light: The Luminist Movement* organized by John Wilmerding at the National Gallery of Art in 1980. Though Luminism has been variously defined by art historians since its inception, the use of the term is ideally restricted to cabinet-size, strongly horizontal paintings of water or recumbent terrain in which clarity of light, atmosphere, and terrestrial forms are paramount features (Fig. 1.9). The quietude and austerity of Luminist compositions are in stark contrast to what is held to be the most typical and surely most visible category of Hudson River School paintings: the monumental, picturesque compositions of Cole, Church, and Bierstadt. Such Hudson River School painters as Kensett and Gifford, among others, are considered to have frequently practiced in the Luminist mode, but some ideal Luminists—the marine painter Fitz Hugh Lane, for example—are not identified with the School.

Baur developed the original theory of Luminism in three articles, beginning in 1948, when he introduced the term obliquely in relation to the work of Lane and Heade, two nonacademic American landscape painters little known up to that time. Baur saw Lane and Heade as part of a "spontaneous and general movement towards research in atmospheric problems" that took form in the 1840s and 1850s, paralleling the trend toward Impressionism in France. He distinguished the movement from that of "our most prominent landscape group of the period, the Hudson River School, [which] tended to neglect these [researches] in favor of romantic composition and a generally brown tonality."[73]

In 1949, in an essay titled "Trends in American Painting, 1815–1865" (the trends were those illustrated by the newly formed Karolik Collection of mid-nineteenth-century American painting), Baur repeated the ideas he had proposed earlier and, using the term "pantheistic realism," added informal composition as one of Luminism's characteristics. Again, he contrasted that feature with "the contrived and artificial feeling" of Hudson River School compositions. More significant for the future study of American art history, however, was that Baur's discoveries led him to the conclusion that "the least productive approach" to American painting "is that which treats of schools and influences."[74]

In 1954, Baur summarized his previous findings and elaborated on them in a third article, "American Luminism." A notable point he made was that the empiricism that guided such Luminist landscapists as Lane and Heade also affected genre painters—William Sidney Mount and George Caleb Bingham, to name but two—who could be considered as adherents to Luminism. Though Baur admitted in his three articles that several Hudson River School painters "contrib-

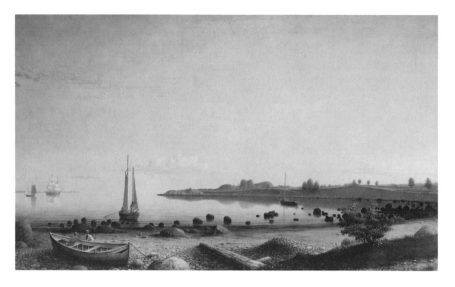

Figure 1.9. Fitz Hugh Lane, *Stage Fort Across Gloucester Harbor*, 1862, 38 x 60 in. (96.5 x 152.4 cm.). The Metropolitan Museum of Art, Purchase, Rogers and Fletcher Funds, Erving and Joyce Wolf Fund, Raymond J. Horowitz Gift, Bequest of Richard De Wolfe Brixey, by exchange, and John Osgood and Elizabeth Amis Cameron Blanchard Memorial Fund, 1978 (1978.203)

uted notably to the [Luminist] movement," he maintained that "the school as a whole was more interested in panoramic and picturesque effects than it was in light."[75]

The design and content of Barbara Novak's *American Painting of the Nineteenth Century: Realism, Idealism, and the American Experience* (1969) confirmed and elaborated on Baur's original theory. Novak made Luminism, which she called "one of the most truly indigenous styles in the history of American art," the core of a conceptual tradition that extended from the portraits of John Singleton Copley to the color-field paintings of Mark Rothko. Whereas to Baur, the common "personality" that defined the Luminists' work was American light and atmosphere,[76] Novak considered the personality to be a peculiarly American attitude toward the objective world, which prevented the Luminist painters from disintegrating form in their exploration of the problems of light and atmosphere, and she contrasted the aesthetic results thus achieved with the amorphous vision of the Impressionists in France a few years later. Both writers found support for their views in the philosophy of American transcendentalism, roughly contemporaneous with the Luminist phenomenon; to both, Ralph Waldo Emerson's well-known image of the "transparent eyeball" was analogous to the egoless persona of the Luminist artist, who refrained from interposing his temperament between the world and the viewer of his painting. To Novak especially, that effacement of self arose from the artist's reverence for the essential

sacredness of every individual object, each imbued with both Platonic and Christian idealism; the attitude was seen as common to both transcendentalism and Luminism.

Further, where to Baur, Luminist compositions were characterized by an overall informality, Novak found a finely calculated "classic structure" both two-dimensional and spatial. In her scheme of how American art developed during the nineteenth century, Luminism, Lane, Heade, Mount, and Bingham each warranted a separate chapter in her book; Hudson River School painting, typified by the work of Cole and Durand, represented essentially a "compromise solution" to the polarities of "the real and the ideal." Novak discerned "a tripartite division" in Hudson River School painting—consisting of ambitious picturesque compositions, plein-air studies, and "a *luminist* style"—but nonetheless deemed Luminism "an alternative tradition" to that of the School, and the marine painter Lane to be Luminism's ideal exponent.[77]

John Wilmerding, in his book *American Art* (1976) and in his introductory essay to the catalogue for the exhibition *American Light* (1980),[78] proposed a historical framework rebutting "the more traditional and often uneven Hudson River school surveys." He emphasized that the School had inaugurated the American landscape painting tradition, yet to him, "the luminist view" was its "culminating phase," its "conclusive development," and "the central movement in American art through the middle of the nineteenth century."[79] He saw in Thomas Cole a co-originator of Luminism with Lane, who to Wilmerding was not merely the ideal exponent of the movement but its "founding figure" as well.[80] Into the development of Luminism, Wilmerding projected more substantive factors: the brighter cadmium pigments being introduced at mid-century and the influential writings of John Ruskin, champion of Joseph Mallord William Turner and the English Pre-Raphaelite artists. He also expanded the ranks of Luminist adherents to include almost all the important Hudson River School painters, particularly Frederic Church, whose explorations of sunset effects could scarcely be ignored in any review of pictorial investigations of light in the 1850s.[81]

The splendid sprawl of the *American Light* exhibition of 1980, with more than three hundred and fifty works, ranging from Washington Allston to Ralph Albert Blakelock and including examples of drawings and photographs, reflected the enlarging ranks of artists considered as Luminists.[82] In the view of some critics, however, the visual appeal of the exhibition and its accompanying book hardly served to give further definition to the Luminist movement;[83] rather, *American Light* constituted something of a weightier

reprise of *A Century of American Landscape Painting*, the Whitney show of 1938, but with a preponderance of mid-century, rather than late-century, pictures.

Throughout the period of the development of the theory of Luminism, its tenets have certainly been questioned and sometimes rejected. Flexner categorized Luminism as "one aspect of the normal practice of the school Kensett led" (that is, Kensett's Hudson River School contemporaries).[84] William Gerdts hailed a Luminist aesthetic in mid-nineteenth century American painting, but found its validity as a movement weakened because its historical lineage, both domestic and international, was not convincingly traced.[85] Theodore Stebbins, in an essay published in Wilmerding's *American Light* catalogue, found Luminism an important but rare phenomenon in American painting, and its modern importance inflated out of all proportion to historical record. He questioned the "indigenousness" of American Luminism, illustrating his doubts with numerous counterparts in contemporary European landscape painting. In proposing that Luminism "may better be seen as a last-ditch attempt to make the Hudson River School style of [Durand] and Church serve the complex psychic and aesthetic needs of post–Civil War America," he seemed to refute the modern assumption that the Hudson River School style was essentially sublime or picturesque.[86] To Stebbins, apparently, Luminism was a kind of reduction of the Romantic conventions that had guided Cole and Durand, and was essentially consistent with the aims and the ideals of the founders of the School.

Few observers today would dispute that the Luminist theory has isolated a distinct and significant strain in American landscape art: one that above all others possesses the most aesthetic appeal; one that reveals a visual similarity with modern art from French Impressionism to the American color-field painting of the 1960s. Some historians, however, have felt that the modern point of view that has helped to shape Luminist theory has inevitably served to distort the perception of historical inheritance in nineteenth-century American landscape painting; that the scholarly focus on Luminism has been made at the expense of a better understanding of historical trends. Over the last four decades, therefore, the varied but integral character of the Hudson River School—the group's cohesiveness and heterogeneity, its insularity and sophistication, conventionality and originality, as well as the specific pictorial effects produced by the amity and rivalry among its representatives—has been more generally assumed than seriously examined. Accordingly, there is a great need to redirect scholarly focus on the School, on its time-acknowledged artistic paternity in Cole and Durand, and on its organizational framework in the National

Academy, the Century Association, and the Tenth Street Studio Building.

THE AMBIGUOUS ATTITUDE toward the Hudson River School manifested by historians in the postwar years has not inhibited the School's commercial revival. On the contrary, interest in Luminism has probably helped to foster one of the most remarkable appreciations in the art market in modern times. Admittedly, the recent focus on collecting mid-nineteenth-century American landscape painting must be regarded in the context of the general revival of interest in American art, which matches the rediscovery by other nations, particularly England, of their own treasures of nineteenth-century academic painting. The market has also been created in part by the gradual disappearance of affordable old-master and Impressionist works.[87] In the domestic market in American paintings, works by the members of the Hudson River School frequently have led the way in setting new price standards.

The restoration of the School to critical attention in the years from about 1915 to 1945 took three decades to accomplish, but its revival in commercial terms is of shorter duration. Demand for School paintings remained slow up to the mid-1960s; until then, the succession of exhibitions, articles, and books devoted to or including the Hudson River School had an only moderate effect on the actual value of representative pictures. Whereas in the 1910s, the paintings could easily be had for well under $100, prices in the $150 to $300 range were the norm by the early 1940s, with exceptional paintings bringing $1,000.[88] Compared with the average cost—about $210—of a painting sold at the Kensett estate auction in 1873, prices of Hudson River School works reflected almost no increase in value during the 1930s and 1940s. A spate of activity following the exhibition in Chicago in 1945 raised the average price of a School painting to about $500. Over the next fifteen years, however, interest subsided, while preference for the Barbizon-style landscapes of Inness continued, with prices for his work generally more than $1,000.[89]

By 1962, striking increases in the prices of mid-nineteenth-century American landscapes began to occur, beginning with the $8,000 paid for a Luminist picture, Fitz Hugh Lane's *Boston Harbor, Sunset* (Fig. 1.10).[90] Over the next few years, the growth in value was extraordinary, first broadening to include, and then to be dominated by, works of Church and Bierstadt—the market leaders of a century earlier. A major canvas by Church, originally sold by the artist for $7,500 and reduced to $1,500 in 1897, was pur-

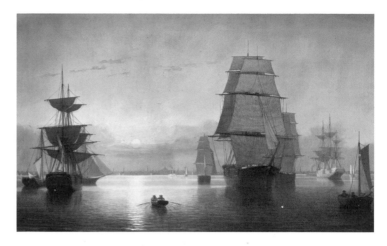

Figure 1.10. Fitz Hugh Lane, *Boston Harbor, Sunset*, 1850–55, oil on canvas, 24 x 39¼ in. (61 x 99.7 cm.). Collection of Jo Ann and Julian Ganz, Jr.

chased for $10,000 in 1965, and was sold in 1970 to a museum for a reported $160,000.[91] In 1972, Bierstadt's *Emigrants Crossing the Plains* brought $175,000—four times as much as its value in 1869.[92] Generalizations on trends in prices are difficult to justify, but it is probably not exaggerating to estimate that the prices of paintings by major Hudson River School artists increased five- to tenfold through the 1960s. At that time, dealers were euphoric: the trading was so feverish that some of them predicted that the market would collapse in from ten to fifteen years.[93]

Yet the furor has hardly subsided. For the six years from 1979 to 1985, the record auction price of an American painting was for Church's monumental canvas *The Icebergs*, sold for $2,500,000 in 1979.[94] Though few other mid-nineteenth-century landscape pictures could rival the scale, historical importance, spectacular visual qualities, and price of that work, noteworthy sums well into the hundreds of thousands of dollars have remained common for Hudson

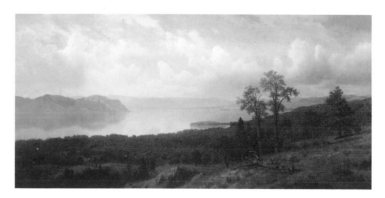

Figure 1.11. Albert Bierstadt, *View on the Hudson Looking across the Tappan Zee towards Hook Mountain*, 1866, oil on canvas, 36¼ x 72¼ in. (92.1 x 183.5 cm.). Private collection

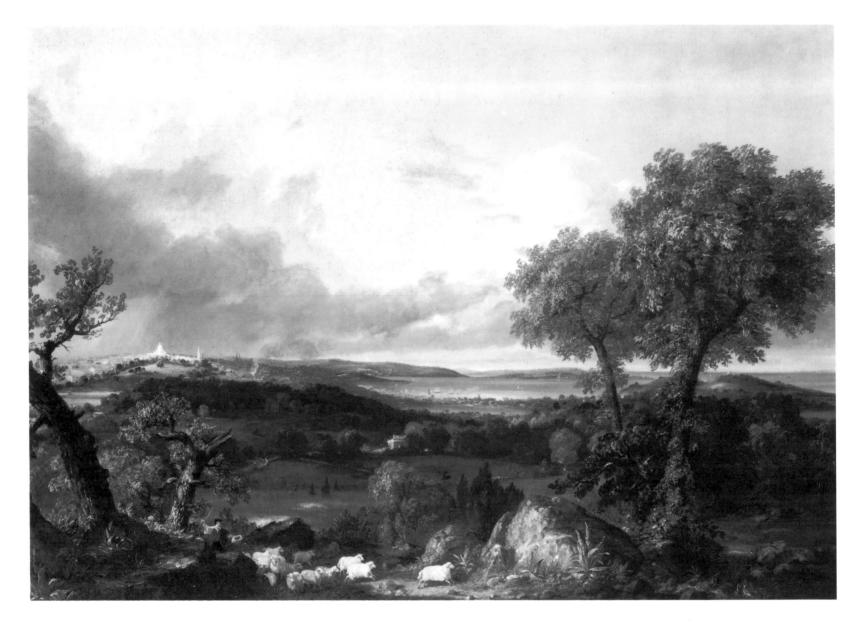

Figure 1.12. Thomas Cole, *View of Boston*, ca. 1839, oil on canvas, 34 x 47⅛ in. (86.4 x 119.7 cm.). Private collection

River School paintings. Bierstadt's *View on the Hudson Looking across the Tappan Zee towards Hook Mountain* (Fig. 1.11), auctioned for $115,000 in 1975, brought $675,000 a decade later.[95] Thomas Cole's *View of Boston* (Fig. 1.12) went for $900,000 in 1984. Other painters have fared almost as well at recent auction: $600,000 for a Cropsey (Fig. 1.13); $540,000 for a Kensett (Fig. 1.14); $185,000 for a Gifford measuring nine by sixteen inches.[96] Paintings by Heade and Whittredge went for about $300,000 at auction in 1981,[97] but more recently sold for considerably higher sums in private transactions. On a lower scale, paintings by

such lesser masters as Francis A. Silva have fetched as much as $125,000,[98] while minor works by Hudson River School masters—small studies and sketches in oil and in watercolor, the kind of paintings that brought about $210 (the equivalent of $1,700 in today's terms) at the Kensett auction in 1873— now bring prices in the tens of thousands of dollars.

The revival of the market for Hudson River School paintings has surely been partly caused by increasing scholarship in the postwar years, but, in its turn, it has stimulated that scholarship. From 1968 through 1976, several important exhibitions devoted to the School have been mounted, and most of its major representatives have been the subject of monographs, dissertations, and retrospective exhibitions.[99] In addition, as Wilmerding's *American Art* makes

clear, the need to render a history of American landscape painting that establishes the proper role of the Hudson River School has already been demonstrated by adherents to the Luminist theory. Recent exhibitions, such as *The Düsseldorf Academy and the Americans*, at the National Collection of Fine Arts in 1973, and *The New Path: Ruskin and the American Pre-Raphaelites*, organized at The Brooklyn Museum in 1985,[100] have also served to illuminate distinct historical movements that affected the Hudson River School aesthetic. It cannot be denied that exploration into new theories has instigated broad investigation of the literary, philosophic, and scientific environment of mid-nineteenth-century art, and has added immeasurably to the understanding of the cultural ambience in which American landscape painters worked. Nevertheless, while serious studies on the careers of the premier Luminists Lane and Heade have both been published, monographs on Cole and Gifford are only now in press.[101] Moreover, students of the art of Durand, Cropsey, Kensett, Whittredge, and most of the secondary landscape painters must be content for the present with dissertations and exhibition catalogues. Only two small books dealing specifically with the Hudson River School have appeared since 1947: *The Hudson River and Its Painters*, by John K. Howat (1972), and *American Wilderness: The Hudson River School*, by Barbara Babcock Lassiter (1978), both designed mainly for a popular audience.[102] In spite of the relative neglect of the School, scholarly writings, the accumulated original papers of American artists and documents on American art made widely available in recent years, and the increased number of newly discovered paintings now make possible a meaningful and definitive study of our first American school of landscape.

WHILE MODERN SCHOLARS have identified a host of distinct styles and sensibilities in mid-nineteenth-century American landscape paintings—from Romantic, Grand, Salon, and panoramic styles to Realist, naturalist, and Luminist—it is clear that contemporary critics recognized in the Hudson River School an overall consistency of approach that bespoke the social unity of the New York landscape painters and justified the single label embracing them all. That painters like Kensett, Gifford, and Heade chose not to tread the histrionic paths of Cole, Church, and Bierstadt did not sufficiently differentiate their basic aims from those of the louder talents. Outwardly, at least, and up to the 1870s, there existed among the academic landscape painters little of the discord that might have engendered styles consciously dissenting from certain basic conventions—among them a

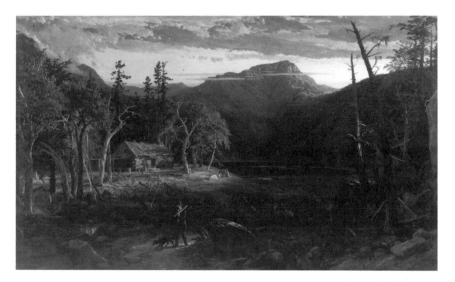

Figure 1.13. Jasper Cropsey, *The Backwoods of America*, 1858, oil on canvas, 42 x 70¼ in. (106.7 x 178.4 cm.). Private collection

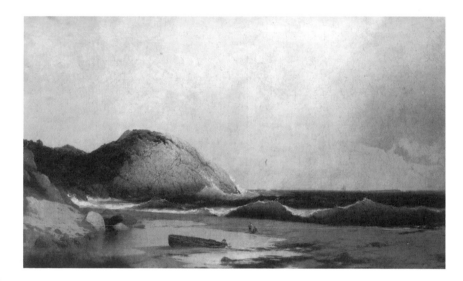

Figure 1.14. John F. Kensett, *Eagle Cliff, Coast of Massachusetts*, 1859, oil on canvas, 28½ x 45½ in. (72.4 x 115.6 cm.). Collection of Alexander Gallery, New York City

general fidelity to the features of a specific place; a carefully constructed composition of those features, however elaborate or simple the artist chose to make it; and a high degree of finish.

In the 1860s, perhaps the only exceptions to any of those standards were those that represented the philosophy and art of Inness and those that represented the American Pre-Raphaelite movement. Inness, in reaction to several academic painters who were mounting ostentatious single-picture exhibitions, deliberately professed his Barbizon-inspired style by showing independently his large canvas *The*

Sign of Promise (repainted as *Peace and Plenty* [1863; Metropolitan Museum]), and by accompanying it with a manifesto of sorts that attempted to justify the role of the emotions in landscape painting. His defiance, which had little immediate effect on the style of his contemporaries, constituted only a distant premonition of the ultimate decline of the Hudson River School style.[103] At the opposite end of the spectrum, the American Pre-Raphaelites—among them Thomas Charles Farrer, John Henry Hill, Charles Herbert Moore, and their spokesman, Clarence Cook—began in 1863 to assail the New York Academicians as not factual enough in their representation of nature. That challenge, voiced largely by Cook in *The New Path*, the movement's literary vehicle, caused considerable consternation within academic circles.[104] Though the American Pre-Raphaelites undoubtedly elevated the standard of fidelity to nature for several landscape painters, as is evident in some of the works of Heade, David Johnson, and, especially, William Trost Richards, the essential standard predated the organization of the movement. The New York painters had been familiar with and sympathetic to Ruskin's precept of "truth to nature" since the early 1850s: it undoubtedly had already been reflected to a greater or lesser degree in Durand's art and aesthetic as expressed in his "Letters on Landscape Painting," published in 1855 in *The Crayon*, and it was especially visible in the art of Church, by 1857 acknowledged as America's leading landscape painter. The work of the American Pre-Raphaelites themselves was not widely purchased or promoted; the movement, rather than vitiating the fundamental principles of academic landscape painting, probably fortified them.

However modern scholars may seek to refine the shifting currents in mid-nineteenth-century landscape painting, there seems to be no good reason to downplay or discard as vague or obsolete the original concept of the Hudson River School. Debate may continue for years as to whether several names—Bierstadt, Heade, Inness, for example—should be associated with the School, but the essential coherence of the School's point of view is self-evident and given meaning by the close social networks among the painters who adopted it. The modern observer may justly dismiss the disparaging connotation of provincialism the term imputes to the mid-nineteenth-century New York landscape painters, and may well agree with Theodore Stebbins that "First New York School" would identify the group more accurately.[105] Nevertheless, the Hudson River School name possesses an authority gained through a century of use, and now seems particularly apt in evoking the urban headquarters of the group, the river communities in which many of the painters took up residence, and the upstate wilds and resorts that were, if not their exclusive ranges, their original and persistent inspiration. The name, designating the first significant artistic fraternity in America, remains fitting.

THE EXALTATION OF AMERICAN LANDSCAPE PAINTING

Oswaldo Rodriguez Roque

THE RISE OF A NATIVE SCHOOL of landscape painting in New York in the middle decades of the nineteenth century must surely be reckoned as one of the most important developments to have taken place in the still short cultural history of the United States. Not only did the creation of a distinctive style of landscape painting hold enormous significance as a manifestation of increasing maturity in the field of art, but it was also a palpable embodiment of a host of ideas either deeply held or deeply pondered by the American people at the time. Major human concerns—relating to God, nature, and morality, as well as to the nation's mission and future, the management of its resources, and the achievement of its social stability and happiness—all found their way into works of art. Other questions, more properly limited to the profession of painting—of draftsmanship, brushstroke, coloring, scale, and proportion—were examined in the context of the larger concerns and made to respond to them. Unlike many of the great American literary figures of the period (Ralph Waldo Emerson, Henry David Thoreau, and Herman Melville among them), who cultivated a degree of detachment and frequently adopted a critical stance in their writings, the Hudson River School painters seldom expressed feelings of alienation or fundamental dissatisfaction with American life. In their canvases, the storms are usually passing ones; the blasted trees and shipwrecks, however negative their immediate associations, are also invitations to salutary meditation; and the moments of eerie calm put us in touch with higher spiritual realities. Pain and loss are sometimes alluded to, not as indictments of accepted social arrangements but always as part of the human lot. Yet escapism did not become the rule as a result of that way of looking at America and the world, nor did a shortage of individual ambition obtain. The drive for personal achievement on the part of the artists—for wealth, status, and a recognizable painting manner; for a chance to address commonly perceived issues in an original and successful way—charged the School in its heyday with considerable dynamism and steered its adherents away from the twin dangers of mindless repetition and imitation.

FROM 1783, AND THE SIGNING of the treaty of peace with Great Britain, America's leading intellectual lights had been clamoring for an art with a recognizably American stamp. After 1820, when the Reverend Sydney Smith, writing in the prestigious *Edinburgh Review*, asked: "In the four quarters of the globe, who reads an American book? Or goes to an American play? Or looks at an American picture or statue?,"[1] the clamor grew in intensity. As the American novelist Charles Brockden Brown saw it, a native art was

something more easily desired than achieved. The British cultural hegemony would be difficult to overthrow, though time would take care of that. Brown considered the intellectual soil of America to be comparatively sterile: "While we can resort to foreign fields, from whence all our wants are so easily and readily supplied, and which have been cultivated for ages, [we do not] find sufficient inducement to labour on our own."[2] Other, more sanguine men—De Witt Clinton, governor of New York, for one—nevertheless called for active encouragement of the arts and pointed to nature as an unexploited source of American inspiration, one practically guaranteed to yield fruitful results. In 1816, in an address he delivered at the opening ceremonies of the New York-based American Academy of the Fine Arts, Governor Clinton praised both the American wilderness and the American cultural landscape as fit subjects for native art:

> And can there be a country in the world better calculated than ours to exercise and to exalt the imagination—to call into activity the creative powers of the mind, and to afford just views of the beautiful, the wonderful, and the sublime? Here Nature has conducted her operations on a magnificent scale: extensive and elevated mountains—lakes of oceanic size—rivers of prodigious magnitude—cataracts unequaled for volume of water—and boundless forests filled with wild beasts and savage men, and covered with the towering oak and the aspiring pine.
>
> This wild, romantic, and awful scenery is calculated to produce a correspondent impression in the imagination—to elevate all the faculties of the mind, and to exalt all the feelings of the heart. But when cultivation has exerted its power—when the forest is converted into fertile fields, blooming with beauty and smiling with plenty, then the mind of the artist derives a correspondent color from the scenes with which he is conversant: and the sublime, the wonderful, the ornamental and the beautiful thus become, in turn, familiar to his imagination.[3]

In spite of such perorations, the American landscape painters working during the first two decades of the nineteenth century had been unable to make a radical break with the eighteenth-century English conventions they knew either through prints or through direct acquaintance with English works of art. Beginning in the mid-1820s, however, with the appearance of Thomas Cole's first successful Romantic landscapes, that situation changed markedly.

Undoubtedly the most ambitious and the most complicated figure in the history of the Hudson River School, Cole was early on recognized as its founding father. In his letters, essays, and poems, he intelligently discussed so many of the problems confronting the American landscape artist in the early days of Jacksonian democracy and articulated so many of the solutions that would later become canonical in Hudson River School doctrine that to discuss his contributions except at some length is impossible. Cole was so much *the* pioneer American landscape painter that to view the work of those who came after him as a long meditation on, or an extension of, his ideas and accomplishments would not be unfair.

In 1818, as a fairly mature young man of seventeen, Cole came to America with his family from Lancashire, England. He had been trained in his native country as an engraver of woodblocks used in the printing of textiles and had been exposed to some traditional schooling. But neither the autobiographical account Cole sent to William Dunlap for use in the latter's *History of the Rise and Progress of the Arts of Design in the United States* (1834) nor the more complete account of his life written after his death by the Reverend Louis LeGrand Noble includes much about Cole's early years in England. Cole confessed to reading travel books, especially about America, and to having entertained a youthful fascination with this country, but never admitted to having been exposed to the Romantic ideas that already decisively shaped his thinking only a few years after his arrival. Cole's insistence on freshness of sensation, his belief that nature manifested to man the mind of the Creator as much as did revealed religion, his acceptance of the role of the artist as seer and prophet, and his confidence in his own superior genius can be understood only in light of the poetic works of Byron, Coleridge, Keats, and Wordsworth, with which Cole was clearly familiar, probably through the agency of his sisters, who ran a school for girls in Ohio. Yet Cole implied by his silence that he was certainly the product of his adopted country, and, when it came to discussing the origins of his career as a painter, asserted that they had been the result of reading a treatise on painting lent to him by an itinerant portraitist he had met in frontier Ohio. Obviously, Cole had entered into the spirit of the American "new man" myth, and probably perceived as early as 1820 that great advantages would accrue to the artist—be he poet, novelist, or painter—who could answer the call for American cultural independence. Thus, even in those early years, one may see developing in Cole ambivalent attitudes toward his European heritage, especially his English background. Still, as one surveys his accomplishments up to the time of his trip to Europe in 1829, it must be admitted that it was squarely within a matrix of English Romantic ideas that his talents as a painter unfolded. In 1823, in Pittsburgh, where Cole had once again followed his ne'er-do-well father, who was now operating a floor-cloth manufactory, one of those epiphanies experienced by sensibilities steeped in early English Romanticism took place. Its implications for Cole's painting style would in short order

push him to the forefront of the ranks of landscape painters in America. As Dunlap tells it:

> The spring had arrived, and the young painter seemed to awake to the beauties of nature in landscape, and to feel not only his love for, but his power in that branch of art. Heretofore, in his pursuit of art, he had been straying in a wrong path. He now began in 1823, to make studies from nature. Every morning before it was light, he was on his way to the banks of the beautiful Monongahela, with his papers and pencils. He made small, but accurate studies of single objects; a tree, a leafless bough—every ramification and twig was studied, and as the season advanced he studied the foliage, clothed his naked trees, and by degrees attempted extensive scenes. He had now found the right path, and what is most extraordinary, he had found the true mode of pursuing it.[4]

That attitude toward the close observation of nature, nurtured by the type of conviction usually reserved for religious beliefs, turned Cole into a painstaking draftsman and a tireless hiker. Washington Irving, then America's most respected literary figure, had pronounced in 1820 that "he . . . who would study nature in its wildness and variety must plunge into the forest, must explore the glen, must stem the torrent, and dare the precipice."[5] Cole could not have agreed more.

From that point on, events moved swiftly for Cole. In November of 1823, now determined to become a painter, he returned to Philadelphia, where he studied the old-master paintings hanging at the Pennsylvania Academy of the Fine Arts and came to admire the landscapes of Thomas Birch and Thomas Doughty (Figs. 2.1; 2.2), two artists who at that point were far more proficient than he. Both Birch and Doughty had made serious attempts in many of their works to convey the recognizably American qualities of the native landscape, but, unfortunately, their lack of familiarity with recent Romantic ideas prevented them from bursting the formal conventions they had come to accept. Eager to disappear into the sometimes threatening bosom of nature, because God dwelt there, Cole became increasingly accomplished in his draftsmanship, sure of his prophetic mission, and full of ideas about the peculiar qualities of the American wilderness, which he regarded as quintessentially sublime and therefore fit for the agitated compositions he had observed at the Pennsylvania Academy in works by, or after, the seventeenth-century Italian master Salvator Rosa. He was now ready to go beyond their example. The Romantic stance that had prompted his Pittsburgh experiments thus came to his rescue once again, and, in the spring of 1825, Cole left Philadelphia for New York, where his family had gone after the failure of his father's Pittsburgh business venture. In New York, a city of rising commercial and cultural importance, of new for-

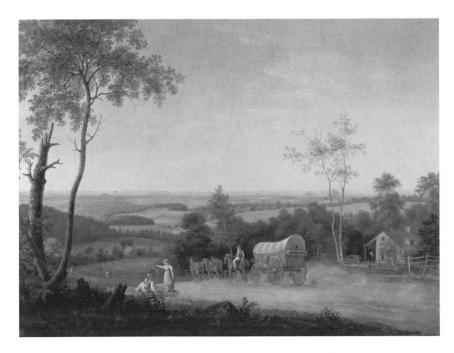

Figure 2.1. Thomas Birch, *Conestoga Wagon on the Pennsylvania Turnpike*, 1816, oil on canvas, 21¼ x 28½ in. (54 x 72.4 cm.). Courtesy, Shelburne Museum, Shelburne, Vermont

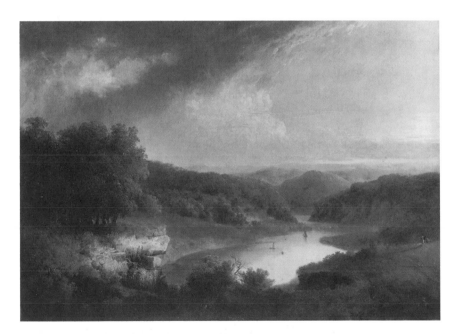

Figure 2.2. Thomas Doughty, *Landscape with Sailboats*, ca. 1825, oil on canvas, 20⅛ x 28 in. (51.1 x 71.1 cm.). The Boston Athenaeum, Bequest of Martha G. Watriss (U.R.34.1936)

tunes and boundless energy, Cole found himself able to seek the novel subject matter, the direct experience of nature, and the freshness of response that were lacking in the work of such other landscape painters as formed his competition.

More than ever, his ambitions seemed attuned to the rising tide of American cultural nationalism. The Knickerbocker writer James Kirke Paulding, soon to become a friend of Cole's, believed that only a great assertion of individuality was likely to produce the true American artist:

> By freeing himself from a habit of servile imitation; by daring to think and feel, and express his feelings; by dwelling on scenes and events connected with our pride and our affections; by indulging in those little peculiarities of thought, feeling and expression which belong to every nation; by borrowing from nature and not from those who disfigure or burlesque her—he may and will in time destroy the ascendancy of foreign taste and opinions and elevate his own in the place of them.[6]

Paulding did not stop to think that his prescription was fundamentally a Romantic one, reflective of European ideas. For him, as for Cole, Romanticism was *the* vehicle of national expression.

By making a long-anticipated, solitary excursion up the banks of the Hudson in the fall of 1825, a trip that immersed him in the striking autumnal beauty of the Catskills, Cole decisively liberated his imagination in the manner prescribed by Paulding. The paintings that resulted caused a sensation in the New York art world and brought Cole to the attention of three of its most important members: John Trumbull, president of the American Academy of the Fine Arts; Asher B. Durand, then admired as the finest American engraver; and William Dunlap, portraitist, playwright, and chronicler of American art, each of whom purchased a work. The venerable Trumbull, himself no stranger to landscape painting, approvingly noted: "This youth has done what I have all my life attempted in vain."[7]

Despite the obvious exaggerations of those early Catskill views of Cole's—excessively contorted trees, improbable chiaroscuro effects, and a palette tending to overheat—they are nothing less than small miracles. The examples of Rosa's works Cole was probably familiar with may have suggested to him how to produce agitated compositions, and some familiarity with the writings of William Gilpin, the English advocate of the theory of the Picturesque, whom Cole had certainly read by then, may have encouraged him to arrange his pictures so that contrasts of form, texture, and tone would create a lively visual drama, but, in the final analysis, Cole's early pictures are mostly the result of his own considerable originality.[8] By adopting unusual points of view, he put the viewer in situations where extraordinary vision was possible and where the painter's own sense of danger and revelation might be shared. In dramatizing the foreground, turning the middle ground into an arena for the clash of large masses, and elevating and deepening the distant ground, Cole created a pictorial formula tailor-made for wilderness scenes. Paintings such as *Falls of Kaaterskill* (see p. 120) and *The Clove, Catskills* (see p. 123) break so decisively with the orderly rules of smooth recession and secure vantage point with which American scenery had been previously approached as to border on aesthetic bad manners. By those works, Cole delivered to the nation what it had desperately yearned for—a recognizable image of itself in art. The well-traveled Philip Hone, former mayor of New York and a highly educated self-made man, was able to sense precisely what Cole had achieved: "His pictures are admirable representations of that description of scenery which he has studied so well in his native forests. His landscapes are too solid, massy and umbrageous to please the eye of an amateur accustomed to Italian skies and English park-scenery, but I think every American is bound to prove his love of country by admiring Cole."[9]

Unfortunately for Cole, the great success of his first New York landscapes put him in a kind of artistic straitjacket. Thenceforth, he found his patrons, eager for more of the same, warning him against any overly fanciful flights of his Romantic imagination. Robert Gilmor, of Baltimore, one of Cole's first patrons, articulated the opinions of the great majority of his new admirers when he advised the painter:

> Above all things however, *truth* in *colouring* as well as in *drawing* the scenes of our own country is essential. . . . As long as Doughty *studied & painted* from nature . . . his pictures were pleasing, because the scene was real, the foliage varied & *unmannered*, & the broken ground and rocks and moss had the very impress of being after *originals*, not *ideals*. His *compositions* fail I think in all these respects, & have now so much uniformity of manner in them that they excite no longer the same agreeable feelings in me that his very *earliest* sketches did. 'Tis true they have more *effect*, & sometimes some spirit in consequence, but these do not compensate for the pleasing verity of *nature*.[10]

In other words, nature was not to be misrepresented or trifled with. Cole, however, knew that his veristic American landscapes were the result of his Romantic attitudes and not of an attempt to achieve realism for its own sake. He therefore resisted all attempts on the part of his patrons, including Gilmor, to confine his art to an easily comprehensible realism. For Cole, fidelity to observed fact was a means for apprehending greater truths. Greater truths, however, could not be made servile to observed fact. If such truths were to be communicated to the viewer, the landscape artist must be free to compose his views according to his own ends. In his

reply to Gilmor, a statement remarkable not only for its seriousness but also for its daring, especially in view of the writer's youth and limited knowledge of actual examples of European art, Cole again revealed his independent turn of mind:

> I really do not conceive that compositions are so liable to be failures as you suppose, and bring forward an example in Mr. Doughty. If I am not misinformed, the finest pictures which have been produced, both Historical and Landscape, have been compositions: certainly the best antique statues are compositions. Raphael's pictures, & those of all the great painters, are something more than imitations of Nature as they found it. I cannot think that beautiful landscape of Wilson's in which he has introduced Niobe and children an actual view; Claude's pictures certainly not. If the imagination is shackled, and nothing is described but what we see, seldom will anything truly great be produced either in Painting or Poetry. You say Mr. Doughty has failed in his compositions: perhaps the reason may be easily found—that he has painted from himself, instead of recurring to those scenes in Nature which formerly he imitated with such great success. It follows that the less he studies from Nature, the further he departs from it, and loses the beautiful impress of Nature which you speak of with such justice and feeling. But a departure from Nature is not a necessary consequence in the painting of compositions: on the contrary, the most lovely and perfect parts of Nature may be brought together, and combined in a whole that shall surpass in beauty and effect any picture painted from a single view. I believe with you that it is of the greatest importance for a painter always to have his mind upon Nature, as the star by which he is to steer to excellence in his art. He who would paint compositions, and not be false, must sit down amidst his sketches, make selections, and combine them, and so have nature for every object that he paints.[11]

In framing his reply in terms of the greatest art of the past, Cole revealed the great hopes he entertained for his own art. Easily inferred from such a statement is that at a remarkably early stage of his career Cole had already decided to make landscape painting answer to the high intellectual and moral goals of what was then called history painting. His conviction, a somewhat controversial one for the 1820s, grew only stronger with the passing of the years. In the account he penned for Dunlap in the early 1830s, he directly avowed it: "Will you allow me here to say a word or two on landscape? It is usual to rank it as a lower branch of the art, below the historical. Why so? Is there a better reason, than that the vanity of man makes him delight most in his own image?"[12]

Though Gilmor could not possibly have known, what he read in Cole's letter was the basic formulation of the

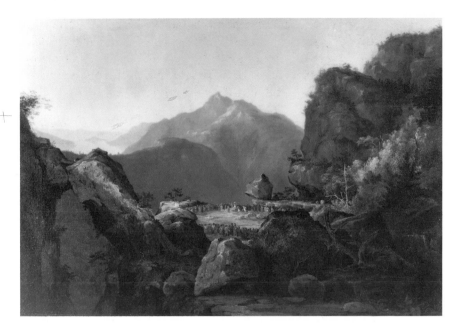

Figure 2.3. Thomas Cole, *Landscape Scene from "The Last of the Mohicans,"* 1827, oil on canvas, 25 x 31 in. (63.5 x 78.7 cm.). New York State Historical Association, Cooperstown

landscape-painting philosophy of the future Hudson River School. Cole's fidelity to observed fact, combined with his concern for idealization and the expression of lofty ideas, became the key ingredients of the American landscape style of the mid-nineteenth century. After receiving his version of Cole's *Landscape Scene from "The Last of the Mohicans"* (Fig. 2.3), one of the artist's most successful early compositions and one that beautifully illustrates his ideas as outlined in his letter, Gilmor found that he could approve of Cole's approach: "The composition scene is by far the most striking, & *perhaps* the most pleasing, though I am by no means prepared to say so."[13] The wealthy Hartford collector Daniel Wadsworth, on receiving the original of the same subject, thought it was realism he was looking at, and fulsomely wrote to Cole: "Of the 'Last of the Mohegans,' I can hardly express my admiration, the Grand & Magnificent scenery,— the Distinctness with which every part of it, is made to stand forward, & speak for itself.—The deep gulfs, into which you look from *real* precipices . . . it seems to me that *nothing* can improve [it]."[14]

Had he continued to produce agreeable compositions of American scenery at once real and ideal, such as the scene from *The Last of the Mohicans*, Cole would have avoided the controversy and frustration that marred his mature years. When he used the word "composition" to describe a certain type of landscape painting, however, he was also envisaging subject matter of a radically different sort: allegorical themes,

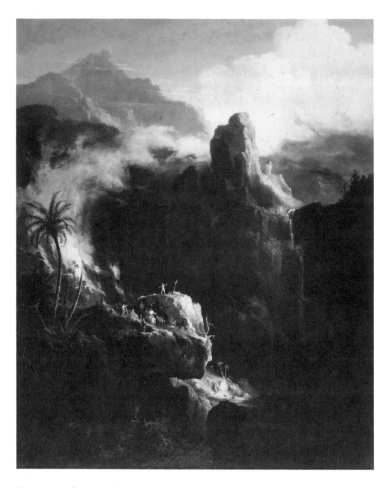

Figure 2.4. Thomas Cole, *Landscape, Composition, St. John in the Wilderness*, 1827, oil on canvas, 36 x 28¹⁵⁄₁₆ in. (91.4 x 73.5 cm.). Wadsworth Atheneum, Hartford, Bequest of Daniel Wadsworth (1848.16)

Reynolds, like Cole's own chronicler William Dunlap, would never have accepted the proposition that landscape could ever rise to such artistic heights. Cole's statement of many years later, "I do feel that I am not a mere leaf-painter. I have higher conceptions than a mere combination of inanimate, uninformed nature,"[16] was a reaffirmation of Reynolds's idealizing and intellectualizing biases: "The value and rank of every art is in proportion to the mental labour employed in it, or the mental pleasure produced by it. As this principle is observed or neglected, our profession becomes either a liberal art, or a mechanical trade."[17] But about that time, perhaps the greatest influence on Cole's thinking came from the *Essays* of the Scottish philosopher Archibald Alison. As Howard Merritt has written:

> Alison was the clearest expositor of the aesthetics of association psychology, and his *Essays* were widely read and of great influence in this country throughout the first half of the nineteenth century. There is no question that Cole, like most of his contemporaries, was deeply sympathetic with an aesthetic that linked so closely beauty and morality, that saw art as a vehicle for the expression of thought, imagination and sentiment, that placed primary emphasis on the association of ideas. For Alison the fine arts were those addressed to the imagination; when any beautiful or sublime subject is presented to the mind, the imagination is engaged, and pleasing or solemn associations are followed out. He reaffirmed the belief that matter is not beautiful in itself, but derives its beauty from the expression of "Mind," which through organized and complex trains of association can give it aesthetic significance.[18]

historical and literary subjects, and religious scenes, in other words, the traditional subject matter of the highest branch of the art of painting—history painting. The following year, he produced *Landscape, Composition, St. John in the Wilderness* (Fig. 2.4), which he sold to Daniel Wadsworth, and *Moses on the Mount* (1827; Shelburne Museum); shortly thereafter, he executed *The Garden of Eden* (location unknown) and *Expulsion from the Garden of Eden* (Fig. 2.5).

Although Cole denied it, all those paintings, but especially the *Moses* and the *Expulsion*, were influenced by the work of the English painter John Martin, known to Cole through engravings. That influence was disapprovingly noted somewhat later by at least one critic, who thought that Cole might also want to be known by Martin's nickname, "Pandemonium."[15]

In insisting on making landscape answer to the high ideals of history painting, Cole embraced the fundamental premise of Sir Joshua Reynolds's *Discourses*, although

In a passage Cole recorded in 1830, while he was in England, he recalled how central Alison's philosophy was to his aesthetic outlook:

> Take away from painting that which affects the imagination, and speaks to the feelings, and the remainder is merely for sensual gratification, mere food for the gross eye, which is as well satisfied with the flash and splendour of jewelry. The conception and reproduction of truth and beauty are the first object of the poet; so should it be with the painter. He who has no such conceptions, no power of creation, is no real painter. The language of art should have the subserviency of a vehicle. It is not art itself. Chiaroscuro, colour, form should always be subservient to the subject, and never be raised to the dignity of an end.[19]

Europe, and England, for which he sailed in June 1829, proved to be both a disappointment and a revelation to Cole. He had been anticipating the trip for some time, knowing that exposure to the galleries and museums of Europe would

be indispensable to his further development as a painter. But if truth be told, he was already too convinced of the rightness of his aesthetic views to drink in everything he saw abroad with the unquestioning eagerness of a student. Some of his friends doubtless worried that European art, especially recent European art, would cloud the Americanness of his vision, but the poet William Cullen Bryant saw that it would be the landscape of Europe and not so much its art that would make an overwhelming impression on Cole:

> Thine eyes shall see the light of distant skies:
> Yet, Cole! thy heart shall bear to Europe's strand
> A living image of our own bright land,
> Such as upon thy glorious canvas lies.
> Lone lakes—savannahs where the bison roves—
> Rocks rich with summer garlands—solemn streams—
> Skies where the desert eagle wheels and screams—
> Spring bloom and autumn blaze of boundless groves.
>
> Fair scenes shall greet thee where thou goest—fair
> But different—everywhere the trace of men.
> Paths, homes, graves, ruins, from the lowest glen
> To where life shrinks from the fierce Alpine air.
> Gaze on them, till the tears shall dim thy sight,
> But keep that earlier, wilder image bright.[20]

Probably on the advice he received from Washington Allston—that he spend at least half his European sojourn in England, because Allston knew of "no modern school of landscape equally capable with the English" and believed that Joseph Mallord William Turner ranked with Claude Lorrain and Salvator Rosa as one of the great landscape painters of all time—Cole planned a disproportionately long stay in London.[21] It turned out to be one of the great regrets of his career. Convinced that it was not the medium but the message that was of primary importance, Cole found English art highly disturbing:

> Although, in many respects, I was pleased with the English school of painting, yet, on the whole, I was disappointed. My natural eye was disgusted with its gaud and ostentation. To colour and chiaroscuro all else is sacrificed. Design is forgotten. To catch the eye by some dazzling display seems to be the grand aim. The English have a mania for what *they* call generalizing, which is nothing more nor less than the idle art of making a little study go a great way; and their pictures are usually things "full of sound and fury signifying nothing."[22]

He confessed to a good deal of admiration for the later pictures of Turner, but hastened to point out that he found them somewhat artificial: "Considered separately from the subject, they are splendid combinations of colour. But they are

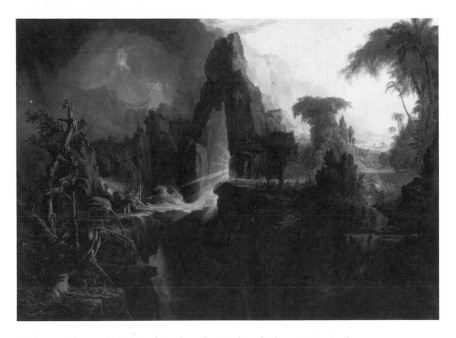

Figure 2.5. Thomas Cole, *Expulsion from the Garden of Eden*, 1827–28, oil on canvas, 39 x 54 in. (99.1 x 137.2 cm.). Courtesy, Museum of Fine Arts, Boston, Gift of Mrs. Maxim Karolik for the Karolik Collection of American Paintings, 1815–1865 (47.1188)

destitute of all appearance of solidity: all appears transparent and soft, and reminds one of jellies and confections."[23]

For Cole, the problem was *detail*. Although he could conceive of certain subjects in which detail must be subordinated to general effect, his "natural eye" demanded clarity of parts. "Detail . . . ought not to be neglected in the grandest subject. A picture without detail is a mere sketch."[24] In May 1831, as Cole left England and set off for France and Italy, he was more convinced than ever that the approach to painting he had summarized in his reply to Gilmor was absolutely correct. That his outlook might contain a good bit of provincialism or that his ideas might be rooted too deeply in the thinking of Reynolds and Alison, which by the early 1830s was rapidly becoming passé, did not seem to occur to him. His opinions were further confirmed in France by acquaintance with the works of Claude, the only painter he approved of without reservation. In one of the most revealing passages he wrote while abroad, Cole signaled the turn his painting style would take as a result of his sojourn in Europe. Rosa, whose works, even if experienced secondhand, had informed so many of Cole's landscapes of the 1820s (prompting even Gilmor to say that Cole's early style was indeed that of Rosa), would henceforth take second place to Claude: "Salvator Rosa's is a great name: his pictures disappointed me. He is peculiar, energetic, but of limited capacity comparatively. Claude, to me, is the greatest of all landscape painters: and

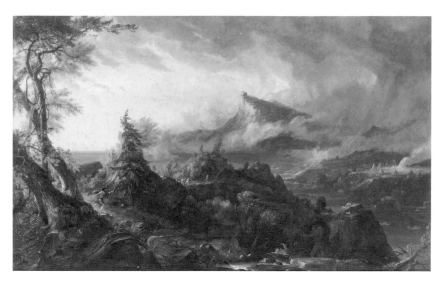

Figure 2.6. Thomas Cole, *The Savage State*, first of *The Course of Empire* series, 1836, oil on canvas, 39¼ x 63¼ in. (99.7 x 160.7 cm.). Courtesy, The New-York Historical Society

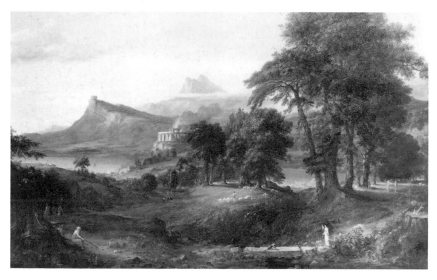

Figure 2.7. Thomas Cole, *The Arcadian or Pastoral State*, second of *The Course of Empire* series, 1836, oil on canvas, 39¼ x 63¼ in. (99.7 x 160.7 cm.). Courtesy, The New-York Historical Society

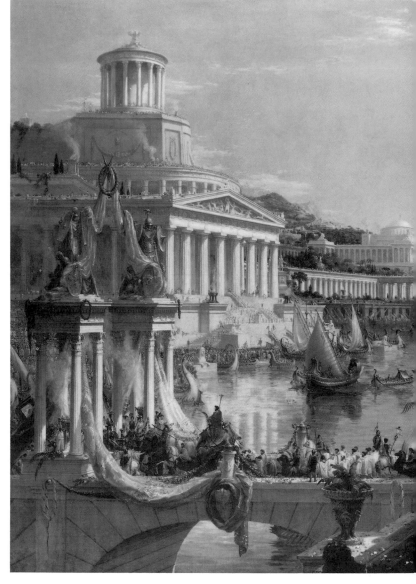

indeed, I should rank him with Raphael or Michael Angelo. Poussin I delighted in, and Ruysdael for his truth, which is equal to Claude, but not so choice."[25] Under the spell of Claude, whose studio he occupied while in Rome, Cole's style began to change considerably,[26] though the changes did not manifest themselves fully until after Cole's return to America in late 1832. Claude's panoramic compositions, his open vistas, his concern with atmosphere, and his proficiency in combining landscape with the kind of subject matter that especially appealed to Cole, energized him and caused him to reach for a greater technical command of his medium,

something that in his case was never easily won. Bryant, although he did not mention Claude, saw the change and, in his funeral oration on Cole in 1848, noted that as a result of Cole's first European trip, "A fluid softness of manner,—in comparison I mean with his later style,—was laid aside for that free and robust boldness in imitating the effects of nature, which has ever since characterized his works."[27] Bryant also thought that Cole would have improved technically whether he had gone to Europe or not, but that is debatable. Cole's facility with paint improved so radically in Italy that some beneficial contact with one or more of the many painters working there may be assumed.

Perhaps the greatest effect Italy had on Cole was in the realm of the imagination. He was overwhelmed by the remnants of classical and medieval antiquity that were every-

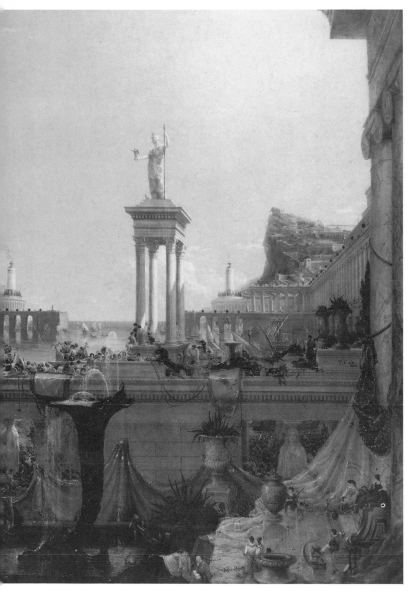

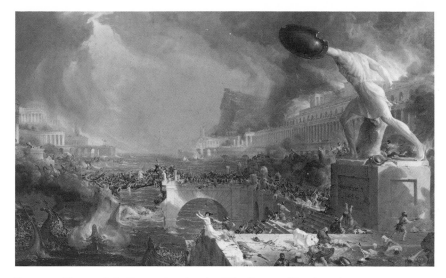

Figure 2.9. Thomas Cole, *Destruction*, fourth of *The Course of Empire* series, 1836, oil on canvas, 39¼ x 63½ in. (99.7 x 161.3 cm.). Courtesy, The New-York Historical Society

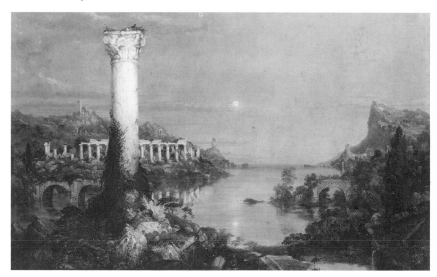

Figure 2.8. Thomas Cole, *The Consummation of Empire*, third of *The Course of Empire* series, 1836, oil on canvas, 51¼ x 76 in. (130.2 x 192 cm.). Courtesy, The New-York Historical Society

Figure 2.10. Thomas Cole, *Desolation*, fifth of *The Course of Empire* series, 1836, oil on canvas, 39¼ x 63¼ in. (99.7 x 160.7 cm.). Courtesy, The New-York Historical Society

where to be seen and by the associations they constantly evoked in his mind. Noble was later to write: "The great difference between Italian scenery, and all other, with which he was acquainted, lay with Cole, less in its material, than in its moral and historic elements."[28] For Cole, the experience of the Italian land contrasted sharply with that of the American wilderness, whose sublime rawness could put him in touch with God, but, up to the time of his departure for Europe, had not provided him with the associational opportunities that seemed to be everywhere he looked in Italy. For the first time in his career, themes and ideas suggested themselves to him that were worthy of the ambitions he had conceived for the art of landscape painting. As Noble put it: "It was here that he began to feel his strength for the grander issues of his art. He had now reached an elevation in the great ascent, one of the shoulders of the heaven-cleaving summit, from which he could survey both man and the visible world in vast, moral perspective."[29]

Italy, and Claude, then, showed Cole how to express his highest ambitions in a manner totally in keeping with everything he had previously come to believe. Back in America, in late 1832, he was now ready, intellectually and

technically, and, after his direct experience of European art, confident enough to undertake landscapes of high moral purpose devoted to the exploration of ideas as much as to the representation of natural features.

The works that best illustrate the extent of the influence his European journey had on Cole are the five large canvases that make up *The Course of Empire* (Figs. 2.6–10). Depicting the progress of a civilization—from the primeval state, through the arcadian and the urban, to destruction and final desolation—the series was the culmination of ideas Cole had been considering in one way or another for more than a decade.[30] Although *The Savage State*, the first painting of the series, contains the agitated trees and stormy scenes associated with the works of Rosa, and *Destruction*, the fourth, echoes the apocalyptic effects of "Pandemonium" Martin, the structuring of pictorial space in all five works is Claudean; further, Cole's familiarity with Italian scenery and antiquities informs all but the first of these remarkable canvases. An increased command of detail is evident throughout, as is a greater, if still imperfect, ability in figure painting. *Desolation*, the last and the most naturalistic of the series, with its panoramic format, varied landscape features, palpable atmosphere, and still body of water, was a prophetic work in terms of its style and was pronounced "one of the most remarkable productions of American art" by critic S. G. W. Benjamin, writing in 1880, a time when no great sympathy was felt for the Hudson River School.[31] Withal, *The Course of Empire* was as much an unexpected revelation to the New York art world of 1836 as Cole's early pictures had been to the connoisseurs of 1825. Everyone agreed that Cole endowed landscape painting with a seriousness and dignity—a richness of meaning—not even hinted at in the work of any other American artist. James Fenimore Cooper voiced the judgment of his contemporaries when he said, "Not only do I consider *The Course of Empire* the work of the highest genius this country has ever produced, but I esteem it one of the noblest works of art that has ever been wrought."[32]

That same concern for meaning Cole also applied to works representing American scenery. As the best and most highly respected painter of the American land, he could ignore native subject matter only at considerable peril to his professional standing. Not long after his return to America he discovered that demand for native views was increasing, and that as the leading practitioner of the genre he was expected to satisfy it. Though he realized that dispirited repetitions of previously attempted formulas would satisfy the majority of New York's unsophisticated patrons, he chose instead to seek the moral high ground, even when it was not especially demanded—a course of action not without diffi-

culties. By 1835, he had devised a general philosophy of American scenery that could inform his works in that genre. His thoughts on the question, unveiled to the public in May 1835, in a lecture he delivered before the New-York Lyceum, were of seminal importance to the developing American landscape-painting tradition and, like his views on draftsmanship and composition, were to become doctrines in the ideology of the Hudson River School.

According to Cole, American scenery had many properties totally unlike the qualities in European scenery. While it did not possess "those vestiges of antiquity whose associations so strongly affect the mind," it more than made up for their absence in other respects. First, America had the wilderness, "still a fitting place to speak of God." Second, America had spots where *combinations* of the picturesque, the sublime, and the magnificent had no parallel anywhere else. Finally, America possessed associations not so much with the past (though these did exist) as with the future. More specifically, Cole pointed to the stillness of American lakes, to the beautiful outlines of the Catskill Mountains, to the arcadian settlements along the Connecticut River, to the spectacular colors and cloud formations of the sunset skies, to the varied hues of autumn, and to the variety of trees in American forests as worthy of special notice. Although he did not spell it out, his discussion of American scenery firmly reasserted the typology established almost twenty years earlier by Governor Clinton in his address before the American Academy of the Fine Arts. For the artist—the poet as well as the painter—America could either be a primeval wilderness or an arcadian pastoral. In either case, it presented an analogy to the early days of the Creation: "We are still in Eden; the wall that shuts us out of the garden is our own ignorance and folly."[33]

As usual, Cole's thoughts found concrete expression in works of art: the painting now universally known as *The Oxbow* (see p. 125) embodies his assessment of American scenery and was painted with that purpose in mind. In it, the primeval wilderness of Mount Holyoke coexists with the arcadian, cultivated Connecticut River valley; associations are of present social harmony and of even greater future achievements; and a Claudean space, having a deeply articulated distance and a strong horizontal sweep, easily accommodates elements of both the sublime and the beautiful. A passing storm has cleansed the atmosphere, which, probably for the first time in the history of American landscape painting, can be palpably felt, and a self-portrait of the artist busily at work recording the scene assures us that this is indeed the stuff of art. Although the view as Cole painted it generally conforms with the actual appearance of the site, the artist

has interpreted its main features to suit his exalted hypothesis. Such realism as exists in *The Oxbow* is deftly placed at the service of the artist's own idealism.

In keeping with his practice of extending his idealizing priorities to accommodate the portrayal of American scenery, Cole soon realized the desirability of interpolating a substantial period of time between his visit to a particular site and the start of work on a view of it: "Have you not found?—I have—that I never succeed in painting scenes, however beautiful, immediately on returning from them. I must wait for time to draw a veil over the common details, the unessential parts, which shall leave the great features, whether the beautiful or the sublime dominant in the mind."[34]

It is surely a reflection of the sorry state of art criticism in the United States in 1836 that when *The Oxbow* was first exhibited, at the National Academy of Design, it was so little noticed in the press. For Cole, the painting marked the beginning of a new stage in the development of his style. A succession of great interpretations of American scenery followed in due course: *View on the Catskill—Early Autumn* (see p. 128); *Schroon Mountain, Adirondacks* (see p. 134); *The Mountain Ford* (Fig. 2.11); *Genesee Scenery* (see p. 138); *A Home in the Woods* (1847; Reynolda House). These formed a body of work that stood as an ever-challenging example to Cole's followers, among them Asher B. Durand, Jasper F. Cropsey, and Frederic E. Church. While it is true that during the last twelve years of his life Cole turned out uninspired works intended to quell his patrons' desire for pedestrian American views (the cause of frequent complaints in his letters), his best productions in the landscape genre—and they are not few—are as meaningful and high-minded as his allegorical series *The Course of Empire* and *The Voyage of Life* (1840; Munson-Williams-Proctor Institute). By the time of his death, in 1848, most knowledgeable critics shared *The Literary World*'s assessment of his achievement:

> What [Cole] saw with the eye of the painter he transferred to his canvas with the mind of the poet; and whether he employed his pencil among the classic ruins of Italy or in the vast and solemn solitudes of the mountains and forests of our own land, we felt that something more was on the canvas, and was reflected from it into our mind, than the mere transcript of a scene which had existed for ages in that guise, or which was daily looked upon by thousands.[35]

Not long afterward, Henry T. Tuckerman, in his *Sketches of Eminent American Painters*, matter-of-factly alluded to the American landscape painters' espousal of Cole's approach by noting, "Numerous modern artists are distinguished by a feeling for nature which has made landscape, instead of mere imitation, a vehicle of great moral impressions."[36]

Figure 2.11. Thomas Cole, *The Mountain Ford*, 1846, oil on canvas, 28¼ x 40¹/₁₆ in. (71.8 x 101.8 cm.). The Metropolitan Museum of Art, Bequest of Maria DeWitt Jesup, from the collection of her husband, Morris K. Jesup, 1914 (15.30.63)

That attitude toward landscape painting would soon receive a strong endorsement from the English-speaking world's most important writer on art, John Ruskin, whose first volume of *Modern Painters*, published anonymously (as written by a "Graduate of Oxford"), appeared in England in 1843, with an American edition following in 1847. It seems impossible that Cole did not read Ruskin avidly. Allowing for a difference of opinion regarding the "truth" of Turner's late works, Cole's and Ruskin's ideas were remarkably similar. When Ruskin wrote, "The landscape painters must always have two great and distinct ends; the first, to induce in the spectator's mind the faithful conception of any natural objects whatsoever; the second, to guide the spectator's mind to those objects most worthy of its contemplations, and to inform him of the thoughts and feelings with which these were regarded by the artist himself,"[37] he was only stating conclusions Cole had already reached. When Ruskin emphasized finish, faithful observation of nature, an attitude of humility on the part of a painter, and the high moral calling of all artists, he again simply reinforced beliefs held by Cole.

Neither Cole's nor Ruskin's philosophy can be said to have been avant-garde for the time. Although Ruskin, in rejecting the authority of the old masters, adopted a radical point of view, he advocated an approach to landscape that in light of subsequent events can only be called antimodern.

There was little room in Ruskin's thinking for the type of art that placed the expression of the artist's feelings above an accurate rendering of nature, an art which, according to the American philosopher Ralph Waldo Emerson, one of the period's most eloquent advocates of self-expression, "By selection and much omission, and by adding something not in nature, but profoundly related to the subject, and so suggesting the heart of the thing, gives a higher delight, and shows an artist, a creator."[38]

Still, it was the Claude-influenced, idea-laden, detailed, and highly composed landscape style synthesized by Cole in the 1830s and 1840s and put forth in representational views of American and, to a lesser extent, Italian scenery that firmly impressed itself on the minds of the American artists who wished to follow in his footsteps. Those younger painters accepted the need for intense sketching from nature and direct observation of its varied spots as an indispensable part of their training. They held to Cole's view that painting was a moral enterprise meant to evoke appropriately elevated thoughts and feelings, as well as to his insistence on having the artistic freedom to "compose" works. They accepted the formal elements—detailed execution, Claudean space, panoramic emphasis, when needed, and atmosphere—that Cole had adopted as well suited to the varied character and large scale of American scenery. Finally, they shared his trenchant stance against any type of art that put the artist and his talent above nature and its facts.

THE FIRST IMPORTANT native-born painter to view himself as a disciple of Cole was Asher B. Durand, who in the early 1820s successfully established himself as America's leading steel engraver. Durand had been one of the three purchasers of Cole's Catskill landscapes in 1825, when those works first came to the attention of the New York art world, and the two men maintained a nodding acquaintance, each keeping track of the other's activities. They were both founding members of the Sketch Club—later the Century Association—and the National Academy of Design, which in 1826 became *the* professional organization and main exhibition venue for New York's younger painters, much to the regret of the older American Academy of the Fine Arts. In addition, they were both friends of Bryant, Cooper, and other leading New York intellectual figures. Durand, though always interested in becoming a painter, found it difficult to relinquish his lucrative engraving work. Thanks in great part to the influence of the New York merchant and budding art patron Luman Reed, Durand decided in 1835 to give up the engraver's trade and embark on a career as a painter. In the

beginning, he confined himself mostly to portraiture, but by 1837, despite some misgivings, he had all but decided to devote himself fully to landscape. On 5 September 1837, he wrote to Cole, with whom he was then frequently in touch and in whose company he had made a long sketching trip to the Adirondacks that summer:

> I am still willing to confess myself a trespasser on your grounds, tho' I trust, not a poacher. Landscape still occupies my attention, well if the public don't wish me to take their heads, I will, like a free horse take my own, and "ope the expanding nostril to the breeze." . . . [T]he vast range of this beautiful creation should be my dwelling place, the only portion of which I am at present able to avail myself of is the neighborhood of Hoboken, which I am permitted to strip of its trees and meadows, two or 3 times a week and for this I am indeed thankful.[39]

The following year, Durand sent to the National Academy of Design exhibition no fewer than nine landscapes, most of which were well received by the press. The *New-York Mirror*, in comparing him to Cole, the recognized luminary of American landscape painting, allowed his considerable talent but uttered the pronouncement that would dog his footsteps until the death of Cole ten years later:

> Mr. Durand has finished a landscape, that, in our estimation, places him second only to Cole in many of the requisites that must combine for that species of painting. The sky is delicately clear; the foliage—whether shining in light, or cooly retiring in the shade—is equally marked by the tints of nature; the foreground is bold, warm and rich; the distance fading in due gradation; and parts of the middle ground—particu-

Figure 2.12. Asher B. Durand, *View of Rutland, Vermont*, 1839–40, oil on canvas, 29⅛ x 42⅛ in. (74 x 107 cm.). The Detroit Institute of Arts, Gift of Dexter M. Ferry, Jr. (42.59)

larly a bluff that advances from the right of the spectator—are touched with masterly pencillings and colours that rival the works of the eminent master named above.[40]

Although Durand was certainly diligent in his attempts to digest the lessons of Cole's style, his early pictures are evidence that he lacked the intimate knowledge of natural forms Cole had already mastered. When compared with Cole's works of the same period—the late 1830s—Durand's appear flabby in execution and uninspiringly formulated. His *View of Rutland, Vermont* (Fig. 2.12) aptly summarizes his progress up to that time. The general composition and the arrangement of its main features recall Cole's *View on the Catskill—Early Autumn* (then in the collection of Jonathan Sturges, who had succeeded his father-in-law, Luman Reed, as Durand's patron and who in 1840 paid for Durand's trip to Europe), as does its arcadian theme, but Durand seems to have been unable to relieve the monotony of the vast, open middle ground or to populate the composition with interesting trees and shrubs. The depiction of the clouds and the sky is perfunctory, as is that of the cattle and diminutive human figures. Overall, the painting pleases, but betrays an inexpert hand.

Nor was the example of Cole's more fanciful paintings, such as *The Course of Empire* series, lost on Durand. Probably the two most ambitious works he produced before departing for Europe in June 1840 are the very large *The Morning of Life* and *The Evening of Life* (Figs. 2.13; 2.14), works that were immediately recognized as highly derivative of Cole's *The Departure* and *The Return* (see p. 130). In reviewing the Academy's exhibition of 1840, the *New-York Mirror* put its finger on the problem: "If Durand devotes his attention to landscape-painting alone, and studies nature more, he will eventually become a first-rate artist in this interesting branch."[41] Still, in their more sophisticated composition and greater concentration on detail, *The Morning* and *The Evening* reveal a considerable improvement in Durand's technique, something the writer for *The Knickerbocker* noticed: "[Durand] has surprised every one, year after year, by his steadily progressive improvement; and should his life be spared, we may predict that Mr. Cole will sooner encounter him as a rival than any other artist now among us."[42]

Durand sailed for Europe on 1 June 1840, in the company of three New York artists who desired to obtain the supposed benefits of the Grand Tour. (Two of them—John W. Casilear and John F. Kensett—would become established landscape painters, but only Kensett would achieve recognition comparable to Durand's.) In England, Durand's experi-

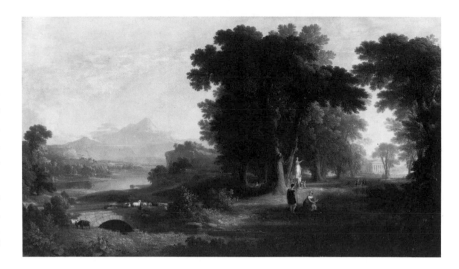

Figure 2.13. Asher B. Durand, *The Morning of Life*, ca. 1840, oil on canvas, 49¾ x 84 in. (126.4 x 213.4 cm.). National Academy of Design, New York City

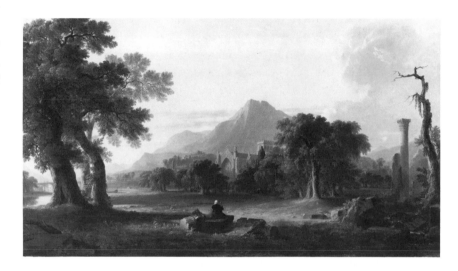

Figure 2.14. Asher B. Durand, *The Evening of Life*, ca. 1840, oil on canvas, 49½ x 83¼ in. (125.7 x 211.5 cm.). National Academy of Design, New York City

ence turned out to be similar to Cole's, though with some important differences. Through the good offices of C. R. Leslie, an American who lived in England but had returned to New York briefly in 1833 to teach drawing at West Point, Durand appears to have gained easier access to the company of English artists, including John Constable, whose biography Leslie was to publish some time later. Durand's admiration for the works of the old masters, which he saw at the National Gallery and at a show at the British Institution, ran to the Dutch School as much as to the acknowledged Italian painters. The names of Both, Van de Velde, Wouvermans, and Cuyp are approvingly noted in his journal. Essentially, however, Durand arrived in England already convinced of

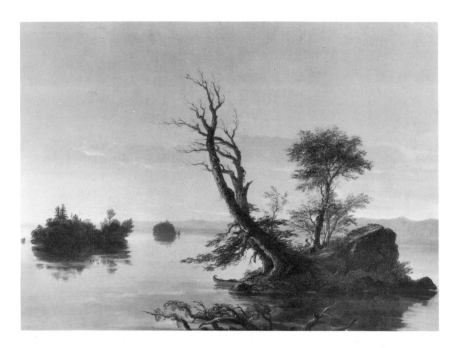

Figure 2.15. Thomas Cole, *American Lake Scene*, 1844, oil on canvas, 18¼ x 24½ in. (46.4 x 62.2 cm.). The Detroit Institute of Arts, Gift of Douglas F. Roby (56.31)

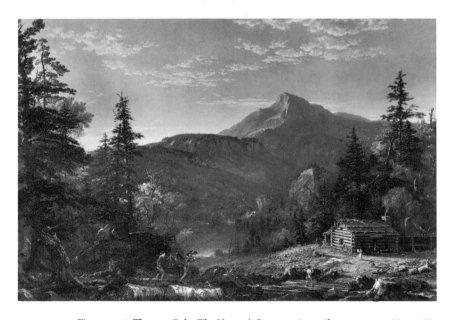

Figure 2.16. Thomas Cole, *The Hunter's Return*, 1845, oil on canvas, 40⅛ x 60½ in. (101.9 x 153.7 cm.). Courtesy, Amon Carter Museum, Fort Worth

the aesthetic tenets embraced by Cole. His reaction to the modern English paintings he saw at the Royal Academy exhibition could just as well have been written by Cole eight years earlier: "Some few pictures are of an elevated character, or, at least, display elements of high intellectual effort, especially in conception and design; at the same time these are marred by crudities. I observe only in a few works expression and character, while correctness in drawing, solidity, finish—naturalness, in short, I look for in vain."[43]

As Durand, destined for Italy, made his way through France, the Low Countries, Germany, and Switzerland, he saw little that altered his attitude. In a letter to Cole, he admitted that at first he had not been greatly impressed by Claude, "But when I came to his seaports, the 'Embarkation of St. Ursula' and the 'Queen of Sheba,' I could realize his greatness in the glowing atmosphere and glowing water."[44] Durand's final conclusion in the matter of Claude and the art of landscape—one that was to be of great importance to the genre's developing American tradition—was that there was much room for improvement: "The result of my observations thus far is the conviction that the glorious field of landscape-painting has never yet been so successfully, so fully cultivated, not even by Claude, as have other branches of art depicting the action and passions of men."[45]

Back in New York in July 1841, Durand was now psychologically ready to attempt a major overhaul of his style. A painstaking approach to the representation of natural features, the influence of the Dutch landscape masters he had admired in Europe, and a difficult-to-define "naturalness," probably the result of his admiration for Constable, began to show themselves more frequently in his works. After the summer of 1842, following Cole's return from a second European journey that he had embarked on in 1841, Durand was further challenged by Cole's example.

Cole had returned to this country with a renewed appetite for painting and with a vastly improved command of color. His experience of the works of Nicolas Poussin at the Louvre and probably also his reading of Ruskin convinced him that he must pay greater attention to the sky as the most expressive part of a landscape painting and as the proper vehicle for the expression of sublime ideas. Curiously, his increasingly artificial compositions, such as *Genesee Scenery* (see p. 138) and *The Mountain Ford* (the latter [Fig. 2.11] a studio concoction praised by William Sidney Mount as Cole's finest landscape) began to appear more realistic, not less. A vivid, atmospheric sky now became standard in Cole's landscapes. In such works as *The Old Mill at Sunset* (1844; Jo Ann and Julian Ganz, Jr.) and *American Lake Scene* (Fig. 2.15), the enhancement of the sky's translucence by its juxtaposition with flat sheets of water introduced into the American landscape tradition a new attention to light. In addition, in a number of later works, chiefly the first version of *Mount Aetna from Taormina*, a large canvas painted for the Wadsworth Atheneum in 1843, and the frontier subjects *The Hunter's Return* (Fig. 2.16) and *A Home in the*

Woods, Cole also explored the advantages of a larger, near-panoramic scale.

Impressed by Cole's progress and driven by his own conviction, Durand became more committed than ever to drawing and to sketching in oil directly from nature. He transformed his pencil studies of trees into small masterpieces of highly detailed realism and meticulous observation. Although most of the remarkable oil studies of rocks and trees (e.g., p. 112) that earned him his reputation as the American pioneer of plein-air painting seem to date mostly to the 1850s, there is evidence that he had actually begun to make them in the previous decade as part of his effort to achieve greater fidelity to nature.

Because Kensett's first accomplished works were not painted until after 1850 and because other younger artists aspiring to careers as landscapists had not yet become forces to reckon with, Cole and Durand practically had the field to themselves from the time Durand returned from Europe in July 1841 until the coming of the next decade. Durand, especially, went from strength to strength in his technique. In 1845, the year he was elected president of the National Academy of Design, his improved knowledge of natural forms decisively showed itself in a painting called *The Beeches* (see p. 104). All at once, Durand's admiration for Constable—whose use of a vertical format in *Cornfield* (ill., p. 106) and *Dedham Vale* (Fig. 2.17) finds repetition in *The Beeches*—his command over detail, his admiration for Dutch landscape painting, his interest in an unpretentious, "natural" approach, and his desire to achieve convincing atmospheric effects came together to produce the first masterwork of a personal style that would exert tremendous influence as the year 1850 approached. Tuckerman admired particularly the realism Durand attained in the painting's sky: "Its charm consists in the atmosphere. The artist has depicted to a miracle the brooding haze noticeable in our climate at the close of a sultry day during a drought." Going on to draw a parallel with Bryant's approach to poetry, Tuckerman noted the simple lyricism of the work and concluded, "The coincidence of feeling in the poet and the painter indicates how truly native is the composition of each."[46]

By 1847, whenever any mention of American landscape painting was made in the press, the names of Cole and Durand inevitably followed, usually in that order. In 1847, the *New York Evening Post* published a comparison of the two artists that, despite many small errors, perceptively recognized the preeminence of both in the field of landscape and identified Durand's unpretentiousness as especially appealing to Americans:

It is now generally conceded, we believe, that Cole and

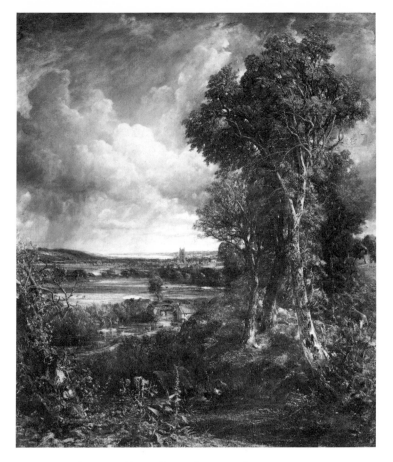

Figure 2.17. John Constable, *Dedham Vale*, 1828, oil on canvas, 57⅛ x 48 in. (145.1 x 121.9 cm.). Courtesy, National Galleries of Scotland, Edinburgh

Durand are the two most prominent landscape painters in this country.—They are indeed artists of superior ability, and will undoubtedly hereafter be looked upon as the founders of two American schools. Each one is distinguished for peculiar excellencies, and it strikes us that an immense deal of breath is wasted by their several admirers in comparing them together, and endeavoring to exalt one above the other. In two particulars alone do we recognize a similarity between these men—they are both highly accomplished, and both possessed of the most refined and elevated feeling.—But their minds are totally different in character.—The productions of Cole appeal to the intellect, those of Durand to the heart; the former we should fancy to be an admirer of Milton and Salvator Rosa, the latter of Wordsworth and Lorraine.

Both of these artists are undoubtedly devoted students, but while one revels upon the whole of a landscape, the attention of the other is invited by an isolated feature of peculiar beauty. Durand paints the better study from nature, so far as individuality is concerned, but Cole produces with greater truth the uncommon effects observable in nature. The touch of the former is undecided, and he produces his effects

by constant glazing, while the latter lays on the paint with greatest freedom, and does not appear to have a knowledge of the glazing art. Cole is constantly giving birth to a new idea, but Durand seems to lack invention and frequently repeats himself. Cole excels in his rocks, skies, and occasionally in his mountains, but Durand in the texture of his trees, and his grasses, his earths and weeds.—Cole has a passion for the wild and tempestuous; Durand is a lover of the cultivated country when glowing in a mellow sunlight. Cole seldom paints a good figure, but Durand hardly ever paints one that is not first rate.

But the most striking difference observable in these two artists is of an intellectual character. Cole possesses an imagination of the highest order, but Durand only a cultivated fancy—we admire the former, but love the latter. Cole is unquestionably the more splendid genius, but the talent of Durand is also of a very high order. Cole was born a painter, and for his reputation is indebted to his stars. Durand has made himself a great artist, and may thank his indomitable perseverance for his fame. Cole is impotent in every department but that of landscape, while Durand has the ability to paint a superior portrait, and has produced the best engraving ever published in this country. The conclusion of the whole matter then is just this: Cole and Durand are among the master artists of the age, and will ever be remembered with pleasure by all lovers of the beautiful and true in art and nature.[47]

Apart from wrongly associating Cole's late work too closely with that of Salvator Rosa, some questionable remarks on his use of glazes, and falsely implying that he had been born with a great natural facility for painting, the reviewer's main error was in predicting that Cole and Durand would give rise to separate schools of American landscape painting. He could not have known that after Cole's death the following year Durand would emerge as his logical heir.

Cole's death further liberated Durand to pursue his own personal style, and it is therefore understandable to find that his most famous work, *Kindred Spirits* (see p. 108), carries to a higher level of accomplishment the elements that had first come together in such a masterly fashion in *The Beeches*. Although the composition is unquestionably in the Cole tradition—perhaps even more so in its adoption of an obviously baroque circular arrangement and a synoptic approach to the representation of the Catskill Mountains—the easy naturalism of the painting discloses that Durand's aesthetic outlook was far more even-tempered than Cole's. For Durand's cooler approach to be perceived, *Kindred Spirits* need only be compared with Cole's *The Architect's Dream* (1840; Toledo Museum of Art), a work intended as a homage to the character and achievements of Ithiel Town,

then one of America's most competent architects. Although Durand never totally abandoned the anecdotal, or literary, quality that attaches to the majority of Cole's works, his astonishing powers of imitation, powerfully displayed in *Kindred Spirits*, actually made it possible for him to reach high levels of iconographic and associational meaning without such trappings. Durand, in effect, first discovered that simple nature could, with judicious selection, reach for the high moral ground of history painting without having to be reinforced by figures of Indians, blasted tree trunks, or other symbolic and iconographic details so prevalent in Cole's compositions. Though *Early Morning at Cold Spring* (see p. 111), despite its allusions to the Sabbath, shows Durand further developing a more contemplative approach to nature, the works in which he explored an untrammeled communion with the land are the numerous scenes of forest interiors that feature what first appears to be only an artless arrangement of rocks, tree trunks, assorted foliage, and, frequently, a stream. In these, Durand's imitative power and crisply focused technique enabled him to endow with visual interest humble pieces of forest scenery in which he actively felt the presence of the Creator. In the second of his series of didactic letters on landscape painting, published in *The Crayon* from January to July 1855, he summarized his reverential attitude toward nature:

> . . . The external appearance of this our dwelling-place, apart from its wondrous structure and functions that minister to our well-being, is fraught with lessons of high and holy meaning, only surpassed by the light of Revelation. It is impossible to contemplate with right-minded, reverent feeling, its inexpressible beauty and grandeur, for ever assuming new forms of impressiveness under the varying phases of cloud and sunshine, time and season, without arriving at the conviction
>
> —— "That all which we behold
> Is full of blessings"——
>
> that the Great Designer of these glorious pictures has placed them before us as types of the Divine attributes, and we insensibly, as it were, in our daily contemplations,
>
> —— "To the beautiful order of his works
> Learn to conform the order of our lives."
>
> Thus regarding the objects of your study, the intellect and feelings become elevated and purified, and in proportion as you acquire executive skill, your productions will, unawares, be imbued with that undefinable quality recognized as sentiment or expression which distinguishes the true landscape from the mere sensual and *striking* picture.[48]

The reader may well regard the passage as a mere repetition of principles already enunciated by Cole, but in so doing

would miss the all-important overtones of Durand's message. Unlike Cole, who in his "Essay on American Scenery" repeatedly alluded to Romantic notions of the sublime, the beautiful, and the picturesque or to combinations thereof, Durand does not attempt to classify nature. He accepts the fundamental tenet of Cole's thinking—that nature reveals God—but his attitude is one of extreme deference to the observed. A good part of that attitude may be attributed to the immense influence of Ruskin's writings, but that it simply reflected Durand's innermost and long-held convictions is just as likely. In any event, the effect of the success of Durand's style was to push American landscape painting further toward nature and away from man. His broader attitude to what was picture-worthy in nature and his assertion that attentiveness to nature's details was the only way of arriving at the truth were of vast import. His approach, of course, was productive of a realism that in subsequent years was taken to be his major contribution to the development of the Hudson River School. But Durand's realism was the result of a highly idealizing attitude inherited from Cole, with whose ambitions for the art of landscape painting he was totally sympathetic. In a subsequent *Crayon* letter, Durand defined the basis of his style:

> . . . [T]he true province of Landscape Art is the representation of the work of God in the visible creation, independent of man, or not dependent on human action, further than as an accessory or an auxiliary. From this point of view let us briefly examine the conventional distinctions of Idealism and Realism. . . .
>
> What then is Idealism? According to the interpretation commonly received, that picture is ideal whose component parts are representative of the utmost perfection of Nature, whether with respect to beauty or other considerations of fitness in the objects represented, according to their respective kinds, and also the most perfect arrangement or composition of these parts so as to form an equally perfect whole. The extreme of this ideal asserts that this required perfection is not to be found or rarely found in single examples of natural objects, nor in any existing combination of them. In order to compare the ideal picture, then, the artist must know what constitutes the perfection of every object employed, according to its kind, and its circumstances, so as to be able to gather from individuals the collective idea. This view of Idealism does not propose any deviation from the truth, but on the contrary, demands the most rigid adherence to the law of its highest development.
>
> Realism, therefore, if any way distinguishable from Idealism, must consist in the acceptance of ordinary forms and combinations as found. If strictly confined to this, it is, indeed, an inferior grade of Art; but as no one contends that

the representation of ordinary or common-place nature is an ultimatum in Art, the term Realism signifies little else than a disciplinary stage of Idealism, according to the interpretation given, and is misapplied when used in opposition to it, for the ideal is, in fact, nothing more than the perfection of the real.[49]

Although Durand did not write his "Letters on Landscape Painting" until 1855, his great works of the 1840s—*The Beeches*; *Kindred Spirits*; *Dover Plains, Dutchess County, New York* (see p. 107)—had been for some time articulating his philosophy in eloquent visual terms. Perhaps because his emphasis on painstaking representation was closer to Ruskin's teachings on technique than to Cole's, or perhaps because a trend toward greater realism was then in the air, the artists who were emerging about 1850 enthusiastically embraced his approach. Of them, the most important to the continuing development of Hudson River School painting were Kensett, Cropsey, and Church.

WITH THE PICTORIAL ACHIEVEMENTS of Cole and Durand firmly in place by 1850, with the increasing dissemination in this country of Ruskin's ideas, and with the steadily rising favor in which landscape painting was held by American patrons, critics, and general public, the stage was set for

Figure 2.18. John F. Kensett, *The Shrine—A Scene in Italy*, 1847, oil on canvas, 30⅜ x 41⅝ in. (77.2 x 105.7 cm.). Mr. and Mrs. Maurice N. Katz, Naples, Florida

the younger artists—Kensett, Cropsey, and Church—to begin to make strides in formulating their own individual styles within the aesthetic territory so ably explored by the two older masters. Kensett, the eldest of the group, returned from Europe in 1847 but did not really come into his own until 1850, when a number of the works he showed at the National Academy of Design elicited the high praise of *The Literary World*. If a successful early painting by Kensett, such as *The Shrine—A Scene in Italy* (Fig. 2.18), painted in Italy in 1847, is compared with his *White Mountains—Mt. Washington*, of 1851 (see p. 149), the rapid change Cole's and Durand's influence caused in his style is apparent. Durand's example was particularly irresistible; a favorable comparison with Durand's pictures was the basis for critical acceptance of Kensett's paintings of 1850: "As a painter of trees and rocks we know of no one superior to KENSETT. The characteristics of his style and finish are in many respects very similar to those of the President of the Academy. Indeed, there are two studies of rocks . . . the former by Durand and the latter by Kensett, which one would suppose, even after a close inspection, to have been the work of but a single hand."[50]

Cropsey, who presents an interesting case because a short essay he prepared in 1845 for the New-York Art Re-Union had already anticipated Durand's arguments, was given early encouragement for his careful observation of nature. In 1847, the critic for *The Literary World* wrote: "Mr. Cropsey is one of the few among our landscape painters who go directly to Nature for their materials. For one so young

Figure 2.19. Frederic E. Church, *Twilight, Short Arbiter 'Twixt Day and Night*, 1850, oil on canvas, 32¼ x 48 in. (81.9 x 121.9 cm.). Collection of The Newark Museum, Purchase, 1956, Wallace M. Scudder Bequest Fund (56.43)

in his art, his attainments are extraordinary, and it is no disparagement to the abilities of those veterans in landscape art, Cole and Durand, to prophecy, that before many years have elapsed, he will stand with them in the front rank, shoulder to shoulder."[51]

Church, surely the most precocious of all American landscape painters, the pupil of Cole from 1844 to 1848, and at the age of twenty-one already an accomplished artist, graduated to the ranks of the true lovers of nature in 1849, when he finished *West Rock, New Haven* (see p. 240). Even before the painting made its appearance at the annual exhibition of the National Academy of Design, the *Bulletin of the American Art-Union* noted: "The sky and water of this piece are truly admirable. Seldom have we seen painted water which fulfils so well as this the 'Oxford Graduate's' condition of excellence. Church has taken his place, at a single leap, among the great masters of landscape."[52]

Even at that early date and while adhering to the canon of realism enunciated by Durand and endorsed by practically all the critics, Church nevertheless showed signs of considerable independence by making use of his ability to achieve effects of light that were already too expressionistic for the taste of some critics. *Twilight, Short Arbiter 'Twixt Day and Night* (Fig. 2.19), one of Church's outstanding essays in the dramatization of the sky, elicited this comment when exhibited at the Academy annual of 1850:

> We have no faith, and we take no satisfaction in the phenomena of nature on the canvas. . . . Surely, there is enough of beauty in nature that is known and can be appreciated; a wide enough field for the artist without the necessity of resorting to rare spectacles which common experience exclaims against. The first word which an observer is apt to give utterance to before such a sunset scene as this is, "how unnatural;" "who ever saw such contrasts of color!" And it is no help so far as the unsatisfactory effect of the picture upon such an one is concerned, for the artist to say, "I saw it just as it is, and painted it accordingly," because a picture must vouch for itself, and must be able to make its appeal to the direct senses of all who are capable of understanding it. A landscape that needs a certificate of genuineness will never do.[53]

About 1851, Kensett, Cropsey, and Church, despite their impatience to set off in directions of their own, produced masterly essays in the Cole–Durand idiom and showed how attached they indeed were to their established precedents. Kensett's *The White Mountains—Mt. Washington*, Cropsey's *American Harvesting* (1851; Indiana University Art Museum), and Church's *New England Scenery* (see p. 242), like Durand's *Dover Plains*, are variations on the theme first sounded by Cole in *The Oxbow*. All deal with recogniz-

able subject matter, all are carefully composed and executed works, all are full of associational meanings, all are panoramic views full of light and atmosphere, and all have to do with an acceptable pictorial type: America as the new arcadia. Not accidentally, they all exude an optimism and youthful vigor that even today cannot fail to evoke an almost regenerative sense of nostalgia in all but the most jaded viewers. Although Cropsey and Church had also inherited Cole's taste for the elevated religious and allegorical landscape—for example, in the case of Cropsey, *Landscape—Morning, from Beattie's Poem* and *Landscape, Evening, from Gray's Elegy* (1846; locations unknown) and *Spirit of War* and *Spirit of Peace* (1851; locations unknown); in the case of Church, *The Deluge* (two versions, 1846 and 1851; locations unknown) and *Christian on the Borders of the Valley of the Shadow of Death* (1847; Olana)—that type of Cole- and Durand-influenced arcadian view, together with its twin, the primeval wilderness scene, constituted the staple productions of Hudson River School painting in the early 1850s. It was a development highly encouraged in most quarters; it was the sort of work—America as seen by Americans in an American style—that *had* to form the backbone of a national school of landscape painting. Those who would stray from that path were duly warned:

> If the landscape art of America has not attained the dignity of a school, it is not because there has not been talent enough employed in its cultivation, so much as because the artists have neglected the elements which should give it distinctiveness. American landscape must by its very nature be very different from that of any other country. While in the old world the associations of historical interest add greatly to the painter's material, and together with the subdued state of nature must give a corresponding tone to the feeling for landscape, the artist in the new, looks to the free, unbroken wilderness for the highest expression of the new world motive, and thence with some mingling of human sympathy to the clearing and the log-cabin; and as he approaches more nearly to the haunts of civilization, to that which is the old and accustomed, he attains that which is common to all pure landscape painting, and therefore less distinctively American. And this is not merely because there happens to be more wilderness than in Europe, but because the strongest feeling of the American is to that which is new and fresh—to the freedom of the grand old forests—to the energy of the wild life. He may look with *interest* to the ruins of Italy, but with enthusiasm to the cabin of the pioneer; to that in which our country excels all others, the grandeur of its natural scenes—its boundless expanses and the magnitude of objective.[54]

As the 1850s progressed, however, it became increasingly obvious that the accepted moral and formal tenets of Hudson

River School painting would have to accommodate to the changing facts of American life and, equally important, to the aspirations of the younger artists.

In the 1840s, when America had turned its attention to territorial expansion, as technology and economic forces increased the pace of rural development, as scientific discoveries began to open new perspectives on the workings of nature, and as artistic lines of communication with Europe were strengthened, the art form that had taken upon itself the task of elucidating the national myth had to find the means of reflecting such changes. Neither history nor genre painting, with their emphasis on the human figure, developed the degree of ambitiousness that had come to characterize landscape, a fact well recognized by 1850, when *The Literary World* noted that it was in that department of art "that the progress of American Art has been, and will continue to be, the most marked and decided."[55]

The issue of "improvement"—that is to say, the exploitation of the resources of the wilderness for economic gain—imposed itself on the consciousness of the landscape painters early on. Cole, in writing his "Essay on American Scenery," had realized that development was inevitable if the "trackless wilderness" was to become the stage of future "mighty deeds." What bothered him was the careless destruction of nature that seemed to accompany such development. In 1835, the problem had been brought almost into his own backyard when the Catskill and Canajoharie Railroad began laying down tracks just beyond his property. Cole, deeply

Figure 2.20. Thomas Cole, *River in the Catskills*, 1843, 28¼ x 41¼ in. (71.8 x 104.8 cm.). Courtesy, Museum of Fine Arts, Boston, Gift of Mrs. Maxim Karolik for the Karolik Collection of American Paintings, 1815–1865 (47.1201)

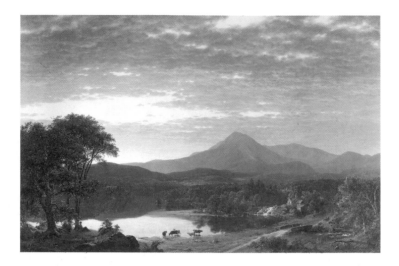

distressed, dealt with his grief by producing a work that altogether ignored the presence of the railroad (see p. 128). Only after six years had passed was he able to show the environmental changes the railroad brought about in *River in the Catskills* (Fig. 2.20), a painting that despite its arcadian overtones still reveals much of the artist's unhappiness. In their canvases, few of Cole's followers expressed doubts concerning the ability of the American arcadian ideal to absorb the effects of technology. Their confidence in the harmonious coexistence of progress and nature was sometimes expressed discreetly, as in Church's *Mt. Ktaadn* (Fig. 2.21), in which a distant lumber mill is an integral part of the wilderness landscape being surveyed by a contemplative youth placed under a Claudean grouping of trees at the left. Sometimes the con-

Figure 2.21. Frederic E. Church, *Mt. Ktaadn*, 1853, oil on canvas, 36¼ x 55¼ in. (92.1 x 140.3 cm.). Yale University Art Gallery, Stanley B. Resor, B.A. 1901, Fund (1969.71)

Figure 2.22. Asher B. Durand, *Progress*, 1853, oil on canvas, 48 x 71¹⁵⁄₁₆ in. (121.9 x 182.7 cm.). The Warner Collection of Gulf States Paper Corporation, Tuscaloosa, Alabama

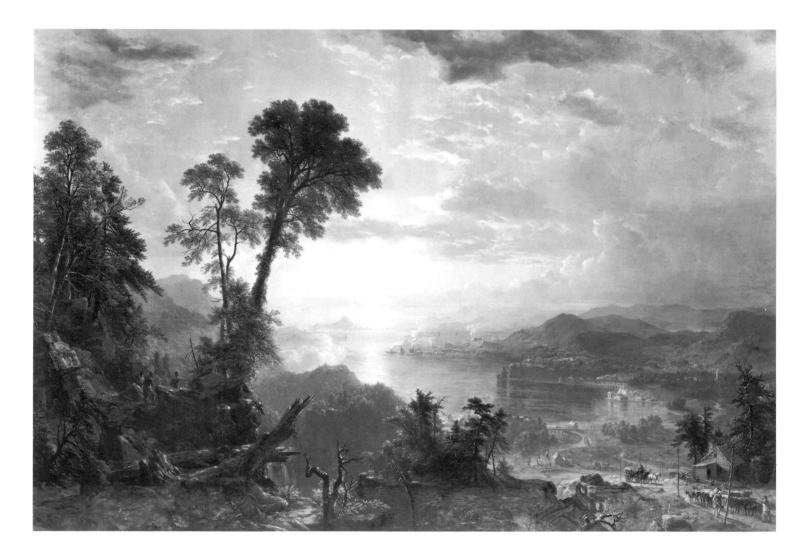

fidence was manifested in a more grandiloquent fashion. The most ambitious and probably the most dramatic example of that point of view was Durand's *Progress* (Fig. 2.22), an idealized Hudson River-like view in which steamboats, a canal, a railroad, and telegraph lines contribute to the well-being of a small city gracing the landscape. A group of Indians—an iconographic device in American painting since before the works of Cole—perched on a rocky height survey the panoramic scene with astonishment and approbation, making the point that they and the wilderness also have a place in this vision of what could be. Durand emphasized the importance of his prophecy-in-paint both by choosing a large canvas (four feet by six) and by lavishing on it his best technical attention. His intention did not escape the eye of the critic for *The Knickerbocker*: "We observe a higher degree of perfection than this fine artist has ever previously attained. It is purely American. It tells an American story out of American facts, portrayed with true American feeling by a devoted and earnest student of Nature."[56]

Two years later, George Inness, in *Delaware Water Gap* (see p. 233), a work still highly influenced by the Hudson River School formulas Inness had absorbed as a young painter, made the railroad appear to be an integral and unobtrusive part of the landscape. In a work related to it—*The Lackawanna Valley* (Fig. 2.23)—Inness dealt more honestly with the deleterious side effects of railroad building, but even there, in a view that anticipates the romanticized portrayals of smoky Pittsburgh produced by many artists in the early part of this century, the mood is optimistic, as if to assure us that the reclining youth surveying the scene can look forward to a prosperous future in that industrialized arcadia. Like Inness, Cropsey approvingly reported the marriage of tree and train being consummated daily in the wilds of Pennsylvania. In *Starrucca Viaduct, Pennsylvania* (see p. 210), a late manifestation of that type of painting, the repeating arches of the viaduct echo the aqueducts of the Roman Campagna painted by Cropsey and by Cole before him. The scale of its up-to-date engineering, dwarfing the small wooden bridge leading to a small village in the middle distance, asserts not only that it is a great work of man but also that progress can happily exist next to both the wilderness and the old rural settlements.

If the well-established formulas of anecdotal landscape painting first set down by Cole in this country served admirably in allowing American artists to deal with the march of progress, something more original was called for if nature were to articulate not just a personal mood—as would be called for in the Barbizon-influenced works of the mature Inness—but a national one. With the annexation of Texas

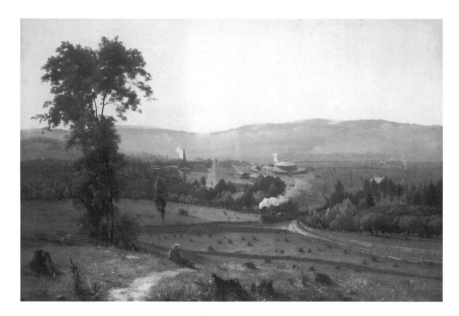

Figure 2.23. George Inness, *The Lackawanna Valley*, 1855, oil on canvas, 33⅞ x 50¼ in. (86 x 127.6 cm.). National Gallery of Art, Washington, D.C., Gift of Mrs. Huttleston Rogers (1945.4.1)

in 1845, the settling of the Oregon question in 1846, and the signing of a peace treaty that concluded the war with Mexico in 1848, the United States expanded its territory clear across the continent to the Pacific Ocean, thus securing its right to fulfill its "manifest destiny." Calls for the takeover of Mexico and the Spanish-held islands of the Caribbean were frequently made on the floor of Congress and in the popular press. Many Americans believed that it was only a matter of time before the entire Western Hemisphere belonged to the United States. Such reckless, enthusiastic nationalism was heady and infectious stuff. It fell to Church—the only one of the younger landscape artists working in the 1850s who had never been to Europe, and so the most quintessentially American in outlook—to first capture on canvas the national fever, which he did with his *Niagara* of 1857 (see p. 243). Lest it be thought that only the overinterpreting minds of twentieth-century scholars could charge a fairly straightforward rendition of the great cataract with so much meaning, the following passage from Adam Badeau's novel *The Vagabond* (1859) should be carefully read:

> Even our painters catch the spirit, and Mr. Church has embodied it in his "Niagara," perhaps the finest picture yet done by an American; at least, that which is the fullest in feeling. The idea of motion he has imparted to his canvass, the actual feeling you have of the tremble of the fall, of the glowing of the sunbeam, of the tossing of the rapids, of the waving of the rainbow, of the whirling of the foam, of the mad rush of the cataract, I take to be the great excellence of his

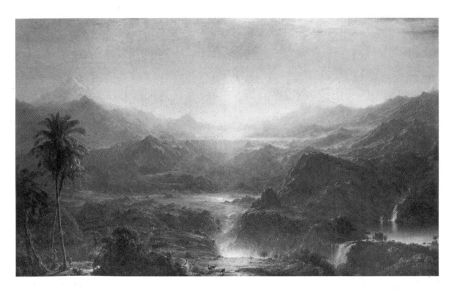

Figure 2.24. Frederic E. Church, *The Andes of Ecuador*, 1855, oil on canvas, 48 x 76 in. (121.9 x 193 cm.). Reynolda House, Museum of American Art, Winston-Salem, North Carolina

production; and surely this is akin to the influence which I describe as paramount in American art.

Neither is this influence to be decried as altogether hasty and uneducated, or unformed. It is not only the fruit of ill-digested thought, it is not only the rapid utterance of youth, the boastful, coarse excitement of ignorance. If it is inspired by Niagara, it is grand and sublime; it is natural to the nation, since nature herself, has given us the archetype; it is wild and ungovernable, mad at times, but all power is terrible at times. It is the effect of various causes; it is a true development of the American mind; the result of democracy, of individuality, of the expression of each, of the liberty allowed to all; of ineradicable and lofty qualities in human nature. It is inspired not only by the irresistible cataract, but by the mighty forest, by the thousand miles of river, by the broad continent we call our own, by the onward march of civilization, by the conquering of savage areas; characteristic alike of the western backwoodsman, of the Arctic explorer, the southern fillibuster, and the northern merchant. So, of course, it gets expression in our art.[57]

Niagara was the first Hudson River School painting to be an instant success. It established Church as being in a class by himself among the fraternity of landscape artists. Wherever it was exhibited, it elicited lavish praise. All over America, critics recognized its special quality as a national icon and a national symbol. In London, where it was shown in the summer of 1857 and where the great Ruskin himself approved of it, the painting was accorded an enthusiastic reception. Some years later, when it was exhibited at the Paris Exposition Universelle of 1867, an article in *Harper's Weekly* re-

ported, "The European critics declared that the 'Niagara' gave them an entirely new and higher view both of American nature and art."[58]

WITH THE PRINCIPLES ESPOUSED by Cole and Durand firmly established in the minds and hearts of the younger painters, and with increasing attention and patronage lavished upon them, the curtain rose on some of the most important stylistic innovations to take place in the history of the Hudson River School. In the late 1850s, two major trends developed that would lift American landscape painting to yet higher levels of originality. One was the almost single-handed forging of a large-picture style by Church—grandiose and stupefying, echoing the French salon style of the eighteenth and early nineteenth centuries. The other, largely unnoticed at the time, was the rise of a type of small, contemplative, unpretentious painting that is now seen as particularly expressive of American philosophic attitudes and that commonly goes by the name of Luminism. Of the two, it was the first kind of picture that seems to have monopolized the attention of the New York art world in the late 1850s. Once again, it was an artistic development that cannot be viewed separately from the ideas that went into its making.

Niagara, as we have seen, ushered in a new era in the history of the Hudson River School. Church's approach was scrupulously realistic and unegotistic—without "manner," as his contemporaries would have put it—and wholly in keeping with Durand's tenets, yet his attempt to achieve "the perfection of the real" had deep roots in his personal background. Beginning with *The Andes of Ecuador* (Fig. 2.24), Church cogitated so thoroughly on his compositions that, working entirely within the strictures of a nearly photographic representation that even then equaled Durand's, he was able to turn each of his major landscapes into a kind of parable in paint. Steeped in the New England Calvinist traditions inherited from a long line of Puritan ancestors, Church, who in keeping with his heritage always refused to discuss the meaning of his works, arrived at a way of representing natural features that incited—even demanded—the pondering of the cosmic truths of which his painted scenes are so obviously emblematic.[59] In the case of *Niagara*, it was a mood of national restlessness, power, and self-confidence that, by a process of typological thinking having longstanding antecedents in American Puritan thought, was made implicit in the picture. In *The Andes of Ecuador*, it was a scene of spiritual regeneration that was placed before the eyes of a public fully aware that the painting "conveyed a new feeling

to the mind."[60] Church's leading modern scholar, David Huntington, elucidated the picture's intended effect:

> Like Adam at the dawn of human consciousness the beholder awakens to the beauty of the earth which has been so long preparing for him. Yet this first awakening is, in effect, the type for a reawakening into a higher consciousness, which is the consciousness of a soul reborn in Christ, as with fresh eyes he "sees all things new." The old dispensation is manifest in the guise of the church and wayside shrine, each marked by a cross. The new dispensation is manifest in the guise of a heavenly cross whose all-pervasive radiant light blesses and hallows all nature. As the crosses made by human hands adumbrate the cross made by divine hands, so has the sequel of ever higher orders of life through aeons adumbrated the mind-spirit which now, for the first time, contemplates Creation with "Intelligence." As he "soars" suspended between earth and heaven in the presence of *Andes of Ecuador* and looks out upon the world's divinity, the spectator becomes a "demi-god."[61]

Such cosmic explanations were most eagerly received by an American public already half convinced that Americans were God's new chosen people and the chief agents of the fulfillment of his Divine Plan.

Although Church was sometimes criticized for going beyond nature in certain of his atmospheric effects, the transcending exaggerations of what he might actually have observed on the scene can now be viewed as requisite to his method. If he were to explore questions of a metaphysical order that went to the heart of the nation's identity, and if he were to do so within the parameters of visual credibility acceptable to most of his audience, he had to turn each of his scenes into a miraculous instance in which nature could readily be felt to be disclosing great truths. In the past, painters such as Cole and John Martin had resorted to landscapes of fantasy and to totally unnatural light effects to represent such moments (e.g., Fig. 2.25). Church, however, remained faithful to his principles. Although in the end he would not escape the grandiloquence endemic in the painting of cosmic events, he continued to live up to his conviction that if God spoke through nature, it should not be necessary for a painter to fantasize. In order to behold those moments of nature's self-revelation on a scale suitable to his purpose, Church traveled to South America to observe the exotic and luxuriant life of the tropics and to capture the terror-inspiring drama of active volcanos; to the North Atlantic to have a firsthand look at icebergs and to witness the unearthly quality of the aurora borealis (Fig. 2.26); to the deepest recesses of Maine to catch the most spectacular of North American sunsets (see p. 251).

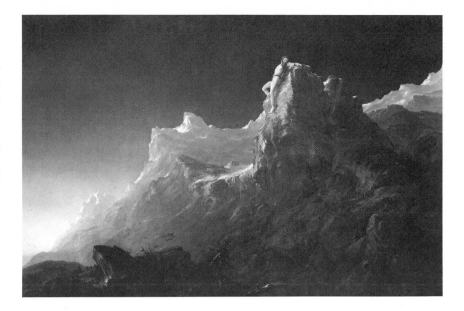

Figure 2.25. Thomas Cole, *Prometheus*, 1846–47, oil on canvas, 64 x 96 in. (162.6 x 243.8 cm.). Philadelphia Museum of Art, on loan from private collection (Mr. and Mrs. John W. Merriam)

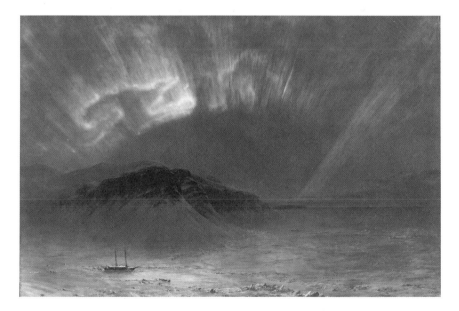

Figure 2.26. Frederic E. Church, *Aurora Borealis*, 1865, oil on canvas, 56⅛ x 83½ in. (142.6 x 212.1 cm.). National Museum of American Art, Smithsonian Institution, Gift of Eleanor Blodgett (1911.4.1)

After the unprecedented success of *Niagara*, Church became a true celebrity. His travels were reported in the press, the progress of his canvases was followed eagerly, and the appearance of each was greeted enthusiastically in one-work exhibitions that bypassed the Academy annuals, that earned the painter substantial revenues in admission fees, and that caused the prices of his paintings to soar.

The zenith of Church's style, in the eyes of his contemporaries, and of his fame, in the eyes of history, came in 1859 with the completion of *Heart of the Andes* (see p. 246). The result of two trips to South America, the painting again explored the themes sounded in *The Andes of Ecuador*, but now Church also tried to do justice to the scientifically descriptive richness of Alexander von Humboldt's well-known *Cosmos: Outline of a Description of the Physical World*, the book that had originally aroused the artist's curiosity about the region. He made no secret of his debt to the great German explorer-scientist—it was reported on in the press even before the painting was actually completed. The *New York Evening Post*, for example, quoting from *The Home Journal*, noted: "Humboldt has given us the word-painting of the magnificent scene of this picture; and now comes the true magician, with his harp of a thousand strings, to present to us the subtle tones that no words can describe, and to make us see with his eyes, and feel with his heart, the grandeur that presented itself to him in the Andes."[62] Humboldt's query now took on special meaning:

> Are we not justified in hoping that landscape painting will flourish with a new and hitherto unknown brilliancy when artists of merit shall more frequently pass the narrow limits of the Mediterranean, and when they shall be enabled, far in the interior of continents, in the humid mountain valleys of the tropical world, to seize, with the genuine freshness of a pure and youthful spirit, on the true image of the varied forces of nature?[63]

Church's purpose in *Heart of the Andes* was clearly to answer Humboldt's call for a type of landscape painting that would unite discovery, science, and art. Although Church, through Cole's emphasis on sketching and close observation and Durand's even greater emphasis on detail, was in his early years fully indoctrinated in the ways of high resolution, as were most of his Hudson River School contemporaries, it was his special interest in science—an interest he did not fully manifest until the mid-1850s—that added a special dimension to this aspect of his art. Tuckerman paid tribute to that special attribute of Church's:

> The proof of the scientific interest of such landscapes as have established Church's popularity, may be found in the vivid and authentic illustrations they afford of descriptive physical geography. No one conversant with the features of climate, vegetation and distribution of land and water that characterize the portions of North and South America, as represented by this artist, can fail to recognize them in all his delineations. It is not that they merely give us a vague impression, but a positive embodiment of these traits. The minute peculiarities of sky, atmosphere, trees, rocks, rivers and herbage are pictured here with the fidelity of a naturalist.[64]

Yet in so doing, Church did not abandon the idealizing task that Cole considered necessary to a painting and that Durand so ably defended. As the *New York Evening Post* advised its readers, *Heart of the Andes* was "not an actual portrait of any single view, but a composition of the characteristic features of South American landscape in those elevated regions."[65] The *New York Times* expanded on the point: "In baptizing the work the *Heart of the Andes* the artist happily indicated the high poetic tenor of the composition. It is not like Niagara a simply magnificent mirror of one moment in Nature but like the noblest works of CLAUDE and TURNER, a grand pictorial poem, presenting the idealized truth of all the various features which go into the making up of the Alpine landscape of the tropics."[66] In comparing Church and Turner, the *Times* was probably only repeating the judgment passed in London by the *Art Journal* when the painting was shown in that city: "On this American more than any other . . . does the mantle of our greatest painter appear to have fallen."[67]

With the success of *Heart of the Andes*, Church pointed the way toward a "salon" style of American landscape painting that many other artists found irresistible. Like the French salon style of Jacques-Louis David and his followers, it was one of large scale and overtly moralizing tone, embracing ideas profoundly relevant to its time and place. It was also, in the best sense of the term, a "public" form of art, meant to be seen and enjoyed by the multitudes. Insofar as Cole's ideas about landscape painting had always inclined in that direction, Church may be seen, as S. G. W. Benjamin saw him, as the fulfillment of his dead teacher's high principles.

The gigantism of *Heart of the Andes*—its panoramic, wraparound quality—was exploited by Church even as he maintained what was by then an almost traditional interest in light and atmosphere. Other painters, obviously finding a challenge in the technical demands such gigantism made on an artist, attempted to demonstrate that they too could meet it. Cropsey, who saw *Heart of the Andes* in the autumn of 1859, when it was exhibited in London, responded to it by painting *Autumn—On the Hudson River* (see p. 206) the following year, probably his most ambitious composition and the one most instilled with a miraculous sense of light. In 1863, Albert Bierstadt unveiled *The Rocky Mountains, Lander's Peak* (see p. 285), the work that along with *Heart of the Andes* can be said to have done the most to establish the large-format style in Hudson River School painting. Not long afterward, Kensett painted his large *Mount Chocorua*

(1864–66) for the Century Association in New York, and Cropsey produced his imposing *The Valley of Wyoming* (see p. 208). Even Inness, who by that time had come to represent everything antithetic to the Hudson River School style, seems to have responded to the allure of size when he painted his famous *Peace and Plenty* (Metropolitan Museum) in 1865. By the early 1860s, then, the large painting was no longer a cause for wonderment at the studio unveilings and annual exhibitions in New York.

Of all the artists whose imaginations were quickened by Church's achievements of the mid- and late 1850s, probably the most misunderstood by both art historians and a number of contemporary critics has been Bierstadt. Because, like Church, Bierstadt worked into his stupendously large pictures the themes of nationalism, expansionism, and science, as well as an apocalyptic approach to the drama of light, he has frequently been regarded as a follower rather than an originator. Because he repeatedly painted scenes of the Rocky Mountains and Yosemite, and did so in a style that was much less sharply focused than Church's, and because he was a much faster worker than Church, he has been accused of cheapening the master's purposes for commercial gain. In actuality, Bierstadt's approach was quite different from Church's, despite their many common aspects. His panoramic views, albeit "composed" from sketches in the manner sanctioned by Hudson River School practice, rely on spatial relationships and tonal values elucidated by photography more than Church's ever did. Bierstadt therefore managed to avoid the awkward recessions and improbable juxtapositions of geologic features that Church sometimes fell into, and to keep his palette in relative balance, even when using extremely hot colors. The viewer, though overwhelmed by Bierstadt's style, is likely to find it less jarring than such effects of Church's as the unexpectedly bright horizon of *Twilight in the Wilderness* (see p. 251) or the foreground abyss of *Cotopaxi* (see p. 254). Bierstadt's increased visual plausibility, which frequently extends to numerous and detailed foreground features—for instance, the carefully studied figures and impedimenta in the Shoshone encampment in *The Rocky Mountains, Lander's Peak*—usually begins to dissipate as the eye travels to the upper reaches of his canvases. In Bierstadt's paintings, the more fantastic and freer approach to the representation of storm clouds, light, and mountain peaks turns them into far more sensuous, and far less rational, achievements than Church's. In 1864, the critic of the *New York Evening Post* saw the revelation of a great religious truth in Bierstadt's formula and, referring specifically to *The Rocky Mountains* and its Indians, wrote:

To us the camp of weary hunters seems one of Nature's most

skilful strokes. Its admission here is as if the artist said to us: "Into this sweet grassy meadow and to the margin of this wondrous crystal pool, Man has come by vast heroic climbings: by persevering toil through grim cañons and up savage precipices. Human skill and patience, audacity and tireless enterprise of knowledge, have pioneered their way, all these thousands of dangerous slow miles into the very vestibule of virgin Nature. But the Holiest of Holies locks its doors against them! The inmost, topmost spirit of things closes the gates of sight behind it and retires into the silent bosom of the Heavens. Skill cannot fly nor patience climb to the opalescent cradle of that glacier-stream. The King of the World is denied his subject's grandest confidence, and stands dwarfed in the valley, mutely, hopelessly gazing whither Nature is closeted alone with God!"[68]

By 1865, Bierstadt had established himself as Church's chief rival and as *the* painter of the American West. His popularity began to outstrip Church's, as did the prices of his extravagant, much-sought-after productions. The waning years of the 1870s, however, saw his reputation steadily declining. In 1880, S. G. W. Benjamin pronounced the damning judgment on Bierstadt that has prevailed in some degree to the present day: "Mr. Bierstadt is naturally an artist of great ability and large resources, and might easily have maintained a reputation as such if he had not grafted on the sensationalism of Düsseldorf a greater ambition for notoriety and money than for success in pure art."[69]

AFTER THE APPEARANCE OF *Heart of the Andes* and *The Rocky Mountains, Lander's Peak*, the Hudson River School salon style came to stand in the minds of many critics, and almost certainly in the eyes of the general public, as the American landscape school's pinnacle of achievement. James Jackson Jarves, among the best educated of mid-nineteenth-century writers on American art and no friend of Hudson River School painting, was typical of his time when he noted in 1864: "The thoroughly American branch of painting, based upon the facts and tastes of the country and people, is the landscape. It surpasses all others in popular favor, and may be said to have reached the dignity of a distinct school." Jarves, a champion of what he called the "idealistic" landscapes of Inness and John La Farge, then proceeded to put Church at the head of that school: "Church leads or misleads the way, according as the taste prefers the idealistic or realistic plane of art."[70] Jarves's analysis of Church's style, although not particularly sympathetic, betrays a degree of grudging admiration for Church's revolutionary transformation of the Cole–Durand "composed" picture tradition. At the same

time, he associates Bierstadt with that transformation and, by implication, identifies both artists as the most successful figures in American landscape painting:

No one, hereafter, may be expected to excel Church in the brilliant qualities of his style. Who can rival his wonderful memory of details, vivid perception of color, quick, sparkling, though monotonous touch, and iridescent effects, dexterous manipulation, magical jugglery of tint and composition, picturesque arrangements of material facts, and general cleverness? With him color is an Arabian Nights' Entertainment,

Figure 2.27. Jasper F. Cropsey, *View of Greenwood Lake, New Jersey*, 1845, oil on canvas, 30¾ x 40¾ in. (78.1 x 103.5 cm.). The Fine Arts Museums of San Francisco, Gift of Gustav Epstein (45.24)

Figure 2.28. John F. Kensett, *Shrewsbury River*, 1858, oil on canvas, 15 x 27 in. (38.1 x 68.6 cm.). Collection of Erving and Joyce Wolf

a pyrotechnic display, brilliantly enchanting on first view, but leaving no permanent satisfaction to the mind, as all things fail to do which delight more in astonishing than instructing. Church's pictures have no reserved power of suggestion, but expend their force in *coup-de-main* effects. Hence it is that spectators are so loud in their exclamations of delight. Felicitous and novel in composition, lively in details, experimentive, reflecting in his pictures many of the qualities of the American mind, notwithstanding a certain falseness of character, Church will long continue the favorite with a large class.

But a competitor for the popular favor in the same direction has appeared in Bierstadt. He has selected the Rocky Mountains and Western prairies for his artistic field. Both these men are as laborious as they are ambitious, regarding neither personal exposure nor expense in their distant fields of study. Each composes his pictures from actual sketches, with the desire to render the general truths and spirit of the localities of their landscapes, though often departing from the literal features of the view. With singular inconsistency of mind they idealize in composition and materialize in execution, so that, though the details of the scenery are substantially correct, the scene as a whole often is false.[71]

All the more surprising, then, is Jarves's overlooking the other great transformation that began to take place in American landscape painting in the late 1850s: that which made a virtue of small size, simple composition, and subtle color effects, and which refined the introspective aspects of American landscape painting that had, in an inconsistent way, already begun to appear in the late 1840s. A considerable degree of intellectual confusion exists regarding this alternative tradition, which commonly is known by the rubric Luminism. Some have sought to place the Luminist style outside the Hudson River School tradition altogether, while others have attempted to explain it as the culmination of the preoccupation with light that had animated Hudson River School painting since the days of Thomas Cole. Admittedly, certain peculiarities in the small-picture style must be acknowledged, but the evidence of its historical roots within the Hudson River School aesthetic can scarcely be questioned. Of the four major painters usually identified by scholars as Luminists—Fitz Hugh Lane, John F. Kensett, Martin Johnson Heade, and Sanford R. Gifford—only Lane, who worked mostly in Gloucester, Massachusetts, can be placed totally outside the mainstream of the School, and even he may well have come under its influence in the mid-1850s.

The history of the development of Luminism cannot be easily traced. Lane's seascapes of the late 1840s and early 1850s, with their still compositions and luminous skies, are

certainly among its first manifestations. In view of their cardboard-cutout appearance and unetherial atmosphere, however, it is doubtful that they influenced any of the younger Hudson River School men when they were exhibited at the New York Art-Union in 1848 and 1849. If a certain stillness and religiosity pervades some of Durand's more sedate compositions and the New England landscapes painted by Church about the same time, those qualities can more logically be seen as emanating not from Lane's works (all of which appear to have escaped the notice of the press) but from Cole's late paintings. Cole's interest in the sky, especially as *the* vehicle of the sublime, is evident in such diverse works as *Genesee Scenery* (see p. 138) and *Prometheus* (Fig. 2.25), as well as in landscapes such as *The Old Mill at Sunset* and *American Lake Scene* (Fig. 2.15), where sky and water are juxtaposed so as to produce a Luminist effect. These provide ample precedents for the type of *atmospheric* luminism that began to appear in Church's *Mt. Ktaadn* of 1853 (Fig. 2.21), as well as in Durand's *Dover Plains* (see p. 107) and Cropsey's *View of Greenwood Lake, New Jersey* (Fig. 2.27).

Atmosphere—the palpable representation of space, with its sublimated contents, so emphasized by Durand in his "Letters on Landscape Painting" as the sign of true mastery of the landscape art—is the indissoluble link that connects the Luminism of Kensett, Heade, and Gifford with the Hudson River School. Although Lane's later works, beginning with his *Approaching Storm* (1860; private collection), do manifest a greater concern with atmosphere, that development in his style ought more probably to be assigned to the influence of Hudson River School examples. By that time, some of the most important steps toward the Luminist aesthetic had already been made by Kensett in his remarkable series of Shrewsbury River scenes (e.g., Fig. 2.28), which he began shortly after a visit to that area of New Jersey in 1853 (though the earliest dated work in the series is 1856) and in some of his Newport coastal views of 1857, such as *Beacon Rock, Newport Harbor* (National Gallery of Art). In these, the stillness found in Lane's seascapes is certainly present, but the subtle tints of sky and water, as well as a sense that paintings apparently representing so little are nevertheless filled with air and light, relate more to Cole, Durand, and Church. The paring-down of the composition to a few large landscape features, which take on an almost abstract quality, can be attributed to Kensett's own genius and can be judged his most important contribution to the small-picture style.

Although much press commentary surrounded the Hudson River School salon style as it developed in the 1850s and as it came to dominate the landscape-painting scene in the 1860s, little record is to be found concerning the small

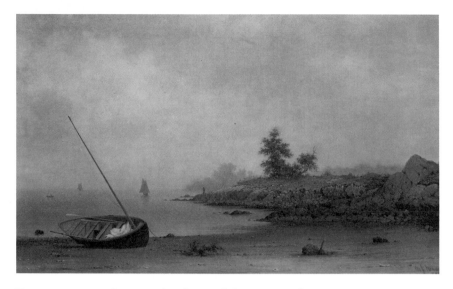

Figure 2.29. Martin Johnson Heade, *The Stranded Boat*, 1863, oil on canvas, 22¾ x 36½ in. (57.8 x 92.7 cm.). Courtesy, Museum of Fine Arts, Boston, Gift of Maxim Karolik for the Karolik Collection of American Paintings, 1815–1865 (48.1026)

paintings. There is scant indication that the nineteenth century saw those works as constituting a separate, much less an "alternative," tradition or that most people thought that Lane and Heade were anything but mediocre painters. Nevertheless, the power of hindsight is considerable; it would be foolish to deny the twentieth century its special insights because of the blindness of the nineteenth. The formal qualities of the small-scale picture style have thus been seen as the embodiment in paint of the ideas on God and nature espoused by Emerson and the transcendentalist school, and as constituting the most important original achievement of American nineteenth-century landscape painting (e.g., Fig. 2.29). Such claims may today appear somewhat forced, but it is still possible to see in the Luminist pictures the reverse side of the coin of expansionism, energy, eagerness for new scientific knowledge, and general confidence that went into the spirit of the salon-style paintings. Although Gifford traveled to the American West and Heade spent a good deal of time in Brazil, Luminist works almost always depict the familiar scenery of the East Coast of the United States. Their thoughtful quality seems to relate to the nagging doubts entertained by many Americans in regard to the future of their country, and to the necessity for more personal and meaningful relations with God. It also seems to be a response to the criticism being increasingly leveled at American landscape painting by the Pre-Raphaelites—those advocates of a strictly Ruskinian approach—and by others who, convinced of the validity of the underlying and mood-oriented approach of

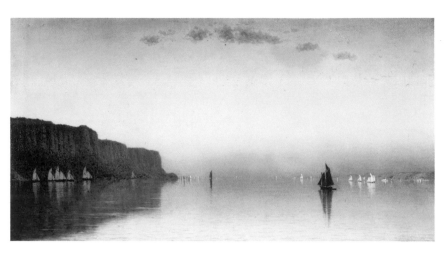

Figure 2.30. Sanford R. Gifford, *A Sunset on the Hudson*, 1879, oil on canvas, 18½ x 34⅛ in. (47 x 86.7 cm.). Private collection, New York

School painting became more frequent, and as the School's chief figures began to betray signs of exhaustion, it was the Luminist paintings that retained a good deal of the old vitality. Gifford, by becoming more concerned with giving his pictures a unifying tone (e.g., Fig. 2.30), was considered acceptable by the generation that lauded the paintings of Inness and La Farge. It was that style too that made possible what was probably the last attempt to achieve the "perfection of the real" advocated by Durand—Kensett's Last Summer's Work of 1872. In those heroically daring and original pictures, the attempt begun by Cole to transfer the aims of history painting to landscape painting ended in a realism that reduced itself to light and abstract shapes. But by that time the struggle had lost its significance. The ideas that had been at the core of the entire Hudson River School tradition lost their immediacy as they confronted, first, a new Darwinian science that made it difficult to see the hand of the Creator operating behind every leaf and rock and, second, a new mood in the country, which after the horrors of the Civil War could no longer perceive of itself as the new Eden. Ideas coming from Europe about art—about the desirability of self-expression and the unimportance of realism—further weakened the intellectual underpinnings of the landscape school. As the 1860s came to a close, the view of art and nature that had caused Cole and his followers to put the representation of the works of God far above any expression of the artist's emotions had already lost much of its relevance.

the painters of the Barbizon School, maintained that there was room for personal expression in landscape art.

By the late 1850s, Kensett, Heade, and Gifford were all producing works in the Luminist mode. Heade's *The Coming Storm* (see p. 164) and Gifford's *The Wilderness* (see p. 218) continue to deal with the concerns of composition, realism, and meaning that are the hallmarks of the Cole–Durand philosophy, but now with a somewhat changed formal emphasis. As the decade of the 1860s wore on, as the challenges mounted by the critics of Hudson River

A CLIMATE FOR
LANDSCAPE PAINTERS

John K. Howat

IN THE EARLY YEARS of the nineteenth century, New York assumed the dominant economic position among American cities; as it grew as a port and effectively straddled the roads and waterways west, it also became the center for the arts, especially painting. In 1800, Boston, Newport, and Philadelphia boasted much more distinguished positions as cradles of artists and art interests than New York. New York was still very much a town—though a large one, bunched in the toe of Manhattan Island—and was yet to enjoy the instructive and exciting presence of enlivening institutions similar to Charles Willson Peale's Museum of art, science, and history in Philadelphia. Longworth's *Directory of 1805*, a guidebook to New York City for that year, contained a glimpse of art then publicly available:

> Exhibitions—Savage's Museum contains many curiosities of nature and art. The *Shakspeare Gallery* has a large collection of prints and paintings; and Delacoste's Cabinet is filled with rare productions of nature. The *American Academy of Arts* are in possession of a number of figures cast from the works of the greatest sculptors of Antiquity.[1]

The offerings sound meager, like dim and scattered reflections of the exhibition presented by Peale's Museum. Shortly before the Civil War, the elderly John W. Francis, who had been New York's leading obstetrician and had become one of its foremost dilettantes of science, history, and the arts, recalled the paucity of art on public view in the city some fifty years before: "Our museums were limited to the one kept by old Gardener Baker, himself and his collection a sort of curiosity shop, composed of heterogenous fragments of the several kingdoms of nature."[2] It was the leadership of foresighted men like Francis that encouraged the establishment and growth of such cultural organizations as the American Academy, the New-York Historical Society, the National Academy of Design, the American Art-Union, the Century Association, and the short-lived New York Gallery of Fine Arts, which by mid-century had placed New York in the vanguard of the American art world. By such time, serious institutions—the forerunners of many larger ones still in existence today—had replaced the "curiosity" shops operated by individual entrepreneurs; New York's art world had been transformed, owing in considerable part to the burgeoning of the landscape school of painting.

Despite the retrospective art-historical glow that surrounds the discovery of Thomas Cole by John Trumbull, William Dunlap, and Asher B. Durand in 1825 and the nearly contemporaneous founding of the National Academy of Design in 1826, the landscape painters of those years struggled against disregard born of public indifference and old-fashioned aesthetic prejudices. In 1833, a reviewer of the

Thomas Cole, 1845–48, possibly by the Mathew Brady studio, New York City. Daguerreotype. National Portrait Gallery, Smithsonian Institution, Washington, D.C., Gift of Edith Cole Silberstein (NPG.76.11)

studio of the American artist, and the latter [history painting] is scarcely to be found. This again is more to be lamented than blamed. In a new country like ours, immense sums are not given for splendid gallery paintings, and the historical painter has no encouragement."[4]

The New York art scene in 1833 was sufficiently barren to elicit a printed welcome for the recently arrived London packet boats, which carried a variety of English prints, reviews of art events in London, and an engraver's plate done after Benjamin West's portrait of Thomas Lawrence and meant for Durand (not yet professionally devoted to landscape painting) to complete. The notice ended with the dispirited comment, "No other work of American art presents itself to our notice, but Part VI of the Views in New York, published by Peabody & Co."[5] The publication of individual topographical prints and portfolios of landscape views was then the most obvious outlet for landscape artists.

From the perspective provided by *The Knickerbocker*, a leading New York magazine, the art situation during the early and mid-1830s seems to have been generally depressed, only occasionally alleviated by importations of curious miscellanea from London that might cause rejoicing:

> The three truly splendid specimens of painting upon glass, recently brought from London, and now exhibiting in this city, are worthy the attention of every lover of exquisite art. The largest is a copy of Martin's noted picture of "Belshazzar's Feast"—and the others, "Love among the Roses," by the same artist, and a group of figures representing Charity, designed by Sir Joshua Reynolds, for the window of New College Chapel, at Oxford, England.[6]

Characteristic commentary on landscape painting at the time held up Thomas Doughty and Cole as the great figures, Doughty being notable for depicting "all that is quiet and lovely, romantic and beautiful in nature"; Cole, for capturing "the grandeur, the wild magnificence of mountain scenery." It was regarded as regrettable, then, that "the splendid talents of [Doughty and Cole] should be so poorly rewarded as to allow the first to leave his native city [Philadelphia], and the other to absent himself from his country, in search of patronage."[7] The latter remark refers to Cole's recently completed three-year sojourn in Europe, the trip that had occasioned William Cullen Bryant's worried poetic warning "to Cole, the Painter, Departing for Europe" to "keep that earlier, wilder image bright."

Recurrent themes in the mid-1830s criticisms of painting were that there were too few good artists and that "even those few . . . find but inadequate support."[8] The sometimes competing exhibitions at the National Academy of Design

annual exhibition of the National Academy of Design penned the following chestnut, which is little more than a distant and simplified echo of Sir Joshua Reynolds's *Discourses*, written in the previous century: "The study of landscape, though calculated to elevate the mind by the contemplation of the beauties of creation, is neither so sublime in itself, nor does it rank so high in art as historical painting."[3] Nevertheless, it is instructive to note that the reviewer's criticism continued in a vein reminiscent of now familiar complaints issued by Washington Allston and John Vanderlyn: "Unfortunately the former [landscape painting] pervades in the

and the American Academy of Fine Arts were disappointing, and gave rise to sharp reviews: "The fact is simply this, that there are not enough good painters in this city to furnish forth even one annual exhibition, without admitting some pictures utterly unworthy of notice, what must then be the case when *two* are bolstered up at one and the same time?"[9] In 1839, a critic who went on to identify himself as "an artist, who has the advantage of having been upward of six years a student in the Royal Academy in London,"[10] lamented, "The condition of painting, in this country, is low, and sculpture has as yet scarcely a being. The causes of this may be, the general diffusion of wealth; the moderate circumstances of the many; the very limited number of those who can afford to pay a stimulating price for the best productions."[11] None of that is surprising, since, in the short run, the great fire of New York, on 16 and 17 December 1835, had been disastrous to the city's economy.

Despite some gloomy outlooks, more than a few contemporary art writers were cheered by what they saw. In 1834, William Dunlap issued his two-volume *History of the Rise and Progress of the Arts of Design in the United States*, the first such publication in the country. In it, the proud Dunlap, himself a painter who had suffered greatly from uncertain patronage, made the claim, "Artists know their stand in society, and are now in consequence of that conduct which flows from their knowledge of the dignity and importance of art, looked up to by the best in the land."[12] In a different vein, *The Knickerbocker*, a generous supporter of American painters, was "gratified in observing the *American* spirit manifested . . . in the choice of subjects, which illustrate native scenery, appeal to national feelings, or revive historical reminiscences."[13] In the same year, 1835, *American Monthly Magazine* was equally encouraging, writing that patriotic Americans should be "gratified to observe that the taste for the liberal arts is . . . cultivated, and that they are, every day, becoming more and more an object of enlightened attention."[14]

It may well be that for American landscape painters in those uncertain times, the critical moment—the turning point—was marked by Cole's "Essay on American Scenery," delivered as a lecture in May of 1835 and later published.[15] In his essay, Cole persuasively presented an idealistic argument in favor of landscape painting in America, stating what he saw as the restorative spiritual value of the art form:

> In this age, when a meager utilitarianism seems ready to absorb every feeling and sentiment, and what is sometimes called improvement in its march makes us fear that the bright and tender flowers of the imagination shall all be crushed beneath its iron tramp, it would be well to cultivate the oasis

that yet remains to us, and thus preserve the germs of a future and a purer system. And now, when the sway of fashion is extending widely over society—poisoning the healthful streams of true refinement, and turning men from the love of simplicity and beauty, to a senseless idolatry of their own follies—to lead them gently into the pleasant paths of Taste would be an object worthy of the highest efforts of genius and benevolence. The spirit of our society is to contrive but not to enjoy—toiling to produce more toil—accumulating in

Asher B. Durand, ca. 1869, carte de visite from Mrs. Vincent Coyler's Album. Photograph by American Phototype Company, New York City. The Metropolitan Museum of Art, David Hunter McAlpin Fund, 1952 (52.605)

order to aggrandize. The pleasures of the imagination, among which the love of scenery holds a conspicuous place, will alone temper the harshness of such a state; and, like the atmosphere that softens the most rugged forms of the landscape, cast a veil of tender beauty over the asperities of life.[16]

Cole had struck a chord that reverberated in many minds, whether of artists, poets, patrons, businessmen, or ordinary citizens. Before creating their pictures, the large number of landscape painters who appeared in subsequent years unquestionably took his admonitions to heart; so did the body of art collectors then increasing in number, but in their own good time.

The years 1835 to 1840 found artists flocking to Cole, following Durand's example. An amusing, if not flattering, comment on that trend appeared in a notice in 1836 of the National Academy of Design annual exhibition. Of number 127, by John W. Casilear, it read, "Yet another engraver trying his hand at colors. A first attempt, probably, or nearly so. Too much green again."[17] The last reflection may be a veiled reference to the prevalent tonality of Durand's landscape work, which by 1836 was becoming a major interest of his. Of course, it may also be that the artists, in their enthusiasm for the out-of-doors, were indeed using green to excess in those early years of the School, for shortly afterward, in 1838, John F. Kensett too was cited for exhibiting "a very fair production from a young engraver; a little too green, however, to be a good representation of nature."[18] The exhibition in 1836 was the twenty-five-year-old Casilear's first showing of landscapes: he submitted two, one of which was listed as the property of A. B. Durand.[19] From that nucleus of ambitious engravers grew the "engine" of mid-century landscape painting in this country.

Repeated remarks that the nation had yet to found a true school of painting in the European sense notwithstanding, critics began in the late 1830s to single out landscape painting as the one area where the art of the United States might achieve great things. In 1839, Thomas R. Hofland, an English immigrant and the son of well-known authors, in an essay titled "The Fine Arts in the United States, with a sketch of their present and past history in Europe," wrote: "In one department of art, and an elevated one, that of landscape painting, we venture to predict, a few years will see the United States occupy a very distinguished rank. Indeed, at the present time, the works of Cole, Doughty, [Alvan] Fisher, etc. may vie with the most eminent of their European contemporaries. The American school of landscape is decidedly and peculiarly original; fresh, bold, brilliant, and grand."[20] Hofland, who advocated the establishing of a national gallery and a "National Academy of Confederated Artists," was only one of

John W. Casilear, probably 1860–69, carte de visite from Mrs. Vincent Coyler's Album. Photograph by Johnston Brothers, New York City. The Metropolitan Museum of Art, David Hunter McAlpin Fund, 1952 (52.605)

many wishing to see a unique school of landscape painting evolve in America. Others, joining a debate that went on for a generation and longer, took the opposite position, holding that Americanness was beside the point. An unidentified commentator, writing in a subsequent issue of *The Knickerbocker* and clearly responding to Hofland's essay, had this to say:

Those who advocate an American school, are constantly crying out to our artists, "Paint from Nature." In this sentiment they seem to imagine that all true excellence consists. We certainly would not condemn the notion of always keeping nature before our eyes, when we attempt to do anything truly great and original. But there are two ways of looking

at Nature. . . . The one [American] gives us Nature in her everyday dress, unvarnished, unadorned, and unattractive; the other [English] seizes her in her happiest moments, when sunshine and gladness clothe her in her richest and most enticing apparel. . . . The idea, therefore, of establishing an American school of painting, by an exclusive study of nature, without first acquiring a knowledge of the great principles of the art, is as idle as it is pernicious and deceptive.[21]

The writer agreed with Hofland about the value of establishing a public art gallery, which "would tend more to the improvement of public taste, and a correct style in our artists, than all the schools, public lectures, and annual exhibitions, that have ever appeared among us."[22] It is worth noting that

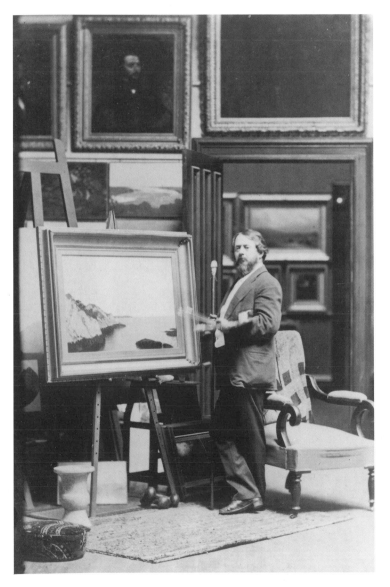

John F. Kensett in his New York City studio, ca. 1864. Photographs of Artists, Collection I, Archives of American Art, Smithsonian Institution

he verged on making the assumption that a "national school," if it came about, would be devoted to nature or landscape painting, a marked change from earlier conservative opinion.

In the growing number of public notices of exhibitions, most often those of the National Academy, the tenor changed in the early 1840s, as landscape painters and landscape painting moved to center stage. An event that drew much attention and that has come to be regarded as an art-historical milestone in America was Durand's departure for Europe in 1840. By then, his career and activities were matters of public concern, commented on in the press:

> Mr. Durand recently sailed for Europe, and we are satisfied from the enthusiasm he has manifested in the study of his art, that no one will avail himself more closely of the privileges there offered, or return more richly laden with the fruits of travel. He has surprised every one, year after year, by his steadily progressive improvement; and should his life be spared, we may predict that Mr. Cole will sooner encounter him as a rival than any other artist now among us.[23]

Accompanied by Kensett, John Casilear, and Thomas Rossiter, Durand had somewhat grudgingly given in to suggestions that he would benefit from acquainting himself abroad with the work of the best masters. This he did, despite his oft-stated insistence that nature and its study must form the soul and substance of painting. He returned from Europe in 1841 to begin painting landscapes that were heavily influenced by European pictures, especially those of Claude Lorrain. Thereafter, to a remarkable degree, Durand combined naturalistic specificity with stylistic coherency in his work, setting a standard for the younger painters.

The public taste for landscape painting had developed strongly by 1842, and a critic could give a mixed review to that year's National Academy exhibition, saying, typically, that though the exhibition was "satisfactory" and the arts were "not declining," there were "too many portraits and too few landscapes and pieces of an historical character." The writer continued, "This to be sure is more the fault of the public than of the artists; but as we have already observed, the taste for these things is forming; the seed is planted, and in good time we doubt not the fruit will ripen and yield an hundred fold."[24]

The advent of the American Art-Union was the single most important occurrence in the art life of mid-century New York, in that it immensely broadened public patronage, which helped to finance young painters, and thereby invited them into the profession. The Art-Union, supported by subscribers from around the United States, was founded in 1838

and disbanded in 1852. In 1849, its most successful year, it had 18,960 members, its *Bulletin* became a monthly publication, a gallery was erected on Broadway on property it owned, and its gross receipts were $96,300.[25] The Art-Union's basic purpose was to purchase works of art from American artists and then to distribute them to the subscribers by means of an annual lottery. Engravings and medals were sent in large numbers to the members, resulting in a wide dissemination of art and a great expansion of support for the artists.

Predictably, of all the types of pictures purchased by the Art-Union, landscape paintings were the most popular. By 1848, the great influence exerted by the Art-Union on New York was noted by *The Knickerbocker*: "The gallery is no longer a superfluity; it has become a necessity. It is part of the public property as much as the fountains, the parks, or the City-Hall. The retired merchant from Fifth Avenue, the scholar from the University, the poor workman, the newsboy, the beau and the belle, the clerk with his bundle—all frequent the Art-Union."[26] Durand, caught in the middle, between the settled interests of the National Academy and the newer ones of the Art-Union, provided his pictures to both organizations. *The Broadway Journal*, a short-lived magazine edited at first in part and in the end entirely by Edgar Allan Poe, contained extensive discussion of contemporary art exhibitions, as well as generous, if occasionally acerbic, criticism of landscape painting. Responding to complaints about these commentaries, the *Journal* editors wrote in their own defense: "There is a growing interest for Art manifested among us, which, for the sake of both artists and public, should not be allowed to decrease; and the press being the only channel through which a knowledge of what is done in Art can be communicated to the public, we have determined to devote a portion of our Journal to that cause."[27]

In its first issue, January–June 1845, *The Broadway Journal* noted the historical importance of the Art-Union purchases and distribution for the year, complimenting the committee of management for its impartial, yet discriminating, taste. The perceptive writer put his finger on the pulse of contention that existed between the Academy and the Art-Union:

> A great part of the pictures were by our young artists; but it is hoped that the increased income of the Art Union will induce our older artists to compete for the prizes of the association with the younger members of the profession. It is greatly to the credit of Mr. Durand that he has seconded the wishes of the committee with zeal and good feeling, putting his pictures at less prices than he would to a private purchaser.[28]

Durand's pictures—ten, of which nine were landscapes—

were regarded as the most popular works in the Art-Union exhibition of 1845. That over half of the painters selected that year by the Art-Union were landscapists seems a remarkable triumph for them, until one realizes that subscribers would of course not care to receive as lottery prizes portraits depicting total strangers, no matter how distinguished the artists.[29] One major criticism *The Broadway Journal* leveled at the painters (and one that would be heard from time to time thereafter) was that they produced overly ambitious canvases. Cole, nearly all of whose paintings "are too large for any drawing-room,"[30] was not excepted. Another complaint was more to the point:

> The great defect of every one of our landscape painters is an ambition to do everything upon one canvass. . . . The pictures by Cole and Durand, in the present exhibition, contain within themselves dozens of other pictures, and the eye wanders from object to object, from light to shadow, from men here to cattle yonder, seeking in vain after repose and a point to pause and hold communion with the artist.[31]

The Broadway Journal, like *The Knickerbocker* delving into the problem of contentiousness within the community of artists, noted:

> The two great parties at present, are the old and the young artists. Each party is divided against itself, but each combines when the other is to be attacked. . . . We do not believe that the evils of which we complain, have so deep a foundation but that SOCIAL INTERCOURSE would remove them. . . . We therefore say—let the artists seek each other's society indiscriminately.[32]

The conflict revolved to a large degree around the activities of the Art-Union, whose annual exhibitions and dispersals of pictures by lottery were seen by many artists, usually the older portraitists, as a challenge to the National Academy, especially to its annual exhibition and attendant sales. As Thomas Seir Cummings, the finest portrait miniaturist in New York, a perennial officer of the Academy, and a dedicated foe of the Art-Union, wrote somewhat crabbedly in his tart *Historic Annuals of the National Academy of Design*:

> During a portion of its existence it [the Art-Union] had a widely extended sphere of action—was extensively known, controlled and distributed large sums of money, *as was said*, for the benefit of art and artists. It probably accomplished a portion of the objects aimed at, whatever may have been the final result. . . . The Art-Union congregated the art patronage into its own hands—it made the demand and furnished the supply; and, it was averred, had its favorites in the distribution of its favors.[33]

Though Cummings's stated opposition to the Art-Union was

based on the artists' losing control of their own destinies, one suspects that at the core of his bitterness was anger at not having benefited himself from the Art-Union's activities. Not long after its published recommendation that "artists seek each other's society indiscriminately," *The Broadway Journal* noted the existence of The New-York Art Re-Union, "where the members of the same profession could meet and converse upon Art."[34] It may be that the establishment of the Century Association in January 1847 was the most enduring result of the artists' dismay over the publicly noted *dis*-union among them. One of the principal founding purposes of the Century, as stated in its earliest documents, was: "To draw closer the bonds of social intercourse between those who should be better known to each other and . . . promote the advancement of Arts and Letters which is in accordance with the progressive Century in which we live."[35] Pacifying leaders from the world of arts and letters, such as Bryant, Durand, Francis William Edmonds, and seven men who had served with them as officers of the Art-Union, were among those joining the feisty Cummings in establishing the Century. Portraitists, landscapists, genre- and history-painters, and others artistically inclined thereafter had a Peaceable Kingdom in which they could all lie down together. As for the American Art-Union, the organization held its last lottery distribution in 1851 and then passed from view, allowing something approaching quiet to descend on the world of art.

The 1850s were halcyon days for landscape painters in America, despite continued doubts being voiced as to the existence of an "American School." Following Cole's early death, in 1848, there was no question that his position of leadership should be taken by Durand, who became the extremely kindly father-figure for a host of followers themselves rapidly assuming the status of masters. Those painters and their activities became objects of lively interest; they became social lions as well. Guidebooks described their works, gave their addresses, and felt free to invite the public to their studios, as in this entry of 1853, which had begun with comments on the landscapists, especially Durand: "In concluding our notice, it may be added, that visitors are generally welcome to the studios of the New-York artists. We need not say that such visits serve to cultivate the tastes of those who thus spend a leisure hour, while they promote and widen true and discriminating patronage of art."[36] In other words, in a city still lacking much in the way of galleries and museums, the artists filled a cultural need; if they were lucky and successful, they did good by doing well. Artists and their works were so well known that self-styled critics, returning from abroad with a superficial knowledge of European art, could be twitted in print for foolish comments such as these:

Durand's landscapes were "tame and unpleasing"; Charles Loring Elliott's portraits "approached the verge of caricature"; Frederic E. Church "would do very well, if he wouldn't attempt the painting of skies"; George A. Baker "failed in color"; and John F. Kensett "must look a little more carefully to the elaboration of his rocks."[37] Sizable space was accorded in papers and magazines to reviews of exhibitions of those men's works, and reports of their divers activities became commonplace.

Until the end of the decade, when Church and Albert Bierstadt burst upon the scene with their large showpieces, Durand was the greatest beneficiary of all the attention. *The Knickerbocker*, in a reprint of material first issued elsewhere, came forth with an extensive comment on the "school," its democratic characteristics, and the acknowledged leadership of Durand:

> Landscape-painting has acquired in our country a dignity and character from the works of its professors, which cannot be claimed for any other branch of the fine arts; and the reasons for this are obvious. The great variety of characters peculiar to American scenery offers points of adaptation to the taste and feeling of every true nature-loving artist. . . . There is also a higher appreciation by our people of those forms of nature with which they are familiar.
>
> There can be no doubt that there is a more genuine and sincere admiration of landscape-painting in our country than for any other; and it is because it is more easily understood by even the most common minds. Hence we find upon our walls a greater preponderance of landscapes. Bad or indifferent the most of them may be, but they indicate the general taste and preference for this form of art. . . .
>
> We cannot go far astray, or offend the general judgement of the community, by placing the name of DURAND at the head of our landscape-painters. Any one who remembers the eloquent and touching speech, unpremeditated as it was, in which he answered the enthusiastic greetings of his name at the opening of the National Academy, cannot but feel that in him NATURE may claim one of its most modest, truthful, and inspired worshippers; and the very earnestness and unanimity of the applause of his auditory proved how strong a hold he has upon their affections and regard.[38]

The article, extremely lengthy for a contemporary art commentary, was completed by an extended characterization, analysis, and praise of Durand's poetically realistic paintings.

The idea that landscape painting was democratic, by virtue of the ease with which it could be appreciated, was echoed in 1854 in *The Illustrated Magazine of Art*, which had begun publishing early in the decade:

> Landscape painting, the only department in which we can hope to form a school, has been cultivated with true devotion.

Frederic E. Church, ca. 1860. Photograph. New York State Office of Parks, Recreation and Historic Preservation, Olana State Historic Site

Here we may gain a proud eminence among the nations, and here alone. The character of our civilisation is too earnest and practical to foster imaginative tastes: the nearness of our past denies to the artist the mellowness and deep perspective of distance. But "the hills rock-ribbed," the course of noble rivers, the repose of lakes, and a climate peculiarly our own, these things, as they appear in the Katskill and Addirondek [*sic*], the Hudson, Lake George, and Schroon, and especially in our autumn loveliness, furnish rich materials for landscape composition.

Our prominent artists have not failed to notice them, and devote themselves to their study. Among those who have succeeded and gained for themselves a name in this department, no one stands so deservedly high as Asher B. Durand, the President of the National Academy of Design, as much on account of the purity and simplicity of his devotion to American landscape as his eminence and skill in his art. The individuality of his trees, true patriarchs of the woods, the charm of his autumn haze, and his quiet, philosophic contemplativeness, give to his works that place in painting which the "Elegy" of Gray, the "Excursion" of Wordsworth, and the "Thanatopsis" of Bryant, occupy in poetry. They are entirely American, and are destined, in our judgement, to become the models after which existing and future artists are to build up a distinctive school of American art in painting—a school whose fame is to be co-extensive with that of our industry. We have artists capable of this great work.[39]

The name of Durand and the widening popularity of art in general and landscape painting in particular were obvious facts of cultural life in the mid-1850s, a situation cemented in our written history with the appearance in 1855 of *The Crayon*. The joint effort of William J. Stillman and John Durand, son of Asher B., *The Crayon*, a thoughtful, well-edited, and widely distributed periodical focusing on literature and the fine arts, was generously welcomed into the publishing fold by *The Knickerbocker*:

"THE CRAYON."—Two excellent numbers of a weekly journal, thus entitled, beautifully printed in sixteen quarto pages, have recently appeared. It is edited by Messrs. STILLMAN and DURAND. The former, "to a practical knowledge of art as a landscape-painter, in which his fidelity to nature is a remarkable characteristic, joins the habit of reflecting and speculating on the philosophy of art, a personal acquaintance with some of the best writers on the arts of design in other countries, a large extent of reading in that department, and no small share of literary skill. His colleague, Mr. Durand, is a man of highly-cultivated taste in art, who has had the opportunity of carefully studying its finest master-pieces in the galleries of Europe. Both of them are men of diligence and capacity, and will spare no pains to give spirit and variety to their periodical. Arrangements of the most liberal nature

have been made for securing the aid of the ablest contributors. There is a call for the establishment of such a journal among a class of readers in this country—a class large enough, we hope, to insure the complete success of *The Crayon*. It will give its readers precisely the kind of journal for which they have occasion—a journal through which they will be informed of all that is going on in the world of art, in both the eastern and western hemispheres, and be furnished with the means of estimating the merit of the various works produced." Admirable original poems by BRYANT and LOWELL have already graced its columns; and the series of letters on landscape-painting, by A. B. DURAND, Esq.[40]

Until 1861, when after having put out eight fat volumes it failed and ceased publication, *The Crayon* fully lived up to its expectations and was the signboard and information center (Fig. 3.1) for American art and artists, as well as the single most influential herald of landscape painting in the country. Asher B. Durand's nine "Letters on Landscape Painting," which appeared in its pages from January to July 1855, formed, with Cole's "Essay on American Scenery," the basic rubric for American landscape painters for almost two generations.

By 1855, the landscape painters truly were in full stride, enjoying attention, social position, and patronage. They had earned their eminence through diligent study at home and on their trips abroad, wide travel in search of subjects, and voluminous production. A review of the National Academy exhibition of 1856 makes clear that a satisfactory leaven of conditions prevailed for the landscapists, some of whom, though still young, already were referred to as senior figures:

> Besides the best efforts of the "great masters," Durand, Kensett, Church, Elliott, Hicks, Lang, and their compeers, certain new candidates for public favor, have made successful endeavors to secure the boon. The Academy, in the pleasant days which bid fair presently to ensue, will be one of the most charming places of resort in the metropolis, both for intellectual and refined enjoyment, and the "best society."[41]

Far from being "generally of retired habits, often fond of seclusion and in many cases utterly averse to society,"[42] as they were perceived of in 1843 (and as Cole certainly was), the artists had come into the New York limelight and had become social ornaments. George Templeton Strong, the New York lawyer and social leader whose diary is one of the most vivid and forthright records of the era, wrote pungently in 1859 that it was "not only creditable but aesthetic and refined to have [artists] at one's parties."[43] The enthusiasm for landscape and its painters found lively parallels as city dwellers bought or built country villas and, following published admonitions by Andrew Jackson Downing and others,

Figure 3.1. *The Crayon* 1 (10 January 1855), p. 29. A typical advertisement

set out in large numbers on country vacations: "Craving for the country is fast becoming a passion; and if centralization in cities is a fact, it is also true that the aggregated tens of thousands seek every opportunity for 'breathing country air,' if not for 'holding converse with Nature.' . . . Art has its most appreciative patrons among the country-lovers."[44]

The country-lovers, in their outings and art purchases, were following (sometimes literally) in the footsteps of the landscape painters (Fig. 3.2), who pursued what was seen as a more adventuresome path in quest of the picturesque:

11.—TABLE-ROCK.

Figure 3.2. "Table Rock." Woodcut illustration in *Harper's Weekly* 2 (2 October 1858), p. 633, showing awe-struck nature-lovers at Niagara Falls

[The true artist] will risk body and brains in his pursuit of a good sketch. Many are the adventures some of our successful painters tell in connection with their pictures—every canvas, indeed, having some interesting bit of history attached to it, which the purchaser of the work should be sure to secure. This pride of profession is a noble sentiment, when it leads the artist to emulation of the best who have honored the calling—when it impels him to study in field and wood, on

Figure 3.3. Thomas Nast, "The Artist in the Mountains," "In the Woods," and "Difficult Travelling." Three woodcuts from "Sketches Among the Catskill Mountains," a full-page spread in *Harper's Weekly* 10 (21 July 1866), pp. 456–57

sea and land, wherever a new thought is to be gleaned, a new feature of Nature to be caught; and he may be regarded as the truest art-devotee who studies Nature most. Our painters are realizing this more and more; and, when the *stampede* to the country for study is made one of the *requisites* of his profession, then we shall see an American School of Art assuming a clearly defined shape.[45]

The practice of the landscape painters during the warm months of the year was to leave the cities and range far afield in search of subjects (Fig. 3.3). That habit was recorded succinctly as a gossip-item by *The Crayon*:

Our chronicle of Art-productions this month [August 1859] is necessarily a short one. The studios are generally deserted, especially by the landscapists, who, as usual at this season, are scattered in all directions, North, East, South, and West. Beginning at Newfoundland, coasting along the shore to Sandy Hook, we hear of Church, Gifford, the Harts, and Boughton, somewhere between the Bay of Fundy and Mount Desert; Colman and Shattuck are on the Androscoggin; Kensett is at Nahant; Strother is somewhere in the vicinity of Boston; Hunt, Staigg, and Ames are at Newport; while Ehninger and Stone, at last accounts, were taking waterscapes off the Neversink Highlands. Going north in the interior, we hear of Leutze at West Point; Casilear among the Catskills; Hubbard in Vermont; and Champney at Conway, N.H. At the west, Durand, Suydam, and Hotchkiss are at

Geneseo. Going south, we find Nichols in New Jersey, at Llewellyn Park; and Weber and Richards, of Philadelphia, examining the landscape beauties of Pennsylvania. Of the remaining Philadelphia artists, Hazeltine is at Mount Desert; Perry somewhere in Maine; and Lewis at Narragansett.[46]

The general situation of art and the artist in the parlors of antebellum New York was markedly different from that of just half a generation before. In 1858, Henry T. Tuckerman, one of New York's most refined and productive litterateurs and, subsequently, author of the masterly *Book of the Artists: American Artist Life*, provided an insight into the new status of art:

> Art, like everything else here, is in a transition state. A few years ago upon entering the dwelling of a prosperous citizen

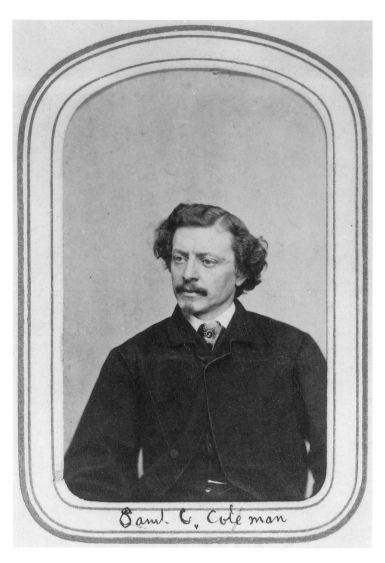

Samuel Colman, probably 1860–69, carte de visite from Mrs. Vincent Coyler's Album. Photograph by George G. Rockwood, New York City. The Metropolitan Museum of Art, David Hunter McAlpin Fund, 1952 (52.605)

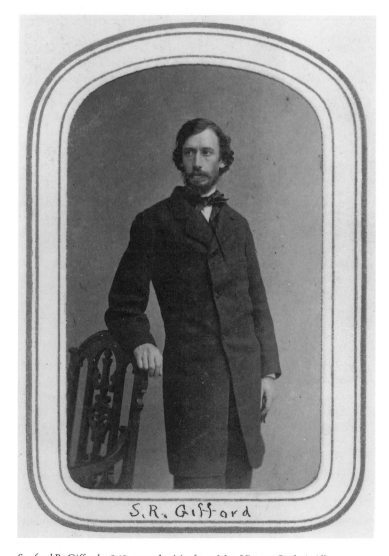

Sanford R. Gifford, 1868, carte de visite from Mrs. Vincent Coyler's Album. Photographer unknown. The Metropolitan Museum of Art, David Hunter McAlpin Fund, 1952 (52.605)

. . . who boasted the refinements of an educated ancestry, we found a full length portrait by Copley, stiff, gorgeous, handsome, but official in costume and aspect [or, possibly, Stuart or Sharpless portraits] . . . now, in addition to these quaint relics, a landscape by Doughty or Cole, Kensett or Durand, a bust by Crawford or Powers . . . indicate a larger sympathy and a more versatile taste. In the cities this increase of works of art as household ornaments is remarkable . . . many gems are scattered through the sumptuous abodes of wealth and fashion . . . and in each metropolis, a rare picture or new piece of native statuary is constantly exhibited, discussed by the press and admired by the people. European travel, the writings of Art-commentators, clubs and academies, the charming or tragic biographies of artists, lecturers, studios, more discrimination in architecture, a love of collecting stan-

dard engravings, the reciprocal influence in society of artists and authors, and their friendly co-operation . . . are among the striking means and evidences of progressive intelligence and sympathy among us in regard to Art.[47]

They were happy days, especially for the well-known landscapists who painted for that thriving market. The March 1860 issue of the *Cosmopolitan Art Journal* contained a rosy article, "The Dollars and Cents of Art," which

William Trost Richards in his Arnold Avenue studio, Newport, R. I., ca. 1904. Photograph by Eleanor Richards Price. The Newport Historical Society, Edith Ballinger Price Collection

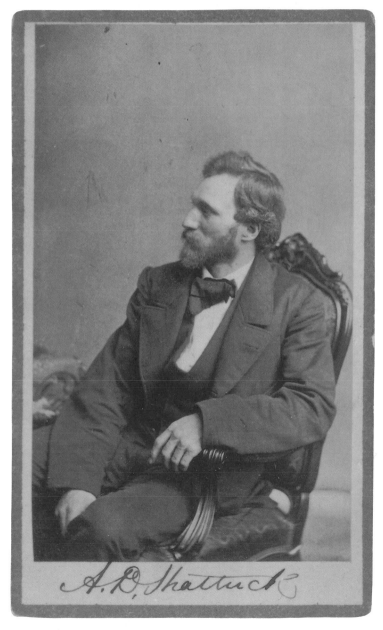

Aaron Draper Shattuck, probably 1860–69, carte de visite. Photograph by George G. Rockwood, New York City. The Metropolitan Museum of Art, The Albert Ten Eyck Gardner Collection, Gift of the Centennial Committee, 1970 (1970.659.725)

explained the contemporary market, possibly as lively a one as this country has ever seen:

> Artists of the elder class, whose reputation gives them commissions sufficient to employ their time wholly, have no really fixed price. A good work by Durand, Kensett, Hicks, Huntington, etc. can be had for three hundred dollars, while they command a thousand dollars for some of their more elaborate labors. Church obtains his own price, for he paints only one picture where one hundred are asked. The same thing may be said of no artist in the country, except it be of James Hart, whose superb canvasses are daily becoming more difficult to obtain. The pictures of Cropsey are not scarce, and command but moderate prices. Some of his best small paintings have, within the last year, been put upon the market by private holders, and have ranged in prices from forty to two hundred dollars. William Hart, Coleman, Shattuck, Gignoux, Mignot, Casilear, Buchanan Read, Sonntag, and art-

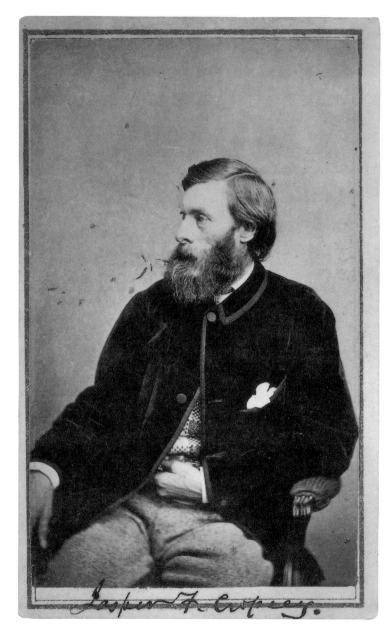

Jasper F. Cropsey, ca. 1865, carte de visite. Photograph by George G. Rockwood, New York City. The Metropolitan Museum of Art, The Albert Ten Eyck Gardner Collection, Gift of the Centennial Committee, 1970 (1970.659.175)

organization as effective sales outlets for art. Williams, Stevens, Williams & Company, on Broadway, was the most established of the dealers, selling artists' supplies, pictures, prints, frames, mirrors, lighting fixtures, porcelains, bronzes, and other decorative items. It had for years made its "superb establishment one of the *necessities* of the town. 'All things rich and rare' are there congregated."[49] Goupil and Company, originating in Paris and the predecessor of the Knoedler Gallery, was the next most important firm. It sold artists' supplies and paintings and published and sold prints. Goupil's usual stock of paintings was of European masters rather than of American, which the American artists correctly viewed as both an aesthetic and a financial threat. The *New York Tribune* printed an article, later picked up by *The Crayon*, concerning a collection of spurious "Old Masters" that was being hauled about for display and sale. The *Tribune*'s advice to the "Croesus" who would buy the pictures was specific and blunt:

1. Always prefer a modern to an old picture.

2. Never buy an old picture which pretends to bear a distinguished name, for you will certainly be cheated.

3. Never buy copies of old pictures, unless you know the artist who makes the copy, and know that he is not a fifth-rate bungler.

4. Have one good picture rather than many poor ones.

5. There are excellent artists in your own country; buy any of them instead of going abroad and faring worse.

6. If you have ever been deluded into making great bargains in Titians, Vandykes, Claudes, or any other old masters' works, burn them up at once if you can afford it; if not, send them to auction to be sold for what they really are, and for what they will bring.

By following these simple suggestions, Mr. Croesus may fill his picture gallery, or furnish his new up-town house with more real success than he has otherwise a right to promise himself.[50]

Instead of relying upon the few dealers, the majority of artists advertised their names, specialties, and studio addresses, usually in *The Crayon*, and held regular visiting days or open houses, when potential buyers could pay calls, peruse the offerings of the studios, and, perhaps, buy. The other most reliable sales outlet, before, during, and after the existence of the American Art-Union, was the annual exhibition of the National Academy of Design, always held in the spring to allow display of the winter's production.

The artists obviously found the situation unsatisfactory, for in 1858, a sizable group of them—of whom over half were landscape painters—founded an association, named Artists' Receptions, for the purpose of holding periodic recep-

ists of their class, average about three hundred dollars for their medium sized works. . . . Works worth more than five hundred dollars are in such slow demand that the artists are rarely tempted into their composition.[48]

In the late 1850s and early 1860s, most of the artists found themselves in the pleasant situation of being able to sell their paintings relatively readily, though at the same time lacking an efficient arrangement for handling their display and sale. Art dealers were few, and still in the early stages of

tions at which their works would be exhibited and sold. The first of these was held in the Dodworth Building, on Fifth Avenue between 53rd and 54th streets, where The Metropolitan Museum of Art had its first home over a decade later. The reception received extensive notice in *The Crayon*:

> . . . It proved to be a decided success; the company being more numerous, and the contribution of works of Art much larger than was anticipated. The Association of Artists, under whose auspices these agreeable and useful entertainments are given, consists of the following gentlemen: Messrs. Greene, Hall, Bellows, J. W. Hill, J. H. Hill, Wenzler, Heine, Blondell, Baker, Pope, Robertson, Dodworth, Tait, J. M. Hart, Stone, Hicks, Church, Staigg, Hubbard, A. B. Durand, Lazarus, Carpenter, Gott, Phillips, Carter, J. Thompson, Rowse, Rossiter, Sonntag, Gray, Mignot, Colyer, W. Hart, Hayes, Cafferty, Shattuck, Richards, Colman, Ehninger, Stillman, Kensett, Blauvelt, Nichols, Gignoux, Wotherspoon, Edmonds and Darley: all were represented by one or more of their respective productions. In addition to the works contributed by the artists above named, several came from other

George Inness, 1862. Photograph by Mathew Brady, New York City. Illustrated in George Inness, Jr., *Life, Art, and Letters of George Inness* (New York: The Century Co., 1917)

Jerome Thompson, *Self Portrait*, 1852, oil on canvas, 20 x 16 in. (50.8 x 40.6 cm.). National Academy of Design, New York City

sources, including pictures from Miss Freeman and Mrs. Greatorex, and Messrs. Gifford, Innes [*sic*], Varley, Hitchings, Falconer, and Parsons, and from several Boston artists, Messrs. F. H. Lane, Rondell, and Morvilier [*sic*]. . . . The paintings, sketches, drawings, etc., exhibited, numbered two hundred and thirty. In addition to these, several portfolios, containing water-colors, were on hand, and photographs of works by celebrated artists.

The pictures and sketches were arranged on the sides and ends of the spacious hall, upon screens, each screen having affixed to it the name of the artist to whom it was appropriated. In the centre of the room were divans, and at the upper end was a piano and music-stands. A choice concert, indeed, was to have formed a part of the evening's entertainment; but, owing to the excitement, we presume, which this novel occasion produced, and the interest of the numerous attractions upon the walls, and in the midst of the audience, music, for once, did not receive its due.

A company like that which honored this reception is rarely brought together in this city in behalf of Art. . . .[51]

The second of the Artists' Receptions, held not long

carefully executed pictures, and a greater variety of subjects. . . . The landscape productions were numerous. . . ."[53] An additional reception was held on 22 March in the new Studio Building (Fig. 3.4), on Tenth Street, which was to be the crossroads of the New York art world for years to come. The *Crayon* notice gives the flavor of the gathering and space:

> . . . There was a large and highly gratified assembly of ladies and gentlemen present; the company visited the several studios in the building, and took much interest in the arrangements of this unique structure. The lighting of the exhibition-room was a decided success. The gas-burners, of a fan-pattern flame, and projecting horizontally, are arranged within the lower edge of the skylight-well; and being very numerous, and the light, in a measure, concentrated, there is an ample supply of it. We have never seen better night-light for pictures, nor a better constructed exhibition-room—thanks to Mr. R. M. Hunt, the architect.[54]

The Artists' Receptions continued to be a success. They were imitated successfully in other cities, although a certain sharp-tongued writer admonished the artists not to be spoiled by the praises and attentions lavished on them at the elegant and very "social" receptions, since it was his impression "that artists are not in want of such nurseries of conceit—their egotism and vanity are not likely to languish."[55] The artists were doing very well, clearly, if such tut-tutting appeared in print. In 1859, *The Crayon* summed up the generally happy situation for art:

> Recent developments in our American world of Art are among the most hopeful and beautiful signs of the times. Art-exhibitions and artists' receptions are increasing in number, popularity, and magnitude. Artists from all parts of the land rush to New York to avail themselves of the executive facilities which no other city on this continent possesses in a similar degree, while Boston—the great nursery of thought of the new world—contemplates the establishment of an American school of Art. The new field which modern civilization opens for Art is well calculated to arrest the attention of the American Artist.[56]

The primary beneficiary of that robust and encouraging situation was the landscape painter. The previous year, when *The Crayon* reviewed the annual exhibition of the National Academy of Design, the most salient comment had been:

> . . . According to the present exhibition, landscape seems to be, for our time, the principal outlet for artistic capacity, being the only department of Art encouraged by the community. If there be an Art of a nobler import to us it is not sufficiently developed, or is perhaps dependent for encouragement upon a state of civilization quite different from the present one. Considering the peculiar aspects of American

Figure 3.4. *Studio Building, 15 West 10th Street, New York City, 1857* (demolished). Photograph. Courtesy, The American Institute of Architects Foundation

afterward, was an equal or greater success: "A large and animated company, consisting of the *élite* of the city, and many distinguished guests graced the occasion. The sidewalls of the assembly-room were hung with pictures and sketches, and these were so arranged as to be seen to better advantage than at the first reception. Landscape Art always forms a large proportion of our gatherings of pictures, and is ever indicating steady progress."[52] The third reception of the season was held on 12 February: "A larger company than usual honored the occasion; more than eight hundred and fifty persons entered the saloon during the course of this evening. The ample collection of works of Art was even more attractive than before, consisting of larger and, generally, more

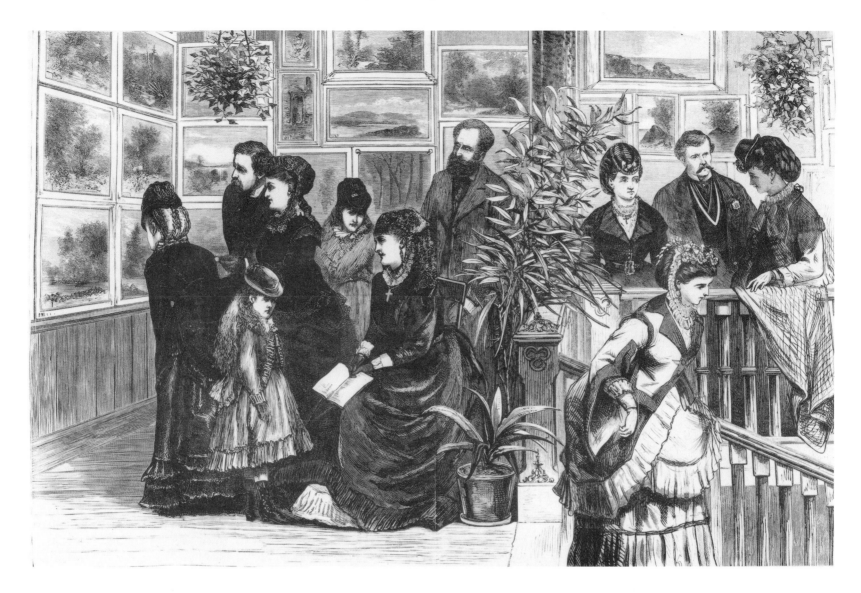

Figure 3.5. "New York National Academy of Design—At the Head of the Staircase." Engraving. National Academy of Design, New York City. Illustrated in *Harper's Weekly* 14 (14 May 1870), p. 316

Figure 3.6. C. S. Reinhart, "Varnishing Day at the New York National Academy of Design." Engraving. National Academy of Design, New York City. Illustrated in *Harper's Weekly* 14 (7 May 1870), p. 292

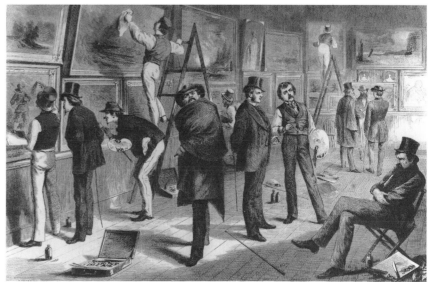

scenery—a scenery which our people appreciate intelligently or intuitively (it makes but little difference which), no one can fail to recognize its inspiration in the landscapes offered for our study and enjoyment. We see the nature we are familiar with through various minds in various forms of skillful expression, always wondering at the diversity of feeling which the same scenery excites. . . .[57]

The art-historical record of the 1860s, particularly in the catalogues of the National Academy of Design (Fig. 3.5),

Martin J. Heade, 1860. Photographs of Artists, Collection I, Archives of American Art, Smithsonian Institution

tions. . . . The way to master both press and dealer, is for artists to concentrate their energies and strive to lead public taste by an improved institutional organization. . . . Then let there be an association formed . . . so as to embrace and control such projects as properly belong to institutional action, an Artist's Fund, a literary organ and the publication of valuable works, if need be. . . . These matters are worthy the attention of artists if they would keep pace with the spirit of the age. We hope that they will reflect over them and discuss them freely.[58]

The dilemma of artists wishing for commercial success

Francis A. Silva, ca. 1861. Photograph. Private collection

show that the landscape painters flourished both in numbers and in the amount of work they displayed: Church, Bierstadt, and Kensett enjoyed particular prominence and popularity. There were, however, hints of trouble in paradise as the collecting of European pictures became more fashionable in the United States. Goupil, Kurtz, Avery, and other leading firms increasingly took over the operation of the art market, making it necessary for the individual artist to find a dealer to sell his paintings. *The Crayon* was forthright in calling attention to the situation, and praised the artists in Europe who banded together in effective organizations to promote their own welfare:

> . . . If American artists do not pursue a similar course, and watch over the interests of their calling, they will soon be lost in the crowd of art speculators, and subject to all the evils of the European picture-dealing system. The dealer now presents exhibitions as large as any got up by institutions; he controls our superficial newspapers, using them at will to puff his wares and to help him to palm off spurious produc-

continued, and even increased. Unable to counterbalance changing taste and marketing arrangements, the artists formed new associations, including in 1866 the American Society of Painters in Water Colors, though the National Academy, more a local than a national organization, remained the center of their world (Fig. 3.6). For those landscapists such as Church and Bierstadt who did not change their styles or subject matter, the period of the late 1860s and the 1870s was an unhappy one of dwindling sales and mounting criticism. The record of the 1870s is replete with indications of the changed climate. In April 1878, by which time the game was definitely up for the painters who had already been given the derisory collective title "The Hudson River School," the *New York Times* printed a revealing appraisal of what had happened to the art world:

> The worst hardship of American artists is not the difficulty of supporting life. . . . The worst hardship is the lack of artist's life in New-York, the absence of intellectual bustle of the ateliers, which, taken in not too great doses, is stimulating and healthful. During the war there was more of this in New-York than now. There was a more liberal spirit among the members of the National Academy. Perhaps there was less competition; certainly there was less public knowledge of what is very bad in art, and certainly there was no good criticism in the press. But the artists held together more, and, while showing greater audacity in work, admitted wider latitudes in judging each others paintings. . . . Now a new era has set in. . . . This is not the place to suggest a remedy. Clubs, associations, a drawing together again of ateliers might do something. Whatever should be done should emanate from the Academicians, if they wish to hold the lead in American art.[59]

The work of certain landscape painters—Kensett, Inness, David Johnson, Alexander Wyant—did undergo stylistic permutations, in some cases more radical than in others, but the majority of Hudson River School artists loyally maintained their familiar styles and thereby lost the support of the art world in general, in which they came to be viewed as living fossils. A paradigm of their unhappiness is found in the diary of Jervis McEntee, who during the 1870s and 1880s, day-by-day and at length, carefully recorded his misery born of diminishing sales and art-world infighting. (McEntee did receive some handsome public notices during the 1870s,[60] but to little avail.) His complaints centered on the apathy and disunity of the National Academy as the artists pursued their own independent paths in the face of the rising tide of imported European art. McEntee's concern led him to buttonhole a number of his fellow Academicians. On 6 May 1873, a Tuesday, McEntee called on Worthington

Albert Bierstadt, 1861, carte de visite from Mrs. Vincent Coyler's Album. Photograph by Bierstadt Brothers, New Bedford, Massachusetts. The Metropolitan Museum of Art, David Hunter McAlpin Fund, 1952 (52.605)

Whittredge "to see if anything could be done about the Academy." The two men and several of their colleagues tried to put together a slate of officers for the Academy that would reconcile differences among the artists. As McEntee duly recorded: "I saw Gifford afterwards and urged him to serve. He did not say positively he would not but was very unwilling to. He says as I believe that the present management, seeing the poor exhibition we have this year are getting tired and

their installation just before the exhibition opened to the public. McEntee, who attended the annual event on 7 April 1874, put down his mixed reaction:

> Naturally my first anxiety ordinarily would be for my own pictures but I confess I was most anxious at this critical stage of the Academy to see what the character of the exhibition was. I was glad to find it much above the average, in fact a most interesting exhibition. My "Cape Ann" is in the large room in a good place. My "Wood Path" on the line in the West Room. My "Deans Rivers" over another picture in the same room and looking very poorly. My "Solitaire" on which I most depended over another picture in the North Room. I feel that I have had a decided snub at the hands of the hanging committee David Johnson, [Carl] Brandt, and [John B.] Irving who took care to have all their pictures on the line. It has made me feel a little depressed but I try to be philosophical. Poor Weir [John Ferguson Weir] was most shamefully treated and was utterly cast down. His picture is hung over another in a dark corner and as he is an Academician and had only sent this picture I regard it as a downright insult.[63]

David Johnson, probably 1860–69, carte de visite from Mrs. Vincent Coyler's Album. Photographer unknown. The Metropolitan Museum of Art, David Hunter McAlpin Fund, 1952 (52.605)

Alexander H. Wyant, ca. 1890. Photographs of Artists, Collection I, Archives of American Art, Smithsonian Institution

are anxious to compromise. I think we had better meet them half way and not wait until they do more damage."[61] Some weeks later, McEntee, in a blue mood brought on by the success of George Boughton's English-flavored pictures, bemoaned the loss of prestige of things American: "A reputation in England is valuable while here it is worth nothing. Our people having no deep seated love of Art are fickle and take up and abandon their favorites in mere caprice. We who are living and working today are the pioneers and I hope and believe that those who come after us, who are strong and original men will have a better time."[62]

The indigenous wrangling of the artists' community seemed to peak each year on varnishing day at the Academy, when the painters could touch up their pictures and appraise

plate switching over from landscape to figure painting and to investigate the possibility of entering into an arrangement with a dealer. One day in 1876, he accompanied Church, his former teacher, on a visit to Church's dealer, the Knoedler Gallery, and recorded: "I was struck with the facilities they have for selling pictures and felt more than ever impressed with the need we artists have of a place to sell our pictures."[65] Some years later, McEntee talked with his close friend Eastman Johnson, who was not selling well but had just met

Jervis McEntee, ca. 1870, carte de visite. Photograph by A. A. Turner, New York City. The Metropolitan Museum of Art, The Albert Ten Eyck Gardner Collection, Gift of the Centennial Committee, 1970 (1970.659.560)

Despite McEntee's gloom, both he and Weir sold their pictures out of the exhibition. McEntee saw that success as a contrast to the prevailing situation: "There seems an utter stagnation in Art matters. Avery told me he did not see anyone who had any idea of buying pictures. I think the dealers are pretty well discouraged. No one comes here. It is a little remarkable that pictures should sell at the Academy where they never had sold before. They are mostly low priced pictures however."[64] He was discouraged enough to contem-

Worthington Whittredge, ca. 1870. Photograph by George G. Rockwood, New York City. Photographs of Artists, Collection I, Archives of American Art, Smithsonian Institution

with the successful dealer Samuel P. Avery: "He [Johnson] had had a plain talk with him as he [Avery] has built a gallery he thinks now he would like to get some of the leading artists to send pictures to him. We talked long as we always do and we were agreed that if Avery would make any advances we would be ready to visit him as we consider him the best man to sell our pictures."[66]

For McEntee, that was something of a concession, since Avery was one of the most active importers of the European pictures—particularly those of the Barbizon and Munich schools, which were anathema to McEntee. Not long afterward, the painter received a call from George Cooper, a New York artist. McEntee noted the conversation: "He assured me people have the greatest hesitancy about coming to artists studios for fear of interrupting them. He seemed to think it quite surprising that I depended on selling my pictures to people who came to my room. The more I think of it the more I am convinced of the necessity of some business management for the sake of our pictures. The whole thing is changing. No one comes to the studio now."[67]

That New York had adopted the European system of relying upon dealers to promote contemporary art is made clear by a notice on "Art in New York" which appeared in *Harper's Weekly* of 8 February 1879:

> The galleries of the principal picture-dealers of New York offer many attractions this winter to the lovers of art. . . . At Goupil's, Kohn's, Avery's, Schaus's, or any other large dealer's, the visitor will find quiet, well-lighted, pleasant galleries, filled with pictures by artists of world-wide fame; some by foreign masters, who, like European authors, find in the New World an appreciation as broad, as cultivated, and as liberal as that which they enjoy at home.[68]

In the article, only the name of J. G. Brown found mention among a welter of Europeans like Jean-Léon Gérôme, Jules Breton, Jules Dupré, and Mihály Munkácsy. On 3 May 1878, McEntee entered this melancholy comment in his diary: "I am more unhappy than I have ever been before for I have not the faith and hope I once had. It seems a sad conclusion that after twenty years spent in New York during which I had won some distinction to find myself today actually unable to pay my rent and my living."[69] Although similar dreary records of disappointments and disaffection continued for years in McEntee's diary, the passage could almost stand by itself as an obituary for the Hudson River School.

McEntee and others made a valiant attempt in 1883 and 1884 to recapture their former situation by establishing a new Art Union, but the organization and its magazine quickly disappeared. In 1881, a memorial exhibition mounted at the Metropolitan Museum for Sanford Gifford (who had died the previous year) was awarded a poor critical reception. Durand died in 1886. His memorial exhibition, held the following year at the Ortgies gallery, was given a kind but lethal critique in *The Art Review.* First deeming it "strongest in historical interest . . . [it] concerns every intelligent student of American art," the writer recalled Durand's wide influence and careful style. He then went on to bestow the coup de grace on the esteemed artist and the Hudson River School: "The public has known little of him for many years—he was ninety when he died in September—but this collection, technically unimportant though it may be, is a reminder that the last of the fathers of American art has passed away."[70]

And thus, in a brief period, little more than fifty years, America's first indigenous school of landscape painting rose to favor and passed into temporary oblivion.

THE HUDSON RIVER SCHOOL IN ECLIPSE

Doreen Bolger Burke and Catherine Hoover Voorsanger

IN STYLE, SUBJECT MATTER, and philosophy, the Hudson River School represented a particularly complimentary mirror of American values in the decades preceding the Civil War. More than twenty years after Appomattox an art critic described the apogee of Hudson River painting with the clarity hindsight bestows:

> This entire school of landscape-painters is the product of the public taste as it existed before the war. The public mind was in greater repose, less cosmopolitan. . . . It is to this . . . aesthetic perception that posterity owes the reproduction of scenes which must ever remain identified with this continent.[1]

In the 1840s and 1850s, when American landscape painting—specifically, the landscape painting of the Hudson River School—was at the height of its popularity, it was regarded as the most ambitious genre in American art, and was looked on with admiration both by the American public and by American art critics.[2] Thomas Cole, Asher B. Durand, Frederic E. Church, Albert Bierstadt, and many other painters active in and around New York City chose the American scenery as the subject of their work. Frequent depictors of the Hudson River valley, the Catskill Mountains, and other wilderness areas, and hailed as the brilliant progenitors of a new national art, free of European traits, those men came to be known as the Hudson River School.[3] The term (one of

disdain when it was first coined, apparently in the late 1870s) denoted an attitude toward painting that resulted in works panoramic in vision and precise in detail. Although compositional and thematic differences existed among the artists, some of whom looked beyond the United States for subject matter, they were united in avoiding obvious evidence of an individual hand or emotion in rendering landscapes that were idealized transcriptions of the natural world.

In the 1860s and early 1870s, as Americans were becoming more cosmopolitan in their tastes, the Hudson River School was repeatedly taken to task by critics who questioned its precepts or found its work boring. In the post–Civil War era, the increasing influence of foreign training and travel on American artists and patrons and the large-scale importation of European art into the United States, especially from France, began to affect the material well-being of the Hudson River artists. At the same time, their principles were called into question by the confluence of several new trends in American art, all having roots in Europe. Among these were the appreciation of Barbizon landscape painting, the fascination with technical virtuosity cultivated by the Munich School, the popularity of French academic training and the figure, its central aspect, and the vogue for the British-inspired Aesthetic movement, which made interior settings and decorative objects more common themes in American

Figure 4.1. David Johnson, *Near Squam Lake, New Hampshire*, 1856, oil on canvas, 18¹⁵⁄₁₆ x 28 in. (48.1 x 71.1 cm.). The Metropolitan Museum of Art, Rogers Fund, 1917 (17.110)

Figure 4.2. David Johnson, *Bayside, New Rochelle, New York*, 1886, oil on canvas, 19½ x 24 in. (49.5 x 61 cm.). The Metropolitan Museum of Art, Bequest of Maria DeWitt Jesup, from the collection of her husband, Morris K. Jesup, 1914 (15.30.65)

paintings and which emphasized the formal qualities of line, color, and design. Those trends prompted a reevaluation of aesthetic criteria, ultimately caused the demise of the Hudson River School, and transformed the world of American art.

When contrasted with the subject matter and style of younger, European-trained American painters, those of the School appeared stagnant and old-fashioned. Its landscapes, criticized as grandiose and elaborate, and its technique, as too literal and detailed, were subjects of fervent discussion throughout the 1870s among the Hudson River painters, their artistic challengers, and the critics who reviewed their work. A reaction to the new influences promulgated by the cosmopolites gradually became evident in landscapes by some of the established painters, as a comparison between David Johnson's *Near Squam Lake, New Hampshire* (Fig. 4.1) and *Bayside, New Rochelle, New York* (Fig. 4.2) suggests. The artist, who over the years had changed from the Hudson River School style to one Barbizon in spirit, was accused of posturing with "effects à la Dupré and Jacque, in place of his life-long reflections of Kensett," by a critic reviewing one of his later paintings.[4]

The dilemma of the native school of painters—whether to resist the influx of new artistic concepts or to adapt themselves and their art accordingly—is audible in the primary sources of the period: the artists' personal diaries and correspondence, the critical reviews of exhibitions held at the National Academy of Design and elsewhere, and the minutes of the Academy meetings. The 1870s were clearly years of transition, as the Hudson River painters, committed to an artistic vision fast losing favor, struggled to maintain critical approval, the patronage of their sponsors, and control over the National Academy, still the most important locus of annual exhibitions anywhere in the country. By 1879, the forces of dissent had coalesced, and members of the artistic community acknowledged the decline in influence of the older group and the emergence of a new and very different breed of painters.

The Hudson River men realized that their generation's best years were over. Jervis McEntee, after attending varnishing day at the Academy in 1879, lamented, "[At this] large gathering of artists, many of them were entire strangers to me where I used to know all."[5] One of his fellow Academicians, in conversation with the writer Earl Shinn, likened himself to "an old hen-goose . . . tied by the leg, and professing to take care of a large flock of little chickens; the chicks were exploring . . . and the old goose was pulling her leg off trying to follow after. So I am trying to get the best view of nature, but there is the old string to my leg."[6] Writers of the period recognized that American art had reached a crossroads and that there were two groups of artists vying for supremacy. Shinn distinguished between "the new tendencies and the old tendencies . . . the fogy pictures and the innovating pictures, the Hudson River school and the impression

school."[7] As John Ferguson Weir, a painter and art teacher as well as a discerning art critic, had observed the previous year:

> We have now, filling the arena, two generations of living artists—a generation either at its prime or about passing into shade (who have achieved in some respects a distinct development for American art—freshness, individuality, and a sincere aim centered in nature); and a new generation of younger men, recently returned from abroad, where they have been schooled in the methods and discipline of Munich and Paris. Here, then, are two, not necessarily opposing, but certainly distinct, phases of art-development existing among us.[8]

The two groups differed in training, working methods, choice of subject matter, styles, artistic philosophies, even in the ways they sold and promoted their work.[9] The direction in American art taken by the "new school" or the "new men"[10] could be studied in any genre, for there were equally dramatic changes in figure and still-life painting. In landscape, as aesthetic priorities gradually altered and new standards were introduced, the changes are of particular interest.[11] With the heightened expectations then being expressed, the very qualities that had once made the works of the older artists esteemed now caused them to be derided. Mariana G. Van Rensselaer, an advocate for the younger men, observed of Sanford R. Gifford in 1882, only two years after his death: "No one could deny that, were he to begin his career today, and were he to follow it out in the same manner that achieved success a score of years ago, it would be impossible for future critics to rank his name where it now stands—among the very first of his artistic generation in this country."[12]

THE NOVELTY OF INTERNATIONAL IDEAS and styles was only one challenge to the preeminent landscape painters. Diminishing enthusiasm on the part of art critics and, presumably, the art-loving public, satiated with Hudson River School productions, is chronicled in the assessments of the National Academy exhibitions published from 1865 through the 1870s. Many writers, even those generally loyal to the artists, found their work increasingly dull. A reviewer for *Putnam's Magazine*, noting in 1869 that the venerable Durand was outdated, associated his meticulous painting style with the most conservative artistic conventions:

> Ten years back Mr. Durand's pictures were considered models of landscape art. . . . But younger artists, of the new school with which he had no sympathy, crowded him out of public favor. People grew tired of his everlasting moonlight scenes, his very green forests and meadows, his tamely correct

Academic style, and lost sight of the genuine feeling and sense of repose that pervaded most of his work.[13]

Durand was not the only landscape painter whose work was deemed too repetitious in theme and treatment during the post–Civil War period: Bierstadt had "copyrighted nearly all the principal mountains"; McEntee, best known as a painter of autumnal subjects, "ought to tell us something new about Autumn, and occasionally give us some evidence that he recognizes the other seasons"; Jasper Cropsey was said "to have lost the key of his color," thus "distracting the eye in a very unpleasant manner"; William Trost Richards, instead of conveying "the general effect," merely gave "every wave, with every fleck of light and patch of color"; Church, accused of exaggeration in a spectacular painting, was being "sensational rather than poetic."[14] The allegation of "intellectual monotony,"[15] while not a relentless harangue, had by 1865 become a *leitmotif* in reviews of Hudson River School works. "So far as the enjoyment and instruction of the public are concerned, the Academy might cover its walls year after year with the same pictures," one ascerbic critic observed.[16] The waning popularity of the Hudson River artists, therefore, is attributable at least in part to their landscape formulas, which had begun to seem drained of vitality.

Hudson River School paintings, once greeted with approbation and awe, could now be perceived as overblown and ridiculous. George W. Sheldon, renowned writer on the art of his day, commented on the School's "tendency to rush to the grandiose, the striving for that which was striking and palpable";[17] Mary Gay Humphreys, a widely read commentator of the period, called attention to its reliance on "phenomenal" subjects, among them the Rocky Mountains, the White Mountains, the Adirondacks, and Niagara Falls.[18] Landscapist Worthington Whittredge, writing around 1900, recalled that because "simplicity of subject was not in demand," his contemporaries had created "some great display on a big canvas to suit the taste of the times."[19]

Compared with works in the newer styles, where the breadth or simplification of detail permitted the artist to convey an impression or an emotion, the Hudson River School's commitment to truth to nature was misinterpreted by critics, who belittled it as mere imitation on the part of the painters.[20] A summary of the School's failings published by painter and critic S. G. W. Benjamin in 1879 is typical:

> If there has been a fault in this school of American landscape art, it has been, perhaps, in endeavoring to get too much in a picture, in trying to be too literal; so that the great attention given to the details had excited wonder rather than stimulated the imagination, and had marred the impression of general effect which should be the chief idea in a work of art.[21]

Figure 4.3. Frederic E. Church, *Heart of the Andes*, 1859 (detail), oil on canvas, 66⅛ x 119¼ in. (168 x 302.9 cm.). The Metropolitan Museum of Art, Bequest of Margaret E. Dows, 1909 (09.95)

The journalist William C. Brownell, a champion of French art, in comparing William Trost Richards's "carefully minute study of wave forms" with John La Farge's "poetic interpretation of the atmosphere and color and spirit of the place," concluded: "No one knows if Mr. La Farge has not made just as careful studies and found them just as necessary, although no trace of them appears in the works to whose excellence they may have contributed."[22] In short, an artist was free to study and to appreciate nature without having to replicate every physical detail, for detail could actually obscure the essential poetry of the landscape.

Church and Bierstadt, two giants of mid-century landscape painting by dint of their reputations and the size of their canvases, best typify what critics found objectionable in the Hudson River School as early as 1865: in panoramic paintings such as Church's *Heart of the Andes* (see p. 246 and Fig. 4.3) or Bierstadt's *Rocky Mountains, Lander's Peak* (see p. 285), they viewed the composition as a mere record of unrelated minutiae. Only thinly veiling his allusion to Church and Bierstadt, Eugene Benson, a painter and critic

leaning to the progressive strains in American painting, mourned in 1868 that artists aimed simply to accumulate facts.[23] Or, as another writer pronounced a few years later, "Mystery . . . is an effect in nature of which our painters rarely seem to have any conception or even perception."[24] Such complaints persisted through the 1870s. In discussing Church's *Heart of the Andes, Cotopaxi* (see p. 254), *Chimborazo* (see p. 259), and other of his paintings, G. W. Sheldon pointed out what he considered a serious defect—"the elaboration of details at the expense of the unity and force of sentiment." He went on to say, "They are faithful and beautiful, but they are not so rich as they might be in the poetry, the aroma, of art."[25] In 1879, a review in the *New York Times* condemned Church's *Niagara* (see p. 243) because it was "direct and literal" rather than "indirect and suggestive."[26] As for Bierstadt, his *Diamond Pool* (location unknown), shown at the National Academy in 1870, was described as "wonderfully elaborate and cleverly handled throughout," but was found to lack the "mystery, the suggestion of hidden beauty, and of poetic feeling" that would have elevated the painting from "admirable" to "great."[27] Previously, it had been suggested that if Bierstadt, in one of his Yosemite Valley pictures, had "imparted to this canvas any deep, inward, intuitive *personal* impression of the scene, he would to *that* extent . . . have made it interesting."[28] Despite like remarks, a number of Hudson River painters continued to strive for high finish and detail for some time. Alfred Thompson Bricher was taken to task for "countless pictures done in metals—hard cast-iron marines, with even rows of little waves like a nutmeg-grater";[29] Arthur Parton was carped at for depicting "every fern-leaf, each blackberry twig and spray of birch" at the expense of "atmosphere, of sunshine as a distinct feature, or of that clear-obscure of what should be seen and what remain a mystery."[30]

Extravagant landscape productions suffered by comparison with advancements in photography. Ironically, several painters—among them Bierstadt, Church, and Thomas Moran—regularly used photographs to augment their preparatory sketches.[31] With the invention of the stereograph, however, the painter's hegemony over the landscape was threatened rather than served. Stereographs, ubiquitous by 1860,[32] could be taken with exposures not previously dreamed of—as fast as a fiftieth of a second.[33] Unlike the daguerreotype, the stereograph, easily manufactured in multiple copies, created a startling illusion of three-dimensional space, which could transport the armchair traveler to the same distant peaks the artist surveyed. Unfortunately, because the camera *appeared* to capture the most truthful rendering of nature possible,[34] it revealed the painter's artistic

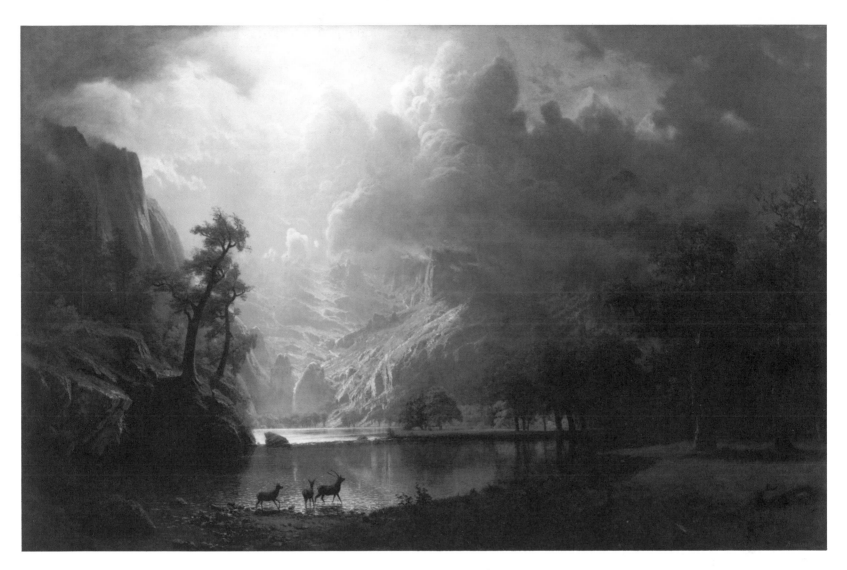

Figure 4.4. Albert Bierstadt, *Sierra Nevada Mountains, California*, 1870, oil on canvas, 56 x 84 in. (142.2 x 213.4 cm.). The Thomas Gilcrease Institute of American History and Art, Tulsa, Oklahoma

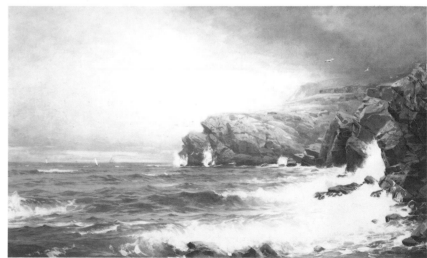

Figure 4.5. William Trost Richards, *Coastal Scene*, 1887, oil on canvas, 19 x 32 in. (48.3 x 81.3 cm.). Collection of Mr. and Mrs. Walter H. Rubin

language to be hyperbole. Hence, a critic for the *New York Evening Post*, writing in 1870 of Bierstadt's *Sierra Nevada Mountains, California* (Fig. 4.4), then on view at the National Academy, condemned it:

> Judging . . . by numerous photographs of this range . . . we doubt the scenic fidelity of Mr. Bierstadt's landscape. . . . Sky-peaks, rocks, clouds, water-falls, trees and animals are jumbled together heterogeneously, the whole seeming to be illuminated in the glare of a Bengal blue light. It is a kind of "frou-frou" of natural appearances . . . a theatrical scene by daylight. This picture has not the merit of pure objective rendering, that simple accuracy of commonplace detail which even when barren of poetic significance, pleases.[35]

More than a decade later, when Richards's *Wild New England Shore* (location unknown; see Fig. 4.5 for a comparable scene) was exhibited at the National Academy, it elicited a similar response from a writer for the *New York Times*: "It is hardly necessary to speak of the fidelity to facts met with in this picture, and yet it is art with the genius left out, a trial of exactness and industry between the painter and the maker of fine colored photographs."[36]

Among the younger painters, technical virtuosity was almost mandatory. Mrs. Van Rensselaer defined "the artistic

Figure 4.6. J. Francis Murphy, *The Path to the Village*, 1882, oil on canvas, 21¼ x 33¼ in. (54 x 84.5 cm.). National Museum of American Art, Smithsonian Institution, Gift of William T. Evans (1909.7.50)

Figure 4.7. R. Swain Gifford, *Near the Coast*, ca. 1885, oil on canvas, 31¼ x 51 in. (79.4 x 129.5 cm.). The Metropolitan Museum of Art, Gift of an Association of Gentlemen, 1885 (85.7)

gospel" preached by "the new band of native artists" (e.g., Figs. 4.6; 4.7): "The painter's first privilege, first task, first duty, [is] *to learn the art of painting*."[37] Members of the old guard were repeatedly attacked for their lack of bravura; their methods were described as "weak and vacillating," "obsolete," and "feeble."[38] The tight brushstrokes, precise details, and smooth finish that had once held both viewers and critics spellbound were now faulted as brittle, contrived, and overly scientific.[39] In the opinion of Mrs. Van Rensselaer:

> Our elder school . . . accorded no such prime importance (as do we) to the proper management of one's tools. The soul, not the eye and wrist, was thought the principal factor in an artist's equipment, and when that seemed of proper quality, the most rudimentary training in the mechanics, so to speak, of painting was held sufficient.[40]

In her generally laudatory evaluation of Gifford's career, Mrs. Van Rensselaer remarked that the distinguished painter "had no idea of managing his brush as that work is understood today by every pupil in an art school."[41]

The painters of Gifford's generation had not disregarded technique, but they did have different artistic priorities. As a writer for *The Crayon* maintained in 1855: "We must give precedence to the man who *conceives* nobly and purely, rather than the one who *executes* admirably."[42] Those ideas continued to prevail among the Hudson River School painters. "I believe in the old instincts, ideas, sentiment and not execution," wrote McEntee in 1878, after attending the first exhibition of the Society of American Artists.[43] To Francis A. Silva, subject was more important than pictorial issues as late as 1884: "A picture must be more than a skilfully painted canvas;—it must tell something. People do not read books simply because they are well printed and handsomely bound."[44]

SANFORD GIFFORD AND JOHN F. KENSETT are two Hudson River School painters whose work of the 1860s and 1870s answered a constantly growing demand for simpler subjects and more unified treatment. As a result, their paintings constituted one standard against which critics judged the work of their peers. Gifford, Kensett, and other painters, including Martin Johnson Heade, worked in a mode now referred to as Luminism. While Luminist paintings and those more typical of the Hudson River School reveal certain similarities—small, unobtrusive brushstrokes, for instance—they differ in that the Luminist artists suppressed detail and concentrated on attaining a unified, light-suffused composition. The definition of Luminism—which is seen as having

emerged after the Civil War (and whose quietude may have been a reaction to that appalling conflict)—and the reasons for its development are complex and, among scholars, controversial.[45] Though Luminism can be thought of as a natural evolution in the style of American landscape painting, the distinction between the Luminist and the more traditional Hudson River School approach is not one that can be attributed simply to generational differences.[46]

Gifford described his work now called Luminist as "air painting"—that is, achieving on canvas the illusion of warm pervasive sunlight and moist atmosphere. G. W. Sheldon, writing in 1877, offered a rationale for Gifford's method: "The condition—that is, the colour—of the air is the one essential thing . . . in landscape painting." He added, "Different conditions of the air produce different impressions upon the mind, making us feel sad, or glad, or awed."[47] The radiant crepuscular light bathing Gifford's landscapes, its source often unspecified (see p. 222), suggests a higher spiritual order—a new manifestation of an old Hudson River School theme—and marks the painter as Joseph Mallord William Turner's true heir.[48] Gifford's *Shawangunk Mountains* (1864; location unknown), submitted in 1865 to the National Academy's annual exhibition, was greeted with an encomium characteristic of those received by his paintings of the 1860s and 1870s: "Here is light and color, perfect fusion of tints and brush work, free, hidden, and mysterious; here is the art that conceals art; here is a canvas from which light and warmth seem to radiate through air that floatingly fills all space."[49]

Kensett's views of placid waters under pellucid summer light (see p. 160) also convey an impression of calm, tranquillity, and peace. In the great body of work the artist produced in the last summer of his life, the spare horizontal bands of shore, sea, and sky make each canvas a statement on the very act of painting. All appear to be devoid of literary or narrative content.

A TANGIBLE ALTERNATIVE to the American landscape tradition was presented by a group of French landscape artists known as the Barbizon painters and consisting of Jean-Baptiste-Camille Corot (Fig. 4.8), Pierre-Etienne-Théodore Rousseau (Fig. 4.9), Charles-François Daubigny, Narcisse-Virgile Diaz de la Peña, Jules Dupré, and Charles-Emile Jacque, along with figure painter Jean-François Millet and animalist Constant Troyon.[50] Centered for the most part in the forested region of Fontainebleau, in the village of Barbizon, not far from Paris, the group started out in the 1830s and 1840s in open opposition to the French Academy. Aban-

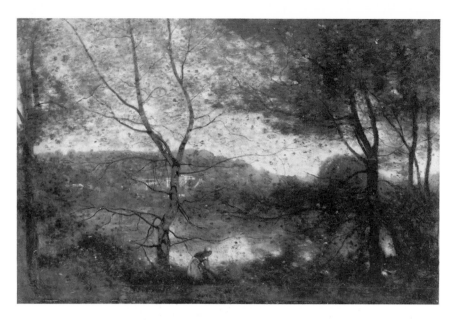

Figure 4.8. Jean-Baptiste-Camille Corot, *Ville d'Avray*, ca. 1870, oil on canvas, 21⅝ x 31½ in. (54.9 x 80 cm.). The Metropolitan Museum of Art, Catharine Lorillard Wolfe Collection, Bequest of Catharine Lorillard Wolfe, 1887 (87.15.141)

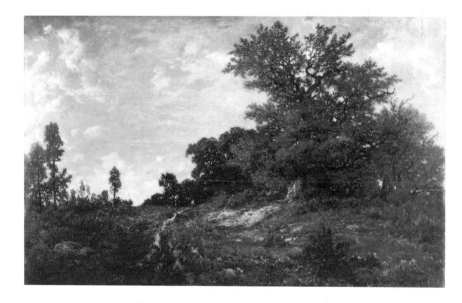

Figure 4.9. Pierre-Etienne-Théodore Rousseau, *The Edge of the Woods at Monts-Girard*, 1854, oil on wood, 31½ x 48 in. (80 x 121.9 cm.). The Metropolitan Museum of Art, Wolfe Fund, Catharine Lorillard Wolfe Collection, 1896 (96.27)

doning the structural formulas of classical landscape established by Nicolas Poussin and Claude Lorrain, they found inspiration in the naturalism of seventeenth-century Dutch landscapes and in the work of such nineteenth-century English artists as John Constable, whose philosophy of painting they took to heart: "It is the business of a painter not to

contend with nature, and put this scene (a valley filled with imagery 50 miles long) on a canvas of a few inches, but to make something out of nothing, in attempting which he must almost of necessity become poetical."[51]

Landscape painting of the Barbizon School was everything that landscape painting of the Hudson River School was not. The gnarled oak trees, cultivated fields, gently winding rivers, and inclement skies of northern France chosen by the Barbizon painters for their subjects differed radically from the raw grandeur and breathtaking vistas so beloved of the native American school. Instead of composing and perfecting a detailed view, the French artists sought to capture the transitory effects of weather and light, as well as their own direct impressions of nature. Working mainly out-of-doors and using vigorous, unblended strokes, they created a rough-textured painting surface usually associated with sketches and studies, and, through their masterly handling of thick pigments and heavy brushwork, minimized pictorial depth—a departure objected to by critics but justified by Dupré, who tartly explained: "The sky is behind the tree, in the tree, in front of the tree."[52]

Inherent in the Barbizon image of the French countryside is the rejection of the city and its industrialization, a melancholic desire to return to the soil, looking to peasant life for solace, solitude, and stability.[53] The social and moral fabric of Barbizon painting, however, was considerably less important to American proponents of the style than was the

style itself, which released them from the constraint of truth to nature as preached by John Ruskin. This was an art based not on nature's physical details but on the painter's subjective response to nature.

In New York, because of the National Academy of Design and the illustrious position of the Hudson River School, the influence of the new French aesthetic was slow to emerge. (Boston, where William Morris Hunt, a student and friend of Millet's, had begun as early as the 1850s to collect and exhibit Barbizon landscape paintings and to paint in a Barbizon manner, embraced it more quickly.) By the late 1850s, Barbizon paintings appeared only occasionally in New York collections and exhibitions—a few of them held at the Academy. Several Hudson River artists visited Fontainebleau early in their careers,[54] mostly without immediate consequence to their work, but, later, as Barbizon art became better known and more appreciated in America, some of them began to adopt its style, subject matter, and artistic principles to varying degrees. Moreover, the French school may have inspired the new direction in Gifford's and Kensett's work of the 1850s; Gifford, as early as 1855 captivated by the work of Troyon and Rousseau, wrote:

> In the French landscape everything like finish and elaboration of detail is sacrificed to the unity of the effect to be produced. . . . The subjects are mostly of the simplest and most meagre description; but by the remarkable truth of color and tone, joined to a poetic perception of the beauty of common things, they are made beautiful.[55]

Moved by that revelation, though he never emulated the Barbizon technique directly, Gifford began in the mid-1850s to engross himself in using light not so much to illuminate as to create "the veil or medium through which we see."[56] The similar shift visible in Kensett's paintings of the same period may also depend on his exposure to the breadth and mood of Barbizon painting.[57]

In the New York of the late 1860s and early 1870s, critical reaction to Barbizon landscape, and to French painting in general, was sometimes disapproving: critics frequently besought artists not to succumb to what they called the blotchiness of French technique or to the triviality of French subject matter. The writer of a review mentioning one of Troyon's paintings (e.g., Fig. 4.10), which was displayed in an exhibition held at the National Academy in 1870, confessed that he was not "able to enjoy nature with the eye of M. Troyon," and continued: "This picture seems to have been fashioned from a study of nature through a piece of dirty colored glass, the view somewhat resembling the outward world during an eclipse, and to have been painted with colors ground up in molasses and liquorice."[58]

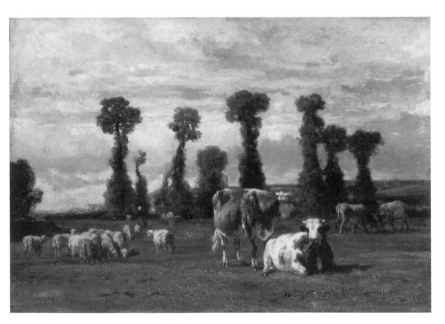

Figure 4.10. Constant Troyon, *Pasture in Normandy*, 1852, oil on wood panel, 15⅛ x 21⅝ in. (38.4 x 54.9 cm.). The Art Institute of Chicago, Henry Field Memorial Collection (1894.1069)

To demonstrate "the superiority of . . . a work belonging to the American school of landscape to any of the landscapes of the French school yet imported among us," Gifford's painting *Shrewsbury River, Sandy Hook* (location unknown), shown at the National Academy exhibition of 1868, was described in contrast with the Barbizon style by then becoming familiar to New Yorkers:

> Compare . . . the commonplace littleness of Rousseau with the comprehensiveness of this work. . . . Compare the monotony of purely technical achievements with the original freshness of a style which is the artist's own. . . . It is time for the leading characteristics and the originality of American art to be enforced, and these are the works by which these qualities are made manifest.[59]

Some critics attempted to find correspondences in the two schools of landscape. Even *The Crayon*, in the late 1850s New York's leading art journal and one fiercely partisan to the Hudson River painters, occasionally published articles that looked for similarities in the two very different styles. A *Crayon* review, describing in 1855 "a picture by the French Rousseau . . . common enough, we should say," yet lauded it, for "upon that commonness Nature bestows her light and shade, her color and her delicacy of form."[60] The review also found Durand's *In the Woods* (see p. 113) striking, "in no wise as the work of the artist, but as a passage of Nature uncommonly beautiful."[61] Implicit in the writer's remarks is that in both works he saw similar arcadian views of nature.

In 1856, *The Crayon* published a letter from Christopher P. Cranch—a minor follower of the Hudson River School—who had seen Barbizon landscapes in Paris, at the Exposition Universelle of 1855. Written at the height of the reign of the native American school, by a painter imbued with its conventions, Cranch's comments are nonetheless remarkably astute. He found the "*material*" side of French landscape painting to have "more photographic truth than any other school; not in painting every leaf and blade of grass . . . but in a certain free, naive handling, broad and transparent in the shadows, bold and full of pigment in the lights." He was much impressed by the Barbizon painters' technique of "scattering their warm and cool tints . . . breaking one color over or beside another. . . . They recognize the fact, that in Nature the most pleasing bits of color are made up of a sort of mosaic, of an infinitude of warm and cool tints, all distinguishable if you look close enough." Nevertheless, Cranch was not able to accept the perfection of mere execution if it resulted in "the comparative neglect of ideas." For him, as for his Hudson River colleagues, an ideal work still contained a measure of literary, narrative, or symbolic con-

tent; Barbizon art, unfortunately, still had to be "helped out by cattle and figures." He concluded that the French artists were "simply something novel—a reaction possibly from the realist school, but without interest enough to claim from us the distinctive name 'Ideal.' "[62]

In spite of the doubts expressed by Cranch, the French style was soon exerting an influence on Hudson River painters. It appears to have affected McEntee in his choice and treatment of subjects, though he would never have admitted to that. The light in his work seems not to emanate from the sun; it is cold, gray, and bleak. Senescent foliage and barren trees invariably evoke melancholy, a quality that McEntee had in common with such members of the Barbizon School as Corot and Daubigny. True to his convictions, despite occasional accusations of monotony leveled at him, McEntee seldom varied his subject matter throughout his long career (see pp. 278; 282). He did, however, become an advocate for expression and unity in painting, and by 1879 had declared himself on the subject: "Imitation is not what we want, but suggestion."[63] When in the same year Thomas Moran, a younger adherent to the Hudson River School style, commented that "a swamp and a tree constitute [the] sum total" of French landscape art, he was deriding Barbizon painting, which he said "scarcely rises to the dignity of a landscape."[64] Notwithstanding, he too eventually abandoned the sweeping views of Wyoming's Yellowstone region that had once preoccupied him, and yielded to a looser style and less prepossessing landscape subjects.

During the 1870s and 1880s, the domesticated landscape held the attention of forward-thinking American painters: to them, motifs such as houses, bridges, haystacks, farms, roadways, fences, and salt marshes were far more fascinating than the wilderness exalted by Cole and his successors. The civilized landscape was thought by George Inness to be "more worthy of reproduction than that which is savage and untamed. It is more significant. Every act of man, every thing of labor, effort, suffering, want, anxiety, necessity, love, marks itself wherever it has been."[65] Significantly, certain landscapists deliberately avoided the associations present in an identifiable site, such as Niagara Falls, for they believed that any view of nature, however modest, held the potential for expression.

The new types of subject being explored by American painters were often misunderstood by their compatriots, who were used to the Hudson River School views. The Newport landscapes La Farge did between 1866 and 1868—*Paradise Valley* (private collection); *The Last Valley: Paradise Rocks* (Fig. 4.11); and *Bishop Berkeley's Rock* (Metropolitan Museum)—provide a case in point. Even though the artist be-

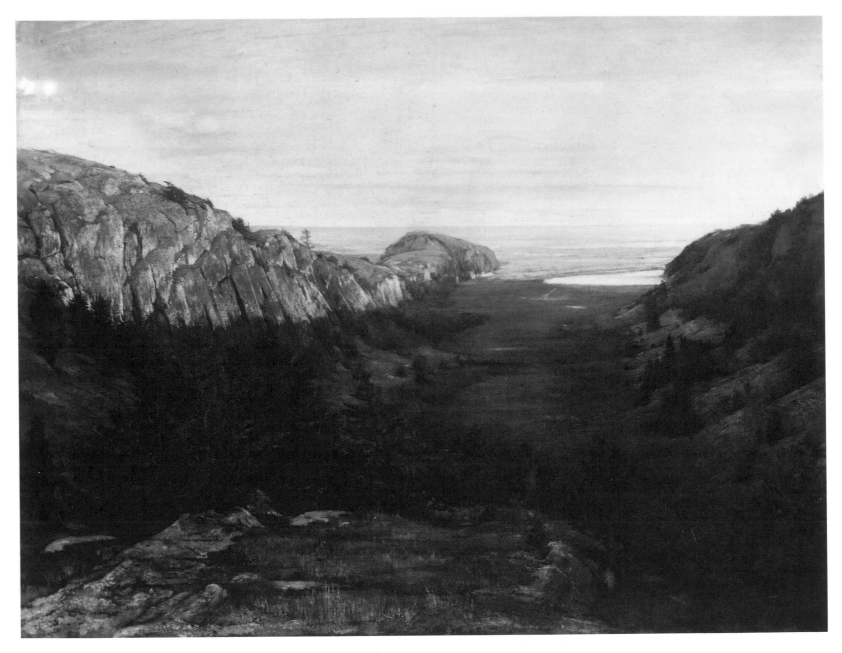

Figure 4.11. John La Farge, *The Last Valley: Paradise Rocks*, 1867, oil on canvas, 32 x 41½ in. (81.3 x 105.4 cm.). Private collection

lieved that he was painting "nature as it really looked,"[66] critics found his seaside meadows and rocky outcroppings bland; after the symbolic and narrative content of typical Hudson River paintings, his simpler subjects were hard to read. In 1876, when La Farge's *Paradise Valley* was first exhibited at the National Academy, it was denounced as "a green map which [La Farge] has the impudence to call a picture."[67] Reviewers searched for meanings the artist had not necessarily intended. To one, the flock of white lambs nestled in the grass recalled the Twenty-third Psalm;[68] another, commenting on *The Last Valley: Paradise Rocks*—a painting that includes no incidental elements—and questioning why such good work had been lavished on so barren a composition, concluded that if the distinctive rock formations did not pinpoint the locale, one might assume the "quaint landscape, suggestive of some dreary episode in moral development" to be an illustration for *Pilgrim's Progress*.[69] Many other artists excised narrative references from the subjects and titles of their landscapes. As a writer commented in 1887, "'Twilight' or 'Autumn' tells nothing. A tree

against a fading sky, or red leaves in a diaper pattern on yellow sod may be only a fancy born of a hazy memory."[70] Art was no longer descriptive, but evocative and emotionally appealing. Sylvester Rosa Koehler, the German-born editor of *American Art Review*, described the Barbizon type of painting as *Stimmungs-Malerei* ("sentiment painting").[71]

The American landscape painter's working methods changed measurably under the influence of Barbizon art and its greater reliance on outdoor painting. The Hudson River School practice had been to combine detailed on-site studies—often in pencil or watercolor, sometimes in oil— with careful composition in the studio. In general, that method allowed the painter to take visual material gathered on sketching trips and, in his studio, to reassemble the parts into complex, idealized compositions. Gifford's procedure could be taken as an example of the traditional approach. His development of *Kauterskill Clove* (see p. 222), for example, consisted of a series of pencil sketches, some of individual elements and others of the entire composition, followed by "a larger sketch, this time in oil, where what has already been done in black-and-white is repeated in color."[72] Though Gifford sometimes experimented in his oil sketch to refine his concept, when it was completed to his satisfaction, it was "a model in miniature" of the proposed painting.[73] That is not to say that Hudson River artists never worked on their exhibition pieces outdoors. Physical evidence present in Kensett's Last Summer's Work strongly suggests that he, for one, actually executed some of his oils *en plein air* and was from the moment he started able to visualize the arrangement of his finished canvases.[74]

By the early 1880s, many of the progressive artists—including some whose completed paintings are literal and highly finished—were constantly working outdoors. In the landscape genre, the shift from studio to open air had far-reaching ramifications, for the business of conceiving and constructing a painting was no longer divided into clearly defined steps. To the mid-nineteenth-century American landscapist, the sketch remained a part of the generative process, merely a means to an end. Later, the distinction between sketches and finished paintings was less sharply defined: a sketch might be considered a completed work; completed works often had sketchlike qualities.[75] "Good sketches and studies are perfect in themselves, however slight and fragmentary," wrote G. W. Sheldon. "They have unity of sentiment, singleness of purpose, homogeneity of expression; whether made within-doors or out-of-doors, they are the spontaneous, honest outcome of communion with Nature; and, finally, their force is concentrated, economized, and well-directed."[76] For some conventional painters, the new prac-

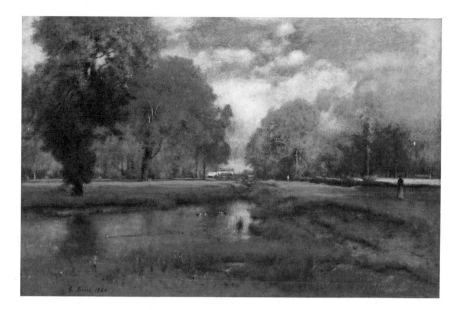

Figure 4.12. George Inness, *October*, 1886, oil on wood panel, 20 x 30 in. (50.8 x 76.2 cm.). Los Angeles County Museum of Art, Paul Rodman Mabury Collection (39.12.12)

tice may have been difficult to accept. That Gifford, for instance, regarded his preliminary works as less than satisfactory representatives of his artistic achievement is illustrated by an anecdote recounted in 1880. A well-known connoisseur visiting Gifford's studio asked to buy an unfinished study of an autumn landscape. To the artist, "The work was not worth selling . . . it was merely a fragment," but he agreed to let it go for a modest price. Before parting with it, however, he devoted several hours to the effort of making it "worthier."[77]

A highly original expression of Barbizon principles can be seen in the late works of Inness, the New York landscapist whose early canvases, such as *Delaware Water Gap* (see p. 233), sometimes cause him to be associated with the Hudson River School. Two trips to Europe Inness made in the 1850s greatly affected the growth of his mature style. On each, he became better acquainted with Barbizon art. Its effect on his subsequent production is readily seen in a work like *Clearing Up* (see p. 236), which depicts the cultivated landscape of Medfield, Massachusetts. Throughout the 1860s, Inness provided the most consistent example of Barbizon ideals available in New York, where he exhibited regularly.[78] His was a point of view divergent from that of the Hudson River School. As Nicolai Cikovsky recently pointed out: "Inness's paintings of the 1860s did not depend for their meaning solely on symbolically articulate conditions of nature, nature in 'her solemn and mystic moods.' Their meaning came equally from properties of artistic form, particularly a

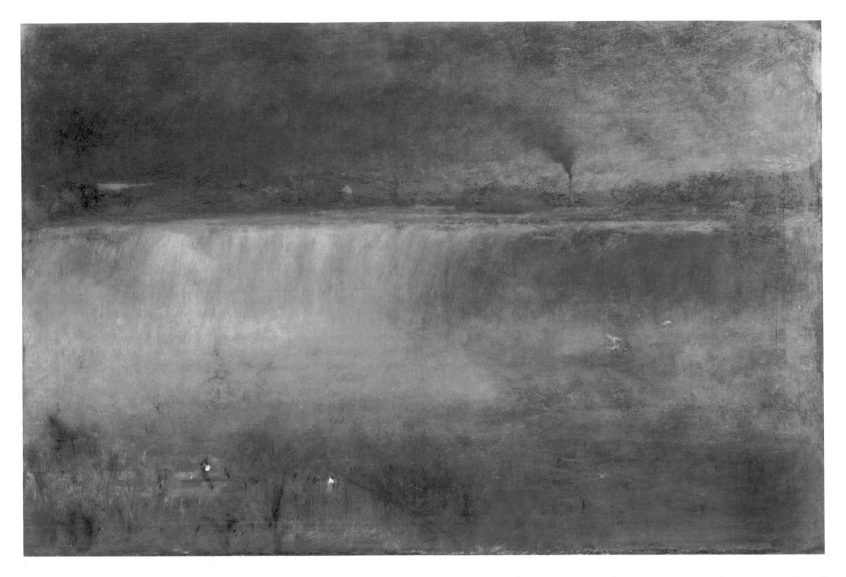

Figure 4.13. George Inness, *Niagara*, 1889, oil on canvas, 30 x 45 in. (76.2 x 114.3 cm.). National Museum of American Art, Smithsonian Institution, Gift of William T. Evans (1909.7.31)

broadly suggestive, vigorously urgent, and expressively charged handling of pigment."[79] In critiques of the 1860s, Inness was complimented for his "contemptuous rejection of the trivialities of detail and . . . thorough mastery of broad, large effects." His technique, which was said to consist of "rugged handling" and "great sprawling marks of the brush," was judged as allying him with Barbizon painters, though he was still revered as an American artist.[80]

The breadth of effect and the focus on formal qualities Inness obtained were largely because he worked from memory, removing himself from the immediate experience of nature. For him, memory and imagination transcended any direct reference to the natural scene; in his late works, such as *October* (Fig. 4.12), he strove "to awaken an emotion." He explained his philosophy:

> Details in the picture must be elaborated only enough fully to reproduce the impression that the artist wishes to reproduce. When more than this is done, the impression is weakened or lost, and we see simply an array of external things which may be very cleverly painted, and may look very real, but which do not make an artistic painting.[81]

Inness executed the preliminary sketch for a painting of Niagara Falls (e.g., Fig. 4.13) in the Buffalo studio of a friend; the viewpoint "was taken from an imaginary point in the middle of the rapids."[82] He found his old studies, "those he had somewhat forgotten," preferable to making new ones, and he went as far as to search through his friends' portfolios to find anything that could suggest a possible subject or effect to him.[83]

Though Inness was greatly admired, writers cautioned against following his methods too closely. ("Any young artist who takes Mr. Inness' rough handling and 'luminous' coloring for a model, is sure to go in the wrong path.")[84] However, several noteworthy younger painters, including Alexander Wyant, whose artistic education in Germany in the 1860s had subjected him to a very different aesthetic, chose to follow Inness's example. In the work of his later years (e.g., Fig. 4.14), Wyant reacted to Inness's work and to Barbizon models with some degree of originality.[85] When he asserted that the artist and his standards were what ultimately determined the difference between the sketch and the finished picture, he was reiterating Inness's principal tenet. In an interview, Wyant expanded on that idea: "If [an artist] paints for expression, and gets it, then the result is complete—it is a picture. In any given case, to decide whether a painting is a sketch or a picture, a fragment or a whole, you must be inside the clothes of the artist who made it." In the same interview, Wyant looked at one of his landscapes as if through Inness's eyes, disparaging it as "hard-tack," because it was so overly finished that "every bit of expression or unity has gone out of it." He concluded: "For that reason it isn't a landscape painting at all. . . . It is still life. . . . You look on it simply as a curiosity."[86]

THOUGH BARBIZON PAINTING was one of the first French styles to capture the American imagination during the second half of the nineteenth century, it was hardly the only one. After the Civil War, American painters and collectors entered into an international age, described as "the second period of American art," in which French art, particularly academic art, was the dominant influence. In 1877, A. T. Rice summed up the artistic climate that had come into existence during the previous decade:

> . . . Vast fortunes were accumulated. . . . Houses were bought and built in countless numbers. Pictures were needed to hang the walls of newly acquired mansions. . . .
>
> Painters were urged to turn out bad imitations and superficial reproductions of foreign and especially of French schools. Purchasers longed to see their walls hung with subjects which would recall to them the Regnaults, the Meissoniers and Geromes, of Transatlantic fame. . . . A finished shoe, with pink heel and silver buckle, became more attractive to the general eye than all the soul and sensibility which might speak from a fine landscape or a fine face.[87]

The American artist's pursuit of French training, and the public admiration for academic French art resulted in the increased importance of figure painting and in the corollary

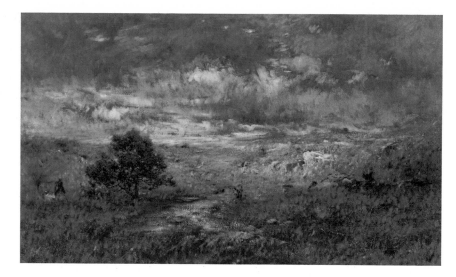

Figure 4.14. Alexander H. Wyant, *Any Man's Land*, ca. 1887–92, oil on canvas, 18½ x 30½ in. (47 x 77.5 cm.). Los Angeles County Museum of Art, Museum Purchase with Funds Provided by Mr. and Mrs. Willard G. Clark, Mr. James B. Pick, and Coe Kerr Gallery (M.80.192)

Figure 4.15. Jean-Léon Gérôme, *Bashi-Bazouks Casting Shot*, after 1867, oil on canvas, 21½ x 24¾ in. (54.6 x 62.9 cm.). The Metropolitan Museum of Art, Bequest of Henry H. Cook, 1905 (05.13.4)

decline of interest in landscape painting.[88] The theories on art formulated by Cole and given expression by the Hudson River artists had elevated the genre of landscape from mere topographical views to idealized compositions, thus endow-

ing it with the artistic status traditionally enjoyed only by history painting and portraiture.[89] During the 1860s and 1870s, as American artists and collectors were exposed to the academic standards of Europe and figure painting was gaining in favor, the old prejudice against landscape, considered easier to paint and less demanding for both the artist and his audience to understand, began to resurface. In the words of one critic: "Most landscape painters have no higher intellectual rank, for they simply describe nature with their brush," thus producing "pictures which shall attract the careless and unthinking that crowd galleries of art for amusement and admire only that which is familiar."[90]

In America, figure painting gradually acquired the primacy it had always enjoyed in Europe, though at first the new generation of American artists offered their European counterparts little competition. Not surprisingly, the figure work of the Americans seemed inept when compared with that of such French artists as Jean-Léon Gérôme (Fig. 4.15) or Jean-Louis-Ernest Meissonier. Art students had for some years been attending life classes at institutions like the National Academy of Design and the Pennsylvania Academy of the Fine Arts, but the instruction had been minimal. During the late 1870s, however, American art schools, both established and newly founded—the Art Students League in New York and the school of the Museum of Fine Arts in Boston among the latter—hired cosmopolitan young instructors, including William Merritt Chase, James Carroll Beckwith, and Thomas Eakins, who were well versed in figure painting, and, in emulation of the rigorous training offered by the Ecole des Beaux-Arts in Paris, expanded their academic pro-

grams. At the same time, droves of American artists went to Europe, especially to Paris, to take advantage of the educational opportunities there. Those factors shaped the style and subject matter of American art over the next decade, during which figure paintings assumed major importance in exhibitions and in contemporary critical writing.

American landscape painters did not ignore the trend. In 1879, Earl Shinn remarked that some of them were "trying to forsake old 'Hudson River' methods, not without success,"[91] and he mentioned *Normandy Shrimpers* (location unknown), a figure painting displayed at the National Academy of Design by Edward Moran, best known for his marines and landscapes. Shinn did not regard the work with favor: "The fancy of Mr. Edward [Moran] trying on the shoes of [Antoine] Vollon and Jules Breton, without any previous visits to the academic shops where the sandals of those trained figure-painters were fitted, is an inspiring spectacle of audacity."[92] Inness featured figures more often and in larger size during the early 1880s in landscapes like *Winter at Montclair, New Jersey* (Fig. 4.16). He also attempted actual figure paintings. His *Return to the Farm, Milton-on-the-Hudson* (1882; Montclair Art Museum) shows the influence of contemporary French academic painters—Jules Bastien-Lepage, notably—and was likely Inness's attempt to update his work. McEntee traveled a similar route. Writing to the literary critic George Ripley in 1874, he reported, "Within the past year I have paid considerable attention to the study of the figure," and he gave as examples *A Wood Path* (location unknown) and *Solitaire* (Fig. 4.17).[93] Over the next several years, McEntee made a valiant effort to improve his skill: he asked the advice of his friend the portraitist and genre painter Eastman Johnson and listened to lectures on anatomy and movement at the National Academy of Design, where he also attended a special life class.[94] Bricher, who in the beginning had other artists add figures to his landscapes, may have been inspired by commercial motives. "My works are in much demand now since I have been varying them with human figures," he wrote in 1879.[95]

In American teaching institutions, classes in portraiture and composition, added to drawing and painting from the nude, expanded the opportunities for an artist to train as a figure painter, but the landscape genre remained largely outside the academic program as late as the 1880s. Art schools hired some landscapists to give instruction in painting or drawing or to act as advisers, and some may also have given occasional lectures,[96] but a course in landscape painting itself is rarely recorded (the Philadelphia School of Design and the art school at the San Francisco Art Association are two exceptions).[97] Instead, many painters aspiring to the genre sought

Figure 4.16. George Inness, *Winter at Montclair, New Jersey*, 1884, oil on canvas, 22 x 36 in. (55.9 x 91.4 cm.). Private collection

training in the studios of its established practitioners: Edward Gay studied with Horace Wolcott Robbins; George H. Smillie, with James M. Hart; Walter Launt Palmer, with Church; Arthur Parton and James B. Sword, with Richards; Carleton Wiggins and Louis Comfort Tiffany, with Inness; and Bruce Crane, with Wyant.

American methods essentially followed the French in landscape instruction. Because it was not taught at the Ecole des Beaux-Arts,[98] students improved their skill in the genre outside the academy, spending their summer vacations painting the countryside, often alongside artists who influenced their advancement more than their formal teachers did.[99] During the 1870s and 1880s, American painters who had worked or studied in France in the formative years of their careers maintained that pattern, creating figural compositions in their studios during the winter and traveling to artists' colonies, such as Cos Cob in Connecticut, Cape Ann in Massachusetts, and the Isles of Shoals, off the coast of Maine, to work on landscapes during the summer months. Plein-air painting schools, of which Chase's, in Shinnecock, New York, was perhaps the best known, became the rage in the 1890s, but a few farsighted Americans had begun to teach outdoor classes two decades earlier; William Morris Hunt, for example, had accepted students at Magnolia, Massachusetts, during the 1870s.[100] Because the art of landscape was exercised largely outside art-school curricula, it may have developed in an inconspicuous fashion, but its freedom from academic restrictions left it open for experimentation and innovation.

THE BRITISH AESTHETIC MOVEMENT, which had far-reaching repercussions in America during the 1870s and 1880s,[101] constituted a further challenge to the Hudson River School. The Aesthetic movement introduced a preoccupation with surface pattern and ornament into all media, thus enriching the design of furniture, wallpaper, carpets, stained glass, ceramics, and metalwork. Many artists found new sources of inspiration in decorative work. Aestheticism, in painting epitomized by the work of James Abbott McNeill Whistler (e.g., Fig. 4.18), stressed the importance of pictorial values ("art for art's sake"); subject matter and narrative took a secondary place to composition, color, and form. La Farge and Tiffany were among the artists who all but abandoned their role as painters in the traditional sense to devote themselves to the decorative arts, especially murals and stained glass. Some of the Hudson River men were caught up in the vogue. Cropsey designed the decorations for the

Figure 4.17. Jervis McEntee, *Solitaire*, 1873, oil on canvas, 21½ x 17¾ in. (54.6 x 45.1 cm.). Collection of Dr. and Mrs. Marvin A. Perer

Figure 4.18. James Abbott McNeill Whistler, *The Lagoon, Venice: Nocturne in Blue and Silver*, 1879–80, oil on canvas, 20 x 25¾ in. (50.8 x 65.4 cm.). Courtesy, Museum of Fine Arts, Boston, Emily L. Ainsley Fund (42.302)

Figure 4.19. View of the Court Hall at Olana, the residence of Frederic E. Church. Olana State Historic Site. Photograph. Courtesy, Friends of Olana, Inc.

large drill room in the Seventh Regiment Armory on Park Avenue in New York City, as well as furniture and stained glass for Aladdin, his home in Warwick, New York. Church devoted much of his energy during the 1870s to building Olana (Figs. 4.19; 4.20), his residence in Hudson, New York, a sumptuously decorated, exotic environment in which the magnificent views of the Hudson River, framed by ogee arches, are a breathtaking decorative element. Samuel Colman was a partner in Tiffany's decorating firm, Associated Artists, where he was designated the expert on

color.[102] That McEntee, Gifford, Whittredge, and Bierstadt all diverted themselves with small genre paintings demonstrates the contemporary interest in the domestic interior and its decoration (e.g., Fig. 4.21).[103]

Hudson River School paintings, still considered meritorious by contemporary standards because they were laden with "sincere and worthy" sentiments, were faulted for "deficiency . . . in the decorative element." The reviewer quoted also demanded that the new influences be heeded:

Why should not Mr. [John] Casilear relinquish his ornamental trees and mountains, and give us something decorative in their stead? Why should not Mr. [Richard William] Hubbard vitalize his greens a little more? . . . Let us note . . . that crowds

of mere lads and misses all over the civilized world, and nowhere more successfully than in the city of New York, are learning how to get color and tone, how to use, if not to master the decorative resources of the painter's art, and then put to ourselves the question whether many elderly Americans cannot go and do likewise?[104]

Some of the old guard remained impervious to aestheticism. McEntee noticed "a growth in the pernicious doctrine of 'Art for Art's sake'" at the National Academy's 1884 exhibition.[105] James M. Hart stated baldly: "I strive to reproduce in my landscapes the feeling produced by the original scenes themselves. That is what I try for—only that, and just that." G. W. Sheldon, publishing Hart's comment, added: "Here, then, are no 'symphonies,' or 'nocturnes,' or 'variations,' or 'arrangements' of color, and no improvements upon Nature."[106] Not all the older artists ignored formal issues, at least in discussing their work. William Hart, brother to James and also a painter, willingly affected the verbiage of the 1880s, acknowledging late in his career the "decorative qual-

Figure 4.21. Albert Bierstadt, *Interior of a Library*, 1886, oil on canvas, 19¾ x 14½ in. (50.2 x 36.8 cm.). Courtesy, Museum of Fine Arts, Boston, Gift of Maxim Karolik to the M. and M. Karolik Collection of American Paintings, 1815–1865 (62.260)

ity" in his work (e.g., Fig. 4.22). This he attributed to chiaroscuro enhanced by color, form, and line. After describing the components ("cattle, cloud, brook, tree") of one of his paintings as "notes to my instrument," he declared: "A picture is a song—a piece of music. In it one expresses, it may be, the sentiment of color, or the hour, or place."[107] A critic defined the new preference for pictorial value over subject matter: "The title is silent, and yet it may make no difference if there be such charm in the picture that we linger over it with pleasure and want it for our home walls."[108] William Trost Richards, who could hardly be accused of accommodating to that aesthetic, was nevertheless aware that it was in sharp contrast to the ideas that informed his own work. When one of his Newport pictures was hung between two of Whistler's paintings at London's Grosvenor Gallery in 1879, Richards

Figure 4.20. View from the Loggia, called the "Ombra," at Olana, the residence of Frederic E. Church. Olana State Historic Site. Photograph. Courtesy, Friends of Olana, Inc.

Figure 4.22. William Hart, *Scene at Napanoch*, 1883, oil on canvas, 23½ x 33⅜ in. (59.7 x 84.8 cm.). The Metropolitan Museum of Art, Gift of descendants of the artist, 1897 (97.6)

A FLANK MOVEMENT ON THE HANGING COMMITTEE.

Figure 4.23. "Flank Movement on the Hanging Committee: A simple device for seeing most of the best pictures at the Academy. (Invented by one of the 'skied.')" Engraving. Illustrated in *Scribner's Monthly* 17 (January 1879), p. 456

observed: "The effect is peculiar and looks like a joke; for my picture is by contrast so exceedingly real."[109]

THE NATIONAL ACADEMY OF DESIGN was the forum in which all the questions first articulated in the 1860s—as to finish, style, subject, and foreign influence in American landscape painting—were aired during the 1870s. The Academy, founded in 1826, was national in name only. From its beginning, the organization was controlled by New York artists; by 1865, it also numbered among its founding and active members virtually all the principal Hudson River School painters.[110] Although a primary purpose of the Academy was to provide free art instruction to promising students, it offered professional artists the opportunity to show their work in a major exhibition at least once a year. In the 1870s, many of the older and more conservative members found themselves at odds with the more progressive exhibitors—among them the Academicians La Farge and Inness—over the allotment of space in the spring annuals, particularly the coveted space "on the line," that is, at eye level. The dispute arose at a time when the nation was suffering from a prolonged depression, and American painters were faced not only with a shrinking market but also with increased competition from imported European paintings for that market.[111] They therefore balked at the Academy's hanging policies and also at a long-standing rule[112] that prohibited the display of a work previously exhibited, even if only in a private club or at a studio reception. Since those places were the most propitious for the sale of their paintings, the artists continued to show privately, sending to the Academy annuals either inferior works or no works at all. In so doing, they diminished the quality of Academy exhibitions.[113] The policies of the hanging committee were also constantly at issue (Fig. 4.23). Elected annually from the roster of Academicians, the committee consisted of three artists who were responsible for the selection and arrangement of pictures in the spring annuals. In 1874, David Johnson was on the committee that rejected seven out of eight paintings submitted by La Farge, and then allocated advantageous places to some of its own works.[114] La Farge's vociferous protests met with initial success. As stated in a resolution passed by the Academy membership at that year's annual meeting, "In its Exhibitions [the Academy] does not propose to exercise judicial functions and to differentiate between different schools and methods in Art, but ... believes the interests of Art to be best aided by the exhibition of all that has obtained sanction in the Artistic Community."[115]

The hanging committee, attempting to ensure the

Academicians' preeminence the following year, nevertheless rejected many works by younger, European-trained artists or displayed poorly those they accepted. "They have determined that the new school shall have no chance," protested Helena De Kay, one of La Farge's pupils.[116] Outraged, many of the up-and-coming artists arranged at Daniel Cottier's New York gallery a concurrent exhibition that included the first major display of Barbizon-inspired works by Americans. In 1876, however, Barbizon paintings were absent and American paintings in the Barbizon mode were less than obvious at the Philadelphia Centennial Exposition, though Hudson River landscapes were present in overwhelming numbers.[117]

In 1877, at the National Academy, the tide of artistic favor turned against the Hudson River men. The hanging committee that year included two young European-trained artists, landscapist Charles H. Miller and landscapist and genre painter A. Wordsworth Thompson, both Academicians of only two years' standing. To redress the imbalances of previous exhibitions, the committee gave highly visible gallery space to young figure painters recently returned from abroad, including Frank Duveneck, Walter Shirlaw, Abbott H. Thayer, Wyatt Eaton, and William Merritt Chase. The entrenched Academicians were furious. Daniel Huntington, then president of the Academy, actually demanded (though to no avail) that the Academy council rehang the show.[118] At the annual meeting of 1877, the Academicians voted down many young artists who could have been elected to Associate membership and, at a special meeting, passed several proposals that guaranteed themselves preferential treatment and space on the line.[119] The pointedly conservative hanging committee for the 1878 exhibition included the Hudson River landscapists John Casilear and Aaron Draper Shattuck.

Tension mounted. With the older painters feeling besieged and the younger painters feeling cheated, a rupture was inevitable. In June 1877, De Kay, Shirlaw, Eaton, and Augustus Saint-Gaudens founded the Society of American Artists.[120] Within a short time, its company boasted several members of the National Academy, among them landscape painters Colman, La Farge, Inness, Miller, Homer D. Martin, R. Swain Gifford, and Thomas Moran. In 1878, the Society, anxious to encourage "good work from whatever source"[121] for its first exhibition, solicited works by women, works by sculptors, and works from American artists abroad. In deliberate opposition to Academy practice, the Society provided favorable exhibition space for all submissions; paintings were displayed according to palette rather than to size. The young artists whose experience in Paris, Barbizon, or Munich had instilled in them reverence for both the old masters and the modern sketch and whose principal work was in figure

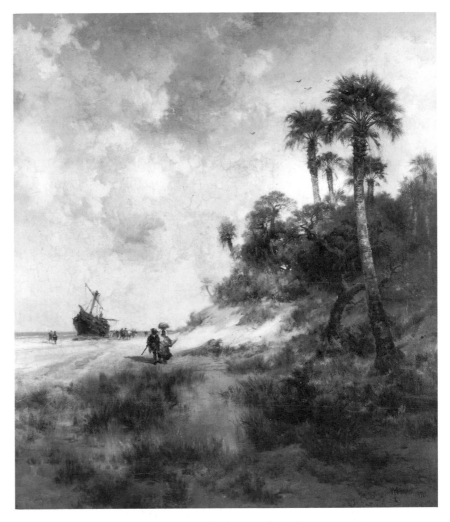

Figure 4.24. Thomas Moran, *Fort George Island, Coast of Florida*, 1878, 25⅝ x 21½ in. (65.1 x 54.6 cm.). The Cleveland Museum of Art, Hinman B. Hurlbut Collection (425.15)

painting were accorded prominent space, but more traditional artists were also welcomed. The acceptance of *Fort George Island, Coast of Florida* (Fig. 4.24), a painting by Moran, who was still associated with the Hudson River School, was a testament to the liberal policies of the Society, at least during its first year.

The show, for the most part enthusiastically received, was criticized for accepting works by Moran and others, "chip[s] off the old Academy block."[122] In response, the Society exhibitions of 1879 and 1880 offered a selection of works that emphasized broad technique and sketchlike effect over "the old fashioned methods."[123] Thus the Society alienated its more conventional members; Moran, for one, resigned in 1880. Figure paintings thereafter edged out landscapes, European subjects proliferated over American

subjects, and decorative paintings—informed by the art of Whistler or by the art of Japan—increased in number with each succeeding year. Under the influence of French plein-air painting (especially as practiced by Bastien-Lepage, whose *Joan of Arc* [1879; Metropolitan Museum], shown in 1881, was the first European work to appear in a Society exhibition), of painters working in Pont Aven, and of Whistler working in Venice, the dark tonalities of the Munich School, which had predominated in 1878, in the Society's first exhibition, gave way to a brighter palette. Within a few years, however, the Society of American Artists had become less radical and the National Academy less obdurate. As early as 1881, S. G. W. Benjamin could find little difference between the two organizations and in 1884, the Society's exhibition was held in the Academy's galleries.

Though the painters of the younger generation had succeeded in unseating the titans of the Hudson River School, theirs was a Pyrrhic victory. Admiration for their virtuoso technique abated when it came to be seen as only "the means to an end";[124] they "may have thought of technique *only* when they should but have thought of technique *first*."[125] As Moran remarked: "They understand the *technique* of their art. . . . It now remains for them to show whether or not they possess invention, originality, the poetic impulse, the qualities which constitute a painter."[126] Many critics concurred, even those kindly disposed toward the younger men. Clarence Cook, in saying that they had a "receipt for painting," went to the heart of the problem.[127]

BY 1886, THE YEAR OF THE DEATH of Asher B. Durand, the work of the older generation of painters could be appreciated as a notable, albeit innocuous, historic American achievement; the School so clearly belonged to the past that it no longer represented a threat to any faction. As was said in one of Durand's obituaries:

> [His landscapes] belonged to what has of late years been disparagingly called the "Hudson River School," and their manner has been rendered obsolete by works the painters of which had the advantage of a wider and deeper technical knowledge. But if we "compare them with the bettering of the time," as SHAKESPEARE counselled, we must acknowledge that with whatever technical weakness they may betray, they exhibit also a sincere love and study of nature, and a power of reproducing poetic impressions with delicacy and grace which the works of younger and better equipped men by no means always show.[128]

The truth is that the Hudson River School, though long past the period of its greatest creativity and influence, left a notable bequest to American art: it had established landscape as the quintessential American genre. In the last decade of the nineteenth century, the younger American painters distanced themselves somewhat from their Paris teachers, most of them figure painters. With the coming of Impressionism, landscape reasserted itself forcefully, and the true value of the Hudson River School's bequest came to be realized. The preference for native subjects by native artists found many advocates among the American Impressionists; in the early years of the twentieth century, with the coming of the so-called Ashcan School, that preference became an insistence. By 1917, when the exhibition *Paintings of the Hudson River School* was mounted at the Metropolitan Museum to celebrate the opening of the Catskill Aqueduct, the revival of interest in the School and a concurrent appreciation for its greatest accomplishments was gathering momentum.

ESSAY NOTES

A HISTORIOGRAPHY OF THE HUDSON RIVER SCHOOL

1. For references to the American landscape school, see Jarves 1864, pp. 212, 238; Tuckerman 1867, pp. 195, 524, 546, 549, 567; "Art. Sale of Pictures of the Late J. F. Kensett," *New York Daily Tribune*, 15 March 1873, p. 7; T. Addison Richards, "The Arts of Design in America from 1780 to the Present Time," *The First Century of National Existence* (Hartford, 1874), p. 324; Strahan 1876, p. 248; "American Art. Society of American Artists," *New York Daily Tribune*, 30 March 1878, p. 6; John F. Weir, "Painting and Sculpture of the Centennial Exhibition. V. The United States," *The American Architect and Building News* 3 (30 March 1878), p. 111; Benjamin 1880, pp. 79, 81, 106. By 1880, Benjamin could qualify the concept of an American landscape painting school by distinguishing the New York Academicians as the "objective school of American landscape-painting."

2. Baur 1942, p. 54.

3. Sherman 1912, p. 16.

4. "The Society of American Artists," *New York Sun*, 16 March 1879, p. 2.

5. "Art Notes," *New York Commercial Advertiser*, 2 April 1879, p. 1. See also "Book and Art Notes. The Unpopular American Society of Artists," ibid., 8 March 1879, p. 1; "Art Notes," ibid., 13 March 1879, p. 1; "Art Notes. The Coming Exhibition at the Academy," ibid., 25 March 1879, p. 1; "Art Notes. The Exhibition of Paintings at the National Academy Last Night—a Noteworthy Display," ibid., 1 April 1879, p. 1.

6. Strahan 1876, p. 39.

7. "The Academy Exhibition. IV," *New York World*, 5 May 1879, p. 4.

8. Robert Jarvis, "Autumn Exhibition of the National Academy of Design," *Art Amateur* 10 (December 1883), p. 8. I am grateful to Doreen Bolger Burke for this reference, as well as for those in nn. 9, 12, 14, 17, 21, 29.

9. Mary Gay Humphreys, "Landscape in America," *Art Journal* (London) 40 (March 1888), p. 82. See also p. 83, where author refers to the "Hudson River school."

10. Isham 1905, p. 232.

11. "The Academy Exhibition. I," *New York World*, 14 April 1878, p. 3. The critic was obviously adopting the title of Thomas Hardy's novel, which had been published that year.

12. Strahan 1879, p. 4. According to the *New York Herald*, 14 April 1879, p. 5, the first issue of *Art Amateur* was to appear on 1 May 1879.

13. Strahan 1879, p. 4.

14. "Strong Talk on Art," *New York Evening Post*, 3 June 1879, p. 3.

15. "Fine Arts. Changes in the National Academy of Design," *New York Evening Post*, 11 June 1869, p. 4.

16. "Boston Correspondence. The Museum Exhibition—American Art Changing Its Field—Figure Painting in the Front Rank—Landscape and Statuary. Boston, Nov. 14, 1880," *Art Amateur* 4 (December 1880), p. 6.

17. "Asher Brown Durand," *Harper's Weekly* 30 (25 September 1886), p. 619. See also "Art Notes," *Art Review* 1 (March 1887), p. 20: ". . . perhaps [Durand] might be called the founder of the 'Hudson River School.' At least, for many

years he presided over the fortunes of the National Academy." I am grateful to John K. Howat for this reference.

18. Cook 1883, pp. 312–13.

19. Hartmann 1902, pp. 56–57, and Isham 1905, pp. 232–54, after having treated the art of Cole and Durand, identify and discuss the Hudson River School and acknowledge that its representatives adhered to Cole's and Durand's ideals and methods.

20. "Sanford R. Gifford," *Art Journal* (New York) 6 (1880), pp. 3–20.

21. "The Inness Exhibition," *New York Daily Tribune*, 12 April 1884, p. 5.

22. "The Week in the Art World," *New York Times Saturday Review of Books and Art*, 19 March 1898, p. 191.

23. Montgomery Schuyler, "George Inness," *Harper's Weekly*, 11 August 1894, p. 787. See also Henry Eckford [Charles De Kay], "George Inness," *The Century* 24 (May 1882), p. 62, for reference to Inness's "comrades in the 'Hudson River School.'"

24. Sherman 1912, p. 16.

25. Schuyler 1894, p. 303.

26. "American Studio Talk," *International Studio* 10 (June 1900), Supplement, p. xiii.

27. Schuyler 1894, p. 303.

28. Ibid.

29. "Mr. Roosevelt on Remington," unidentified clipping, annotated "? Times Aug 29/10(?)," in Frederic Remington Memorial Gallery, Ogdensburg, N.Y.

30. "American Art. An Open Letter," *The Studio* (New York) n.s. 5 (11 October 1884), p. 56. *The Studio* was founded (1884) and edited by Clarence Cook.

31. "Art at Home and Abroad. A Glance at the Really Notable Pictures of the New York Historical Society, Which is About to Move into its New Building—a Collection Too Little Known," *New York Times*, 26 July 1908, sec. 6, p. 6.

32. *The Hudson-Fulton Celebration—Catalogue of an Exhibition Held in the Metropolitan Museum of Art* (New York: The Metropolitan Museum of Art, 1909); "Early American School of [Portrait] Painting Makes a Meagre Showing, Compared with the Dutch [Portrait] Schools," *New York Times*, 12 September 1909, sec. VI, p. 3.

33. Hendricks 1974, p. 154; *Catalogue of Modern Paintings Belonging to the Estate of Wm. B. Dinsmore* (New York: Ortgies & Co., 1892), no. 114; "The Dinsmore Picture Sale," *New York Times*, 16 April 1892, p. 3. Most of the information on Bierstadt's prices has been taken from contemporary newspaper and journal accounts, which were not above exaggerating the amounts the artist actually received for some of his pictures in the 1860s and 1870s. A surviving receipt of payment dated 15 November 1868 and signed by Bierstadt for his *Emigrants Crossing the Plains*, however, indicates that at that time he could command at least $15,000 for an eight-foot-wide landscape. I thank Nancy Anderson for her insights into Bierstadt's prices.

34. Hendricks 1974, p. 314.

35. "2 Britons Find U. S. Artist's Long-Lost Icebergs," *New York Times*, 17 August 1979, p. 1; see also Carr 1980, pp. 93–96. I am grateful to Stuart P. Feld for informing me of the fate of Bierstadt's *Emigrants Crossing the Plains*. I also thank Jerome Turk, editor of *Ohio Motorist*, and Thomas F. Pappas, of the

Western Reserve Historical Society, Cleveland, Ohio, for further information on Bierstadt's *Emigrants*.

36. I am grateful to William S. Talbot for information on Church's *Twilight in the Wilderness*. For Bierstadt's picture, see "Brooklyn Museum Gets Huge Canvas," *New York Times*, 6 July 1976, p. 27; for Cropsey's, see "Hastings School Discovers Art by Cropsey," *New York Times*, 22 April 1971, p. 34; for Thompson's, see p. 146, this publication. I am grateful to Nancy Acevedo, of the Alexander Gallery, New York, for information on Gifford's *Mansfield Mountain*.

37. *Catalogue of Mr. Aaron Healy's Collection of Modern Paintings* (New York: Fifth Avenue Art Galleries, 1891), no. 25, Durand, *The Traveler's Home*, 48 x 33 in., $1,000; no. 62, Daubigny, *Moonrise*, 27 x 15 in., $6,850.

38. *Catalogue of Modern Paintings; the Private Collection Formed by the Late Frederick S. Gibbs* (New York: American Art Association, 1904), no. 51, Gifford, *On the Bronx [River]*, 1861, 12 x 10 in., $110; no. 77, Cropsey, *On the Sawmill River*, 1891, 12 x 20 in., $130; no. 226, Inness, *The Light Triumphant*, 1862, 12 x 18 in., $1,150.

39. "$45,000 for an Inness," *New York Times*, 17 January 1917, p. 8.

40. Peter Curtis Neger, "Patterns of American Collecting, 1825–1875: The Hudson River School" (Senior essay, Yale University, 1977), p. 16.

41. "Huntington Collection Sale," *New York Times*, 28 January 1916, p. 8.

42. John K. Howat, *John Frederick Kensett, 1816–1872*, exh. cat. (New York: American Federation of the Arts, 1968), unpaged [p. 12].

43. Hartmann 1902, p. 60.

44. Isham 1905, pp. 235, 255.

45. Caffin 1907, pp. 66, 71, 82.

46. Ibid., p. 75.

47. Van Dyke 1919, pp. 4–5.

48. Cortissoz 1923, p. 112.

49. LaFollette 1929, p. 133.

50. Ibid., p. 170.

51. Burroughs 1917, pp. 3, 10. For the Jesup bequest, see "Bequest of Mrs. Morris K. Jesup," *Bulletin of the Metropolitan Museum of Art* 10 (February 1915), pp. 22–23; B. B. [Bryson Burroughs], "The Jesup Collection," *Bulletin of the Metropolitan Museum of Art* 10 (April 1915), pp. 64–69.

52. Preceding the Metropolitan show was an exhibition of "the early American school of landscape painting," including Doughty, Cole, Durand, Casilear, Cropsey, "the two Giffords," Inness, Kensett, Martin, Sonntag, W. T. Richards, Wyant, and "the two Morans," in 1915, at the Ehrich Galleries, New York. See "Good Examples of the Early American School of Landscape Painting," *New York Times*, 14 November 1915, sec. 4, p. 21. For accounts of other exhibitions of or including works by Hudson River School painters, see *New York Times*, 14 October 1917, sec. 3, p. 4; ibid., 1 November 1917, p. 14; ibid., 13 February 1919, p. 14; and "Early American Paintings; a Traveling Exhibition of Portraits and Landscapes," *American Magazine of Art* 12 (April 1921), pp. 121–24.

53. William B. M'Cormick, "The Hudson River Men; the First Real School of American Painting," *Arts and Decoration* 6 (November 1915), p. 11.

54. "Good Examples of the Early American School of Landscape Painting," *New York Times*, 14 November 1915, sec. 4, p. 21.

55. Goodrich 1925a, pp. 252, 254. In an earlier article, commemorating the centenary of George Inness's birth, Goodrich pointed to the "melancholy spectacle" of the Hudson River School generation of landscape painters, from which Inness had emerged, whose representatives were "entirely satisfied with their limitations." See Goodrich 1925, p. 107.

56. *Paintings of the Hudson River School*, exh. cat. (New York: Macbeth Gallery, 1932), Foreword.

57. Edward Alden Jewell, "Art. Art by Americans on View," *New York Times*, 26 January 1932, p. 21. For other comments on or related to that show, see "Hudson River School. Macbeth Galleries," *Art News* 30 (30 January 1932), p. 9; "Art Trends: The Years Between," *New York Times*, 31 January 1932, sec. 8, p. 13; "New York Criticism," *Art Digest* 6 (15 February 1932), p. 18; Edward Alden Jewell, "The Hudson River School," *Creative Art* 10 (March 1932), pp. 223–26; "American Art Notes. The Hudson River School,"

The Connoisseur 89 (January–June 1932), pp. 284–85.

58. "New York Exhibition May Start Revival of the Hudson River School," *Art Digest* 6 (1 February 1932), p. 5; see also "Hudson River," *Art Digest* 6 (1 January 1932), p. 9.

59. Thomas C. Linn, "In the Galleries: Recent Openings," *New York Times*, 5 February 1933, p. 12, reviewing the exhibition "American Genre Painting—a Forgotten School" at Newhouse Galleries, New York.

60. See, for example, Clyde H. Burroughs, "Early American Landscape Paintings," *Bulletin of the Detroit Institute of Arts* 15 (March 1936), pp. 86–89; "The Hudson River Men," *Bulletin of the Minneapolis Museum of Arts* 25 (7 November 1936), pp. 142–47; Leona E. Prasse, "A Drawing by Jasper Francis Cropsey in the Museum Collection," *Bulletin of the Cleveland Museum of Art* 24 (June 1937), pp. 98–101; Henry S. Francis, "Thomas Cole: Painter of the Catskill Mountains," ibid. (July 1937), pp. 113–16; C. C. Cunningham, "Recently Acquired American Landscapes," *Bulletin of the Museum of Fine Arts* (Boston) 36 (June 1938), pp. 39–41.

61. "Landscapes of the Hudson River School," *The Month at Goodspeed's* (Boston), February 1933, pp. 174–78; "The Hudson River School," typewritten catalogue, Frazier Galleries, Boston, [1938]. I am grateful to Robert C. Vose, Jr., of Vose Galleries, Boston, for the above references and for several of those cited at n. 67. See also "The Hudson River School," typewritten catalogue, Albany Institute of History and Art, 1939; "Thomas Cole," typewritten catalogue, Albany Institute of History and Art, 1941, Introduction by John Davis Hatch, Jr.

62. Edward Alden Jewell, "College Art Association Opens Today Exhibition of 'Background of American Painting,'" *New York Times*, 2 February 1933, p. 15; Goodrich 1938; Soby and Miller 1943.

63. See, for example, Frederick Fairchild Sherman, "A Century of American Landscape," *Art in America* 26 (April 1938), p. 85.

64. Sweet 1945.

65. C. J. Bulliet, "Chicago Surveys the Hudson River School in Major Exhibition," *Art Digest* 19 (1 March 1945), p. 26.

66. [Mary] Bartlett Cowdrey, "The Hudson River School and Its Place in American Art," *American Collector* 14 (May 1945), p. 11; Margaret Bruening, "Hudson River School at the Whitney," *Art Digest* 19 (1 May 1945), p. 8.

67. See the following catalogues and notices: "The Hudson River School, Their Contemporaries and Successors" (loan exhibition from Vose Galleries, Boston), exh. flyer, The High Museum of Art, Atlanta, Ga., 1946; "American Artists Discover America," essay and exh. cat., Oberlin College, Oberlin, Ohio, *Bulletin of the Allen Memorial Art Museum* 3 (February 1946), pp. 5–22; "Hudson River School," exh. flyer, Walters Art Gallery, Baltimore, Md., 1947; "Art Center Ready for Opening Today—Hudson River School Featured," *Daily Oklahoman* (clipping annotated "1948?" in Vose Galleries, Boston, files); "Hudson River School of Painting," exh. flyer, Dallas Museum of Fine Arts, Dallas, Tex., 1949; *Hudson River School, 1815–1865*, exh. cat. (Yonkers, N.Y.: The Hudson River Museum, 1954); Edgar J. Driscoll, Jr., "Cows and Catskills Make Pleasant Viewing," *Boston Sunday Globe*, 8 January 1957, reviewing an exhibition of Hudson River School paintings at the Hayden Gallery, Massachusetts Institute of Technology, Cambridge, Mass.

68. [Mary] Bartlett Cowdrey, "John Frederick Kensett, 1816–1872, Painter of Pure Landscape," *American Collector* 14 (February 1945), p. 13; Elizabeth McCausland, "Martin Johnson Heade, 1819–1904," *Panorama* 1 (October 1945), pp. 4–8; [Mary] Bartlett Cowdrey, "Jasper F. Cropsey, 1823–1900," *Panorama* 1 (May 1946), pp. 86–94; idem, "Asher Brown Durand, 1796–1886," *Panorama* 2 (October 1946), pp. 15–23; Howard Devree, "Baroque to Modern: a Wide Range of Styles in the New Shows," *New York Times*, 16 January 1949, sec. 2, p. 9, reviewing the Cole exhibition at the Whitney Museum.

69. See, for example, Clara Endicott Sears, *Highlights among the Hudson River Artists* (Boston: Houghton Mifflin Co., 1947). Sears's book, professedly nonscholarly but replete with quotations from contemporary sources, is anecdotal, even folksy.

70. Virgil Barker, *American Painting* (New York: Macmillan, 1950), pp. 417–46, 583–96. Barker found "a completeness of logic" in the development of the

Hudson River School, though he believed that the exclusive attention enjoyed by the group in previous years had been at the expense of important contemporary artists, American marine painters in particular, who had been ignored. Flexner 1962, pp. xiv, 3–60, 119–37, 156–73, 266–85, 293–302. To Flexner, the School, its tradition, style, and "method" were accepted and deemed essential to the progress of a "Native School" extending through Winslow Homer.

71. Born 1948, pp. 75–118, 214.

72. Richardson 1956, pp. 217–68.

73. Baur 1948, pp. 3, 7.

74. Baur 1949, pp. xxxvi, xl–xli, liv.

75. Baur 1954, pp. 91, 94–95, 97–98.

76. Baur 1948, p. 9.

77. Novak 1969, pp. 80–124.

78. Wilmerding 1976, pp. 76–99; Wilmerding 1980, pp. 11–19; 97–152. For related comments, see John Wilmerding, "Fire and Ice in American Art; Polarities from Luminism to Abstract Expressionism," McShine 1976, pp. 39–56.

79. Wilmerding 1980, p. 11.

80. Wilmerding 1976, p. 94.

81. Ibid., pp. 92–99; Wilmerding 1980, pp. 11, 13, 15–17.

82. See Linda S. Ferber, "Luminist Drawings," and Weston Naef, "'New Eyes'—Luminism and Photography," in Wilmerding 1980, pp. 237–65; 267–89.

83. Mahonri Sharp Young, "New Light!" *Apollo* n.s. 111 (May 1980), pp. 399–400; Andrew W. Wilton, "Washington. American Light: The Luminist Movement 1850–1875," *Burlington Magazine* 122 (October 1980), pp. 715–16.

84. Flexner 1962, p. 280. See also Flexner's review of Novak's *American Painting* in *New York Times*, 25 January 1970, sec. 7, p. 6; for Novak's rebuttal and Flexner's reply, see ibid., 15 March 1970, sec. 7, p. 42.

85. Gerdts 1978, unpaged.

86. Theodore E. Stebbins, Jr., "Luminism in Context: A New View," Wilmerding 1980, pp. 211–34; see p. 213 for quoted passage.

87. Gerald Reitlinger, *The Economics of Taste*, 3 vols. (London: Barrier and Jenkins, 1961–70), 3, pp. 32–33; "Prices Soar for 19th Century American Art," *New York Times*, 28 February 1968, p. 42; Hilton Kramer, "When the Meretricious Becomes Delicious," ibid., 17 August 1969, sec. 2, p. 19. I am grateful to Stuart P. Feld for sharing with me his thoughts and observations on the commercial revival of the Hudson River School.

88. *Art Prices Current* (London: Art Trade Press) 21 (1942–43); 22 (1943–44); 23 (1944–45); 24 (1945–46).

89. Peter Curtis Neger, "Patterns of American Collecting" (Senior essay, Yale University, 1977), pp. 20–21.

90. Ibid., p. 21.

91. *Executors' Sale by Order of . . . Executors of the late Marshall O. Roberts, Modern Paintings* (New York: Fifth Avenue Art Galleries, 1897), no. 155. I thank Gerald L. Carr for information on the original sale price of the picture, whose title remains confidential at the request of the owner.

92. Dean Krakel, *Adventures in Western Art* (Kansas City, Mo.: Lowell Press, 1977), pp. 231–32. I thank Donald W. Reeves, Curator of Collections, National Cowboy Hall of Fame and Western Heritage Center, Oklahoma City, Okla., for this reference and for other information on the painting.

93. *New York Times*, 28 February 1968, p. 42; Neger, "Patterns of American Collecting," p. 1.

94. Carr 1980, p. 8. Not until Rembrandt Peale's portrait of his brother, *Rubens Peale with a Pot of Geraniums*, was auctioned in 1985 for $4,070,000 did *The Icebergs* surrender the record.

95. Richard Hislop, ed., *1970–1980 Auction Prices of 19th Century Artists*, 2 vols. (Pond House, Weybridge, Surrey, England: Art Sales Index, 1981), 1, p. 82; *Art and Auction* 8 (February 1986), p. 98.

96. Michael David Zellman, comp., *American Art Analog*, 3 vols. (New York: Chelsea House, 1986), 1, pp. 126, 170, 198, 202.

97. Ibid., pp. 186, 190.

98. "American Paintings, Sotheby's New York, 23 April 1981," *International Art Market* 21 (May 1981), p. 107, no. 31.

99. The following are selected exhibitions of Hudson River School paintings since 1960, including several in which School representatives figure prominently: *The Hudson River School*, Munson-Williams-Proctor Institute, Utica, N.Y., 1961; *The Hudson River School*, American Federation of Arts, New York, 1962; Davidson, Hattis, and Stebbins 1966; Jones 1968; Miller 1969; *19th-Century American Landscape Painting*, Metropolitan Museum, New York, 1972; *The Hudson River School: American Landscape Paintings, 1821–1907*, R. W. Norton Art Gallery, Shreveport, La., 1973; McShine 1976; Stebbins 1976; Gerdts 1978; Wilmerding 1980; Novak and Blaugrund 1980; *William Cullen Bryant and the Hudson River School of Landscape Painting*, Nassau County Museum of Fine Art, Rosslyn, N.Y., 1981. See Short Titles and Abbreviations, p. 331, this publication, for many other exhibitions and monographs devoted to individual Hudson River School painters.

100. Wend von Kalnein and Donelson F. Hoopes, *The Düsseldorf Academy and the Americans*, exh. cat. (Atlanta, Ga.: The High Museum of Art, 1973); Ferber and Gerdts 1985.

101. Ila S. Weiss, *Poetic Landscape: The Art and Experience of Sanford R. Gifford*, forthcoming; Ellwood C. Parry III, *Ambition and Imagination in the Art of Thomas Cole*, forthcoming.

102. Howat 1972; Barbara Babcock Lassiter, *American Wilderness: The Hudson River School of Painting* (Garden City, N.Y.: Doubleday and Co., 1978). In Howat's book, his introductory essay, "The First New York School," provides a useful summary of the growth of the Hudson River School and the characteristics of its major figures. As Howat acknowledges, however, the illustrations, exclusively of Hudson River subjects, belie the almost global geographic range of the School's subject matter. Lassiter's book is a refreshing and novel narrative of the School's social development, though it includes too few illustrations and pictorial analyses and contains neither notes nor a bibliography.

103. "[The artist] does not offer this picture as a perfect illustration of the epic in landscape, but only as a visible expression of a strongly felt emotion of Hope and Promise." Quoted in Cikovsky 1977, pp. 192–93. According to Cikovsky, the author of the pamphlet accompanying the exhibition of *The Sign of Promise* is not known, though the text, which closely reflects Inness's ideas, was probably written by the artist himself.

104. Linda S. Ferber, "Determined Realists: The American Pre-Raphaelites and the Association for the Advancement of Truth in Art," in Ferber and Gerdts 1985, pp. 11–35.

105. Stebbins 1976, p. 6.

THE EXALTATION OF AMERICAN LANDSCAPE PAINTING

1. Sydney Smith, *Edinburgh Review*, January 1820, quoted in Ruland 1976, p. 157.

2. Charles Brockden Brown, *The American Review and Literary Journal*, 1902, quoted in Ruland 1976, p. 66.

3. See Cummings 1865, pp. 8–17, for full text of address. The quoted passage is on p. 12.

4. Dunlap 1834, 2, p. 357.

5. Washington Irving, *The Sketch Book of Geoffrey Crayon, Gent.*, 1820, rev. ed. (New York: New American Library, 1981), p. 284. The quoted passage is from the chapter titled "Philip of Pokanoket."

6. James Kirke Paulding, *National Literature*, 1819–20, quoted in Ruland 1976, p. 136.

7. Dunlap 1834, 2, p. 360.

8. For a thorough consideration of Gilpin's influence on Cole's early paintings, see Earl A. Powell III, "Thomas Cole and the American Landscape Tradition: The Picturesque," *Arts* 52 (March 1978), pp. 110–17.

9. Allen Nevins, ed., *The Diary of Philip Hone, 1828–1851*, 2 vols. (New York: Dodd, Mead & Co., 1927), 1, p. 93.

10. Gilmor to Cole, 13 December 1826, reprinted in Merritt 1967, p. 45.

11. Cole to Gilmor, 25 December 1826, reprinted in Merritt 1967, p. 47.

12. Dunlap 1834, 2, p. 365.

13. Gilmor to Cole, 13 December 1827, reprinted in Merritt 1967, p. 56.

14. Wadsworth to Cole, 4 December 1827, reprinted in McNulty 1983, pp. 22–23.
15. Merritt 1969, p. 25, quoting from a review in *American Monthly Magazine* of the 1833 exhibition of the American Academy of Fine Arts.
16. Noble 1853, p. 263.
17. Sir Joshua Reynolds, *Seven Discourses Delivered in the Royal Academy by the President* (London: T. Cadell, 1778), p. 101.
18. Merritt 1969, pp. 13–14.
19. Noble 1853, p. 116.
20. Flexner 1962, p. ix.
21. James B. Flagg, *The Life and Letters of Washington Allston* (London: Richard Bentley and Son, 1893), pp. 203–4.
22. Noble 1853, p. 114.
23. Ibid., p. 115.
24. Ibid., p. 117.
25. Ibid., p. 171.
26. Ibid., p. 145.
27. William Cullen Bryant, *Funeral Oration Occasioned by the Death of Thomas Cole, Delivered Before the National Academy of Design, New York, May 4, 1848* (New York: D. Appleton & Co., 1848), p. 21.
28. Noble 1853, p. 153.
29. Ibid., pp. 153–54.
30. For a full discussion, see Koke 1982, 1, pp. 192–99.
31. Benjamin 1880, p. 59.
32. Cooper to Noble, 6 January 1849, quoted in Noble 1853, p. 225.
33. Thomas Cole, "Essay on American Scenery," 1835, reprinted in McCoubrey 1965, p. 109.
34. Noble 1853, p. 248.
35. *The Literary World* 3 (8 April 1848), p. 186.
36. Tuckerman 1849, p. 80.
37. John Ruskin [A Graduate of Oxford], *Modern Painters*, rev. ed., 5 vols. (London: Smith, Elder & Co., 1846–60), 1, p. 43.
38. Emerson's *Journals*, entry dated June 1862, quoted in William H. Gilman, ed., *Selected Writings of Ralph Waldo Emerson* (New York: New American Library, 1965), p. 173.
39. Durand to Cole, 5 September 1837, quoted in Lawall 1971, p. 71.
40. *New-York Mirror* 15 (6 January 1838), p. 224.
41. Ibid. 18 (18 July 1840), p. 30.
42. *The Knickerbocker* 16 (July 1840), p. 81.
43. Durand 1894, p. 147.
44. Ibid., p. 159.
45. Ibid., pp. 159–60.
46. Tuckerman 1849, pp. 86–87.
47. *New York Evening Post*, 23 April 1847, p. 2.
48. *The Crayon* 1 (17 January 1855), p. 34.
49. Ibid. (6 June 1855), p. 354.
50. *The Literary World* 6 (7 April 1850), p. 424.
51. Ibid. 1 (15 May 1847), p. 347.
52. *Bulletin of the American Art-Union* 2 (April 1849), p. 20.
53. *The Literary World* 6 (7 April 1850), p. 425.
54. Ibid. 10 (8 May 1852), p. 331.
55. Ibid. 6 (4 May 1850), p. 447.
56. *The Knickerbocker* 42 (1 July 1853), p. 95.
57. Adam Badeau, *The Vagabond* (New York: Rudd & Carleton, 1859), pp. 123–24.
58. *Harper's Weekly* 11 (8 June 1867), p. 364.
59. See David Huntington, "Church and Luminism: Light for America's Elect," Wilmerding 1980, pp. 155–90.
60. Ibid., p. 158.
61. Ibid.
62. *New York Evening Post*, 20 April 1859, p. 2.
63. Ibid.
64. Tuckerman 1867, pp. 371–72.
65. *New York Evening Post*, 30 April 1859, p. 2.
66. *New York Times*, 24 November 1859, p. 4.
67. *Art Journal* (London), October 1859, p. 298.
68. *New York Evening Post*, 2 April 1864, p. 12.
69. Benjamin 1880, p. 98.
70. Jarves 1864, p. 190.
71. Ibid., p. 191.

A CLIMATE FOR LANDSCAPE PAINTERS

Marilyn Lippman Lutzker's "Art in America, 1835–1855: A Story of Art Theory, Criticism and Patronage" (Master's thesis, New York University, 1956) provided an invaluable list of mid-nineteenth-century New York publications dealing with art matters.

1. Reprinted in W. W. Pasko, Ed. & Pub., *Old New York*, 2 vols. (New York, 1890), 1, p. 159.
2. John W. Francis, M.D., L.L.D., *Old New York or Reminiscences of the Past Sixty Years* (New York, 1866), pp. 19–20, quoting part of a discourse given at The New-York Historical Society, 17 November 1857.
3. *American Monthly Magazine* 1 (1833), p. 405.
4. Ibid.
5. *The Knickerbocker* 1 (April 1833), p. 255.
6. Ibid. 5 (January 1835), p. 89.
7. Ibid. 2 (July 1833), p. 34.
8. *American Monthly Magazine* 4 (1834), p. 245.
9. Ibid. 3 (1834), p. 353.
10. *The Knickerbocker* 13 (June 1839), p. 553.
11. Ibid., p. 549.
12. Dunlap 1834, 2, p. 117.
13. *The Knickerbocker* 5 (June 1835), p. 551.
14. *American Monthly Magazine* 6 (1835), p. 213.
15. Cole's lecture, given 9 May 1835 at the New-York Lyceum, was published in the January 1836 issue of *The American Monthly*. For full text, see McCoubrey 1965, pp. 98–110.
16. McCoubrey 1965, pp. 100–101.
17. *The Knickerbocker* 8 (July 1836), p. 114.
18. *New-York Mirror* 15 (26 May 1838), p. 382.
19. Cowdrey 1943, 1, p. 71.
20. *The Knickerbocker* 14 (July 1839), p. 50.
21. Ibid. (November 1839), pp. 420–21.
22. Ibid., p. 423.
23. Ibid. 16 (July 1840), p. 81.
24. Ibid. 19 (June 1842), p. 593.
25. *The Art Union* 1 (March 1884), p. 61.
26. Cowdrey and Sizer 1953, 1, p. 211, quoting *The Knickerbocker* for November 1848.
27. *The Broadway Journal* 1 (January–June 1845), p. 36.
28. Ibid., p. 12. The *Journal*, by then entirely in Poe's hands, ceased publication after the issue of its second volume, early in 1846. Poe's *The Pit and the Pendulum* was first published in *The Broadway Journal*.
29. A page-by-page scan of Cowdrey and Sizer 1953 showed that of forty-four exhibiting artists, twenty-three were landscapists.
30. *The Broadway Journal* 1 (January–June 1845), p. 21.
31. Ibid., p. 276.
32. Ibid. 2 (12 July 1845–3 January 1846), p. 91.
33. Cummings 1865, pp. 148–49.
34. *The Broadway Journal* 2 (12 July 1845–3 January 1846), p. 104.
35. Century Association, minutes of first meeting, 13 January 1847, Century Association Archives.
36. C. S. Francis, *Francis's New Guide to the Cities of New-York and Brooklyn* (New York, 1853), p. 79.
37. *The Knickerbocker* 42 (July 1853), p. 93.

38. Ibid. (January 1853), pp. 77–79.
39. *The Illustrated Magazine of Art* 3 (1854), p. 263.
40. *The Knickerbocker* 45 (February 1855), p. 220.
41. Ibid. 47 (April 1856), p. 440.
42. *Brother Jonathan* 5 (8 July 1843), p. 289.
43. Nevins and Thomas 1952, 2, p. 397.
44. *Cosmopolitan Art Journal* 1 (September 1857), p. 144.
45. Ibid. 2 (September 1858), p. 209.
46. *The Crayon* 6 (August 1859), p. 256.
47. *Cosmopolitan Art Journal* 3 (December 1858), p. 5.
48. Ibid. 4 (March 1860), p. 30.
49. *The Knickerbocker* 36 (November 1850), pp. 482–83.
50. *The Crayon* 1 (14 February 1855), p. 100.
51. Ibid. 5 (February 1858), p. 59.
52. Ibid. (March 1858), p. 87.
53. Ibid. (April 1858), p. 114.
54. Ibid. (May 1858), p. 148.
55. *Cosmopolitan Art Journal* 4 (March 1860), p. 34.
56. *The Crayon* 6 (May 1859), p. 145.
57. Ibid. 5 (June 1858), pp. 175–76.
58. Ibid. 8 (January 1861), p. 21.
59. *New York Times*, 14 April 1878, p. 7.
60. See Clement and Hutton 1880, s.v. "McEntee, Jervis."
61. McEntee diary, entry for 6 May 1873.
62. Ibid., 21 May 1873.
63. Ibid., 7 April 1874.
64. Ibid., 20 April 1874.
65. Ibid., 4 January 1878.
66. Ibid., 24 January 1878.
67. Ibid., 13 February 1878.
68. *Harper's Weekly* 23 (8 February 1879), p. 110.
69. McEntee diary, entry for 3 May 1878.
70. *The Art Review* 1 (March 1887), pp. 19–20.

THE HUDSON RIVER SCHOOL IN ECLIPSE

1. Rice 1877, p. 456.
2. For comments on the continued preeminence of the American landscape school, see Rice 1877, pp. 455–57; Sheldon 1879, p. 10; Greta [pseud.], "Boston Correspondence: The Museum Exhibition—American Art Changing Its Field," *Art Amateur* 4 (December 1880), p. 6; S. G. W. Benjamin, "The Exhibitions: VII.—National Academy of Design," *American Art Review* 2, pt. 2 (1881), p. 21.
3. Earl Shinn, using the pseudonym Edward Strahan, may have been the first to coin the term "Hudson River School." See Strahan 1879, p. 4. Rice 1877 referred to the American landscape painters as a "school" (p. 455), but did not specifically call them the Hudson River School.
4. Strahan 1879, p. 4.
5. McEntee diary, entry for 29 March 1879.
6. Strahan 1879, p. 4.
7. Ibid. The term "fogy," referring to an older generation of American painters, including those of the Hudson River School, appears even earlier in critical journalism. See, for example, "Fine Arts. Changes at the National Academy of Design," *New York Times*, 11 June 1869, p. 4. The term "impression school" was then generally understood as referring to Barbizon painters. See Herbert 1962, pp. 48, 62–63. In an obituary, for example, Corot was called "the founder and father of . . . the *école de l'impression*" ("Corot. From the French of Jean Rousseau," *Art Journal* [New York] 1 [July 1875], p. 211). The term "impressionist" was also applied to American artists whose technique and subject matter were inspired by the Barbizon painters and the Munich School. See J.B.F.W., "Society of American Artists," *The Aldine* 9 (1879), p. 278.
8. John F. Weir, "American Art: Its Progress and Prospects," *Princeton Review* n.s. 1 (May 1878), p. 818, quoted in Weiss 1977, pp. 362–63.
9. The theme of two distinct generations is a common one in the criticism of the late 1870s and the 1880s. See Strahan 1879, pp. 4–5; "Fine Arts. The Fall Exhibition of the National Academy of Design," *New York Evening Post*, 7 November 1882, p. 3; Cook 1883, pp. 311–20, especially pp. 311–13; Robert Jarvis, "Autumn Exhibition of the National Academy of Design," *Art Amateur* 10 (December 1883), p. 8; "The National Academy Exhibition," *New York Evening Post*, 8 April 1885, p. 3; "Art Notes and Hints," *Art Amateur* 16 (February 1887), p. 61.
10. McEntee diary, entries for 3, 18 March 1881.
11. For discussions of late-19th-century American landscape painting, see Corn 1972; Quick 1976; Gerdts 1980; Gerdts 1984; Ferber and Gerdts 1985; Gerdts and Weber 1987. For publications on the Luminist style, see n. 45; for those on the influence of French painting on American art, see n. 50.
12. Van Rensselaer 1882, p. 64.
13. "Fine Arts. The National Academy of Design," *Putnam's Magazine* n.s. 3 (June 1869), p. 748.
14. "Fine Arts. National Academy of Design," *New York Times*, 14 May 1868, p. 5; "National Academy of Design," ibid., 23 May 1867, p. 5; "The Fine Arts. The Academy Exhibition," ibid., 3 April 1876, p. 4; Sordello [pseud.], "National Academy of Design. Fortieth Annual Exhibition. Third Article," *New York Evening Post*, 22 May 1865, p. 1; "Fine Arts. The Academy Exhibition. Second Notice," *New York Times*, 19 April 1874, p. 4.
15. "National Academy of Design. Fourth Notice," *New York Evening Post*, 22 June 1870, p. 1. For another expression of critical ennui, see Sordello [pseud.], "A Painter's Feuilleton. A Spring Revery," ibid., 10 April 1866, p. 1.
16. "National Academy of Design," *New York Times*, 23 May 1867, p. 5.
17. George William Sheldon, *Recent Ideals of American Art* (New York and London: D. Appleton & Co., 1888–89), p. 42. Interestingly, the exact same phrasing had appeared in "Sketchings. Exhibition of the Academy of Design, No. II," *The Crayon* 1 (4 April 1855), p. 218.
18. Mary Gay Humphreys, "Landscape in America," *Art Journal* (London) 40 (March 1888), p. 81.
19. Baur 1942, p. 53.
20. For a period definition of breadth, see Benjamin 1879, unpaged, section titled "Robert Swain Gifford": "A landscape painting or a portrait in which many of the details are entirely omitted or merely suggested, and in which the general effect is always the prominent idea of the work, is said to have breadth."
21. Ibid., section titled "Sanford R. Gifford."
22. [William C. Brownell], "The Art Schools of Philadelphia," *Scribner's Monthly* 18 (September 1879), p. 748.
23. Eugene Benson, "The Old Masters in the Louvre, and Modern Art," *Atlantic Monthly* 21 (January 1868), p. 118.
24. William P. Longfellow, "Art," *Atlantic Monthly* 33 (May 1874), p. 629.
25. Sheldon 1879, p. 13.
26. "American Art Methods: The Society of Artists," *New York Times*, 10 March 1879, p. 5. We are grateful to our colleague Kevin J. Avery for bringing this article to our attention.
27. "The Fine Arts. Fourth Winter Exhibition of the Academy of Design," *New York Times*, 27 November 1870, p. 3.
28. "National Academy of Design. South Room," *New York Times*, 13 June 1865, p. 4.
29. "American Art. The Academy of Design. A Second View of the Exhibition. Landscapes by the Younger Artists," *New York Times*, 8 April 1877, p. 4.
30. S[usan] N. C[arter], "The Academy Exhibition. II. The Landscapes," *New York Evening Post*, 24 April 1875, p. 1.
31. As early as 1840, Samuel F. B. Morse had advised using the daguerreotype as a preparatory short-cut. See Lindquist-Cock 1977; Kilgo 1982.
32. An estimated three and a half to four million stereograph views were issued in the United States between 1858 and 1920. Lindquist-Cock 1977, p. 100, citing William Culp Darrah, *Stereo Views* (Gettysburg, 1964). See also Edward W. Earle, *Points of View: The Stereograph in America—A Cultural History*, exh. cat. (Rochester, N.Y.: The Visual Studies Workshop, 1979).

33. Aaron Scharf, *Art and Photography* (Harmondsworth, England: Pelican Books, 1974), pp. 181–82; p. 354, n. 52.

34. John Ruskin's dictum of "truth to nature," as expressed in his *Modern Painters*, was a powerful influence on mid-19th-century landscape painters: "Every class of rock, every kind of earth, every form of cloud, must be studied with equal industry, and rendered with equal precision." Quoted in Lindquist-Cock 1977, p. 18. Though Ruskin thought photography the "most marvelous invention of the century" in the 1840s, he was thoroughly disenchanted with it by 1870. See Lindquist-Cock 1977, especially pp. 158–75.

35. "National Academy of Design. Second Notice," *New York Evening Post*, 9 May 1870, p. 1.

36. "More Pictures at the Academy," *New York Times*, 20 April 1884, p. 6. We are grateful to Linda S. Ferber, chief curator, The Brooklyn Museum, for locating the Richards painting illustrated (Fig. 4.5).

37. Van Rensselaer 1886, Introduction, unpaged.

38. Benjamin 1880, p. 69; "Asher Brown Durand," *Harper's Weekly* 30 (25 September 1886), p. 619; L., "The Clever vs. the Serious in Art," *The Studio* 1 (27 January 1883), p. 28.

39. For an excellent general summary of the status of the native school of landscape in 1873, see Weir 1873; the term "scientific," here applied to Frederic Church, appears on p. 144.

40. Van Rensselaer 1882, p. 64.

41. Ibid.

42. "Feeling and Talent," *The Crayon* 1 (10 January 1855), p. 17, quoted in Weiss 1977, p. 362.

43. McEntee diary, entry for 16 March 1878.

44. Francis A. Silva, "American vs. Foreign-American Art," *The Art Union* 1 (June–July 1884), p. 130.

45. The basic texts on Luminism include Baur 1948; Baur 1954; Davidson, Hattis, and Stebbins 1966; Novak 1969; Talbot 1973; Gerdts 1978; Wilmerding 1980; Elayne Genishi Garrett, "The British Sources of American Luminism," Ph.D. diss., Case Western Reserve University, 1982.

46. In 1865, Durand and Casilear were the oldest living Hudson River School painters (sixty-nine and fifty-four, respectively); Bierstadt, Church, and Cropsey, like Gifford, Heade, and Kensett, were in their thirties and forties.

47. Sheldon 1877, p. 284.

48. An elaboration on this theme can be found in "National Academy of Design. First Notice," *New York Evening Post*, 27 April 1870, p. 1.

49. Sordello [pseud.], "National Academy of Design. Fortieth Annual Exhibition. Third Article," *New York Evening Post*, 22 May 1865, p. 1.

50. See Herbert 1962. For information on the American response to Barbizon painting, see Lois Marie Fink, "The Role of France in American Art, 1850–1870," Ph.D. diss., University of Chicago, 1970; Bermingham 1972a; Bermingham 1975; Fink 1978, pp. 87–100; Murphy 1979; O'Brien 1986; Rosenfeld and Workman 1986.

51. Constable to John Fisher, letter of August 1824, quoted in Peter Galassi, *Before Photography: Painting and the Invention of Photography* (New York: Museum of Modern Art, 1981), p. 27.

52. Quoted in Herbert 1962, p. 30.

53. Ibid., pp. 64–65.

54. Kensett, who was in France between 1840 and 1843 and again in 1845, frequently sketched at Fontainebleau; Cropsey stopped there in 1848; Whittredge in 1849; Gifford in 1855 and 1856, after viewing Barbizon paintings at the Paris Exposition Universelle of 1855. Thomas Moran visited Corot in 1866. See Driscoll and Howat 1985, pp. 30, 54; Bermingham 1975, pp. 21, 42, 48, 52, 59.

55. Gifford's journal entry for 29 September 1855, quoted in Weiss 1977, p. 90; also quoted in Bermingham 1975, p. 52.

56. Sheldon 1877, p. 285; also cited in Bermingham 1975, p. 52.

57. It has been recently noted that the expression of Kensett's "tranquil, poetic feeling" changed in the mid-1850s, "when a new style emerged from his easel." See John Paul Driscoll, "From Burin to Brush," Driscoll and Howat 1985, p. 99; see also pp. 70, 82, 102ff. Though no attempt has been made to link the change with Kensett's exposure to Barbizon painting (as has been suggested of Gifford's work in the 1850s), Kensett is known to have sketched in Fontainebleau (see n. 54) and to have acquired Barbizon paintings for his own collection. His papers reveal little of the experience, making the extent of his interest in the Barbizon painters and their experiments with the effects of light and atmosphere difficult to assess, but that he was unaware of them is hard to believe. Benjamin 1880, pp. 63–64, noted "Kensett's early perception of a theory of art practice which has since become prominent in foreign art" (quoted in Bermingham 1975, n. 15, pp. 105–6). Hartmann 1902, pp. 55–56, also recognized that prescient quality in the work of Kensett and Gifford: "[They] were the first to strive for more pleasing colour harmonies and a more careful observation of atmospheric changes, the play of sunlight in the clouds and misty distances . . . these lyrical attempts were really forerunners of the modern school, as it was not so much things as feelings that they tried to suggest" (quoted in Theodore E. Stebbins, Jr., "Luminism in Context: A New View," Wilmerding 1980, p. 214).

58. "National Academy of Design. The Winter Exhibition," *New York Evening Post*, 12 December 1870, p. 2.

59. "National Academy of Design. First Notice," *New York Evening Post*, 22 April 1868, p. 1.

60. "Sketchings. Exhibition of the Academy of Design, No. II," *The Crayon* 1 (4 April 1855), p. 218.

61. Ibid., p. 219.

62. All the quotations in this paragraph are drawn from C[hristopher] P[earse] Cranch, "French Landscape" [Letter to the Editors], *The Crayon* 3 (June 1856), pp. 183–84. We are indebted to Leslie Yudell, Office of Public Programs, Division of Education Services, Metropolitan Museum, for her generosity in sharing with us her extensive research on American critical reaction to Barbizon painting.

63. Sheldon 1879, p. 52. In his diary entry of 26 November 1874, McEntee recorded: "I am trying for more freedom in handling, it only comes from knowledge of detail to be successful."

64. Moran, in Sheldon 1879, p. 127, quoted in Spassky 1985, p. 520.

65. Inness 1878, p. 461. For discussions of Inness's treatment of "the civilized landscape," see Nicolai Cikovsky, Jr., "The Civilized Landscape," *American Heritage* 36 (April/May 1985), pp. 33–34; idem, "The Civilized Landscape," Cikovsky and Quick 1985, pp. 11–44.

66. La Farge, quoted in Yarnall 1981, p. 206. See also pp. 201–30 for a discussion of La Farge's three major landscapes of the late 1860s, including *Bishop Berkeley's Rock*, originally titled *Autumn Study. View Over Hanging Rock, Newport, R. I.*, painted in a much looser and spontaneous manner and believed to be an unfinished easel painting (p. 229). Recently unearthed evidence appears to confirm that opinion. We are grateful to the author for sharing with us this and other information on various aspects of La Farge's work, which will appear in *Catalogue Raisonné of the Works of John La Farge*, begun by La Farge's grandson Henry and being completed by Dr. Yarnall and Henry's widow, Mary A. La Farge (New Haven, Conn.: Yale University Press, forthcoming).

67. "The Fine Arts. Exhibition at the National Academy—An Unusually Poor Array," *New York Times*, 8 April 1876, p. 7.

68. "The Arts, Representative Pictures at the Academy," *Art Journal* (New York) 15 (15 April 1876), pp. 209–10, cited in Yarnall 1981, p. 213.

69. "National Academy of Design. Third Notice," *New York Evening Post*, 10 June 1870, p. 1.

70. C. B., "American Art Association Exhibition," *Art Amateur* 16 (January 1887), p. 27.

71. S. R. Koehler, *American Art* (New York: Cassell & Co., 1886), p. 23.

72. Sheldon 1879, p. 16. For discussions of Gifford's working method, see also Sheldon 1877, pp. 284–85; Ila Weiss, "Sanford R. Gifford in Europe: A Sketchbook of 1868," *American Art Journal* 9 (November 1977), pp. 83–103.

73. Sheldon 1879, p. 16.

74. For a discussion of Kensett's plein-air methods, see Dianne Dwyer, "John F. Kensett's Painting Technique," Driscoll and Howat 1985, pp. 163–80.

75. In the American literature on the subject, the word sketch can refer to a preparatory work, a study of an effect or a detail in nature, or the initial work on a painting. Not routinely specified are the more subtle French distinctions of

esquisse (a preliminary step in the production of a finished work, but one requiring the use of the artist's imagination), *étude* (a study of a separate feature of a landscape or a figure; if a landscape feature, executed under nature's inspiration), and *ébauche* (unfinished painting). For an in-depth discussion of the sketch in 19th-century French art and aesthetics, see Boime 1971, chapters 8 and 9.

76. Sheldon 1882, p. 128.

77. "Sanford R. Gifford," *Art Journal* (New York) n.s. 6 (October 1880), p. 320.

78. Peter Bermingham brings to light the sponsorship, starting about 1859, of Inness by George Ward Nichols, a former pupil of Thomas Couture and the owner of the Crayon Art Gallery at Eighth Street and Broadway in New York. Art critic for the *New York Evening Post* briefly, and sometimes writing anonymously for the *New York World*, Nichols was among the first New York dealers to carry the work of Rousseau and Corot. His support of Inness was crucial in launching the artist's career. See Bermingham 1975, pp. 29–30.

79. Cikovsky, "The Civilized Landscape," in Cikovsky and Quick 1985, p. 26.

80. Ibid., quoting period criticism.

81. Inness 1878, p. 458.

82. Inness 1917, p. 178.

83. J. A. S. Monks, "A Near View of Inness," *Art Interchange* 34 (June 1895), p. 148.

84. "Art Gossip," *Cosmopolitan Art Journal* 4 (1860), p. 183.

85. For a discussion of Wyant's response to Barbizon painting, see Bermingham 1975, pp. 55–68.

86. "Alexander H. Wyant," *Harper's Weekly* 24 (23 October 1880), p. 678.

87. Rice 1877, pp. 457, 459.

88. Greta [pseud.], "Boston Correspondence: The Museum Exhibition—American Art Changing Its Field," *Art Amateur* 4 (December 1880), p. 6. For other period comments on the growth of figure painting and the decline of landscape, see S. G. W. Benjamin, "Tendencies of Art in America," *American Art Review* 1, pt. 1 (1880), p. 109; "Pictures at the Academy Viewed in the Quiet of Varnishing Day," *New York Times*, 31 March 1883, p. 5; "The National Academy of Design Exhibition. Fourth Notice," *New York Evening Post*, 21 April 1884, p. 4; Van Rensselaer 1886, Introduction, unpaged.

89. In fifteen lectures delivered at the Royal Academy in London between 1768 and 1789, Sir Joshua Reynolds defined painting in the Grand Manner as consisting of "being able to get above all singular forms, local customs, particularities, and details of every kind." Reynolds's *Discourses*, as they were called, constitute the most representative English statement of 18th-century aesthetic principles. Central to Reynolds's theory of art was a hierarchy of painting in which he ranked such "noble" categories as history painting and historical portraiture above such lesser ones as landscape, genre, and still life. The sketch, which was to become so valued a part of late-19th-century aesthetics, was at the very bottom of the list, along with the copy. Reynolds's hierarchy of painting informed the artistic training offered by the National Academy of Design, which emulated the Royal Academy in its emphasis on figure study, both from life and from antique casts. Landscape painting was not a part of the National Academy's formal curriculum.

90. Sordello [pseud.], "National Academy of Design. Forty-first Annual Exhibition. Second Article," *New York Evening Post*, 11 May 1866, p. 1. The English art critic Philip Gilbert Hamerton, whose writings were widely read in America, disputed "the popular impression that landscape painting is easy." In Hamerton's view, nature is so changeable that the painter inevitably has difficulty in mastering its complexity. He saw figure study as essential training for any artist; he proposed that by learning to draw, model, and color a motionless cast or figure under fixed conditions, the landscape painter could best prepare himself to grapple with the "intricacy" and "changeableness" of landscape. See Philip Gilbert Hamerton, "English Painters of the Present Day: XV.—The Landscape Painters," *The Portfolio* 1 (1870), pp. 145–50.

91. Strahan 1879, p. 4.

92. Ibid. Strahan was apparently unaware that Moran had gone to France in 1877 to study figure painting. See Paul D. Schweizer, *Edward Moran (1829–1901): American Marine and Landscape Painter*, exh. cat. (Wilmington, Del.: Delaware Art Museum, 1979), pp. 44, 46, 68.

93. McEntee to Ripley, 28 October 1874, reprinted in "Jervis McEntee's Diary," *Journal of the Archives of American Art* 8 (July–October 1968), p. 29. Many additional references to his resolve to paint figures can also be found in McEntee's diary; see, for example, entries for 27 December 1873; 5, 20 April, 4, 5 June, 4 September 1874; 7 February 1875. See entries for 27 March and 7 April 1874 for references to *A Wood Path* and *Solitaire*; *Solitaire* is also discussed in entries for 8, 23, 28, 29 January, 7 March, and 20 April 1874.

94. McEntee diary, entry for 23 January 1874. The lectures were by James Wells Champney on anatomy and Eadweard Muybridge on motion photography and animal locomotion. See diary entries for 20, 22 January, 3 February, 6 April 1880; 27 December 1882; see also Minutes, Council Meeting, National Academy of Design, 20 November, 11, 20 December 1882.

95. Bricher to H. R. Latimer, of the Brooklyn Art Academy, 18 December 1879, quoted in John Duncan Preston, "Alfred Thompson Bricher, 1837–1908," *Art Quarterly* 25 (Summer 1962), p. 155. For a discussion of Bricher's treatment of figures, see Jeffrey R. Brown, assisted by Ellen W. Lee, *Alfred Thompson Bricher 1837–1908*, exh. cat. (Indiana: Indianapolis Museum of Art, 1973), pp. 23–24.

96. R. Swain Gifford was an instructor at the Cooper-Union; T. Addison Richards, at New York University; John La Farge and J. Foxcroft Cole were members of the directing committee at the School of Drawing and Painting at the Museum of Fine Arts, Boston; James M. Hart was a member of the school committee of the National Academy of Design. Charles H. Miller and George Inness lectured at the Art Students League, New York, in 1883 ("A Suggestion," *The Studio* 1 [10 March 1883], p. 73).

97. Theodore C. Grannis, "The Art Schools of America," *The Aldine* 9 (1878), p. 67; Raymond L. Wilson, "The First Art School in the West: The San Francisco Art Association's California School of Design," *American Art Journal* 14 (Winter 1982), pp. 47, 50, 53–54. In 1870, at a meeting of the membership of the National Academy of Design, a landscape class was one of those proposed as additions to the Academy's curriculum (Minutes, Stated Meeting, National Academy of Design, 9 February 1870, Archives, National Academy of Design).

98. Boime 1971, pp. 146–47. Landscape painting, though not part of the curriculum, was eligible for the Prix de Rome competition until the reforms of 1863 at the Ecole. Another landscape prize was established six years later.

99. See David Sellin, *Americans in Brittany and Normandy 1860–1910*, exh. cat. (Arizona: Phoenix Art Museum, 1982).

100. Martha J. Hoppin, "Women Artists in Boston, 1870–1900: The Pupils of William Morris Hunt," *American Art Journal* 13 (Winter 1981), pp. 17–46; Frederic A. Sharf and John H. Wright, *William Morris Hunt and the Summer Art Colony at Magnolia, Massachusetts, 1876–1879*, exh. cat. (Salem, Mass.: Essex Institute, 1981); William H. Gerdts, "The Teaching of Painting Out-of-Doors in America in the Late Nineteenth Century," Gerdts and Weber 1987.

101. For a thorough study of the subject, see *In Pursuit of Beauty: Americans and the Aesthetic Movement*, exh. cat. (New York: The Metropolitan Museum of Art, 1986).

102. Information on Cropsey's decoration of The Seventh Regiment Armory was provided by Ruth M. O'Brien, Curator for The Veterans of the Seventh Regiment Armory. Cropsey's ceiling decoration for the drill room has recently been published in William Nathaniel Banks, "Ever Rest, Jasper Francis Cropsey's house in Hastings-on-Hudson, New York," *The Magazine Antiques* 130 (November 1986), pp. 994–1009. On Olana, see Peter I. Goss, "An Investigation of *Olana*, the Home of Frederic Edwin Church, Painter," Ph.D. diss., Ohio University, 1973); Clive Aslet, *Olana* (Hudson, N. Y.: Friends of Olana, n. d.); Roger B. Stein, "Artifact as Ideology: The Aesthetic Movement in Its American Cultural Context," *In Pursuit of Beauty*, pp. 24–25. On Colman and the Associated Artists, see Wilson H. Faude, "Associated Artists and the American Renaissance in the Decorative Arts," *Winterthur Portfolio* 10 (1975), pp. 101–30; *In Pursuit of Beauty*, pp. 123–24, 474–75, 481–82, and passim.

103. We are grateful to Celia Betsky McGee for bringing the Bierstadt painting to our attention. For views by Gifford and Whittredge, see Weiss 1977, pp. 352–53; pl. IX J 6; Edward H. Dwight, *Worthington Whittredge (1820–1910): A Retrospective Exhibition of an American Artist*, exh. cat. (Utica,

N.Y.: Munson-Williams-Proctor Institute, 1969), p. 40; Cheryl A. Cibulka, *Quiet Places: The American Landscapes of Worthington Whittredge*, exh. cat. (Washington, D.C.: Adams Davidson Galleries, 1982), p. 46.

104. "Art as Sentiment. Pictures in the Fifty-Sixth Annual Exhibition of the National Academy of Design," *New York Evening Post*, 9 April 1881, p. 1.

105. McEntee diary, entry for 7 April 1884.

106. Sheldon 1879, pp. 47–48.

107. "Talks with Artists. III.—William Hart on Painting Landscape and Cattle," *Art Amateur* 17 (July 1887), p. 35.

108. C. B., "American Art Association Exhibition," *Art Amateur* 16 (January 1887), p. 27.

109. Richards to George Whitney, 5 May 1879, quoted in Ferber 1980, p. 308. We are grateful to our colleague Carrie Rebora for bringing this quotation to our attention.

110. Before being elected an Associate of the Academy and, in turn, elevated to Academician, an artist had to exhibit at that year's spring annual. From 1843 to 1846, the number of new Academicians was limited to two a year; from 1846 to 1852, the total number of Academicians could not exceed thirty-five; from 1852 to 1865, fifty. After 1865, there was no restriction as to number. A prerequisite for election was the vote of two-thirds of the Academicians present at the annual meeting. Until 1869, membership excluded artists living outside New York; thereafter, a quorum was still defined by Academicians having studios in the city. Those regulations, while necessitated by the difficulties of 19th-century travel, nevertheless resulted in established New York artists maintaining full control of the Academy. Younger painters, many returning from study abroad, often lacked the acquaintance of Academicians and the means of attaining it; their election to membership was therefore difficult to achieve. Copies of the Academy constitution and amended versions documenting the changes are in the Academy Archives. We are grateful to Abigail Booth Gerdts, special assistant to the director of the Academy, for her assistance in confirming these historical data.

111. American artists frequently discussed among themselves the possibility of having higher tariffs imposed on imported art works. For a brief synopsis of taxes levied in the 19th century on "art used for luxury," see Huth 1946, p. 248, n. 47.

112. For a history of the rule, see Minutes, Council Meeting, National Academy of Design, 25 January 1875. Gifford formally protested the rule to the Academy Council in spring 1875, but to no avail; he then submitted his resignation, which was not accepted. The following week, he donated $500 to the Academy's mortgage fund, so obviously all was forgiven. See Minutes, Council Meeting, National Academy of Design, 8, 22 March; 19, 26 April 1875. The rule was later repealed; see Clark 1954, p. 98.

113. The problem of lackluster submissions to the annual exhibition was discussed frequently during the 1870s, both at Academy meetings and in the press.

114. Fink and Taylor 1975, pp. 73–75.

115. Minutes, Annual Meeting, National Academy of Design, 13 May 1874.

116. Helena De Kay, quoted in Fink and Taylor 1975, p. 76.

117. The Boston painter William Morris Hunt and his followers were represented, but in small numbers, and their works were generally disregarded in commentary on the exhibition. Not a single painting by Inness was exhibited. See E[arl] S[hinn], "The International Exhibition," *The Nation* 23 (28 September 1876), pp. 193–94; John F. Weir, "Group XXVII. Plastic and Graphic Art. Painting and Sculpture," *United States Centennial Commission, International Exhibition 1876*, 9 vols., Francis Walker, ed., *Reports and Awards*, vols. 3–8 (Washington, D.C.: Government Printing Office, 1880), 7, pp. 608–41; Matthews 1946; Bermingham 1975, p. 69, p. 108, n. 2; Susan Hobbs, *1876: American Art of the Centennial*, exh. cat. (Washington, D.C.: Smithsonian Institution Press, 1976).

118. McEntee diary, entry for 2 April 1877, quoted in Fink and Taylor 1975, pp. 77–78.

119. Minutes, Special Meeting of Academicians, National Academy of Design, 20 April 1877. Prior to the Members' annual meeting, the names of artists proposed for election as Associate or Academician, along with those of their sponsors, were for many years entered in a log still in the Academy Archives.

120. Jennifer A. Martin Bienenstock, "The Formation and Early Years of the Society of American Artists: 1877–1884," Ph.D. diss., The City University of New York, 1983, p. 30. Our discussion of the Society of American Artists is drawn largely from this excellent study.

121. Ibid., p. 44.

122. Ibid., p. 73, quoting [George Sheldon], "Secession in Art," *New York Evening Post*, 19 March 1878, p. 1.

123. Ibid., p. 74, quoting William Merritt Chase, as cited in Thurman Wilkins, *Thomas Moran: Artist of the Mountains* (Norman, Okla.: University of Oklahoma Press, 1966), p. 117.

124. S. G. W. Benjamin, "The Exhibitions: VII.—National Academy of Design. Fifty-Sixth Exhibition," *American Art Review* 2, pt. 2 (1881), p. 23.

125. Van Rensselaer 1886, Introduction, unpaged.

126. Quoted in Sheldon 1879, p. 125.

127. Clarence Cook, "The Artists' Fund Society, Twenty-fifth Annual Exhibition," *The Studio* n.s. 1 (17 January 1885), p. 139.

128. "Asher B. Durand," *Harper's Weekly* 30 (25 September 1886), p. 619.

THE PAINTINGS

LIST OF CONTRIBUTORS

K.J.A.
Kevin J. Avery
Research Associate, Department of American Paintings and Sculpture, The Metropolitan Museum of Art

B.B.B.
Barbara Ball Buff
M.A. candidate in the History of Art, Hunter College, New York

G.L.C.
Gerald L. Carr
Senior Postdoctoral Fellow, Office of Research, National Museum of American Art, Washington, D.C.

L.D.
Lauretta Dimmick
Assistant Curator, Department of American Decorative Arts and Sculpture, Museum of Fine Arts, Boston

L.S.F.
Linda S. Ferber
Chief Curator and Curator of American Paintings and Sculpture, The Brooklyn Museum

B.D.G.
Barbara Dayer Gallati
Assistant Curator, American Paintings and Sculpture, The Brooklyn Museum

M-A.H.
Merrill-Anne Halkerston
Research Assistant, Department of American Paintings and Sculpture, The Metropolitan Museum of Art

J.K.H.
John K. Howat
The Lawrence A. Fleischman Chairman of the Departments of American Art, The Metropolitan Museum of Art

K.E.M.
Katherine E. Manthorne
Assistant Professor, School of Art and Design, University of Illinois

G.O.
Gwendolyn Owens
Curator of Painting and Sculpture, Herbert F. Johnson Museum of Art, Cornell University

C.R.
Carrie Rebora
Chester Dale Fellow, The Metropolitan Museum of Art

O.R.R.
Oswaldo Rodriguez Roque
Associate Curator, Department of American Decorative Arts, The Metropolitan Museum of Art

D.S.
David Steinberg
Graduate student in the History of Art, University of Pennsylvania, Philadelphia

D.J.S.
Diana J. Strazdes
Assistant Curator, Carnegie Museum of Art

C.T.
Carol Troyen
Associate Curator, Department of American Paintings, Museum of Fine Arts, Boston

E.T.T.
Esther T. Thyssen
Ph.D. candidate in the History of Art, Yale University

ASHER B. DURAND
(1796–1886)

Asher Brown Durand was born in Jefferson Village (now Maplewood), New Jersey, the eighth of eleven children. His frail health exempted him from working on the family farm; instead, he helped his father, a watchmaker and silversmith. Following an apprenticeship to engraver Peter Maverick from 1812 to 1817, Durand entered into full partnership with Maverick and ran the New York branch of the Newark-based firm. The partnership dissolved in 1820 in a dispute concerning Durand's acceptance of John Trumbull's commission to engrave *The Declaration of Independence*, which Durand had apparently taken on without deferring to Maverick's position as senior partner. (Maverick, who interpreted the act as a violation of their partnership agreement, heatedly accused Durand of trying to sabotage his career.) The completion of the work in 1823 established Durand's reputation as one of the country's finest engravers. An active member of the New York art community, Durand was instrumental in organizing the New-York Drawing Association in 1825 (later the National Academy of Design, which he served as president from 1845 to 1861) and the Sketch Club in 1829 (later the Century Association). During the late 1820s and early 1830s, when his interest gradually shifted

from engraving to oil painting, he demonstrated a growing competence in portraiture and genre subjects. With the encouragement of his friend and patron Luman Reed, Durand ended his engraving career in 1835.

In 1837, a sketching expedition to Schroon Lake, in the Adirondacks, with his close friend Thomas Cole seems to have determined Durand's decision to concentrate on landscape painting. In 1840, with money advanced by Jonathan Sturges, Reed's son-in-law and business partner, Durand embarked on a two-year European Grand Tour, part of which was spent in the company of the artists John Casilear, John Kensett, and Thomas Rossiter. Durand's annual summer sketching trips in the Catskill, Adirondack, and White mountains yielded hundreds of drawings and oil sketches that he later incorporated into finished academy pieces. These are the embodiment of his Hudson River School style. With the death of Cole, in 1848, Durand was recognized as the leader of American landscape painting. He died on the family property in Maplewood, to which he had retired from active professional life in 1869.

Select Bibliography

A[sher] B. Durand. "Letters on Landscape Painting," In *The Crayon*, Letter I, 1 (3 January 1855), pp. 1–2; Letter II, 1 (17 January 1855), pp. 34–35; Letter III, 1 (31 January 1855), pp. 66–67; Letter IV, 1 (14 February 1855), pp. 97–98; Letter V, 1 (7 March 1855), pp. 145–46; Letter VI, 1 (4 April 1855), pp. 209–11; Letter VII, 1 (2 May 1855), pp. 273–75; Letter VIII, 1 (6 June 1855), pp. 354–55; Letter IX, 2 (11 July 1855), pp. 16–17.

Daniel Huntington. *Asher B. Durand: A Memorial Address*. New York: The Century, 1887.

John Durand. *The Life and Times of A. B. Durand*. New York: Charles Scribner's Sons, 1894.

David B. Lawall. *A. B. Durand: 1796–1886*. Exhibition catalogue. Montclair, N. J.: Montclair Art Museum, 1971.

——. *Asher Brown Durand: His Art and Art Theory in Relation to His Times*. New York and London: Garland Publishing, 1977.

——. *Asher B. Durand: A Documentary Catalogue of the Narrative and Landscape Paintings*. New York and London: Garland Publishing, 1978.

The Beeches, 1845

Oil on canvas, 60⅜ × 48⅛ in. (153.4 × 122.2 cm.)
Signed and dated at lower left: A. B. Durand/1845
The Metropolitan Museum of Art, New York City. Bequest of
 Maria DeWitt Jesup, from the collection of her husband,
 Morris K. Jesup, 1914 (15.30.59)

Durand painted *The Beeches* in 1845 for the New York collector A. M. Cozzens. When it was exhibited at the National Academy of Design the following year, it was warmly received by the press. John Durand, the artist's eldest son, writing in 1894 in *The Life and Times of A. B. Durand*, noted its lasting popularity and called it "novel and original in treatment."[1] The painting did indeed introduce new elements to Durand's oeuvre, the most important of which was the vertical orientation of the composition. Because of that shift in format, *The Beeches* may be looked on as a pivotal work in the development of Durand's mature landscape style. Though the painter himself was silent on the matter, by examining *The Beeches* in the context of his art to that date, the critical reaction to the painting, and what can be learned from his response to the work of other artists, it is possible to put forward a set of incentives and sources for its stylistic innovations.

It must be remembered that although Durand was well into his forties when he painted *The Beeches*, his apprenticeship as a landscape specialist had not yet ended. His early attempts at landscape were shaped by his admiration for the work of Thomas Cole and Claude Lorrain; the names of both artists appeared frequently in critical commentary on Durand's work. Durand's travels in Europe in 1840 and 1841 represent an important component in his self-education as a landscapist, for they afforded him his first opportunity to see genuine works of the masters "without suspicion of their originality."[2]

Durand, who had approached the paintings of Claude with great enthusiasm, came away disappointed. Remarks he made in a draft of a letter to Cole written in Florence indicate his confusion: "It may be hopeless to expect more perfect light and atmosphere than we find in the seaports and, occasionally, other scenes by Claude. Still, I have not felt in contemplating them that I was so completely in the presence of Nature. . . . So far as I have seen, he attempted nothing beyond a soft, unruffled day—no storm effect, not even a common shower. . . . I should suppose his pictures to be all compositions from nature, often beautiful and judiciously arranged, yet not remarkable for varied and picturesque scenery. . . . He seems to have no knowledge of English effects, not even of cloud shadows."[3]

That on his return to the United States Durand's style displayed little change is somewhat surprising. Between 1841 and 1844, he exhibited a number of European subjects and continued in a Claudean vein, focusing on quiet pastoral scenes populated by cattle. Although the critics universally acknowledged Durand's artistic talent, the consensus was that his work fell short of genius.

In 1843, one critic ended his comments on Durand by saying: "[The paintings] want the power which all works of men of talent always must want, to seize upon the mind and lead it away from the objects which surround the spectator, until he forgets himself, and sees in reality the objects of which the artist has furnished a likeness."[4]

Ironically, what the writer found lacking in Durand—an objective reality—is what Durand had looked to Claude for, without success. And so, by 1844, the critics found Durand's art pleasing, but unexciting. They constantly discovered Claudean influences in his paintings. What's more, they consistently placed his work second to that of his friend Cole, a state of affairs that must have disturbed him. With those factors in mind, it is possible to look to *The Beeches* as a radical attempt by Durand to modify his art.

The Beeches must be discussed in terms of Durand's European experience before its stylistic sources can be postulated. Durand's disappointment when he first encountered Claude's work was counterbalanced by the pleasure he derived from his introduction to the landscapes of the English painter John Constable. Durand, impressed by Constable's attention to nature, commented on one of his works: "I saw . . . one picture by Constable evincing more of simple truth and naturalness than any English landscape I have ever before met with."[5]

In London, Durand had visited the American expatriate artist and writer Charles Robert Leslie, through whom he had the opportunity to examine a selection of Constable's plein-air studies. Constable's reliance on the plein-air experience parallels Durand's own affinity for the practice. Yet Durand, who is credited with having been the first American artist to execute outdoor studies in oil—perhaps as early as 1832—had from the late 1830s to 1844 limited his studies to pencil. As Durand reevaluated his own art, he may have reconsidered that of Constable, in which he recognized the truthfulness to nature he sought to achieve in his own work. As David Lawall has suggested, the publication in 1843 of Leslie's *Memoirs of John Constable* may have inspired Durand to resume using oil in making his plein-air studies.[6] It is probably no coincidence that Durand's sketching excursions in 1844 marked his return to the oil medium for those purposes, resulting in *Landscape with Beech Tree* (New-York Historical Society), a detailed oil study featuring the majestic beech and linden trees that furnish the major motif on the left side of *The Beeches*.

Again, the most notable difference between Durand's other work to date and *The Beeches* is its use of the vertical format. By that relatively simple change, Durand rejected the emphatically Claudean horizontality that had dominated his previous compositions. Because in his own thinking Durand had already loosely established Claude and Constable as conceptual opposites, it is reasonable to look again to Constable for the direct inspiration for Durand's shift to the vertical—specifically, to Constable's painting *The Cornfield* (ill.). Surely Durand knew the work. In 1837, the year of Constable's death, it had been presented to the National Gallery in London. In view of the hours of study Durand spent at the gallery in 1840, he could not have been unaware of such an

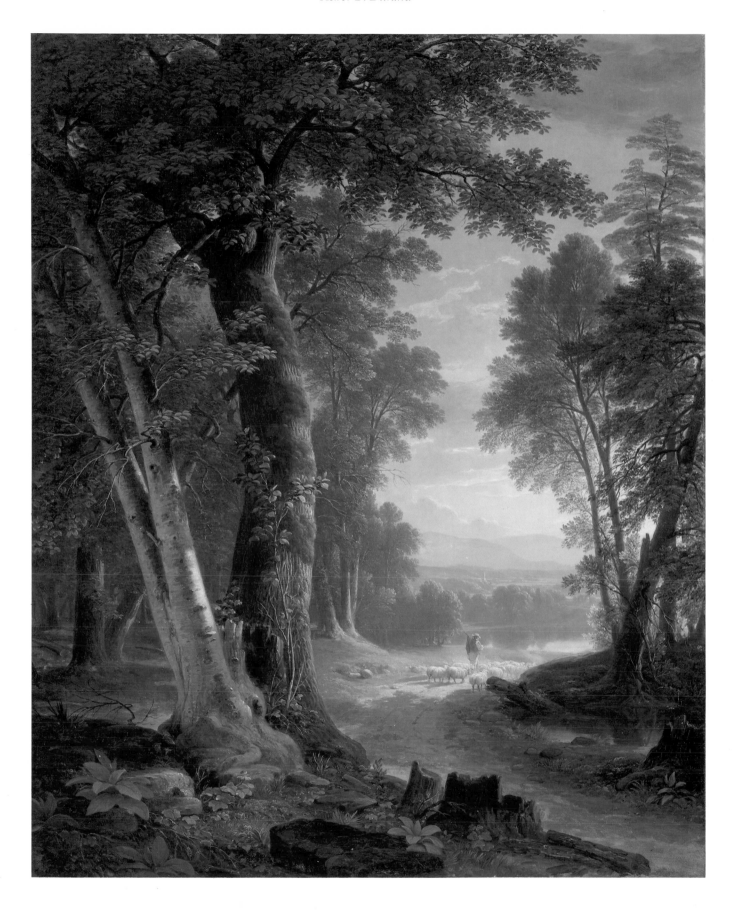

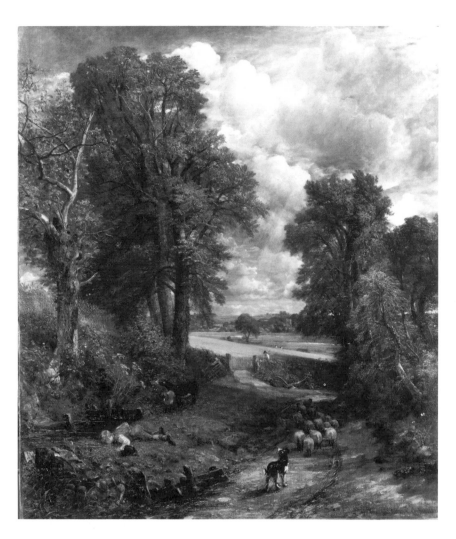

John Constable, *The Cornfield*, 1826, oil on canvas, 56¼ x 48 in. (142.8 x 121.9 cm.). Reproduced by courtesy of the Trustees, The National Gallery, London

which he represents the atmosphere of the American summer."[7] Nevertheless, the problem of "the natural landscape in art" persisted in Durand's thinking. As he wrote in the second of his "Letters on Landscape Painting," the memory of Constable lingered in his mind: "If it be true . . . that Constable was correct when he affirmed that there was yet room for a natural landscape painter, it is more especially true in reference to our own scenery; for although much has been done, and well done, by the gifted Cole and others, much more remains to do."[8]

B.D.G.

Notes

1. Durand 1894, p. 173, where the painting is referred to as *Passage Through the Woods.*
2. Ibid., p. 146.
3. Ibid., pp. 160–61.
4. Lawall 1978, p. 40, quoting *New World* 6 (19 June 1843), pp. 693–94.
5. Durand 1894, p. 151.
6. Lawall 1977, pp. 337–38.
7. Lawall 1978, p. 52, quoting *The Albion* n.s. 12 (19 March 1853), p. 141.
8. Durand 1855, II, p. 34.

important work by a recently deceased contemporary, especially one whose devotion to the natural landscape was so closely aligned with his own. Although markedly different in facture, *The Cornfield* and *The Beeches* share remarkably similar compositional elements in addition to their vertical formats: prominent trees on the left, a winding rural road leading from the foreground to a peaceful village indicated by a church in the distance, and sheep that make their way down the road.

The Beeches represents an important experiment by Durand. In it he combined the atmospheric qualities he admired in Claude's work with the specific attention to nature he had learned from Cole and found reinforced by his knowledge of Constable's art. Durand's efforts in *The Beeches* were rewarded not only by the favorable reception the painting met with in 1846, when it was first shown, but also again in 1853, when it reappeared in the Washington Exhibition in Aid of the New-York Gallery of the Fine Arts. A reviewer of that exhibition wrote, "Durand is immeasurably beyond every other painter in the fidelity and truthfulness with

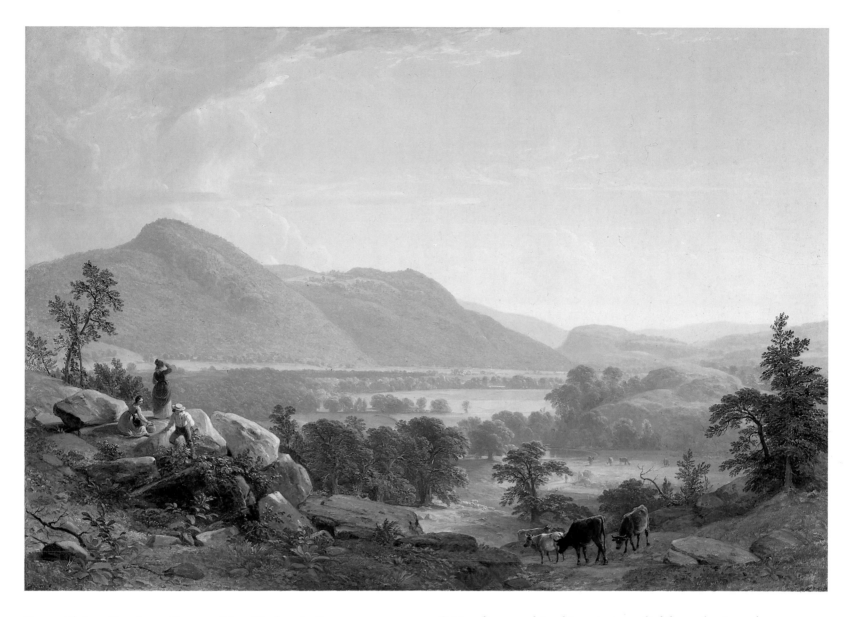

Dover Plains, Dutchess County, New York, 1848

Oil on canvas, 42½ × 60½ in. (107.9 × 153.7 cm.)
Signed and dated at lower left: A B Durand/1848
*National Museum of American Art, Smithsonian Institution. Museum
 purchase and gift of Thomas M. Evans*

Durand's approach to landscape composition, though dramatically effective in *The Beeches* (see p. 104), is of a subtler kind in *Dover Plains*. Here, Durand chose a deliberately undramatic, or, as contemporary critics would have put it, "unromantic," panoramic view of flatlands stretching to distant mountains. The space is moderated by the small tree on the left, which acts as a vestigial footnote to the Claudean formula; the rocky foreground forms a gentle curve that cradles the plain, whose intervals are measured by the stands of trees cutting across its broad expanse.

Critics discovered in this painting relief from the "merely elegant and beautiful" depictions of American scenery for which Durand had become known.[1] When the painting was exhibited at the National Academy of Design in 1848, it elicited such approbatory comments as: "It is full of truth as well as beauty, and so invested with the characteristics of the natural scenery of certain portions of our land, that almost every visitor who looks upon it could localize the scene."[2] The writer's linking of truth and beauty coincided with the concerns Durand himself had expressed for his art. For Durand, however, the issue of truth was a relative matter. A drawing in the collection of The New-York Historical Society records the topographical generalities of the same scene from a slightly different angle and a closer point of view.[3] An oil study of 1847 portrays the locale, again from a slightly different angle, and gives prominence to a large tree in the left foreground that was eliminated in the finished painting.[4] Durand's practice, which be-

gins with observation of selected elements of local reality, reaches completion with the careful manipulation of those elements to create a composed yet essentially true image.

Dover Plains was also exhibited in 1848 at the American Art-Union[5] and was engraved by James Smillie for that organization in 1850 as part of a set of five prints that included another landscape, Thomas Cole's *Dream of Arcadia* (1838; Denver Museum). The contrasts presented by the Durand and Cole prints are interesting to note. Whereas Cole's work, embodying the notion of landscape as a vehicle for social and literary metaphor, operates as an extension of the European landscape tradition, Durand's more or less pragmatic, seemingly unenhanced view of natural scenery stands as a statement of the emerging nativist attitude toward the American landscape.

B.D.G.

Notes

1. Lawall 1978, p. 72, quoting *Literary World* 3 (13 May 1848), p. 287.
2. Ibid., pp. 72–73. The painting was no. 95 in the exhibition.
3. Drawing inscribed "Dover Plains," ca. 1847–48, pencil on buff paper, ten by fourteen inches, Collection of The New-York Historical Society.
4. Oil study, *Dover Plains, N. Y.*, 1847, reproduced in Lawall 1978, fig. 231, cat. 388.
5. The painting was no. 46 in the exhibition.

Kindred Spirits, 1849

Oil on canvas, 46 × 36 in. (116.8 × 91.4 cm.)
Signed and dated at lower left: A. B. Durand/1849
Inscribed (on tree at left): BRYANT/COLE
The New York Public Library, New York City. Astor, Lenox and Tilden Foundations

This famous painting shows two of America's best-known cultural figures, nature poet William Cullen Bryant and nature painter Thomas Cole, engaged in conversation against a backdrop of Catskill Mountain scenery. Probably Durand's best-known work, it commemorates the death of Cole in February 1848 and was commissioned by Jonathan Sturges to present to Bryant in appreciation of the eulogy of Cole that Bryant had delivered at the National Academy of Design on 4 May 1848. Sturges, son-in-law and former partner of the late Luman Reed, who had provided Durand with the financial and moral support that enabled him to move from engraving to landscape painting, was himself a patron of Durand's and of Cole's too, and an associate of Bryant's in managing the American Art-Union. It was Sturges who, in a letter to Bryant announcing the gift of the painting, suggested its title: "I requested Mr. Durand to paint a picture in which he should associate our departed friend and yourself as kindred spirits."[1]

The work was first exhibited at the National Academy of Design's spring annual of 1849. Though a review of the exhibition in the *New York Evening Mirror* stated a preference for another of Durand's entries, it acknowledged that "*Kindred Spirits* from the associations which it calls up will no doubt be a great favorite."[2] The portraits of two men well known to the average viewer of the day are clearly recognizable, though their names are inscribed on the trunk of a tree at the left side of the canvas in order to allay any doubt as to their identity. Cole and Bryant shared a deep love of nature, which each in his own way extolled in poetry. Their friendship included Durand and extended to a lively correspondence, meetings at their clubs and at the Academy, and, most important in relation to this painting, frequent treks together in the wilds of the Catskill, Adirondack, and White mountains. (Bryant, who wrote frequently on art and reviewed the National Academy exhibitions as editor of the *New York Evening Post*, described in its pages those wilderness trips.) The three men worked closely together on projects such as *The Talisman*, a special Christmas gift book of fiction, poetry, and humor that Bryant published in 1827, and the *American Landscape* of 1830, which featured writings of Bryant's illustrated with Durand's engravings of his own paintings and those of Cole and other artists.

In *Kindred Spirits*, Durand, in keeping with his belief that only when an artist had immersed himself in nature until he was intimately acquainted with her infinite variety could he "approach her on more familiar terms, even venturing to choose and reject some portions of her unbounded wealth,"[3] composed a view that

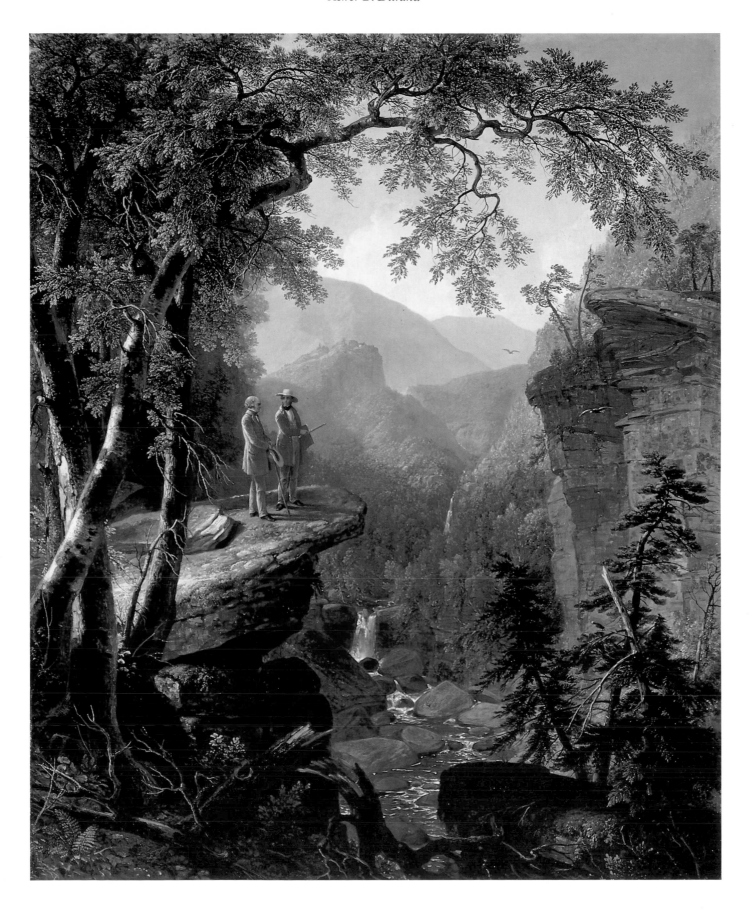

includes both the Clove of the Catskills and Kaaterskill Falls—a combination geographically impossible. He arranged other elements of the landscape—tree trunks, arching branches, cliffs, and broken stumps in the foreground—in such a way as to create a circular, decorative pattern, a major step in the artistic development of a painter who up to that time had preferred a horizontal, panoramic format. In style, however, the work is a highly realistic exemplification of Durand's directive on landscape painting, for it expresses with botanical truthfulness "the more simple and solid materials, such as rocks and tree trunks . . . earth banks and the coarser kinds of grass, with mingling roots and plants."[4]

Elements of the painting may be read in several ways. The blasted tree in the foreground, which Durand also used as part of the background of his 1838 portrait of Cole and which appears frequently in his landscapes and those of Cole (see p. 123), was to become a virtual hallmark of Hudson River painting. Here, it may have been intended as a reminder of Cole's repeated use of the same motif or, possibly, as a symbol for Cole himself, cut off at an early age. Bryant's inclined head may show merely that he is listening to Cole, who is apparently expounding on the panorama before them, or, because Bryant holds his hat in his hand, it may signify sorrow and respect on the death of his friend. The single eagle soaring off into the distance could be read as referring to Cole's spirit, now released from his body. Because several of the foreground elements—the stream falling through the rock bed, the figures posed on a rocky ledge, and the cliffs at the right side—are similar to those in Cole's *Expulsion from the Garden of Eden* (1827–28; Museum of Fine Arts, Boston), it has been proposed that Durand may have been attempting "to represent man in the process of returning . . . to an immortal life in a purely spiritual Paradise."[5] That postulation aside, it is evident that Durand's use of those devices can be construed as an artistic tribute to a dear friend and mentor.

Daniel Huntington, president of the National Academy of Design at the time of Durand's death, in 1886, called the painting "one of the best [Durand] works of that period."[6] Perhaps a more specific evaluation was one made by the only serious character in a satiric article written about the Academy exhibition: "It is worth going to see for DURAND's sake. . . . No one can look at his picture of Bryant and Cole in the Catskills, without rising at once, both in sense and association, into a higher range of feelings. Perhaps it may not be free from criticism, but it is a picture that illustrates [Durand's] power, not only of reproducing nature to the sight through the medium of art, but also of conveying to the sympathies the moral of its beauty and grandeur."[7]

In its embodiment of all the elements that typify the Hudson River School—fidelity in botanical representation; reverence of nature as a manifestation of God; the Catskills, particularly the Clove, as the actual birthplace of Hudson River painting; the association of the artist friends with the area and with each other;[8] and the average viewer's acquaintance with all these aspects and with the personalities depicted—*Kindred Spirits* can be regarded as a definitive essay on Hudson River painting.

After Bryant's death, the canvas passed to his daughter, Julia, who gave it to the New York Public Library in 1904. Over the years, this great classic of American landscape painting has traveled to many exhibitions here and abroad.

B.B.B.

Notes

1. Sturges to Bryant, quoted in *The Letters of William Cullen Bryant*, 3 vols.; reprint, ed. by William Cullen Bryant II and Thomas G. Voss (New York: Fordham University Press, 1977), 2, p. 542. The phrase "kindred spirits," from Keats's *Seventh Sonnet*, was undoubtedly familiar to all three men.
2. *New York Evening Mirror*, 28 April 1848, p. 2.
3. Durand 1855, I, p. 2.
4. Ibid., V, p. 145.
5. Lawall 1977, pp. 522–23.
6. Daniel Huntington, *Asher B. Durand: A Memorial Address* (New York: The Century, 1887), p. 33.
7. "The Colonel's Club," *The Literary World* 4 (21 April 1849), p. 358.
8. The ties and interrelationships among these artists are thoroughly discussed in James T. Callow, *Kindred Spirits: Knickerbocker Writers and American Artists, 1807–1855* (Chapel Hill: University of North Carolina Press, 1967).

Early Morning at Cold Spring, 1850

Oil on canvas, 60 × 48 in. (152.4 × 121.9 cm.)
Signed and dated at lower right: A. B. Durand/1850
Montclair Art Museum, Montclair, New Jersey. Lang Acquisition Fund
(45.8)

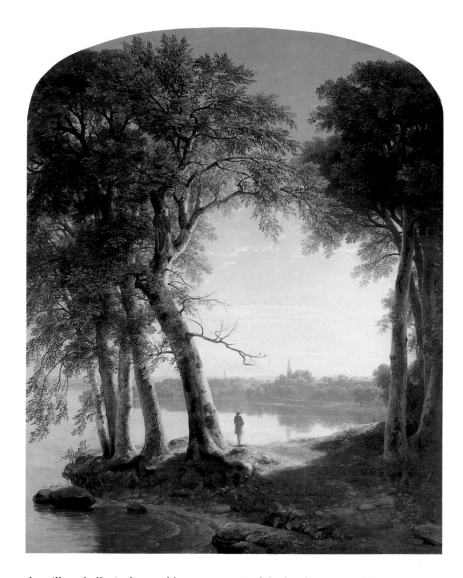

This view of Cold Spring, New York, was painted for Gouverneur Kemble, noted congressman, diplomat, and owner of a Cold Spring cannon foundry. During the nineteenth century, the work was often referred to as *Sabbath Bells*, a title originating in two lines from William Cullen Bryant's poem "A Scene on the Banks of the Hudson" that accompanied the listing for the painting when it was exhibited at the National Academy of Design in 1850: "O'er the clear still water swells/The music of the Sabbath bells."

In the painting, the solitary figure of a man is shown enclosed in the gentle embrace of nature, separated from his fellow citizens making their way to Sunday worship along a placid curve of the Hudson River. The contemplative mood that permeates the work is largely dependent on the presence of the isolated figure, through whom the artist conveys the importance of the natural environment as a valid means of communicating with the creative urge. Durand's belief in the efficacy of nature as an avenue of worship is confirmed in a shipboard letter he wrote on his transatlantic journey:

> To-day again is Sunday. I do not attend the church service, the better to indulge reflection unrestrained under the high canopy of heaven, amidst the expanse of waters. This mode of passing the Sabbath became habitual with me in early life—then 'midst other scenes than here, it is true; yet if more consonant with my feelings (as the world of woods, plains, and mountains ever is), certainly not less impressive. All the sounds of inanimate nature are of mournful solemnity—the rush of many waters as on the mighty ocean, the roar or whisper of the winds through the shadowy forest, the endless murmur of the waterfall, the patter of the summer shower, all tending to excite mournful meditation.[1]

Viewed in that context, the content of *Early Morning at Cold Spring* functions in much the same way as that of *Kindred Spirits* (see p. 108), painted the previous year. Although far less programmatic, owing to the differing nature of the two commissions, this painting documents Durand's position as an intimate of the natural world.

While the critics readily discerned the meditative mood of the painting, they either failed to perceive, or avoided discussion of, the philosophical implications of the interrelation of God, man, and nature contained in it. Only one critic is known to have noted the presence of the small but significant figure, and he remarked briefly only on its harmonious blending with its wooded surroundings.[2] For the most part, the painting was discussed in poetic terms that focused on the simple truths of the scene presented: "Here a glowing warmth, almost, and yet hardly sultry, is spread over the scene; and the hush of the Sabbath morning, broken only by the village bells, is denoted by every trait of the landscape, and the misty atmosphere which pervades it."[3]

B.D.G.

Notes
1. Durand 1894, pp. 145–46.
2. Lawall 1978, p. 80, quoting *The Albion* 9 (27 April 1850), p. 201.
3. Ibid., quoting *Literary World* 6 (27 April 1850), p. 424.

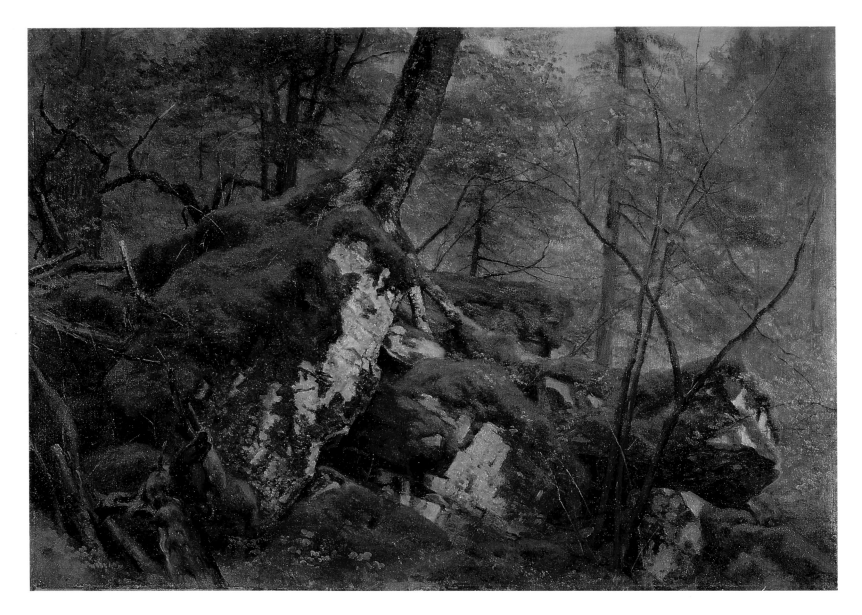

Interior of a Wood, ca. 1850
Oil on canvas, 17 × 24 in. (43.2 × 61 cm.)
Unsigned
Addison Gallery of American Art, Phillips Academy, Andover,
 Massachusetts (Gift of Mrs. Frederic Durand)

Oil studies such as *Interior of a Wood* were an integral part of
Durand's creative process. Although to the modern eye many of
the artist's studies possess a finished look that permits them to
stand as a complete work of art, Durand's aesthetic does not allow
that interpretation. His studies of selected segments of nature,
painted largely in plein-air during his summer sketching tours,
served as a repository of motifs that he incorporated into finished
paintings in his studio during the winter months.

The role these studies played in Durand's art is enunciated
in his "Letters on Landscape Painting," in which he asserted that
"all Art is unworthy and vicious which is at variance with Truth"[1]
and that the best method for achieving truth in art was first to
address nature directly, painting out-of-doors. He advised the
hypothetical young artist to whom his letters were directed to ap-
proach nature reverently, for its careful study would reveal the basic
laws of art. As Durand wrote: "Let [the artist] scrupulously accept
whatever [nature] presents him until he shall, in a degree, have
become intimate with her infinity . . . never let him profane her
sacredness by a wilful departure from truth."[2]

According to Durand, the artist who attained technical and
stylistic maturity was ultimately accorded the freedom to choose
or reject certain aspects of nature. It is clear that this freedom was
exercised by Durand in his finished paintings. The specificity exhib-
ited in the studies diminishes in the completed works, paralleling

the difference between imitation and representation as Durand distinguished them in his written theories. Unlike those of his contemporaries who had succumbed to the Ruskinian dictum demanding exact replication of all aspects of nature on a canvas, Durand acknowledged that to sustain an imitative technique throughout the whole process of creating a painting was impossible. Instead, as he wrote: "It should be [the artist's] endeavor to attain as minute portraiture as possible . . . for although it may be impossible to produce an absolute imitation of [rocks, tree trunks, grass, leaves], the determined effort to do so will lead you to a knowledge of their subtlest truths and characteristics, and thus knowing thoroughly that which you paint, you are able the more readily to give all the facts essential to their *representation*."[3]

<div style="text-align: right;">B.D.G.</div>

Notes
1. Durand 1855, I, p. 2.
2. Ibid.
3. Ibid., V, p. 145.

In the Woods, 1855

Oil on canvas, 60¾ × 48 in. (154.3 × 121.9 cm.)
Signed and dated at lower right: A. B. Durand/1855
The Metropolitan Museum of Art, New York City. Gift in memory of Jonathan Sturges by his children, 1895 (95.13.1)

By 1855, it appeared that Durand had achieved as much as any artist could hope to. The man was held in high esteem by his colleagues, as was his art; he never wanted for commissions; and his works continued to be displayed prominently at the National Academy of Design by virtue of both their popularity and their painter's status as president of that powerful body. Even so, the critics still maintained that Durand's art, while admirable in most respects, was also predictable.

When Durand exhibited *In the Woods* at the Academy in 1855, the critics discovered new importance in his work. Though he had continued as leader of the American landscape school since Cole's death, in 1848, the critics seldom failed to compare the art of the two men, placing that of Durand in a subordinate position. With this painting, however, Durand appears to have won the long struggle to escape the shadow of Cole. One writer called Cole a "sentimentalist," adding that he seemed "to have regarded the forms of Nature only as characters, by means of which he impresses on us his story," but proclaimed Durand's *In the Woods* as indicative of the "modern spirit, based on reality, and admitting no sentiment which is not entirely drawn from Nature."[1]

The "modern spirit" implicit in Durand's intensified portrayal of nature was, to be sure, an extension of his personal aesthetic as he outlined it in his nine "Letters on Landscape Painting" in *The Crayon*. It can nevertheless also be attributed in large part to the arrival in America of the aesthetic advanced by the English critic John Ruskin. Ruskin's call for "truth to nature" spread from England to the United States not only by way of the publication of his *Modern Painters* and *Elements of Drawing* but also (perhaps even more relevant where Durand was concerned) because of the pro-Ruskinian sentiments propounded by William James Stillman and John Durand in their roles as co-editors of *The Crayon*. It is likely not coincidental that the new direction in Durand's art revealed in *In the Woods* emerged as Ruskin's influence in America approached its zenith.[2] Other, younger artists were responding to Ruskin's theories at the same time. Stillman, in his *Saranac Lake, Adirondack Mountains* of 1854 (ill.), also exhibited at the National Academy of Design in 1855, is one example. Stillman's painting and *In the Woods* are similar in that both display close up views of tree trunks and intense accuracy in the depiction of the forest floor. Stillman, who had met Ruskin in 1849, obviously ascribed wholeheartedly to the Ruskinian notion of the unselective eye. In his painting, the eccentric cropping of the trees at close range violates the traditional rule of composition and invests the work with a sense of direct experience of nature. In contrast, Durand's picture

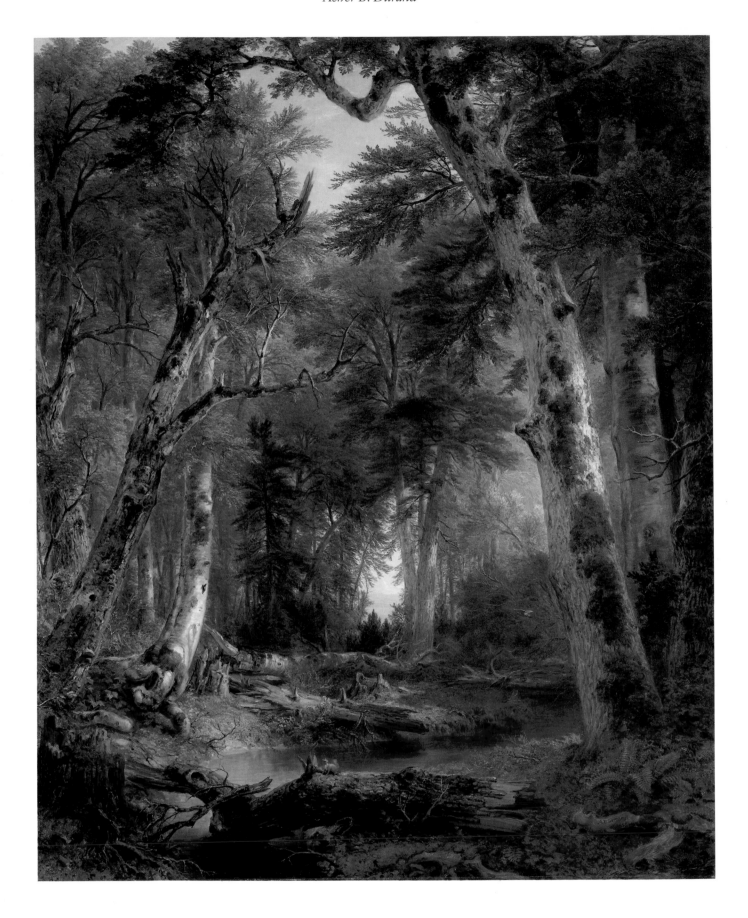

maintains a strong sense of premeditation in selecting a particular view that is ultimately "composed" in the studio rather than discovered in nature. Moreover, factual detail, although present in both, is rendered in the extreme by Stillman, while Durand's brushstroke remains comparatively loose.

The similarities and differences discovered in comparing Durand's and Stillman's paintings point up the factionalism that was developing among American landscapists and the issue of philosophy versus practice that was its nexus. Whereas Durand's philosophy of art often closely paralleled Ruskin's, his painting technique never revealed the obsession with detail demonstrated in the work of the American Pre-Raphaelite group (called The Association for the Advancement of Truth in Art), whose works were literal translations of Ruskin's words into paint. Although *In the Woods* predates the official formation of the American Pre-Raphaelite movement, critics and artists alike were becoming increasingly aware of Ruskin's influence on American art. In his comments on *In the Woods*, one reviewer of the 1855 Academy exhibition was likely referring to Stillman's *Saranac Lake*:

> There are some young painters, who have exhibited this year, who would do well to take lessons from the study of this picture. It should teach them that Mr. Durand, the acknowledged head of landscapists in New-York, does not despise manipulation and care, even to the minutest object; and still he is not a Pre-Raphaelite.[3]

In *In the Woods*, the vaulted space of the forest interior created by the majestic trees provides a veiled metaphor for Durand's religion of nature, the turning of the forest into a primeval cathedral. The architectonic character of the natural forms corresponds to a passage in one of Durand's "Letters on Landscape Painting:"

> The external appearance of this our dwelling-place, apart from its wondrous structure and functions that minister to our well-being, is fraught with lessons of high and holy meaning, only surpassed by the light of Revelation. It is impossible to contemplate . . . without arriving at the conviction . . . that the Great Designer of these glorious pictures has placed them before us as types of the Divine attributes.[4]

When the painting was first exhibited, it was owned by Jonathan Sturges, son-in-law and former partner of Durand's important patron Luman Reed. Sturges's pleasure in the work is confirmed in a letter he wrote on 23 May 1857 to the artist: "Enclosed please find check for Two hundred dollars which I desire to add to the price of the wood picture. The trees have grown more than two hundred dollars worth since 1855."[5] *In the Woods*, which was exhibited at the Paris Exposition Universelle in 1867, remained in the Sturges family until it was given to The Metropolitan Museum of Art in 1895.

B.D.G.

Notes
1. Lawall 1978, p. 108, quoting *Putnam's Monthly* 5 (May 1855), pp. 505–7.
2. An extensive study of the American Pre-Raphaelite movement is contained in Ferber and Gerdts 1985.

3. Lawall 1978, p. 110, quoting *Knickerbocker* 45 (May 1855), p. 532.
4. Durand 1855, II, p. 34.
5. Lawall 1978, p. 110, quoting letter from Sturges to Durand, 23 May 1857.

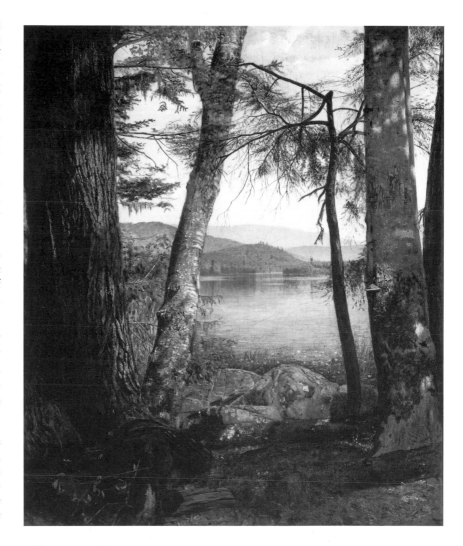

William James Stillman, *Saranac Lake, Adirondack Mountains*, 1854, oil on canvas, 30½ x 25½ in. (77.5 x 64.8 cm.). Courtesy, Museum of Fine Arts, Boston, Gift of Dr. J. Sydney Stillman (1978.842)

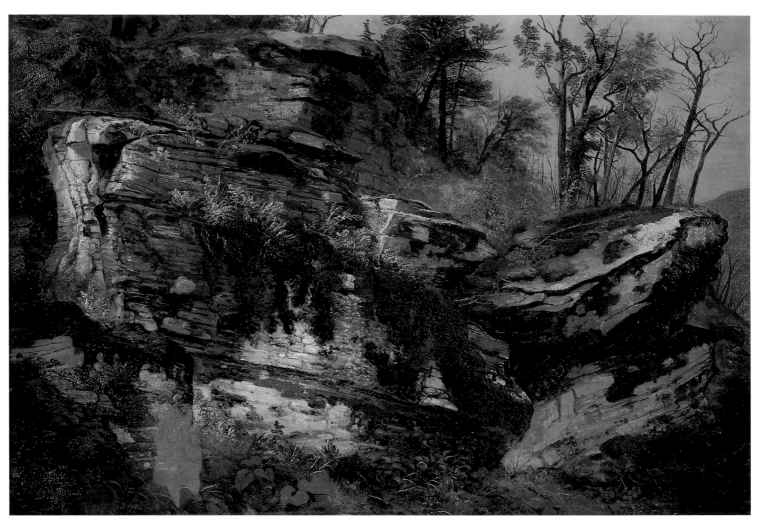

Rocky Cliff, ca. 1860

Oil on canvas, 16½ × 24 in. (41.9 × 61 cm.)
Signed at lower right: ABD
Reynolda House, Museum of American Art, Winston-Salem,
North Carolina

Durand's art and the ideas he conveyed in his "Letters on Landscape Painting" no doubt appealed to the growing confidence and independence American artists enjoyed in the decade prior to the outbreak of the Civil War. Durand, in both media, was ratifying the idea of a uniquely American art that would be achieved by minimizing the importance of the study of the old masters and by virtually ignoring formal academic training in the tradition of Sir Joshua Reynolds and Benjamin West. Durand explained the reasoning behind his recommendation of the American landscape as a primary subject:

> I desire not to limit the universality of the Art, or require that the artist shall sacrifice aught to patriotism; but, untrammelled as he is, and free from academic or other restraints by virtue of his posi-

tion, why should not the American landscape painter, in accordance with the principle of self-government, boldly originate a high and independent style, based on his native resources?[1]

Although his studies from nature were not treated as finished works, they were exhibited. Their accessibility to the public, in conjunction with Durand's public declaration of his aesthetic philosophy in *The Crayon,* provided a means for the aspiring artist to approach art through nature. As the development of his technique demonstrates, Durand's theories were formed well before John Ruskin's writings appeared in America. However, it may be speculated that in preparing his "Letters," Durand drew inspiration from the English critic both in organizing his ideas and in the manner in which he met the challenge of putting them into words. Given Durand's efforts toward developing a legitimate school of American subject matter and art theory, the publication of his "Letters" can be seen as a timely, albeit veiled, response to the Ruskinian presence in America.

B.D.G.

Notes
1. Durand 1855, II, p. 35.

Kaaterskill Clove, 1866

Oil on canvas, 38¼ × 60 in. (97.2 × 152.4 cm.)
Signed and dated at lower right: A. B. Durand/1866
The Century Association, New York City

Kaaterskill Clove so frequently served the painters of the Hudson River School as a subject that it must be considered as one of their icons. A great gorge in the heart of the Catskill Mountains, the Clove follows the course of Kaaterskill Creek from west to east, past the villages of Tannersville and Palenville.

In 1867, Henry Tuckerman wrote of Durand's *Kaaterskill Clove*: "That lofty and umbrageous gorge is clad in the verdure of its summer glory. The peculiar fidelity and sentiment of nature with which Durand always depicts trees, is eloquently manifest. The aerial perspective, the gradations of light, the tints of foliage, the slope of the mountains—in a word, the whole scenic expression is

harmonious, grand, tender, and true." Of the artist, no longer a young man, he reported: "We rejoice to find that Durand's powers of execution and tone of feeling are as vivid and pure as ever."[1]

For Durand and the other artists who chose the Clove as a subject, treks to the area offered a choice between the comforts of the elegant Catskill Mountain House, itself an attraction of international fame (see pp. 203; 226), or the vicissitudes of lesser accommodations. In either case, there were hazards. As Durand noted in October 1848 from the town of Palenville:

> The Clove is rich in beautiful wilderness beyond all we have met with heretofore. . . . With the exception of two days, the weather has been so cold that we have worked in overcoats and overshoes, and, in addition, have been obliged to have a constant fire alongside for an occasional warming, all of which I have endured pretty well, with no worse effect than a slight cold. . . . I caught a fine trout which I ate for breakfast—the only decent one I have had since I came here; sour bread, salt pork, and ham being the staple commodities.[2]

On the same trip, clearly not spent at the Mountain House, a

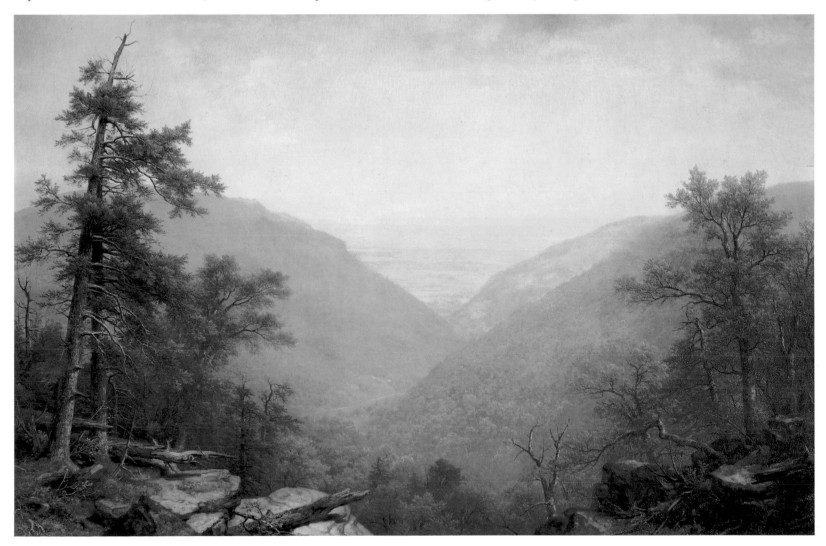

member of his family wrote: "Besides Casilear and Kensett, we have Mr. Volmering [Joseph Vollmering], the Dane, with us. . . . The bar-room does all it can to lighten our troubles. Wet floors are disagreeable and tobacco smoke in a close room unpleasant, but we all put on the best faces."[3]

It has been suggested that one of Durand's other canvases of the Clove (*Kaaterskill Clove*, ca. 1866; Yale University Art Gallery) was a study for this version.[4] The two works are closely related in vantage point and foreground details, but here, the distant view draws the eye past the double range of interfolding mountains in such a way that the trees in the right and left foreground are reduced in importance. The painting's greatest effect, however, derives from the breathtaking vista it depicts and the impression it conveys that the viewer is hovering on the very brink of the chasm.

This *Kaaterskill Clove* (Durand's final version) was executed when the artist was seventy years old and no longer artistically active. The picture is therefore all the more remarkable in that Durand was still interested enough in his work to break out of his regular patterns. Though his composition owes a large debt to *The Clove, Catskills* by Thomas Cole (see p. 123) and the vantage point is similar, Durand's canvas, painted forty years after Cole's, reveals the vision of a man still open to ideas that at the time were engaging the attention of younger artists, John Kensett and Frederic Church among them. Durand's treatment of the clear, calm sky and the hazy light that gives the foliage its shimmering quality are in direct contrast with the brooding quality of Cole's view. Further evidence of Durand's efforts to keep abreast of the times is visible in his punctuating his canvas with rugged fir trees, which replace the unobtrusive, pastoral elements of his usual landscapes, reflecting the influence of John Constable and Claude Lorrain.

Kaaterskill Clove, which Durand exhibited as for sale in 1866 at the National Academy of Design, was purchased for the Century Association, in whose collection it remains today. It was one of the paintings and portraits included in the memorial exhibition of Durand's work held at Ortgies's Art Gallery, New York, 13–14 April 1887.[5]

B.B.B.

Notes

1. Tuckerman 1867, p. 195.
2. Quoted in Lawall 1977, pp. 142, 188.
3. Quoted in Durand 1894, p. 186. Durand was president of the National Academy from 1845 to 1861; John W. Casilear, John F. Kensett, and Joseph Vollmering were all members.
4. Lawall 1978, p. 188.
5. *Executor's Sale . . . Studies in Oil by Asher B. Durand, N. A. . . .* See Richardson 1956, p. 170.

THOMAS COLE
(1801–1848)

Cole, born in Lancashire, England, was trained as an engraver of woodblocks used for printing calico. Because he did not have any formal education in art, his aesthetic ideas derived from poetry and literature, influences that were strongly to mark his paintings. The Cole family emigrated to America in 1818, but Thomas spent a year alone in Philadelphia before going on to Steubenville, Ohio, where his family had settled. He spent several years in Steubenville designing patterns and probably also engraving woodblocks for his father's wallpaper manufactory. He made his first attempts at landscape painting after learning the essentials of oil painting from a nebulous itinerant portraitist named Stein. In 1823, Cole followed his family to Pittsburgh and began to make detailed and systematic studies of that city's highly picturesque scenery, establishing a procedure of painstakingly detailed drawing that was to become the foundation of his landscape painting.

During another stay in Philadelphia, from 1823 to 1825, Cole determined to become a painter and closely studied the landscapes of Thomas Doughty and Thomas Birch exhibited at the Pennsylvania Academy. His technique improved greatly and his thinking on the special qualities of American scenery began to crystallize. Cole next moved to New York, where the series of works he produced following a sketching trip up the Hudson River in the summer of 1825 brought him to the attention of the city's most important artists and patrons. From then on, his future as a landscape painter was assured. By 1829, when he decided to go to Europe to study firsthand the great works of the past, he had become one of the founding members of the National Academy of Design and was generally recognized as America's leading landscape painter.

In Europe, Cole's visits to the great galleries of London and Paris and, more important, his stay in Italy from 1831 to 1832 filled his imagination with high-minded themes and ideas. A true Romantic spirit, he sought to express in his painting the elevated moral tone and concern with lofty themes previously the province of history painting. When he returned to America, he found an enlightened patron in the New York merchant Luman Reed, who commissioned from him *The Course of Empire* (1836), a five-canvas extravaganza depicting the progress of a society from the savage state to an apogee of luxury and, finally, to dissolution and extinction. Most New York patrons, however, preferred recognizable American views, which Cole, his technique further improved by his European experience, was able to paint with increased authority. Although he frequently complained that he would prefer not to have to paint those so-called realistic views, Cole's best efforts in the landscape genre reveal the same high-principled, intellectual content that informs his religious and allegorical works. A second trip to Europe, in 1841–42, resulted in even greater advances in the mastery of his art: his use of color showed greater virtuosity and his representation of atmosphere, especially the sky, became almost palpably luminous.

Cole's remarkable oeuvre, in addition to naturalistic American and European views, consisted of Gothic fantasies (*The Departure* and *The Return*, 1837), religious allegories (*The Voyage of Life*, 1840), and classicized pastorals (*The Dream of Arcadia*, 1838). He consistently recorded his thoughts in a formidable body of writing: detailed journals, many poems, and an influential essay on American scenery. Further, he encouraged and fostered the careers of Asher B. Durand and Frederic E. Church, two artists who would most ably continue the painting tradition he had established. Though Cole's unexpected death after a short illness sent a shock through the New York art world, the many achievements that were his legacy provided a firm ground for the continued growth of the school of American landscape.

Select Bibliography

Cole Papers. New York State Library, Albany, N.Y.

Louis L. Noble. *The Course of Empire, Voyage of Life, and Other Pictures of Thomas Cole, N. A. . . .* New York: Cornish, Lamport & Co., 1853.

Howard S. Merritt. *Thomas Cole.* Exhibition catalogue. Rochester, N.Y.: Memorial Art Gallery of the University of Rochester, 1969.

Matthew Baigell. *Thomas Cole.* New York: Watson-Guptill, 1981.

Falls of Kaaterskill, 1826

Oil on canvas, 43 × 36 in. (109.2 × 91.4 cm.)
Signed at lower middle (on rock): T. Cole
Signed, dated, and inscribed on back: Tho Cole/1826/Falls/of/Kaaterskill
The Warner Collection of Gulf States Paper Corporation, Tuscaloosa,
Alabama

In the fall of 1825, three of Cole's paintings were happened on in a Manhattan shop by a group of New York's leading artistic lights: Colonel John Trumbull, president of the American Academy of Fine Arts; William Dunlap, portraitist, playwright, and the first chronicler of American art; and Asher B. Durand, distinguished young engraver and soon-to-be landscape painter. Cole's works— the result of a sketching trip on the banks of the Hudson River financed by G. W. Bruen, one of the artist's first patrons—were destined to revolutionize American landscape painting. According

Figure 2. Thomas Cole, *Double Waterfall—Kaaterskill Falls*, 1826, pencil, charcoal, black-and-white crayon on paper, 16½ x 14⅝ in. (41.9 x 37.2 cm.). The Detroit Institute of Arts, Founders Society Purchase, William H. Murphy Fund (39.503)

Figure 1. Thomas Cole, *Kaaterskill Falls*, ca. 1825–26, pencil on paper, 14 x 10⅜ in. (35.6 x 26.4 cm.). The Detroit Institute of Arts, Founders Society Purchase, William H. Murphy Fund (39.206.A)

to Dunlap, Trumbull, a landscape painter of some accomplishment though primarily a history painter, had remarked to him at the time: "This youth has done what I have all my life attempted in vain."[1] The words of William Cullen Bryant, a friend of Cole's, echo Trumbull's feeling and aptly summarize the general reaction of New York's artistic community: "Here, we said, is a young man who does not paint nature at second hand, or with any apparent remembrance of the copies of her made by others. Here is the physiognomy of our own woods and fields; here are the things of our own atmosphere; here is American nature and the feeling it awakens."[2]

Encouraged by this first recognition and knowing he had only just begun to exploit the pictorial possibilities of the Hudson River and its adjacent areas, Cole made another trip to the Catskill Mountains in the summer of 1826. On 6 July, he wrote to Daniel Wadsworth, one of his first admirers in New England and a relative of Trumbull's by marriage: "I am now in the Village of Catskill with the intention of spending the Summer here. Retired from the noise and bustle of N[ew] York and surrounded by the beauties of Nature I shall have every opportunity of improvement I can wish."[3] About three weeks later, he wrote to his patron Robert Gilmor, a Baltimore collector of art: "I have wandered much in the Catskills this summer and have made many sketches."[4] One of those

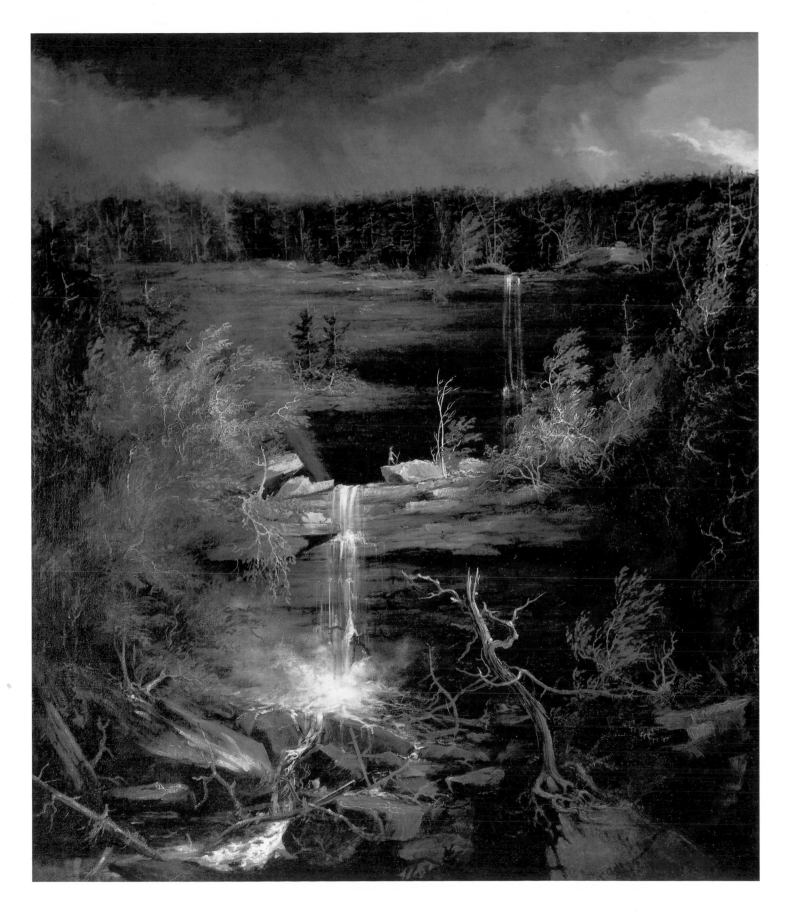

sketches, titled *Kaaterskill Falls* (Fig. 1) and probably done on the spot, doubtless furnished the original inspiration for *Falls of Kaaterskill*. A chiaroscuro drawing executed in charcoal and chalk and identified by Cole as "Double Waterfall—Kaaterskill" (Fig. 2) was likely a compositional study made in the studio. Cole did not pinpoint the exact location of either drawing, but the theory that it is Kaaterskill Falls has long been accepted.[5]

While Cole's view in the painting is generally faithful to what he would have observed at the time, he has highly arranged, or "composed," the scene, especially in the foreground. He defended this right to exercise his imagination in his compositions in a letter to Gilmor of 25 December 1826:

> [A] departure from Nature is not a necessary consequence in the painting of compositions: on the contrary, the most lovely and perfect parts of Nature may be brought together, and combined in a whole that shall surpass in beauty and effect any picture painted from a single view. I believe with you that it is of the greatest importance for a painter always to have his mind upon Nature, as the star by which he is to steer to excellence in his art. He who would paint compositions, and not be false, must sit down amidst his sketches, make selections, and combine them, and so have nature for every object that he paints.[6]

In his reply, Gilmor acknowledged the validity of the greater part of Cole's argument and mentioned an observation made by the English writer William Gilpin that is of particular relevance to *Falls of Kaaterskill*: "He [Gilpin] inculcates fidelity in the view, but very properly leaves the foreground at the disposal of the artist, who he says 'by walking a few yards to the right or to the left can vary it at his pleasure,' and in a foreground an artist may exert his talent at composition, provided he will faithfully take his *materials* from nature."[7]

A passage in another of Gilmor's letters, attesting to the persuasive powers of that knowledgeable collector, may also account for the inclusion of an Indian at the geometric center of the painting: "I differ however with you in approving the omission of figures, which always give character & spirit even to solitariness itself, but it depends upon their propriety—an Indian Hunter judiciously introduced . . . with his rifle levelled & one or two deer crossing an open space, would not defeat your object, but rather assist the idea of solitude."[8]

Thus *Falls of Kaaterskill* not only represents a highly successful attempt to portray the wild and solitary aspects of American scenery, albeit now in a more technically accomplished fashion than is visible in Cole's paintings of the previous two years, but also embodies many of the aesthetic issues pondered by the artist in his ongoing effort to define his style. It incorporates his preferences for the colors of autumn, the inclusion of water, twisted and blasted tree trunks, and dramatic atmospheric effects—preferences that characterize the majority of his early paintings. Yet it is relatively free of the visual agitation that led Gilmor to claim that Cole's style was that of Salvator Rosa,[9] renowned seventeenth-century Italian master of what generally accepted eighteenth-century aesthetic theory defined as the Sublime. Rather, the pronounced hori-

zontality of the areas that define the foreground, the middle ground, and the distance, as well as the extremely high placement of the horizon line itself, is evidence of Cole's unusually fresh and inspired grasp of the essential qualities of each natural scene he interpreted.

O.R.R.

Notes

1. William Dunlap, *A History of the Rise and Progress of the Arts of Design in the United States*, 2 vols. (New York, 1834), 2, p. 360.
2. William Cullen Bryant, "Address Before the National Academy of Design," reprinted in Parke Godwin, *Prose Writings of William Cullen Bryant*, 2 vols. (New York, 1884), 1, p. 333.
3. Cole to Wadsworth, 6 July 1826, reprinted in McNulty 1983, p. 1.
4. Cole to Gilmor, 28 July 1826, reprinted in *Annual II: Studies on Thomas Cole: An American Romanticist* (Baltimore Museum of Art, 1967), p. 43.
5. But see Baigell 1981, p. 32, where the site represented is said to be Haines Falls, about five miles removed from Kaaterskill Falls. Baigell accounts for the confusion in nomenclature by suggesting that the plummeting stream now known as the West Branch of the Kaaterskill was probably referred to in Cole's time simply as "the Kaaterskill."
6. Cole to Gilmor, 25 December 1826, *Annual II*, p. 47.
7. Gilmor to Cole, 27 December 1826, *Annual II*, p. 48.
8. Gilmor to Cole, 13 December 1826, *Annual II*, p. 44.
9. Gilmor to Cole, 13 December 1827, *Annual II*, p. 55.

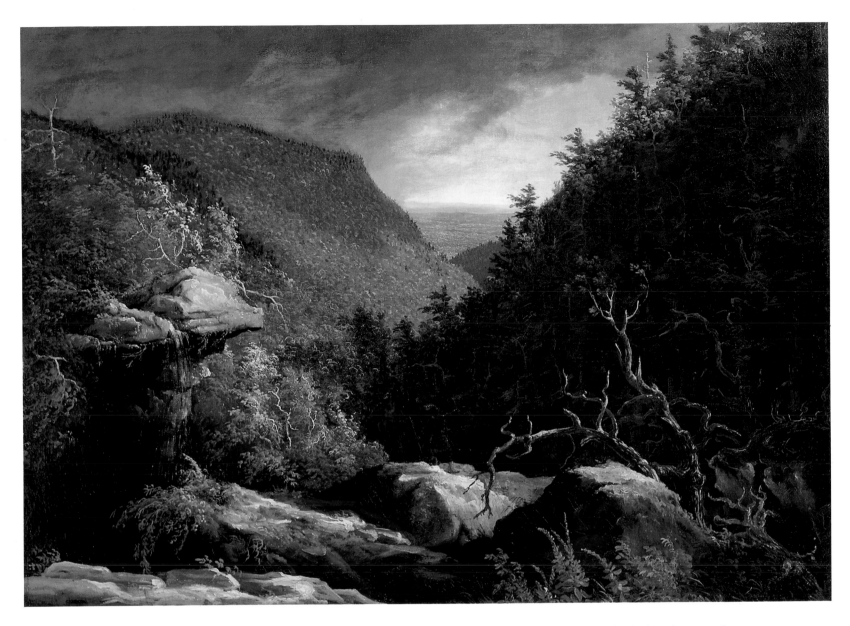

The Clove, Catskills, ca. 1827
Oil on canvas, 25 × 36 in. (63.5 × 91.4 cm.)
Unsigned
The New Britain Museum of American Art, New Britain, Connecticut.
Charles F. Smith Fund

The Clove, Catskills is probably the masterpiece of Cole's early career. In a bold composition dominated by diagonals articulated by sharp contrasts of dark and light, Cole has given expression to many of the emotions he experienced in the American wilderness. The view is toward the east, with the Berkshire Mountains visible in the distance.[1] The passing storm clouds, the blasted tree trunks, the autumnal colors of the forest, and the lone figure of an Indian speak of solitude, fear, violence, and death, but the emerging sunlight, the deep vista, and the cascading freshet speak of regeneration and infinity. In his many rambles in the Catskill Mountains in 1825 and 1826, as well as during his tour of Lake George in 1826 and of the White Mountains a year later, Cole had felt directly the emotional effect of those various and variable aspects of the wild. As was his habit, he voiced his reactions in his poems, letters, and diary entries. Though no specific passage in the painter's writings describes the scene depicted in this painting, a number of accounts register his thoughts as he explored similar Catskill locales. In the autumn of 1825, of a trip to Windham, New York, a town in the Catskill area, he wrote:

> At an hour and a half before sunset, I had a steep and lofty mountain before me, heavily wooded, and infested with wolves and bears, and, as I had been informed, no house for six miles. . . . After

climbing some three miles of steep and broken road, I found myself near the summit of the mountain, with (thanks to some fire of past times) a wide prospect. Above me jutted out some bare rocks; to these I clambered up, and sat upon my mountain throne, the monarch of the scene.[2]

About the same time, Cole gave a dramatic account of being caught in a threatening storm in the Catskills, from which he took refuge under an overhanging rock:

> I felt as feeble as a child. Every moment my situation was becoming more comfortless, as well as romantic. A torrent, to all appearance parted by the projecting crag which formed the roof of my shelter, came rushing down on both sides of me, and met again a short distance below me. . . . The wind now drove the chilly vapour through my portal, the big drops gathered on my stony ceiling, and pattered on my hat and raiment, and, to complete my calamity, the water began to flow in little brooks across my floor. . . . I had one remaining hope, the sudden cessation of the storm. I knew the sun was hardly yet setting, although the darkness had deepened fearfully within the last few moments. But this turned out, to my great joy, to be the crisis of the tempest. All at once, a blast, with the voice and temper of a hurricane, swept up through the gulf, and lifted with magical swiftness the whole mass of clouds high into the air. This was the signal for general dispersion. A flood of light burst in from the west, and jewelled the whole broad bosom of the mountain.[3]

Both recollections communicate (as does *The Clove, Catskills*) the sense of threatening and dangerous conditions having been overcome. The reward for the painter, as well as for the viewer, is a glimpse of the Sublime, an exalted feeling of nature in its infinity. Cole, who frequently found himself elevated to that intensity of feeling during his rambles in the Catskills, gave voice to it in a poem titled *The Wild*:

> Friends of my heart, lovers of nature's works,
> Let me transport you to those wild, blue mountains
> That rear their summits near the Hudson's waves.
> Though not the loftiest that begirt the land,
> They yet sublimely rise, and on their heights
> Your souls may have a sweet foretaste of heaven,
> And traverse wide the boundless. . . .[4]

The intensity of his sentiments led Cole to transform the pictorial principles enunciated by such English theorists of the aesthetic of the Picturesque as William Gilpin and Uvedale Price—who advocated roughness, variety, contrast, and the composed view—into a personal style directly subservient to Romantic spirituality. It is in this manner that *The Clove, Catskills*, together with a few other early landscapes by Cole, including *Sunny Morning on the Hudson River* (1827; Museum of Fine Arts, Boston) and *Falls of Kaaterskill* (see p. 120), lays the groundwork for his major later accomplishments, among them *Schroon Mountain, Adirondacks* and *Genesee Scenery* (see pp. 134; 138). His attitude toward landscape painting set Cole apart from his contemporaries and prompted the Reverend Louis LeGrand Noble, his biographer, to note of him, " . . . he was always the poet, when he was the painter—which, of course, is to say almost more than can be said of any landscape painter that has appeared."[5]

The Clove, Catskills is in all likelihood the work exhibited in 1827 at the National Academy of Design under the title *Landscape, The Clove, Catskill*. Despite its extraordinary quality, it does not appear to have been originally owned by any of the well-known New York collectors.

O.R.R.

Notes
1. Baigell 1981, p. 34.
2. Quoted in Noble 1853, p. 66.
3. Ibid., p. 70.
4. Ibid., pp. 63–64.
5. Ibid., p. 80.

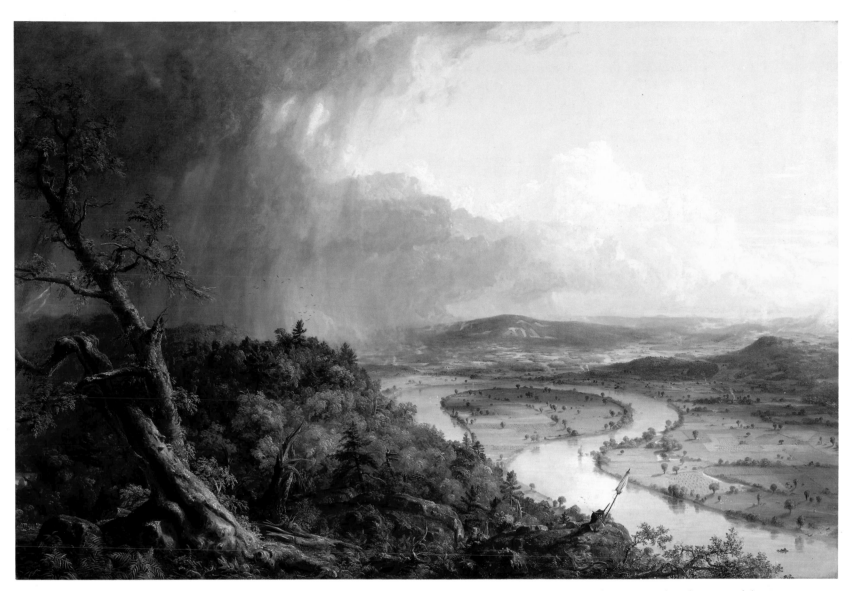

View from Mount Holyoke, Northampton, Massachusetts, after a Thunderstorm (The Oxbow), 1836

Oil on canvas, 51½ × 76 in. (130.8 × 193 cm.)
Signed and dated at lower right (on portfolio): T Cole/1836
*The Metropolitan Museum of Art, New York City. Gift of
 Mrs. Russell Sage, 1908 (08.228)*

This view of the oxbow formed by the Connecticut River just south of Northampton, Massachusetts, has long been regarded as one of Cole's finest achievements and one of the earliest statements of an identifiably American landscape painting tradition. Pictorial formulas that would become commonplace in later Hudson River School paintings—a broad panoramic vista encompassing varied and contrasting scenery, faithfully rendered details, and light-filled atmosphere—make their appearance here in a strikingly successful, if not yet fully masterly, way.[1] It might be supposed that a work subsequently accorded the highest possible accolades would have elicited greater appreciation in its own time, yet that was not the case. After exhibition at the National Academy of Design in 1836, *The Oxbow* quietly entered the collection of Charles N. Talbot, who purchased it for five hundred dollars, then a respectable though not an immoderate sum. Save for being included in the exhibition held for the benefit of portraitist-playwright-historian William Dunlap at the Stuyvesant Institute in 1838 and in the Cole Memorial Exhibition at the American Art-Union ten years later, the work was not much noticed in New York's art circles. Nor do the artist's own comments imply that he thought highly of it himself. In a letter of 2 March 1836 to his patron Luman Reed, who had joined with Asher B. Durand in suggesting a temporary cessation of work on the exhaustive five-painting series *The Course of Empire* (Figs. 2.6–10, pp. 28–29), Cole replied:

I should take advantage of your kind advice (and Mr. Durand's) and paint a picture expressly for the exhibition and for sale. The only thing that I doubt in the matter is that I may be able to sell the picture.—I think I never sold but two pictures in Exhibition in my life.—It is running a risk of which I should think nothing if my circumstances did not require that everything I do now should be productive.—but you encourage me and I will do my best——I have revolved in my mind what subject to take & have found it difficult to select such as will be speedy of execution & popular—Fancy pictures seldom sell & they generally take more time than views so I have determined to paint one of the latter. I have already commenced a view from Mt. Holyoke—it is about the finest scene I have in my sketchbook & is well known—it will be novel and I think effective—I could not find a subject very similar to your second picture & time would not allow me to invent one. You will perhaps

think I have acted injudiciously in painting the scene as large as the largest picture of the series on account of selling—but I had not altogether my choice for the only canvass I had was the one on which I made the first sketch of your large picture—To get another smaller frame made & to cut the canvass and stretch it would have taken some of the time of which I have none too much before Exhibition. This reason decided me on the size but inclination if not judgment urged me to paint the larger, for having but one picture in the exhibition, & that painted expressly for it & understanding there will be some dashing landscapes there, I thought I should do something that would tell a tale. The execution will scarcely take more time than in the smaller and as I shall run some risk it shall be to some purpose—but you must not be surprised if you find the picture hanging in my room next year.[2]

That confession of potboiling is nevertheless contradicted by other evidence. Cole had probably been thinking about a painting of the famous Connecticut River oxbow since his first trip to Europe, from 1829 to 1832. A drawing of his titled *Mount Holyoke Mass.* (Fig. 1) is a direct tracing of a plate in Captain Basil Hall's *Forty Etchings Made with the Camera Lucida in North America in 1827 and 1828* (Fig. 2), and must have been made shortly after the much-discussed volume was published in London in 1829. Undoubtedly, the painter was struck by the pictorial possibilities of the plate and had not forgotten the context of adverse criticism of all things American in which it appeared. Captain Hall liked what he saw from the top of Mount Holyoke, but he was blisteringly disapproving of this country, its manners, its people, and its scenery, and he cast particular doubt on the ability of Americans to appreciate the beauties of their land, if indeed there were any to be found.[3]

The Detroit tracing was made in circumstances that are of enormous importance in understanding *The Oxbow*, but it was not the "sketchbook scene" Cole referred to in his letter to Reed. In the summer of 1833, during a trip to Boston to draw a view of the city for an unrelated commission, Cole went to the top of Mount Holyoke and made a detailed sketch (Fig. 3) of what he saw.[4] It was that drawing, with its thorough notations and strong topographical flavor, that served as the basis for the painting. (Cole, despite his having already determined the key aspects of the composition, also experimented with the coloring and massing of the work in a somewhat freely painted oil sketch [Fig. 4], as was his habit.)

When the pencil drawing is compared with the finished oil, the great transformation that took place in Cole's studio is easily perceived. The scene became more panoramic, spatial depth was greatly increased, the mountains were made bolder, and, most important, a sharp opposition in the left and right halves of the canvas was contrived. The changes, while all in keeping with the artist's developing thoughts regarding the special qualities of the native landscape as he had articulated them, principally in his "Essay on American Scenery" of 1835,[5] must also be viewed in the context of a response to the denigrating attitude of Captain Hall and other detractors of America. According to Cole, the singularity of the

Figure 1. Thomas Cole, *Mount Holyoke Mass.*, ca. 1829, pencil on tracing paper, 4½ x 8⅜ in. (11.4 x 21.3 cm.). The Detroit Institute of Arts, Founders Society Purchase, William H. Murphy Fund (39.70)

Figure 2. Basil Hall, "View from Mount Holyoke in Massachusetts," etching, 4½ x 8⅜ in. (11.4 x 21.3 cm.), from *Forty Etchings Made with the Camera Lucida in North America . . .* , London, 1829, pl. XI. The Beinecke Rare Book and Manuscript Library, Yale University

Figure 3. Thomas Cole, Sketch for *The Oxbow*, ca. 1833, pencil on paper, 8⅞ x 13¾ in. (22.5 x 34.9 cm.), from sketchbook no. 8, p. 67. The Detroit Institute of Arts, Founders Society Purchase, William H. Murphy Fund (39.566)

Figure 4. Thomas Cole, Sketch for *View from Mount Holyoke, Northampton, Massachusetts, after a Thunderstorm (The Oxbow)*, oil on composition board, 5⅞ x 9⅝ in. (14.9 x 24.5 cm.). Private collection

American landscape resided in its ability to vary and to combine the established typology of late-eighteenth-century aesthetic theory, that is, that Niagara possessed "both the sublime and the beautiful in an indissoluble chain," American skies displayed "the blue, unsearchable depths of the northern sky, the upheaped thunderclouds of the Torrid Zone, the silver haze of England, the golden atmosphere of Italy," the wilderness existed side by side with fledgling Arcadian settlements, and the "wild Salvator Rosa" took his place alongside "the aerial Claude Lorrain."[6]

In a sense, then, Cole forced the material he had at hand—his detailed sketch—to respond to an intellectual program. His finished painting remains generally faithful to observed fact, but it also gives clear expression to his thoughts, chief among which (again, as articulated in the "Essay") was the notion that views of the American landscape evoked associations not of the past, as was the case with European scenery, but of the future:

Seated on a pleasant knoll, look down into the bosom of that secluded valley, begirt with wooded hills through enamelled meadows and wide waving fields of grain; a silver stream winds lingeringly along—here seeking the green shade of trees—there glancing in the sunshine; on its banks are rural dwellings shaded by elms and garlanded by flowers—from yonder dark mass of foliage the village spire beams like a star. You see no ruined tower to tell of outrage—no gorgeous temple to speak of ostentation; but freedom's offspring—peace, security and happiness dwell there, the spirits of the scene. . . . And in looking over the yet uncultivated scene, the mind's eye may see far into futurity—mighty deeds shall be done in the now pathless wilderness; and poets yet unborn shall sanctify the soil.[7]

As an expression of those images and ideas, *The Oxbow* can be regarded as the most meaningfully devised American landscape work up to that time. In it, Cole's inclusion of himself as the painter further reinforces the link between art and idea, since it casts the artist as mediator between nature and spectator.[8] Possibly as a reminder of an implied covenant between America and God and possibly because he was bothered by what he knew were the shortcomings of American society, Cole delineated in the cleared areas of the mountain in the center characters that can be interpreted as Hebrew letters approximating the spelling of the word "Noah" or, if viewed upside down, "Shaddai"—the Almighty. If that iconographic device was indeed intended, it can be concluded that *The Oxbow* "was a desperate plea for a return to a simpler and more moral life," an anti-industrial attitude with which Cole is known to have sympathized fully.[9]

After entering the Metropolitan Museum's collection in 1908 as the gift of Mrs. Russell Sage, who had purchased it from the estate of Charles N. Talbot, *The Oxbow* became one of the established icons of American art. It has been reproduced in virtually every textbook on American painting and has been exhibited numerous times.

O.R.R.

Notes

1. See comparable comments in Novak 1969, pp. 75–77.
2. Cole to Reed, 2 March 1836, Cole Papers.
3. Hall's more offensive comments are to be found in his *Travels in North America*, 2 vols. (London, 1829). *Forty Etchings* was a companion volume of illustrations.
4. The sketch appears in Cole sketchbook 8, Archives, Detroit Institute of Arts. Its position in the book indicates that it was executed on the way to Boston, not on the return trip.
5. Cole delivered his "Essay" before the New-York Lyceum in May 1865. It was published in pamphlet form, then in *The American Monthly* the following January, and is now readily available in McCoubrey 1965, pp. 98–110.
6. McCoubrey 1965, p. 108.
7. Ibid.
8. Besides the figure's striking resemblance to Cole, the inscription "T. Cole" on the painter's portfolio, near the umbrella, further identifies him. This postulation was published in greater detail in Oswaldo Rodriguez Roque, "*The Oxbow* by Thomas Cole: Iconography of an American Landscape Painting," *Metropolitan Museum Journal* 17 (1984), pp. 63–73.
9. A suggestion made in Matthew Baigell and Allen Kaufman, "Thomas Cole's 'The Oxbow': A Critique of American Civilization," *Arts* 55 (January 1981), pp. 136–39.

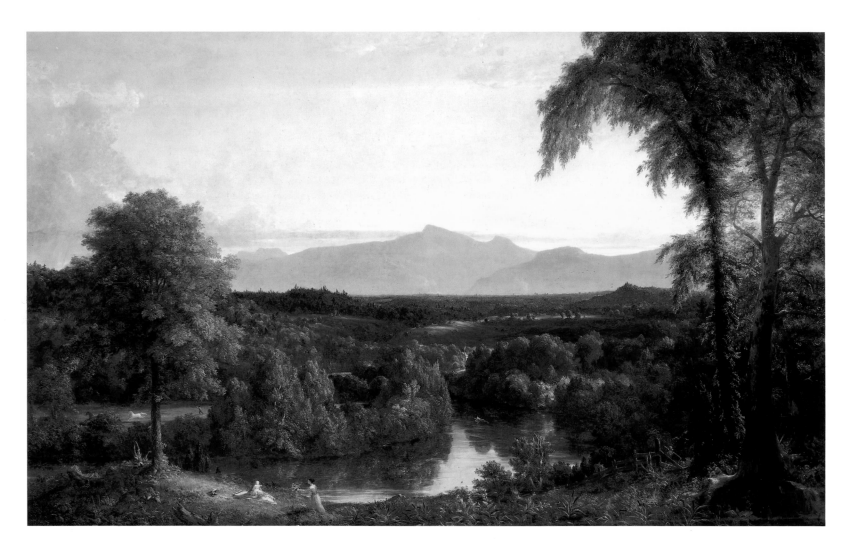

View on the Catskill—Early Autumn, 1837

Oil on canvas, 39 × 63 in. (99 × 160 cm.)
Signed and dated at lower right: T. Cole/1837
The Metropolitan Museum of Art, New York City. Gift in memory of
 Jonathan Sturges by his children, 1895 (95.13.3)

The history of *View on the Catskill—Early Autumn* is intimately bound up with the history of the area near the village of Catskill, New York, where Cole frequently worked in his early years and where in 1836 he set up his house and studio. The painting was executed in the winter of 1836–37 for Jonathan Sturges, prominent New York merchant and the business partner of Cole's most munificent patron, Luman Reed. Its emotional origins, however, go back to the spring of 1836, when Cole, displeased with the progressing construction of the Catskill and Canajoharie Railroad, gave Reed the following account of events along Catskill Creek:

> The copper-hearted barbarians are cutting *all the trees* down in the beautiful valley on which I have looked so often with a loving eye

—this throws quite a gloom over my spring anticipations—tell this to Durand, not that I wish to give him pain, but that I want him to join with me in maledictions on all dollar-godded utilitarians.[1]

Twenty days later, his anger somewhat abated, Cole, probably fearing that Reed, a successful capitalist, might think him too radical, penned a more detailed description of his reaction to the development of the area:

> After I had sealed my last letter I was in fear that what I said about the tree-destroyers might be understood in a more serious light than I intended—although I despise the miserable creatures who destroy the beautiful works of nature wantonly and for a paltry gain, my "maledictions" are gentle ones—and I do not know that I could wish them anything worse than that barrenness of mind, that sterile desolation of the soul in which sensibility to the beauty of nature cannot take root. Bye and bye, one reason why I am in so gentle a mood is that I am informed that some of the trees will be saved yet—thank them for that—If I live to be *old enough* I may sit down under some bush the last left in the utilitarian world and feel thankful that intellect in its march has spared one vestige of the ancient forest for me to die by.[2]

Unfortunately, the artist's guarded optimism turned out to be premature; the deforestation continued apace. By late summer, the part of Catskill Creek shown in the painting—literally just outside Cole's doorstep—had lost much of its former scenic splendor. Cole's expressions of grief now betray a feeling of helplessness:

> August 1, 1836. Last evening I took a walk up the Catskill above Austin's Mill, where the Rail Road is now making—This was once a favourite walk but the charm of quietness and solitude is gone—it is still lovely, man cannot remove the mountains, he has not yet felled *all* the woods and the stream will have its course. If men were not blind and insensible to the beauty of nature the great works necessary for the purpose of commerce might be carried on without destroying it, and at times might even contribute to her charms by rendering her more accessible—but it is not so—they desecrate whatever they touch—they cut down the forest with a wantonness for which there is no excuse, even gain, and leave the herbless rocks to glimmer in the burning sun.[3]

Although Cole could do little to reverse this course of events, it was at least within his power to pay homage to Catskill Creek by painting it as it had looked in the fullness of its grandeur. In the winter of 1836–37, he began work on *View on the Catskill—Early Autumn*.

So that his attempt to recapture the past would prove convincing, Cole turned to sketches of the site he had done in about 1833 or earlier. Of the many drawings of the spot he made at different times during his career, the large sketch on pages 44 and 45 of his 1832 sketchbook (Detroit Institute of Arts) is most likely the one on which the painting is based. Many features of the finished work, such as the foreground trees and the figures, are not present in the sketch, but the topographically salient points (marked with appropriate numbers to indicate relative distance) and the friezelike arrangement of the mountain stretching across the panoramic view are almost identical.

We do not know what specific comments Cole made to Sturges regarding his program for the picture, but a letter from Sturges to Cole of the following spring makes it clear that the artist had explained his intentions in detail and had assured his patron that the painting would be important enough to send to the National Academy exhibition that year. As Sturges wrote:

> I shall be happy to possess a picture showing what the valley of the Catskill was before the art of modern improvement found a footing there. I think of it often and can imagine what your feelings are when you see the beauties of nature swept away to make room for avarice—we are truly a destructive people. I have no fears but what *I* shall be satisfied with the picture—I am only anxious that it shall be a picture that people can not get away from in the academy.[4]

That Cole considered the work an important one is evident not only in the size he chose for its depiction but also in the attention he lavished on it. As E. P. Richardson noted in his perceptive history of American painting, what resulted was "a picture which he never surpassed in imaginative realism or lyric sentiment. . . . The brushstroke is minute in detail, but the details fall into place in a luminous and spacious whole."[5] Considering what had happened in his own backyard, Cole's intent must have been to paint a work that would be more than a mere evocation of a nostalgic memory. In *View on the Catskill—Early Autumn*, the programmatic image of harmony between man and nature he presented accounts for the inclusion of the many small-scale figures that at first appear out of place in such a panoramic landscape. The person in the rowboat, the man chasing after his horses in the meadow, the woman gathering wildflowers, her baby sitting by the bank of the stream, the hunter coming into view at the right are all symbols of a happy and sane relationship with the environment. The houses in the middle distance, as well as the dam in the stream (suggesting the presence of a mill), are signs of man's exploitation of nature. In this scene, however, that "development" has not spoiled scenic beauty.

Only in 1843 was Cole able to paint a more reportorial view of the area as it had probably looked some seven years earlier. In the later work, titled *River in the Catskills* (Museum of Fine Arts, Boston), it is a somewhat depressing scene of deforestation that meets the viewer's eye. The foreground is littered with felled trees and, on the left, where the maple tree stands in the Metropolitan's painting, a man with an ax surveys a bare landscape now traversed by a railroad in the middle distance.

O.R.R.

Notes
1. Cole to Reed, 6 March 1836, Cole Papers.
2. Cole to Reed, 26 March 1836, Cole Papers.
3. Cole, "Thoughts and Occurrences," 1 August 1836, Cole Papers.
4. Sturges to Cole, 23 March 1837, Cole Papers.
5. Richardson 1956, p. 166.

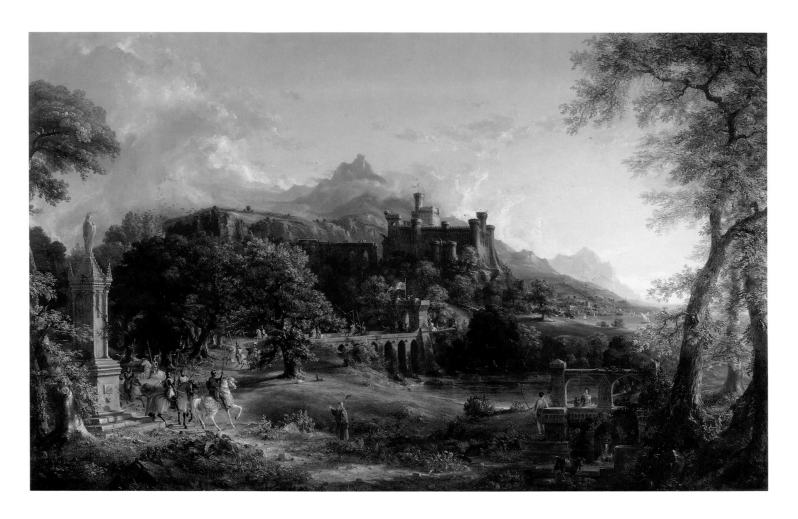

The Departure, 1837

Oil on canvas, 39½ × 63 in. (100.3 × 160 cm.)
Signed and dated at lower right: TC/1837

The Return, 1837

Oil on canvas, 39¾ × 63 in. (101 × 160 cm.)
Signed and dated at middle left: T Cole/1837; at lower middle: T Cole.
1837

*The Corcoran Gallery of Art, Washington, D.C. Gift of
William Wilson Corcoran, 1869 (62.2, 3)*

In October 1836, Cole's recently completed series *The Course of Empire* (Figs. 2.6–10, pp. 28–29) was exhibited at the National Academy of Design in New York City. The reception accorded the five paintings by the critics and the general public was enthusiastic: favorable notices appeared in the newspapers and admission receipts totaled almost thirteen hundred dollars. Impressed by Cole's

ambitious work, William P. Van Rensselaer, of Albany, wealthy son of Stephen Van Rensselaer, New York's "last patroon," commissioned a pair of landscapes representing Morning and Evening, with no special requirements as to size, content, price, or even frame style. In replying to Van Rensselaer's letter, Cole gratefully acknowledged the great latitude given to him and reassured his patron on the wisdom of his decision:

> The subjects Morning and Evening afford wide scope for selection or invention—Your silence as to the particular kind of scenery, whether Italian or American or whether the scene be real or ideal implies that you leave the choice to me, which supposition is gratifying to me, and is a surety for my working con amore.[1]

Despite his avowed enthusiasm, Cole appears to have done little or no work for Van Rensselaer until the summer of 1837. On 8 July, in reply to an inquiry from Van Rensselaer, he admitted, "Your pictures are on the easel, but far from being finished. . . . I shall now proceed with them, I hope, without interruption. But I must ask your indulgence as to time. I am afraid that they cannot be finished before autumn."[2] By mid-October, though only one painting had been completed, he had at least worked out the subject matter of both works:

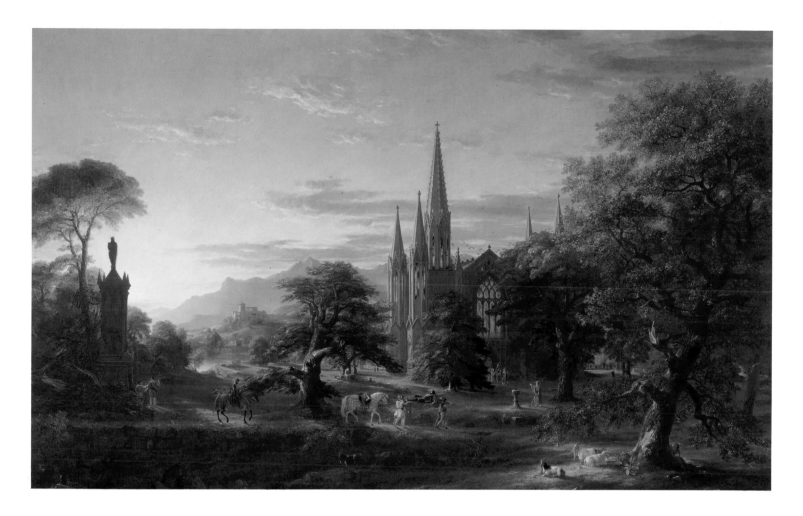

Having advanced so far, I thought it might be agreeable to you to learn something of the work which I am about to offer you. I have therefore taken the liberty to give you a hasty sketch of what I am doing; at the same time, let me say, that a written sketch can give but an inadequate notion of my labours.

The story, if I may so call it, which will give title, and, I hope, life and interest to the landscapes, is taken neither from history nor poetry: it is a fiction of my own, if incidents which must have occurred very frequently can be called fiction. It is supposed to have date in the 13th or 14th century.

In the first picture, Morning, which I call The Departure, a dark and lofty castle stands on an eminence, embosomed in woods. The distance beyond is composed of cloud-capt mountains and cultivated lands, sloping down to the sea. In the foreground is a sculptured Madonna, by which passes a road, winding beneath ancient trees, and, crossing a stream by a Gothic bridge, conducting to the gate of the castle. From this gate has issued a troop of knights and soldiers in glittering armour: they are dashing down across the bridge and beneath the lofty trees, in the foreground; and the principal figure, who may be considered the Lord of the Castle, reins in his charger, and turns a look of pride and exultation at the castle of his fathers and his gallant retinue. He waves his sword, as though saluting some fair lady, who from battlement or window watches

her lord's departure to the wars. The time is supposed to be early summer.

The second picture—The Return—is in early autumn. The spectator has his back to the castle. The sun is low: its yellow beams gild the pinnacles of an abbey, standing in a shadowy wood. The Madonna stands a short distance from the foreground, and identifies the scene. Near it, moving towards the castle, is a mournful procession; the lord is borne on a litter, dead or dying—his charger led behind—a single knight, and one or two attendants—all that war has spared of that once goodly company.

You will be inclined to think, perhaps, that this is a melancholy subject; but I hope it will not, in consequence of that, be incapable of affording pleasure. I will not trouble you with more than this hasty sketch of my labours. I have endeavored to tell the story in the richest and most picturesque manner that I could. And should there be no story understood, I trust that there will be sufficient truth and beauty found in the pictures to interest and please.[3]

From that time on, Cole must have worked steadily on the unfinished picture, for on 2 November he asked Asher B. Durand to obtain gilded frames for both paintings within three weeks' time at most.[4] In early December, Cole met Van Rensselaer in New York City and personally delivered the finished paintings. Their comple-

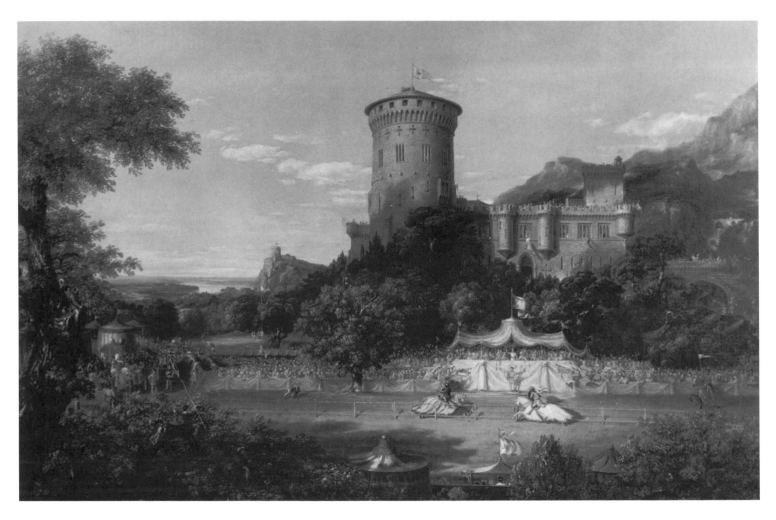

Figure 1. Thomas Cole, *The Past*, 1838, oil on canvas, 40 x 61 in. (101.6 x 154.9 cm.). Mead Art Museum, Amherst College, Purchase (1950.189)

tion, obviously the object of some anticipation, was duly reported by the *New York Mirror* on 23 December:

> We have had the pleasure, the very great pleasure, of seeing two pictures recently finished by the American landscape painter, T. Cole, Esq., for William Van Rensselaer, Esq., of Albany. When an artist has produced works of the highest character, both for conception and execution, it is incumbent upon him to sustain the character he has acquired; if, after expressing our opinion, as we did some months past, of Mr. Cole's five pictures on "The Progress of Empire," we were now only to say that he has *equalled himself*, we should, to those who have seen that series of paintings, appear to bestow great praise. But we can do more: we can say that, in our opinion, he has, as far as the subjects would admit, *outdone himself*, and produced two more perfect works of art.[5]

The paintings made a lasting impression on William Cullen Bryant, who, eleven years later, in the oration he composed after Cole's death, praised them as being among Cole's noblest works

and pointed out that in them the artist had achieved some of his most successful figure painting.[6]

At a thousand dollars apiece, *The Departure* and *The Return* were not inexpensive for their time, yet their enthusiastic reception prompted Peter G. Stuyvesant, another scion of an old New York Dutch family, to write to Cole, ordering a pair of large paintings in terms as liberal as those Van Rensselaer had offered. At the end of his letter Stuyvesant added: "Mrs. S. and myself were much pleased with the paintings of Mr. V. Rensselaer and I have much pleasure in adding that they are universally admired."[7]

Both *The Departure* and *The Return*, as well as Stuyvesant's pair, *The Past* and *The Present* (Figs. 1, 2), may be considered the offspring of *The Course of Empire* in a number of ways, including serial format, landscape setting used to depict past events, and thematic concern with the inevitability of death and decay. Yet in choosing medieval subjects for the two pairs, Cole took a highly original turn both in terms of his own art and of contemporary American painting: he tapped into one of the richest cultural veins of his time—the renewed interest in things Gothic that had begun in England in the mid-eighteenth century and made significant advances in America by the 1830s. Although Cole did not refer to

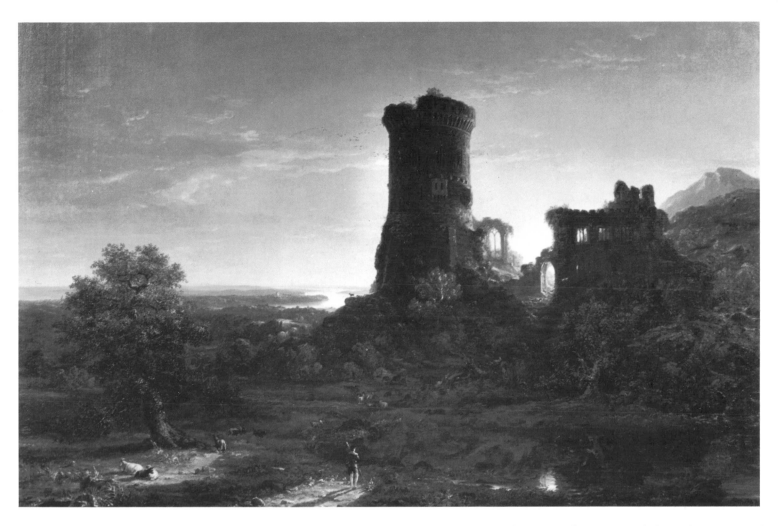

Figure 2. Thomas Cole, *The Present*, 1838, oil on canvas, 40 x 61 in. (101.6 x 154.9 cm.). Mead Art Museum, Amherst College, Purchase (1950.190)

any specific historic or literary subject in determining the iconography of *The Departure* and *The Return* (as he had stated in his 15 October 1837 letter to Van Rensselaer), his choice of an overtly Gothic context made him susceptible to a number of visual and intellectual influences, primarily of English origin. Cole's chapel in *The Return* has strong ties with the tradition of English collegiate Gothic architecture that had made its way to America in A. J. Davis's New York University building of 1836.[8] Further, the Druidic-looking old man in both canvases relates to the figure of a Welsh poet in John Martin's picture *The Bard* (1817; Laing Art Gallery, Newcastle-upon-Tyne), which Cole probably saw in England during his first trip to Europe, and establishes a link between Cole's works and Martin's original inspiration, Thomas Gray's poem *The Bard*. Similarly, Cole's armor-clad knights appear to derive from engraved illustrations published in an 1836 edition of Gray's *Elegy Written in a Country Church-Yard*. The famous stanza nine of the *Elegy*, certainly evoked in *The Departure* and *The*

Return, returns to the major themes sounded in *The Course of Empire*:

> The boast of heraldry, the pomp of power,
> And all that beauty, all that wealth e'er gave,
> Awaits, alike, th' inevitable hour:—
> The paths of glory lead but to the grave.
>
> O.R.R.

Notes

1. Cole to Van Rensselaer, undated but probably about 15 December 1836, quoted in Novak 1969, p. 294, n. 27.
2. Noble 1853, pp. 242–43.
3. Ibid., pp. 244–45.
4. Cole to Durand, 2 November 1837, Cole Papers.
5. *New-York Mirror* 15 (23 December 1837), p. 203.
6. William Cullen Bryant, *A Funeral Oration Occasioned by the Death of Thomas Cole . . .* (New York: D. Appleton & Co., 1848), p. 25.
7. Stuyvesant to Cole, 15 December 1837, Cole Papers.
8. These connections are made in Ellwood C. Parry III, "Gothic Elegies for an American Audience: Thomas Cole's Repackaging of Imported Ideas," *The American Art Journal* 8 (November 1976), pp. 27–46.

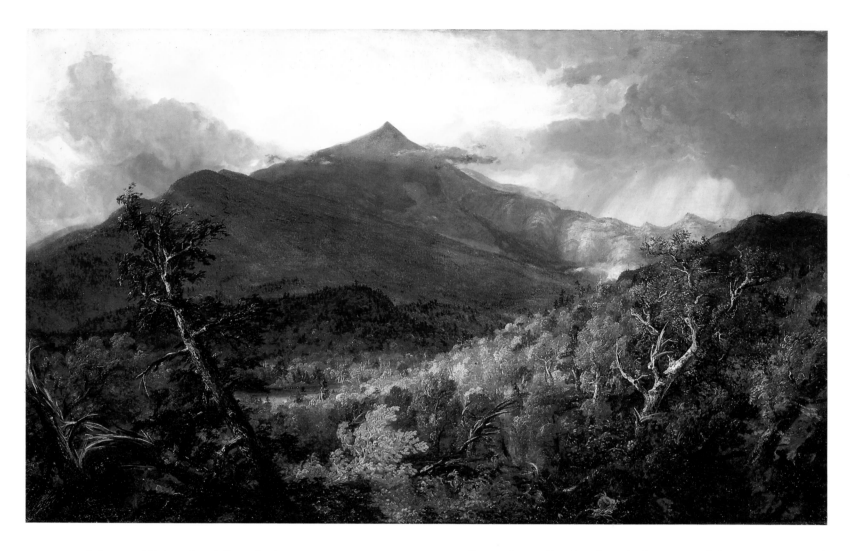

Schroon Mountain, Adirondacks, 1838
Oil on canvas, 39⅜ × 63 in. (100 × 160 cm.)
Signed and dated at lower left: T. Cole/Catskill 1838
The Cleveland Museum of Art, The Hinman B. Hurlbut Collection
 (CMA 1335.17)

This view of what is today known as Hoffman Mountain, immediately to the northwest of Schroon Lake in the eastern Adirondacks, has long been recognized as one of Cole's most successful attempts at heroic landscape painting. Its subject matter, as well as its size and panoramic format, relates *Schroon Mountain* to such later achievements of the Hudson River School as Frederic Church's *Heart of the Andes* and Albert Bierstadt's *Rocky Mountains, Lander's Peak* (see pp. 246; 285). At the time it was painted, however, the work seems to have elicited little notice. When shown at the 1838 National Academy of Design exhibition, under the title *View of Schroon Mountain, Essex Co., New York, After a*

Storm, it was listed as for sale, but none of the major New York collectors evinced any interest in it. Shortly thereafter the painting passed into the possession of Cole's brother-in-law and good friend Dr. George Ackerly. It was exhibited in New York in 1839 at the Apollo Association and again listed as for sale, that time by Ackerly's daughter. By 1848, when the picture was shown at the Cole Memorial Exhibition at the American Art-Union, it was still in the possession of Emma Ackerly, though by that time she was listed as Mrs. J. J. Chapman. The pattern of ownership suggests that Ackerly may have bought the canvas as a favor to the artist or perhaps received it as a gift for past services.

Cole first visited the area of Schroon Lake in the autumn of 1835 and made the following entry in his diary:

October 7th.—I have just returned from an excursion in search of the picturesque towards the head-waters of the Hudson. * * In the neighbourhood of Schroon the country is more finely broken. The lake I found to be a beautiful sheet of water, shadowed by sloping hills clothed with heavy forests. Rowing north for half an hour or so, you will see the lake expanded to the breadth of two or three miles. Here the view is exceedingly fine. On both hands, from

shores of sand and pebbles, gently rise the thickly-wooded hills: before you miles of blue water stretch away: in the distance mountains of remarkable beauty bound the vision. Two summits in particular attracted my attention: one of a serrated outline, and the other like a lofty pyramid. At the time I saw them, they stood in the midst of the wilderness like peaks of sapphire. It is my intention to visit this region at a more favourable season.[1]

In June 1837, having completed *The Oxbow, The Course of Empire,* and *View on the Catskill—Early Autumn,* Cole again set off for the Adirondacks, this time in the company of his wife, Maria, and Mr. and Mrs. Asher B. Durand. That nature trip proved to be one of Cole's happiest, and he recorded with relish the group's adventures. His account of how he and Durand reached the all but inaccessible spot from which Schroon Mountain was best seen reads like a pilgrimage tale. Once attained, the view of the majestic mountain is presented as an unexpected, almost mystic revelation:

> We entered the wood, and found it but a narrow strip. We emerged and our eyes were blessed. There was no lake-view as we had expected, but the hoary mountain rose in silent grandeur, its dark head clad in a dense forest of evergreens, cleaving the sky, "a star-y pointing pyramid." * * * Below, stretched to the mountain's base a mighty mass of forest, unbroken but by the rising and sinking of the earth on which it stood. Here we felt the sublimity of untamed wildness, and the majesty of the eternal mountains.[2]

It was this perception of eternal permanence that impressed Cole most during his Adirondack trip. As he commented, "The scenery is not grand, but has a wild sort of beauty that approaches it: quietness—solitude—the untamed—the unchanged aspect of nature—an aspect which the scene has worn thousands of years, affected only by seasons, the sunshine and the tempest."[3] In a poem inspired by his experience on Schroon Mountain, he describes a lofty peak as the lonely and eternal dwelling place of a spirit who sees tempests, floods, and quakes come and go, but who remains unscathed and untouched to sing his "hymn of gladness all alone."[4]

Cole's on-the-spot pencil sketch of Schroon Mountain (ill.), while faithfully recording what he actually saw, conveys none of the emotionally charged associations he felt and wrote about in his diary. Because the sketch did not altogether serve his purpose in painting the finished picture, he took his usual liberties, in this case choosing the autumn season and an imaginary, elevated point of view.[5] In a letter to Durand, he revealed his highly romantic and idealizing approach to painting:

> And what have I been doing? toiling up mountains, even Schroon mountains, solitary and companionless. I took the notion, and got into a mountain fever, and nothing would do but that I must allay it by painting the sable pyramid from the sketch made in the clearing, before we dashed on to the Grisly Pond. I consider it our grandest view. I have taken the liberty of elevating myself a little, as though on a treetop, to get a glimpse of the nearest pond by which we passed. How I have succeeded you shall judge.
>
> Painting this picture has recalled our Schroon days, and already, in my mind, they begin to take the hue of romance. That was a glorious day, the day of the lake hunt—Grisly Pond day. The

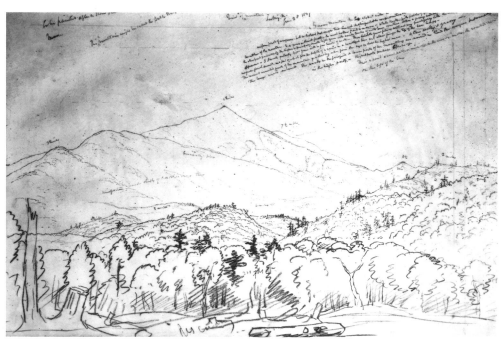

Thomas Cole, *View of Schroon Mountain Looking North, June 28, 1837,* pencil on paper, 9¹⁵/₁₆ x 15 in. (25.1 x 38.1 cm.), in sketchbook no. 10, p. 76. The Detroit Institute of Arts, Founders Society Purchase, William H. Murphy Fund (39.568.76)

thoughts of it stir me now like the music of running waters in an umbrageous valley. Have you not found?—I have—that I never succeed in painting scenes, however beautiful, immediately on returning from them. I must wait for time to draw a veil over the common details, the unessential parts, which shall leave the great features, whether the beautiful or the sublime dominant in the mind.[6]

For Cole, as *Schroon Mountain, Adirondacks* demonstrates, time obscured the unessential and highlighted the indispensable not only in the pictorial sense but in the intellectual sense as well. The blasted trees in the foreground, the passing storm pointedly noted in the picture's original title, the autumn season portending winter death, the peak of the mountain elevated to a celestial height are all vehicles for communicating the artist's feelings when he first beheld the scene, feelings made all the more memorable by the passage of time.

<div align="right">O.R.R.</div>

Notes

1. Noble 1853, p. 206, where asterisks were used to denote deleted material.
2. Ibid., p. 241.
3. Ibid., p. 239.
4. Ibid., pp. 241–42.
5. Cole, before going to the canvas, produced in his studio a highly emotional charcoal study (Detroit Institute of Arts, 39.501), in which sharp contrasts of light and dark were dramatically exploited.
6. Cole to Durand, 4 January 1838, quoted in Noble 1853, p. 248.

Mount Aetna from Taormina, 1844

Oil on canvas, 32¼ × 48 in. (81.9 × 121.9 cm.)
Signed and dated (on column drum): T. Cole 1844
Lyman Allyn Museum, New London, Connecticut

In April 1842, toward the end of a second European journey, Cole traveled to Sicily. "As usual, nature and the vestiges of antiquity were the great objects of attraction," his biographer notes.[1] Cole visited many of the famous Greek and Roman sites in Sicily, but it was the juxtaposition of the ruins with the eternal features of the landscape that particularly appealed to him. As he put it, "There is a sad pleasure in wandering among the ruins of these cities and palaces. We look at arches and columns in decay, and feel the perishable nature of human art: at the same glance, we take in the blue sea rolling its billows to the shore with the freshness, strength and beauty of the days, when the proud Caesars gazed upon it."[2] At Taormina, where the spectacular ruins of an ancient theater stood against a panoramic vista of the awesome, volcanic Mount Aetna, the contrast between the mutable works of man and the eternal works of God was especially marked. "I have never seen anything like it," the artist wrote. "The views from Taormina certainly excel anything I have ever seen."[3]

By the time Cole painted this work, in 1844, he had already produced a number of views of Mount Aetna, including *Mount Aetna from Taormina* (1843; Wadsworth Atheneum), a version measuring just under seventy-eight by a hundred and thirty inches, of which the present picture is a copy. The earlier view, exceeded in size by only one other work in Cole's oeuvre, had been painted in just five days in early December 1843 for a small exhibition of the artist's works scheduled to open at Clinton Hall in New York City within a week's time.[4] Cole's description of the larger *Mount Aetna from Taormina*, which varies from this one mainly in its evidence of hasty execution and its more open sense of space, not only identifies the main pictorial elements of his composition but also serves to reaffirm the keen sense of history Cole had previously revealed in his letter to William P. Van Rensselaer (see pp. 130–31), in which he discussed the subject matter for *The Departure* and *The Return*. As recounted by Noble, "Subjoined is Cole's description of the picture":

The scene, from which the artist took this picture, is considered one of the finest in the world. In the distance rises Mount Aetna, clad in snows, which the fires of the volcano never entirely dissolve. Its height is about eleven thousand feet above the Mediterranean, which, on the left of the picture, is seen to indent the eastern coast of Sicily. In the middle distance of the picture, forming part of the vast base of Aetna, is a varied country, broken yet fertile, and interspersed with villages, olive groves and vineyards. Crowning a hill, on the right of the picture, may be seen part of the village of Taormina, anciently a city of consequence, and now interesting to

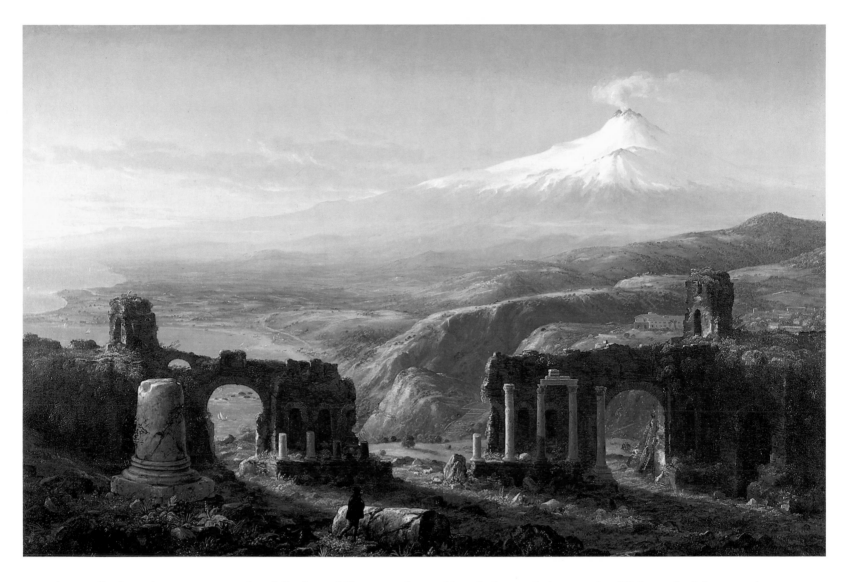

the traveller from the numerous remains of Grecian and Roman antiquity, which still exist. In the foreground, is the ancient theatre of Taormina, one of the most remarkable remains of antiquity. This theatre was built by the Greeks. The Romans afterwards altered it, so as to adapt it to their less tasteful and refined exhibitions. It afterwards became a Saracenic palace and fortress, and more recently, the villa of a Sicilian nobleman. It has been abandoned for many years, and has suffered from time and violence, and is now in the state in which it is represented in the picture. The time is soon after sunrise.[5]

Although Cole kept a detailed pencil drawing he had made on the spot, the many aspects of coloring and composition shared by both paintings suggest that this version was executed while the artist still possessed the larger canvas and could refer to it. If so, the present picture was probably commissioned by an admirer—perhaps Henry Chauncey, who is listed as its owner at the time of its inclusion in the 1848 Cole Memorial Exhibition—after seeing the original hanging in Clinton Hall. Because Cole is known to

have shipped that painting to the Wadsworth Atheneum in Hartford on 4 March 1844, the subject of this entry must have been substantially completed by that date.[6]

O.R.R.

Notes
1. Noble 1853, p. 324.
2. Ibid.
3. Ibid., p. 325.
4. Merritt 1969, p. 39.
5. Noble 1853, pp. 354–55.
6. McNulty 1983, p. 69.

Genesee Scenery, 1847

Oil on canvas, 51 × 39 in. (129.5 × 99.1 cm.)
Signed and dated at lower left: T Cole/1847
Museum of Art, Rhode Island School of Design, Jesse H. Metcalf Fund,
 38.054

Cole painted *Genesee Scenery* for the American Art-Union exhibition and distribution of 1848. He appears to have been pleased with the work. In a diary entry of 1 February 1848, his birthday, he mentions it with satisfaction as one of the accomplishments of

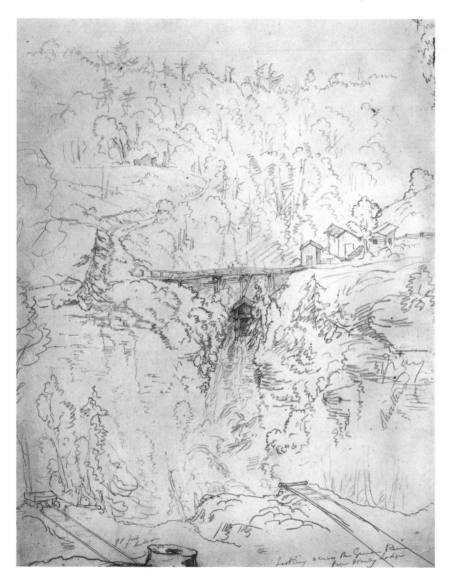

Thomas Cole, *Looking Across the Genesee River from Hornby Lodge*, 1839, pencil on paper, 14⁷⁄₁₆ x 10⁵⁄₁₆ in. (36.7 x 26.2 cm.). The Detroit Institute of Arts, Founders Society Purchase, William H. Murphy Fund (39.192)

the previous year: ". . . I have been able to make considerable progress in my pictures, and hope to finish them before the coming year is gone. I have painted several smaller pictures, one for the Art Union in Cincinnati, two for the Art Union in New York, Home in the Woods, and Genesee Scenery. . . ."[1]

In August 1839, Cole visited the Genesee River country, in western New York, at the request of Samuel Ruggles, then the state's canal commissioner. Ruggles wanted Cole to paint a view of the striking scenery of the gorge of the river—specifically, a precipitous bluff atop which stood Hornby Lodge, a picturesque log structure—before it was disfigured by a projected tunnel for the Genesee Valley Canal. He intended to present the painting to Governor William H. Seward of New York, a strong backer of the canal project. Cole, who had already heard his Connecticut patron Daniel Wadsworth praise highly that scenic section of the Genesee River just north of the town of Portage, undertook his task with enthusiasm.[2] He produced many detailed on-the-spot drawings of the site, and not long afterward fulfilled Ruggles's commission with a large painting that today hangs in the historic Seward House, in Auburn, New York.[3]

According to Cole's biographer, who in all probability heard about it directly from Cole, the Genesee trip had had a tonic effect on the painter's spirits, which had been dampened by the difficult task of determining the style and context of his second great series, *The Voyage of Life* (1840; Munson-Williams-Proctor Institute). As Noble tells it: "The Voyage of Life, which he was now mentally composing, exhibits here and there, in the sweet windings of its stream, in its alternately rapid and placid current, in the fine verdure of its banks and groves, and in its delightful atmospheric effects, the influence upon his mind and feelings of this pleasant and refreshing excursion."[4]

Eight years later, Cole, wishing to produce a "pleasant and refreshing" landscape that would appeal immediately to a wide audience, returned to his Genesee sketches for inspiration. Of these, one titled *Looking Across the Genesee River from Hornby Lodge* (ill.), a view of Deh-ga-ya-soh Creek as it plummets into the main channel, provided the visual data Cole chiefly relied on. It is evident from the finished painting that some of the other sketches were consulted, but because none of them was followed exactly, the topography Cole presented so compellingly in this painting must be largely the product of his imagination. *Genesee Scenery*, even more than *Schroon Mountain, Adirondacks*, is a carefully composed view from which unessential parts have been removed. True to his stated conviction, Cole had waited for time to draw a veil over the common details, leaving the great features dominant in his mind.[5] Noble's opinion of it has, for the most part, been shared by posterity:

> The picture of a cascade, on the upper waters of the Genesee, was painted from a sketch made at the time, not one of his most finished landscapes, perhaps, but translating the very spirit of nature, when she delights and inspires in a quiet way. It cools and refreshes in its most luminous parts. A voice seems to pervade its stillness. The repose of its woods is yet breezy and life-like. Its lofty blue sky

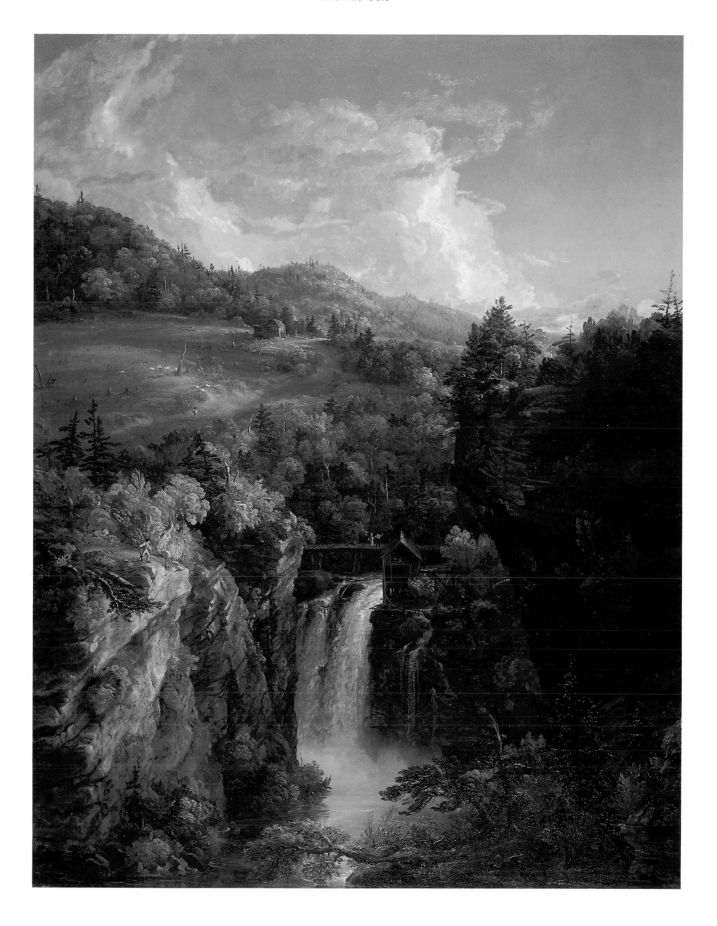

possesses that marvellous quality of elasticity and moisture, for which Cole stands almost, if not entirely alone, among both ancient and modern landscape painters.[6]

The emphasis on the infinity of the sky, which *Genesee Scenery* shares with many of Cole's most successful later works, including *The Mountain Ford* (1846; Metropolitan Museum) and *The Arch of Nero* (1847; Newark Museum), probably results from two important events that took place relatively late in the artist's life: his second trip to Paris, during which he was exposed to the works of Nicolas Poussin, and his August 1847 visit to Niagara Falls, which caused him to rethink his concept of the Sublime. As he expressed it:

> Not in action, but in deep *repose*, is the loftiest element of the sublime. With action, waste and ultimate exhaustion are associated. In the pure blue sky is the highest sublime. There is the illimitable. When the soul essays to wing its flight into that awful profound, it returns tremblingly to its early rest. All is deep, unbroken repose up there—voiceless, motionless, without the colours, lights and shadows, and ever-changing draperies of the lower earth. There we look into the uncurtained, solemn serene—into the eternal, the infinite—toward the throne of the Almighty.[7]

Genesee Scenery, representing a section of the country frequently visited by tourists and artists as they traveled to the Niagara region, must be regarded as Cole's own response to the great falls, which had not fulfilled his expectations. In the painting, both the dramatic and pastoral qualities of an otherwise picturesque composition are assimilated in the artist's new approach to the Sublime. In its mood of quietness, in its translucent sky and crisply detailed rocks and trees, the work stands as a major signpost on the path to the aesthetics of what is now called Luminism.

O.R.R.

Notes
1. Noble 1853, p. 380.
2. See Howard S. Merritt and Henry W. Clune, *The Genesee Country*, exh. cat. (Memorial Art Gallery of the University of Rochester, New York, 1976), p. 86, no. 20.
3. Ibid., p. 98, no. 90.
4. Noble 1853, pp. 275–76.
5. Ibid., quotes Cole to Durand, 4 January 1838.
6. Ibid., p. 276.
7. Ibid., p. 376. The points concerning Poussin and Cole's rethinking of what constituted the Sublime are made in Mandel 1977, pp. 26–31.

JOHN W. CASILEAR
(1811–1893)

John William Casilear, a New Yorker, spent most of his life in his native city. In 1827, at sixteen, he was apprenticed to the engraver Peter Maverick until Maverick's death four years later, after which he continued his apprenticeship with Asher B. Durand, who had trained with the same master. Casilear and his brother formed a partnership that was part of a chain of engraving firms that eventually became the American Bank Note Company, still the most important private firm of bank-note engravers in this country. His success as an engraver enabled him to retire by 1857 and devote his entire time to painting. He had made his first real attempt—a landscape—when he was twenty. When Durand saw the work, he recognized his pupil's talent and acquired the canvas for his own collection. Until the end of his life, Durand, who instructed the young man in the technique of landscape painting, continued to be Casilear's mentor and friend.

In 1833, Casilear was elected an Associate of the National Academy of Design; he was made a full Academician in 1852. His first entries to the Academy annuals were engravings, but he began in 1836 to show only paintings, a practice he continued until his death.

In 1840, Casilear made his first trip to Europe, accompanied by Durand, John F. Kensett, who had been a friend since their apprenticeship days in Maverick's studio, and Thomas P. Rossiter, another artist friend. He traveled extensively in England and on the Continent, where Durand introduced to him the work of Claude Lorrain, whose influence would become visible in many of Casilear's landscapes. Casilear and Kensett frequently took long trips together, sketching and looking at paintings, and both became prominent members of the colony of American artists in Paris.

In 1854, Casilear moved into Waverly House at 697 Broadway in New York with Kensett and the artist Louis Lang; he moved to the newly completed Tenth Street Studio Building four years later. After a second trip to Europe, in 1858, during which he spent much of his time in Switzerland, his characteristic scenes of the American Northeast became interspersed with depictions of Swiss views. He was active in New York's artistic circles as a member of the Academy, the Century Association, and the Artists' Fund Society, and sketched each summer with his artist friends in the Catskills, the Adirondacks, the White Mountains, and the Genesee valley. As did many of his friends, he also traveled in the American West, probably in the 1870s. After a long career as a well-known landscape painter, he died suddenly in Saratoga Springs, New York.

Select Bibliography

Benjamin Champney. *Sixty Years' Memories of Art and Artists.* 1869. Reprint. Woburn, Mass.: Wallace and Andrews, 1900.

Theodore Sizer, ed. *The Recollections of John Ferguson Weir.* New York and New Haven: The New-York Historical Society and The Associates in Fine Arts at Yale University, 1957.

J. Miller. "Drawings of the Hudson River School: the first generation." In *Connoisseur* 174 (August 1970), pp. 307–8.

Lake George, 1860

Oil on canvas, 26¼ × 42¼ in. (66.7 × 107.3 cm.)
Signed and dated at lower right: JWC '60
Wadsworth Atheneum, Hartford, Connecticut. Bequest of
 Clara Hinton Gould (Mrs. Frederick Saltonstall Gould), 1948

In common with many American artists of the mid-nineteenth century, Casilear turned repeatedly for subject matter to Lake

George and its environs. As early as 1855, his summer work included sketches on the lake,[1] and until the 1870s he frequently exhibited works titled *Lake George* at the Brooklyn Art Association and the National Academy of Design in New York, the Pennsylvania Academy of the Fine Arts in Philadelphia, and the Boston Athenaeum.[2] Though each of his views is taken from a different part of the lake, all share a similarity of composition: a group of trees in the right or the left foreground and a shoreline

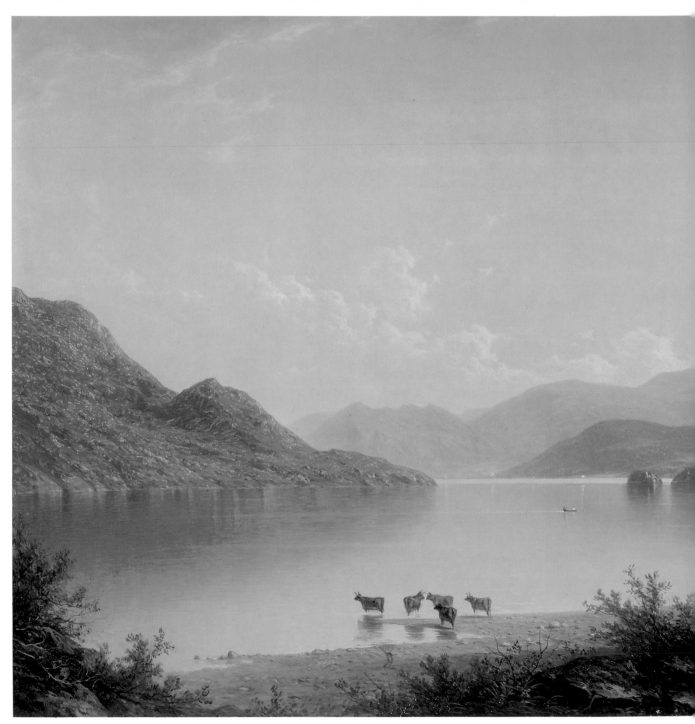

that acts as a frame for a receding view of the lake and its enclosing mountains.

As typified in this version, Casilear's approach to landscape is very much in the tradition of the second-generation Hudson River painters. That the panorama, though still grand, is no longer in its original, untouched state is conveyed to the viewer by the domestic cattle—a favored Casilear motif—at the edge of the water and by the two figures, one relaxing on a foreground rock and the

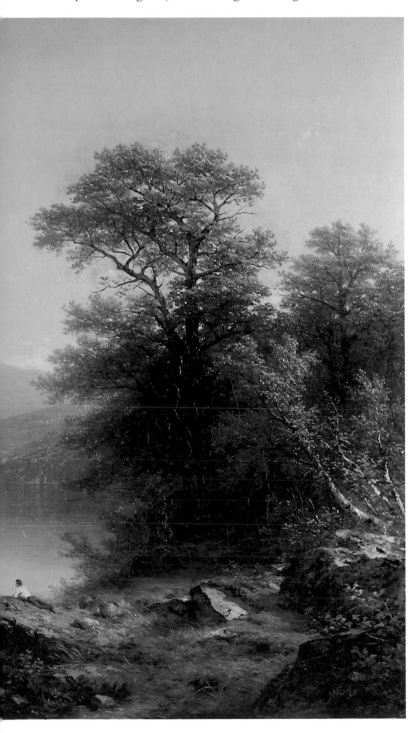

other fishing from a tiny boat on the lake. No longer awesome, the land and the lake have both yielded to the needs of man. Henry Tuckerman, writing in 1867, found this particular Casilear canvas "One of his most congenial and successful American subjects. . . . The glassy surface of the lake, its smoothness disturbed only by the ripples caused by leaping trout, spreads beyond and across to the opposite hills. A small boat, propelled by one person, leaves a slender wake behind it. A few light clouds hover above the hill-tops, and summer's peace seems to pervade the scene."[3] Though Benjamin Champney, with whom John Kensett and Casilear sketched in New Hampshire during the summer of 1850, considered Casilear as an artist "not so original as Cole and Durand," he still found in his work much to praise: "His skies are luminous, and his distances tender and melting . . . there is a poetic pastoral charm in all his work."[4]

Casilear had returned from a trip to Europe with Durand, Kensett, and Thomas Rossiter by the time he made this painting. In it, the influence of Claude Lorrain, whose work Durand had introduced him to, is visible in the beautifully structured trees and in the soft, light, cloud-strewn sky. Always notable for his handling of distant light—in this version of *Lake George* demonstrated in the silvery haze seen across the lake—Casilear frequently illuminated his canvases in the manner that has in recent years been termed Luminism. The minute rendering of foreground details, however, is attributable to Casilear's own background as an engraver, an aspect of his work that did not go unnoticed by his contemporaries. John Ferguson Weir, once a neighbor of Casilear's in the Tenth Street Studio Building, said of his paintings that they had a "trace of that earlier practice in the landscapes of those who had been engravers, as shown in a certain dryness of method."[5] The writer of one of Casilear's obituaries referred to "his peaceful and gracefully delicate landscapes [which] show strongly the influence of his early work."[6]

Like Durand, Casilear left a large body of drawings. In these he was said to emerge "as a fascinating innovator in mid-nineteenth century American Art."[7] As for his oils, he is particularly remembered for the excellence of his water scenes, which Tuckerman found to possess "a pure light, and neat outline, and distinct grace or grandeur."[8]

B.B.B.

Notes

1. "Domestic Art Gossip," *The Crayon* 2 (21 November 1855), p. 330.
2. Other canvases titled *Lake George* are at the Metropolitan Museum, the Brooklyn Museum, the Corcoran Gallery of Art, and in a private collection.
3. Tuckerman 1867, pp. 521–22.
4. Champney 1869, pp. 143–44.
5. Sizer 1957, p. 63.
6. Obituary, unidentified source, Archives of American Art, microfilm roll no. 177, frame 935.
7. J. Miller, "Drawings of the Hudson River School: the first generation," *Connoisseur* 174 (August 1970), p. 308.
8. Tuckerman 1867, p. 522.

Upper Hudson River Landscape, ca. 1860

Oil on canvas, 22 × 30 in. (55.9 × 76.2 cm.)
Signed at lower left: J.W.C.
From the Collection of The Downtown Club, Birmingham, Alabama

This painting may have been the one titled *Scene on the Hudson* that Casilear exhibited in 1861 at the Pennsylvania Academy of the Fine Arts.[1] That no work with the present title appears in any of his exhibition records strengthens this supposition, as does the absence of the 1861 title from the list of Casilear's works recorded in the Inventory of American Paintings. The view has been "set somewhere upriver of Troy,"[2] with the near mountains the Heldebergs and the far ones the Catskills.[3] Because Casilear spent many summers at Saratoga Springs and, in the company of artist friends who included Asher B. Durand, John Kensett, and Benjamin Champney, frequently traveled to upstate New York to paint, he would have known that part of the river well.

In 1858, an article in the *Cosmopolitan Art Journal* urged American artists to use native subjects in order to interpret for their countrymen "the work of the Creator."[4] Casilear, though his oeuvre includes many European scenes made on his trips abroad, can be said to have responded to that appeal. Much of his work has the same air of quietude and gentle appreciation for familiar landscape that imbues *Upper Hudson River Landscape*. The domestication of a once wild part of the country is manifested by the presence of a series of motifs all favored by the artist: the cattle, the small boat on the river, and the house on the distant shore. That combination of elements gives the work a strong resemblance

to *The River Scene* (1854; Metropolitan Museum) by Casilear's mentor, Durand. The influence of Durand and of Claude Lorrain, whom Durand admired and emulated in certain characteristics, is traceable in this canvas in the large, distinctively realized trees Casilear placed across the middle ground and in the softly outlined, billowing clouds with which he filled the sky. His foreground— dark, like those of Claude—contrasts with a background that is bathed in a diffused light emanating from a hidden source. As always, Casilear's training as an engraver can be credited for the precision of detail seen here in the careful delineation of the foreground rocks and flora and in the well-defined tree trunks standing out clearly from the shadowy central grove.

No description of Casilear's pictures can improve on that made by Henry Tuckerman in 1867: "They are finished with great care, and the subjects chosen with fastidious taste; the habit of dealing strictly with form, gives a curious correctness to the details of his work; there is nothing dashing, daring, or off-hand; all is correct, delicate, and indicative of a sincere feeling for truth, both executive and moral; not so much a passion for beauty as a love of elegance, is manifest; the precise, the firm, and the graceful traits of artistic skill, belong to Casilear."[5]

B.B.B.

Notes
1. Rutledge 1955, p. 131.
2. Howat 1972, p. 184.
3. Barry Hopkins, director of Kindred Spirits Wilderness Experiences, Catskill, New York, letter to author, 9 May 1986.
4. "Character in Scenery. Its Relation to the National Mind," *Cosmopolitan Art Journal* 3 (December 1858), pp. 9–11.
5. Tuckerman 1867, p. 521.

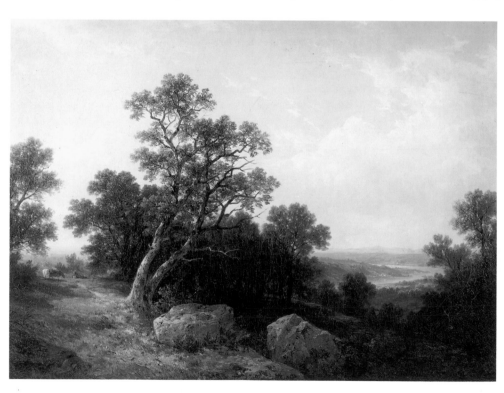

JEROME THOMPSON
(1814–1886)

Thompson, a native of Middleborough, Massachusetts, was the seventh of eight children born to Cephas Thompson, an itinerant portrait painter. In 1831, at the age of seventeen, the junior Thompson began painting portraits in Barnstable, on Cape Cod, earning a considerable local reputation. He moved to New York City in 1835, and for the next ten years worked primarily on portraits—from 1842 to 1844, on commissions in the South—which he exhibited intermittently at the American Academy of Fine Arts and at the National Academy of Design.

Thompson began painting genre subjects as early as 1848, and by 1850 had begun combining them with carefully observed landscape settings, showing a preference for picnic or sporting scenes. During the 1850s, Thompson became acquainted with New York landscape painters, including Asher B. Durand and Jasper Cropsey, and he frequently sketched in oils from nature. He was elected an Associate of the National Academy in 1851, and a year later traveled to England for two years of study.

In 1860, Thompson painted the first of a succession of "pencil ballads"—illustrations of popular songs and poems—that were widely sold in the form of chromolithographs and won him nationwide renown, as well as considerable wealth. From about 1861 to 1863 he traveled in the West, especially in Minnesota. His trip inspired a series of western subjects, mostly genre, and several pictures, done in the 1870s, based on Longfellow's poem *The Song of Hiawatha*. In the same decade, Thompson also painted several allegorical pictures on the model of *The Voyage of Life* and *The Cross and the World* by Thomas Cole.

In 1876, eleven years after the death of his first wife, Thompson remarried. Two years later, he bought an estate in Glen Gardner, New Jersey, where he lived until his death.

Select Bibliography

Donelson F. Hoopes. "Jerome B. Thompson's Pastoral America." In *Art and Antiques* 1 (July–August 1978), pp. 92–99.

Lee M. Edwards. "The Life and Career of Jerome Thompson." In *The American Art Journal* 14 (Autumn 1982), pp. 5–30.

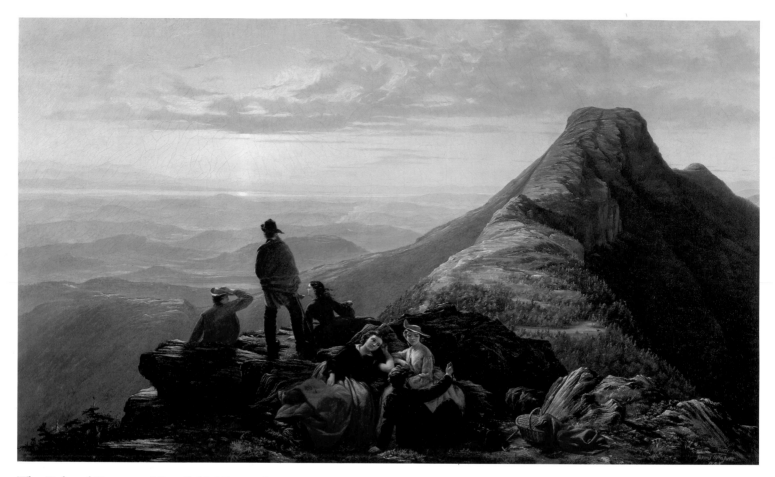

The Belated Party on Mansfield Mountain, 1858

Oil on canvas, 38 × 63⅛ in. (96.5 × 160.3 cm.)
Signed and dated at lower right: Jerome Thompson/1858
The Metropolitan Museum of Art, New York City. Rogers Fund, 1969
 (69.182)

Thompson's oeuvre is distinguished chiefly for attractive combinations of landscape and genre, the two most popular categories of American painting in the mid-nineteenth century.[1] Thompson began his career as a portraitist, but turned to genre painting by 1850; before the end of the decade his pictures were frequently reviewed as landscape paintings at National Academy of Design exhibitions.

The Belated Party on Mansfield Mountain derives its title from a quiet exchange taking place among the members of a group at the base of the scene.[2] A seated young man holds up his pocket watch to warn of the lateness of the hour (connoted also by the setting sun) and the need for the party to descend before dark. Wearied from the climb, two young ladies react to his warning with indifference or dismay; to their left, three companions taking in the prospect of the peak, perhaps considering the challenge of climbing it, ignore him completely. A wicker basket at the right indicates that they have had a picnic here or along the way. The group is situated on the so-called Nose, one of the several peaks

composing Mansfield Mountain, in northern Vermont. The Chin, the highest elevation in the state (4,393 feet), is the rocky summit at the right, and Lake Champlain is the dimly visible plane of water on the horizon.[3]

The painting, which Thompson submitted to the 1859 Academy exhibition along with his *Haymakers* (1859; private collection), also showing the mountain in the background, is one of several with Vermont or Mansfield Mountain settings that he and other artists exhibited at the Academy between 1857 and 1860.[4] Also shown at the Academy in 1859, in the same gallery, was Sanford R. Gifford's *Mansfield Mountain* (ill.),[5] of nearly the same size as *The Belated Party* and with similar scenery. The following year, Richard Hubbard exhibited his own large *Mount Mansfield, Vermont* to considerable acclaim.[6]

The pictures by Thompson, Gifford, and Hubbard reflect a surge of interest and activity in the Green Mountains of Vermont in the 1850s. The region had been ignored by sightseers previously, but the introduction of the railroad into the interior of the state and the publication of guidebooks and articles recommending the Green Mountains encouraged the tourism that was to become a mainstay of Vermont's economy.[7] Interest in the panorama to be viewed from Mansfield Mountain was probably excited by factors other than the mountain's lordly height. In 1854, Zadock Thompson (a distant relative of the artist) published his *Northern Guide,*

in which he drew attention to the "exceedingly fine" prospect from the Chin of Mansfield Mountain: "On the west the whole valley of Lake Champlain appears spread out as a Map, bounded by the lofty and picturesque Adirondacks on the south-west, and opening in the north-west into the valley of the St. Lawrence to the city of Montreal."[8]

In 1858, the growing number of summer visitors to the mountain led to the construction, between the Nose and the Chin, of the Summit House hotel, with a carriage path winding up to it.[9] Probably, it was during that same summer that Gifford sketched on the mountain and Thompson painted a small, rough oil sketch (Kennedy Galleries, New York) that is obviously the basis for *The Belated Party*.[10] While there is no evidence that the two men met in Vermont, the striking resemblance between Gifford's *Mansfield Mountain* and Thompson's painting attests to the picturesque appeal provided by the vista from the Nose, bounded at the north by the beetled pyramid of the Chin, in the splendor of a summer sunset. Gifford, by elongating his painting, casting over it a hazy veil, and adding to it small and rugged figural types, restored a wilderness flavor to the scene he depicted.[11] Characteristically dividing his attention between landscape and figure, Thompson portrayed the more genteel adventurers who reflected the region's altered conditions. In effect, he was challenging the scenic stereotype so often cherished by the Hudson River School painters.

When contrasted with the sunny aspect of Thompson's other Vermont paintings, the deeper tonality and more solemn mood of *The Belated Party* have caused a few modern critics to interpret the work as a wistful eulogy to the age of Edenic innocence that preceded the Civil War—even as a premonition of the approaching conflict.[12] Though to credit Thompson with clairvoyance is hazardous, it has been noted that such features of the picture as the watch and the setting sun could be considered symbolic of the transience of human life,[13] especially when seen against the permanence of Nature embodied by Mansfield Mountain.

No doubt because *The Belated Party* was more somber in feeling than *The Haymakers* and was relegated to the last gallery in the 1859 Academy exhibition,[14] the work attracted relatively little notice. The critic for *The Home Journal* nevertheless found merit in the characterization of the young man with the watch, remarking, "In the long descent of the valley, you feel the urgency of his summons for departure, in conflict with the desire to wait and watch the sun disappear beyond the far distant dim line where earth and sky blend in the blaze of light."[15] Of the picture's formal qualities, he commented that the "sense of space and aerial gradation is quite successfully given, the drawing generally good, the figures skilfully introduced," but saw the silvery glow the painting possesses as "somewhat over-gray and monotonous."[16]

The Belated Party was purchased before the Academy exhibition by one H. Anderson. It was later acquired by Uriah Allen, a New Jersey artist, but disappeared after the 1876 auction of his estate.[17] It came to light in 1969, when it was discovered by a carpenter in the loft of a barn being demolished near Philadelphia.

K.J.A.

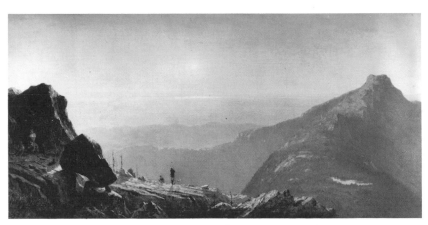

Sanford R. Gifford, *Mansfield Mountain*, 1859, oil on canvas, 30 x 60 in. (76.2 x 152.4 cm.). Private collection

Notes

1. Henry T. Tuckerman singled out Thompson for his "rustic scenes, half landscape and half rural labors or sport." Quoted in Edwards 1982, p. 5.
2. The title, given for the painting's exhibition at the Academy in 1859, was explained by a critic for *The Home Journal*. Quoted in Edwards 1982, p. 15.
3. [Walter H. Crockett], *Vermont Lakes and Mountains* (Montpelier, Vt.: Vermont Bureau of Publicity, 1932), p. 9. For 19th- and 20th-century photographs of the Mansfield Mountain Chin, taken from the Nose, that are comparable to the imagery in Thompson's painting, see William C. Lipke and Philip N. Grime, eds., *Vermont Landscape Images, 1776–1976*, exh. cat. (Burlington, Vt.: Robert Hull Fleming Museum, 1976), p. 69; Ray Bearse, ed., *Vermont; a Guide to the Green Mountain State* (Boston: Houghton Mifflin Co., 1968), ills. following p. 156.
4. According to a letter Thompson wrote to Asher B. Durand, dated 3 July 1856, Sherburne, Rutland County, Vermont, he was sketching in Vermont as early as 1856. Durand Papers. At the Academy, Thompson exhibited in 1857 *Recreation* (no. 126; Fine Arts Museums of San Francisco); in 1858, *Apple Gathering*, set in Vermont (no. 23; Brooklyn Museum). In 1858, he was reportedly at work on *The Gathering of Vermonters Previous to the Battle of Plattsburg* (location unknown). See Edwards 1982, pp. 10, 12–16.
5. The picture was rediscovered in 1985 in a house in New Jersey.
6. Cowdrey 1943, 1, pp. 182 (no. 791), 242 (no. 470); 2, p. 158 (no. 775).
7. W. Storrs Lee, *The Green Mountains of Vermont* (New York: Henry Holt and Co., 1955), pp. 203–4.
8. Zadock Thompson, *Northern Guide* (Burlington, Vt.: S. B. Nichols, 1854), pp. 34–35.
9. Lee, *Green Mountains*, pp. 206–7.
10. The oil sketch is reproduced in Hoopes 1978, p. 98. For Gifford's trip to Mansfield Mountain, see Weiss 1977, p. 176.
11. In another painting of the mountain (1859; National Academy of Design), Gifford included Indian inhabitants who had long since been driven from the region.
12. Hoopes 1978, p. 98; Edwards 1982, p. 15.
13. Edwards 1982, p. 15.
14. See *Catalogue of the Thirty-Fourth Annual Exhibition of the National Academy of Design, 1859* (New York, 1859), p. 46. Thompson's painting, no. 775, was hung in the sixth and last room of the Galleries Tenth-Street, near Broadway, where the Academy annuals were then held.
15. Quoted in Edwards 1982, p. 15.
16. "Fine Arts. The National Academy of Design," *The Home Journal*, 4 June 1859, p. 2.
17. Cowdrey 1943, 2, p. 158. See also *Private Gallery of Fine Modern Paintings Belonging to Uriah Allen, Esq., Jersey City*, sale cat., The Messrs. Leavitt, Auctioneers, 817 Broadway, New York, 5 and 6 April 1876, no. 27, listed as *Belated Party, Mount Mansfield*.

JOHN F. KENSETT
(1816–1872)

Eulogized by the Honorable George William Curtis of New York as "a man of great gifts, and of the sweetest nature," John Frederick Kensett throughout his nearly forty-year career enjoyed the affection of his fellow artists, the support of collectors, and the enthusiastic approbation of the general public. A prolific painter and regular participant in the major exhibitions of his day, Kensett had a congenial personality that led him to positions of leadership in many important art organizations. He was a member of the United States Capitol Art Commission in 1859, the principal organizer of New York's Sanitary Fair Exhibition in 1864, a founding trustee of The Metropolitan Museum of Art in 1870, and, at his death in 1872, president of the Artists' Fund Society.

Born in Cheshire, Connecticut, in 1816, Kensett received his first artistic training from his father, Thomas, and an uncle, Alfred Daggett, both engravers. During the 1830s, he worked in print shops in New York, New Haven, and Albany, but grew increasingly restless at the engraver's trade and eager for a career in the fine arts. In 1840, he sailed for Europe, where he lived and worked in England and Paris and toured the Rhine region, Switzerland, and Italy.

On his return to New York late in 1847, Kensett's artistic career began to flourish. He was elected an Associate of the National Academy of Design in 1848; in 1849, the year he was also elected to the prestigious Century Association, he was made an Academician. During that period, he established what would become his lifelong working practice: he spent the summers sketching the White Mountains, Lake George, the Newport coast, or the Adirondacks and the winters painting in his Washington Square studio. He occasionally visited more exotic locales (the Mississippi River in 1854 and 1868, the American West in 1857 and 1870, and Europe in 1856 and 1867), but it was the picturesque scenery of New York and New England that most attracted him and that became the subject of his best pictures.

Although Kensett's initial popularity stemmed from a series of classically balanced, arcadian landscapes he produced in the 1850s, by the 1860s he had evolved another manner, for which he is most admired today. It consists of an asymmetrical, reductive composition; a subdued, near-monochrome palette; and an interest in the effects of light and atmosphere rather than topography. That style culminated in what is called the "Last Summer's Work," a group of almost forty paintings Kensett executed in the summer of 1872, the last of his life. He died of heart failure that December, at the age of fifty-six.

Select Bibliography

Ellen H. Johnson. "Kensett Revisited." In *The Art Quarterly* 20 (Spring 1957), pp. 71–92.

John K. Howat. *John Frederick Kensett, 1816–1872*. Exhibition catalogue. New York: American Federation of Arts, 1968.

John Paul Driscoll. *John F. Kensett Drawings*. Exhibition catalogue. University Park, Pa.: Museum of Art, The Pennsylvania State University, 1978.

John Paul Driscoll and John K. Howat. *John Frederick Kensett: An American Master*. Exhibition catalogue. Worcester, Mass., and New York: Worcester Art Museum in association with W. W. Norton & Company, 1985.

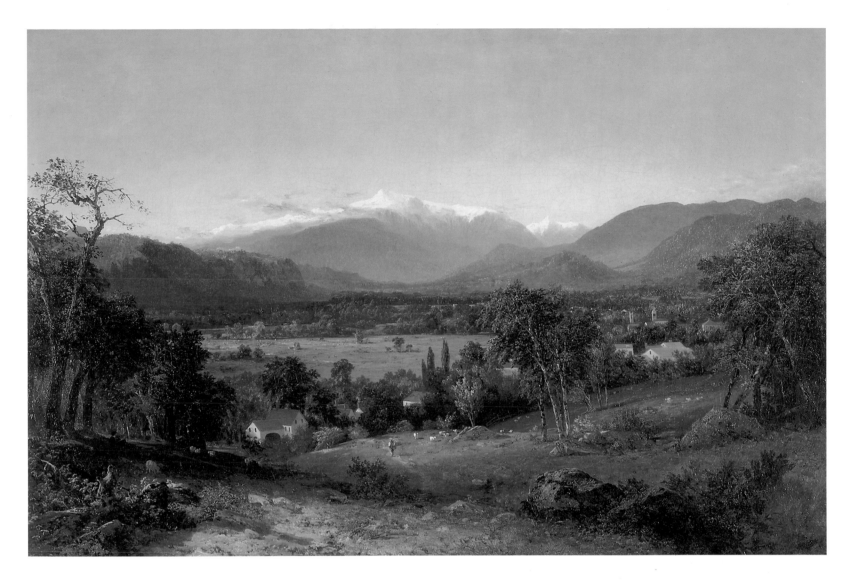

The White Mountains—Mt. Washington, 1851

Oil on canvas, 40 × 60 in. (101.6 × 152.4 cm.)
Signed at lower right: J.K.
Collection of The Wellesley College Museum, Wellesley, Massachusetts.
 Gift of Mr. and Mrs. James B. Munn (Ruth C. Hanford, Class of
 1909) in the name of the Class of 1909

Explorers and naturalists, artists and writers had visited the White Mountains as early as the 1780s, but it was Thomas Cole's concept of the region that first captured the public's imagination in the early years of the nineteenth century. In paintings such as *View in the White Mountains* (1827; Wadsworth Atheneum) and *Storm near Mount Washington* (ca. 1825–30; Yale University Art Gallery) and culminating with the dramatic *Notch of the White Mountains* (1839; National Gallery of Art), Cole had presented the mountains

as wild, forbidding country, demonstrating on his canvases man's frailty in the face of the mysterious and often violent power of nature. The region of the White Mountains, and especially Mount Washington, its most magnificent site, was perceived as savagely beautiful and dangerous, and it remained sparsely settled and resistant to cultivation and tourism until the 1840s, when the railroads came. By 1850, the year Kensett, Benjamin Champney, and John Casilear first summered at North Conway, New Hampshire, a new era had begun.

At mid-century, the population of Conway and North Conway, counted together, approached two thousand. By 1851, the railroad was bringing travelers to within eight miles of Mount Washington, and several hotels—the Glen House, the Crawford House, Thompson's Tavern (where Kensett and Champney stayed)—were built to accommodate them.[1] Although Kensett wrote his friend Thomas P. Rossiter in 1850 that there were not many tourists in North Conway,[2] by 1853, some forty artists were known to be stopping there.[3] A number of guidebooks to the White

Figure 1. John F. Kensett, *Sketch of Mount Washington*, 1851, oil on canvas, 11⅜ x 20 in. (28.9 x 50.8 cm.). The Corcoran Gallery of Art, Gift of William Wilson Corcoran, 1868 (69.74)

Figure 2. James Smillie, after Kensett's *The White Mountains—Mt. Washington*, engraving, 1851, 7 x 10⅜ in. (17.8 x 26.4 cm.). Courtesy, American Antiquarian Society

Mountains were published in that decade, all recounting with great relish the alarming Indian legends about the area and the gruesome stories of those who had perished in earlier days, but all emphasizing the present-day pleasures and safety of travel in the mountains.[4] That by the 1850s the White Mountains had come to be perceived as radiantly benign and an ideal subject for artists was expressed in the most famous of those guidebooks, *Incidents in White Mountain History*:

> One who visits the Conway meadows, sees the original of half the pictures that have been shown in our art-rooms in the last two years. All our landscape painters must try their hand at that perfect gem of New England scenery. One feels, in standing on that green plain,

with the music of the Saco in his ears, hemmed in by the broken lines of its guardian ridges, and looking up to the distant summit of Mount Washington, that he is not in any country of New Hampshire, not in any namable latitude of this rugged earth, but in the world of pure beauty—the *adytum* of the temple where God is to be worshipped, as the infinite Artist, in joy.[5]

Kensett's *White Mountains—Mt. Washington*[6] was the most celebrated image of that region to be produced in the 1850s and was the perfect embodiment of the new, sanguine regard for New Hampshire's most famous vista. It depicts the flat, verdant Intervale from the elevated perspective of Sunset Hill in North Conway. The viewer's eye traverses the canvas along the diagonal of the little town's main road, past a white house (which would become Champney's house and studio), the Baptist Church, and the Academy (where George Inness worked in the 1870s), and then back along a path of greenery toward the sheltering hills, ultimately arriving at the commanding, snow-covered Mount Washington some fifteen miles away. The warm, golden light of this composition and its classic balance, with framing elements at left and right and a gentle zigzag movement into the picture's space, were inspired by Claude, the European master Kensett most admired, and capture the sense of supreme beauty and grandeur that guidebooks advertised for the spot. Civilization is indicated by the row of well-maintained houses, the picturesque flock of sheep, and the young man placidly returning home at the end of the day. For the rest of his career Kensett would remain faithful to the world view he presented here: nature as essentially benevolent, and the wilderness as a graceful, ordered, and harmonious setting for human activity.

Several drawings—studies of individual birch trees, for the most part—and compositional studies in pencil and in oil preceded *The White Mountains—Mt. Washington*. While an oil sketch (Fig. 1), showing a centralized view of the beneficent mountain and foothills surrounding a somewhat compressed valley floor, most closely anticipates the arcadian mood of the final image, there is no precedent in Kensett's early work for the scale and ambitious composition of this picture. He had already won the attention of his fellow artists, having been elected to the National Academy of Design and the Century Association in 1849 and to the Sketch Club the following year, but it seems he was seeking—and indeed attained—a wider audience with *The White Mountains*. The painting was acquired in 1851 by the American Art-Union, was reproduced in an engraving by James Smillie (Fig. 2), and in that form was circulated to the Art-Union's more than thirteen thousand subscribers. Subsequently, Kensett's design was the source for a lithograph published by Currier and Ives (*Mount Washington and the White Mountains from the Valley of Conway*, by Frances Flora Bond [Fanny] Palmer, ca. 1860), through which Kensett's interpretation of the scene reached many more households.

The afterlife of Kensett's concept makes clear the degree to which his bucolic vision had captured the public's imagination. He painted several more views of the North Conway area in the succeeding decade,[7] and returned to the compositional program, the

large scale, and, above all, the pastoral imagery of *The White Mountains—Mt. Washington* for his most important commission: a picture of nearby Mount Chocorua, painted in 1864–66 for the Century Association. Several other artists, among them Frederic Church, Benjamin Champney, and David Johnson, made paintings of Mount Washington that were strongly influenced by Kensett's, and a number of lesser talents copied his canvas almost exactly.[8] Thus, although Kensett's work entered a private collection in 1852, after the auction sale following the dissolution of the American Art-Union, and was not again available to the public until 1977, when it was bequeathed to The Wellesley College Museum, it nonetheless remained for several generations the signature image of the White Mountains.

C.T.

Notes

1. Donald D. Keyes, "Perceptions of the White Mountains: A General Survey," *The White Mountains: Place and Perceptions*, exh. cat. (Durham, N. H.: University Art Galleries, University of New Hampshire, 1980), p. 44.

2. Kensett to Rossiter, 22 September 1850, Kensett Papers. Archives of American Art, microfilm roll no. 033, frames 389–96.

3. Keyes, "Perceptions." See also Samuel C. Eastman, *The White Mountain Guidebook* (Concord, N. H.: Edison C. Eastman, 1858), p. 131, where North Conway is identified as "the favorite resort of our New England artists."

4. "Many fancy that there is much danger attendant upon a visit to this famous place; but the fact that no serious injury has been suffered by the thousands who here climb to the clouds, with the exception of this solitary case [an accident resulting in the death of a 'young English baronet' who attempted to climb Mount Washington alone late in October 1851], ought to make assurance double, that . . . danger here is trifling." John H. Spaulding, *Historical Relics of the White Mountains. A Concise White Mountains Guide* (Boston: Nathaniel Noyes, 1855), p. 62.

5. Benjamin G. Willey, *Incidents in White Mountain History* (Boston: Nathaniel Noyes, 1856), p. 174.

6. Elsewhere, the painting has been referred to by the title *The White Mountains—From North Conway*. See, for example, Driscoll and Howat 1985, pl. 4, p. 65.

7. For example, *October Day in the White Mountains* (1854; Cleveland Museum) or *Conway Valley, New Hampshire* (1854; Worcester Art Museum).

8. For example, Otto Sommer, *View of Conway Valley* (n. d.; private collection). See also Benjamin Champney, *The White Mountain ECHO and Tourist Register*, 12 August 1893, as quoted in Charles and Gloria Vogel, "Painters in the White Mountains, 1850," *The Magazine Antiques* 119 (January 1981), p. 236: " . . . the fine picture became widely known and interested artists and others in our mountain scenery. So much so that the next season many artists followed in our wake bringing friends and lovers of mountain scenery with them."

Bash-Bish Falls, 1855

Oil on canvas, 36 × 29 in. (91.4 × 73.7 cm.)
Signed and dated at lower right: JF. (monogram) K. 55
National Academy of Design, New York City

Kensett painted Bash-Bish Falls at least five times between 1852 and 1860. The site, a lively waterfall formed by a runoff through the Berkshire Mountains near South Egremont, in the southwest corner of Massachusetts, was in the mid-nineteenth century the object of romantic pilgrimages. The subject itself—a picturesque cascade through a forested gorge—was one in which Kensett specialized in the 1850s, also painting Trenton, Rydal, and Catskill falls (as well as Niagara) in that decade. The present picture, made for Kensett's friend the painter and collector James Suydam and exhibited at the National Academy of Design in 1858, is virtually identical in composition to a slightly smaller work, blond rather than silvery in tone, which Kensett sold for three hundred dollars to New York Governor Hamilton Fish in 1855 (ill.).[1] Both works show a frontal view of the falls, with cliffs rising more or less symmetrically on either side of the cascade. The same general composition recurs in *Woodland Waterfall* (ca. 1855; Nelson-Atkins Museum), a contemporary representation of a narrower, rockier gorge beneath a stormy sky.

A writer for *The Crayon* described Bash-Bish Falls in 1855 as "one of the wildest and most beautiful cascades in the country."[2] The romantic fascination of the site was enhanced by a celebrated Algonquin legend that Kensett must have known, although none of his pictures of Bash-Bish alludes to it directly.[3] For him, the chief attraction of Bash-Bish Falls was not its wildness or the myths connected with it but the natural grandeur and beauty of the spot. His image is measured and restrained compared with the fearsome waterfall views, rich in historical and literary associations, that were immortalized by earlier landscape painters Kensett admired, especially J. M. W. Turner and Thomas Cole.[4] Kensett's challenge in painting Bash-Bish Falls was to persuade his audience of its breathtaking height and rugged beauty while remaining faithful to the cool, muted palette, well-balanced composition, and modest scale with which he worked most comfortably.

Kensett dramatized the great height—some two hundred and seventy-five feet—of the gorge by replacing the tiny oval shape he had chosen for a previous picture of Bash-Bish (1851; Lyman Allyn Museum) with a larger, vertical format, which among Hudson River School painters only he and Durand used repeatedly and successfully. Further, instead of showing the falls from the usual tourist's perspective (that is, gazing down into the gorge from the high, narrow bridge), Kensett selected a very low vantage point, nearly at the base of the lower pool, with massive boulders rising on either side and thick trees arching overhead. The high horizon, the dense foliage forming a lacy screen across the picture surface, and the tiny, fragile-looking bridge contrasting with the rocky walls

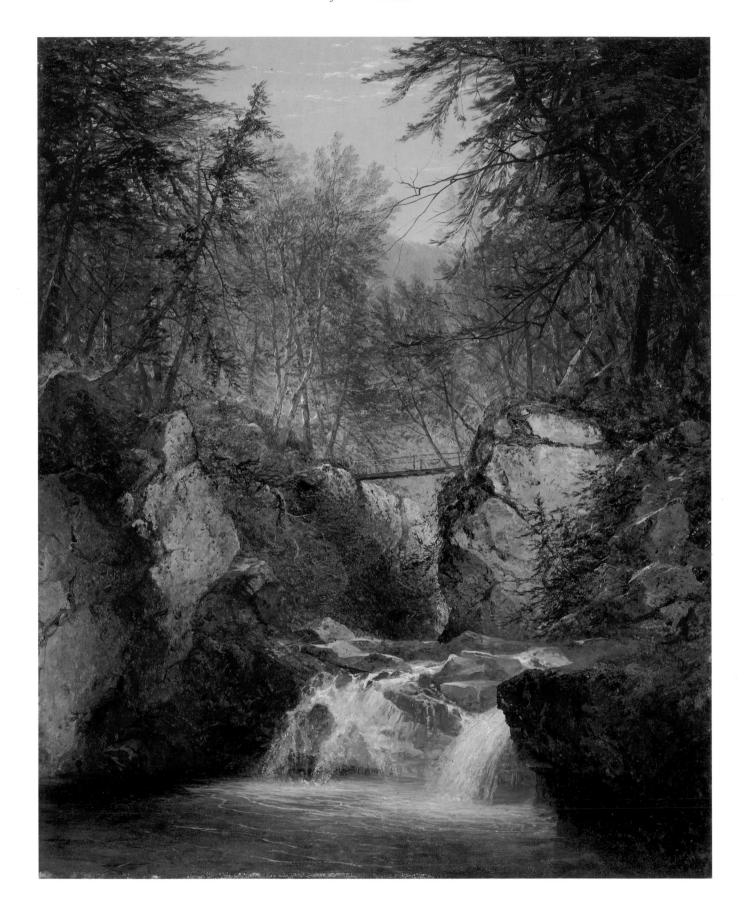

John F. Kensett, *Bash-Bish Falls, South Egremont, Massachusetts*, 1855, oil on canvas, 29½ x 24 in. (74.9 x 61 cm.). Courtesy, Museum of Fine Arts, Boston, Bequest of Martha C. Karolik for the Karolik Collection of American Paintings, 1815–1865 (48.437)

3. The tale describes the fate of an Indian maiden, who, driven to madness because she was unable to bear a child to the son of the chief of the tribe, fell prey to the summons of the witch of the cascade and disappeared into the swirling wake. Her horrified lover threw himself into the falls after her and was drowned. See Richard V. Happel, "Notes and Footnotes," *The Berkshire Eagle*, 24 April 1980, p. 24, quoted in *Next to Nature*.

4. See, for example, Turner's watercolor *The passage of Mount St. Gothard, taken from the center of the Teufels Broch, Switzerland* (1804; Abbot Hall Art Gallery, Kendal, Cumbria) or Cole's primeval *Katterskill Falls* (1826; Wadsworth Atheneum) and his *Scene from Byron's "Manfred"* (1833; Yale University Art Gallery).

it spans exaggerate the great height of the falls. At the same time, these features deprive the spectator of any peripheral view and virtually eliminate his understanding of deep space. Kensett's lively brushwork and clear, dark colors animated by tiny highlights create a sparkling, silvery surface. His careful alternation of light and shade—from the dark, cavernous foreground space, to a sunlit glade barely glimpsed in the middle ground, to the softer shadows near the horizon—also confounds any impression of distance. Standing at the base of the falls, cut off from the rest of the woodland, the viewer sees not the potential treachery and terror of the falls but looks up in wonder at a magical, otherworldly grotto, a place of private enchantment.

C.T.

Notes

1. *Next to Nature: Landscape Paintings from the National Academy of Design* (New York: American Federation of Arts, 1980), p. 121.

2. "Domestic Art Gossip," *The Crayon* 2 (July 1855), p. 57.

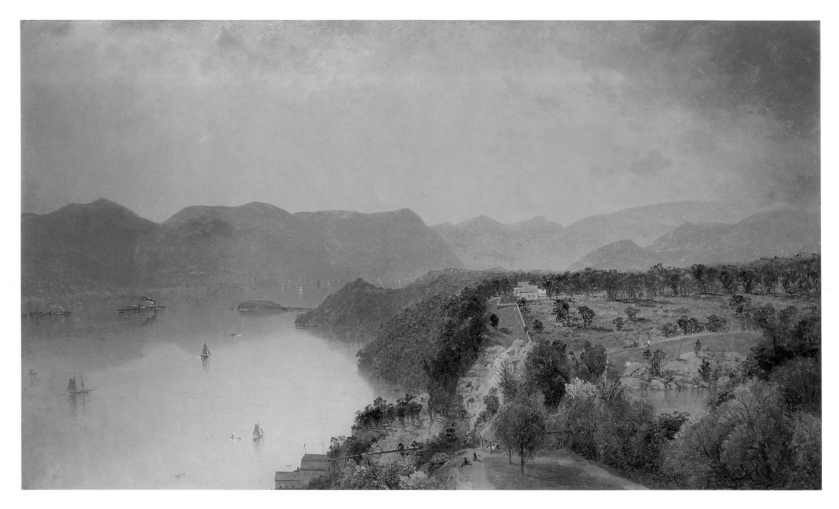

View from Cozzens' Hotel Near West Point, 1863

Oil on canvas, 20 × 34 in. (50.8 × 86.4 cm.)
Signed and dated at middle bottom: JFK '63
The New-York Historical Society, New York City. The Robert L. Stuart
 Collection, on permanent loan from the New York Public Library,
 1944 (Stuart 189)

By the outbreak of the Civil War, Kensett's career was flourishing. For almost a decade he had been showing half a dozen pictures or more at the annual exhibitions of the National Academy of Design. He sold between fifteen and twenty canvases a year (in addition to works produced on commission), and, although his pictures never attained the five-figure prices commanded in those days by Frederic Church or Albert Bierstadt, he enjoyed a healthy income (generally earning several hundred dollars per canvas) and the patronage of New York's leading collectors, many of whom had also become his personal friends. One of the most avid collectors of his work was the sugar magnate Robert L. Stuart, who owned *View from Cozzens' Hotel Near West Point* and at least four other paintings,

having acquired the first in 1859. Of these, he seems to have favored the imposing *White Mountain Scenery* (1859; New-York Historical Society), which he commissioned, then subsequently lent to the National Academy of Design in 1859, to the Exposition Universelle in Paris in 1867, and to the Centennial Exposition in Philadelphia in 1876. *View from Cozzens' Hotel*, taken from the hotel's site on the Hudson about forty miles north of New York City, was also painted on Stuart's order,[1] possibly as a memento of a pleasant excursion. The hotel was operated by William Cozzens, who was also the proprietor of the famed American Hotel in Manhattan and the uncle of humorist and writer Frederick S. Cozzens. Stuart, Kensett, and Frederick Cozzens were all members of the Century Association and as such part of the same social, intellectual, and artistic circle that flourished in New York City at mid-century.

Kensett had visited the West Point area of the Hudson before, most notably in the summer of 1853, when he made sketches that probably contributed to the large-scale *Hudson River Scene* (ill.), which was purchased for five hundred dollars by Shepard Gandy, another prominent New York collector, the year it was executed.[2] That painting, Kensett's most important representation of the site before *View from Cozzens' Hotel*, is far more conventionally composed than the present picture and, for all the rough grandeur of

the natural forms it depicts, retains a pastoral flavor, with white-sailed boats gliding effortlessly across glassy water and the central foreground occupied by a group of picnickers, one of them a woman whose vivid red coat acts as a magnet to the eye.

Many of the same motifs are found in *View from Cozzens' Hotel*—the mirrorlike water, the rocky hillside sprinkled with tiny houses, and the brightly dressed tourists (here gathered around the gazebo in the foreground)—yet the entirely different representations of this scene demonstrate Kensett's evolution from a classically ordered, Claudean compositional style to an independent, innovative manner. *View from Cozzens' Hotel*, a much smaller work than *Hudson River Scene*, is asymmetrical rather than harmoniously balanced, is cooler in tone, and makes use of a dramatically elevated perspective almost without precedent in the artist's work.

The master of the panoramic, omniscient vantage point was, of course, Frederic Church, with whose gargantuan, sensational pictures Kensett's more modest and restrained work was sometimes favorably compared,[3] but whose fame and market were nonetheless far greater than Kensett's at the time. In such works as *The Andes of Ecuador* (1855; Reynolda House) or *Cotopaxi* (see p. 254), Church assumed an exaggeratedly high vantage point almost on a plane with a distant peak or the fiery sun. Such a viewpoint—directly opposite a great, centrally placed mountain peak or another heroic motif—suggested an association between the divine Creator and the artistic creator who stood at that impossible spot to survey, then replicate, the magnificent panorama before him. Kensett, though describing the Hudson from a similarly elevated position, did not attempt a theatrical rearrangement of natural elements to emphasize an iconic form. Instead, attracted to the picturesque irregularities of the scene before him, he recorded a placid, deeply satisfying image of what a modern scholar has aptly called "charming arcadian vistas cast in a bell jar world."[4]

The composition in *View from Cozzens' Hotel*, more rudimentary than that of most of Kensett's previous efforts, is based on an asymmetrical arrangement of four simple elements: land, water, sky, and a band of distant hills. The perspective is strangely distorted: while the river and the cliffs lining it define a logical progression into space, the high plateau in the foreground does not recede naturally into the distance but is presented as a flat, sharply rising plane. Its warm autumnal colors, contrasting markedly with the cool grays of the water, the distant mountains, and the stormy sky, throw the hillside into relief against the atmospheric backdrop. In few other works by Kensett is one so aware of line: the jagged profile formed against the water by the foreground cliffs; the crisp silhouette of the mountains standing out against the sky, its edge all the more prominent for Kensett's careful pencil underdrawing still visible beneath the thinly applied pigment.

As a result of the small size of the canvas and especially of the elevated vantage point, such objects as trees, houses, and boats are depicted on a miniaturist's scale. In the absence of any rhythmic groupings or clear focus, the almost naive accumulation of details on the foreground plateau runs counter to the careful opposition

John F. Kensett, *Hudson River Scene*, 1857, oil on canvas, 32 x 48 in. (81.3 x 121.9 cm.). The Metropolitan Museum of Art, Gift of H. D. Babcock, in memory of his father, S. D. Babcock, 1907 (07.162)

of natural and man-made forms that characterized Kensett's earlier works. The paint handling remains sophisticated, but the reductive composition, the disjointed treatment of space, the additive arrangement of foreground details, and the particularized drawing—especially of the houses, which refuse to conform to any consistent perspectival scheme, and of the odd, walled-in meadow at the center of the canvas—have an almost primitive flavor. It is as though Kensett were seeking a new, more natural voice with which to express his reactions to the panorama before him. His vision in this painting is more reminiscent of the work of Martin Johnson Heade and Fitz Hugh Lane than that of more traditional masters such as Church. Here, Kensett's approach seems deliberately anti-classical, a clear departure from the well-made pictures, including *The White Mountains—Mt. Washington* (see p. 149) or *Hudson River Scene*, that had been his mainstay in the previous decade and that seem to have been preferred by his patrons, Stuart and Gandy among them. *View from Cozzens' Hotel Near West Point* is an early essay on the kind of formal arrangement that Kensett would perfect in the succeeding decade, the one on which his present fame rests: asymmetrical, reductive, atmospheric, and, above all, luminous.

C.T.

Notes
1. Koke 1982, 2, p. 242.
2. Spassky 1985, p. 33.
3. See, for example, Jarves 1864, p. 191, as quoted in Rodriguez Roque 1985, p. 156.
4. John Paul Driscoll, "From Burin to Brush: The Development of a Painter," Driscoll and Howat 1985, p. 70.

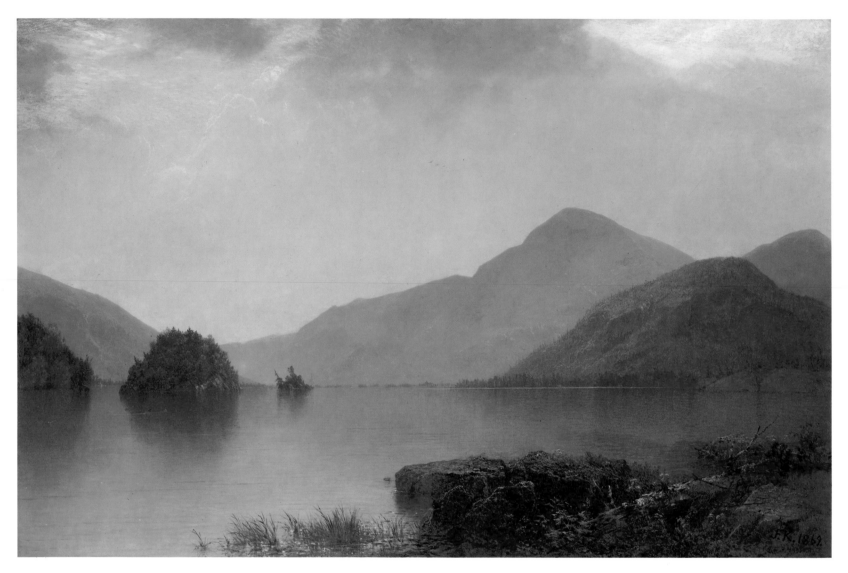

Lake George, 1869

Oil on canvas, 44⅛ × 66⅜ in. (112.1 × 168.6 cm.)
Signed and dated at lower right: J.F. (monogram) K. 1869.
*The Metropolitan Museum of Art, New York City. Bequest of
Maria DeWitt Jesup, from the collection of her husband,
Morris K. Jesup, 1914 (15.30.61)*

Although from mid-century many artists, amateur and professional, were drawn to Lake George, few found the lake and surrounding Adirondack scenery as compelling as Kensett did.[1] He made at least a dozen formal compositions of the lake during his long career; the earliest of his depictions of it were probably produced about 1850. He was at Lake George for a month in 1853, making exquisite pencil sketches of single trees, compositional studies in pencil and in oil, and, originating from that and sub-

sequent visits, a series of handsome finished canvases that were eagerly sought after by such prominent New York collectors as A. M. Cozzens and Robert Olyphant.[2] Kensett showed at least six paintings representing Lake George at the National Academy of Design between 1859 and 1869. The next year, he painted a small, lively view of the lake during an autumn storm (1870; Brooklyn Museum) and in 1872, the last summer of his life, he produced a group of sketches based on his memories of the lake, possibly renewed on a subsequent visit.

That Kensett considered the present *Lake George* to be an especially important undertaking is indicated by the high price (three thousand dollars) he charged his patron the banker and philanthropist Morris K. Jesup for the scene and by its ambitious size—at more than forty-four by sixty-six inches, it was one of the largest he ever painted.[3] Until the mid-1860s, almost all Kensett's paintings had been of moderate dimensions, their scale affording an intimacy appropriate to the modesty of their themes. At that point, perhaps stimulated by the prestige of an 1864 commission

from the Century Association (realized in the Century's *Mount Chocorua*), Kensett began working larger, not always with felicitous results. Many of the pictures he produced in that grander format are overcomplicated panoramas, having numerous coulisses defining multiple layers of space, stuffed with picturesque details, and rendered with busy, fussy brushwork. In *Lake George*, however, Kensett eliminated detail rather than manufacturing it. He reduced his composition to a few strong, perfectly placed shapes and his palette to warm, golden shades of brown and green. The result is Kensett's most serene and harmonious picture, the culminating example of his great Lake George canvases.

Kensett chose to paint this version of Lake George from Crown Island, off Bolton's Landing on the western shore, looking northeastward across the lake toward the Narrows.[4] The view is very much simplified; Kensett's decision to paint a reductive, stately, and above all beautiful Lake George reflects a mature artistic voice. Here is neither the obsessive preoccupation with detail characteristic of Asher B. Durand nor the taste for sublime melodrama often exhibited by Frederic Church and Albert Bierstadt. Kensett did not feel obliged to show every island actually visible from his chosen vantage point, nor did he attempt to enhance the drama of his vista by featuring a violent climatic change, by showing an expansive panorama from an elevated point of view, or by including staffage figures to provide a reminder of man's diminutive stature in the face of nature's grandeur. He selected instead a vantage point low to the ground, looking across the still, gray waters of the lake, a distance he seems to have somewhat compressed. A series of land masses, placed alternately at either side of the composition and rendered progressively lighter in tone, guide the viewer's eye through the picture and toward the low horizon.[5] Kensett's mountains are not particularly massive; the largest of them, Mount Erebus, is placed off-center, its elegant contours softened by the low, hazy sun. The one picturesque detail Kensett did include—a figure in a canoe, situated at left in the middle distance and obscured by the shadow of the island—is so understated as to be barely noticeable. What dominates is the light: a soft glow, diffused by autumn mist. Kensett's color is rich, but nowhere bright. He carefully avoided brilliant hues and startling accents, choosing instead a subdued palette and applying translucent glazes to give greater depth and richness to his forms and their reflections.

Lake George appears to be faithful to nature, but at the same time it creates the impression of an ideal, idyllic world. Nature here is grand, benign, and majestically ordered. Tranquil and reassuring, *Lake George* has long been considered the artist's masterpiece, representing him in numerous exhibitions devoted to nineteenth-century American painting. With each display, public and critical reaction echoed that which greeted the painting's debut at the National Academy of Design in 1869: "One of the noblest pictures in the gallery . . . [it] always draws an admiring crowd about it."[6]

C.T.

Notes

1. Casilear, Cropsey, and Gifford, among many others, all painted at Lake George. See their paintings of 1860 (Wadsworth Atheneum and other versions; see also p. 142); 1871 (New-York Historical Society); and 1879 (private collection), respectively. Other than Kensett's picture, the most famous image of Lake George is Heade's eerie painting of 1862 (see p. 166).

2. Cozzens owned a smaller, earlier view of Lake George, richly painted but less daring compositionally than the present picture. It is likely the painting now in the collection of Jo Ann and Julian Ganz, Jr. Olyphant's picture, now in the Corcoran Gallery, was celebrated in its day, having represented Kensett in 1867 both at the National Academy of Design exhibition and at the Exposition Universelle in Paris.

3. Between 1864 and 1869, Kensett painted at least four pictures as large as, or even slightly larger than, *Lake George: Mount Chocorua* (1864–66; Century Association), *Lake George* (1864; Corcoran Gallery), and *Coast Scene with Figures* (1869; Wadsworth Atheneum).

4. Information provided by Peter L. Fisher, Glens Falls Historical Association, as quoted in Spassky 1985, p. 35.

5. The program was first worked out in a pencil drawing of 23 August 1853 (private collection) made at the lake, in which the same movement from island to island and the same evolution from dark to light is used, affording the eye a measured, respectful progression into the depths of the picture.

6. *New York Evening Post*, 27 April 1869, p. 1, as quoted in Spassky 1985, p. 36.

Beach at Newport, ca. 1869–72
Oil on canvas, 22 × 34 in. (55.9 × 86.4 cm.)
Unsigned
National Gallery of Art, Washington, D.C. Gift of
 Frederick Sturges, Jr., 1978 (1978.6.5)

Kensett visited the American West in 1857 and 1870 and traveled up the Mississippi River in 1868, but, unlike Frederic Church and Albert Bierstadt, he did not make the distant and exotic sight his stock-in-trade. Nor did he share with Martin Johnson Heade and Fitz Hugh Lane an affection for the undistinguished, commonplace scene—anonymous marshlands or local inlets—that could be elevated to a more sublime beauty. Kensett's principal subjects were the tourist meccas; his best works were handsome pictures made at favorite resorts and beauty spots.

Newport, Rhode Island, in the 1860s had not yet been invaded by the robber barons—its Breakers and other fabulous palaces were begun in the 1880s and 1890s—but it was already much visited by prominent New York and Boston families. Full of

historical associations and attractive landmarks, among them Bishop Berkeley's Rock, First and Second Beaches, and Spouting Rock, Newport was eminently paintable. Whereas such artists as Heade or John La Farge, who were also working at Newport in the 1860s, sought out its operatic side—the great black thunderstorms electrifying Narragansett Bay or the settings of its romantic legends, impressionistically rendered—Kensett interpreted the local scenery in a more topographical and conventional manner. He first visited Newport about 1854 and returned there frequently, painting all aspects of the terrain. *Beach at Newport* was one of the most harmonious and evocative of those pictures.

Beach at Newport probably depicts one of the many small inlets, created by boulders projecting into the sea, that form the southern coast of Aquidneck Island, the largest island in Narragansett Bay and the one on which Newport is situated.[1] The coast was largely unpeopled. The few figures Kensett does include in his picture—a man carrying a straw basket and a man in a dory, as well as tiny tourists just visible over the hill at the far left—suggest that the area was one not of commerce but of recreation and repose. The compositional arrangement is one Kensett developed and perfected in the 1860s: two masses in harmonious, if asymmetrical,

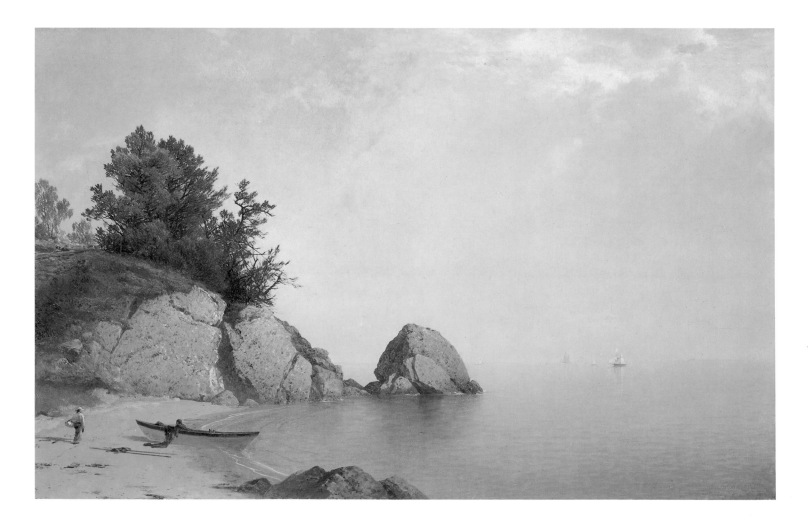

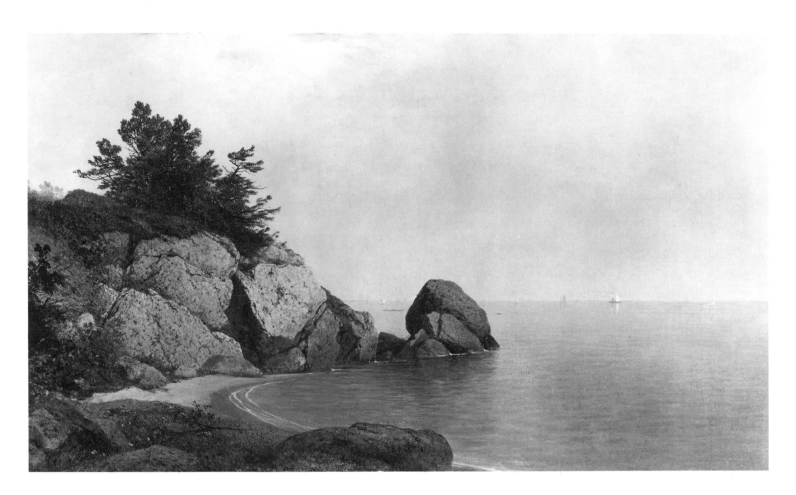

John F. Kensett, *Newport Coast*, ca. 1865–70, oil on canvas, 18¼ x 30¼ in. (46.4 x 76.8 cm.). Courtesy, Amon Carter Museum, Fort Worth

balance—here, a simple spit of land projecting into a body of calm water—with a large part of the composition given over to the sky. The low horizon dotted with tiny sailboats creates an astonishing sense of distance, an effect all the more dramatic because Kensett uses the same soft gray tones and thin, nearly imperceptible brushstrokes for both water and sky, virtually eliminating any distinction between them. By contrast, the rocky promontory, painted much more vigorously and in warm earth colors, has a strong sculptural presence. Kensett seems to have taken this view on a hazy summer's day, when strong shadows were cast upon the beach and the boulders were thrown into high relief against the moist air of the bay.

Kensett painted two very similar images of the beach at Newport, one for Henry Sayles, a Boston collector who owned several Kensetts, and this one for Jonathan Sturges, one of Kensett's New York patrons and a fellow Centurion. The Sayles painting, *Newport Coast* (ill.), the smaller of the two, seems to have been done on a clearer day (the summer's haze is replaced by crisp autumn air) and from a closer, lower vantage point. As a result, large flat rocks come into sight in the immediate foreground, and the large boulders punctuated by a blaze of red foliage seem more vertical

and have a more commanding presence. In *Beach at Newport*, the addition of figures in the foreground provides an anecdotal element—the two men seem to be engaged in conversation—and substantiates the towering scale of the rocks. This composition, however, is generally the more reductive, the more austere of the two, and as such has an even greater sense of timelessness, order, and stillness. Nonetheless, there is no convincing evidence to establish which painting was made first; neither clearly represents a revision or refinement of the other.[2]

C.T.

Notes
1. Robert G. Workman, *The Eden of America: Rhode Island Landscapes, 1820–1920* (Providence, R.I.: Museum of Art, Rhode Island School of Design, 1986), p. 29.
2. I thank Franklin Kelly of the National Gallery of Art for sharing with me his thoughts about the picture.

Eaton's Neck, Long Island, 1872

Oil on canvas, 18 × 36 in. (45.7 × 91.4 cm.)
Unsigned
The Metropolitan Museum of Art, New York City.
 Gift of Thomas Kensett, 1874 (74.29)

Eaton's Neck is situated about eight miles south and slightly east of Contentment Island, off Darien, Connecticut, where Kensett owned nine acres of land and where he maintained a studio in the summer of 1872. It was one of many points of land on either side of Long Island Sound that attracted Kensett's attention that productive summer. Though the landscape has not been rendered with sufficient specificity to be certain, this picture most likely represents the Neck from the Long Island side of the sound, with the Connecticut shore in the far distance. The view, while appealing, is relatively unspectacular; nonetheless, it inspired one of the most striking and dramatic pictures Kensett ever painted.

Eaton's Neck, Long Island is the best-known painting of the legendary Last Summer's Work, a group of about thirty-eight pictures Kensett produced the summer before his death.[1] Admired for its simplicity and clarity, *Eaton's Neck* has been featured in nearly all the monographic exhibitions devoted to Kensett since the Second World War and in many of the important surveys of nineteenth-century American art.[2] The painting, however, seems to have been less appreciated in its own day. Although it was exhibited with most of the Last Summer's Work in a private showing at New York's Twenty-third Street YMCA in the winter of 1872/73 and, subsequently, at the National Academy of Design, *Eaton's Neck* elicited no critical notice. Moreover, it was assessed at only five hundred dollars on an unnamed appraiser's "Memo of the pictures belonging to the Estate of John F. Kensett," when most of the pictures, other than those designated as "small" or as "studies," were valued at between eight hundred and twelve hundred dollars, and several were appraised at fifteen hundred dollars or more.[3] Nor was *Eaton's Neck*—or, for that matter, any of the rest of the Last Summer's Work—shown in a special exhibition again for nearly seventy-five years.

There are many explanations for the relative disregard for *Eaton's Neck* in its own time and our great admiration for it today. In the mid-1870s, it fell victim to the changing taste among collectors and the general public that adversely affected the pictures of the Hudson River School. It may have been seen as somewhat small, even among Kensett's intimately scaled paintings, and therefore minor. Compared with others of the Last Summer's Work, it is not markedly naturalistic; furthermore, it is empty. The modest value assigned it suggests that the appraiser of Kensett's estate regarded it as neither special nor striking. The picture contains no obvious drama: no breathtaking vista or spectacular climatic effects (as in *Sunset on the Sea* [Metropolitan Museum], probably

the picture designated as *Sunset* and assessed at eighteen hundred dollars), no evocative landmark (such as that in *Newport Rocks* [Metropolitan Museum], probably *Newport* [large], fifteen hundred and fifty dollars), or heroic motif (*The Old Pine, Darien* [Metropolitan Museum], noted as *Pine Tree* [a thousand dollars]). Interestingly, it seems not to have been considered unfinished, since other works (including the breathtakingly beautiful *Fish Island from Kensett's Studio on Contentment Island* [Montclair Art Museum], nonetheless valued at eight hundred dollars) are clearly marked as such on the same list.

That point—whether or not *Eaton's Neck* should be considered a finished work—has preoccupied most modern students of the painting and accounts in some measure for the work's popularity today. The absence of anecdotal detail; the powerful, reductive composition; the abstract, geometric clarity of the picture's three forms—sky, sea, and spit of land—have raised the question as to whether what we see is simply the handsome underpinnings of what would have been a somewhat more complicated composition.[4] Dianne Dwyer's recent insightful study of Kensett's technique brings helpful information to the debate. She notes that although Kensett has described certain areas—the vegetation on the beach in particular—more summarily than usual, the same free brushwork exists in other of Kensett's works of the period, and that the construction of the picture in two layers, with dark paint beneath a lighter scumble, conforms to Kensett's normal practice. She further notes that the sailboats that Kensett always added as a final touch are already present along the horizon. Her evidence seems incontrovertible, yet she concludes, almost in deference to the contemporary investment in the painting's being unfinished, "One could postulate the ultimate addition of some small figures on the beach. . . . To this degree *Eaton's Neck* may be unfinished."[5]

It would seem that *Eaton's Neck* is admired today partly *because* it is perceived as unfinished. Modern romantic taste favors the uncompleted work, which is believed to provide a more intimate glimpse of the artist's thoughts and practices and which in this case serves as a poignant reminder of a prematurely interrupted career.[6] Certainly it is *Eaton's Neck*'s very emptiness, its abstract quality, that makes it so compelling. Its minimalist composition and its close, resonating color harmonies have been seen as foreshadowing in visual, if not historical, terms the work of such esteemed twentieth-century masters as Milton Avery, Mark Rothko, and Barnett Newman.[7] To the contemporary eye, which regards the aesthetic of Kensett's day as characterized by clutter and detail, such evocative modernity seems inexplicably anachronistic, unless the painting is understood as unfinished.

Eaton's Neck has been hailed as the quintessential example of what is referred to as Luminism, that facet of nineteenth-century American landscape painting that has attained the most eager following in the exhibition halls and in the marketplace.[8] The power of the work itself stems from the paucity of its compositional elements and the virtual absence of picturesque detail. The proportions of the canvas—the width twice the height—are more serene and satisfying than the blockier shapes Kensett previously favored.

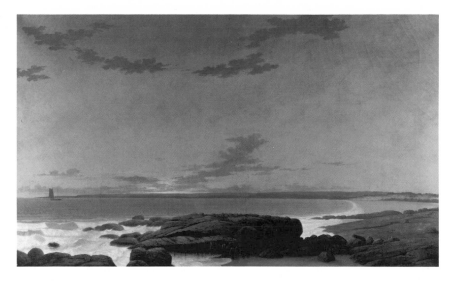

Fitz Hugh Lane, *Ipswich Bay*, 1862, oil on canvas, 20 x 33 in. (50.8 x 83.8 cm.). Courtesy, Museum of Fine Arts, Boston, Gift of Mrs. Barclay Tilton in memory of Dr. Herman E. Davidson (53.383)

Two-thirds of the picture is taken up by a placid, softly brushed sky. The lowered horizon, stretched taut behind the perfect curve of the shoreline that effectively bisects the composition, serves to flatten and compress the space, augmenting the abstract quality of the work. Because the main spit of land does not precisely coincide with the horizon, the picture's geometric severity is relieved and its naturalism is preserved. Kensett maintains the same delicate balance between realism and abstraction in his color harmonies. The gray green of the sea at the shoreline is echoed by the grassy patches on the bluff. Beyond the shore, the sea is a deep teal, as is the sky, over which lighter hues have been scumbled to create a sense of atmosphere. Yet those colors are not entirely soothing, for the white strip of sandy beach cuts a brilliant gash into the predominantly grayed, subdued scene, an intrusion made all the more shocking by the darkness of the adjacent bluff.

While more daring in its abstract simplicity than anything else in Kensett's oeuvre, the suggestion that *Eaton's Neck* represents a "quantum leap" in the artist's development and in the work of the period seems somewhat overstated.[9] In several works he painted about 1860—for example, *View of the Beach at Beverly, Massachusetts* (1860; Santa Barbara Museum of Art) or *Forty Steps, Newport, Rhode Island* (1860; Jo Ann and Julian Ganz, Jr.)—Kensett addressed similar subjects and experimented with the same close color harmonies, although he did not attempt the extreme horizontality or spareness that distinguish *Eaton's Neck*. By the end of the decade, he was using the drawn-out format featured here, as well as the low horizon and severely simplified composition. Even the formula of the arching shoreline with a second point of land visible just at the horizon has antecedents in such pictures as *Coast at Newport* (1869; Art Institute of Chicago).

In that same period—the decade before Kensett painted *Eaton's Neck*—several artists, Fitz Hugh Lane, Martin Johnson

Heade, and Sanford Gifford among them, were also using the extremely horizontal canvas, reductive composition, near-monochrome palette, and controlled brushwork that give Kensett's picture its abstract quality. Particularly in the hands of Heade and Lane, those features, all identified with the Luminist style, were often used to express a vision that seems violent, disturbing, even primeval. Where works such as Heade's *Approaching Storm, Beach Near Newport* (see p. 171), or Lane's *Ipswich Bay* (ill.), both in the Museum of Fine Arts, Boston, seem apocalyptic in their radical emptiness, Kensett's treatment of the same stylistic traits defines a more sanguine and reassuring vision. Kensett sees nature as consistently benign, but here, stripped of all anecdotal detail and topographical elaboration, that natural harmony takes on sublime proportions. However unassuming its size, *Eaton's Neck*'s powerfully designed composition, balanced, uniform treatment of sea and sky, and absence of any feature by which scale or distance can be measured create an awe-inspiring, elevating sense of the infinite.

C.T.

Notes

1. The thirty-eight or, by some accounts, thirty-nine paintings created by Kensett in the summer of 1872, depicting views of the Connecticut coast, Long Island Sound, Newport, and Lake George, remained in his studio at his death in December 1872. They were first offered for sale as a group, and then donated to the Metropolitan Museum by Thomas Kensett, the artist's brother, in 1874. Of the original group, nineteen pictures are still in the Metropolitan's collection. For a complete and thought-provoking analysis of these works, see Rodriguez Roque 1985.

2. *Eaton's Neck* was featured in 1968 in a traveling exhibition dedicated to Kensett's works organized by the American Federation of Arts (catalogue by John K. Howat); in 1972, in the centennial exhibition of the Last Summer's Work held in Connecticut at the Darien Historical Society; and, most recently, in the monographic exhibition *John F. Kensett: An American Master*, originating in 1985 at the Worcester Art Museum. The painting was the only example of the Last Summer's Work to be included in *American Light: The Luminist Movement* (Washington, D.C.: The National Gallery of Art, 1980).

3. See Appendix I, Driscoll and Howat 1985, p. 181.

4. According to John K. Howat, "Although essentially a completed picture, it was not signed" (Howat 1968, no. 46). John Wilmerding, in "The Luminist Movement: Some Reflections," notes, "It was unfinished at his death in 1872" (Wilmerding 1980, p. 115). Most recently, Natalie Spassky writes that *Eaton's Neck* and a few others of the Last Summer's Work "have been brought almost to completion" (Spassky 1985, p. 38).

5. Dianne Dwyer, "John F. Kensett's Painting Technique," Driscoll and Howat 1985, p. 176.

6. "Such studies interrupted in process provide an invaluable insight into Kensett's working methods, and in their unfinished state, with their abstract qualities more pronounced, they have a special appeal to the modern viewer." Spassky 1985, p. 38.

7. Rodriguez Roque 1985, p. 137.

8. See, for example, Powell 1980, p. 86.

9. Rodriguez Roque 1985, p. 148.

MARTIN JOHNSON HEADE

(1819–1904)

Heade was born and reared in Lumberville, a small community near Doylestown, in Buck's County, Pennsylvania. He was the eldest son in the large family of Joseph Cowell Heed, the owner of a farm and a lumber mill. The youth's first lessons in art were provided locally by Edward Hicks and probably also by Thomas Hicks, Edward's cousin, a rudimentary instruction apparently never replaced by more formal training. Nevertheless, Heade's artistic sophistication increased considerably within a short time, and, around 1840, he took a study trip to England and the Continent, where he spent two years in Rome.

By 1843, he was living in New York; he then moved to Brooklyn, changed the spelling of his name to Heade, and in 1847 went to Philadelphia. In 1848, a second trip to Rome and perhaps a visit to Paris established his long-standing pattern of extensive, almost constant travel to distant places. His peripatetic nature prevented his establishing himself early in any American city. After returning from Rome, he lived for about a year in Saint Louis, but between 1852 and 1857 he moved at least three other times, to Chicago, Trenton, and Providence.

A turning point in Heade's artistic career came after he returned to New York in 1859 and rented quarters in the Tenth Street Studio Building. Proximity to so many landscape painters, especially Frederic Church, seems to have inspired him, for it signaled the beginning of his development of a personal style and sparked his lasting interest in the landscape's broad panorama and subtle atmospheric effects. Even though New York left an enduring mark on Heade's landscape painting and is the city to which he was most closely bound, he seems not to have put down deep roots even there: he never, for example, joined the National Academy of Design, not even as an Associate.

In the years from 1861 to 1863, which he spent in Boston, Heade interpreted the chaste coastal landscape in a manner uniquely his own. In the latter half of 1863, he took a trip to Brazil and stayed on through March 1864. His purpose in going there was to illustrate a complete series of South American hummingbirds, which he hoped to have published in Britain. Though he failed in that endeavor, hummingbirds in tropical settings continued as a staple subject in his painting. He set out again for South America in 1866; four years later, he made a third trip.

Views of New England and New Jersey, along with floral still lifes and recurring scenes of the tropics, dominated Heade's work from the early 1860s to the early 1880s, those years when he produced the landscapes for which he is most remembered today. Though their effect was often described as disquieting, with them Heade developed one of the best instincts in the Hudson River School for capturing nature's remote, fleeting beauty.

Heade exhibited widely—at the National Academy of Design, the Pennsylvania Academy of the Fine Arts, the American Art-Union, the Boston Athenaeum, and the Royal Academy in London—but achieved at best only moderate recognition. Little written documentation exists about him, and he left no identifiable body of writing.

In 1883, Heade married and moved to Saint Augustine, Florida, where he continued to paint landscapes and flower pieces. In New York, he was virtually forgotten. His work, which was rediscovered during the revival of interest in Hudson River School painting in the 1940s, has been increasingly appreciated in the intervening years and is today accorded major status.

Select Bibliography

Robert J. McIntyre. *Martin Johnson Heade, 1819–1904*. New York: Pantheon Press, 1948.

Commemorative Exhibitions of the Paintings of Martin Johnson Heade and Fitz Hugh Lane. Exhibition catalogue. New York: Knoedler & Co., 1954.

Theodore E. Stebbins, Jr. *Martin Johnson Heade*. Exhibition catalogue. College Park, Md.: University of Maryland Art Gallery, 1969.

——. *The Life and Works of Martin Johnson Heade*. New Haven and London: Yale University Press, 1975. Revised edition forthcoming.

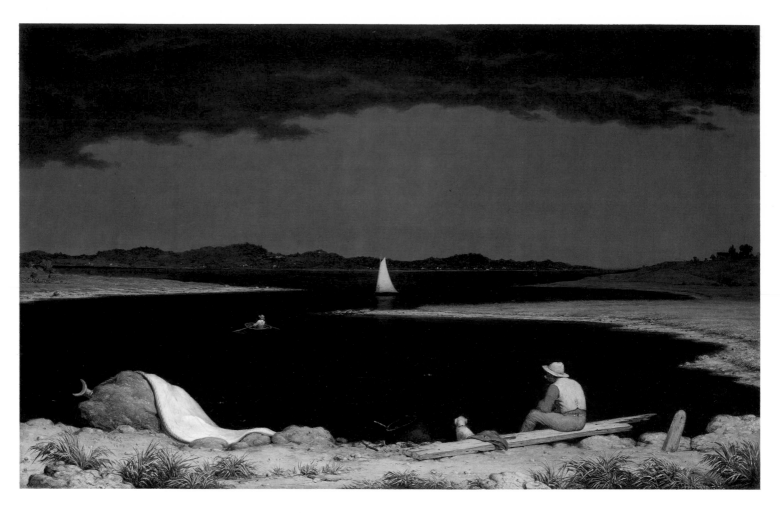

The Coming Storm, 1859

Oil on canvas, 28 × 44 in. (71.1 × 111.8 cm.)
Signed and dated at lower left: M J Heade/1859
The Metropolitan Museum of Art, New York City. Gift of
Erving Wolf Foundation and Mr. and Mrs. Erving Wolf,
1975 (1975.160)

Heade's familiarity with the Hudson River School style of landscape painting was a gradual process, helped along by his intermittent periods of residence in the vicinity of New York City—from 1843 to 1847, when he lived in New York and in Brooklyn, then from 1855 to 1857, when he lived in Trenton. Increasingly, his scenes focused upon the bright light, broad vistas, topographical irregularity, and fresh detail of the Hudson River School approach. They suggested real sites, portrayed without preconception.

When Heade moved back to New York, in 1859, he continued that already established direction in his art, but at an accelerated pace and with a much more ambitious, serious, and personal intent that is surely attributable to his arrival at the Tenth Street Studio Building. The change in his attitude is first apparent in *The Coming Storm*, the largest painting Heade had then produced, and his first probing look at the forces of nature.

The Coming Storm presents the gathering of a summer thundershower. On the shore of a bay, a fisherman who has been repairing his sailboat pauses to watch lightning flash faint red in the left distance. His boat's sail is spread out at the left; an iron kettle and a large brush are visible at the center of the composition. As the fisherman watches the storm approach, a second man rows to shore, leaving his sailboat in the bay.

In a sense, the painting is surprisingly conventional, even by the earliest Hudson River School standards. For example, the purpose served by the fisherman in the foreground would be more appropriate to an eighteenth-century picturesque landscape: he is a "rustic" type who demonstrates to the viewer how to look at the painting. Lumpy and large, he sits on a board made rough and broken for visual variety. The rowing figure in the middle distance is also a conventional landscape device, meant to measure pictorial space and to provide a seamless, easily understood narrative of a type Heade thereafter abandoned.

These elements were perhaps necessary assurances for an

artist who in so many other ways was entering new territory. Heade's most obvious departure from the old-fashioned tradition was in the overall site he chose to depict, one hardly "picturesque" in the eighteenth-century sense. Unassuming and somewhat barren, it is a place where mundane work goes on. It can be argued that Heade, by refusing to prettify his scenery by association, was attempting to inject into his artistic vision a serious, monumental simplicity it had not previously possessed.

Another novelty is the picture's coloring, which uses strong contrasts of both hue and value. Horizontal registers of shore, sea, and sky progress from a buff foreground rimmed with dark green to the brown black of the water that becomes gray in the distance. Fingers of yellow green land encroach upon the sea. Behind them, the hills on the horizon modulate from darker to lighter gray and finally yield to a similarly toned sky, its clouds edged in pale light.

Heade also decided to open his composition and radically empty it. Just as the seated figure is turned toward the blackened bay and sky, so the viewer's attention is directed to the vast scale of nature's activity. The horizon stretches uninterruptedly from one edge of the canvas to the other. The bay in front of it is a nearly complete figure eight, its center fixed by the sailboat at anchor, a regularity that gives the scene an effect of absolute calm that even the bolt of lightning does not disturb.

To judge by the canvas's numerous pentimenti, Heade fixed these compositional characteristics after considerable trial and error. The rock on the shore was once in the water and the hills along the horizon were originally higher and more jagged. By pushing the rock aside and lowering the hills, Heade increased the openness of the scene, achieving a view so insistently broad that it appears as if seen through a wide-angle lens.

Heade must have learned the effect of an infinitely expansive horizon from Frederic Church, either from such earlier Church pictures as *Grand Manan Island, Bay of Fundy* (1852; Wadsworth Atheneum) or the more contemporaneous *Niagara* (see p. 243), though Heade's streamlining of virtually every compositional element did not come directly from Church's work. Yet the relatively unadorned shore, the mostly empty space that takes over the center of the painting, and the elemental color contrasts are neither the rudimentary forms of a novice painter nor accidental choices. Heade must have consciously decided to abandon the greater complexity of his previous landscapes for what he perceived as nature's more important phenomena.

Its size suggests that Heade must have intended his belabored painting to be an exhibition piece. It may be the work titled *Approaching Thunderstorm* that was shown at the National Academy of Design in New York in the spring of 1860, appropriate timing for a picture completed the previous winter. That proposition has been raised but rejected, in part because the work on exhibit was not deemed noteworthy by the critics.[1] Their neglect, however, may have been the inevitable reaction to a painting by a little-known artist whose chief innovation was to replace the interesting details of a landscape with a great deal of void.[2]

D.J.S.

Notes

1. Spassky 1985, pp. 121–22.

2. To reject *The Coming Storm* as the work shown at the National Academy in 1860 implies that Heade accomplished the feat of painting two major landscapes of the same subject in 1859. It seems improbable that a canvas as extensively reworked as *The Coming Storm* would not have been submitted for exhibition or would have allowed the artist sufficient time to complete another entry.

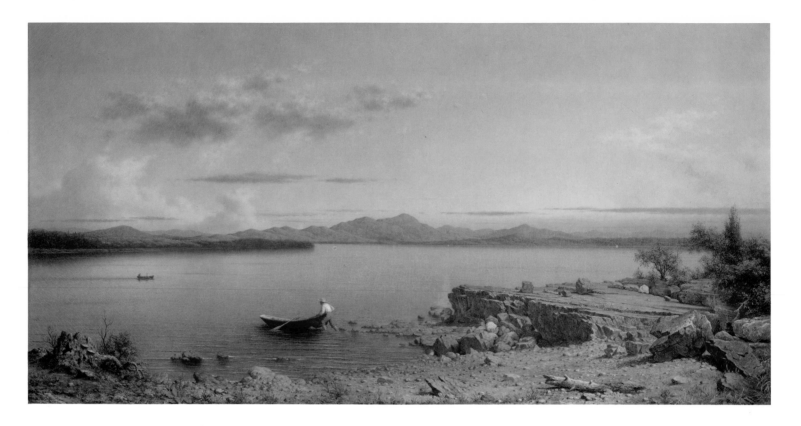

Lake George, 1862

Oil on canvas, 26 × 49¾ in. (66 × 126.4 cm.)
Signed and dated at lower right: M J Heade 1862
Museum of Fine Arts, Boston, Massachusetts. Bequest of Maxim Karolik
(64.430)

Heade's residence in Boston from 1861 to 1863 was a period of significant maturation for his art. There he made coastal views his specialty, painted a great many works, and apparently determined to increase his technical powers and to develop a distinct style. He produced views of diverse sites—Maine, New Hampshire, New York, Newport—experimenting all the while with different sizes, compositions, and expressive possibilities. In 1862, becoming particularly interested in so-called high realism, he made several tightly handled dawn and late afternoon scenes that emphasized terrains of rocks, bare earth, and other unexpectedly harsh aspects of the land. Of those scenes, *Lake George* is the most ambitious. It was Heade's largest painting to date, his most important work of the early 1860s, and one of the most remarkable achievements of his career.

Heade visited Lake George in 1862, during a trip that took him from Lake Champlain, at the border of New York and Vermont, across Maine to Passamaquoddy Bay, at the southern tip of New Brunswick. Lake George is a long, narrow body of water situated in the mountains of northeastern New York just south of Lake Champlain and not far from Vermont. It was visited by almost every member of the Hudson River School, and by the end of the nineteenth century had become a popular tourist area.

Hudson River School painters from Thomas Cole, who wrote poetry about it, to John Kensett, who painted it three times between 1869 and 1872, all felt the lake to be endowed with special purity, and thus to be hallowed ground.[1] Their depictions usually focused on its clear, placid waters, its hazy sky, and the majestic mountains that come right to its shores. Kensett, who made use of just those elements for which Lake George was so admired, created perhaps the consummate statements of the prevailing attitude toward the place (see p. 156). They bear comparison to Heade's version of the same subject because they point up how deeply Heade diverged from Lake George's picturesque tradition.

Heade resisted his contemporaries' inclination to romanticize the lake. Although his view was taken from the Fort William Henry Hotel,[2] he portrayed the site neither as a tourist area nor as the type of spot tourists expected to find. In place of majestic mountains and graying mist, he imposed flatness and thinned atmosphere. In his hands, Lake George retained its pristine quality but became a considerably more mundane environment, possessing not even so much as a promise of pleasing detail: dead tree trunks have fallen by the shore, saplings force themselves through bare rocks, and the water is not even reflective.

Aside from a couple of minuscule sailboats in the distance, there are just two signs of human activity: a man knee-deep in water, his back to the viewer, who tries to free his boat from rocks on the shore, and a pair of figures in a rowboat whose wake trails off the left side of the canvas. Its occupants seem neither to be noticed by nor to notice the man struggling against the rocks. It is as if Heade wanted to show nature unsoftened by shadow, diverting detail, or pleasing incident, and to suggest that there is equal harshness to man's existence.

The minute detail and relatively high finish of the painting have been associated with the influence of John Ruskin and English Pre-Raphaelite art, which affected Heade as it did numerous American artists from the late 1850s through the 1860s. Ruskin's ideas were given broad play in America during those years, especially in New York. Not only did his writing appear in periodicals, *The Crayon* among them, but his sentiments were reinforced by the essays of enthusiasts such as *The Crayon*'s co-editor William Stillman and one of its most notable contributors, Asher B. Durand, father of co-editor John.

Heade must have seen the exhibition of more than two hundred British paintings, including the work of the English Pre-Raphaelites, shown in New York, Philadelphia, and Boston in 1857 and 1858.[3] The landscapes exhibited—by John Brett, John Ruskin, and Ford Madox Brown—apparently inspired the new harshness that surfaced in Heade's painting, emerging full force in *Lake George* and in three other works of 1862: *Dawn*, a small landscape (Museum of Fine Arts, Boston), *Two Hunters in a Landscape* (private collection), and *The Lookout, Burlington, Vermont*, an oil sketch (private collection).

Lake George is arguably Heade's most finely wrought act of faith to Ruskin and the painters of Pre-Raphaelite sympathies. It represents a willingness to embrace harsh objectivity and to make the not-so-beautiful a new standard for beauty itself. Its light allows everything to be seen with almost hallucinatory clarity. The colors are hot and dry, somewhat like those of Brett or William Holman Hunt. The rocks are a singularly Pre-Raphaelite detail, perhaps borrowed from Heade's Tenth Street Studio Building colleague Charles Moore, who was using bare rocks as a focal point in landscape at precisely the time they could have inspired Heade to do the same.[4]

Heade manipulated the composition in a way consistent with Ruskinian clarity of detail. He equalized all elements of the landscape. Sky and sea have the same size and visual impact, and different objects in the landscape all make similar horizontals. Moreover, the mountains are reduced, while the grass and boulders of the foreground are emphasized, and the human presence is made neither more nor less prominent than those natural elements: nothing dominates nature; no one thing is held up as more important than anything else. Even the color harmony follows that plan. Yellow greens and lavenders, together with gray blue and salmon hues, appear in the sky, the water, and the land, as if all those deserted areas were constituted of the same essential elements. Heade seems to be saying that there is unity among nature's ele-

ments, but there is also something inexplicable and uncommunicative about every natural phenomenon.

<div style="text-align: right">D.J.S.</div>

Notes
1. Stebbins 1975, p. 37.
2. Ibid., p. 39.
3. Ibid., p. 28.
4. Ferber and Gerdts 1985, p. 267.

Lynn Meadows, 1863

Oil on canvas, 12 × 30⅛ in. (30.5 × 76.5 cm.)
Signed and dated at lower left: M J Heade/1863
Yale University Art Gallery, New Haven, Connecticut. Gift of
Arnold H. Nichols, B.A., 1920 (1967.19)

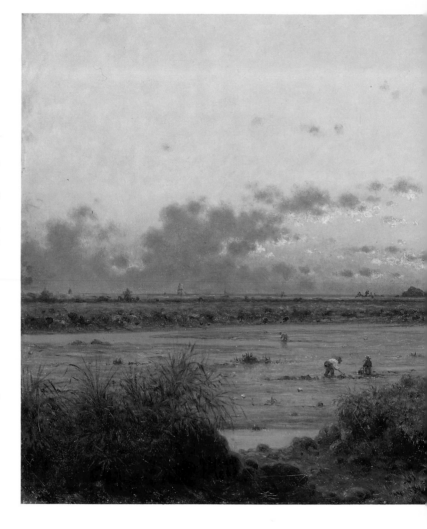

The salt marshes and flatlands of the eastern seaboard were subjects of special interest to Heade from 1859 to the very end of his career. He never tired of the visual limitations of what could justifiably be described as a monotonous and unglamorous setting for landscape. The mundane uniformity of the salt marsh seems to have given him an inexhaustible opportunity to explore the subtleties of nature's spontaneous, continuous, and usually overlooked changes.

From the beginning, Heade emphasized the unyielding flatness and lonely emptiness of his sites. By their flatness, the marshes offered little barrier to the incursion of natural forces; they were open to the ocean, interwoven with inlets of water, and responsive to the smallest atmospheric changes. In their emptiness, the marshes suggested a vast, eternal, and uncompromised environment—a true wilderness, even though it was commonly found and near at hand. The presence, in various combinations, of haystacks, workmen, or a stray tree mitigated only slightly the barrenness of Heade's scenes.

Heade's earlier marsh views—those before 1865—were more forthrightly operatic than their small sizes suggest. Often set at sunset or at twilight, they emphasized the mood-creating qualities of strong backlighting, long shadows, and intensely warm or cool coloring. They also inclined toward the telling of specific stories, a tendency that reached a peak in 1863.[1] By the later 1860s, Heade's marshes no longer played up those overtly romantic qualities.

Lynn Meadows portrays a marsh in Lynn, Massachusetts, a seaboard town that was rapidly losing its rural character to industrialization when Heade painted it. In a sense, Heade's interest in the site ran counter to the general social verdict: the marsh would have been thought tantamount to wasteland, because such terrain was unfit for industrial development. In truth, the scene only partly resembled the actual site.[2] Heade made the marsh larger and deeper. The result is perhaps a better setting for his most insistently horizontal painting until the 1880s, his only landscape with a locomotive running through it, and one of the most dramatic of his early sunsets.

The painting shows three men clamming in the middle ground of a deserted marsh, against an infinitely broad horizon. To the far left is the sea, where, on the horizon line, one can faintly see ships in full mast arriving at harbor. At the extreme right, a steam locomotive crosses a wooden trestle bridge and all but passes out of the picture. These activities occur at the unexpected hour of sunset, when the drama in the sky can easily make such events seem insignificant. The two men digging in the muck are oblivious to their surroundings in a way that recalls the figure in *Lake George* (see p. 166), but, considering the events in the background, their level of ignorance seems profound.

By most measurements, there is not much to see. The foreground swells considerably, but is cast in shadow and nearly empty. The greatest activity and visibility are along the horizon, which is the most brightly lit area of the composition. Nothing interferes with it: the clouds, the ships, and the locomotive all work to emphasize its breadth and its ultimately unchanging quality.

The picture's greatest drama is in the meteorologic changes that occur from left to right. On the left, against the deep pink of the setting sun, clouds well up from the horizon line. They yield at the right to the effects of twilight—a grayed sky touched with a few small, dark, wandering clouds. The center of the picture is framed on either side by an arc of clouds and the arc's smaller, mirror image made by the train's plume of smoke. The diagonal of the foreground draws one's eye into this area of color and sweeping motion, making the discrepancy between the unity of the dynamic sunset and the disjointed, visually insignificant human activity all the more obvious.

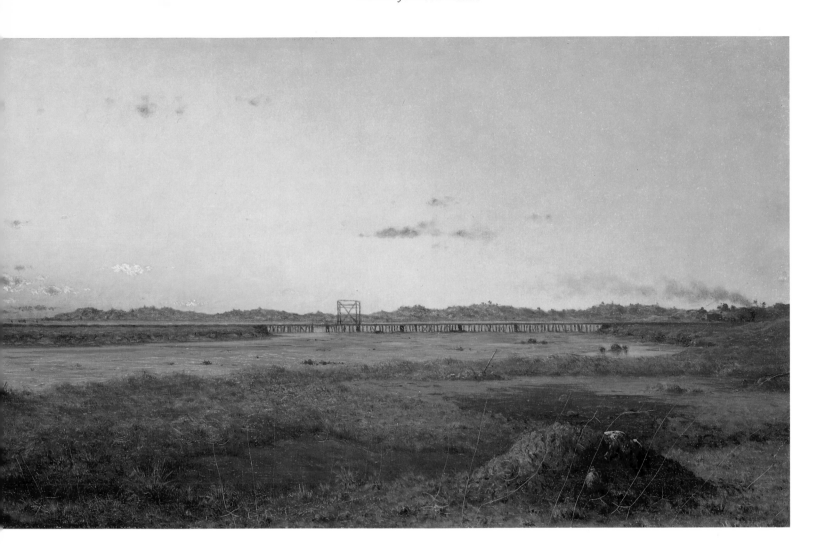

The mood of the painting, which has been described as an uncertain one,[3] is in part brought on by the uneasy coexistence of the train racing through the pictorial field and the slimy, repetitive labor of the clam diggers. The foreground shows only a jug and a jacket left by one of them. This evidence of man's presence closest to the viewer takes the form of limp, rumpled litter, making another uneasy juxtaposition against the setting sun and broad horizon.

To determine what meaning Heade intended for his various pictorial elements is difficult; indeed, it has been claimed that they have none.[4] Yet the sheer oddness of the composition requires some explanation. The square-riggers entering the harbor are willfully anachronistic, and the locomotive is especially puzzling, for a locomotive was frequently used as a symbol of man's penetration into the wilderness and the inevitable predominance of technological achievement. Here, however, it seems to be abandoning the site.

These elements may be setting the stage for an allegorical progress of civilization, from the arrival of the tall ships in the New World to the ever more accelerated, mechanized move inland. When the painting is read from left to right, as if the horizon were a time line, one sees the majestic sailing ship give way to the smoke and increasing speed of the locomotive, which ultimately leaves the bog behind. That panorama of progress occurs at a distinct remove from the drudgery of the laborers, and Heade's poignant message seems to be that not all men are touched by, or have any concern with, such natural and mechanical wonders.

D.J.S.

Notes
1. Stebbins 1969 [p. 8].
2. For this observation I am grateful to the Boston geologist Clifford A. Kaye.
3. Stebbins 1975, p. 46.
4. Susan Danly Walther, *The Railroad in the American Landscape: 1850–1950*, exh. cat. (Wellesley, Mass.: Wellesley College Museum, 1981), p. 87.

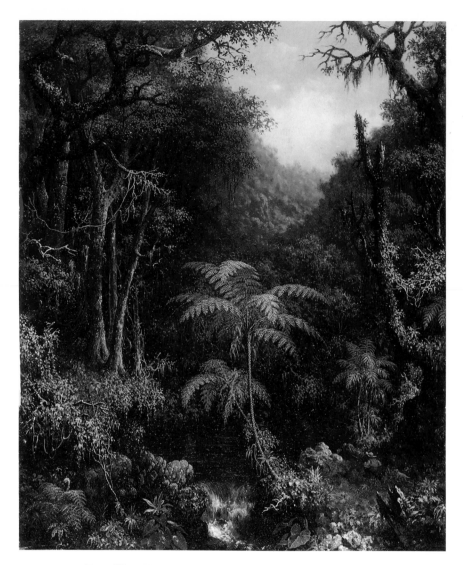

Brazilian Forest, 1864

Oil on canvas, 20¹⁄₁₆ × 16 in. (51 × 40.6 cm.)
Signed and dated at lower left: M J Heade/1864
Signed on reverse: By M. J. Heade—London/1864
Inscribed on stretcher: From Forest Studies in South America/
 —The Tree Fern
Museum of Art, Rhode Island School of Design, Gift of Mr. and Mrs.
 Richard Steedman, 68.052

Heade's first trip to South America took him to Brazil in 1863. The fruits of his journey were numerous on-site sketches of Brazilian scenery, followed by a series of small canvases depicting the Brazilian hummingbird. Between 1863 and 1865 came a handful of harbor views of Rio de Janeiro, a smaller number of panoramas of the Brazilian interior, and this picture, which Heade painted in London while trying to arrange for a chromolithographer to publish *Gems of Brazil*, his hummingbird illustrations.[1]

 The inscription on the canvas stretcher indicates that, much in common with the hummingbird pictures, *Brazilian Forest* is meant to be a portrait of a single natural specimen, in this case a sapling tree fern. As are the hummingbirds, the tree fern is set against an approximation of its lush, rain-forest habitat, its leaves precisely picked out and brightly lit. The tree, surrounded by an ideal, largely imagined setting that has as much effect on the viewer as the specimen itself, rises directly over a small waterfall, behind which is a pool of still water. The same line of sight provides the narrow vista into the distance. Near the tree fern in the lower foreground is a hunter who poises his shotgun at the waterfall's edge and who seems strangely immobilized by the weight of the surrounding vegetation.

 Heade, who rarely made vertical landscapes, chose that format for *Brazilian Forest* because it so successfully reined in the horizon and the horizontal expanse of sky. By limiting any extended side-to-side eye movement, he locks the viewer into the center of the forest. As with the North American forest interiors of John Kensett and Worthington Whittredge, the deep view into a densely wooded area becomes this painting's sole focal point.

 The correspondence to Kensett's *Bash-Bish Falls* (see p. 151) is particularly striking. Despite drastic shifts in climate between the Kensett and *Brazilian Forest*, the two views emphasize nature's chaotic dominance in a similar way. Both show a dark, densely forested foreground, a rocky waterfall almost obscured by surrounding trees, and, beyond the waterfall, a small but brilliant patch of white sky. Most important, both imply that man's incursion—whether in the form of a footbridge, in Kensett's case, or a lone hunter, in Heade's—is hardly noticeable and barely matters.

 The visual features unique to Heade's picture are perplexing. By placing his fern directly in front of the watery hollow of the middle ground, the painter gives a studied and theatrical calm to his composition. Yet, for all his deliberation, the tree fern is not firmly rooted: the entire forest appears to be sitting on the surface of the canvas rather than receding convincingly into space. That effect is partly the result of the brushwork Heade used—soft, mossy, and poorly defined—which causes one rain-forest form to merge into another. The vagueness of nearly every growing element in Heade's landscape is particularly at odds with the sharp individuality present in Kensett's *Bash-Bish Falls*. It suggests that Heade either did not want the tropical forest's growth to be understood or was not able to understand it himself.

 More consequential than the individual plants depicted is the general mood of the painting, which encourages the viewer to react rather than to understand.[2] Conveying the sense of eerie impenetrability and some of the faintly threatening quality found in his hummingbird paintings, Heade created *Brazilian Forest* through use of the same backdrop of haze, mountains, and boggy scrub. Such was the signature he had developed for the Brazilian rain forest: in part familiar, in part unfathomable, and neither part separable from the other.

<div align="right">D.J.S.</div>

Notes
1. See Mandel 1977, pp. 38–41.
2. Stebbins 1975, p. 87.

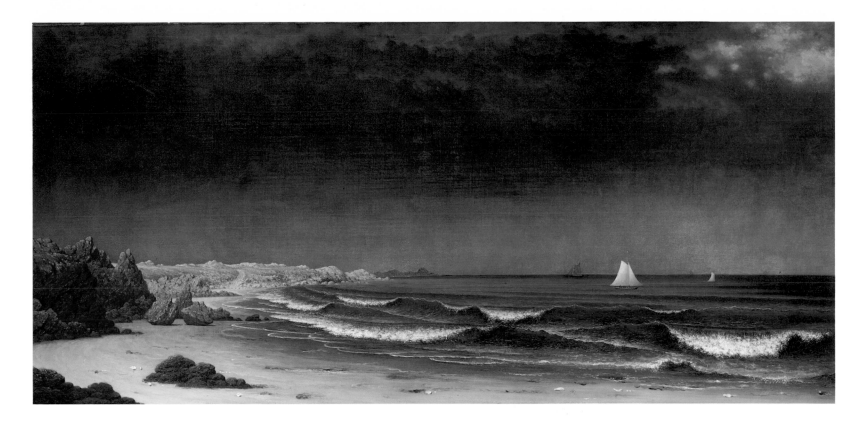

Approaching Storm, Beach Near Newport, ca. 1866–67
Oil on canvas, 28 × 58¼ in. (71.1 × 147.9 cm.)
Unsigned
Museum of Fine Arts, Boston, Massachusetts. M. and M. Karolik
Collection (45.889)

One of Heade's most provocative, enigmatic, and individual works is the canvas known as *Approaching Storm, Beach Near Newport.* It is generally agreed to be a landmark in his art, no doubt belonging to the 1860s, and probably to the later years of that interval, when his creativity was at its peak. But because the canvas is not dated and because Heade never painted anything else so harsh and frozen, a scholarly consensus on its exact chronological place has been difficult to achieve.

The most specific identification is that it was Heade's view of Point Judith, a major work exhibited at New York's National Academy of Design in 1867 and in Philadelphia in 1868.[1] After seeing the National Academy exhibition, Henry Tuckerman wrote his only assessment of Heade's art, which included this statement: "Another clever and novel landscape by Heade is a view of Point Judith, where the effect of a thin overflow of water on the glistening sand of the beach is given with rare truth."[2] It is a peculiar comment, suggesting that Tuckerman was faced with an unusual landscape and was therefore unprepared to offer more appropriate adjectives for describing it.[3]

Approaching Storm, Beach Near Newport might well prompt such a reaction. It is a uniquely chilling view, with a horizontality that denies any feeling of a protected harbor but instead creates an effect of vulnerability to whatever disturbances may arise on the open sea. The setting readily evokes Point Judith, an isolated promontory at the edge of Narragansett Bay on Rhode Island's southwestern shore. Closer to Block Island than to Newport, the point is directly exposed to the harshness of the Atlantic.[4]

Heade's composition is divided into three registers: the sea and shore, the storm clouds hovering at the top of the canvas, and, between the two, a peculiar area of thin, glowing air. Sky and sea are darkened, color is reduced, and tonal contrast is increased, so that the viewer is left with a blackened sky and sea against a bright yet barren foreground illuminated by an invisible source of light. All maintain a careful balance between uncongenial roughness and eerie stillness.

The painting is surely Heade's least communicative. Except for a clump of boulders, the shoreline is completely empty, as is the sea, except for three mysterious sailboats that appear to be suspended on its surface. The white-capped waves rolling to shore, seemingly frozen in time, contribute to the unreal effect. These manipulations are not unexpected, for in the later 1860s Heade apparently decided to hone the coastal views he had defined as his own. The result was a body of simpler, more intense, and more creative work, with which *Approaching Storm* stylistically shares a great deal.

It might be said that Heade had been preparing for *Approach-*

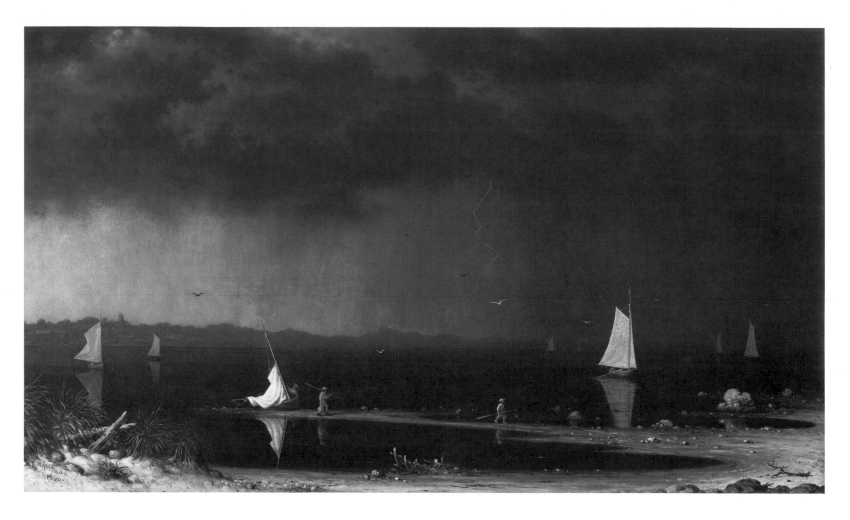

Figure 1. Martin Johnson Heade, *Thunderstorm over Narragansett Bay*, 1868, oil on canvas, 32⅛ x 54½ in. (81.6 x 138.4 cm.). Courtesy, Amon Carter Museum, Fort Worth

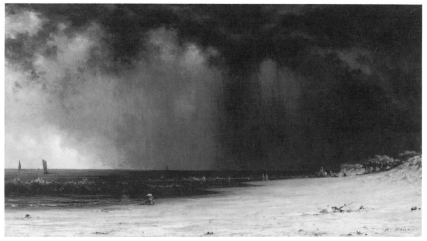

Figure 2. Martin Johnson Heade, *Thunderstorm at the Shore*, ca. 1870, oil on paper mounted on canvas, 9⁷/₁₆ x 18⅜ in. (24 x 46.7 cm.). The Carnegie Museum of Art, Pittsburgh, Howard Eavenson Memorial Fund, for Howard N. Eavenson Americana Collection (72.54)

ing Storm for nearly a decade. The pictorial motif originated with *The Coming Storm* of 1859 (see p. 164). In the next dozen years, he painted three more shore scenes in a similar vein: this canvas, followed by *Thunderstorm over Narragansett Bay* (Fig. 1) and *Thunderstorm at the Shore* (Fig. 2). All seem to have been stimulated by the Rhode Island coast—their common theme being the arrival of a cataclysmic summer storm—and all depict either the storm's near-invisible onset or the moment of dead calm before its eruption.

The present painting is by far the most taut and severe of the four. It is also the most horizontal, contains the least detail, and presents the sharpest visual contrasts. In the two subsequent versions, the clouds become more pervasive, and there is less distinction between the storm-filled sky and the sea below, causing the divisions in the landscape to be less abrupt. (The earliest version has a more varied and interesting foreground and is considerably more anecdotal.) In contrast to those three, *Approaching Storm* allows the viewer no opportunity to become lost either in narrative or in the subtleties of sea and shore.

Varied meanings have been assigned to Heade's compositional choices in this picture. It has been argued that the silence and empty space represent the artist's soul and, beyond that, man's

soul in union with God, in accordance with the practice of other nineteenth-century landscape painters.[5] The most specific interpretation is that the painting is an allegory of the failures of the Civil War, a traumatized landscape acting as a metaphor for a nation turned upside down.[6] Yet another reading of the image suggests that Heade's message has more to do with the sheer terror inherent in man's apprehension of nature's irrational, persistent reality.[7]

To discuss *Approaching Storm* without referring to the concept of the Sublime and the degree to which it operates in the painting is all but impossible. The landscape indeed conveys the emotions of fear, mystification, and awe traditionally associated with the Sublime concept. It presents nature at its extremes, thereby transforming the mere picture of a place into a discourse on the power of nature's forces, and it uses the vehicle of the thunderstorm to do so. However, when Heade substituted tension for visual excitement and deadly calm for drama, he broke with the convention of the Romantic Sublime, and thus in two essential factors courted its antithesis.[8]

Modern observers have concluded that Heade habitually depicted nature as an uncongenial, even sinister and alien force. In 1969, *Approaching Storm* and *Thunderstorm over Narragansett Bay* provoked this comment:

> Unlike his contemporaries in the Hudson River School, who saw even the wilderness as a place where one might wander by entering the scene bounded by the picture's frame, Heade always stands just at the edge of a world; that one would hesitate to enter, either for fear of disfiguring it or being assaulted by it.[9]

Because the painting does not invite the viewer's participation, because it presents nature as a diffident, perhaps hostile element, and because of its abstraction and lack of descriptive detail, whether it is a work that even belongs to the Hudson River School would be questioned by some.

Observations to the contrary notwithstanding, aspects of *Approaching Storm* do suggest a naturalist's keen interest in nature's inner dynamics. Expected colors and textures are reversed: the sky is as dark and mottled as the earth should be, while the sand is almost as bright and textureless as the sky would be. Even though the inversion creates a powerfully unnatural effect, Heade took care that it would not be capricious but would refer back to nature's own rules. By the same token, he seems to have reduced and abstracted nature in order to clarify its essential symbiosis. Sky affects the behavior of the sea, and the sea alters the form of the shore. The jagged waves darken the shoreline as they pull against it, their shapes mirrored in the craggy rocks on the beach. *Approaching Storm*, this strange product of the Hudson River School era, remains true to the idea that natural phenomena are closely interlocked, even if they are not benign, even if man has no place among them.

D.J.S.

Notes

1. Stebbins 1969 [p. 14].
2. Tuckerman 1867, p. 543.
3. Stebbins 1975, pp. 76–77.
4. Although Theodore E. Stebbins, Jr., in 1975 convincingly argued for 1866–67 as the painting's date and for Point Judith as its site, the exhibitions in which the work has appeared since then continued to assign it the vaguer date of ca. 1860 or 1860–70 and the incompatible qualifier, "Beach Near Newport."
5. Powell 1980, pp. 69–94.
6. John Wilmerding, *American Art* (Harmondsworth, England, and New York: Penguin Books, 1976), p. 97; idem, *American Marine Painting*, exh. cat. (Richmond, Va.: Virginia Museum of Fine Arts, 1976), pp. 17–18.
7. Stebbins 1975, p. 77.
8. See Carol Troyen, *The Boston Tradition, American Paintings from the Museum of Fine Arts, Boston*, exh. cat. (New York: American Federation of Art, 1980), p. 122.
9. John Canaday, "M. J. Heade, American Loner," *New York Times*, 16 November 1969, Section D, p. 25.

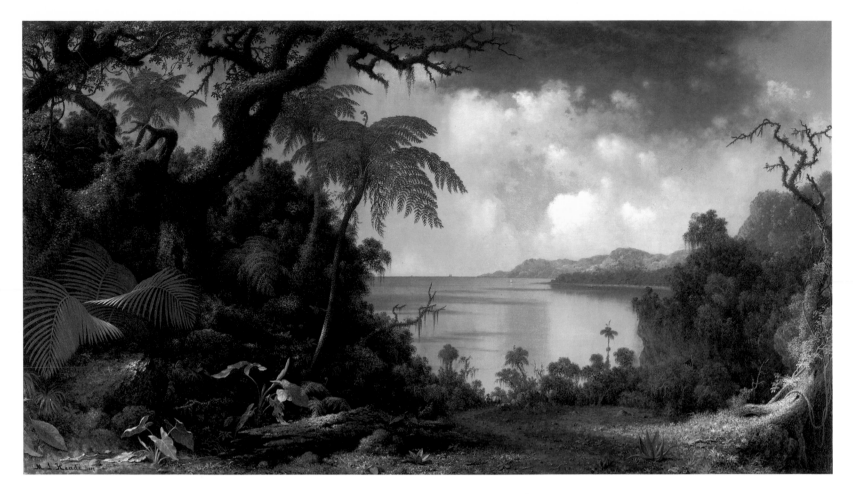

View from Fern-Tree Walk, Jamaica, ca. 1870
Oil on canvas, 53 × 90 in. (134.6 × 228.6 cm.)
Signed and dated at lower left: M. J. Heade—1887
Hirschl & Adler Galleries, New York City

When Heade returned from his last visit to South America in the early spring of 1870, he made a detour to Jamaica, perhaps at Frederic Church's suggestion. Church himself had been to the island in 1865, and on returning urged Heade to go again to the tropics. Heade spent about three months in the vicinity of Kingston, filling most of a sketchbook with drawings of individual plants, flowers, and trees, as he had done while in South America.

After arriving in New York, he busied himself with two large landscapes, *Jamaica* and *Mountains of Jamaica*. The latter (location unknown) was exhibited with considerable success in the United States and abroad between 1870 and 1873—success that may have inspired two additional views of the island, both dated 1874. The other large painting, *Jamaica*, appears to have been *View from Fern-Tree Walk, Jamaica*.[1] Heade seems not to have sold the work until 1887, when Henry Flagler, pioneer Florida resort developer and a patron of Heade's, bought it, newly signed and dated by the artist. It is a gargantuan canvas; of Heade's known works, only his *Great Florida Sunset* (1877; Flagler Museum) is larger.

View from Fern-Tree Walk, Jamaica depicts a place called "Fern Gully," one of the notable sites on the island and one also sketched by Church. Near Ocho Rios Bay on the north coast of Jamaica, it is the four-mile-long valley of a former river that has become covered by magnificent tree ferns. Heade obviously wanted to emphasize the swelling profile of the old river banks, the lushness and scale of the vegetation, and the distance the gully travels on its winding path to the sea.

The vantage point Heade chose is a clearing on a thickly forested hilltop, giving way to a steep descent, and so yielding an unexpected panorama of the bay. Except for the implied presence of the viewer in the foreground clearing, the human element in Heade's picture is pushed well into the background. Only the faintest narrative suggestions appear. Along the winding dirt road that connects the foreground and the sea is a Jamaican leading a mule, both of whom seem to be there merely to offer a sense of the huge scale of the surrounding plants. Farther in the distance are a few tiny sailboats; they dot an exceptionally smooth, glasslike sea that

seems untroubled either by the presence of the boats or the mottled clouds of an impending tropical shower.

Trees, ferns, and bushes are compressed into a knot of impenetrable, recognizably Jamaican vegetation. A number of the forms in the painting correspond to sketches Heade had made during his trip (Fig. 1). The rest—moss-covered palms, philodendron, tree ferns, and trees with intertwined branches and hanging roots—are prominent in the oil sketches Church made while visiting the island in 1865 (Fig. 2).[2] In *Fern-Tree Walk*, those forms give a sense of the rain forest's writhing activity and rapid regrowth. Clouds and sky contribute to the visual tangle, and even the smallest details, such as the tiny birds and red flowers that dot the foreground, point up nature's profusion.

Figure 1. Martin Johnson Heade, *Sheet of Studies: Tropical Vegetation with Bamboo Vines*, pencil on paper, 7⁷/₁₆ x 10³/₁₆ in. (18.9 x 25.8 cm.). Courtesy, Museum of Fine Arts, Boston, M. and M. Karolik Collection (1973.317)

Apart from the representativeness of those details, Heade's composition is mostly invented, the inevitable result, perhaps, of his fragmentary on-site records. Mostly of botanical details, his various sketches of Jamaican tree ferns provide scant idea of the broader surroundings that could have been the basis for future paintings. In *Fern-Tree Walk*, consequently, individual plants are evidently true to actual detail, while the fabric that binds them together is of the artist's own weaving.

Heade gave *Fern-Tree Walk* (as well as most of his panoramic views of the tropics) a surprising sense of order. In spite of the deep crevice in the earth to the right and the steep drop between the foreground and the sea, Heade infused into this painting remarkably little of the sublime drama that Church liberally bestowed on his own tropical landscapes. No gaping ravines appear where solid land should be; no insistent projection into seemingly limitless distance is visible; vegetation does not swallow the viewer. Instead, the forested area is set back from his implied space and visually

Figure 2. Frederic E. Church, *Rain Forest, Jamaica*, 1865, oil with pencil on paperboard, 12 x 20 in. (30.5 x 50.8 cm.). Cooper-Hewitt Museum, Smithsonian Institution's National Museum of Design (1917-4-678B)

introduced by a vignette of low, generously spaced plants. Light still hits them in the flickering pattern of the densest jungles, but this rain forest has the comforting remove of a stage set.

Fern-Tree Walk is reminiscent of the earliest North American views of the Hudson. It looks curiously like Thomas Cole's *Oxbow* (see p. 125) transferred to a tropical location. Both paintings depict the details of nature with robust irregularity: in both, the framing foreground seems actually to bulge out; both provide an arched space off-center in the foreground to reveal the view below; in both, the rapid and abundant regrowth of nature is emphasized in the form of scrub, moss, and underbrush. And in both, the foreground overgrowth is contrasted with the stilled, seemingly eternal and unchangeable bodies of water in the background. To be sure, Heade's reliance on Cole's compositional ideas affirms that they had become a prominent part of the general landscape lexicon. Nonetheless, the differences between Cole's and Heade's canvases underline the significant change in attitude almost thirty-five years had made.

Heade made a far stronger contrast than Cole did between the chaotic, almost throbbing life of nature perceived at close range and the serenity of nature viewed from a distance. That such a peculiar double vision would ensue was perhaps inevitable. During the 1860s and 1870s, two ideologies that had long existed as one within the Hudson River School finally became two separately identifiable entities in American landscape painting. The prescription that artists should give themselves over to nature's numerous, unique details was one; the demand that artists be ever more aware of nature's breadth and unity was the other. Once Heade had decided to return to the earlier Hudson River School compositional style, it naturally followed that the divergent ideas he portrayed in

this canvas would show themselves as the polarities they had become.

But why would Heade have wanted to make a Jamaican *Oxbow* at all? He could easily have capitalized on the exoticism of the tropical setting, as Church had done, but chose not to. For Heade, when the truly unfamiliar loomed large, the balancing power of tradition seems to have had a particular attraction. It provided order, calm, and an important assurance that nature is comprehensible to man.

D.J.S.

Notes
1. Stebbins 1975, pp. 93–94.
2. See Theodore E. Stebbins, Jr., *Close Observation: Selected Oil Sketches by Frederic E. Church*, exh. cat. (Washington, D.C.: Smithsonian Institution, 1978), nos. 52–59.

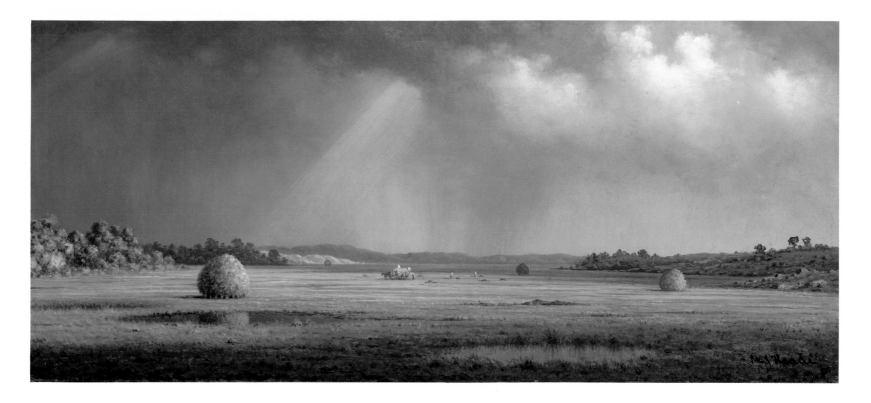

Newburyport Meadows, ca. 1872–78

Oil on canvas, 10½ × 22 in. (26.7 × 55.9 cm.)
Signed at lower right: M. J Heade
Inscribed (on back of stretcher): Newburyport Meadows
The Metropolitan Museum of Art, New York City. Purchase,
 The Charles Engelhard Foundation Gift, in memory of
 Charles Engelhard; Morris K. Jesup, Maria DeWitt Jesup, and Pfeiffer
 Funds; John Osgood and Elizabeth Amis Cameron Blanchard
 Memorial Fund; Thomas J. Watson Gift, by exchange; and Gifts of
 Robert E. Tod and William Gedney Bunce, by exchange, 1985
 (1985.117)

Salt marshes, a subject that appeared in Heade's work with a frequency and variety not matched by any of his other themes, accounted for his greatest commercial success.[1] From 1859 until the end of his life, he painted them in locations that extended along the eastern seaboard from northernmost Massachusetts to southern New England, New Jersey, and Florida. The marshes of Newburyport, Massachusetts, made intermittent appearances within that chronology. Heade treated them first in 1862 and went back to them in the 1870s; thereafter, they vied with the marshes of Hoboken, New Jersey, for his repeated attention.

Heade's pictures of coastal marshlands always emphasized their pristine flatness, their uninterrupted view of the sky, and the readiness with which atmospheric changes were reflected on their terrain. During the late 1860s, however, a subtle shift in Heade's point of view became evident. The geometric tautness, precise detail, and evocative light of his earlier images gave way to less rhythmic, less rigorous, and less minutely executed compositions. In them, winding, sharp-edged inlets were replaced by puddles; stately, volumetric haystacks were succeeded by lumpy, randomly arranged ones; and suggestively tinted skies were abandoned in favor of the lesser drama of cloudy daylight.[2] At the same time, the horizons of the marshes became broader and lower; signs of human presence, less evident. Though Heade's scenery as a whole was not as striking as before, neither was it as rigid and contrived; thus it could better suggest nature's fleeting phenomena.

Newburyport Meadows exemplifies Heade's altered artistic priorities. In this image, he downplayed foreground detail in order to draw the viewer's attention into the distance. There, the atmospheric complexities convey a marshland in constant change. There is great delicacy and depth to the stormy sky. The weather, though it would seem at first glance to be meteorologically uneventful, is a surprisingly rich combination of haze, storm, and sunshine. Both foreground and background have been subjected to continual small changes in color, texture, and value. A reddish light is cast on the rocks to the left, and small horizontal striations mark the marsh grass. Heade took care to make the haystacks and stray bushes dotting the marsh neither more nor less interesting than the sky, the horizon, or even the foreground shadows. As a result, the eye wanders freely over the scene and only gradually understands what it is observing.

Marsh views like *Newburyport Meadows* show man's intimate involvement with a nature that runs its own course—an essen-

tial attitude of the Hudson River School. To suggest the independent movement of natural forces, Heade turned to storms and passing clouds in simple daylight—the same modest moments of transition advocated by Asher B. Durand. The present painting can be considered the result of such Durand prescriptions as this:

> The best time to observe the ordinary effect of sunshine on the landscape is to watch the gradual clearing up of a cloudy day, when its presence is first announced by occasional patches of light. The first sensation conveyed is, of course, that of light—the next, that of color: the entire mass of such light being warm compared with the surrounding shade. Study the effect, first, in the middle distance, when a cloudy sky just begins to open and lets its first burst of sunlight in.[3]

Heade, in creating his various marsh scenes, nevertheless took exception to at least two important Hudson River School practices. He seems not to have relied on preparatory sketches and to have embraced willingly a compositional monotony that would not have been acceptable to Durand, Thomas Cole, or even Frederic Church.

In 1880, Heade was said to have painted more views of the Hoboken and Newburyport meadows than of any other subject, so great was the demand for them.[4] If this painting's first owner—Stephen Wallace Dorsey, a carpetbagger land speculator and United States senator from Arkansas—provides any indication, Heade's marshes would have been unknown, unfamiliar views to a good many of their purchasers. Dorsey, who apparently acquired the work when he was serving in Washington, D.C., between 1872

and 1878, took it to northeastern New Mexico when he left office. There, it decorated the salon of his newly built log-and-sandstone mansion, along with other landscape, genre, and still-life paintings by New York artists. It has survived in unusually pristine condition, which permits the subtleties of Heade's style to be seen especially clearly.

That the novelty of these admittedly simple sites did not wear off either for Heade or for his patrons is amazing. One reason may be that the Adirondack and White mountains, Lake George, and the Newport beaches were becoming increasingly popular as tourist attractions, but marshes like Newburyport's still had much of the quality of wilderness that first attracted Hudson River School painters. Marshes are beyond human control: the grass grows without cultivation and largely unnoticed; even when harvesting is in progress the marshland changes little. Because the grass is high and because no roads lead through the boggy soil, few workers and hardly any onlookers venture there. As in the scenes of the tropics he was then producing, Heade becomes the viewer's ambassador to a part of the world that few have ever carefully observed.

D.J.S.

Notes
1. Stebbins 1975, p. 101.
2. See the discussion of Heade's haystacks in Stebbins 1975, pp. 94–97.
3. Durand 1855, VI, p. 210.
4. Clement and Hutton 1880, 1, p. 340.

WORTHINGTON WHITTREDGE
(1820–1910)

Thomas Worthington Whittredge, born on his family's farm near Springfield, Ohio, trained as a house- and sign-painter in Cincinnati. He soon turned to portraiture and then to landscapes, three of which he exhibited at the Cincinnati Academy of Fine Arts in 1839. He worked as a daguerreotypist in Indianapolis, Indiana, and as a portraitist in Charleston, West Virginia. In 1844, he returned to Cincinnati and concentrated on landscape painting, exhibiting his work at the Western Art-Union and, in New York, at both the American Art-Union and the National Academy of Design. In April 1849, with several commissions from Cincinnati patrons in hand, he sailed for Europe for what would be a ten-year stay. After arriving in London, he traveled through Belgium and Germany and stopped briefly in Paris before settling in Düsseldorf. He never enrolled in formal classes at the Düsseldorf Academy, but he associated with many of the influential artists who taught or studied there, developing friendships with Emanuel Leutze, Carl Friedrich Lessing, Andreas Achenbach, and Albert Bierstadt.

In 1855, he began to sign his canvases "W. Whittredge" instead of his usual "T. W. Whitridge" or "T. W. Whitredge." In August 1856, he traveled to Italy, sketching along the way with Sanford R. Gifford and William Stanley Haseltine. By early 1857, he was living in Rome with Gifford and Bierstadt. The three artists spent the following summer sketching in the Alban and the Sabine hills and in the Campagna. In May 1859, Whittredge returned to New York and rented space in the Tenth Street Studio Building, where he was in the company of his friends Thomas Buchanan Read, William Holbrook Beard, Gifford, Haseltine, and Bierstadt.

He then began to develop associations with leading members of the Hudson River School, including John Kensett, Frederic Church, John Casilear, Jervis McEntee, and Aaron Draper Shattuck.

Whittredge was elected to the National Academy of Design as an Associate in 1860 and a full member two years later. In 1862, he joined the Century Association, where he developed friendships with artists of the Hudson River School and their intellectual mentor, William Cullen Bryant. Between 1860 and 1866, Whittredge often sketched in the Catskill and Shawangunk mountains. In 1866, perhaps spurred by the success of Bierstadt's landscapes of the Rocky Mountains, he joined an expedition led by General John Pope to the American West. The trip proved to be highly consequential to his artistic development: liberated in spirit, he began to apply the fruits of his European experience to interpretations of his native land. He returned to the West twice in the 1870s and continued to sketch in the Catskills, along the upper Delaware River, and on the Rhode Island coast throughout the 1870s.

Whittredge, president of the National Academy of Design from 1875 to 1877, helped to organize the foreign and American art exhibits at the Centennial Exposition in Philadelphia in 1876. In the same year, he auctioned off seventy-five of his paintings at Ortgies and Company, though he still remained artistically active. He received a silver medal at the Pan-American Exposition in Buffalo in 1901. In March 1904, he exhibited a hundred and twenty-five of his paintings at the Century Association in New York City. The following year, he completed his autobiography, which remains a rich source of information on the Hudson River School.

Select Bibliography

John I. H. Baur, ed. "The Autobiography of Worthington Whittredge, 1820–1910." In *Brooklyn Museum Journal* 1 (1942), pp. 7–68.

Edward H. Dwight. *Worthington Whittredge (1820–1910): A Retrospective Exhibition of an American Artist*. Exhibition catalogue. Utica, New York: Munson-Williams-Proctor Institute, 1969.

Anthony F. Janson. *The Paintings of Worthington Whittredge*. Forthcoming. Originally Ph.D. diss., Harvard University, 1975.

Cheryl A. Cibulka. *Quiet Places: The American Landscapes of Worthington Whittredge*. Exhibition catalogue. Washington, D.C.: Adams Davidson Galleries, 1982.

The Old Hunting Grounds, ca. 1864

Oil on canvas, 36 × 27 in. (91.4 × 68.6 cm.)
Signed at lower right: W. Whittredge
Reynolda House, Museum of American Art, Winston-Salem,
 North Carolina

Whittredge's *The Old Hunting Grounds* represents an interior woodland scene composed along principles common during the mid-nineteenth century, such as the darkened lateral edges emerging from a shaded foreground and the middle ground occupied by a pool of water that reflects the background, often distant mountains (ill.), though in this picture the slender trunks of white birches. That technique of composition was originally derived from the classic landscapes of Claude Lorrain, and its use remained prevalent in England, Germany, and Scandinavia during the first third of the last century. Asher B. Durand was a strong American exponent of

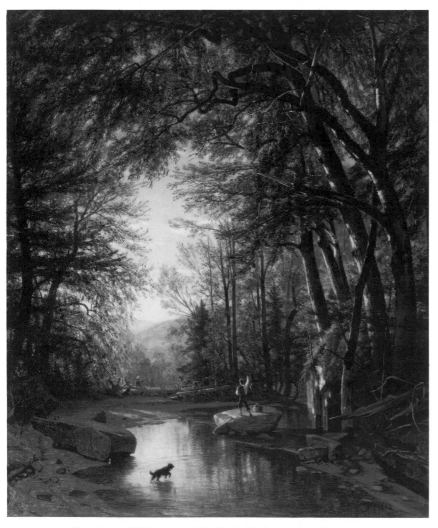

Worthington Whittredge, *A Glen by the Hudson*, 1862, oil on canvas, 18 x 30¼ in. (45.7 x 76.8 cm.). Private collection

the formula, especially in his vertical woodland scenes of the 1850s and 1860s, which focused on the Catskills. For artists of the second generation of the Hudson River School who depicted the native landscape, the use of the Claudean convention invoked pastoral associations and helped to reinforce the developing myth of America as a new Eden.[1] It is therefore not surprising that Whittredge, having painted in Europe for the previous decade and now struggling to understand the American scenery, should have chosen to follow the formula. As he later recalled of that post-homecoming time: " . . . It was the most crucial period of my life. It was impossible for me to shut out from my eyes the works of the great landscape painters which I had so recently seen in Europe, while I knew well enough that if I was to succeed I must produce something new which might claim to be inspired by my home surroundings. I was in despair."[2]

Most of the paintings Whittredge completed between his return to the United States in 1859 and his first trip to the American West, in 1866, were interior scenes, either of woodlands[3] or of old American manor houses, perhaps an indication of the introspection that preoccupied him. His attempts to integrate elements of his European training with his growing understanding of the American landscape constituted a conscious effort on his part and, in turning to the works of Durand, he found an excellent guide. Because several of Durand's practices and ideas on art were based on European roots, Whittredge had no difficulty in taking them to himself. Durand's advice to sketch from nature coincided with the custom Whittredge himself had developed in Düsseldorf. "Sure, however, that if I turned to nature I should find a friend, I seized my sketch box and went to the first available outdoor space I could find," he later wrote.[4] Whittredge's habit of sketching at Durand's favorite sites near Shokan and Shandanken, and his frequenting the company of John Casilear, John F. Kensett, Sanford R. Gifford, and Jervis McEntee on study trips[5] were perhaps manifestations of his strong desire to become an accepted member of that group of landscapists.

The Old Hunting Grounds was exhibited at the National Academy of Design in 1864, where it found a purchaser in the noted collector James W. Pinchot. Three years later, the painting was chosen for the Paris Exposition Universelle, and its merits were recognized by Henry T. Tuckerman in his *Book of the Artists*:

> [Whittredge's] "Old Hunting Ground" has well been called an idyl, telling its story in the deserted, broken canoe, the shallow bit of water wherein a deer stoops to drink, and the melancholy silvery birches that bend under the weight of years, and lean towards each other as though breathing of the light of other days ere the red man sought other grounds, and left them to sough and sigh in solitude.[6]

Tuckerman's intuitive expression of Whittredge's feelings about the landscape were later confirmed by the artist in his autobiography: "The forest was a mass of decaying logs and tangled brush wood, no peasants to pick up every vestige of fallen sticks to burn in their miserable huts, no well-ordered forests, nothing but the primitive woods with their solemn silence reigning everywhere."[7]

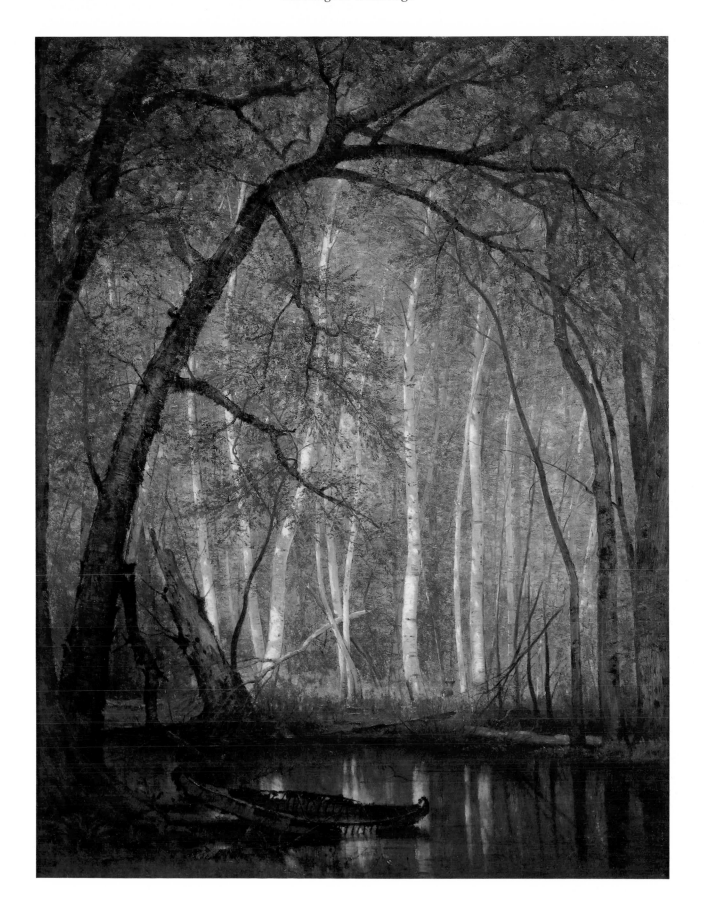

In *The Old Hunting Grounds*, painted four years after his return to America, Whittredge clarified a particular reading of the native forest: the decaying Indian canoe established on the landscape concrete evidence of previous human presence, and so endowed the land with an ancient history. Thus the Indians were seen to have fulfilled a function in America's forests that was similar to the pastoral duties of European peasants.

As a member of the Century Association, beginning in 1862, Whittredge was in close contact with the leading members of the artistic and literary intelligentsia, and their ideas may have shaped his interpretation of the American landscape.[8] Although never himself an original thinker, Whittredge was able to express in visual form contemporary thoughts regarding the interrelationship of nature and history in America so successfully that *The Old Hunting Grounds*, which was commended for excellence at the Centennial Exposition in Philadelphia,[9] remained relevant as an icon for decades. By 1880, the type of landscape exemplified by the painting had become so prevalent that art historian Samuel G. W. Benjamin was able to write, "A faithful delineator of the various phases of American wood interiors, Mr. Whittredge has deservedly won a permanent place in the popular favor."[10]

E.T.T.

Notes
1. Novak 1980, p. 230.
2. Baur 1942, p. 42.
3. Anthony F. Janson, "The Paintings of Worthington Whittredge," Ph.D. diss., Harvard University, 1975, pp. 72–73.
4. Baur 1942, p. 42.
5. Cheryl A. Cibulka, *Quiet Places: The American Landscapes of Worthington Whittredge*, exh. cat. (Washington, D.C.: Adams Davidson Galleries, 1982), p. 19.
6. Tuckerman 1867, p. 518.
7. Baur 1942, p. 42.
8. Janson 1979, pp. 74, 77.
9. Matthews 1946, p. 159.
10. Benjamin 1880, p. 73.

Twilight on Shawangunk Mountain, 1865

Oil on canvas, 45 × 68 in. (114.3 × 172.7 cm.)
Signed and dated at lower left: W. Whittredge 1865
Private collection

The landscape of the Shawangunk region, which lies southwest of the Catskills, is mostly rocky terrain studded with thorny knolls and tall pines. It became a favorite sketching ground for Whittredge and Sanford Gifford during the 1860s, when both artists were growing particularly fond of the effects of light the setting sun produced among the rocky promontories and in the river valleys. The autumn season, especially, endowed the Shawangunk area with luminous colors and varied textures and offered a painter abundant possibilities for landscape compositions. In 1865, both Whittredge and Gifford exhibited Shawangunk subjects (including this painting of Whittredge's) at the National Academy of Design.[1] A review of the exhibition evaluated Whittredge's *Twilight on Shawangunk Mountain* as "simple, direct . . . [and] characterized by a truth to nature and solemnity of sentiment."[2]

Twilight—the short, transitory period between day and night—is neither day nor night yet clearly encompasses both antipodes. Whittredge gave visual expression to its transient quality by silhouetting the darkened foreground (night) against the brightly lit sky (day). The duel being fought between night and day is fiercest on the left side of the composition, where tall pines and gnarled aspen pierce the sunlit horizon and stretch beyond the upper limits of the picture space. Because the rocky promontory shelters the foreground cove from the rays of the setting sun, there it is already night, and the men and the dog have gathered around the fire, a man-made source of light.[3] A peaceful resolution of the conflict is suggested at the right side of the composition, where the colorful light is gently modulated by the grassy surfaces of the sloping hillsides.

The degree of sophistication attained by Whittredge in fine-tuning the structure of *Twilight on Shawangunk Mountain* went unnoticed by a public now expecting a large canvas to depict spectacular scenery or cosmic dramas, as those of Frederic Church and Albert Bierstadt did.[4] Whittredge's painting, neither portraying a meteorologic miracle nor focusing on a geographic wonder, could thus be disdained by a contemporary critic as "not an example of creative power."[5] He was wrong: Whittredge's powers of artistic creation emerge forcefully. The painter was able to convey temporal change as a tenet of divine order in nature, manifested indiscriminately in the common landscape of America's wilderness. The originality of Whittredge's accomplishment notwithstanding, *Twilight on Shawangunk Mountain* was undoubtedly his response to the contemporary interest in twilight scenes launched by Church's epic *Twilight in the Wilderness* (see p. 251). Whittredge, though using

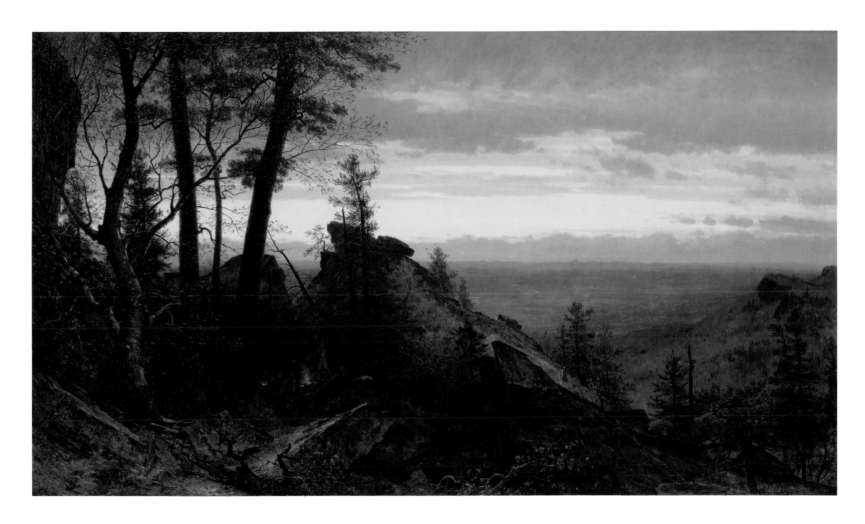

the new and colorful pigments commercially available, which often enticed artists to virtuoso depictions of sunsets, was not deterred from approaching his subject with the discipline that is one of his greatest strengths.

In 1867, Henry T. Tuckerman would list *Twilight on Sha-wangunk Mountain* among Whittredge's "principal landscapes."[6] The painting indeed exemplifies Whittredge's art, as the noted art historian E. P. Richardson described it: "Remarkable for a limpid self-effacement; a sensitiveness to the life of nature; an understanding of the character of a place, a season, an hour of the day."[7]

E.T.T.

Notes

1. Gifford showed *Afternoon Effects on the Shawangunk Mountains*, no. 349 in the exhibition catalogue; Whittredge's painting was no. 205. Naylor 1973, 1, p. 341; 2, p. 1024.
2. Sordello [pseud.], *New York Evening Post*, 22 May 1865, p. 1.
3. The motif of men around a campfire is the chief subject of Albert Bierstadt's *Trapper's Camp* (1861; Yale University Art Gallery). It is to that work that Whittredge's group most closely relates.
4. Frederic E. Church, *Niagara* (see p. 243), *Heart of the Andes* (see p. 246), *Twilight in the Wilderness* (see p. 251), and *Cotopaxi* (see p. 254); Albert Bierstadt,

The Rocky Mountains, Lander's Peak (see p. 285).
5. Sordello, p. 1.
6. Tuckerman 1867, p. 517.
7. E. P. Richardson, *A Short History of Painting in America* (New York: Harper & Row, 1963), p. 163.

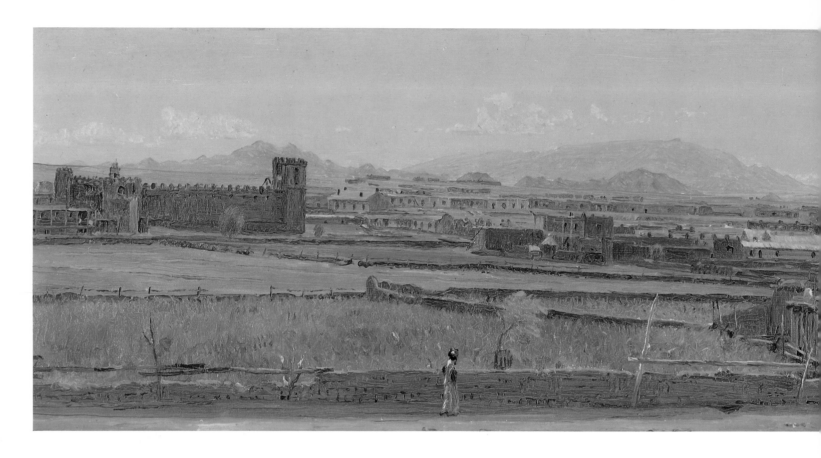

Santa Fé, 1866

Oil on paper mounted on canvas, 8⅛ × 23⅛ in. (20.6 × 58.7 cm.)
Signed and dated at lower right: Sante Fe/July 20" 66/W. Whittredge
*Yale University Art Gallery, New Haven, Connecticut. Gift from the
estate of William W. Farnam, B.A. 1866, M.A. 1869, to the Peabody
Museum of Natural History (1929.780.1)*

This oil sketch[1] of Santa Fé, dated precisely 20 July 1866, is one
of a series of sketches Whittredge executed during his first trip to
the American West, when he traveled with the army expedition of
General John Pope. The party left Fort Leavenworth, Kansas, on
1 June;[2] arrived in the Denver, Colorado, area by 18 June;[3] and
was approaching New Mexico by 9 July.[4] During the excursion,
it was Whittredge's habit to set out on short sketching trips after
making camp in the early afternoon,[5] carrying his revolver,
campstool, umbrella, and, of course, his sketch box.[6] The sketch
box contained tubes of colors, brushes, knives, and a palette, and,
when it was laid on the painter's knees, it could act as a small easel,
since its opened lid could be secured at different angles. Special
interior compartments could accommodate two or three wet
studies at a time.[7] When Whittredge had nearly finished painting
Santa Fé, he was confronted by a rough-looking fellow, brandishing
a pistol, who demanded to buy the picture. Whittredge, maintain-

ing his calm, pacified his would-be customer by explaining that he
was merely doing a "sketch to make a large picture from," which
would be sold in New York.[8]

The Santa Fé sketch preserves the contemporary panorama
of the town, with its "low adobe huts" and "flat grassgrown roofs"
in front of the "great valley of the Rio Grande with the beautiful
San Dia mountains in the distance."[9] The sun-baked-earth tones
of the buildings dissolve into the warm air, which vibrates with
specks of highlights bouncing off the lines of the roofs and the tops
of the fence posts. Man-made objects in the landscape are arranged
in narrow strips layered in planes parallel to the picture space, for
Whittredge perceived the western plains as endless strips of land
receding toward the horizon.[10] The uniformity and order that
characterize the town contrast with the irregularity of the distant
ranges and their variegated surfaces. Yet this is a town clearly the
product of its natural environment, rising from the very soil of the
plains and conforming to the contours of the land. The elongated
format of *Santa Fé* is characteristic of all the sketches Whittredge
made of the western plains in 1866. Of the studies so far located,
it appears to be the last he painted during the expedition.[11]

Soon after Whittredge sketched Santa Fé, General Pope's
party continued to Albuquerque. Whittredge then took a one-week
trip into what he called the Tuerto Mountains with two of the army
officers.[12] On 26 and 28 July, the *Santa Fé Weekly Gazette* reported
that the Pope party was back in town following its excursion to

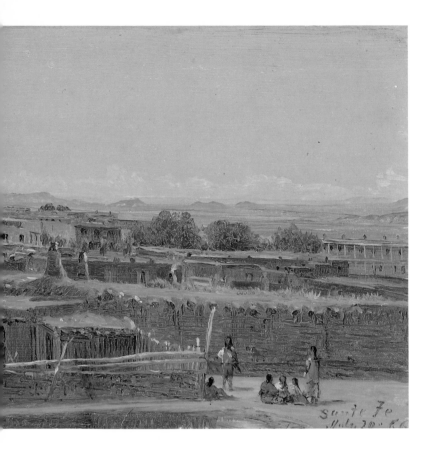

dorf associates Bierstadt and Emanuel Leutze, among others. Whittredge had originally planned to travel with William Holbrook Beard and Bayard Taylor,[18] but perhaps preferred the more extensive itinerary offered by the military expedition to the more limited one the artists could plan on their own.[19]

That Marsh, a paleontologist and scientist, collected Whittredge's western sketches testifies to their fidelity to both spirit and topographical accuracy. Whittredge's direct approach to painting and his expertise in selecting appropriate vistas resulted in a series of sketches that shortly after their creation were perceived as invaluable artifacts, as well as objects of great aesthetic merit.

E.T.T.

Notes

1. When the painting was removed from its frame at the Yale University Art Gallery on 14 April 1986, it was apparent that the original paper was mounted on a layer of canvas, which in turn was backed by an aluminum sheet. The painting had been treated in March 1971, but no record was left of the process.

2. Baur 1942, p. 45.

3. Worthington Whittredge, *Long's Peak* (18 June 1866; Joslyn Museum). See Moure 1973, p. 19, for a letter from Pope, in Denver, dated 2 July 1866.

4. Worthington Whittredge, *Raton Pass, Spanish Peaks* (9 July 1866; Yale University Art Gallery).

5. Baur 1942, p. 45.

6. Ibid., p. 47.

7. The sketch box Whittredge used was of a type popular with landscapists of the Düsseldorf School. For a description, see *The Crayon* 5 (October 1858), p. 292.

8. Baur 1942, p. 49.

9. Ibid.

10. In addition to *Long's Peak from Denver, Colorado* (Fig. 1, p. 187), other such sketches from Whittredge's 1866 trip include *The Little Blue River* (Joslyn Museum), *Graves of the Travellers, Fort Kearney* (Cleveland Museum), and *Junction of the Platte Rivers* (Yale University Art Gallery).

11. Undated sketches were apparently executed during the earlier part of the expedition. See list above, as well as *Encampment on the Plains* (Joslyn Museum).

12. Baur 1942, p. 52.

13. See "A letter from Major General Pope to Major General Sherman," in *Annual Report of the Secretary of War, House Executive Documents*, No. 1, 39th Congress, 2nd Session, 1866, v. 3, pp. 23–30.

14. Moure 1973, p. 19; Baur 1942, p. 52.

15. These data were obtained from Guy St. Clair, fine arts representative at the Union League Club in 1979. See Trenton and Hassrick 1983, p. 379; p. 376, n. 360.

16. *Collection of the late Professor Othniel C. Marsh*, sale cat., American Art Galleries, New York, 29 February 1900. Exactly when Whittredge sold his western sketches to Marsh is difficult to determine. In 1881, Marsh bought eight "studies from nature" mostly dating from Whittredge's second trip West. See Whittredge to O. C. Marsh, 27 May 1881, Othniel C. Marsh Papers, General Correspondence, Manuscripts and Archives, Yale University Library, New Haven, Conn.

17. Trenton and Hassrick 1983, p. 212.

18. Taylor to Beard, May 1866, Taft Papers, Kansas State Historical Society, Topeka, Kansas. See also Trenton and Hassrick 1983, p. 374.

19. Bayard Taylor, *Colorado: A Summer Trip* (New York: G. P. Putnam and Son, 1867), p. 146; idem, *Life and Letters of Bayard Taylor* (Boston: Houghton, Mifflin and Co., 1884), 2 vols., ed. by Marie Hansen-Taylor and Horace E. Scudder, 2, p. 461.

Albuquerque. By 11 August, the party had reached Fort Union, New Mexico, on its way back East. According to a letter written by General Pope to General William Tecumseh Sherman,[13] the expedition was to leave Fort Union on 15 August for Fort Leavenworth. From there it went to Fort Riley, Kansas, where it disbanded.[14] Whittredge, who probably reached New York by early September, likely soon set to work on the studio pictures that he developed from his western sketches. *Crossing the Ford, Platte River, Colorado* (see p. 186), based on *Long's Peak from Denver, Colorado* (Fig. 1, p. 187), was almost completed by January 1868, and by January 1869 the large, finished *Santa Fé* had been hung in the private exhibition room of the Union League Club in New York. Whittredge had submitted it to the club in 1868 as his initiation fee and payment of his first year's dues. (Though the painting was still at the Union League Club in 1909, its present location is unknown.)[15]

The sketch found its way into the collection of Othniel C. Marsh, who owned nineteen works by Whittredge.[16] Marsh, professor of paleontology at Yale Scientific School, was appointed director of Yale's Peabody Museum in 1866. Because under his leadership some of Yale's scientific expeditions had been supported by the army, it may be that Marsh had arranged for Whittredge to join General Pope in 1866.[17] Though Marsh may have encouraged him, it was probably the painter's own idea to go on a sketching trip to the West, perhaps motivated by the example of his Düssel-

Crossing the Ford, Platte River, Colorado, 1868 and 1870

Oil on canvas, 40¼ × 69⅛ in. (102.2 × 175.6 cm.)
Signed and dated at lower right: W. Whittredge/1870/W. Whittredge/
 1868
The Century Association, New York City

In *Crossing the Ford, Platte River, Colorado*, Whittredge created an equilibrium between the principles of the Hudson River School aesthetic and the logic of composition, drawing, and coloring he had assimilated during his five years in Düsseldorf, Germany. *Crossing the Ford*, formerly titled *The Plains at the Base of the Rocky Mountains*, represents an Indian camp in a verdant cottonwood grove on the far side of a gently flowing river. Departing from the near bank (a rocky patch of which serves as a *repoussoir*), some figures on horseback are fording the shallow water. They are heading toward the most prominent tepee of the camp, the fulcrum of the composition. The solitary cottonwood tree in the center of the painting picks up the rhythm established by the intervals between the foreground bank, the horsemen, the tepee, and the tree that beckons toward the snowcapped mountain ranges in the dis-

tance. This perfect equilibrium conveys the calm of the plains, a quality of the West that Whittredge valued more than the drama of great heights and rugged scenery.[1] The painter likened his experience of the plains to his recollections of the Roman Campagna, where he had traveled and painted with Sanford Gifford and Albert Bierstadt before returning to America in 1859.[2] Despite his personal reaction to the immediacy of the plains, the artist felt compelled to interpret the land in a historical context, choosing to depict the Indians living peacefully and in harmony with nature before the coming of the white man disturbed their arcadian habitat.

Whittredge based this large studio work on sketches he made during 1866, when he toured Nebraska, Colorado, and New Mexico with General John Pope, who was undertaking the inspection of Indian settlements after the Civil War.[3] From Pope's reports to Congress, and also from Whittredge's autobiography, it emerges that conditions with the Indians were not idyllic: "At that time the Indians were none too civil; the tribe abounding in the region were the Utes. We seldom saw any of them, but an Indian can hide where a white man cannot, and we had met all along our route plenty of ghastly evidences of murders, burning of ranches, and stealings innumerable."[4]

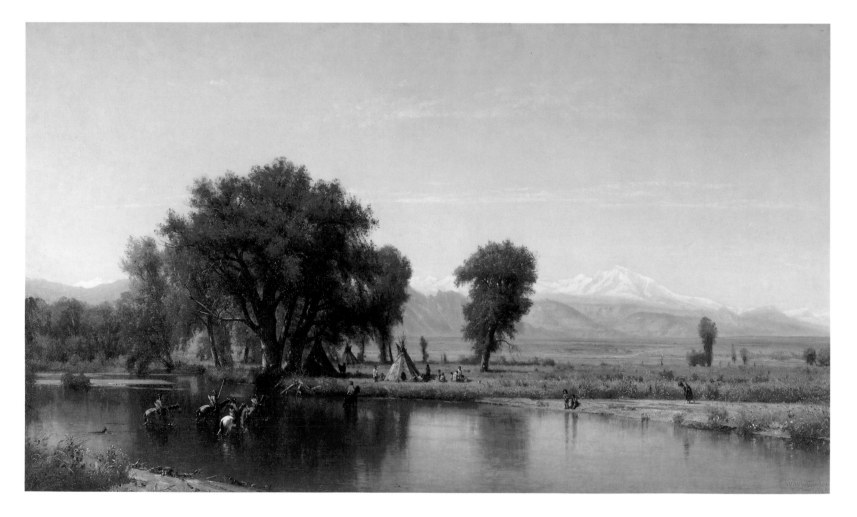

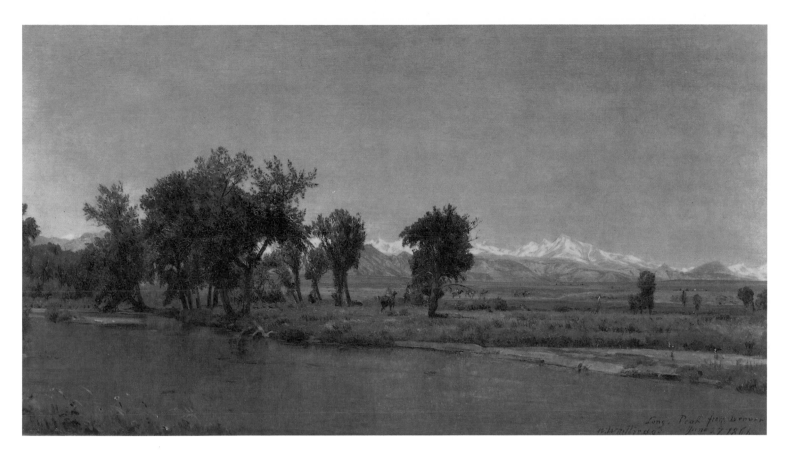

Figure 1. Worthington Whittredge, *Long's Peak from Denver, Colorado*, 1866, oil on canvas, 12⅞ x 23⅝ in. (32.7 x 60 cm.). Courtesy, Buffalo Bill Historical Center, Cody, Wyoming

Because the red men were in a constant state of starvation, they frequently raided white settlements for food.[5] The underlying inconsistency between Whittredge's actual observation of the Indians and the manner in which he chose to portray them in *Crossing the Ford* was a hallmark of the Hudson River School. In the East, artists avoided depicting the effects of industrialization; in the West, they ignored the plight of the native Americans. Yet the sketch for *Crossing the Ford* (Fig. 1) conveys some of the bewildered feelings described by both Pope and Whittredge. A critic writing for *Harper's Bazaar* in 1868, on visiting Whittredge in his New York studio, observed the distinction in tone and content between the large studio picture and the original field sketch:

> The prominent picture this afternoon soars mighty in proportions above the modest little study for it standing below. . . . The study would be to some more interesting as being a defiant little bit of form and color, not softened by the warm atmosphere of the great picture above, nor brightened by the light and color in the wigwams and figures, nor made more tender and graceful in form by art.[6]

Whittredge imbued the studio work with historical overtones. Though he deviated from the details of the actual topography as little as possible, he refined the composition until every object in

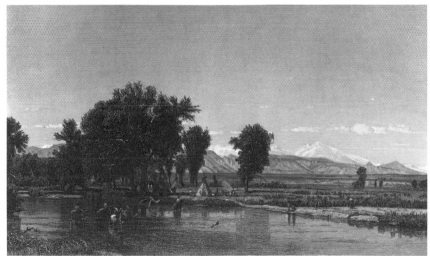

Figure 2. R. Hinshelwood, after Whittredge's *The Rocky Mountains*, engraving, 1871, 5⁵⁄₁₆ x 8¹⁵⁄₁₆ in. (13.5 x 22.7 cm.). Courtesy, Amon Carter Museum, Fort Worth

the landscape served a specific purpose. That working method was a characteristic of landscapists of the Düsseldorf School and at the same time Whittredge's answer to the challenge posed by Thomas Cole: that landscape paintings should project some moral or historical meaning.

Prior to painting *Crossing the Ford* in 1868, Whittredge produced an almost identical work somewhat smaller than the field sketch. Titled *Indians Crossing the Platte*,[7] it depicts the scene at twilight and includes a few details contained in the field sketch but omitted from *Crossing the Ford*, suggesting that it was the basis for *The Rocky Mountains* (Fig. 2), an engraving after Whittredge's composition.[8] Whittredge, who signed and dated *Crossing the Ford* in 1868, exhibited the painting that year at the Brooklyn Art Association and at the National Academy of Design in New York as *The Plains at the Base of the Rocky Mountains*.[9] Despite the acclaim that greeted it, the picture did not sell, and Whittredge decided to improve it by repainting the cottonwood grove on the left. In 1870, to collect fresh studies, he undertook a second journey to the West, that time traveling with his friends Gifford and John Kensett. *The Rocky Mountain News* (Denver) announced on 2 August 1870 that the artists had taken a coach to Loveland Pass.[10] Whittredge was seeking a specific group of trees along the Cache la Poudre River, some fifty miles from Denver, which he remembered from the trip four years before.[11] Early in August, after Gifford parted company with them to join a geological survey led by F. V. Hayden, Whittredge and Kensett continued toward Greeley. There Whittredge located the trees. By the end of September, he and Kensett were heading toward New York, where he repainted the grove in *Crossing the Ford* and redated the canvas 1870. The following year, the Century Association purchased the work[12] and hung it near the fireplace in the main meeting room. When *Crossing the Ford* was exhibited at the Philadelphia Centennial Exposition, it was perceived as a perfect example of American landscape painting and was commended for "excellence in landscapes."[13] The picture also characterized American landscape painting at the Paris Exposition Universelle of 1878. By the time of the World's Columbian Exposition, in 1893, *Crossing the Ford* was a veteran at representing the highpoint of the Hudson River School tradition, which had then diminished in favor.

E.T.T.

shelwood engraving could therefore have been based on *Crossing the Ford* in its original, 1868 state. See Trenton and Hassrick 1983, p. 376, n. 47, for that opinion. If the print was executed after 1870 (it was not published until 1871), it could have been based on the 1867 *Indians Crossing the Platte*, which was not altered. The size (eleven by twenty-two inches) of *Indians Crossing the Platte* also suggests that it was the source for the engraving, which was published in William Cullen Bryant, ed., *Picturesque America*, 2 vols. (New York: D. Appleton & Co., 1872–74), 2, p. 488.

9. Marlor 1970, no. 224; Naylor 1973, 2, no. 353.
10. Baur 1942, p. 64; Trenton and Hassrick 1983, p. 213.
11. *Rocky Mountain News*, 2 August 1870.
12. Baur 1942, p. 42; A. Hyatt Mayor and Mark Davis, *American Art at the Century* (New York: The Century Association, 1977).
13. U. S. Centennial Commission, *Official Catalogue of the U. S. International Exhibition*, 1876, p. 31, no. 491; Matthews 1946, p. 159.

Notes
1. Baur 1942, p. 45.
2. Ibid., p. 46.
3. Moure 1973, p. 18; Trenton and Hassrick 1983, p. 374, n. 23.
4. Baur 1942, p. 46.
5. Moure 1973, p. 18. See also "A letter from Major General Pope to Major General Sherman," in *Annual Report of the Secretary of War, House Executive Documents*, No. 1, 39th Congress, 2nd Session, 1866, v. 3, pp. 23–30.
6. Quoted in Trenton and Hassrick 1983, p. 212.
7. For a discussion and illustration, see Anthony F. Janson, "The Western Landscapes of Worthington Whittredge," *American Art Review* 3 (November/December 1976), p. 59.
8. Note the details of driftwood, dogs, billowing smoke, and position of clouds. The most significant difference is found in the profile of a large cottonwood on the left margin, which appears in *Indians Crossing the Platte* (1867; private collection) and the Hinshelwood engraving. The profile of the tree may have appeared in *Crossing the Ford* when it was originally completed in 1868, and could have been painted out in 1870, when Whittredge reworked the cottonwood grove. The Hin-

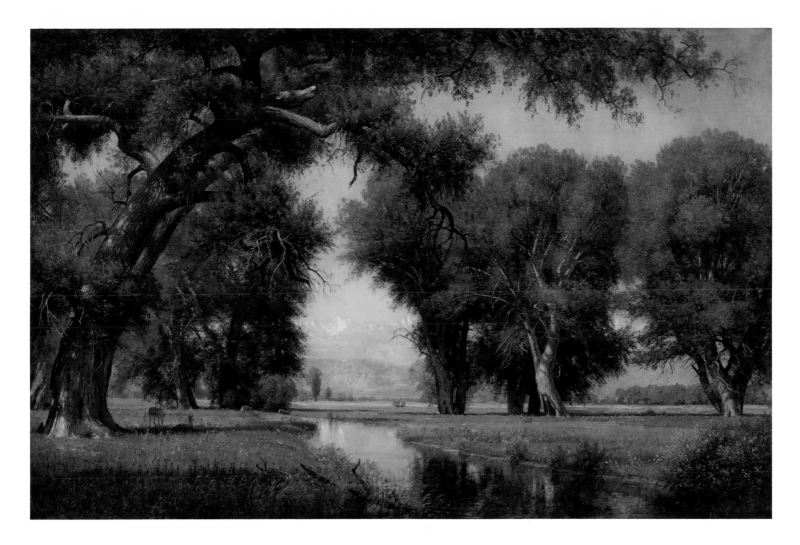

On the Cache La Poudre River, Colorado, 1876

Oil on canvas, 40¼ × 60⅜ in. (102.2 × 153.4 cm.)
Signed and dated at lower right: W. Whittredge 1876
Amon Carter Museum, Fort Worth

This painting of age-old cottonwoods along the banks of a slow and calm river that meanders across the plains represents the cul-mination of Whittredge's encounters with the landscape around Greeley, Colorado. The cottonwoods had captured his imagination on his first trip West, in 1866, but they did not become the sole subject of a painting until after he had revisited the West in 1870 and in 1871. Whittredge returned to Colorado in July 1870 with his friends John Kensett and Sanford Gifford expressly to collect fresh studies of cottonwoods so as to be able to repaint the grove in his epic *Crossing the Ford, Platte River, Colorado* (see p. 186). Between 1866 and 1870, Whittredge's style had undergone some changes, perhaps under the influence of Barbizon painting[1]—his

brushwork became looser, he began scumbling the pigment, and he abandoned the glazing technique that had produced the even modulation and eternal lighting of *Crossing the Ford*. Despite his newer technique, Whittredge still adhered to the compositional principle he had developed in that painting.[2] Indeed, several of the western sketches he produced in 1870 and 1871 reveal that he selected views that conformed to his compositional formula,[3] which encompassed views into the distance, although during the trip in 1870 he also produced many foreground studies.[4] Whit-tredge probably did not execute the sketch for *On the Cache La Poudre River* until his second return to Colorado, in 1871, when he traveled alone and concentrated on painting the valley region west of Greeley.[5] A reporter for the *Greeley Tribune* wrote an account of the trip, and its results, on 19 July 1871:

> Some of his [Whittredge's] views of the Cache La Poudre are charm-ing, for there can be no more picturesque stream in the world; these, however, have been painted this summer, and are not wholly completed.
>
> . . . Those who visit Colorado seem to think no studies worthy their attention below the mountains. With rare and good judgment

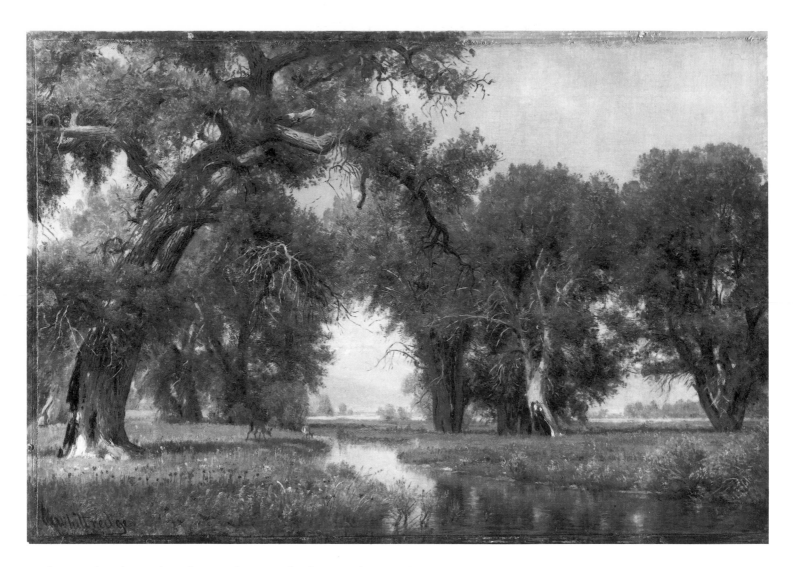

Worthington Whittredge, *On the Cache La Poudre River, Colorado*, 1871, oil on canvas, 15⅛ x 22¾ in. (38.4 x 57.8 cm.). The Fine Arts Museums of San Francisco, Museum Purchase, Roscoe and Margaret Oakes Income Fund (1986.39)

. . . Whittredge has lingered lovingly along the Cache La Poudre, the Thompson, St. Vrain and Platte, and he has reproduced some of their loveliest aspects.[6]

Whittredge completed *On the Cache La Poudre River* some five years after he made the sketch (ill.), but it follows the sketch in almost every detail, reproducing the impressions conveyed of humid air, the smell of decaying bark, and the weight of the opaque foliage. Although Whittredge consciously associated the region with his memories of the Italian countryside (writing in the *Greeley Tribune*, he said, "The many gorgeous sunsets that I have seen there [were] more gorgeous and beautiful I think, than anything ever witnessed on the world renowned Campagna of Rome"),[7] he radically reinterpreted his visual representation of the idyllic aspects of the Greeley landscape when he executed this later picture. He had felt compelled to infuse *Crossing the Ford* with a sense of

history, but by the time he painted *On the Cache La Poudre River* he was prepared to accept the patriarchal cottonwoods as an adequate subject in themselves. The intense interplay of light and shadow on the trunks and branches of the trees seen against the backdrop of snow-covered ranges creates the feeling of a reality that Whittredge no longer seeks to connect with a mythic past.

E.T.T.

Notes

1. Whittredge completed *On the Cache La Poudre River* in the year of the Centennial Exposition. As president of the National Academy of Design, he was on the exposition's selection committee, and ensured that the exposition would include landscapes by his friends in great proportion, even to the exclusion of paintings by the younger, Barbizon-influenced artists. That selectivity was partly responsible for establishing the aesthetic identity of a group of artists who were subsequently considered as constituting the Hudson River School. Ironically, in the very year in which Whittredge worked so hard to uphold the validity of Hudson River School painting, he completed an important work in the Barbizon style, thereby acknowledging that style's ascendancy. For an analysis of the categories of landscapes at the Centennial Exposition, see Matthews 1946, pp. 143–60.

2. Whittredge continued to apply that compositional principle in subsequent paintings, including *Crossing the River Platte* (ca. 1871; The White House, Washington, D.C.) and *On the Plains, Colorado* (1872; St. Johnsbury Athenaeum).

3. *Indian Encampment on the Platte River* (Coe Kerr Gallery, New York City), *Long's Peak from Denver, Colorado* (Kennedy Galleries, New York City), and *The Foothills, Colorado* (Denver Museum).

4. Trenton and Hassrick 1983, p. 213.

5. Ibid., p. 214.

6. Ibid.

7. Ibid., p. 215.

Second Beach, Newport, ca. 1878–80

Oil on canvas, 30½ × 50¼ in. (77.5 × 127.6 cm.)
Signed at lower left: W. Whittredge
Walker Art Center, Minneapolis, Minnesota. Gift of the T. B. Walker Foundation

Views of beaches and of the ocean became extremely popular not only with painters but also with the American public after the Civil War, by the 1870s supplanting the Adirondack, Lake George, and White Mountain subjects favored by the first generation of Hudson River School artists.[1] *Second Beach, Newport*, a New England coastal scene painted by Whittredge in that period, belongs to a group of contemporary beach views that include his *Seconnet Point, Rhode Island* (National Museum of American Art) and *Breezy Day* (Amon Carter Museum).

The horizontal composition of *Second Beach, Newport* maintains the Luminist principles Whittredge had developed a decade earlier.[2] Although the static weight of the rocky promontory anchors the energy of the sweeping beach, some of its momentum reverberates in the frothy treatment of the breaking waves that repeat the curve of the strand. The free handling of the paint, and the moody, naturalistic sky and its reflection in the water reveal his assimilation of the Barbizon style.

Whittredge chose a significant geographic site along the coast of Rhode Island as the focal point of *Second Beach, Newport*. The unusual rock formation of Sachuest Beach, known variously as Hanging Rocks, Paradise Rocks, or Bishop's Seat, is a unique relic of the past: for many persons in the nineteenth century, geologic time and biblical time were fused together, and ancient rocks and primeval forests provided clues to the truths of Creation. Artists felt privileged to depict such vestiges of an era that proved this land to be "as old as the Flood."[3]

The ancient rock of Sachuest Beach was further distinguished by its association with Bishop Berkeley, whose persona embodied references to a historical and religious heritage.[4] In 1728, George Berkeley, then dean of Londonderry Cathedral and later bishop of Cloyne, came to the New World with a charter to found Saint Paul's College in Bermuda. While he waited for the British Parliament to allocate the necessary money, Berkeley intended to establish a farm in Rhode Island to provide food for the college. Both projects failed for lack of funds, but Berkeley nevertheless left a lasting impression on the intellectual landscape of New England. While living in Rhode Island, he wrote in whole or in part his *Alciphron, or, The Minute Philosopher*. The second of its seven dialogues concerning the Christian religion is set on Sachuest Beach:

> . . . After breakfast, we went down to a beach about a half mile off; where, we walked on the smooth sand, with the ocean on one hand, and on the other wild broken rocks, intermixed with shady trees

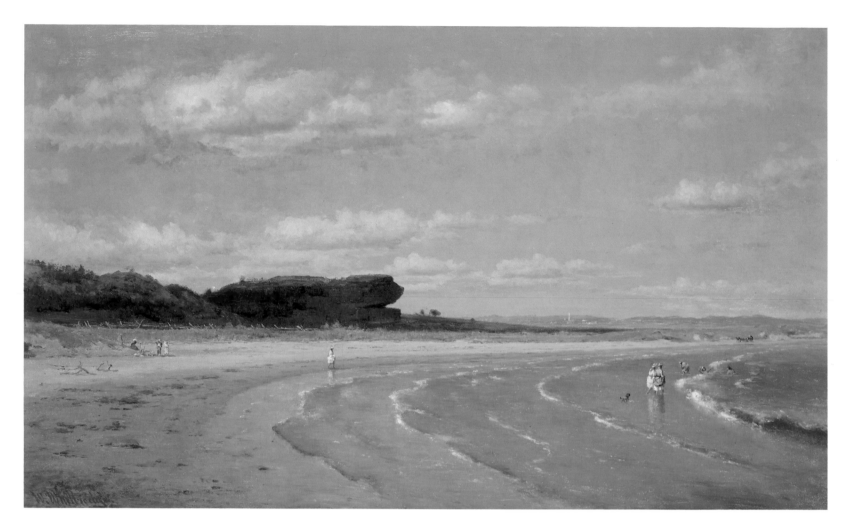

and springs of water, till the sun began to be uneasy. We then withdrew into a hollow glade, between two rocks.[5]

By choosing Hanging Rocks as a suitable place for meditation on theological subjects, Berkeley was prevalidating the transcendentalist belief that the Creator revealed himself through nature. Perhaps building on Berkeley's foundation, William Ellery Channing, Ralph Waldo Emerson's teacher and a founding father of American transcendentalism, also chose Sachuest Beach for formulating his thoughts upon nature:

> No spot on earth has helped me to form so much as that beach. There I lifted up my voice in praise amidst the tempest. There, softened by beauty, I poured out my thanksgiving and contrite confessions. There, in reverential sympathy with the mighty power around me, I became conscious of the power within. There, struggling thoughts and emotions broke forth as if moved to utterance by nature's eloquence of the winds and waves. There began a happiness surpassing all worldly pleasure, all gifts of fortune, — the happiness of communing with the works of God.[6]

By the 1850s, guidebooks to Rhode Island often quoted similar passages from Channing and also retold the story of Berkeley's wanderings along Newport's beaches:

One hundred and twenty-four years ago, the wanderer near the Hanging Rock, might have noted, sitting beneath the superincumbent mass, a man of grave yet pleasant aspect, reading or committing his thoughts to paper: this was the celebrated Dean Berkeley. . . . Here would he repair from his dwelling in the immediate neighborhood, and amid nature's fairest scenery, lift his thoughts to Nature's God.[7]

Thus, by the time that Whittredge, an avid peruser of guidebooks, returned from Europe in 1859 and began painting along the New England coast, the mythology of Sachuest Beach was complete. By the mid-1860s, Newport had assumed its role as the summer retreat of wealthy Easterners and had also emerged as an important artists' colony. Whittredge's friend John Kensett painted Sachuest Beach as early as 1856 and again in 1865.[8] James Augustus Suydam's version also dates from 1865, as does Whittredge's first painting of the site (ill.).[9] Although Whittredge may have been introduced to the subject by his artist friends, with whom he frequently spent the summer in the vicinity of Newport,[10] none of them infused the site with the spirit Whittredge gave it. By employing a naturalistic style and including bathing figures, Whittredge integrated the contemporary life of the beach with its layers of

accrued historic association, and in so doing presented an aggregate history of *Second Beach, Newport.*

E.T.T.

Notes

1. Kathie [Katherine E.] Manthorne, in Novak and Blaugrund 1980, p. 59.
2. Wilmerding 1980, p. 127.
3. Ralph Waldo Emerson, *Modern Anthology*, ed. by Alfred Kazin and Daniel Aaron (Boston: Houghton, Mifflin, 1958), p. 59. Quoted in Novak 1980, p. 226.
4. Sadayoshi Omoto was the first to link Bishop Berkeley and Worthington Whittredge through their associations with Newport and Sachuest Beach. See Sadayoshi Omoto, "Berkeley and Whittredge at Newport," *The Art Quarterly* 27 (Winter 1964), pp. 42–56.
5. George Berkeley, *Alciphron, or, The Minute Philosopher: An Apology for the Christian Religion* (London, 1732), quoted in Omoto, "Berkeley and Whittredge," p. 47.
6. William Ellery Channing, "Christian Worship: Discourse at the Dedication of the Unitarian Congregational Church, Newport, Rhode Island, July 27, 1836"; [George C. Mason], *Newport Illustrated in a Series of Pen and Pencil Sketches* (New York: D. Appleton, 1854), p. 50.
7. John Ross Dix, *A Hand-book of Newport and Rhode Island* (Newport, R. I.: C. E. Hammett, Jr., 1852), p. 80.
8. John F. Kensett, *Berkeley Rocks, Newport* (1856; Vassar College Art Gallery) and *Paradise Rocks* (1865; Newark Museum). Both views differ from Whittredge's composition. For Kensett's relationship to the Rhode Island coast, see Kevin Avery, in Novak and Blaugrund 1980, p. 126.
9. Suydam, *Paradise Rocks* (1865; National Academy of Design); Whittredge, the erroneously titled *Third Beach, Newport* of 1865 (ill.).
10. Rhode Island held special meaning for Whittredge. As he noted in his autobiography, "It was the land of my forefathers." Only eleven days after his return from Europe in 1859, he went to Rhode Island in search of subjects. See Baur 1942, pp. 40, 63.

Worthington Whittredge, *Third Beach, Newport, Rhode Island,* 1865, oil on canvas, 18 x 30 in. (45.7 x 76.2 cm.). Private collection

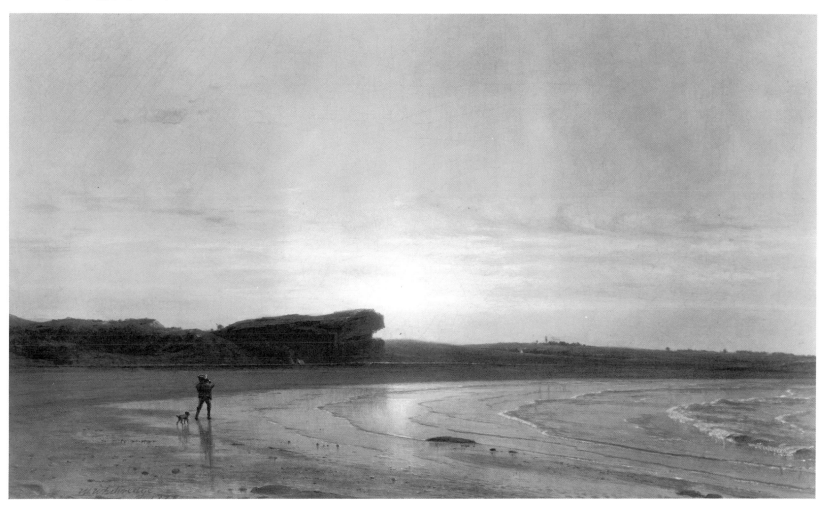

ROBERT S. DUNCANSON
(1821?–1872)

The first black American artist to achieve international success as a landscape painter, Robert Scott Duncanson was born in Seneca County, New York, to a black mother and a Canadian father of Scottish descent. Duncanson's early years were spent in eastern Canada, where he apparently began to paint. In 1842, he was living near Cincinnati. Although he sketched throughout the eastern half of the United States and spent much time in Detroit, Canada, and Europe, Cincinnati remained his home base throughout his career.

During the early 1840s, Duncanson supplemented his income by working in the production of daguerreotypes while establishing himself as a painter of still lifes, genre and biblical scenes, and landscapes. Exhibited in Cincinnati and Detroit, his paintings attracted the attention of prominent abolitionists in both cities. He also received portrait commissions from such figures as Nicholas Longworth, an important Cincinnati patron of the arts, who asked Duncanson in 1848 to paint murals for Belmont, his residence, now the Taft Museum in Cincinnati. Duncanson's pleasing still lifes and European-inspired landscapes won him increasing renown in that city, where he enjoyed the patronage of the newly founded Western Art-Union for the next several years.

Duncanson's first documented trip to Europe, in the company of his fellow Cincinnati painters William L. Sonntag and John Robinson Tait, is recorded as having begun in 1853 and is said to have been financed by an antislavery society. Duncanson wrote to his friend Julius Sloan on 22 January 1854 (letter in Newberry Library, Chicago) that of the hundreds of landscapes he viewed in England, France, and Italy, he had particularly noted the works of J. M. W. Turner, though he did not like them much. He returned to Cincinnati in 1854 and continued to exhibit there and in Detroit, again supplementing his income with daguerreotypy. He painted some landscapes based on sketches he had made in Italy and elsewhere in Europe. Throughout his career, he drew inspiration from literary sources: in 1861, he completed his major work in that genre, *Land of the Lotus Eaters* (collection of His Royal Majesty the King of Sweden), based on Tennyson's poem *The Lotos-Eaters*. Duncanson exhibited the painting in England and Scotland in 1863, where it was reportedly seen and admired by Tennyson and won great critical acclaim. Duncanson returned to Cincinnati after the Civil War. He made a final trip to Scotland in 1870–71, painting Scottish scenes that represent a prominent part of his oeuvre. Tragically, while enjoying his greatest success as a landscapist, he became mentally ill. He was confined to the Michigan State Retreat, a mental hospital, where he died on 21 December 1872.

Select Bibliography

James A. Porter. "Robert S. Duncanson, Midwestern Romantic-Realist." In *Art in America* 39 (October 1951), pp. 98–154.

Guy McElroy. *Robert S. Duncanson: A Centennial Exhibition*. Exhibition catalogue. Entries by Richard J. Boyle. Cincinnati, Ohio: Cincinnati Art Museum, 1972.

Joseph D. Ketner II. "Robert S. Duncanson (1821–1872): The Later Literary Landscape Paintings." In *The American Art Journal* 15 (Winter 1983), pp. 35–47.

Lynda Roscoe Hartigan. "Five Black Artists in Nineteenth-Century America." Robert Scott Duncanson, pp. 51–68. In *Sharing Traditions: Five Black Artists in Nineteenth Century America*. Exhibition catalogue. Essay by James Oliver Horton. Washington, D.C.: Smithsonian Institution Press for the National Museum of American Art, 1985.

Allan Pringle. "Robert S. Duncanson in Montreal, 1863–65." In *The American Art Journal* 17 (Autumn 1985), pp. 28–50.

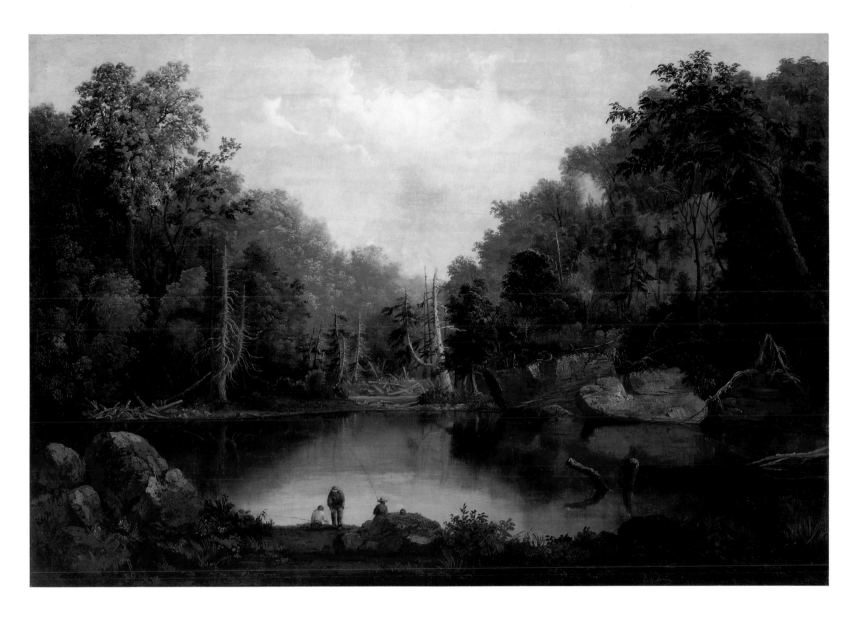

Blue Hole, Little Miami River, 1851

Oil on canvas, 28½ × 41½ in. (72.4 × 105.4 cm.)
Signed and dated at lower right: R.S. Duncanson/Cinti O./1851
*Cincinnati Art Museum, Cincinnati, Ohio. Gift of Norbert Heermann
and Arthur Helbig (1926.18)*

When Robert S. Duncanson moved from Canada to Cincinnati in
the early 1840s, he was entering a major regional art center from
which he would derive enormous benefit. He must have already
taught himself the rudiments of painting, for in the 9 June 1842
exhibition held in Cincinnati by the Society for the Promotion of
Useful Knowledge, Duncanson exhibited three paintings (present
locations unknown): *Fancy Portrait, Infant Savior,* and *The Miser,
A Copy.* Although there is no indication that Duncanson received

any formal art instruction in Cincinnati, the young painter un-
doubtedly studied closely the number of paintings then accessible
to him.[1]

By the end of the 1840s, the Cincinnati art world was favor-
ably disposed toward the paintings of the Hudson River School
masters. Thomas Cole had painted in Cincinnati in the late 1820s,
an association still treasured by the local promoters of art. Paintings
by Cole and other practitioners of the style—Asher B. Durand,
Thomas Doughty, and Jasper Cropsey—were collected by the city's
leading art patrons and featured in the city's exhibitions. Cincinnati
became in effect a provincial outpost of the Hudson River School
style, as practiced by local painters Worthington Whittredge and
William L. Sonntag (see pp. 179; 197).

Duncanson, eager to establish himself as a professional artist,
assimilated characteristics of the Hudson River School style, in-
cluding a preference for landscape as subject matter and the use of

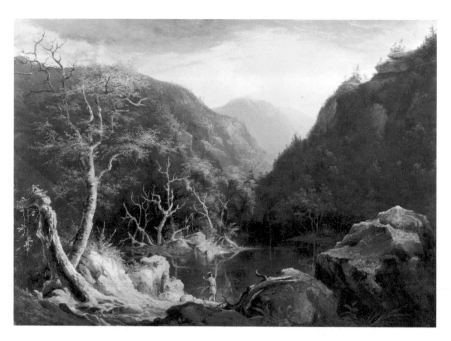

Thomas Cole, *Autumn in the Catskills*, 1827, oil on wood, 18⅝ x 25⁷⁄₁₆ in. (42.2 x 64.6 cm.). Permanent Collection, Arnot Art Museum, Elmira, New York

a horizontal format, dark palette, and tight brushwork. During that phase of his career, Duncanson's chief influence was apparently that of Sonntag: an affinity for Sonntag's style can be discerned in most of Duncanson's work in the early 1850s. The two men (along with John R. Tait) had traveled together to Europe in 1853. In Italy, both of them did paintings of the Temple of Sibilla. Duncanson's, though not identical to Sonntag's, still demonstrates a marked similarity to it.[2]

The hills, valleys, forests, and rivers around Cincinnati provided local artists with the same type of raw material that had inspired the pantheistic compositions of the first-generation Hudson River School painters. The Little Miami River, which joins the Ohio River seven miles above Cincinnati, was a favorite subject for a number of them, including Sonntag, Godfrey N. Frankenstein, and Alexander Wyant.[3] Miner K. Kellogg, also a Cincinnati painter, described the falls of the river and the area known as the Blue Hole in his journal of 1833: "Below the falls is a place called the 'Blue Hole.' It is a deep chasm (circular) into which empty the waters of the Miami. It appears to be *perfectly* blue, very dark . . . the depth has not yet been ascertained."[4]

The *Ohio Gazetteer* of the same year described the falls and the Blue Hole: "When being compressed to less than ten yards . . . [the stream] falls, from a ledge . . . into a narrow fissure of such great depth, that for several rods below, there is no perceptible current. The sides of the fissure . . . rise by estimation 50 feet above the surface of the water."[5] The lack of a "perceptible current" gave a sense of peace and tranquillity to the Blue Hole, which explains its appeal to pleasure-seekers and artists alike. As Duncanson's canvas shows, it also provided good fishing. One of the earliest known paintings of the site was executed in September 1839 by

Godfrey Frankenstein (*Blue Hole on the Little Miami River*, Collection of Proctor and Gamble Company, Cincinnati).[6] Both the Frankenstein painting and this 1851 work of Duncanson's feature the pool of water surrounded by gnarled trees. A distinctive element along both sides of the river, the trees were described by Kellogg as "old & young, dead & alive cedars, so closely interwoven as not to be penetrated with the eye."[7]

In terms of composition, Duncanson's *Blue Hole* is strikingly similar to Thomas Cole's *Lake with Dead Trees* (1825; Allen Museum) and *Autumn in the Catskills* (ill.). The influence of Sonntag is again visible in Duncanson's treatment of the site, particularly in his depiction of the men fishing in the foreground.

L.D.

Notes

1. For Cincinnati as a regional art center, see Guy C. McElroy, "Robert Duncanson: A Problem in Romantic Realism in American Art," Master's thesis, University of Cincinnati, 1972, pp. 47–53; Denny Carter, "Cincinnati as an Art Center, 1830–1865," pp. 13–21, *The Golden Age: Cincinnati Painters of the Nineteenth Century Represented in the Cincinnati Art Museum*, exh. cat. (Cincinnati, Ohio: Cincinnati Art Museum, 1979).

2. Compare Sonntag's *Classic Italian Landscape* (ca. 1857–59; Corcoran Gallery) with Duncanson's *Landscape with Classic Ruins (Temple of Sibilla)*, 1859, a painting whose location has been given as the collection of the Reverend Andrew H. Newman and Mrs. Newman, of Bellbrook, Ohio. Joseph Ketner II, curator of the Washington University Gallery of Art, St. Louis, Missouri, who has extensively researched Duncanson and his works, informs me that he has been unable to get in touch with the Newmans, and that the painting's present whereabouts is therefore not known (conversation, 27 May 1986).

3. For Sonntag's painting, see *The Golden Age*, no. 276, p. 104; for Frankenstein's, see Porter 1951, p. 106; for Wyant's, see Olpin 1971, cat. nos. 31, 32; pp. 270–71.

4. "M. K. Kellogg's Journal. Cincinnati May 18th 1833. Vol. 1st," pp. 16, 17, Cincinnati Historical Society. I am grateful to Mrs. Elmer S. Forman, the society's reference librarian, for providing me with copies of this journal and of the 1833 *Gazetteer* (see n. 5).

5. [John Kilbourn,] *The Ohio Gazetteer, or, Topographical Dictionary* (Columbus, Ohio: Scott and Wright, 1833), pp. 277–78.

6. I am grateful to Joseph Ketner II, who provided me with information on the Frankenstein painting (conversation, 4 April 1986).

7. "M. K. Kellogg's Journal," p. 16. Duncanson may have painted the Blue Hole more than once. *Water Hole on the Miami River*, attributed to him, is mentioned in Cedric Dover, *American Negro Art* (Greenwich, Conn.: New York Graphic Society, 1960), p. 26, as being at Wilberforce University, Wilberforce, Ohio. Linda Renner, office of the university president, kindly checked records of the university's art holdings but found no information about the painting (conversation with author, 11 June 1986).

WILLIAM L. SONNTAG
(1822–1900)

William Louis Sonntag's family moved from East Liberty, Pennsylvania (now part of Pittsburgh), to Cincinnati in 1823, the year after his birth. By the time he reached his teens, Sonntag had decided to become a professional artist, much to the dismay of his father, who tried to discourage him by apprenticing him to a carpenter. When the apprenticeship lasted just three days, his father sent him off on an expedition to the Wisconsin Territory. Still not dissuaded, Sonntag was next apprenticed to an architect. Only when he quit after three months did his father allow him to follow his artistic pursuits.

Largely self-taught and first exhibiting a painting in 1841 in Cincinnati, Sonntag enjoyed an early and enduring reputation as a landscape painter. When he was about twenty-four, his work gained him the attention of the Reverend Elias Lyman Magoon, from 1846 to 1850 pastor of the Baptist Ninth Street Church in Cincinnati, for whom Sonntag executed *The Progress of Civilization* (location unknown), a series of four paintings based on William Cullen Bryant's poem *The Ages*. By the end of the 1840s, Sonntag was exhibiting and selling paintings at both the newly founded Western Art-Union in Cincinnati and the American Art-Union in New York. In 1852, the director of the Baltimore and Ohio Railroad commissioned Sonntag to paint scenes of the company's routes between Baltimore and Cumberland, and Sonntag and his bride, Mary Ann Cowdell, whom he had married the previous year, used the excursion as a delayed wedding trip.

Sonntag began exhibiting at the Pennsylvania Academy of the Fine Arts in 1853, the year he made his first trip abroad in the company of John R. Tait, who shared a studio with Sonntag and studied under him, and fellow Cincinnati painter Robert S. Duncanson. Although the group visited London and Paris, Sonntag spent most of his eight-month stay in Italy and later painted a number of works based on Italian scenery. By 1857, after a second trip to Italy, the Sonntags were living in New York, where Sonntag established his studio.

Sonntag first exhibited at the National Academy of Design in 1855, a practice he continued every year for the rest of his life. He was elected an Associate of the Academy in 1860 and an Academician the following year. A member of the Artists' Fund Society, Sonntag also belonged to the American Society of Painters in Water Colors, where he exhibited regularly. Known for his depictions of American mountains and forests, he made sketching trips through Ohio, Kentucky, the Carolinas, West Virginia, Pennsylvania, and, during and increasingly after the Civil War, in the mountains of New England. He painted in the Hudson River School manner throughout most of his career, although the influence of the Barbizon style becomes evident in his later work. An exceedingly prolific artist, Sonntag enjoyed an enviable reputation during the last thirty years of his life as a result of having his paintings exhibited in New York and Brooklyn, in the cities of upper New York state, and in Boston, Chicago, Saint Louis, Cleveland, San Francisco, and Paris.

Select Bibliography

"William Louis Sonntag." In *Cosmopolitan Art Journal* 3 (December 1858), pp. 26–28.

George C. Groce and David H. Wallace. *The New-York Historical Society Dictionary of Artists in America, 1564–1860*. New Haven, Conn.: Yale University Press, 1957, p. 593.

Vose Galleries. *William L. Sonntag, 1822–1899* [sic]; *William L. Sonntag, Jr.* Exhibition catalogue. Essay by William Sonntag Miles, the senior Sonntag's grandson. Boston, Mass.: Vose Galleries, 1970.

Nancy Dustin Wall Moure. *William Louis Sonntag: Artist of the Ideal, 1822–1900*. Los Angeles: Goldfield Galleries, 1980.

Autumn in the Alleghenies, ca. 1860–66
Oil on canvas, 30 × 50 in. (76.2 × 127 cm.)
Signed at lower left: W. L. Sonntag
Collection of Mellon Bank

When Sonntag took a studio in New York City in 1857, the Cincinnati artist had already established a reputation in the city's art circles. Although many of his earliest paintings had been based on literary or allegorical themes (*Jupiter and Calisto*, 1841; *The Progress of Civilization*, 1847; and *Paradise Lost and Paradise Regained*, 1850; locations unknown), after 1850 Sonntag gave himself over to the study of nature, painting and finishing his pictures on the spot. According to a contemporary critic, that sort of study served the painter well, for not only did it impart to him a true understanding of nature, it also earned him a profitable living:

> By such a faithful study of Nature, it were strange if the artist did not learn well of his master of masters! The works produced during those five years of study, served to give the artist high rank, and also to fill his pockets with plenty. Few painters in the country commanded such extensive and lucrative patronage.[1]

From that early point in his career Sonntag worked in a manner heavily indebted to the Hudson River School. He knew the paintings of Thomas Cole,[2] Asher B. Durand, Thomas Doughty, Jasper Cropsey, and Worthington Whittredge by reputation and had seen a number of them at exhibitions in Cincinnati. Sonntag shared with those painters a deep regard for the natural, untouched beauty of America's mountain scenery, a pantheistic attitude suffusing the period and reported on by an article in the contemporary press: "This country of ours possesses sublime composition direct from the Creator's hand; and when our painters learn to catch the spirit and majesty of these divine works, then shall we see works as noble as any of the generations have ever known."[3] Sonntag, eager to fulfill the prophecy, painted his idealized concepts of America's rugged natural beauty in the characteristic Hudson River style: using a broad, horizontal format for grand views of wooded, mountainous scenery and applying thin, uniform pigment with careful attention to detail.

Autumn in the Alleghenies[4] is thought to have been painted sometime during the first half of the 1860s, when Sonntag's career was at its height. He preferred to depict the edge of the American wilderness, where man's intrusion had only begun. In this canvas, a hunter, dwarfed by the surrounding scenery, is returning to a crudely built cabin in the center of the composition. The large painting, called an example of the artist's "classic period,"[5] is of a type he preferred: a central body of water surrounded by hills and trees and often, as in this picture, with a strong diagonal axis that leads the eye into the canvas from lower right to upper left.

The painting is Sonntag at his best. Autumn, a time when nature is her most colorful, was a favorite time of year for the Hudson River School painters; Sonntag, who painted many autumnal scenes in the 1860s, was no exception. His warm palette, composed of browns, golds, beiges, and russets used to depict the foliage and the rocks, is balanced by the cool grays and purples of the water and the mountains and by the light blue of the sky. His dramatic exploitation of the sunlight and his choice of pastels to portray the mountains and sky are evidence of the influence of Frederic Church (see p. 246).

While Sonntag's mature painting style relies on formulas developed by the early painters of the Hudson River School, he evolved his own highly individual manner. As a contemporary reviewer wrote, "The rapidity of Mr. Sonntag's hand, the precision of his touch, the clearness of his lines, the tones of his colors"[6] accounted for the marked individuality of his paintings. Although

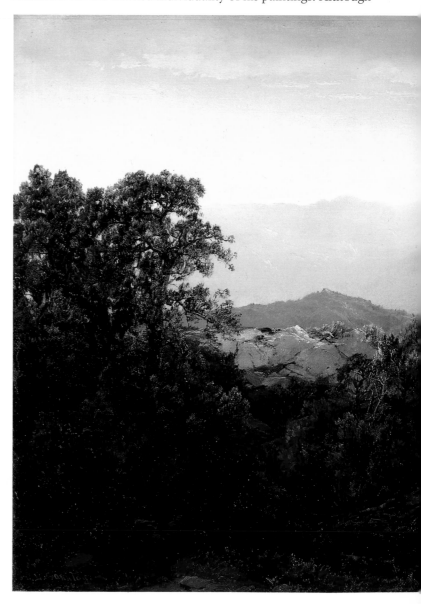

James Jackson Jarves included Sonntag's paintings with those he found "painfully disappointing from their insensibility to low tones and harmonies of coloring,"[7] another critic liked Sonntag's palette and technique: "With regard to Mr. Sonntag's system of coloring and his way of producing his effects, we find much that is fresh, original, and decidedly pleasing."[8]

Sonntag's painting style slightly changed after the Civil War as a result of his interest in the Barbizon painters, whose influence was strongly felt in the American art of the period. In the 1870s, Sonntag's vision of nature began to close in and his canvases became smaller in size and scope. In those paintings of more intimate, suggestive scenes, he paid less attention to exact transcriptions of natural appearances. *Autumn in the Alleghenies*, however, documents the early success he attained through his allegiance to the tenets of the Hudson River School.

L.D.

Notes

1. "William Louis Sonntag," *Cosmopolitan Art Journal* 3 (December 1858), p. 28.
2. Sonntag's early allegorical series of four paintings, *The Progress of Civilization*, had no doubt been inspired by his knowledge of Thomas Cole's five-painting series, *The Course of Empire* (Figs. 2.6–10, pp. 28–29).
3. "Our Artists and Their Whereabouts," *Cosmopolitan Art Journal* 2 (1858), p. 209.
4. Sonntag's original name for the painting is not known today. The title *Autumn in the Alleghenies* was given by a dealer, who assumed that those were the mountains depicted, for Sonntag had painted them many times (Jane Lane, art consultant for Mellon Bank, conversation with author, 7 May 1986). Nancy Dustin Wall Moure suggests instead that the painting may represent New England, perhaps the White Mountains, for during and after the Civil War Sonntag's sketching sites changed from the mountain ranges of the mid-Atlantic and southern states to those of New England (conversation with author, 25 May 1986).
5. Moure 1980, p. 49.
6. *Cosmopolitan Art Journal* 3 (December 1858), p. 28.
7. Jarves 1864, p. 236.
8. *Cosmopolitan Art Journal* 3 (December 1858), p. 28.

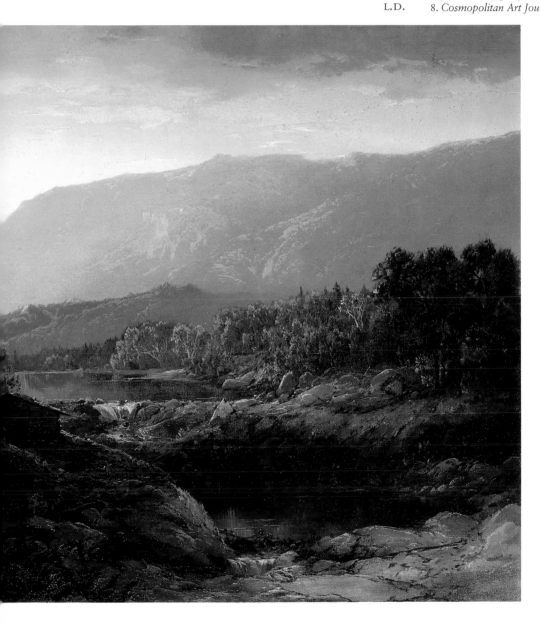

JASPER F. CROPSEY

(1823–1900)

Jasper Francis Cropsey, born in Rossville, Staten Island, showed an early interest in drawing and architecture. At the age of fourteen, he was awarded diplomas from the New York Mechanics' Institute and the American Institute of the City of New York for an elaborately detailed model of a house, the product of two years' work. The architect Joseph Trench offered Cropsey a five-year apprenticeship in his New York office and encouraged his talent for drawing and painting by supplying him with artist's materials. In 1840, Trench hired Edward Maury, a now obscure British painter, to give the young architect watercolor lessons. That instruction, along with several classes in life drawing at the National Academy of Design, constituted Cropsey's formal artistic education. His earliest watercolor and oil paintings, depicting Italian landscapes and Dutch-type scenes of peasants and rural cottages, reveal his reliance on books and prints for subject matter and supplementary training.

Cropsey opened his own architectural practice in New York about 1843, the year he first exhibited at the National Academy of Design. By late 1845, he was devoting himself entirely to landscape painting. In the same year, he delivered a lecture titled "Natural Art" at the New-York Art Re-Union. Cropsey's favorite spot for communing with nature was Greenwood Lake, New Jersey. It was his paintings of that site that won him an Associate membership at the National Academy in 1844 (he became a full Academician in 1851), and it was there that he met Maria Cooley, whom he married in May 1847. The couple spent their honeymoon on a two-year trip to Italy. On their return to New York, in 1849, Cropsey set to work producing paintings from sketches he had made on their travels. He soon turned to American scenery, sketching during the summers in New Jersey, the White Mountains of New Hampshire, and New York's Hudson River valley. The style and technique of his paintings from the early 1850s betray the influence of his Hudson River School predecessors Thomas Cole and Asher B. Durand, whom he greatly admired. (Cropsey's essay "Up Among the Clouds," which appeared in *The Crayon* in August 1855, clearly emulates Durand's "Letters on Landscape Painting," printed in the same publication earlier that year.)

The paintings of autumnal scenery Cropsey began to show on his second trip abroad, from 1856 to 1863, won him accolades from the English critics. When *Autumn—On the Hudson River* overwhelmed Queen Victoria, as well as the London press, Cropsey became something of a celebrity, and that triumph won him a reputation that preceded him back across the Atlantic and endured throughout the 1860s. His ensuing financial success enabled him in 1867 to begin to design and build his dream house, Aladdin, in Warwick, New York, a two-year project. The house proved costly to maintain. Cropsey's painting career was becoming progressively less lucrative, and he returned to architecture to support his family. Despite several important commissions, he was forced to sell Aladdin in 1884.

The next year, the Cropsey family moved to a house they named Ever Rest, in Hastings-on-Hudson, where the artist replicated his Aladdin studio as an addition. Work from the last fifteen years of his life, much of it in watercolor, most of it either depictions of his neighborhood or embellished travel sketches from years past, and all somewhat retardataire, is evidence that Cropsey maintained his enthusiasm for the idealized American landscape long after the market for paintings of the Hudson River School type had almost disappeared.

Select Bibliography

Jasper Cropsey. "Reminiscences of My Own Time." Manuscript, 1846, prepared for C. Edwards Lester's *Artists of America*. Typescript in Cropsey Papers.

———. Autobiographical Sketch. Manuscript, 1867, prepared for Henry T. Tuckerman's *Book of the Artists*. Typescript in Cropsey Papers.

William S. Talbot. *Jasper F. Cropsey 1823–1900*. New York and London: Garland Publishing, 1977.

Kenneth W. Maddox. *An Unprejudiced Eye: The Drawings of Jasper F. Cropsey*. Exhibition catalogue. Yonkers, N. Y.: The Hudson River Museum, 1980.

William S. Talbot. *Jasper F. Cropsey 1823–1900*. Exhibition catalogue. Foreword by Joshua C. Taylor. Washington, D.C.: The Smithsonian Institution Press, 1980.

Carrie Rebora. *Jasper Cropsey Watercolors*. Exhibition catalogue. Introduction by Annette Blaugrund. New York: National Academy of Design, 1985.

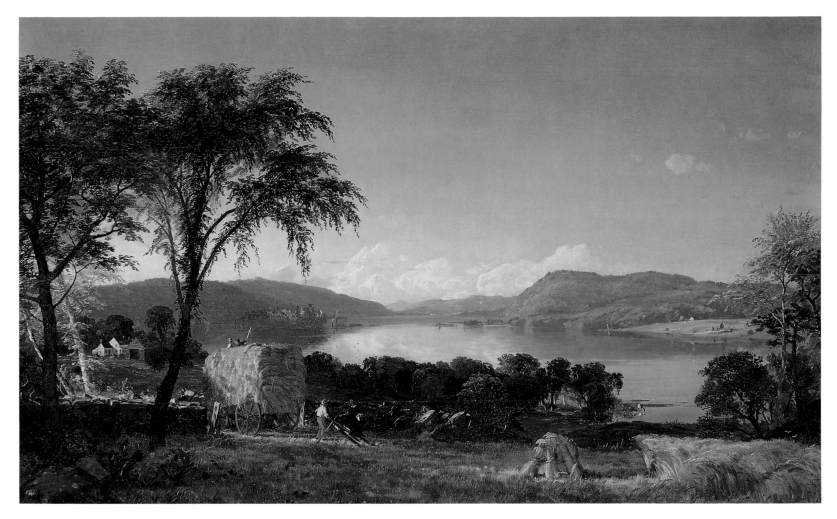

Harvest Scene, 1855

Oil on canvas, 21¾ × 35¾ in. (55.2 × 90.8 cm.)
Signed and dated at lower left: J. F. Cropsey/1855
Collection of The San Antonio Museum Association, San Antonio, Texas

Known as *Landscape* when the Witte Museum of San Antonio acquired it in 1945 and catalogued as *Harvest Scene* in 1972 by William S. Talbot,[1] this painting remains without a recorded title, early provenance, or exhibition record. Nevertheless, its subject and composition, when combined with biographical information, provide evidence that creates a substantial basis for deciphering Cropsey's reasons for producing it.

Cropsey first treated the subject of harvest in 1850, in *Bareford Mountains, West Milford, New Jersey* (Brooklyn Museum). In 1851, *American Harvesting Scenery*, now lost and known only through a replica (Fig. 1), was exhibited and engraved by the American Art-Union, which described it as "a striking American scene—

one of the best works of the artist" and sold it for the then handsome price of three hundred and eighty-five dollars.[2] The engraving inspired copies by other painters and a chromolithograph by Currier and Ives.[3] That *American Harvesting Scenery* boosted Cropsey's reputation and achieved for him his first public success in America may have caused him to repeat the subject in 1855, now with greater compositional emphasis on the harvesting activity.

Yet *Harvest Scene*, while it retains the subject of the 1851 painting and some of its scenic elements—the woman in the foreground, the house and the body of water in the middle distance, and the village in the background—is in many ways a more provocative painting than its predecessor. *American Harvesting Scenery* is clearly a tribute to Thomas Cole. The canvas is arranged in ordered, diagonal registers, a compositional device found often in Cole's work. Cropsey's vivid contrast between wilderness and cultivated landscape exaggerates Cole's model by multiplying the number of blasted and decaying tree stumps (Cole's trademark), by emphasizing by means of a fence the division between wild and cultivated nature, and by crowning the scene with a tremendous mountain, an obvious quotation from Cole's *Course of Empire* series (Figs. 2.6–10, pp. 28–29). By contrast, *Harvest Scene*, be-

his wife) explains why he made so many sketching trips to the region. By 1846, Maria's father, Judge Isaac P. Cooley, had offered to build her suitor a studio at the lake.[6] Instead, Cropsey married Maria and took her away to Europe for a two-year honeymoon. The trip did not diminish the artist's attraction to Greenwood Lake; over the course of his career, he produced more drawings and paintings of it than of any other site.[7] The Cropseys visited the lake each summer between 1849 and 1855 and must have raved about it to their friends, for one of them, P. R. Strong, wrote on 26 September 1852 from Flushing, New York, "I *did* used to think, until I made your acquaintance, that 'no good thing could come out of such a Nazareth' as our sister state; But I am ready to believe anything with regard to it, and expect to find its women all Venuses, its men all Apollos, and its territory a terrestrial Paradise."[8]

If *Harvest Scene* is true to Greenwood Lake's appearance, then Strong's expectations would have been fully realized. The lake, under Cropsey's hand, became an Italian campagna. The composition imitates the classic landscape formula of Claude Lorrain—figures in the foreground, a glassy pool of water shimmering in the middle distance, an edifice to one side, and a hazy mountain range in the background. More than a mere glorification of a place Cropsey was fond of, the concept of the painting is quite ingenious. The harvesting activity, the clothing, and the architecture set the scene for an American provincial myth in which a farmer Apollo meets his countrified Venus in a field of sweet, freshly cut grain; the lovers take refuge behind a wagon from the paternal eye in the distant house. This Venus hails from New Jersey—her dress, her dark hair, and her facial features match those in paintings of Maria Cooley Cropsey.[9] Add to that the identification of the house as the Cooley homestead, based on a later painting (Fig. 2), and the pictorial statement becomes part of the tradition of estate painting, a genre common in Great Britain by 1750 and practiced in America by the beginning of the nineteenth century.[10] The picture records the Cooley estate as its proprietor's bountiful, personal arcadia and the testament of his good fortune. As the elements of the composition suggest, Cooley's domain encompassed the overall peace and happiness of the scene: the abundant waving grain, the tied shocks, the daughter not in a rapturous encounter but chastely separated from her swain by the implements each holds, the loaded wagon and the workers, all leading diagonally to the stately house. In common with all estate paintings, this portrait equivalent of Cooley describes the man perhaps more grandly and specifically than could any rendering of his person.

Why would Cropsey produce an estate painting, a flattering portrait, for his father-in-law in 1855? In view of a confrontation between the two men almost a decade earlier as to the issue of Maria's two-year honeymoon in Europe, Cropsey's motive emerges. He was planning a second trip abroad, in 1856, and he may have intended the painting as a means of mollifying Cooley before another long separation from Maria. Another possibility, acknowledging that most traditional estate paintings are designed by patron and artist together, is that Cooley himself commissioned

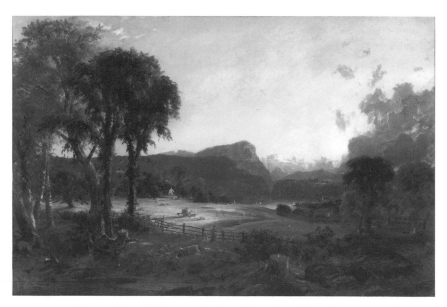

Figure 1. Jasper F. Cropsey, *American Harvesting*, 1864, oil on canvas, 35½ x 52¾ in. (90.2 x 134 cm.). Courtesy, Indiana University Art Museum, Gift of Mr. and Mrs. Nicholas H. Noyes (69.93)

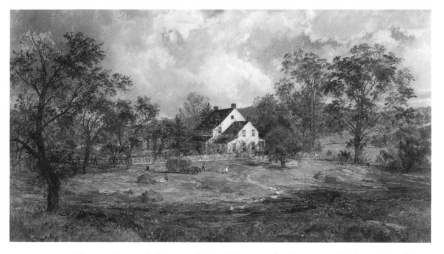

Figure 2. Jasper F. Cropsey, *Cooley Homestead—Greenwood Lake*, 1886, oil on canvas, 19½ x 35½ in. (49.5 x 90.2 cm.). The Newington-Cropsey Foundation, Hastings-on-Hudson, New York

cause of its particular subject and composition, is less an encomium to Cole than an expression of Cropsey's own devices.

Based on comparison with other Cropsey paintings, the site of *Harvest Scene* can be identified as Greenwood Lake, New Jersey, which adds particular interest to the picture.[4] Cropsey took his first sketching trip to Greenwood Lake in 1843. The following year, he exhibited five paintings at the National Academy of Design, three of them products of that trip.[5] The Academy made Cropsey an Associate on the basis of the Greenwood Lake paintings, and the American Art-Union engraved one of them for distribution to its members. Cropsey's success with these paintings (and his obsession with Maria Cooley, who lived at the lake and who later became

Harvest Scene. Without proper documentation, neither postulation can be established. The only sure outcome of the Cooley identification is the extra dimension it adds to our understanding of and interest in Cropsey's realization of an otherwise simple landscape.

C.R.

Notes

1. Talbot 1977, no. 88.

2. *Catalogue of Pictures and Other Works of Art, The Property of the American Art-Union* (New York, 1852), p. 7, no. 349. Talbot 1977, p. 361, records that the painting was sold to J. L. Adams.

3. Copies after the American Art-Union engraving are owned by the Princeton University Art Museum and by the Museum of Fine Arts, Boston. A copy of the Currier and Ives chromolithograph, *A Summer Landscape: Haymaking* (undated), is in the collection of the Metropolitan Museum (51.567.42).

4. Talbot 1977, p. 385, has previously identified the site as Greenwood Lake. This painting most clearly resembles *Greenwood Lake* (1864; Newark Museum) and *Greenwood Lake* (1866; Newington-Cropsey Foundation).

5. Talbot 1977, p. 25; Cowdrey 1943, 1, p. 100.

6. Talbot 1977, pp. 37–38.

7. Cropsey painted the site at least nine times; the last picture, a watercolor, dates to 1897 (Mobile Gallery).

8. P. R. Strong, in Flushing City, to Maria Cropsey, in West Milford, N. J., 26 September 1852, Cropsey Papers.

9. A portrait of Maria by Daniel Huntington (ca. 1857) hangs in Cropsey's house, now the Newington-Cropsey Foundation. See also *Mrs. Cropsey and Daughters in the Stateroom of the Cunard Liner* (1856; Mrs. John C. Newington).

10. For a concise discussion of the British tradition of estate painting, see Solkin 1982, pp. 113–15. For a brief discussion of American artists, including Thomas Doughty and Francis Guy, who were well known for their estate paintings, see William H. Gerdts, "American Landscape Painting: Critical Judgments, 1730–1845," *The American Art Journal* 17 (Winter 1985), pp. 36–37.

Catskill Mountain House, 1855

Oil on canvas, 29 × 44 in. (73.7 × 111.8 cm.)
Signed and dated at lower right (on a foreground rock): J. F. Cropsey/
1855
The Minneapolis Institute of Arts, Minneapolis, Minnesota. Bequest of
Mrs. Lillian Lawhead Rinderer in memory of her brother,
William A. Lawhead, and the William Hood Dunwoody Fund

You are aware, I suppose, reader, that the Mountain House is an establishment vieing in its style of accommodations with the best of hotels. Between it and the Hudson there is, during the summer, a semi-daily line of stages, and it is the transient resort of thousands, who visit it for the novelty of its location as well as for the surrounding scenery.[1]

So explained the British explorer Charles Lanman in 1856, on visiting the Catskill Mountain House, also known to its annual visitors as the Grand Hotel and to residents of the region as the Yankee Palace.[2] The hotel, opened in 1823 by the Catskill Mountain Association, was from 1826 until the early 1900s a highlight of the American Grand Tour, just a short hike from Catskill Falls, Kaaterskill Clove, and other natural attractions of the area.[3] Located on South Mountain, it sat some twenty-two hundred feet above sea level on the precipice of the Pine Orchard, a site recorded in Indian legend, in revolutionary-war folklore, and in James Fenimore Cooper's *Pioneers*.[4]

The Mountain House received its greatest acclaim for the view it commanded and for its splendid accommodations. From its hundred-and-forty-foot neoclassical porch and its crowning widow's walk, "Creation seemed presented in one view—at least half the hemisphere of earth appeared to be beneath . . . varied with mountain and valley, rugged hills, luxuriant fields, towns, farm-houses, huts, mill-streams, and creeks, and the Hudson river," according to one tourist in 1828.[5] According to another, "The scene is indescribable . . . I know of but one picture which will give the reader an idea of this ethereal spot. It was the view which the angel Michael was polite enough, one summer morning, to point out to Adam, from the highest hill of Paradise."[6] In 1854, author T. Addison Richards proclaimed, "The staple, *par excellence*, of the Mountain House is the 'sunrising.' . . . Every body does the 'sunrise,' and every body rhapsodizes thereon."[7] Inside the hotel, guests enjoyed dancing, singing, and fine dining, apparently relishing the peculiar juxtaposition of rugged wilderness and refined comfort. In 1840, Nathaniel P. Willis remarked, "How the proprietor can have dragged up, and keeps dragging up, so many superfluities from the river level to the eagle's nest, excites your wonder. It is the more strange, because in climbing a mountain the feeling is natural that you leave such enervating indulgences below. . . . But here you may choose between Hermitages, 'white' or 'red' Burgundias, Madeiras, French dishes, and French dances."[8] Numerous other accounts confirm that the Mountain House was indeed one of the world's most fashionable, sophisticated resorts.[9]

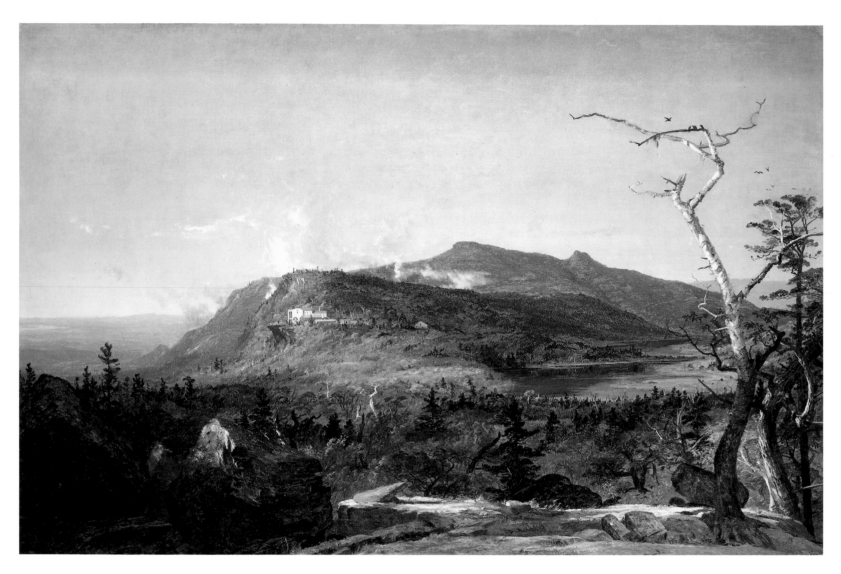

It seems all the more remarkable, therefore, that the vantage point Cropsey selected acknowledges neither the resort's amenities nor the spectacular view from the Pine Orchard. The same vantage point from North Mountain appears in many other paintings and prints of the hotel. The view was shown in five pictures by Thomas Cole; in William Henry Bartlett's drawing *Two Lakes and the Mountain House on the Catskills*, published in 1840, and an anonymous painting after it; in Leslie Hooper's engraving for *Harper's New Monthly Magazine* of July 1854; in Sanford R. Gifford's 1862 painting (see p. 226); in Thomas Nast's drawing for *Harper's Weekly* of July 1866; in Fritz Meyer's engraving published in 1869; and in an engraving in *Lippincott's Magazine* in the late summer of 1879.[10] In each, the Mountain House is the distant focal point, its stark white exterior standing out against the wilderness that constitutes the primary subject matter; in each, the picture of the hotel presented is very different from that described in the words of the tourists and authors.

The particulars of Cropsey's commission for this painting are unknown. He almost certainly painted *Catskill Mountain House* for James Edgar, whose name is noted on 22 March, 3 June, and 29 December in the artist's 1855 account book, recording a total payment of three hundred and fifty dollars for the painting and its frame.[11] Though that documentation would seem to prove that Edgar commissioned the work, other information complicates matters. An item in *The Crayon* for 5 December 1855 reports that Cropsey "has painted a view on the Catskills, taken from the North Mountain, embracing the mountain-house.... [It is] the property of a gentleman of Chicago."[12] Research in city directories has not located Edgar in Chicago. Further, the painting was listed in the 1859 Chicago Exhibit of Fine Arts as owned by one E. H. Sheldon.[13] Finally, Cropsey is known to have painted more than one picture of the subject: the catalogue of his one-man exhibition and sale at the Pall Mall Gallery in London lists two titles that include the name of the Catskill Mountain House.[14]

While knowledge of who commissioned the canvas and where the other one or two are would establish the provenance of

the work, the fact remains that the concept of the painting did not originate with Cropsey. Either for his patron or for reasons of his own, he chose to use Cole's 1844 canvas (Fig. 1) as his model. That is not to say he copied Cole's painting directly. Cropsey's preliminary drawing (Fig. 2) is dated 22 June 1852. On that day, he must have climbed North Mountain in search of Cole's vantage point. Standing on the spot Cole had occupied many years earlier and seeing as if through Cole's eyes, he sketched the Mountain House not as a famed tourist hotel but as a classical ruin in an American arcadian forest. He conveyed that impression in his finished painting by excluding all modern elements, as had Cole,

and by carefully emphasizing the uncultivated surrounding landscape. There too Cropsey followed Cole's example, for he painted the scene in a mythic past tense that sympathized with the nostalgia felt by many mid-century Americans for the primitive wilderness of the country's early years.[15] Both Cole's and Cropsey's Mountain House pictures thus represent a sublime American dream in which violent, unindustrialized nature prevails over man's attempts to civilize it. Cropsey takes the idea a bit farther than Cole had by omitting any reference to human life in his composition. His signature—the sole evidence of human presence on North Mountain—is inscribed on a tombstone-like rock, symbolically negating even his own presence at the site.

C.R.

Figure 1. Thomas Cole, *A View of the Two Lakes and Mountain House, Catskill Mountains, Morning*, 1844, oil on canvas, 36¼ x 54 in. (92.1 x 137.2 cm.). The Brooklyn Museum, Dick S. Ramsay Fund (52.16)

Figure 2. Jasper F. Cropsey, *Mountain Landscape*, 22 June 1852, pencil on buff paper, 8⁵⁄₁₆ x 12¹⁄₁₆ in. (21.1 x 30.6 cm.). Courtesy, Museum of Fine Arts, Boston, Gift of Maxim Karolik for the M. and M. Karolik Collection of American Watercolors and Drawings, 1800–1875 (54.1642)

Notes

1. Charles Lanman, *Adventures in the Wilds of the United States and British American Provinces*, 2 vols. (Philadelphia: John W. Moore, 1856), 1, pp. 182–83.
2. Ibid., p. 182. See also Charles Lanman, *Letters of a Landscape Painter* (Boston, 1845), p. 10.
3. On the history of the resort, see Evers 1972; Alf Evers et al., *Resorts of the Catskills* (New York: St. Martin's Press, 1979); Van Zandt 1966.
4. The altitude of the hotel varies according to the source from about 2,200 feet to about 3,000. J. H. French's *Gazetteer of the State of New York* (Syracuse, 1860), p. 333, n. 7, gives 2,212 feet above sea level. On legends and literature about the Pine Orchard, see Van Zandt 1966, pp. 23–26.
5. "A Visit to the Cattskills," *The Atlantic Souvenir; A Christmas and New Year's Offering* (Philadelphia: Carey, Lea & Carey, 1828), p. 274.
6. Willis Gaylord Clark, quoted in Murdoch 1846, p. 15.
7. Richards 1854, p. 147.
8. Willis 1840, 1, p. 106.
9. See *The Rural Repository, or, Bower of Literature* 5 (7 June 1828), p. 7; Murdoch 1846; George William Curtis, *Lotus Eating: A Summer Book* (New York: Harper & Brothers, 1852), pp. 35–38; Charles Rockwell, *The Catskill Mountains and the Region Around: Their Scenery, Legends, and History* (New York: Taintor Brothers & Co., 1869); Dexter A. Hawkins, *The Traditions of the Overlook Mountain* (Islip, N.Y.: Herald Power Press Print, 1873); "Catskill and the Catskill Region," *Lippincott's Magazine* 24 (August 1879), pp. 150–52; Van Zandt 1971.
10. In addition to his picture of 1844 (Fig. 1), Cole did at least four other versions of the painting; see p. 227, n. 1. Bartlett's engraving appeared in Willis 1840, 1, opp. p. 105. The painting done after Bartlett is illustrated in Howat 1972, no. 71. Hooper's engraving is in Richards 1854, p. 147. Weiss 1977, pp. 233, 435, mentions and lists the seven Mountain House paintings that are included in the Gifford Memorial Catalogue; see also p. 227, n. 8. Thomas Nast, "Sketches Among the Catskill Mountains," *Harper's Weekly* 10 (21 July 1866), pp. 456–57. Fritz Meyer, *Catskill Mountain Album* (New York, 1869), pl. 7. "Catskill and the Catskill Region," *Lippincott's Magazine* 24 (August 1879), p. 151.
11. Account book, 1855, Cropsey Papers.
12. "Domestic Art Gossip," *The Crayon* 2 (5 December 1855), p. 361.
13. Chicago Exhibit of Fine Arts, *Catalogue of the First Exhibition of Statuary and Painting* (Chicago, May 1859), no. 26, as listed in Talbot 1977, p. 291.
14. Pall Mall Gallery, *A Catalogue of a Collection of Finished Pictures and Sketches of that Talented American Artist, J. F. Cropsey, Esq. . . .* (London, 1863), lots 110, 119.
15. See Alan Wallach, "Thomas Cole and the Aristocracy," *Arts Magazine* 56 (November 1981), pp. 98–99, for the suggestion that Cole's nostalgic vision "could engender powerful longings for the untouched wilderness of the early frontier. But it could also involve a sense of a more complex historical development, a sublimated or mythic version of the actual history of aristocracy's slow rise and precipitous fall."

Autumn—On the Hudson River, 1860

Oil on canvas, 60 × 108 in. (152.4 × 274.3 cm.)
Signed and dated at lower middle: Autumn,—on the Hudson River/
 J. F. Cropsey/London 1860
*National Gallery of Art, Washington, D.C. Gift of the Avalon
 Foundation (1963.9.1)*

Autumn—On the Hudson River, today by far the most popular and best known of Cropsey's paintings and considered his tour de force, established his reputation in 1860 as the foremost painter of American autumnal scenery. Though the circumstances surrounding the painting's production are well documented, the motive for Cropsey's painting it has not yet been fully explored. His success with it was not entirely fortuitous; he devised this enormous, meticulous showpiece for the explicit purpose of carrying the image of his beautiful country to England.

Cropsey and his wife, Maria, sailed for London in the spring of 1856. Immediately after their arrival Cropsey set to work painting American landscapes. In 1857, at the Royal Academy of Arts, he exhibited *An Indian Summer Morning in the White Mountains, America* (the catalogue entry accompanied by a quotation from Longfellow) and *The Clove, Catskill Mountains, America*;[1] he submitted *The Backwoods of America*, a series of designs for woodcuts, in 1858.[2] That was the year Cropsey received John Ruskin's approval of his paintings. As reported by a correspondent for the *Cosmopolitan Art Journal*, "[Cropsey's] studio is often visited by Ruskin, who at first could scarcely believe the brilliant combinations in this artist's autumnal sketches were other than exaggerations of 'Young America;' but . . . he now believes fully in the radiant truth of his trans-Atlantic studies."[3]

With these pictures of America and with Ruskin's commendation, Cropsey embarked on a course designed to show Londoners what his homeland looked like. In 1847, before Cropsey's first trip abroad, a writer for *The Literary World* had praised him for being "thoroughly American," but added, "When he surrenders his nationality may 'his right hand forget its cunning.'"[4] The critic's admonition echoed William Cullen Bryant's plea to Thomas Cole, before that artist sailed for Europe in June 1829, that he should look at foreign landscapes, "but keep that earlier, wilder image bright."[5] Cole reassured his public that he had followed Bryant's advice in his "Essay on American Scenery," in which he also expressed his favoritism for the scenery of the United States over that of Europe, especially in autumn.[6] Similarly, Cropsey returned to Europe not to paint European landscapes but to give ultimate proof of his national allegiance. To suggest that Cropsey's patriotic mission was entirely selfless would be naive. His displays of American scenery, new to most of the English, might be likened to Benjamin West's calculated exclamation, "How like a Mohawk warrior!," on seeing the Apollo Belvedere.[7] West's remark, like

Cropsey's autumnal canvases, was a deliberate exploitation of the New World's novelties, designed to titillate an eager public.

Cropsey was not alone in his tactics. As the *Times* of London reported on 30 April 1860, "American artists are rapidly making the untravelled portion of the English public familiar with the scenery of the great Western continent."[8] Frederic Church's *Niagara* and *Heart of the Andes* (see pp. 243; 246), shown in London in 1857 and 1859, respectively, certainly set a precedent for extravagant displays of American landscape paintings. Cropsey's large autumnal scene, which he began in late summer 1859, was the third in that chronology of American landscape spectacles, Cropsey's shown not in a gallery but in his studio, permitting its intimate and concentrated display.

Reviews of Cropsey's one-painting show appeared in English periodicals steadily from March through July 1860. Reporters praised "the red and gold gorgeousness of those trees," claimed that "the scene, which possesses a grand wildness, mixed with indications of advancing civilization and industry, present[s] a combined effect impossible to surpass," and lauded the artist for "rendering Nature herself in a manly and straightforward way." Perhaps Cropsey's biggest coup was when the *Morning Chronicle* printed a review congratulating him for having avoided the defects its critic had found in Church's paintings.[9] In America, *The Crayon* and the *Boston Evening Transcript* printed excerpts from those English papers.[10] Cropsey increased the sensationalism of his painting's reception by sending for leaves from American trees, which he pasted on cardboard and hung on the wall near the painting, and by printing a flyer reproducing excerpts from fourteen enthusiastic notices.[11]

When Cropsey moved the painting to a gallery in Pall Mall, he had a second flyer printed.[12] It described the picture's vantage point—on the west bank of the Hudson River, between West Point and Newburgh, about sixty miles from New York. The stream running into the Hudson is the Moodna, and the scene represents "a dreamy, warm day" at three o'clock in the afternoon. The leaflet also pointed out the residence of the popular American author Nathaniel Parker Willis. An engraving was planned: a book of order forms exists for a "proposed line engraving by Mr. T. O. Barlow [of] Mr. Cropsey's 'Autumn on the Hudson River,'" to be published by Thompson & Company in Pall Mall.[13]

The painting was further esteemed when, on the strength of its success, Cropsey was presented to Queen Victoria, on 27 June 1861,[14] and when the commissioners for the London International Exhibition selected it for inclusion in the art section in 1862.[15] That November, one Thomas Slatterey purchased *Autumn—On the Hudson River* for two thousand dollars, the highest price Cropsey had received to date.[16]

Cropsey painted smaller versions of the work, none of which is located. One was recorded on exhibition in Boston in May 1860; another was sold to a J. W. Brown on 7 March 1860 for a hundred and seventy-five dollars. When in June 1863 Cropsey departed for home, he left behind a third, along with some of his belongings, since he intended to return.[17] Those pictures and a painting titled

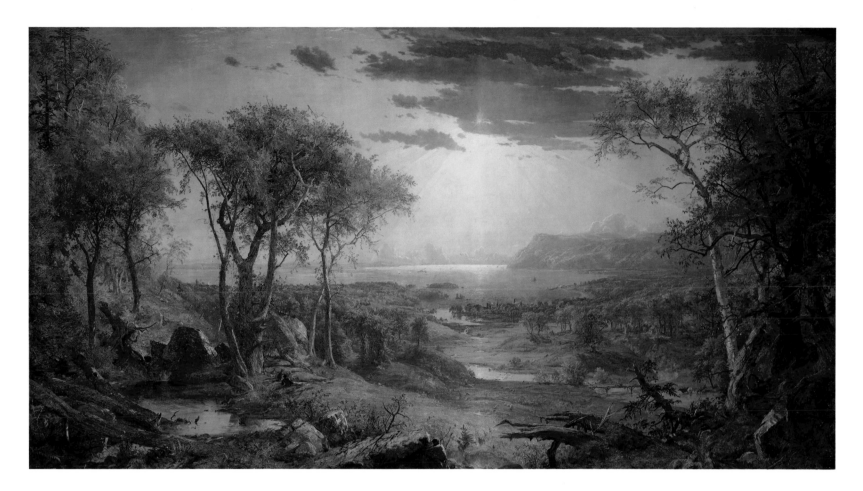

Autumn in the White Mountains, America, shown at the Royal Academy in 1862, may have been attempts to follow up on his initial success. Cropsey, looking back on his life sometime later, said that he had "spent seven years [in London], gaining social and artistic position of high order, receiving many attentions and having many inducements to stay and make it my home for life." [18] Painting and exhibiting *Autumn — On the Hudson River* there may have been the reason he made the trip in the first place, but it turned out to be the key to his happy memories of England.

<div align="right">C.R.</div>

Notes

1. Algernon Graves, comp., *The Royal Academy of Arts: A Complete Dictionary of Contributors and Their Work from Its Foundation in 1769 to 1904*, 8 vols. (London: Henry Graves and Co. and George Bell and Sons, 1905), 2, p. 208.

2. Cropsey reminisced in 1867, "While in London [I] painted many pictures, but those which attracted the greatest attention were 1st 'The Back-Woods of America' exhibited in the Royal Academy—a series of designs for woodcuts." See Jasper Cropsey, Autobiographical Sketch (1867), p. 9, typescript, Cropsey Papers.

3. "Foreign Art Items," *Cosmopolitan Art Journal* 2 (1858), p. 144.

4. *The Literary World* 1 (1847), p. 323.

5. William Cullen Bryant, "To Cole, the painter, Departing for Europe," reprinted in James Thomas Flexner, *That Wilder Image* (New York: Dover Publications, 1970), p. ix.

6. Thomas Cole, "Essay on American Scenery," McCoubrey 1965, p. 102.

7. Quoted in Neil Harris, *The Artist in American Society: The Formative Years 1790–1860* (Chicago and London: University of Chicago Press, 1982), p. 14.

8. *Times* (London), 30 April 1860, clipping in Cropsey Papers.

9. "Autumn on the Hudson. The Painting by Mr. Cropsey," *Art-Journal* (1860), p. 198. Excerpts from *Morning Chronicle*, 16 April 1860; *Athenaeum*, 9 June 1860; *Illustrated London News*, 16 June 1860. In pamphlet, *Mr. J. F. Cropsey's Picture of "Autumn on the Hudson River." Opinions of the Press*, Cropsey Papers.

10. "Domestic Art Gossip," *The Crayon* 7 (July 1860), p. 204; "Cropsey's New Picture," *Boston Evening Transcript*, 18 May 1860, p. 2.

11. *Mr. J. F. Cropsey's Picture of "Autumn on the Hudson River."*

12. The date of the exhibition is unknown. The flyer, "Mr. Cropsey's Autumn on the Hudson River," is annotated in Cropsey's hand: "The picture was on Exhibition in Pall Mall London—for a few weeks—this circular was used for that purpose." Cropsey Papers.

13. Book of order forms, Cropsey Papers. No engravings have been located.

14. Talbot 1970, p. 34.

15. *International Exhibition 1862. Official Catalogue of the Fine Art Department* (London, 1862), p. 275, no. 2871.

16. Account book, 1862, Cropsey Papers.

17. "Art Matters," *Boston Evening Transcript*, 19 May 1860, reported, "The original from which that picture was painted and enlarged, is not in the gallery of Sowle and Jenks, in Summer Street." Account book, 1860, Cropsey Papers, lists "Original study of 'Autumn on the Hudson River.'" A "List of Pictures in England," dated 7 January 1865 and in Cropsey's hand, includes "Small Autumn on the Hudson River." Cropsey Papers.

18. Jasper Cropsey, Autobiographical Sketch (1867), p. 8, typescript, Cropsey Papers.

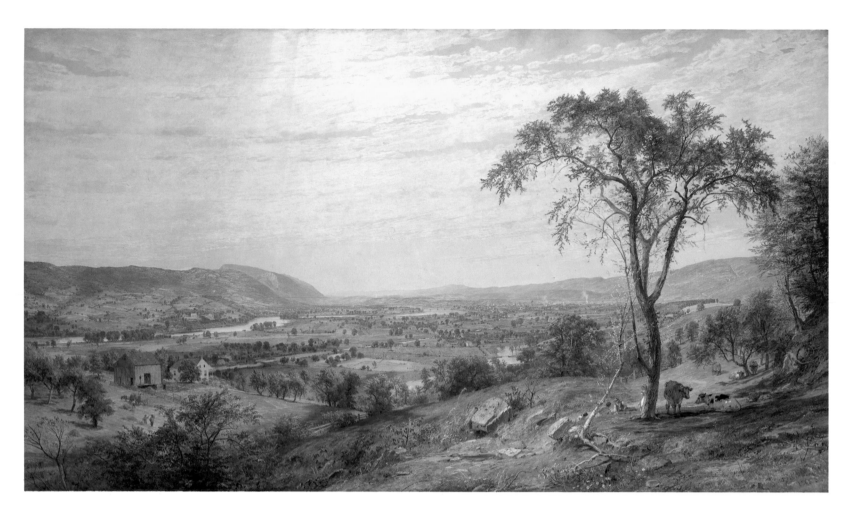

The Valley of Wyoming, 1865

Oil on canvas, 48½ × 84 in. (123.2 × 213.4 cm.)
Signed and dated at lower right: J. F. Cropsey/1865
The Metropolitan Museum of Art, New York City. Gift of
Mrs. John C. Newington, 1966 (66.113)

On Susquehanna's side, fair Wyoming!
Although the wild-flower on thy ruin'd wall
And roofless homes, a sad remembrance bring
Of what thy gentle people did befall;
Yet thou wert once the loveliest land of all
That see the Atlantic wave their morn restore.
. . . Beneath thy skies,
The happy shepherd swains had nought to do
But feed their flocks on green declivities.
Or skim perchance thy lake with light canoe,
. . . So sweet a spot of earth, you might, (I ween)
Have guess'd some congregation of the elves
To sport by summer moons, had shaped it for themselves.

These lines from Scottish poet Thomas Campbell's *Gertrude of Wyoming* (1809) appear on a plaque affixed to the picture's frame. The poem, of almost a hundred stanzas, relates the story of young,

British-born Gertrude, her widowed father, Albert, the Indian chief Outalissi, and his ward, Waldegrave, an American boy. The setting is Pennsylvania's Wyoming Valley, where the children grow up and eventually fall in love. When Waldegrave asks for Gertrude's hand in marriage, Outalissi tells him to take his bride away because of the impending invasion of armed British troops. Reluctant to follow that advice because of his loyalty to the valley, Waldegrave ignores Outalissi's warning, only to watch Gertrude and Albert die at enemy hands. The captivating tale of peace destroyed and pastoral love forsaken, reprinted many times in England and in America, effectively popularized the actual battle of 1778 known as the Wyoming Massacre, in which troops of Indians and British soldiers stormed the valley and took control of the settlements — burning, mutilating, and slaying in the name of Pennsylvania and Connecticut territorial rights.[1] While Campbell's version of the massacre dispensed with any detailed account of the various political factions involved, in its cast of characters and implied racial tensions it represented the reality of the event. Cropsey's use of verses from Campbell's poem, which by the 1860s was very well known, might be said to do the same.

In the stanzas he selected, however, Cropsey chose to perpetuate the particular nostalgia that surrounds the Wyoming Val-

ley. As Roger Stein has noted: "The conflict of cultures, the family strains, and the ultimate violence and loss which are central to Campbell's vision have been consciously eliminated both from the poetic fragment and from the painting. . . . Cropsey's *Wyoming* vision not only denies the historical experience; it evades the cultural implications of tension and conflict."[2] Though the artist focused on the landscape and showed no interest in its gory history, he was not ignorant of the massacre. By quoting from the poem, he proved that he knew the story and had limited himself to illustrating only the parts that suited his purpose.[3]

As do most other mid-century pictures of the Wyoming Valley, Cropsey's painting centers on the rural peace of the landscape. His message appealed to the tourists eager for images of the site, as did pictures by William Henry Bartlett, T. Addison Richards, Paul Weber, William Trost Richards, and others.[4] Cropsey's bias in designing his picture is directly linked to its commissioning. Milton Courtright, a civil engineer who later became the first president of the New York Elevated Railroad Company, ordered the painting in early August 1864.[5] While information about his exact instructions for the commission is lacking, Courtright, the son of a farmer, is known to have grown up in Plains, Pennsylvania, in the Wyoming Valley, and apparently wanted a painting of his childhood home. Cropsey's sketches for the painting, dated 8 and 9 August 1864, show three possible views: the valley from Plains, in a drawing titled *The Birthplace of Milton Courtright, Esq., Wyoming Valley Aug'st 9th, 1864* (Sordoni Art Gallery); the valley from Prospect Rock (Museum of Fine Arts, Boston); and the valley from Inman's Hill, in which the town and other prominent features are carefully labeled (Fig. 1). Cropsey worked the last scene into a small oil study (Fig. 2) for the finished painting. His search for the best view followed the recommendation of Charles Miner, a local historian, who wrote in 1845 that the area then differed greatly from its appearance in 1778, when it had been "a perfect indian paradise." As he assured his readers, "From various points, the valley may be seen to advantage. Prospect rock, on the eastern mountain, near the turnpike, affords a very fine, though rather distant, view. . . . But from Inman's Hill, the eye embracing part of Hanover, and the broad expanse of the Wilkesbarre and Kingston meadows, the prospect is eminently picturesque; presenting a scene rich in a single aspect, but in detail, studded with innumerable beauties."[6]

Cropsey's finely detailed canvas, showing Courtright's hometown in the far distance, was finished in time for the National Academy of Design's exhibition of spring 1865. In May, Cropsey received a total fee of thirty-five hundred dollars from Courtright.[7] In reviews of the exhibition, the *New York World* praised the work for "the courage with which a vast sweep of country is laid bare," and the *New York Times* called it "a monument of patient and accurate labor . . . a topographical survey of a highly picturesque and romantic region."[8] The critics neither took notice of Campbell's verses on the frame nor commented on the lack of historical authenticity in the scene, but saw the picture as a straightforward document of the valley's appearance. The sort of appreciation ac-

Figure 1. Jasper F. Cropsey, *Wyoming Valley from Inman's Hill*, 1864, pencil on paper, 12 x 18¼ in. (30.5 x 46.4 cm.). Courtesy, Museum of Fine Arts, Boston, Bequest of Maxim Karolik (1972.761)

Figure 2. Jasper F. Cropsey, *Wyoming Valley, Pennsylvania*, 1864, oil on canvas, 15 x 24 in. (38.1 x 61 cm.). The Metropolitan Museum of Art, Bequest of Collis P. Huntington, 1900 (25.110.63)

corded it would have been fostered by Cropsey's meticulous technique and the extraordinarily wide expanse he portrayed.

Cropsey, in composing a depiction of two histories—that of Courtright and that of the valley—may have been struggling with his subject. For his patron he needed a brightly optimistic composition, which he attained through the use of an overall light tone and the inclusion of genre scenes of children and farmers. In his representation of the Wyoming Valley, therefore, he had to rid the site of any reminder of its tragic history. To achieve that purpose without compromising the happiness of the scene by reminders of previous atrocities, Cropsey elevated the site into a symbol of the

regenerative power of the American land. His *Wyoming Valley* exhibits no signs of the devastation, blood, and sorrow it had once witnessed; rather, to inform the viewer that this is a magic landscape, Cropsey has bestowed a curious haze on parts of the canvas.

Cropsey's selective use of certain of Campbell's verses affirmed that his portrayal of the valley closely matched its appearance long ago, when "The happy shepherd swains had nought to do/But feed their flocks on green declivities." Since Cropsey was always somewhat ambiguous in differentiating between reality and invention in his art, it is unlikely that the image he showed in this painting was accurate to conditions in 1864. At least twenty years before, in a lecture he gave called "Natural Art," he had proclaimed, "Imitative art is kindred to Poetry." The best of America's artists studied nature intensely before composing their pictures, he added, explaining, "The mind being thoroughly educated from this close observation of parts and an undeviating resemblance to nature, gives [a man] power to make judicious selections."[9] Never more wholeheartedly did he express that philosophy than in *The Valley of the Wyoming*, on Courtright's behalf. In this painting of an actual site, carefully studied and put to canvas through the filter of his own poetic imitation and his patron's cherished memories, Cropsey demonstrated the truth of one of the points he had made in his lecture: "If the mind be affected by a truthful poetical description, then will it be by a truthful painted description:—If poetical language has conveyed to your mind scenes of your youth, your home; then will an imitation on canvass of your birthplace recall the same."[10]

C.R.

Notes

1. See Stein 1981, p. 31. On the history of Wyoming Valley, see William L. Stone, *The Poetry and History of Wyoming* (New York and London, 1841); Charles Miner, *History of Wyoming, in a Series of Letters, from Charles Miner, to his son William Penn Miner, Esq.* (Philadelphia, Pa.: J. Crissy, 1845); Henry T. Blake, *Wyoming or Connecticut's East India Co., Two Lectures Delivered Before the Fairfield County Historical Society, Bridgeport, Conn., March 10, 1893–April 21, 1893* (Bridgeport, Conn., 1897).
2. Stein 1981, p. 60.
3. Cropsey owned a copy of the 1830 London edition of *Campbell's Poetical Works*. See Talbot 1977, p. 179.
4. See F. Charles Petrillo and Roger B. Stein, *Vale of Wyoming: Nineteenth Century Images from Campbell's Ledge to Nanticoke*, exh. cat. (Wilkes-Barre, Pa.: Sordoni Art Gallery, Wilkes College, 1986).
5. Account book, 1864, Cropsey Papers, records payment on 4 August of $125, on account from Courtright for "Wyoming Valley."
6. Charles Miner, *History of Wyoming*, pp. xiii–xiv.
7. Account book, 1865, Cropsey Papers, records January, March, and May payments totaling $3,375. *Catalogue of the Fortieth Annual Exhibition of the National Academy of Design, 1865* (New York: Sackett & MacKay, 1865), no. 232. Cropsey also exhibited *The Old Homestead, Wyoming Valley*, no. 551 (location unknown).
8. *New York World*, 16 May 1865, p. 4; *New York Times*, 13 June 1865, p. 5.
9. Jasper Cropsey, "Natural Art," lecture presented to the New-York Art Re-Union, 24 August 1845, p. 5, typescript, Cropsey Papers.
10. Ibid.

Starrucca Viaduct, Pennsylvania, 1865

Oil on canvas, 22⅜ × 36⅜ in. (56.8 × 92.4 cm.)
Signed and dated at lower right: J. F. Cropsey/1865
Toledo Museum of Art, Toledo, Ohio. Gift of Florence Scott Libbey, 1947 (47.58)

The Starrucca Viaduct, ten hundred and forty feet long and almost a hundred feet high, with its seventeen gray sandstone arches each spanning fifteen feet, crosses Starrucca Creek and Starrucca Valley at Lanesboro, Pennsylvania. The viaduct was built by Julian W. Adams and James P. Kirkwood for the New York and Erie Railroad during the summer of 1848, at a cost of approximately three hundred and thirty-five thousand dollars, completing the track line between Deposit and Binghamton, in New York state.[1] Within three years, artists were composing pictures around the engineering marvel. William McIlvaine's two watercolors of 1851, Edwin Whitefield's watercolor of 1853, and oil paintings by other artists emphasize its solid geometry, massive dominance, and sculptural rhythm against the surrounding landscape.[2] In marked contrast to those pictures, Cropsey's painting de-emphasizes the structure by nestling it within the landscape. The train, emitting puffy white smoke and sliding unobtrusively along its gently winding track, is just beginning its passage across the viaduct. Bathed in sunlight, the train and the bridge harmonize, chameleonlike, with the setting. By organizing his composition around two intersecting curves—the line of the foliage in the foreground and the line of the train track in the background—Cropsey further minimizes the disjunction between subject and setting.

Cropsey first painted a view of Starrucca in 1864, as recorded in his account book: "From Charles Isham for study of 'Starrucca Vale,' N.Y. and E. R. R.—$200.00."[3] The following year, he sold three paintings with similar titles, suggesting similar, if not identical, pictures. One was an engraver's copy, which sold to a Mr. Sintzenich (probably Edward Sintzenich, a New York auctioneer) in April for five hundred dollars. On 7 June, Cropsey recorded having received eight hundred dollars from James Brown for "N.Y. and E. R. R." and its frame. In late November, the New York art dealer Henry W. Derby, acting as agent for Sintzenich, paid Cropsey three thousand dollars for "Starrucca Vale—Erie Rail Road" and its frame.[4] That last painting appeared a little more than a year later, on 21 January 1867, as the third prize in the Crosby Opera House lottery in Chicago. Uranus H. Crosby had built the theater as a gift to Chicago, but its construction caused his bankruptcy. To pay his debts, he devised a lottery in which the opera house itself was first prize, and oil paintings valued at a total of two hundred thousand dollars, by many noted American artists, were also raffled off.[5] Lottery tickets sold for five dollars each, with a chromolithograph of Cropsey's painting offered as a premium to anyone buying four or more tickets.[6] A description of the lottery in Cropsey's papers values his painting—reportedly eight by fourteen feet—at six thousand dollars, but whether or not the painting was awarded

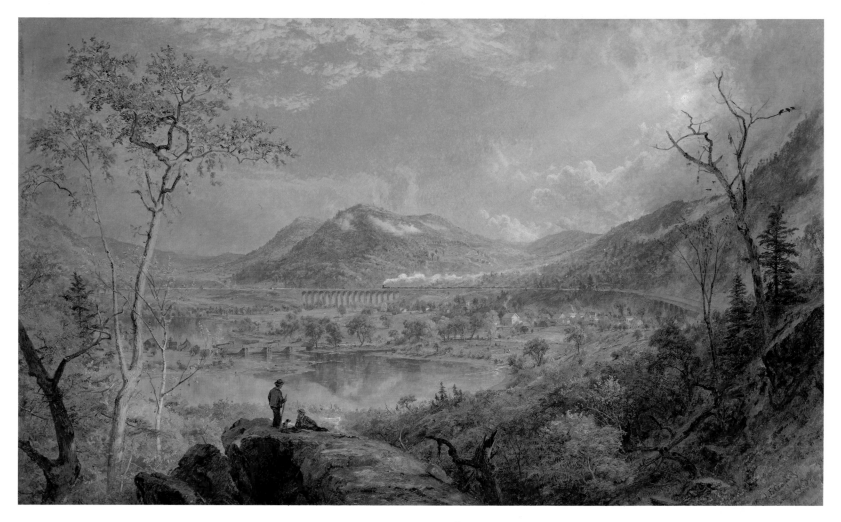

is unknown, for it burned along with the opera house in the Chicago fire of 1871.[7] *Starrucca Viaduct* could be either of the two other pictures Cropsey sold in 1865; its resemblance to the chromolithograph suggests that it might have been the engraver's copy. The only additional information as to its provenance, and not particularly helpful for identifying purposes, is that a painting of these exact dimensions, untitled but described in the sale catalogue as "a View across a wide valley with a railway viaduct crossing a river," was sold on 26 February 1947 at Sotheby's in London as part of the collection of Brigadier General H. Clifton Browne.

Cropsey's vantage point is the same as that described in a January 1854 newspaper article about train travel along the Erie Railroad:

> From the summit of the hill, just before you descend to Lanesboro, as perfect a picture lies before you as the eye ever longed for. The landscape is skirted by thickly-wooded hills—the mirror-like Susquehanna sleeps through the midst of green meadows. Over it you see an old rural bridge, contrasting, pleasingly, with the elegant Tressel Bridge near by. . . . The solid masonry of the Starrucca Viaduct, with its regular arches, is seen in the distance, blending

with the scenery, the grandeur, and dignity of art, like the effect of a piece of colossal statuary in a green park.[8]

The similarity between the scene described and Cropsey's canvas is easily explained: the summit portrayed in each was the site of an unscheduled train stop that afforded passengers the opportunity to get out and enjoy the scenic vista.[9] Cropsey, whose earliest known sketches for the painting date to autumn 1853 (Fig. 1), surely rode the train to reach the spot, which had been described and illustrated in *Harper's New-York and Erie Rail Road Guide* of 1851 (Fig. 2).[10] Cropsey must have seen a copy of the book, a popular, chatty guide to highlights along the train route that recommended the view of the viaduct from the opposite side of the Susquehanna as "an epitome of the glories, natural and artificial, of the New York and Erie Rail-road," a sight that should be seen in autumn.[11] His composition clearly derives from the guidebook illustration, by William MacLeod, right down to the poses of the two figures, though Cropsey's is a much more intricate scheme.

It has been said that in this picture Cropsey painted "An echo of Italy in the American landscape. . . . Valley and hills, the long line of the railroad viaduct . . . recalled the landscape and aqueducts

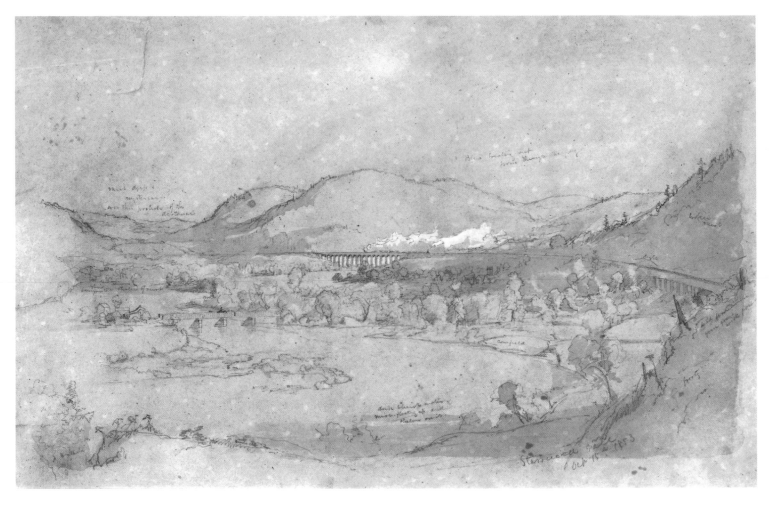

Figure 1. Jasper F. Cropsey, *Starrucca Vale, October 15th, 1853*, pencil and lightwash, touched with white, on pale buff paper, 11¹³⁄₁₆ x 18½ in. (30 x 47 cm.). Courtesy, Museum of Fine Arts, Boston, M. and M. Karolik Collection of American Watercolors and Drawings, 1800–1875 (52.1594)

about Tivoli."[12] Indeed, an interesting comparison might be made between *Starrucca Viaduct* and Cropsey's *Italian Campagna with the Claudian Aqueduct* (1848; Brown Reinhardt), which itself derives from Thomas Cole's *Roman Campagna* (1843; Wadsworth Atheneum). Both Cropsey paintings employ the traditional pastoral formula, in which a catastrophic act of God is imposed on an otherwise tranquil landscape. As the shepherd in *Italian Campagna* contemplates the passage of time, symbolized by the ruined aqueduct, so the idle figures in *Starrucca Viaduct* gaze over the valley toward the train, a symbol of progress and change. The composition of *Starrucca Viaduct* also conforms remarkably closely to pastoral views painted by eighteenth-century British artists; it matches almost precisely a painting by Richard Wilson of *Lake Avernus and the Island of Ischia* (Fig. 3). Cropsey would have known that Italian site, famous to travelers on the Grand Tour as the grotto of the Cumaean sibyl, where Aeneas began his descent to the underworld; Cropsey may also have known Wilson's

painting.[13] Just as Wilson diminished the contrast between the men and the ruins and emphasized the overall tranquillity of his scene, Cropsey translated the pastoral ideal for his American compatriots by showing the train being swallowed into the wilderness and so making no threat to the established natural order.

Since the sixteenth century, that ideal—a world in which natural order predominates over complex changes—had suited the industrialists and landowners by belittling the undesirable effects of progress: cities, trains, and nature under cultivation appear romantic, controlled, and insignificant. In *Starrucca Viaduct*, the pastoral ideal Cropsey presented was one that appealed to mid-nineteenth-century notions of the country's promised millennium: an America forever young, always wild, and prospering in perpetuity without destruction or decline. Progress, under divine Providence, would be absorbed and purified by the nation's unsullied environment.[14] Though the promise of an American millennium was but a rhetorical ideal, it nonetheless captured the imaginations of historians, authors, and artists. Cropsey's painting, for example, can be tied directly to the interests of his patrons, who ascribed to the myth that technology would not damage the natural landscape. To put it bluntly, Cropsey was in sympathy with the concerns of railroad magnates, such as Milton Courtright, the Pennsylvanian

Figure 2. William MacLeod, *Starrucca, from the West*, 1851, engraving. Illustrated in *Harper's New-York and Erie Rail Road Guide* (New York, 1851). General Research Division, The New York Public Library, Astor, Lenox and Tilden Foundations

Figure 3. Richard Wilson, *Lake Avernus and the Island of Ischia*, ca. 1752–57, oil on canvas, 18½ x 28½ in. (47 x 72.4 cm.). The Tate Gallery, London

Jersey.[15] Moreover, Cropsey's powerful image of a train's idyllic progress made *Starrucca Viaduct* the perfect choice for the chromolithograph premium for Crosby's Chicago Opera House lottery — a raffle in a railroad hub. For those men, the painting represented the supreme validation of their interests and prosperity.

C.R.

Notes

1. See William S. Young, *Starrucca: The Bridge of Stone* (Aiken, S. C.: Privately printed, 1986).
2. See Stein 1981, pp. 62–63, figs. 4, 48; Maddox 1981, p. 25.
3. Account book, 1865, Cropsey Papers. Cropsey painted the scene for the last time in 1896. See *Starrucca Viaduct, Wayne County*, 1896, illustrated in sale cats., Sotheby's, New York, 9–10 May 1958, lot 289A, and 15–16 January 1960, lot 323.
4. Account book, 1864, Cropsey Papers. The sale of the last painting is also mentioned in the *Journal of Commerce* (28 December 1865), clipping in Cropsey Papers.
5. *M. & M. Karolik Collection of American Watercolors & Drawings 1800–1875*, 2 vols. (Boston: Museum of Fine Arts, 1962), 1, p. 25.
6. The lithograph, titled *American Autumn, Starucca* [sic] *Valley, Erie R. Road*, was engraved by William Dreser and published by Thomas B. Sinclair in Philadelphia. A proof is in the Museum of Fine Arts, Boston (62.74). Prints in the published state are in that museum's collection (51.2546) and at the Metropolitan Museum (1975.524).
7. Talbot 1977, p. 183.
8. *The Independent* (New York), 12 January 1854, p. 11.
9. Maddox 1981, p. 25.
10. Cropsey's other sketch, a closer view of the viaduct, dated 15 October 1853, is also in the Museum of Fine Arts, Boston (52.1595). A *Sketch of Starrucca Vale*, dated 1853, is in the Cropsey Papers, as are an oil sketch, *Starrucca Viaduct— Autumn*, dated 1856, and pencil studies of the rifle and of the two figures, all dated 1865.
11. *Harper's New-York and Erie Rail Road Guide* (New York: Harper & Brothers, 1851), p. 120.
12. E. P. Richardson and Otto Wittmann, Jr., *Travelers in Arcadia: American Artists in Italy 1830–1875*, exh. cat. (Detroit Institute of Arts and The Toledo Museum of Art, 1951), p. 33.
13. Solkin 1982, p. 203.
14. Dorothy Ross, "Historical Consciousness in Nineteenth-Century America," *American Historical Review* 89 (October 1984), p. 912.
15. For a discussion of Cropsey's work for Pullman, see Barbara Finney, "Jasper F. Cropsey's Commission for the Sixth Avenue Elevated Passenger Stations (1878)" (Master's thesis, George Washington University, 1983).

civil engineer who had commissioned *The Valley of Wyoming* that Cropsey was working on in early 1865 (see p. 208), and the midwestern industrialist George M. Pullman, originator of the railroad parlor cars that bear his name, for whom Cropsey was later to design a town house in Chicago and a villa in Long Branch, New

Mt. Washington from Lake Sebago, Maine, 1871
Oil on canvas, 16 × 30 in. (40.6 × 76.2 cm.)
Signed and dated at lower left: J. F. Cropsey/1871
Mint Museum, Charlotte, North Carolina. Bequest of
 Miss Elizabeth Boyd. 45.3

Lake Sebago, in Cumberland County, fifteen miles northwest of Portland, is the second largest lake in Maine. Today the primary feature of Sebago Lake State Park, it was a popular area for fishing and sailing by the second quarter of the nineteenth century.

Nathaniel Hawthorne is reported to have said, "I have visited many places called beautiful in Europe and the United States, but . . . in an October afternoon just when the oak leaves put on their red coats, the view from [Lake Sebago] looking to the slopes of Rattle-snake Mountain through the haze of Indian summer, was to me more enchanting than anything else I have ever seen."[1] Approximately fifty miles northwest of the lake, in the northern section of New Hampshire's White Mountain range, sits Mount Washington. The highest mountain (6,288 feet) in the northeastern states, it accommodated travelers by the 1840s with a bridle path and, later, with a carriage road. Most Hudson River School artists sketched in the White Mountains: Cropsey completed at least fifteen paintings showing different aspects of the numerous mountains and

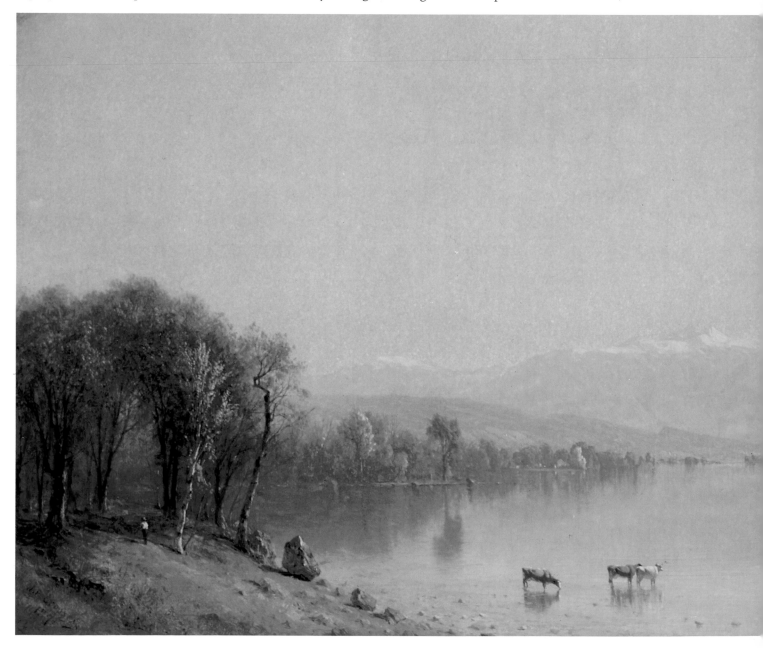

rivers in the region, the earliest dating from shortly after his first trip there in the late summer of 1852.

According to William S. Talbot, who established the site of this painting of 1871, three titles had previously been assigned to the picture: *Landscape with Mountains, Autumn on the Hudson,* and *Lake Wawayanda*.[2] Talbot identified the scene by comparing it with that of two similar paintings, both dated 1867 and both titled *Mt. Washington from Lake Sebago, Maine* (private collections; Fig. 1). The title for the two works was arrived at by connecting the paintings to entries in Cropsey's account book for 1867, which records that a *Glimpse of Mt. Washington from Lake Sebago* sold to "J. Lord Cooper for Mrs. Day" on 9 March, and that a *Mt. Washington from Lake Sebago* sold to a Lewis Roberts on 26

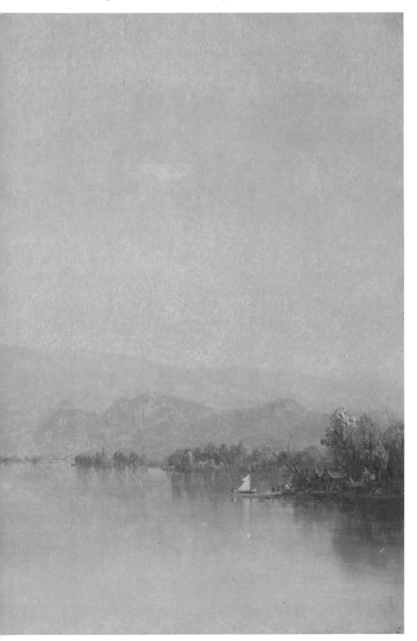

April.[3] Though the attribution of the title and identification of those two paintings and this version of *Mt. Washington* seem plausible, documented provenances and exhibition records are still lacking.[4]

A clue to establishing the history of the subject of this entry is that a virtually identical painting, called *A Dreamy Day in New England* (Fig. 2), is signed by Cropsey's colleague Sanford Gifford. A sketch by Gifford (Albany Institute) that relates to his painting is dated September 1854, and a similar Gifford work, *Mountain and Lake Scene* (Washington University Art Gallery), is dated 1860. From those works it might be supposed that Gifford and Cropsey visited Lake Sebago together in 1854, but neither artist's papers offer documentation of such a trip. Talbot states that Cropsey's "three versions of this view . . . are the only evidence that Cropsey was ever in the state of Maine."[5] At the same time, however, by suggesting that Cropsey used Gifford's painting as his model, he implies that Cropsey never visited Maine at all. Gifford scholar Ila Weiss would identify the painting as a Gifford "if it were not signed and dated 'J. F. Cropsey 1871.'" Of the foreground boulder in Cropsey's picture, a realistic focal point in an otherwise dreamlike landscape, Weiss says, "[It is] a motif Gifford used repeatedly from about 1859 into the early 1860s."[6]

Whether or not Cropsey copied Gifford's canvas, he certainly produced *Mt. Washington from Lake Sebago, Maine* with Gifford's style in mind. Cropsey modeled his work on that of his colleagues throughout his career, using their compositions and techniques as catalysts for change in his own style. He learned early on to imitate Thomas Cole's style by copying and adapting Cole's manner of composition—see, for example, *Italian Campagna with the Claudian Aqueduct* (1848; Brown Reinhardt), which is based on Cole's *Roman Campagna* (1843; Wadsworth Atheneum), and *Catskill Mountain House* (see p. 203), which is based on Cole's rendition of the same subject (Fig. 1, p. 205). Later in his career, Cropsey emulated Frederic Church by producing several large spectacle pictures (see pp. 206; 210). During the 1870s, Cropsey modified his style to match that of his contemporaries Gifford and John Kensett. Like them, he reduced the narrative aspect of his compositions and emphasized the serenity of nature rather than its violence and unpredictability, thus creating an aesthetic of tranquillity that appealed to an audience finding intellectual and emotional peace in such homogenized, conflict-free pictures.

That shift in Cropsey's style—the last major change in his work—coincides with significant changes in his life. In 1869, after a prosperous decade resulting from the success of *Autumn—On the Hudson River* (see p. 206), he moved his family into a house he designed for them in Warwick, New York. During the 1870s, owing in part to the high cost of its maintenance, he revived his architectural practice and experimented with a variety of landscape styles—some as detailed and vigorously rendered as his earliest work; others with more generalized forms and open expanses of sky and water, the latter exemplified by this *Mt. Washington from Lake Sebago, Maine* of 1871. His vacillation between styles during that period reveals him to be a somewhat irresolute artist, greatly

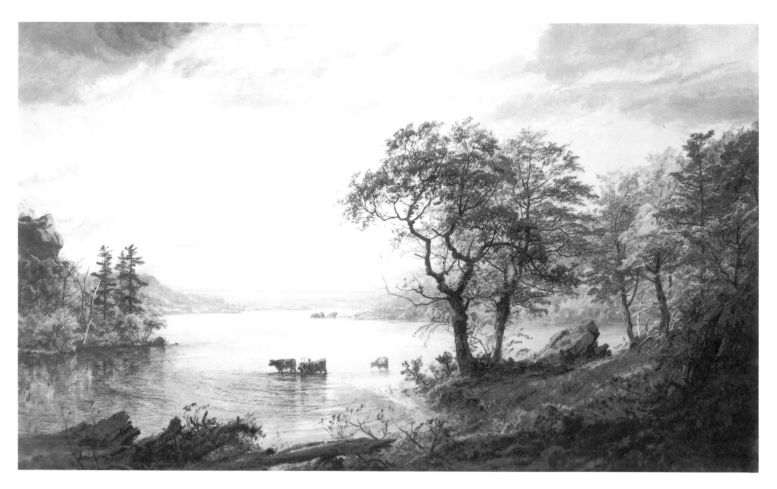

Figure 1. Jasper F. Cropsey, *Mt. Washington from Lake Sebago, Maine*, 1867, oil on canvas, 20 x 33 in. (50.8 x 83.8 cm.). Private collection

affected by the post–Civil War fluctuations in the art market that had diminished the demand for meticulous landscape paintings. Cropsey eventually found the means of satisfying his need to paint landscapes in the watercolors he did in the 1880s and 1890s, pictures that happily combined all the stylistic influences he had mastered.[7]

C.R.

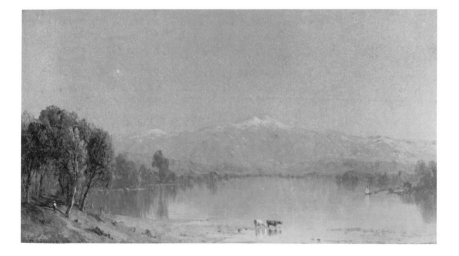

Figure 2. Sanford R. Gifford, *A Dreamy Day in New England*, ca. 1854–70, oil on canvas, 5¾ x 10¹/16 in. (14.6 x 25.6 cm.). The Baltimore Museum of Art, Gift of Mrs. Paul H. Miller (1942.6)

Notes

1. Quoted in Herbert G. Jones, *Sebago Lake Land: In History, Legend and Romance* (Portland, Me.: The Bowker Press, 1949), p. 10.
2. Talbot 1977, p. 443.
3. Account book, 1867, Cropsey Papers.
4. A pencil sketch of Lake Sebago dated 8 August 1869 (Cropsey Papers) suggests that Cropsey may have visited the lake at that time. Otherwise, there is no evidence that he was at the site around the time those three pictures were produced.
5. Talbot 1970, p. 97.
6. Weiss 1977, pp. xiv–xv.
7. See Carrie Rebora, *Jasper Cropsey Watercolors*, exh. cat. Introduction by Annette Blaugrund (New York: National Academy of Design, 1985).

SANFORD R. GIFFORD
(1823–1880)

Sanford Robinson Gifford was born in Greenfield, New York, but was reared in Hudson, where his father was co-owner of an iron foundry. After attending Brown University for two years, Gifford left for New York City to begin a career in art, studying perspective and anatomy with John Reubens Smith in 1845 and, during the next two years, drawing in the Antique and Life schools at the National Academy of Design. Influenced by the paintings of Thomas Cole and after sketching trips to the Berkshires and the Catskills in 1846, Gifford turned from the portraits of his earlier years to landscape painting, submitting his first entries to the Academy and to the American Art-Union the following year. He was elected an Associate of the Academy in 1851 and an Academician three years later.

Gifford sketched in the Catskill, Berkshire, Adirondack, and Shawangunk mountains, as well as in New Jersey and New Hampshire, until 1855. In the next two years, he visited several European countries, among them England and France—where he met John Ruskin and Jean-François Millet—and Italy, where he spent part of his time in the company of Albert Bierstadt. On his return to the United States, Gifford began a tenancy in the new Tenth Street Studio Building that was to last until his death. In 1861, he enlisted in the Seventh Regiment of the New York State National Guard and spent part of the next three summers in and around Washington, D.C.

On a visit to eastern Europe in 1868–69, Gifford extended his travels to include Jerusalem, Syria, Lebanon, and Egypt. In the United States, he sketched each summer in various places in the East; in 1870, he joined John F. Kensett and Worthington Whittredge on a trip to the Rocky Mountains of Colorado; then, joining a government survey expedition, he went on to Wyoming. In subsequent years, while continuing to sketch in his accustomed haunts in the East, he traveled along the west coast from Alaska to California. In 1880, after a trip to Lake Superior, he died in New York City of malarial fever and pneumonia. Three months later, the Century Association in New York honored him at a memorial meeting; the following year, The Metropolitan Museum of Art presented an exhibition of Gifford's paintings and also published a memorial catalogue that listed 739 of his works.

Select Bibliography

Gifford Memorial Meeting of The Century. New York: The Century Association, 1880.

A Memorial Catalogue of the Paintings of Sanford Robinson Gifford, N. A. Biographical and critical essay by John F. Weir. New York: The Metropolitan Museum of Art, 1881.

Nicolai Cikovsky, Jr. *Sanford Robinson Gifford (1823–1880).* Exhibition catalogue. Austin: University of Texas, 1970.

Ila S. Weiss. *Sanford Robinson Gifford, 1823–1880.* New York and London: Garland Publishing, 1977.

Steven Weiss. *Sanford R. Gifford, 1823–1880.* Exhibition catalogue. Essay and chronology by Ila S. Weiss. New York: Alexander Gallery, 1986.

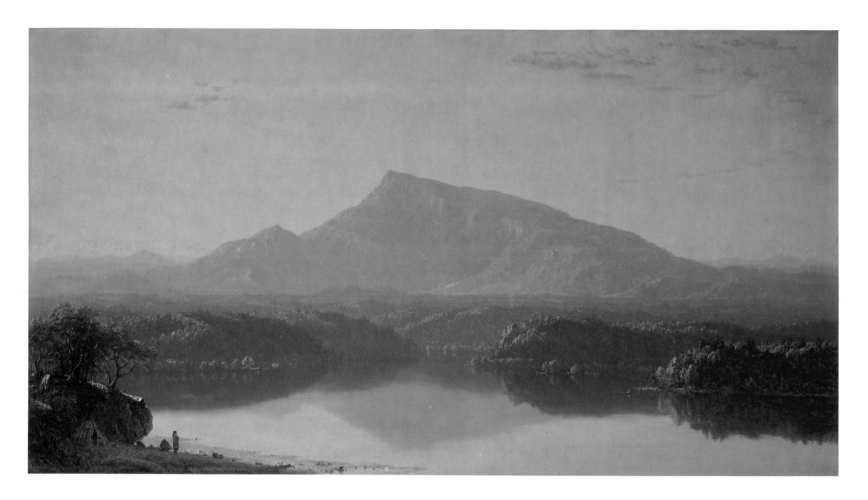

The Wilderness, 1860

Oil on canvas, 30 × 54⁵⁄₁₆ in. (76.2 × 138 cm.)
Signed and dated at lower left: S. R. Gifford 1860
Toledo Museum of Art, Toledo, Ohio. Gift of Florence Scott Libbey,
1951 (51.403)

The Wilderness, among Gifford's most ambitious paintings of American scenery, appears to be a conflation of pencil and oil studies of forms he recorded in Nova Scotia, Maine, and New Hampshire in July and August 1859. According to a letter the artist wrote that June to the Reverend Elias L. Magoon, a noted collector, the primary destination of his summer's journey, made with genre painter George H. Boughton, was Nova Scotia. "Boughton and I, fired by accounts we have read and heard of the scenery and people of Nova Scotia, have made an alliance offensive and defensive for an expedition into that land of 'Blue Noses,' Acadians, and 'Forest Primeval.' We will probably get away thitherward by the first of July."[1] Gifford was probably the writer of a letter, dated 26 July 1859 and appearing in *The Crayon* the following September, in which a Nova Scotia sojourn was described in disappointed terms: " . . . there was not a sign of the 'forest primeval—the murmuring

pines and the hemlocks' that the poet sings of. . . . By the way, Longfellow's description of the scenery is not wonderfully accurate."[2] While the allusion was to Henry Wadsworth Longfellow's *Evangeline*, it has been suggested that the immediate inspiration for Gifford's trip may have been *Acadia: or, a Month with the Blue Noses*, a book by Frederick S. Cozzens that was published the year of Gifford's journey.[3] That his sketchbook of July–August 1859[4] contains little record of the Nova Scotia landscape accords with the sentiments expressed in the *Crayon* letter, although several pages from mid-July are filled with drawings of the Micmac Indians who lived in the region and of their tepees and canoes (ill.). The *Crayon* letter writer briefly described a day spent with the "simple and friendly" Micmacs: "We paddled about in their canoes, and in the evening had a pow-wow and smoked a pipe with them about the fire in a wigwam."[5] In *The Wilderness*, which includes features modeled on details recorded in Gifford's mid-July sketches, a squaw awaits the homecoming of her brave, who paddles toward her from the opposite shore of the lake. To her left is a tepee with a papoose propped in its entranceway; a slain deer hangs from a nearby ledge. The painting's dominant feature, however, is Mount Katahdin, in Maine, reflected in the lake occupying the middle ground.

Apart from the finished painting, there is no evidence that

Gifford observed Mount Katahdin on his trip and scant documentation that he even traveled in Maine at that time. His sketchbook shows a three-day gap between the last drawing he made in Canada and the first he made in New Hampshire, suggesting a swift passage through the state, if indeed he even traveled that route. An unlocated painting titled *Indian Summer in Maine*, also dated 1860, may attest to a visit the previous year.[6] Another possible proof of his presumed journey through Maine is an oil study of a lake (private collection) that may have provided the basis for the scenery in *The Wilderness*: the terrain depicted resembles the forest tablelands in the Mount Katahdin area, though the mountain itself is not included.[7] Small, so-called postage-stamp drawings done in

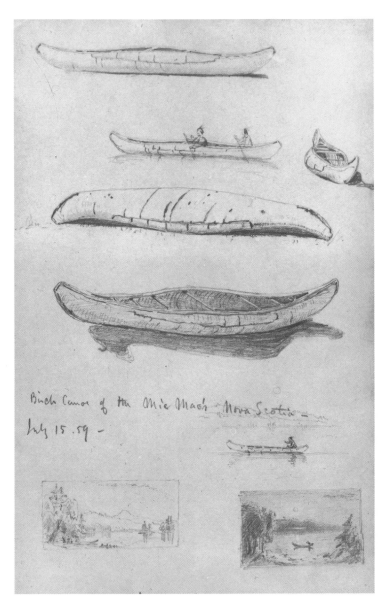

Sanford R. Gifford, "Birch Canoe of the Mic Mac's Nova Scotia—July 15.59," pencil on paper, 6 x 9½ in. (15.2 x 24.1 cm.). In Gifford's Nova Scotia and Shelburne 1859 sketchbook. Vassar College Art Gallery, Gift of Edith Wilkinson

late July in the vicinity of Northumberland, New Hampshire, appear to rehearse the painting's compositional scheme of a central mountain rising above a forested lake.

The Wilderness is thus very much an idealization of the "forest primeval" that the artist found embodied in no single site. The lyric subtitle—"Home of the red brow'd hunter race"—with which Gifford first exhibited the picture[8] emphasizes both the poetic nature of Gifford's concept and the key role played by the staffage figures, their diminutive size notwithstanding. It has been proposed that Gifford, by including Indians in this and other paintings of the time, may have been responding to the words of a contemporary art critic: "As an accessory in landscape, the Indian may be used with great effect. He is at home in every scene of primitive country."[9] With the Indians and with the archetypal form of Mount Katahdin rising like a mirage in the background, *The Wilderness* could be thought of as an American version of Thomas Cole's *Savage State*—the first of his *Course of Empire* series (Fig. 2.6, p. 28)—a painting that describes the primitive beginnings of an ancient European civilization. Yet the mellow light and hazy atmosphere of Gifford's Indian summer afternoon betoken an intent not so much allegorical and portentous as reflecting the painter's own nostalgic awareness that, in the critic's words, the Indian was "fast passing away from the face of the earth."[10]

Whether Gifford himself observed Mount Katahdin (the Indian word for "highest land") or merely knew its appearance from another source, his choosing it as his principal motif was particularly apt. The mountain stands in monumental isolation in the rugged lake country of northern Maine; reaching it by stagecoach, canoe, on foot, and finally ascending its long rocky slope had already challenged, among others, Henry David Thoreau, Frederic E. Church, and Theodore Winthrop, the last two soon to be neighbors of Gifford's in the Tenth Street Studio Building. Both Thoreau and Winthrop were more impressed by the mythic aspect of Katahdin when seen from afar than by the flat, cloud-obscured prospect its summit commanded. Thoreau, as he approached the mountain, found that it remained "still distant and blue, almost as if retreating from us";[11] Winthrop declared simply, "Katahdin's self is finer than what Katahdin sees."[12] Gifford's treatment of the peak, showing it suspended in an airy realm between spirit and substance, is in keeping with an observation made by Thoreau: "Only daring and insolent men, perchance, go there. Simple races, as savages, do not climb mountains—their tops are sacred and mysterious tracts never visited by them. [The Indian god] Pomola is always angry with those who climb to the summit of Ktaadn."[13]

The Wilderness was warmly, if not enthusiastically, received when it was shown at the National Academy of Design in 1860. Six years later, Henry T. Tuckerman praised it elaborately, citing it for "a scope, a masterly treatment of light and shade, full of reality and poetically suggestive . . . a seeming space which is one of the most subtle illusions of the art."[14] The painting was exhibited for sale at the Academy, but found no buyer, and was exhibited again the same year at the Boston Athenaeum, where it was purchased by the Bostonian Harrison Maynard. It passed through several

private collections in Boston until 1951, when it was bought and then given to the Toledo Museum.[15] Because of its Indian iconography, the subject was originally interpreted as a western theme.[16] Despite clarification of that issue, the picture is still—and justifiably—associated with the frontier strain in American landscape painting.[17]

K.J.A.

Notes

1. Gifford to Dr. E. L. Magoon, 5 June 1859, quoted in Weiss 1977, p. 184.
2. "Country Correspondence, N——, July 26, 1859," *The Crayon* 6 (September 1859), p. 285, quoted in Weiss 1977, p. 185.
3. Weiss 1977, p. 185.
4. Sketchbook with drawings dating from July and August 1859, Vassar College Art Gallery. Archives of American Art, microfilm roll no. D254.
5. "Country Correspondence," quoted in Weiss 1977, pp. 185–86.
6. Gifford Memorial Catalogue, no. 206.
7. Weiss 1977, p. 200.
8. *Catalogue of the Thirty-Fifth Annual Exhibition of the National Academy of Design, 1860* (New York, 1860), p. 35, no. 561.
9. "The Indians in American Art," *The Crayon* 3 (January 1856), p. 28, quoted in Weiss 1977, p. 180.
10. Ibid.
11. Henry David Thoreau, *The Maine Woods* (1864; reprint, ed. by Joseph J. Moldenhauer, Princeton, N. J.: Princeton University Press, 1972), p. 59. The first part of Thoreau's account, titled "Ktaadn" and quoted here, was originally published in *Union Magazine*, July 1840.
12. Theodore Winthrop, *Life in the Open Air* (Boston: Ticknor and Fields, 1863), p. 102.
13. Thoreau, *The Maine Woods*, p. 65. See also *Springs, Waterfalls, Sea-Bathing Resorts, and Mountain Scenery of the United States and Canada* (New York: J. Disturnell, 1855), p. 20, in which the Indian legend of Pomola's habitation on Mount Katahdin is described.
14. Tuckerman 1867, p. 527.
15. Susan E. Strickler, *American Paintings*, ed. by William Hutton (Toledo, Ohio: Toledo Museum of Art, 1979), p. 54. After Maynard, the painting belonged first to the Pittman family and then to Mrs. Morton C. Bradley, both of Boston. In 1951, it was purchased by Vose Galleries of Boston and sold to Toledo Museum donor Florence Scott Libbey.
16. Margaret C. Whitaker, "The Artist Looks at Nature," *Toledo Museum News* n.s. 2 (Autumn 1959), p. 21.
17. Patricia Hills, *The American Frontier; Images and Myths*, exh. cat. (New York: The Whitney Museum of American Art, 1973), no. 30.

A Lake Twilight, 1861

Oil on canvas, 15½ × 27½ in. (39.4 × 69.9 cm.)
Signed and dated at lower right: S. R. Gifford 1861
Private collection

On Gifford's death, in 1880, his friend the artist John Ferguson Weir remembered him for the combination of boldness and restraint he had shown in the rendition of nature's most resplendent yet aesthetically risky effects:

> Gifford loved the light. His finest impressions were those derived from the landscape when the air is charged with an effulgence of irruptive and glowing light. He has been criticised for painting the sun; for dazzling the eye with the splendors of sunlight verging on extravagance. But is it not a quality of genius, in all arts, to *verge* on extravagance, and yet remain calm: to pause within the bounds of reason and good taste?[1]

Though Weir undoubtedly had such major works of Gifford's as *Kauterskill Clove* (see p. 222) in mind when composing these words, the sentiments he expressed could apply just as well to *A Lake Twilight*. Gifford painted several small oil sketches of sunset or twilight effects as early as the mid-1850s, but this is among his earliest known exhibition-size pictures of such subject matter.[2] While its theme and the manner of its execution may have been inspired by the popular sensation made in the previous year[3] by the exhibition of Frederic Church's *Twilight in the Wilderness* (see p. 251), the painting in itself is a forecast of the major statements of twilight iconography Gifford made during the decade. They include *Twilight in the Adirondacks* (1864; Adirondack Museum) and *Hunter Mountain, Twilight* (see p. 229), and they have been admired at least as much as Church's interpretations of the same phenomenon.

If Church's influence is revealed in *A Lake Twilight*, it is that of his modest scenes, produced in the early and mid-1850s, in which the sun has just deserted a hill-enclosed valley, its expiring heat still glowing in the notch formed by overlapping slopes at the right of the picture.[4] Gifford distinguishes himself from Church here and elsewhere, however, by refraining from elaborating the clouds for dramatic effect. Typically, he prefers to study the subtle tonal modulation of the sky, in this picture going from almost white where the sun has just set to deep azure at the upper left corner of the canvas. To be sure, Gifford uses clouds to display the color range of twilight, but, because they are reduced in quantity and simplified in outline, their formal purpose is clearer than that in Church's twilights. Here, one band of clouds reinforces the horizontal emphasis of the picture, which is repeated by the reflection of the hills in the water. The curve of clouds at the upper right, roughly paralleling the slope of the mountain toward the source of the light, diminishes into flecks whose tapering trail mirrors the contour of the summit.

A Lake Twilight is an ideal example of what Weir perceived

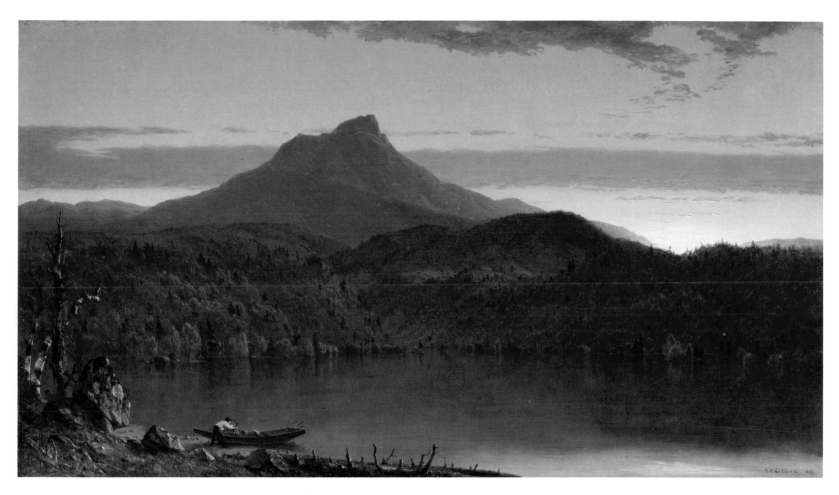

as "not merely the literal rendering of the facts of nature with pedantic precision [but a] lucid reminiscence."[5] The title itself suggests the accuracy of Weir's observation. The mountain in the picture, probably identifiable as Camel's Hump in Vermont,[6] is used for purely expressive purposes. The composition varies the kind of picturesque formula of lake and mountain that serves as a medium for the study of different effects of light.[7] The essentially synthetic nature of Gifford's arrangement betrays itself in that the western point of view from which he observes the mountain is inconsistent with the time of day he is presumably depicting. The combination of a particular topography and specific light effects, apparently observed in separate instances, together with the clarity of the atmosphere, creates a mood of latent brutality. The antlers of the slain buck grasped by the hunter in the foreground find analogues in the stiffened limbs of the tree trunk lying at the base of the picture, the broken trees at the left, the conifers bristling in the light across the lake, the brittle flakes of cloud at the upper right, and the toothlike profile of the mountain. To what degree the menacing quietude of *A Lake Twilight* may be linked to events in Gifford's own life can only be surmised. The year 1861 witnessed not only the outbreak of the Civil War, in which Gifford served, but also the loss of Charles, his beloved elder brother, who apparently took his own life.

A Lake Twilight was sold in 1861 to the Young Men's Association of Troy, New York, but had disappeared by the time of Gifford's death. It came to light in the 1960s and has since been frequently exhibited.[8]

K.J.A.

Notes

1. Address given by John F. Weir. See Century 1880, p. 23.
2. *A Lake Twilight*, no. 233 in Gifford Memorial Catalogue, was painted in the same year as *Twilight in the Catskills—Kauterskill Clove*, no. 235, a major unlocated picture also exhibited by Gifford at the National Academy of Design, there as no. 255. Earlier, he had painted at least one such exhibition-size subject, *Sunset in the Wilderness* (location unknown), no. 153 in the memorial catalogue; other small twilight or sunset pictures painted around that time are nos. 155, 228, 232, 234.
3. Church's picture was exhibited independently at Goupil's in New York in the spring of 1860. For critical and popular response to it, see p. 249.
4. See *Twilight, Short Arbiter Twixt Day and Night* (Fig. 2.19, p. 38); *Twilight* (ca. 1856; reproduced in Wilmerding 1980, p. 16, fig. 5); *Sunset* (1856; Munson-Williams-Proctor Institute).
5. Century 1880, p. 26.
6. The profile agrees with that in photographs of the mountain and in two paintings by John F. Kensett, *Sunset, Camel's Hump, Vermont* (ca. 1851; Princeton University Art Museum), and *Camel's Hump from the Western Shore of Lake Champlain* (1852; High Museum). A Vermont trip by Gifford to the vicinity of Camel's Hump

is suggested by the title of a painting, *The Winooski Valley, Vermont* (1861; location unknown), no. 238 in Gifford Memorial Catalogue. When *A Lake Twilight* was discovered in the early 1960s, it was identified by the inscription on an old label on the back of the canvas: "In the Green Mountains, Vt." (information from Vose Galleries, Boston, 18 March 1986).

7. In several instances, Gifford painted virtually the same scenery and composition to explore completely different light effects or variations on a single light phenomenon. *Landscape and Cows* (1859; Austin Arts Center) and *Sunset* (1863; private collection) are nearly identical except that the bright daylight in the first becomes a lurid red glow in the second. Two oil studies (Weiss 1986, nos. 22, 23) for *Twilight in the Adirondacks* (1863; Adirondack Museum) record varying twilight effects.

8. The picture was sold in 1964 by Robert Sloan Galleries to Vose Galleries, which then sold it to a private collector (information from Vose Galleries, Boston, 18 March 1986). For its subsequent exhibition, see Cikovsky 1970, no. 19; John Paul Driscoll, *All That Is Glorious Around Us; Paintings from the Hudson River School*, exh. cat. (University Park: Pennsylvania State University Museum of Art, 1981), pp. 29, 74–75; Weiss 1986, no. 20.

Kauterskill Clove, 1862

Oil on canvas, 48 × 39⅞ in. (121.9 × 101.3 cm.)
Signed and dated at lower left: S R Gifford/1862
*The Metropolitan Museum of Art, New York City. Bequest of
 Maria DeWitt Jesup, from the collection of her husband,
 Morris K. Jesup, 1914 (15.30.62)*

Kauterskill Clove is one of at least five major paintings[1] Gifford did of the subject between 1850 and 1880, a period nearly covering his career. The Gifford Memorial Catalogue lists at least twenty-four smaller oil studies and sketches[2] of the Clove, augmented by numerous pencil drawings, making the site the most often represented of all his subjects. Asher B. Durand and Thomas Cole also painted the Clove (see pp. 117; 123), but their views show the eastern prospect, toward the Hudson River valley, whereas Gifford chose the western prospect, toward Haines Falls.

Gifford's friend Worthington Whittredge characterized Gifford's feeling for the Catskill Mountains as a filial devotion to the locale on whose borders he was born and reared and where he spent part of almost every summer.[3] Ample record exists of his hikes in the Catskills, and specifically in the Clove, in the company of members of his family or of friends, including fellow landscape painters. As Whittredge wrote: "Many years ago [Gifford] hunted up a little house in Kauterskill Clove in which lived a family of plain country folk, and as the place was secluded and there were no boarders, he liked it, and managed to obtain quarters there. This house, scarcely large enough to hold the family, was nevertheless for many summers the abiding place of a congregation of artists."[4]

Gifford's datable paintings and drawings give evidence that his interest in the Clove intensified in the years 1860 through 1863. At least six pencil drawings[5] and three oil sketches[6] of views of the Clove survive, as does an oil study (private collection)[7] that clearly establishes the composition of the present painting. This succession of images reveals a fascinating transition that begins as essentially topographical transcriptions and culminates in a visionary homage to sunlight transfigured by atmosphere, recalling the radiant landscapes of J. M. W. Turner and of Gifford's colleague Frederic E. Church, especially his *Andes of Ecuador* (1855; Reynolda House).

One of the first two pencil sketches Gifford made in July and August 1860—a horizontal view taken from the south wall of the Clove—emphasizes its breadth; the drawings done a year later, taken from the opposite wall, assume a vertical format. The oil sketches are also vertical: in one of them (ill.), for the first time, Gifford explored the effects of atmosphere and contre-jour sunlight seen in the finished painting. In the small oil study, the painter addressed the problem of idealizing a direct observation. He contrived a central vantage point looking down into the Clove that permits the sides of the surrounding mountains to cascade into the middle of the picture space, thus aligning the barely visible after-

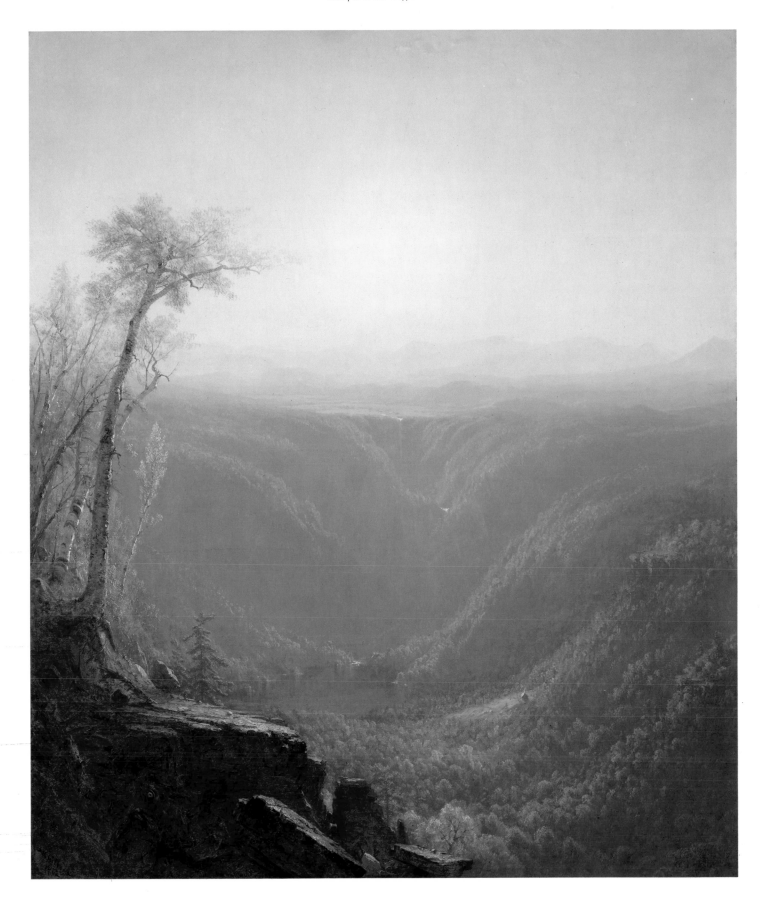

noon sun and the distant waterfall along a central axis that descends into the Clove's base. He imposed a rocky ledge in the foreground that answers the curve of the remote hillsides and, by means of a birch tree on the ledge and the gentle outward swing of one of its upper limbs, directs the viewer's eye up toward the sun. Unlike the seasonless evergreens recorded in the foreground of his preliminary sketches, the orange-yellow birch tree reflects the conversion throughout the picture from the late summer foliage the artist originally observed to the Indian-summer mantle he typically preferred.

It is that autumnal impression that Gifford has transferred almost directly to the final painting, with the addition of a lake and a cabin at the base of the Clove. He has created a symmetrical bowl of space that expands toward the viewer and is rendered palpable by layers of violet glazing that augment the illusion of deep recession. The scheme serves also to evoke earthly symbols of the sun's primal influence: the concentric semicircles formed by the perspective of hillsides articulating the sun's expanding radiation; the waterfall that doubles as the brightest of several sunbeams piercing the distant forests; and the birch tree's brilliant plumes, which appear to be attracted by the sun's warmth and kindled by its fire. The effect the painting conveys is that of a dream or reminiscence, a spirit in Gifford's landscapes aptly described by a critic as "American in character; Oriental in feeling."[8]

That the misty, elegiac character of *Kauterskill Clove* seems further informed by its immediate autobiographical context has been suggested.[9] Soon after the outbreak of the Civil War, Gifford enlisted in the Seventh Regiment of the National Guard and was stationed in summer 1862 at Fort Federal Hill, in Baltimore. He saw little action and found himself largely bored with military life. In a letter written in July of that summer to his friends the Wheelers in Nestledown, New York, he said, "[I] think often of my . . . studio—of the green fields, and the grand mountains, where, but for these unhappy times, I would now be sitting on a camp stool under a peaceful umbrella."[10] As he explained in a subsequent letter, he was therefore all the more grateful for news from upstate:

> Your most welcome letters came to me last week and made my heart to be glad. Their lively descriptions of the goings-on at Nestledown and in the Catskills was almost like being there myself—they somehow make me think I have a right to be there . . . climbing with you . . . among the cloves of the Catskills, but when under the hallucination I go to the gate of the Fort and am rudely roused from my dreams by the sentry sharply bringing his musket to "arms port"! and an abrupt "Halt"! . . . I find myself obliged to right-about, and limit my walk to the round of the parapet, or mingle again with the busy-idle crowd in the quarters.[11]

In Gifford's pencil drawings and oil sketches of the Clove done in the previous year and later that summer, small figures on foreground ledges—hikers waving or merely sitting and looking into the valley—testify to the artist's periodic gratification of his "right" and to the fulfillment of his "dreams." The finished painting, however, includes a variation on the staffage motif: the rocky foreground platform is empty; scrabbling to reach it is the figure

of a hunter accompanied by his dog. The hunter creates an air of expectancy: he is still struggling to attain a vantage—one he can now only imagine—that the viewer already enjoys.

Kauterskill Clove was not exhibited upon its completion but was sold directly to Morris K. Jesup.[12] In 1863, Gifford showed at the Academy a *Kauterskill Clove, in the Catskills* (location unknown) apparently almost identical to this one in size and treatment. A critic for the *New York Times*, while admitting that the visual impression was "marvelously effective," declared Gifford "a perfect master of the art of 'how not to do it.'" He added, "A little more botany and geology in the foreground is due to its otherwise transcendent merits."[13] The *New York Post* critic, however, harbored no reservations about the audacity of Gifford's concept:

> The precipitation of one's whole artistic ability and reputation into a chasm several hundred times larger than that which Quintus Curtius stopped for the good of Rome, is a piece of boldness only justified by its success. Gifford has so bathed this vast unrelieved depression in the face of nature with broad yellow sunshine, and interpreted its giant distances by such curiously skilful gradations of distinctness in its forest lining from ridge to base, that one begins to admire a gorge as he does a mountain—in fact, as the largest kind of mountain turned inside out.[14]

A visual paradox of immaterial form, *Kauterskill Clove* has remained, as Gifford scholar Ila Weiss put it, "Gifford's masterpiece of marginal-visibility."[15]

K.J.A.

Notes

1. The paintings, as listed in Gifford Memorial Catalogue, are: no. 28, *Kauterskill Clove* (1850); no. 235, *Twilight in the Catskills, Kauterskill Clove* (1861); no. 276, *Kauterskill Falls* (1862; now called *Kauterskill Clove*); no. 282, *Kauterskill Clove, in the Catskills* (1863); no. 719, *October in the Catskills* (1880). Only no. 276, the Metropolitan's painting, and no. 719, in the Los Angeles County Museum, are known today.

2. Gifford Memorial Catalogue, nos. 4, 213, 214, 264, 265, 270, 295, 296, 300, 306, 307, 308, 309, 311, 313, 314, 318, 384, 407, 465, 575, 577, 717, 719. Some of his many paintings, now lost, of Catskill subjects may also have shown views of the Clove.

3. "We are told that [Gifford] was born in Saratoga County. As an artist he was born in the Catskill Mountains. He loved them as he loved his mother, and he could not long stay away from either." Quoted in Century 1880, p. 43.

4. Ibid.

5. Two related drawings are in the Albany Institute and are reproduced in Weiss 1977, pls. VII C 6, VII C 7; four others, dating to July–August 1860 and July–September 1861 and in two Gifford sketchbooks (private collection), are reproduced on microfilm, Archives of American Art, roll no. 688.

6. In addition to the sketch illustrated, there are two other oil sketches or studies of the Clove (private collections) nearly identical in imagery. These are reproduced, respectively, in *American 18th Century, 19th Century & Western Paintings, Drawings, Watercolors and Sculpture*, sale cat., Sotheby Parke Bernet, New York, 17 October 1980, no. 122, and Cikovsky 1970, no. 31.

7. Reproduced and discussed in Earl A. Powell, *An American Perspective*, exh. cat. (Los Angeles and Washington, D.C.: Los Angeles County Museum of Art and National Gallery of Art, 1981), pp. 28–29, 131–32.

8. "Our Artists. II. S. R. Gifford," *New York Commercial Advertiser*, 17 October 1861, Archives of American Art, microfilm roll no. D33.

9. Weiss 1977, p. 228.

10. Gifford to "Mrs. Wheeler, Cannie, Tom, Jerome, and Lamb," Fort Federal Hill, Baltimore, Md., 2 July 1862, quoted in Weiss 1977, p. 225.

11. Gifford to "My dear friends at Nestledown," Mount Clare Station, B. & O. R.R., Baltimore, Md., 27 July 1862 (transcript in private collection).

12. In 1876, Jesup lent the painting to the *Centennial Loan Exhibition of Paintings* mounted jointly by the Metropolitan Museum and the National Academy of Design (no. 188); it was probably the picture titled *Waterloo Falls*, dated 1862 and owned by Jesup, shown in the exhibition at Gifford's Century Association memorial service (see Century 1880, no. 29). In 1892, again as no. 188, it was in an Academy loan exhibition celebrating the quadricentennial anniversary of Columbus's discovery of America.

13. "National Academy of Design," *New York Times*, 24 June 1863, p. 2.

14. "The National Academy of Design. Its Thirty-Eighth Annual Exhibition. Second Article," *New York Evening Post*, 16 May 1863, p. 1.

15. Weiss 1977, p. 227.

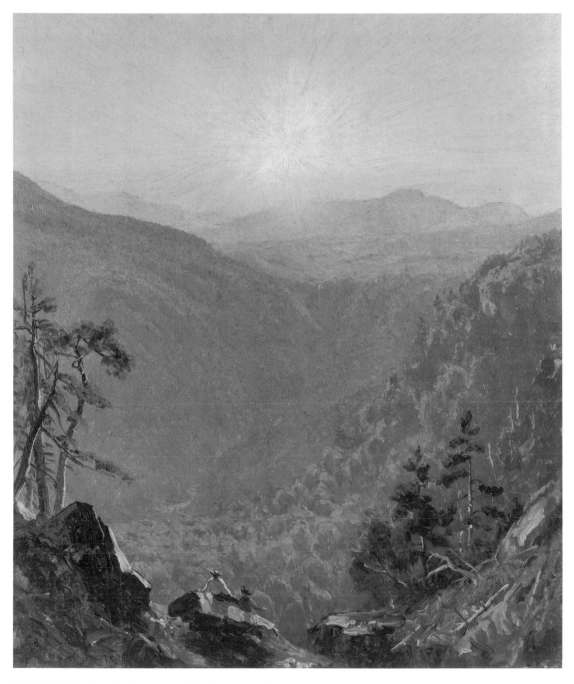

Sanford R. Gifford, *A Sketch in Kaaterskill Clove*, 1861, oil on canvas, 12⅞ x 10¾ in. (32.7 x 27.3 cm.). Family of the Artist

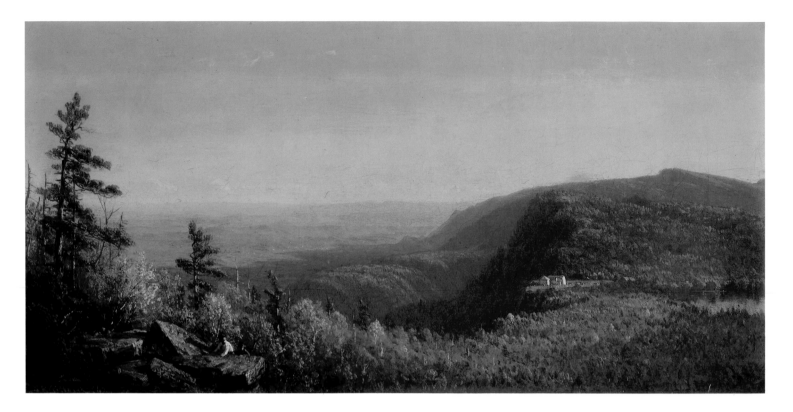

Catskill Mountain House, 1862

Oil on canvas, 9⁵⁄₁₆ × 18½ in. (23.7 × 47 cm.)
Signed and dated at lower left: S. R. Gifford '62
Austin Arts Center, Trinity College, Hartford, Connecticut.
 The George F. McMurray Collection

Gifford's *Catskill Mountain House* is one in a long succession of images of the famed resort by various artists. In the nineteenth century, the hotel was frequently illustrated in engraved travel books and was painted several times by artists of the Hudson River School. Thomas Cole depicted it at least four times;[1] almost identical to one of his views is a version by Jasper Cropsey (see p. 203).

The painters' interest in the subject was understandable.[2] Opened in 1824, the hotel was host to many wealthy New Yorkers who were attracted by its combination of picturesque environment, creature comfort, and proximity to the city. It was the headquarters for convenient access to natural wonders such as Kaaterskill Clove and Falls; its front porch, perched on an escarpment more than twenty-two hundred feet above the Hudson River valley, offered a vista all but unrivaled in the eastern United States. It was itself not the least of the scenic attractions of the area. Its simple whitewashed form was visible for miles against a foil of mountain ridges, evoking in its beholders images of "an illumined fairy palace," a "white dove cot," "the eagle's or lammergeyer's nest, or some feudal for-

tress on its foe-defying height."[3] The painter Worthington Whittredge, a friend of Gifford's, recalled after Gifford's death: "The particular part of the Catskills which . . . pleased Gifford best was the summit, or the region round about the Mountain House. Upon the edges of the cliffs of North and South Mountains, overlooking the great plain of the Hudson River, how often his feet have stood! The very lichens there remember him."[4]

Despite Whittredge's remark, the Mountain House was no haven for artists. Most of them could not afford its high rates and sought cheaper and more secluded accommodations in the area,[5] considerations that led Asher B. Durand in 1847 to buy a house in Newburgh, to the south, only to sell it a few years later when the railroad built a line near his property.[6] And as Whittredge reported, Gifford himself "hunted up a little house in Kaaterskill Clove . . . of plain country folk," which became "the abiding place of a congregation of artists."[7] That site too had to be abandoned when it was discovered by travelers from the city.

While Gifford painted as many as three small pictures of the Mountain House, this is the only one that is known today.[8] The autumn view is essentially the same as those in the better-known pictures by Cole and Cropsey: looking from one of the ledges on North Mountain toward the hotel on South Mountain, with North Lake visible to the right. Gifford's view is distinctive in that he has chosen a higher and more western vantage, thus producing several unique effects. In Cole's and Cropsey's pictures, South Mountain and the hotel are directly in front of and above the spectator, but in Gifford's they are lower and to the right, where, along with the slope of North Mountain, they become parenthetical elements

framing the Hudson River valley beyond. The hotel remains the focal point of the picture, its white profile attracting the eye along the lyric curve formed by the ridge linking North and South Mountains. Again unlike Cole and Cropsey, Gifford acknowledges the very reason for the hotel's existence: the broad prospect from its lofty site. It is no accident that pronounced highlights of white single out and unite conceptually the hotel, a tiny figure mounting the lookout rock in the foreground, and several dwellings glinting in the distant valley.

Gifford's version of the subject is unusual too for being illuminated from the west, exposing the less picturesque rear aspect of the Mountain House and ignoring the spectacle of sunrise seen from the escarpment, which was a feature prized by all who stayed at the hotel.[9] The artist's choice, while reflecting his preference for scenes of late afternoon, sunset, or twilight, also underscores his broader visual scope. The travel writer Bayard Taylor anticipated the motive for this choice of Gifford's when he recalled his first impression of the view from the Mountain House ledge:

> It was a quarter of an hour before sunset—perhaps the best moment of the day for the Catskill panorama. The shadows of the mountain-tops reached nearly to the Hudson, while the sun, shining directly down the [Kaaterskill] Clove, interposed a thin wedge of golden luster between. The farm-houses on a thousand hills beyond the river sparkled in the glow, and the Berkshire Mountains swam in a luminous, rosy mist. The shadows strode eastward at the rate of a league a minute as we gazed.[10]

Catskill Mountain House is probably the picture listed in the Gifford Memorial Catalogue as number 278, dated 1862, and sold to a William Allen. Three small pencil sketches of the subject, dating to about 1861 and contained in a Gifford sketchbook at the Albany Institute, appear to be studies for the painting.[11]

<div align="right">K.J.A.</div>

Notes

1. Cole's paintings of the Catskill Mountain House include *Beach Mountain House* (private collection), *Catskill Mountain House* (1843–44; Alexander Gallery), and *View of Two Lakes and Mountain House, Catskill Mountains, Morning* (Fig. 1, p. 205). In addition, an engraving by Fenner Sears & Company, titled *View of the Catskill Mountain House, New York* and based on an unlocated painting by Cole, was published in J. H. Hinton, ed., *History and Topography of the United States* (London, 1830), no. 59.
2. See Van Zandt 1966 for a history of the Mountain House and its environs.
3. Murdoch 1846, pp. 16, 20, 24.
4. Century 1880, p. 44.
5. Van Zandt 1966, pp. 176–78.
6. Durand 1894, pp. 184–85.
7. Century 1880, p. 44.
8. This picture, no. 278, is the only one in the memorial catalogue that cites the Catskill Mountain House as its subject. The other two were exhibited at the Century memorial meeting as belonging to Gifford's estate: *Mountain House, Catskills—Autumn*, and *Catskill Mountain House*. See Century 1880, nos. 43, 49. Other paintings (locations unknown) whose titles include the name of the Mountain House, though not as the subject, are nos. 479, 481, and 618 in Gifford Memorial Catalogue.

9. The site is thought to be that from which Frederic E. Church painted *Above the Clouds at Sunrise* (see p. 239).
10. Bayard Taylor, "Travels at Home," *New York Tribune*, 12 July 1860, quoted in Murdoch 1846, p. 42.
11. The drawings are reproduced in Cikovsky 1970, nos. 22a, 22b. A pencil sketch of the Mountain House and its environs, dated August 1861 and closely resembling the composition both of Cole's *View of Two Lakes and Mountain House . . .* and Cropsey's *Catskill Mountain House* (see p. 203), is in a Gifford sketchbook (private collection).

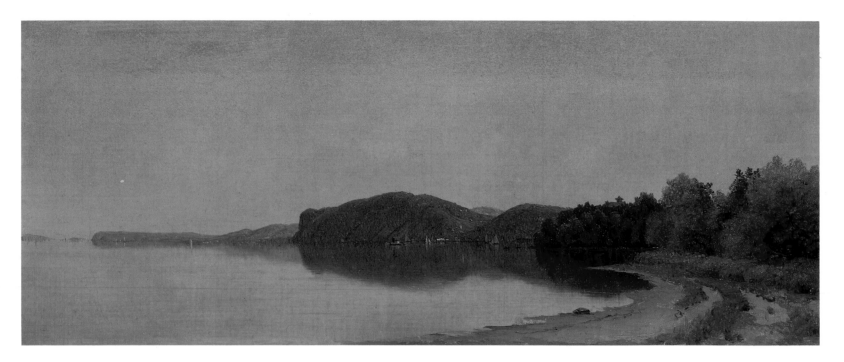

Hook Mountain, Near Nyack, on the Hudson, 1866

Oil on canvas, 8⅛ × 19 in. (20.6 × 48.3 cm.)
Dated in pencil at lower right (under frame): 1866
Yale University Art Gallery, New Haven, Connecticut. Given by
 Miss Annette I. Young, in memory of Professor D. Cady Eaton and
 Mr. Innis Young (1969.113.3)

Hook Mountain, Near Nyack, on the Hudson is the first of four depictions of the site based on drawings Gifford made following a camping and sketching trip to the Adirondacks in August and September 1866.[1] The mountain, rising 730 feet at its summit and still a prominent landmark on the river, occupies the center of the composition. Though the view appears to have been taken from the west shore of the Hudson, a few miles to the north, it is more consistent with the perspective from the east shore, at Croton-on-Hudson, near the present site of the Amtrak Croton–Harmon station. The woods and the beach in the foreground are part of the southern shore of Croton Point, with the Hudson continuing between the clump of trees at the right and the mountains in the background. Sailboats and a single steamer are suspended in the mountain's reflection in Haverstraw Bay. Visible beyond are the town of Piermont (with Nyack concealed by Hook Mountain) and the headland of Sparkill, New York. Dropping down to the river in the distance are the Palisades, crowned at the north by the mountain; beyond, partly visible, is the Tappan Zee, today spanned by a bridge bearing its name. Hook Mountain derives its name from the Dutch *Verdrietige Hoek*, which can be translated as "troublesome point," because there sailing vessels often encoun-

tered contrary winds that made navigation difficult or impossible. (The harbor of Nyack came to be known as "Sleeper's Haven," for there becalmed boats awaited favorable winds and tides.)[2]

Gifford transformed two later versions of the same scene into more picturesque, closed, vertical compositions, but in this earlier painting he remained faithful to the wide format of three of the four original pencil sketches (one of which extends over a page and a half of his sketchbook)[3] as well as to the elongated character of the shoreline topography. Yet even here, Gifford's approach to the scene was not purely perceptual. A series of rule-drawn parallel lines in one of the drawings strictly defines the water plane on which each sequential landform rests. In the painting, the landforms are described in successively weaker colors, from the beach at the right to the distant Palisades at the left. The rigorous, original concept produces a series of telescoping elements that are spatially believable as well as laterally compelling—the trees, the mountain, the Palisades. The tautness of the horizontal impression is reinforced by the clarity of Gifford's vision, a quality uncommon in his work of the 1860s. Distant forms, while lighter, are not dissolved by atmosphere; contours remain distinct. The spare effect is softened only by the curving line of beach in the foreground.

Gifford's Hook Mountain pictures probably belong in the larger context of the views of Haverstraw Bay and Tappan Zee he painted right up to 1880, the year of his death. Most of the paintings in the group were of the same proportions—the length twice the width—as *Hook Mountain*.[4] It has been suggested[5] that this work may be considered in the still wider company of seashore views Gifford began in the mid-1860s, following a trend in subject matter started a little earlier by Martin Johnson Heade and John F. Kensett. In *Hook Mountain*, the still, velvety surface of the river, the distinctive but undramatized topography, and the visual clarity

are particularly reminiscent of Kensett's scenes of the Shrewsbury River.[6] Other artists shared Gifford's interest in the lower Hudson River region. Albert Bierstadt, who in 1866 was building a villa at Irvington-on-Hudson, painted a large horizontal *View on the Hudson Looking across the Tappan Zee towards Hook Mountain* the same year (Fig. 1.11, p. 17); Samuel Colman painted a view upriver from Ossining the following year.[7] To Bierstadt, Colman, and Gifford, the broad reaches of the Hudson at Tappan Zee and at Haverstraw Bay supplied the kind of expansive vista akin to that of the sea, making those sites especially suitable for panoramic treatment. Features of *Hook Mountain*, such as the wide format, pellucid light, planar spatial development, and quiet mood, have caused it in recent years to be considered a prime example of the mode of representation termed Luminism by historians of American art.[8]

 Hook Mountain, dated September 1866, is listed as number 420 in the Gifford Memorial Catalogue. At the April 1881 auction of Gifford's work, the painting was sold to Henry L. Young, a prominent Poughkeepsie banker.[9] It remained in the Young family until it was given to Yale University in 1969.

<div align="right">K.J.A.</div>

Notes

1. The two other Hook Mountain views are listed in Gifford Memorial Catalogue: no. 439, *Hook Mountain, Near Nyack, N.Y.* (1867; private collection), and no. 440, *Hook Mountain on the Hudson River* (1867; location unknown). A fourth version, dated 1867 and apparently not catalogued, is in a private collection. See Weiss 1977, pp. 264–65; 442, nn. 7–10; pls. VII J 4, VII J 5.

2. For Hook Mountain, see Wilfred B. Talman, *How Things Began in Rockland County and Places Nearby* (New City, N. Y.: Historical Society of Rockland County, 1977), p. 55; Paul Wilstach, *Hudson River Landings* (Indianapolis, Ind.: Bobbs-Merrill Co., 1933), p. 215.

3. Reproduced in Cikovsky 1970, nos. 36a, 36b, 36c.

4. See Gifford Memorial Catalogue, nos. 421, 422, 426, 457, 458, 470, 713, 715. A *Haverstraw Bay* possibly identifiable with no. 458 is reproduced and discussed in Weiss 1977, p. 272; pl. VII K 6.

5. Weiss 1977, p. xvii.

6. For an example, see Fig. 2.28, p. 46.

7. Bierstadt's picture is reproduced in *Important American Paintings, Drawings and Sculpture*, sale cat., Sotheby Parke Bernet (New York, 5 December 1985), no. 61. Samuel Colman's *Looking North from Ossining, New York* (1867; Hudson River Museum) is reproduced in Howat 1972, pl. 23.

8. Theodore E. Stebbins, Jr., "American Landscape: Some New Acquisitions at Yale," Yale University Art Gallery *Bulletin* 33 (Autumn 1971), p. 25; Barbara Novak, "On Defining Luminism," Earl A. Powell, "Luminism and the American Sublime," and Linda S. Ferber, "Luminist Drawings," in Wilmerding 1980, pp. 28, 86, 256.

9. *Catalogue of Valuable Oil Paintings [by] Sanford R. Gifford, N. A., Deceased . . .* (New York: Thos. E. Kirby & Co., 1881), no. 30.

Hunter Mountain, Twilight, 1866

Oil on canvas, 30½ × 54 in. (77.5 × 137.2 cm.)
Signed and dated at lower right: S. R. Gifford 1866
Inscribed on back: Hunter Mountain/S.R. Gifford pinxit
Daniel J. Terra Collection, Terra Museum of American Art, Chicago, Illinois

Hunter Mountain, Twilight fits into two categories of subject matter treated by Gifford: the "home in the woods" theme, in which he was undoubtedly influenced by the paintings of Thomas Cole, and scenes of twilight, which enjoyed a particular vogue following the appearance of Frederic Church's *Twilight in the Wilderness* (see p. 251) in 1860. *Hunter Mountain, Twilight*, representing a locale in the Catskills not far from the Gifford family home in Hudson, New York, and another painting of virtually identical size titled *A Home in the Wilderness* (1866; Cleveland Museum), based on a scene in New Hampshire,[1] were both completed in the same year and were both exhibited at the Paris Exposition Universelle of 1867.[2]

 Preliminary studies—one a drawing dating to about September 1865 (ill.)[3] and two oils—for *Hunter Mountain* suggest a fairly rapid and direct formulation of the finished painting. In the drawing, a mere outline sketch of the stump-littered clearing that slopes downward from left to right, the recumbent ridge of Hunter Mountain in the background is proportionally smaller than that in the finished painting. In the small oils, one dated 9 October 1865,[4] the artist added the twilight effect but altered few of the features he had observed firsthand, only magnifying or lessening their prominence: he extended the mountain and the range of hills at the right closer to both sides of the picture; he reduced the number of tree stumps and rocks; and he diminished their size (as he did with the house and shed in the middle ground), thus making them appear farther removed. In the finished painting, he straightened the sloping topography of the drawing and clarified a natural depression previously only suggested into a shallow bowl reflecting the contour of the mountain looming above it. Though the final composition is virtually symmetrical, a subtle diagonal axis that begins at the boulder at the left and follows a broken line through the reflecting rivulet, the house, and upward into the mountain cleft at the extreme right has been maintained. The picture's mellow, almost melancholy tenor is accented by a sickle moon and an evening star.

 Hunter Mountain was exhibited to high acclaim at the annual exhibition of the National Academy of Design in 1866. The sight of it stirred the critic of the *New York Post* to declare:

> Year after year we are indebted to Mr. Gifford for the most powerful and perfect examples of landscape art that the galleries of the Academy of Design contain. And again we have to go to his pictures as illustrating the highest that has yet been attained by American landscape painters. . . . [*Hunter Mountain*] best expresses the inten-

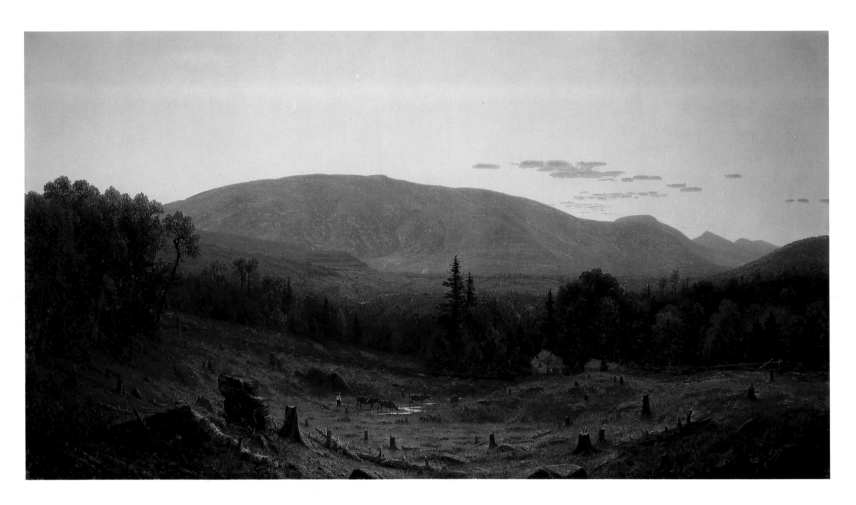

sity and disciplined strength of Mr. Gifford's genius. A more perfect piece of mountain drawing, or a more wonderful rendering of the lovely and intense color of a mountain form at twilight, we have never seen. . . . What an idea of silence and endurance is expressed by that mountain! its large flowing outlines smiting abruptly against the fading light, resting there sentinel-like, while night creeps into every cleft of its mighty sides, and the last clouds linger and flush and deepen in tint as the sun goes from the lucid air. What depth and clearness of tone! what largeness and delicacy of form! Certainly Mr. Gifford knows the mountain, and he has expressed with intensity and grace the solemnity of the color and the beauty of his subject.[5]

Despite the enthusiasm of Gifford's American partisans, *Hunter Mountain* and *A Home in the Wilderness* were all but ignored when they were exhibited at the Exposition Universelle in Paris the following year. Possibly because Gifford's work was hung in an inconspicuous place,[6] French critics seem to have passed over him in favor of the more spectacular entries of Church and Albert Bierstadt. The English critics, however, were more attentive. "The landscapes by Mr. Gifford, of New York, are poetic in thought, and warm in tone; lake, mountain, and sunset sky have been thrown together with excellent effect," said one.[7] A colleague, anticipating the post–Civil War shift in American taste, grouped

Gifford's paintings among the "topographical" American productions that included the works of Church, Bierstadt, Jasper Cropsey, and other New York landscape painters, which he disparaged; he praised as "French in origin" the landscapes of an odd company in which he named James McNeill Whistler and Gifford's close friends Jervis McEntee and Worthington Whittredge.[8]

Hunter Mountain was purchased by the wealthy New York dry-goods merchant James W. Pinchot prior to its exhibition at the National Academy, and remained in private collections for over a century. Since its reappearance, in the 1970s, the painting has been interpreted by a number of art historians as a sober assessment, a possible rejection, of the effects of human settlement in the wilderness.[9] Even in its own day, *Hunter Mountain* was cited by one critic as possessing "a more sombre character than the majority of Mr. Gifford's pictures,"[10] though the writer did not appear to associate that quality with the desolation of scattered stumps and fallen trees by which the viewer is introduced to the scene. That the stump iconography, along with the sagging foreground, the impoverished streamlet within it, the scarred hillsides beyond, and the flayed appearance of the mountain itself, is scarcely picturesque is undeniable. At the same time, the fluidity of the composition and the roseate light in which Gifford has bathed these features mitigate their starkness and charge them with a strange poignancy.

Yet no comment by Gifford or by any of his contemporary critics has shed light on the artist's attitude toward the subject.

Circumstances surrounding the region depicted, however, may have a bearing on its imagery. Gifford, the grandson of a tanner, must have known of the depredations wrought by the region's once thriving leather-tanning industry, whose wholesale harvesting of the hemlock for the tannin in its bark had converted the forest of the area from mostly coniferous trees to deciduous in little more than half a century.[11] One of the largest and most prominent of the tanneries[12] operated near Hunter Mountain throughout the Civil War, when the industry reached its peak. A shrinking market in the postwar era, along with the depletion of the hemlock stands, forced most Catskill plants to close by 1870, with some of the former laborers staying on to farm the land left by the cutting. Whether meant as a symbol or merely as a compositional device, the tall conifer silhouetted against Hunter Mountain in the center of the composition is a conspicuous feature of Gifford's scene.

Gifford's imagery may have struck a responsive chord in his patron. James Pinchot numbered the artist among his intimate friends, even naming his first son, born in 1865, after him. One of Pinchot's longstanding concerns was forestry: he wrote articles on the subject and eventually served as vice president of the American Forestry Association, founded in 1875. He cultivated in his elder son a similar enthusiasm. Gifford Pinchot, who became the country's first professional forester, a staunch conservationist, and twice governor of Pennsylvania, to the end of his life credited his parent with being "the Father of American Forestry."[13] After his death, in 1946, the painting reentered the art market. Whatever Sanford Gifford meant to express in it, *Hunter Mountain* could hardly have found two owners better attuned to its terrible beauty.

K.J.A.

Sanford R. Gifford, Sketch for *Hunter Mountain, Twilight*, pencil on paper, 6 x 9⅝ in. (15.2 x 24.5 cm.). In Gifford's 1865–66 sketchbook. Vassar College Art Gallery, Gift of Edith Wilkinson

(Grand Rapids, Mich.: Grand Rapids Art Museum, 1977), p. 83. *Hunter Mountain* is among other nineteenth-century American landscapes in which the iconography of the tree stump is considered "emblematic." Cited in Nicolai Cikovsky, Jr., " 'The Ravages of the Axe': The Meaning of the Tree Stump in Nineteenth-Century American Art," *Art Bulletin* 61 (December 1979), p. 622, n. 68.

10. *The Albion* (New York), 12 May 1866, p. 225. The critic attributed the somber quality of the picture to "the nature of the subject," but did not elaborate.

11. A summary of the Catskills tanning industry is given in H. A. Haring, *Our Catskill Mountains* (New York: G. P. Putnam's Sons, 1931), pp. 83–106.

12. This was the New York Tannery, begun by Colonel William Edwards in 1817 and continued by his son after 1849, in Edwardsville, now Hunter, New York, at the foot of the so-called Colonel's Chair, a hill adjacent to Hunter Mountain on the north. See Evers 1972, pp. 332–40; 386–92.

13. M. Nelson McGeary, *Gifford Pinchot, Forester-Politician* (Princeton, N. J.: Princeton University Press, 1960), pp. 3–5.

Notes

1. Weiss 1977, pp. 257–58.

2. *A Home in the Wilderness* was no. 19, "Un Intérieur dans le desert," at the 1867 Exposition Universelle in Paris; *Hunter Mountain, Twilight* was no. 18. See *Exposition Universelle de 1867 à Paris. Catalogue Générale Publié par la Commission Impériale. Prémière Partie* (Paris: E. Dentu, 1867), p. 202.

3. The drawing, reproduced in Cikovsky 1970, no. 35b, is in a Gifford sketchbook (Vassar College Art Gallery) dating from September 1865 to September 1866, thus preceding the 9 October 1865 oil sketch cited in the text.

4. *A Sketch of Hunter Mountain, Catskills* (Terra Museum), no. 405 in Gifford Memorial Catalogue; the other, *A Study of Hunter Mountain at Twilight* (private collection), is no. 406.

5. Sordello [pseud.], "National Academy of Design. Forty-First Annual Exhibition." *New York Evening Post*, 11 May 1866, p. 1.

6. Frank Leslie, "Report on the Fine Arts," in *Reports of the Commissioners to the Paris Universal Exposition, 1867*, ed. by William P. Blake, 6 vols. (Washington, D.C., 1870), 1, p. 9, complained that Gifford's *Hunter Mountain* had been hung "in very bad light" and in a passage "constantly crowded, so that the lower ranges or tiers of pictures could seldom be seen, or if at all, at a great disadvantage."

7. "Pictures from America," *Art-Journal* (London) n.s. 6 (November 1867), p. 248.

8. "The French Exhibition. Paris, June 1867," *Athenaeum* (London), 6 July 1867, p. 24.

9. Barbara Novak, "The Double-Edged Axe," *Art in America* 64 (January–February 1976), p. 48; J. Gray Sweeney, *Themes in American Painting*, exh. cat.

GEORGE INNESS
(1825–1894)

Inness, born near Newburgh, New York, was the fifth of thirteen children. His father, a prosperous grocer, tried to make a grocer out of him, but the youth decided instead to become an artist. Around 1841, he received a month's instruction from John Jesse Barker, a painter living in Newark, New Jersey, where the Inness family had moved in 1829. From the age of sixteen, Inness served a two-year apprenticeship as an engraver with the New York map-making firm of Sherman and Smith. He took some instruction in painting from Régis Gignoux about 1843, around the time he was studying and being influenced by prints of the paintings of Claude Lorrain and the seventeenth-century Dutch landscape masters. He was also seeing the work of the leading Hudson River School painters—particularly that of Thomas Cole and Asher B. Durand—whose style is recalled in some of his early canvases.

Inness exhibited for the first time at the National Academy of Design in 1844 and continued to exhibit there almost every year until the end of his life. Though he was elected an Associate of the Academy in 1853, he was not made an Academician until 1868. He was one of the important early members of the Society of American Artists, an exhibition organization founded in 1877 to challenge the conservative policies of the Academy.

By the late 1840s, Inness was exhibiting regularly in New York and had attracted a patron, Ogden Haggerty. Inness married Elizabeth Hart in 1850, and the following February the couple departed for a fifteen-month stay in Italy made possible by Haggerty's financial support. On their way home, they stopped in Paris, where Inness visited an exhibition that included work by the Barbizon painter Théodore Rousseau; after a second trip abroad, in 1853–54, the work of Rousseau and other Barbizon painters exerted a strong influence on Inness's art.

Inness and his family left New York in 1860, moving first to Medfield, Massachusetts, and later to an estate near Perth Amboy, New Jersey. In the early 1860s, fellow artist William Page introduced Inness to the theories of Emanuel Swedenborg, which made a deep and lasting impression on him; indeed, became a major force in his intellectual life. Throughout that decade, spent in rural surroundings, he sought to make his paintings convey the profound spiritual meaning he felt the landscape around him possessed.

In 1870, the Innesses moved to Italy for four years, during which time the artist sent back paintings to be sold by the Boston dealers Williams and Everett, receiving in exchange regular monthly payments. Stopping again in Paris on the way back to the United States, in 1874, Inness first saw works by the Impressionists in an exhibition he visited, but he thought little of that new style of painting.

In 1878, Inness's fortunes improved when Thomas B. Clarke, a prominent New York art dealer, became his agent. He took a studio in the New York University Building and bought a house and studio in Montclair, New Jersey. His theories on painting were published in *Harper's New Monthly Magazine* in 1878 and 1882; in 1882, Charles De Kay, under the pseudonym Henry Eckford, wrote an important critical article about his work. Two years later, a major exhibition of Inness's work was sponsored by John F. Sutton, proprietor of the American Art Association, from which the artist emerged as the leading light in American landscape painting, an eminent position he enjoyed for the rest of his career. During the last years of his life, he spent summers traveling and painting in Connecticut, New York, Massachusetts, Virginia, California, and Florida. He and his wife returned to Europe in 1894, when Inness once again visited Paris, as well as Baden-Baden and Munich. On his way home, he died of a stroke in the Bridge of Allan, a small Scottish resort village. On 23 August 1894, the National Academy of Design held an impressive funeral service for Inness, who was by then one of its most illustrious members.

Select Bibliography

George Inness, Jr. *Life, Art, and Letters of George Inness*. New York: The Century Co., 1917.

Elizabeth McCausland. *George Inness: An American Landscape Painter, 1825–1894*. Springfield, Mass.: George Walter Vincent Smith Art Museum, 1946.

Leroy Ireland. *The Works of George Inness: An Illustrated Catalogue Raisonné*. Austin: University of Texas Press, 1965.

Nicolai Cikovsky, Jr. *George Inness*. New York: Praeger Publishers, 1971.

Nicolai Cikovsky, Jr., and Michael Quick. *George Inness*. Exhibition catalogue. Los Angeles, Cal.: Los Angeles County Museum of Art, 1985.

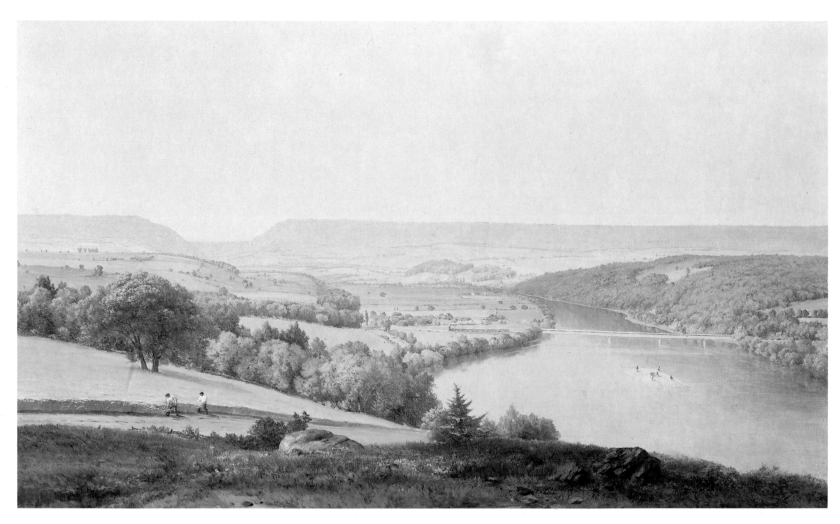

Delaware Water Gap, 1857

Oil on canvas, 32 × 52 in. (81.3 × 132.1 cm.)
Signed and dated at lower right: GI (monogram) 1857
James Maroney, New York City

George Inness is best known today, as he was during his own lifetime, for his evocative, highly individualistic renderings of landscape. These painterly, suggestive images are the result of a long evolution, the culmination of many years of experimentation. Essentially self-taught, Inness learned to paint by emulating the models available to him in the 1840s in the New York area, where the leading artists of the day were the Hudson River School masters Thomas Cole and Asher B. Durand, and he supplemented his art education by studying prints of paintings by European masters, which he found in books and in local print shops. Those prints, which may well have been after paintings by seventeenth-century artists like Meindert Hobbema, Claude Lorrain, and Gaspard Poussin, made a strong impression on the young Inness.[1] In his

own words, "There was a power of motive, a bigness of grasp in them. They were nature, rendered grand instead of being belittled by trifling detail and puny execution." He said that when he compared them "with nature as she really appeared . . . the light began to dawn. . . ."[2] Though he "found some of their qualities in Cole and Durand,"[3] from his own description and from the direction his painting soon took it can be inferred that he was dissatisfied with the goals and achievements of the Hudson River School painters. He studied nature, as Durand (the closest approximation to a theorist among the Hudson River School painters) advised,[4] but his response was totally at variance with the master's. Instead of making a literal transcription of a scene, he exhibited an early preference not for art based on nature but for art based on art.

Inness had the opportunity to observe the world-renowned old-master paintings firsthand on two trips abroad in the 1850s, still very early in his career.[5] Of greater significance for his development, however, was his exposure to paintings by the French Barbizon School artists, whose style had a tremendous effect on him. When he returned to America for the second time, in late 1854, he attempted to assimilate aspects of the Barbizon style into his own work. It was at that point that his art began visibly to depart

from the conventions of the Hudson River School artists. Inness's independence of thought is all the more remarkable when contrasted with the attitudes of his exact contemporaries, such up-and-coming painters as Frederic Church, Sanford Gifford, and Jasper Cropsey. Those men, who represented the second generation of Hudson River painters, were finding rapid success in the established American art world by continuing to practice the dictates of their predecessors. Inness, though he developed along very different lines in terms of style and technique—exchanging the tight brushwork and descriptive nature of the Hudson River tradition for his own loosely painted, subjective vision—would nevertheless continue to share with the School two essential traits: the primacy of landscape as subject and the belief that in landscape one could find higher, moral truth.[6]

Delaware Water Gap, painted in 1857, documents both Inness's knowledge of the Hudson River School style and his movement away from it. The painting's broad, horizontal format, with its panoramic view of a river valley, is closely related to the wide, scenic transcriptions of nature done by Cole and by Cole's pupil, Church. There are certain affinities between this painting and Cole's *Oxbow* (see p. 125), including the point of view and the high-keyed palette.[7] With his precise layout of cultivated fields and sprinkling of homesteads, Inness seems to have made a great effort to portray accurately the topography of the scene; in that, his early apprenticeship to a mapmaking firm undoubtedly served him well. Too, the possibility that the work was commissioned and intended for commercial purposes could account for his unusually painstaking, descriptive representation. That precision of topographical detail, a characteristic very much in keeping with the Hudson River School style, is one that was in time to disappear from Inness's painting. When in later years an observer unadvisedly inquired of him what locale one of his paintings depicted, Inness snapped: "Nowhere in particular; do you think I illustrate guidebooks? That's a picture."[8]

Although *Delaware Water Gap* portrays a detailed view that includes figures, houses, a train, and a barge, Inness did not paint it with the tight, invisible brushwork typical of the Hudson River School. He maintained the use of thin paint he had learned from those models, but many other aspects of the painting demonstrate that he was veering away from the prescribed American technique. For example, his canvas is coarse, his paint is directly applied, and his pigment is neither layered nor scumbled.[9] Perhaps the most arresting quality of the work is Inness's palette, which is composed primarily of pastel blues and greens, touched with yellow and pink. There are no saturated colors in the painting; white is used in nearly every pigment. It has been noted that the lightened color of Inness's paintings of the period is a result of the artist's exposure to Barbizon models.[10] While that may be true, here Inness has gone to an extreme, using colors even lighter than those of Barbizon paintings and almost foreshadowing those of the French Impressionists.[11] The pervading lightness and brightness of *Delaware Water Gap* (though not its diffused treatment) relate it to the Luminist paintings of John Kensett and Martin Johnson Heade. The work comes

in Inness's oeuvre at the time when he was experimenting with various influences, and shows that he has not mastered every problem. That is most evident in his representation of the barge, which seems weightless, actually flying, though it was meant to be seen as floating down the river.

The scene depicted is where the Delaware River cuts through the Kittatinny Mountain ridge of the Appalachians from eastern Pennsylvania to New Jersey. The vantage point is from the Pennsylvania side of the "Gap," with Mount Minsi seen in the distance on the near side of the river and Mount Tammany visible on the New Jersey side. This is the first canvas Inness painted of the fertile valley, though he returned to the subject many times,[12] so often that one early-twentieth-century author remarked: "He brought a large vision and a poetic insight to the interpretation of the casual, familiar scenes, surprising beauty where others had found only suburban triviality. The despised hills of New Jersey and . . . the undiscovered Delaware valley took their place in our art with the Grand Cañon and Yosemite Valley."[13] Why Inness chose to paint the area so many times has been the cause of speculation: was it because of the area's natural beauty or because of its fame as a picturesque subject? Or was it simply because Inness knew it so well from his trips to visit his brother James, who lived in Pottsville, Pennsylvania?

> But perhaps he painted it so often because of what it meant. Its combination of natural beauty and the railroads, rafts, and felled tree that exemplify human enterprise made it a pictorial type of definite meaning. Asher B. Durand painted a similar (but in his case invented) image in 1853. There was no doubt what it meant: the painting was entitled *Progress* and the wood engraving after it, published in 1855, was called *Advance of Civilization*. Inness was candid about his preference for civilized over wild and untamed landscape. . . . [His paintings of the area are of] a pictorial type virtually emblematic of civilization and progress.[14]

Another possibility advanced regarding the *Delaware Water Gap* is that it may have been one of a suite of paintings commissioned by the Delaware, Lackawanna, and Western Railroad around 1855.[15] If so, other paintings that may have been part of the suite are *The Lackawanna Valley* (ca. 1855; National Gallery of Art) and *Delaware Water Gap* (1859; Montclair Art Museum). All three paintings reveal the same golden luminosity, all feature trains, all measure thirty-two by fifty-two inches, and all were done about the same time. Inness later explained the now well-known *Lackawanna Valley*:

> Here . . . is a picture I made of Scranton, Pa., done for the Delaware and Lackawanna Company, when they built the road. They paid me $75 for it. Two years ago, when I was in Mexico City, I picked it up in an old curiosity shop. You see I had to show the double tracks and the round house, whether they were in perspective or not. But there is considerable power of painting in it, and the distance is excellent.[16]

When in 1911 Elliott Daingerfield published his remem-

brance of Inness and his art, he commented on the paintings:

> Wide reaches of field and meadow, the business of the harvest, grazing cattle—the rush of trains, flowing streams under broadly-lit skies—all typical American scenes. Such pictures brought him many commissions. . . .
>
> He told me of doing a set of these pictures for the Erie Railroad people about the time that road was finished, which were reproduced and used in advertising. Many years later he found one of these huge canvases in a dim little shop in Mexico City, which he gleefully bought for a few Mexican dollars.[17]

At least one of the three paintings—the 1859 *Delaware Water Gap*—was reproduced both as an etching and, in 1860, as a color lithograph.[18] It appears likely that the Delaware, Lackawanna, and Western Railroad did give the commission to Inness, for burgeoning railroad companies were eager to advertise their trains by making known the scenic beauty they made accessible. The Baltimore and Ohio Railroad, for example, invited artists on an excursion that was later reported on in *The Crayon* of July 1858. The article noted that the artists had been invited along "for the purpose of making the beautiful scenery of the road known to the public through this observant class."[19] The Baltimore and Ohio had commissioned William L. Sonntag (see p. 197) to paint scenes along its route in 1852, and thirty years later it was still promoting its trains by the same means. In 1881, it commissioned Thomas Moran to depict scenes of the line that were published the following year in *Picturesque B & O, Historical and Descriptive*.[20]

Whereas this *Delaware Water Gap* of 1857 depicts the view from the Pennsylvania side of the Delaware River, the 1859 version portrays the view from the New Jersey side; each painting shows a different part of the railroad line. When these views are combined with *Lackawanna Valley*, featuring the roundhouse in Scranton, Pennsylvania, of which the company was so proud,[21] it seems plausible that the three paintings were a suite or part of a suite intended as advertisements for the line.

L.D.

Notes

1. Nicolai Cikovsky, Jr., who has made an exhaustive study of Inness's paintings, has concluded that Inness derived less inspiration from the Hudson River School and more from the prints of old-master paintings than has been previously assumed. See Cikovsky 1970a, pp. 36–57. See also Cikovsky 1971, pp. 25–27; Cikovsky 1977, pp. 167–68, 285–86; and Cikovsky and Quick 1985, pp. 11–15, 46.

2. Quoted in Inness 1917, p. 14. See also "Art Gossip. Departure of George Inness for Europe," *New York Evening Mail* 31 (March 1870), quoted in Cikovsky and Quick 1985, p. 13.

3. Inness 1917, p. 14.

4. Durand 1855, I, p. 2.

5. On Inness's early trips abroad, see Cikovsky and Quick 1985, pp. 14–19.

6. See Charles De Kay [Henry Eckford], "Inness," *Century Magazine* 11 (May 1882), p. 63, for comments on the deep spiritual significance the landscape held for Inness.

7. Noted by James Maroney, *The Odd Picture* (New York: James Maroney, 1984), pp. 11–12.

8. Quoted in Reginald Cleveland Coxe, "The Field of Art: George Inness," *Scribner's Magazine* 44 (October 1908), p. 511.

9. These observations were made by Dianne Dwyer, Paintings Conservation Department, the Metropolitan Museum, who recently cleaned the painting.

10. Cikovsky 1970a, p. 43; Cikovsky 1971, p. 30.

11. For Inness's views of the Impressionists, see *A Letter from George Inness to Ripley Hitchcock* (New York: Privately printed, 1928).

12. Nicolai Cikovsky, Jr., has noted, "Inness painted no other subject as often or over so many years (first in 1857 and last in 1891) as this one, Delaware Water Gap." See Cikovsky and Quick 1985, p. 96. The paintings are catalogued in Ireland 1965, p. 37 passim.

13. John E. D. Trask and J. Nilsen Laurvik, eds., *Catalogue DeLuxe of the Department of Fine Arts, Panama-Pacific International Exposition*, 2 vols. (San Francisco: Paul Elder & Co., 1915), I, p. 16.

14. Cikovsky and Quick 1985, p. 96; see also pp. 17, 74–76. For an excellent discussion on Inness's attitude toward the "civilized landscape," trains, and progress, see Cikovsky 1970a.

15. Nicolai Cikovsky, Jr., who has suggested and will soon publish this theory, has generously shared his idea, as well as his source, with me.

16. "His Art His Religion," *New York Herald*, 12 August 1894, p. 6. For more on the history of this painting, see Cikovsky 1970a, p. 48; Inness 1917, pp. 108, 111; and Ireland 1965, p. 28.

17. Elliott Daingerfield, *George Inness. The Man and His Art* (New York: Privately printed, 1911), pp. 16–17. According to Luke Willis Brodhead, *Delaware Water Gap* (Philadelphia, 1870), p. 271, the line was finished in 1855; according to Henry Varnum Poor, *History of the Rail Roads and Canals of the United States* (New York, 1860), p. 435, by 1856.

18. Howard B. Leighton, "Nineteenth-century American paintings in the Montclair Art Museum," *The Magazine Antiques* 104 (November 1973), p. 844. See also "'Lost' Inness," *Art Digest* 20 (15 December 1945), p. 9; "The 'Lost' Inness," *Montclair Art Museum Bulletin*, December 1945, unpaged [p. 5].

19. "An excursion on the Baltimore and Ohio Railroad," *The Crayon* 5 (July 1858), p. 208. This excursion was noted in Moure 1980, p. 129. For more on this practice, see Maddox 1981, pp. 17–36.

20. For information regarding the Sonntag and Moran commissions from the Baltimore and Ohio, see Moure 1980, p. 19.

21. See Cikovsky 1970a, pp. 50–51.

Clearing Up, 1860

Oil on canvas, 15¼ × 25⅜ in. (38.7 × 64.5 cm.)
Signed and dated at lower left: G. Inness 1860
George Walter Vincent Smith Art Museum, Springfield, Massachusetts
 (1.23.38)

In the late 1850s, following his second trip abroad, Inness grappled with the new technical and stylistic possibilities he had witnessed in the work of the Barbizon painters. In the canvases of Rousseau and Corot, among others, he discovered qualities to which he responded instinctively; their painterly approach, for example, held greater attraction for him than the tight, smooth surfaces of the Hudson River School masters. A painting like *Delaware Water Gap* (see p. 233) plainly demonstrates his attempts to graft the French style onto an American, and particularly a Hudson River School, format; the result is a hybrid of sorts, a sparkling, diffused view of expansive nature. But another quality Inness found attractive in the Barbizon style was the portrayal of intimate, quiet views of the tamed countryside; *Clearing Up* demonstrates his movement toward that vision.

In the early summer of 1860, Inness and his family moved from New York City to the rural area of Medfield, Massachusetts. *Clearing Up*, painted that same year, may be a result of the inspiration he derived from that charming, peaceful countryside.[1] In the painting, he has come to terms with the Barbizon style, though the work is not a slavish imitation of the French mode. With a broad, horizontal axis and a huge sky, Inness still invokes characteristics of his Hudson River School antecedents in portraying an American space, but when the work is compared with his *Delaware Water Gap* of just three years earlier, it is evident that his vision is gradually closing in. The *paysage intime* of the Barbizon painters held new possibilities for him.

Clearing Up was probably imbued with meaning for Inness. He was living in a rural atmosphere and was attuned to the land in the 1860s, and those factors intensified his desire to deliver a subtle, yet tangible message through his paintings.[2] He was later able to express verbally his feeling toward the landscape:

> The highest art is where has been most perfectly breathed the sentiment of humanity. Rivers, streams, the rippling brook, the hill-side, the sky, clouds—all things that we see—can convey that sentiment if we are in the love of God and the desire of truth. Some persons suppose that landscape has no power of communicating human sentiment. But this is a great mistake. The civilized landscape peculiarly can; and therefore I love it more and think it more worthy of reproduction than that which is savage and untamed. It is more significant. Every act of man, every thing of labor, effort, suffering, want, anxiety, necessity, love, marks itself wherever it has been. In Italy I remember frequently noticing the peculiar ideas that came to me from seeing odd-looking trees that had been used, or tortured, or twisted—all telling something about humanity. American landscape, perhaps, is not so significant; but still every thing in nature has something to say to us.[3]

Clearing Up portrays a winding river along which people are

fishing. The river, spanned by a bridge, meanders back into a small country village that has as its most distinctive element a church spire. The spire, the figure in the foreground who by fishing from a pond partakes of the earth's abundance, and the vaporous clouds in the clearing sky constitute the focus of the picture. While Inness's message is immediately perceptible, a contemporary critic found in another of his landscapes of the same period a more profound meaning that could also apply to *Clearing Up*: "The picture has a moral in its subject and a moral in its treatment. It expresses hopefulness, the promise of good; it implies a divine purpose in the fertilizing shower, the genial sunshine. . . ."[4]

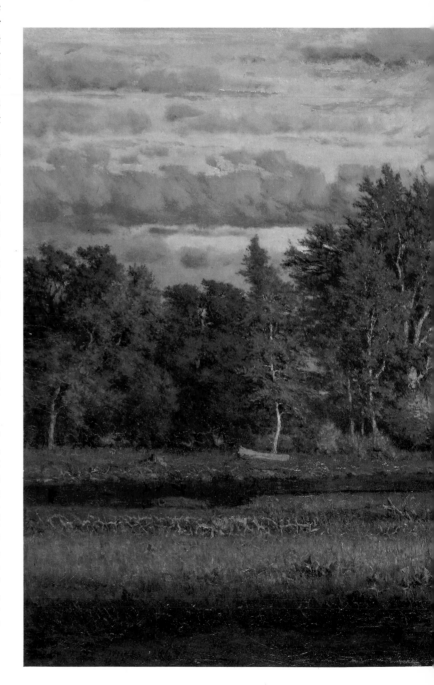

The atmospheric effect achieved by Inness in *Clearing Up* is truly spectacular. The artist's obvious delight in painting the various conditions of the sky and clouds has been noted: "It was with color, light, and air that Inness scored his greatest successes. Almost all of his pictures will be found to hinge upon these primary features. He was very fond of moisture-laden air, rain effects, clouds clearing after rain, rainbows, mists, vapors, fogs, smokes, hazes— all phases of the atmosphere."[5] Nowhere, perhaps, was he more successful than in this work.

<div align="right">L.D.</div>

Notes

1. Cikovsky and Quick 1985, p. 86.
2. Cikovsky 1971, pp. 35–38.
3. "A Painter on Painting," *Harper's New Monthly Magazine* 56 (February 1878), p. 461.
4. Quoted in Cikovsky 1977, p. 193; p. 267, n. 69. The critic was discussing Inness's *Peace and Plenty* (1865; Metropolitan Museum). Cikovsky has noted elsewhere (Cikovsky and Quick 1985, p. 21) that *Clearing Up* may be weighted with Inness's feelings concerning the impending Civil War.
5. John C. Van Dyke, "George Inness as a Painter," *Outlook* 73 (7 March 1903), p. 539. A perusal of the Index of Inness's paintings listed in Ireland 1965 reveals over seventy titles that deal with stormy weather themes.

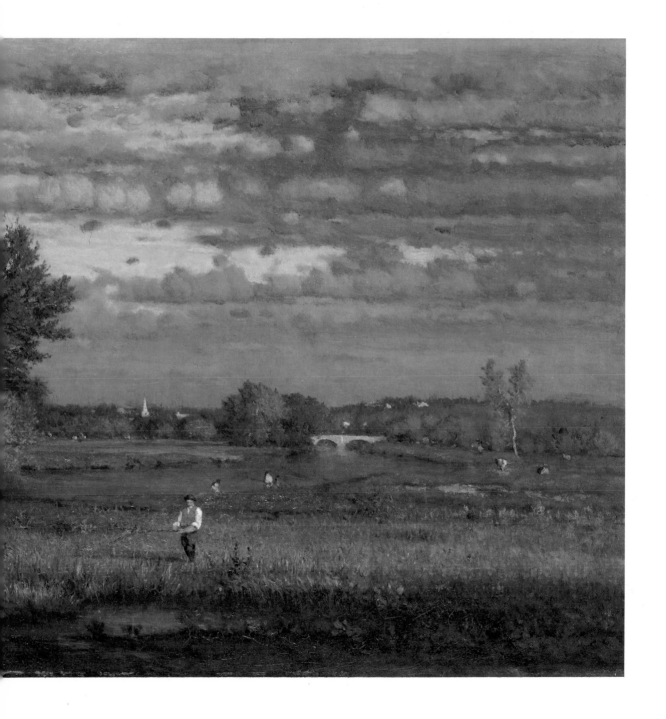

FREDERIC E. CHURCH
(1826–1900)

Frederic Edwin Church, born in Hartford, Connecticut, was the son of a wealthy man whose considerable assets provided the youth with the means to develop his early interest in art. By the age of sixteen, he was studying drawing and painting; two years later, Daniel Wadsworth, son-in-law of John Trumbull and, like Trumbull, a patron of Thomas Cole's, prevailed upon Cole to take Church as his pupil. Church's precociousness displayed itself quickly. Within a year, he had been shown in the National Academy of Design annual exhibition; the following year, he sold his first major oil, to Hartford's Wadsworth Atheneum. Extraordinarily gifted as a draftsman and a colorist, Church reached his early maturity by 1848, the year he took a studio in New York City, accepted William James Stillman as his first pupil, traveled widely and collected visual materials throughout New York and New England, particularly Vermont, and turned out a number of pictures, all of which sold well. As did so many contemporary landscape painters, Church settled into his own pattern of travel, hiking, and sketching from spring through autumn, followed by winter in New York painting, pursuing business affairs, and socializing. In April 1853, Church and his friend Cyrus Field set forth on an adventurous trip through Colombia (then called New Granada) and Ecuador. Church's first finished South American pictures, shown to great acclaim in 1855, transformed his career; for the next decade he devoted a great part of his attention to those subjects, producing a celebrated series that became the basis of his ensuing international fame. Nevertheless, his tastes and curiosity kept him ranging for other topics. From 1854 through 1856, in addition to retracing familiar paths, he followed new ones as well, visiting Nova Scotia, traveling widely in Maine, New Hampshire, and Vermont, and going several times to take sketches of Niagara Falls. For Church, from the late 1850s until the beginning of the

Civil War was a time of triumph piled upon triumph. A second trip to Ecuador, in 1857, and a voyage to Newfoundland and Labrador, in 1859, provided material for future major paintings, but it was his *Niagara* (see p. 243), completed in 1857, and *Heart of the Andes* (see p. 246), in 1859, that guaranteed for him, still a young man, the role of America's most famous painter.

In 1860, Church bought farmland at Hudson, New York, and married Isabel Carnes, whom he had met during the exhibition of his *Heart of the Andes*. His marriage to both—his wife and his farm—became the joint center of his life, in later years tending to divert his attentions from painting major canvases. Church's happiness was blasted in March of 1865, when his son and his daughter died of diphtheria, but with the birth of Frederic junior in 1866, Church and his wife began a new family that was eventually to number four children. In late 1867, the Churches launched on an eighteen-month trip to Europe, North Africa, the Near East, and Greece that was the genesis of several important pictures. Church, however, began to devote his creative energies increasingly to gentleman farming and to the designing and redesigning of Olana, his hilltop fantasy of a "Persian" villa at Hudson, New York, a seemingly endless undertaking begun in 1869 in consultation with the architect Calvert Vaux. From the 1870s until his death afflicted with painful rheumatism of the right arm, which interrupted or prevented work on major pictures, Church still managed to produce in his later years a few large retrospective canvases. His final artistic legacy was a multitude of breathtaking small oil sketches, mostly of Olana or of the area around Millinocket Lake in Maine, where he bought a camp in 1880, or of Mexico, where he began wintering in 1882. These are at once a magnificent testimony to his undiminished gifts as a draftsman, painter, and colorist and one of the glories of American art.

Select Bibliography

Charles Dudley Warner. *Paintings by Frederic E. Church, N. A.* Memorial exhibition catalogue. New York: The Metropolitan Museum of Art, 1900.

David C. Huntington. "Frederic Edwin Church, 1826–1900: Painter of the Adamic New World Myth." Ph.D. diss., Yale University, 1960.

———. *The Landscapes of Frederic Edwin Church: Vision of an American Era.* New York: George Braziller, 1966.

Theodore E. Stebbins, Jr. *Close Observation: Selected Oil Sketches by Frederic E. Church.* Washington, D.C.: Smithsonian Institution Press, 1978.

Gerald L. Carr. *Frederic Edwin Church: The Icebergs.* Introduction by David C. Huntington. Dallas, Texas: Dallas Museum of Fine Arts, 1980.

Jeremy Elwell Adamson. "Frederic Church's 'Niagara': The Sublime as Transcendence." 2 vols. Ph.D. diss., University of Michigan, 1981.

Elaine Evans Dee. *To Embrace the Universe: Drawings by Frederic Edwin Church.* Exhibition catalogue. Yonkers, New York: The Hudson River Museum, 1984.

Katherine Manthorne. *Creation and Renewal: View of Cotopaxi by Frederic Edwin Church.* Exhibition catalogue. Essay by Richard S. Fiske and Elizabeth Nielson. Washington, D.C.: Smithsonian Institution Press, 1985.

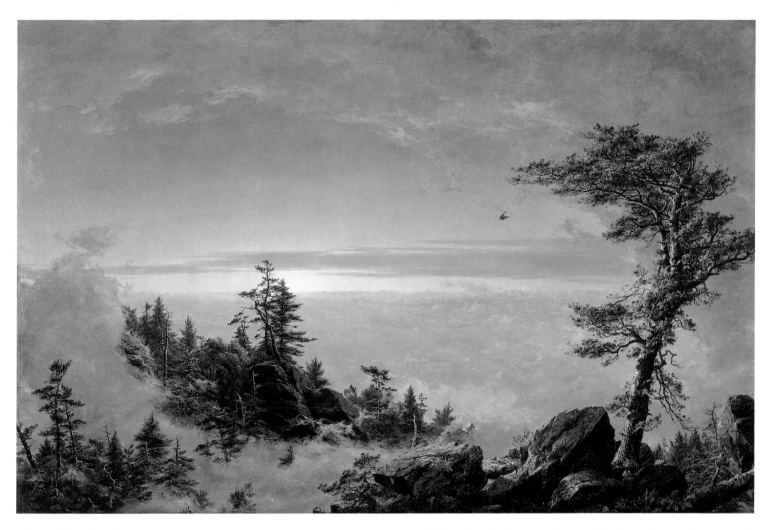

Above the Clouds at Sunrise, 1849

Oil on canvas, 27 × 40 in. (68.6 × 101.6 cm.)
Signed and dated at lower middle right: F. E. Church/1849
The Warner Collection of Gulf States Paper Corporation, Tuscaloosa,
Alabama

Above the Clouds at Sunrise was one of eight paintings sold by Church to the American Art-Union in 1849. That year, most issues of the Art-Union *Bulletin* from April through December printed an identical brief description of the picture: "Above the Clouds at Sunrise, 40 × 27 [inches]. The foreground is the top of a mountain, with rock and pine trees. The distance is a sea of mist, beyond which the sun is rising, and across which it is beginning to dart its rays, tinging the clouds with rose color. Wreaths of mists are curling among the rocks and trees in the foreground."[1] The scene, previously unidentified, has been associated with the eastward prospect from the Catskill Mountain House by Franklin Kelly and Gerald L. Carr, on the basis of existing preliminary sketches. The picture,

containing the whole array of natural effects of a special mountain sunrise, is an early but not fully developed statement of the pictorial formula familiar in Church's mature, more complicated and larger showpieces of the late 1850s and 1860s. Here, every detail of rock and tree, as to form, color, and texture, is captured, as are the dazzling variations of color and texture in the circling mist and receding layers of cloud. Every element of the foreground composition acts as part of a twisting, swirling frame that surrounds the glory of the sun rising above the distant bed of clouds. The battered and mossy pine tree at the right gestures toward the solar disk in an almost anthropomorphic manner, releasing, yet still partly embracing, a bird that darts toward the sun, the focus of the scene. The intense naturalism (especially the attention to light and cloud effects), the forceful, even radical, composition that demands attention to the central point, and a heightened sense of drama and awe of nature are key elements in this and later major works by the artist. In such a picture we can read Church's deep interest in the study of the anatomy of nature (geology, botany, meteorology, and optics), as well as his religious wonder at the world around him.

Henry Tuckerman, writing in 1867, aptly recalled Church's early work:

Caspar David Friedrich, *Traveller Looking over a Sea of Fog*, ca. 1815, oil on canvas, 38¾ x 29⁷⁄₁₆ in. (98.4 x 74.8 cm.). Hamburger Kunsthalle

The sky was the field of his earliest triumphs. . . . Few artists have so profoundly and habitually studied sunshine and atmosphere. . . . Thus, before he explored tropical scenery, or ice-haunted waters, he found in the magnificent clouds of America, in her autumn-tinted forests and her peerless cataracts, the most congenial and inspiring subjects.[2]

Above the Clouds is not only a masterstroke but also an uncanny stylistic parallel to the highly charged landscape scenes of the German Romantic painter Caspar David Friedrich, which set a high standard for the spiritualistic depiction of nature in the nineteenth century (ill.). The combination of sharp but selective vision, specificity, and great natural drama in Friedrich's and Church's pictures represented the fully developed Romantic movement in landscape painting in its highest form.

<div align="right">J.K.H.</div>

Notes
1. *Bulletin of the American Art-Union* 2 (April 1849), p. 24; ibid. (May), p. 22; ibid. (June), p. 34; ibid. (September), p. 34; ibid. (October), p. 28; ibid. (November), p. 31; ibid. (December), p. 28, quoted in Cowdrey and Sizer 1953, 2, p. 70.
2. Tuckerman 1867, p. 371.

West Rock, New Haven, 1849

Oil on canvas, 27 × 40 in. (68.6 × 101.6 cm.)
Signed and dated at lower left: F Church/1849
The New Britain Museum of American Art, New Britain, Connecticut.
 John B. Talcott Fund

In 1849, when Church exhibited *West Rock, New Haven* at the annual spring exhibition of the National Academy of Design, the painting was immediately recognized for its astonishing qualities and was greeted with warm applause. The American Art-Union's April *Bulletin* highlighted it, saying, "The sky and water of this piece are truly admirable. Seldom have we seen painted water which fulfils so well as this the 'Oxford Graduate's' [John Ruskin] conditions of excellence. Church has taken his place, at a single leap, among the great masters of landscape."[1] The next issue of the *Bulletin* remarked again on the "'New Haven Scenery,' the praises of which are in everybody's mouth."[2] Such resounding approbation was remarkable both because Church was a very youthful twenty-three and because of the perceptive accuracy of the *Bulletin* writer. With this exhibition, Church had taken his initial step as an artist of the first rank onto the all-important stage of New York City's art world. That is not to say Church was a complete neophyte: he had studied painting and drawing since the age of sixteen and in 1845, after just one year of study with Thomas Cole, had exhibited two landscapes at the Academy. Church's first known sale, that of his *Hooker and Company Journeying through the Wilderness from Plymouth to Hartford in 1636* (ill.), to the Wadsworth Atheneum in his native Hartford, was concluded in 1846, when he was merely twenty years old. In 1847, his success accelerated with the sale of five pictures to the American Art-Union, whose activities he heartily supported and in whose building he

Frederic E. Church, *Hooker and Company Journeying through the Wilderness from Plymouth to Hartford in 1636*, 1846, oil on canvas, 40¼ x 60³⁄₁₆ in. (102.2 x 152.9 cm.). Wadsworth Atheneum, Hartford

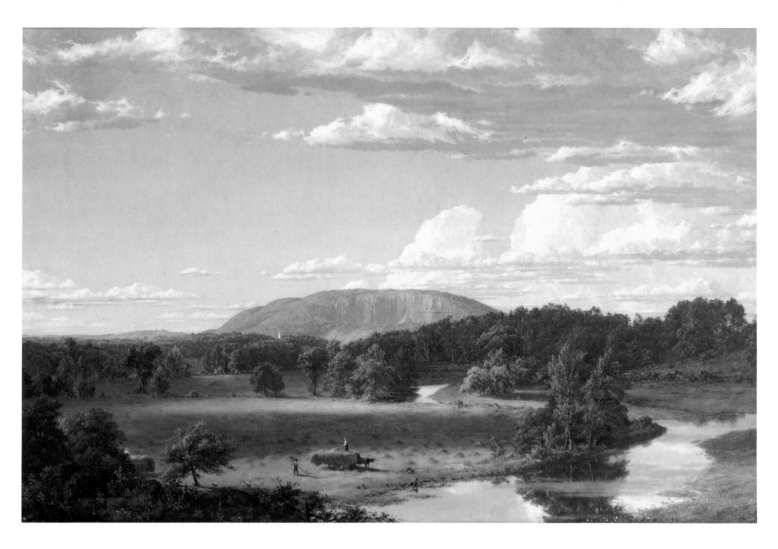

kept rooms. In 1848, he received several notices in the press, felt advanced enough in his profession to take his first pupil, and set forth in the summer on a sketching trip through upstate New York and into New England that provided him with the material for several pictures, including *West Rock, New Haven*. The results of a remarkable and exceedingly brief period of maturation are found in this painting, which goes well beyond the stylistic example set by Cole (and ably reflected by Church in his large, stagey, and heavily textured *Hooker and Company*) to establish a mode of landscape painting that was new for both Church and American art.

Hooker and Company, in its truthfulness to nature, accuracy of detail, and powerful, unified composition, demonstrates how well Church had absorbed the most important tenets of Cole's teaching. *West Rock*, despite its wide range of form, texture, color, and light effects, presents a radical simplification and massing of compositional elements that puts it in a new realm of visual acuity far more precise and less consciously "artistic" than that of Cole. Here, the viewer is introduced almost brusquely into a boldly composed, centrally focused picture space from which any use of spatially reassuring *repoussoirs*, or framing elements, has been omit-

ted. Alternating bands of light and dark, of differing textures (the glistening water, the verdant meadow, the bushy trees, the jointed rock, and finally the cloud-streaked sky), provide the visual ladder that persuasively leads the eye through space and through the detailed glories of nature. Pictorially and mentally, *West Rock* draws us beyond the grandiloquence of Cole's *Oxbow* (see p. 125), with its carefully arranged composition, emphasis on drama, and distant, almost Jovian view of nature. Instead, Church takes us down onto a rustic plain where the effects of atmosphere and distance do not obscure the minutest details, whether of nature or of farmers haying a field. This picture is an early but fully formed statement of Church's lifelong belief, related closely to that of Ruskin, that art should be the mirror of nature, that a picture should replicate what the artist sees.

<div style="text-align: right">J.K.H.</div>

Notes
1. *Bulletin of the American Art-Union* 2 (April 1849), "Fine-Art Gossip," p. 20.
2. Ibid. (May 1849), "The National Academy of Design," p. 14.

New England Scenery, 1851

Oil on canvas, 36 × 53 in. (91.4 × 134.6 cm.)
Signed and dated at lower right: F Church '51
George Walter Vincent Smith Art Museum, Springfield, Massachusetts
 (1.23.24)

New England Scenery was painted in 1851 and was sold the next year to the American Art-Union, in whose *Bulletin* appeared this description: "This picture is considered by many to be the chef d'oeuvre of the artist. It is a view of water and mountain scenery, glowing with sunlight. It contains great breadth of effect, with a wonderful excellence in details."[1] And, indeed, the picture is still regarded as "the masterpiece of Church's youth . . . a conclusion to the beginning of the painter's career."[2]

In this precocious work, Church utilized the techniques and mental constructs that thereafter determined the nature of his larger canvases: relying on small sketches of different details made during warm weather travels, Church assembled, first, a unified preliminary sketch and, finally, the large, complete canvas, a composite view. The sketches (both in pencil and gouache and in oil) include views of the falls of the Genesee River in upstate New York and ocean shore views from Mount Desert Island, in Maine, all sites Church had visited during the summer and fall of 1850 and 1851.

The small oil study (ill.) that first brought together the diverse elements of the final composition is characterized, because of its size and the artist's obvious enthusiasm, by extremely rich paint surfaces; forceful, almost staccato contrasts of light and dark; and a dramatized presentation of agitated cloud formation and other natural phenomena. The final canvas presents a much more serene vista, a composition that is the melding of realistic depiction and artistic idealization. It is a perfect "portrait" of a place that never

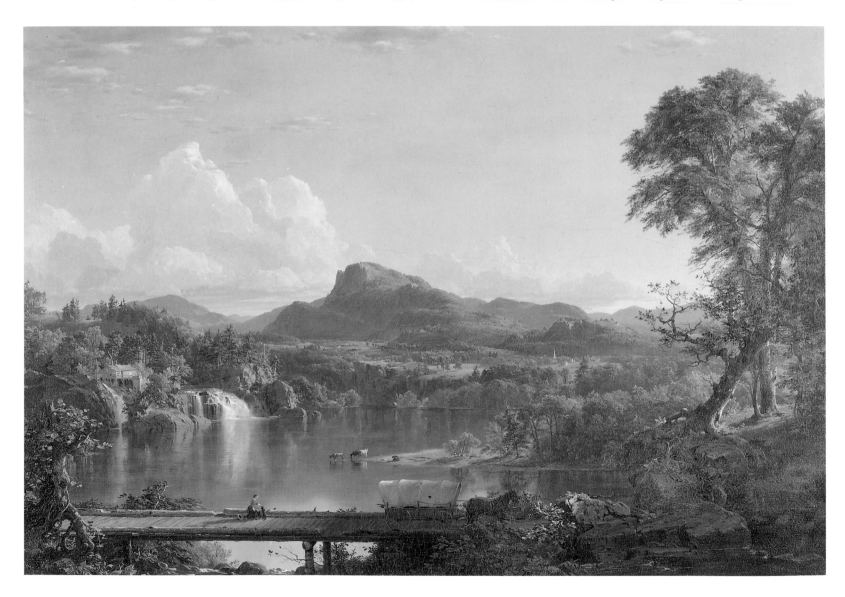

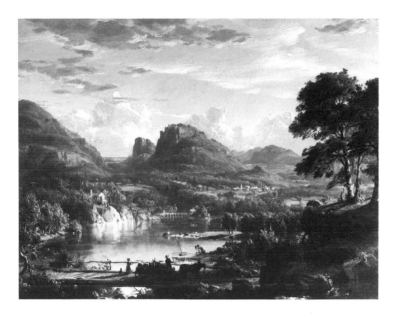

Frederic E. Church, Oil study for *New England Scenery*, 1850, oil on canvas, 12 x 15 in. (30.5 x 38.1 cm.). Lyman Allyn Museum

Niagara, 1857

Oil on canvas, 42½ × 90½ in. (108 × 229.9 cm.)
Signed and dated at lower right (painted over): F.E. CHURCH/1857
The Corcoran Gallery of Art, Washington, D.C.

existed, yet could be sensed or imagined almost anywhere throughout New England. The broad selection of details arranged from foreground to the far distance—a bridge, human figures, a wagon, cattle, a sawmill, and a small village with its steeple—are brought together around the anchoring, middle-ground body of water. The work is a gathering of many separate small spaces (meadows, plateaus, valleys), all of which are articulated by trees, mountains, and clouds and unified in a pure bath of sunlight radiating from the viewer's right. Here is an icon of perfection in New England intimating the simple beauties and pleasures of a rural life wherein human industry and all nature blend harmoniously.

Henry Tuckerman, in a particularly perceptive passage that bears close but not specific relation to this painting, wrote:

> Church exhibits the New England mind pictorially developed. His great attribute is skill; he goes to nature, not so much with the tenderness of a lover or the awe of a worshipper, as with the determination, the intelligence, the patient intrepidity of a student; he is keenly on the watch for facts, and resolute in their transfer to art; to master the difficulties of his profession is more of an inspiration to him than to utter, through it, what is innate and overpowering in his own conceptions.[3]

New England Scenery contains both patient industry and artful concept in ample portion, going well beyond a mere "daguerreotype," as at least one of his early pictures was denigrated.

J.K.H.

Notes
1. Cowdry and Sizer 1953, 2, p. 73.
2. Huntington 1966, p. 34.
3. Tuckerman 1867, p. 375.

From the time of its first exhibition, beginning on 1 May 1857, at a Manhattan art gallery, Church's *Niagara* was a momentous cultural event.[1] The impression the picture made on its viewers caused such a sensation that thousands of people flocked to see it, and numerous newspaper and magazine critics pronounced it the greatest oil painting, as well as the greatest representation and evocation of America's most renowned natural wonder, yet produced in this country. The *New York Daily Times*, quoted in the gallery brochure, commented in a typically enthusiastic manner: "You pass from the bustle of the street into the small back room of the Messrs. Williams and Stevens—and behold! there is the marvel of the western world before you. . . . To write of this picture is like writing of the Falls themselves."[2] Critics ransacked their thesauri for praiseful adjectives to establish the picture as altogether beautiful, wondrous, truthful, sublime, religious, and patriotic. When *Niagara* was sent on tour in England and Scotland that summer and the following year, the British art world, notably including John Ruskin, greeted this Yankee creation with surprise, admiration, and the conviction that with it American art had finally achieved a leading place on the international scene. The adulation voiced in the London *Art-Journal*, at the time the most important art publication in the English language, set the tone of sophisticated approval: "No work of its class has ever been more successful: it is truth, obviously and certainly. Considered as a painting, it is a production of rare merit: while admirable as a whole, its parts have been all carefully considered and studied; broadly and effectively wrought, yet elaborately finished."[3] Almost all subsequent writing concerned with the history of American painting has named *Niagara* as the picture that beyond all doubt established the importance of what became known as the Hudson River School. Henry Tuckerman, among the foremost and most influential of those writers, noted in 1867 that *Niagara* "was immediately recognized as the first satisfactory delineation by art of one of the greatest natural wonders of the western world." He continued, "Indeed, this work forms an era in the history of native landscape art, from the revelation it proved to Europeans."[4]

The galvanizing effect of *Niagara* was the result of the picture's remarkable boldness in scale, dramatic point of view, and subtle but firm design, unusual for its implacable horizontality and admirable attention to detail and finish. What elicited the most praise, however, was the vantage point. As one writer put it, "Mr. Church has shown himself the great artist in the selection of his point of view."[5] The canonical banality of the countless preceding Niagara views was entirely displaced by a new and astounding

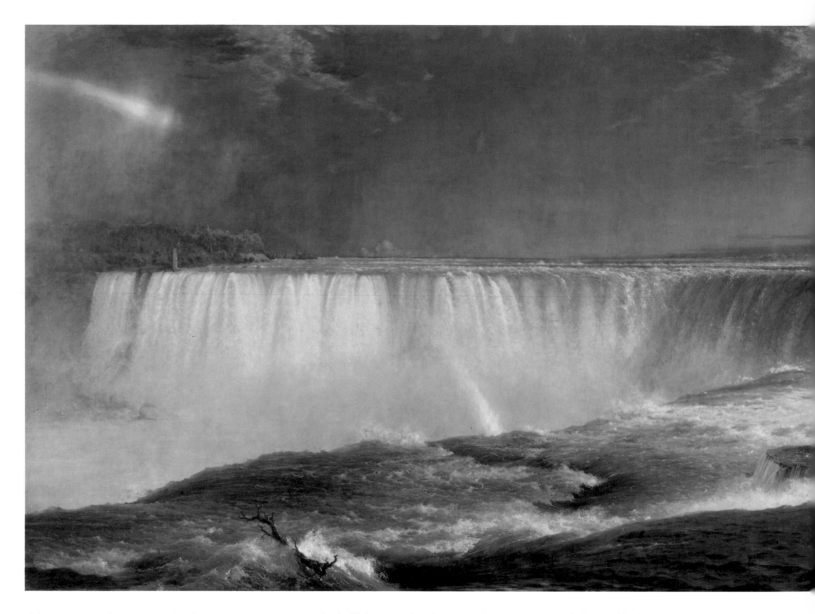

vision presented on an outsized canvas some seven and a half feet wide. With no visible footing, the viewer is propelled giddily out over the rushing upper rapids near the Canadian shore to come full face with the spectacle of water in relentless, terrifying action as it hurtles into the gulf at freight-train speed. Through the careful arrangement of compositional outlines—the light and shadow of the brink of the fall, the insistent horizon, the rainbow and clouds above—one's eye tends to focus on the central point of the painting, where a brightly foaming salient of the cascade thrusts itself out of adjacent shadow. Inexorably drawn into the scene and suspended there, surrounded, one seems to witness firsthand the heartstopping awesomeness and terrible beauty of nature.

To achieve his objective, the making of a great picture, Church approached the task in his usual thoughtful and painstaking manner, requiring some years of seasoning. At mid-century, views of Niagara were the commonest of topographical items,

familiar to all. They provided the stuff of everyday art to an unsophisticated public. In the mid-1840s, Church, then a student of Thomas Cole's, made an oil sketch of Niagara using an engraving after Cole as his model. After this initial attempt, he apparently did nothing more with the subject until the summer of 1851, when, following a tour through Virginia and the middle reaches of the Mississippi River in the company of Cyrus Field and his family, he visited the Falls and sketched there.[6] He returned to the Falls in mid-March, in early July, and again in September and October of the following year. Evidence that the painter was intent on gathering natural details—mostly of water-action and atmospherics— from every aspect of the Falls to serve as pictorial building blocks for determining an overall scheme can be found in some twenty-one sketches he made during or shortly after those visits.[7] In several of the late ones, which use variations of the forceful horizontal format and dramatically exposed point of view, the idea for the final com-

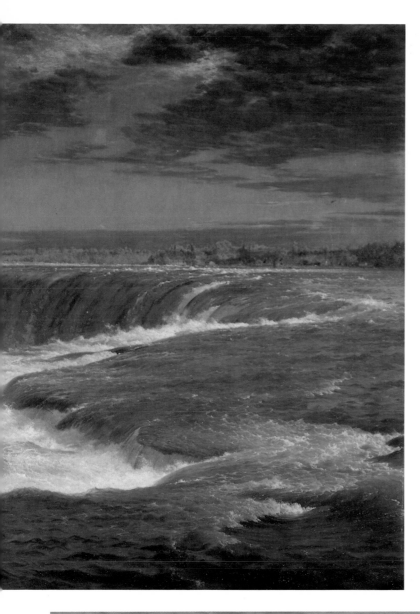

position is seen near resolution.[8] The final sketch (ill.) was reported on by a writer for *The Crayon* in February 1857:

> Mr. Church, as one of the results of his summer studies, exhibits a sketch of Niagara Falls, which more fully renders the "might and majesty" of this difficult subject than we ever remember to have seen these characteristics of it on canvas. The point of view is happily chosen, and its impressiveness seems to be produced by admirable drawing aided by a skillful subordination of accessories; the eye is not diverted, led away, as it were, from the soul of the scene by diffuse representation of surrounding features. We shall look forward to the picture to be made from this sketch with much interest, as we believe Mr. Church intends to reproduce it on a more extended scale.[9]

The Connecticut writer Henry French provided in 1879 a specific description of Church's studio procedure with the picture:

> Strictly speaking, the painting was the work of just six weeks, but in reality, of a long and patient study and many sketches. The perfect accuracy in drawing was accomplished in a way solving to some degree the mystery of the success. The artist prepared two canvases of the same size. On one he experimented till his critical eye was satisfied with a line or an object; then placed it on the other.[10]

Though written some twenty-two years after the fact, the account has the ring of authenticity.

In May 1857, *The Crayon* took note that Church had completed his large Niagara Falls picture and again lauded it warmly:

> To our mind, the grand effect of Niagara is expressed in this picture by the long lines of the horse-shoe fall, which take up so great a portion of it in their majestic sweep; also to the fact that no belittling object is allowed to divert the eye in the immediate foreground. So treated we realize the vast quantity of water, a characteristic which distinguishes this fall above all others in the world; we have never before seen it so perfectly represented.[11]

Because of the distinction of its innate qualities and the skill with which it was presented to a large public (both by extensive exhibition and by reproduction in lithographs and engravings),

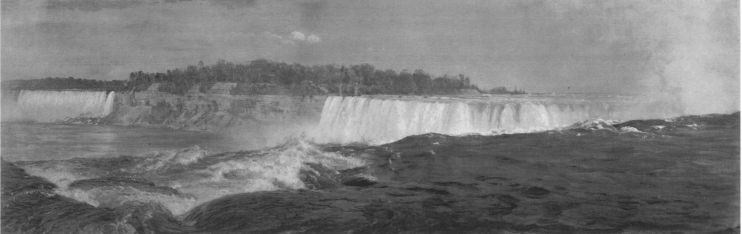

Frederic E. Church, *The Great Fall, Niagara*, ca. 1856, oil on canvas, 12 x 35 in. (30.5 x 88.9 cm.). Private collection

Niagara had a rapid and immense effect on the work of many American landscapists, including in particular Jasper Cropsey, Régis Gignoux, Martin Johnson Heade, John F. Kensett, and Albert Bierstadt. The immediate progeny of Church's masterly creation, a considerable number of large-scale canvases those artists composed with bold simplicity and finished in fine detail still survive.

<div align="right">J.K.H.</div>

Notes

1. For a full-length account of the creation, meaning, and reception of the painting, see Adamson 1981. For broader and more recent information on the history of topographical and artistic depictions of Niagara Falls, see Elizabeth McKinsey, *Niagara Falls: Icon of the American Sublime* (New York: Cambridge University Press, 1985); Jeremy Elwell Adamson et al., *Niagara: Two Centuries of Changing Attitudes, 1697–1901*, exh. cat. (Washington, D.C.: The Corcoran Gallery of Art, 1985).
2. *Church's Painting of Nature's Grandest Scene. Niagara the Great Fall, by Frederic Edward* [sic] *Church* (New York: Williams, Stevens, Williams & Co., 1857).
3. *Art-Journal* 19 (1857), p. 262. Quoted in Adamson 1981, 1, p. 36.
4. Tuckerman 1867, p. 376.
5. From the *New York Times*, quoted in Adamson 1981, 2, p. 352.
6. Samuel Carter III, *Cyrus Field: Man of Two Worlds* (New York: G. P. Putnam & Sons, 1968), pp. 69–70.
7. Adamson 1981, 2, pp. 307–34.
8. The penultimate sketch is in the Church Archives; the ultimate, in a private collection.
9. *The Crayon* 4 (February 1857), p. 54. Quoted in Adamson 1981, 2, p. 331.
10. Henry W. French, *Art and Artists in Connecticut* (Boston: Lee and Shepard; New York: Charles T. Dillingham, 1879), p. 129.
11. *The Crayon* 4 (May 1857), p. 157.

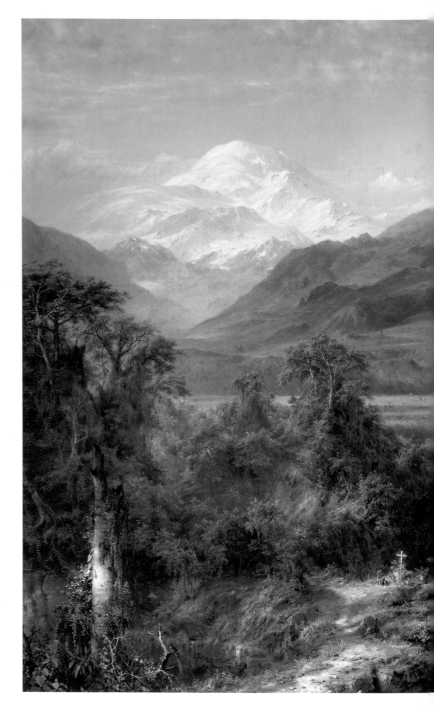

Heart of the Andes, 1859
Oil on canvas, 66⅛ × 119¼ in. (168 × 302.9 cm.)
Signed and dated at lower left (on tree): 1859/F.E. CHURCH
The Metropolitan Museum of Art, New York City. Bequest of
* Margaret E. Dows, 1909 (09.95)*

The famous story of *Heart of the Andes*, of its creation and public acceptance, tells of one of the pivotal events of the mid-nineteenth-

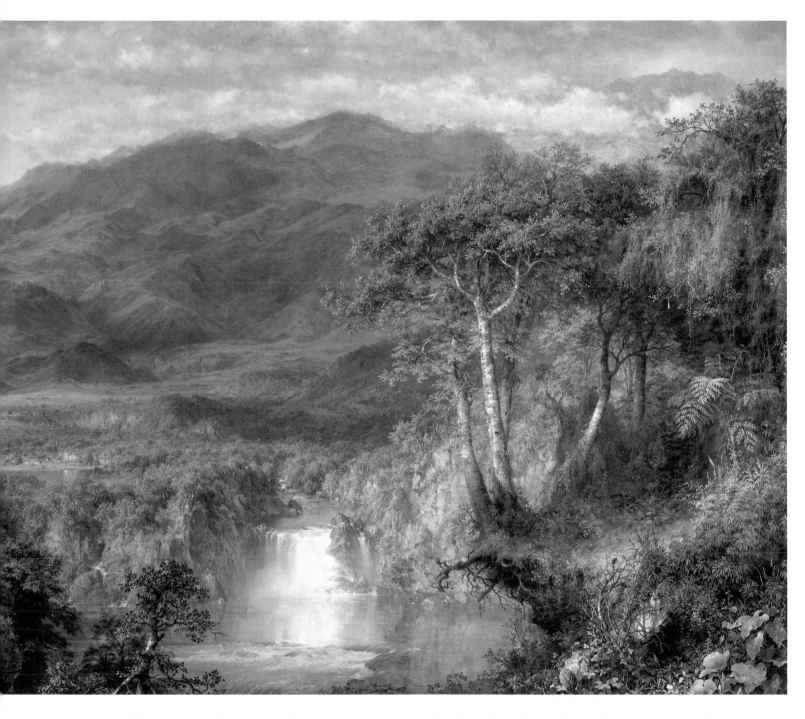

century art world in America. The painting, first presented in 1859 at a time when single-picture exhibitions were special but not uncommon features of art life, created such a stir and drew such large numbers of paying crowds that at no time during that century can any other American work of art claim to have been accorded anything approaching its great, lively, and almost rapturous popular reception. The clever presentation and publicizing of the picture by Church and his agents created a model of how to use the printed word to market a work of art: first, its popular exhibition for a

fee; then, the widespread sale of steel-engravings of it; and, finally, its sale at a very high price to a grateful collector. That success could have eluded Church, however, if he had not created a masterpiece that brilliantly summed up the new interests, ideas, and taste of his educated and supportive public. Prior to *Heart of the Andes* and its few South American predecessors by Church, subject matter for American landscape painters had been confined mostly to native locations, with relatively few depictions of European scenes being done. In this country, Church had been of paramount influ-

ence in expanding the repertoire of landscape subject matter to include not just South America, but the Arctic, the Caribbean, and all the countries of the Mediterranean basin. That widened view represented the revolution and acceleration toward exoticism, especially during the final three decades of the nineteenth century, that found wide expression in this questing country. In the same period, African and Asian subjects also became popular, a development in American painting that followed the model of European schools.

Church's interests, which were to find expression in *Heart of the Andes*, were the result of an exceedingly lively intelligence that roved through the welter of books and articles on science, religion, travel, art, poetry, and fiction that had formed his intellectual diet since youth. John Ruskin's *Modern Painters* (the first volume issued in 1843) and Baron Alexander von Humboldt's *Cosmos: Outline of a Description of the Physical World* (the English edition of which appeared serially in five volumes from 1848 through 1858)[1] were among the standard readings that both formed and fed Church's desire to retrace Humboldt's path and to present the Andean region in pictorial form, as the baron had advocated. Church's first visit to Latin America began in April 1853, when he and Cyrus Field embarked on a tour that lasted into October. Field, later the successful projector of the transatlantic cable, and the artist had maintained in New York the longstanding connections of business and friendship enjoyed by their two families in Hartford and western Massachusetts. Isabella Field Judson, relying on her father's letters and notes, published in 1896 a concise but unusually descriptive itinerary of the trip:

> They sailed as far as Savanilla, New Granada (now Colombia), at the mouth of the Magdalena, and from there up that river for six hundred miles. Disembarking at the head of navigation, they passed four months in mountain travel on mule-back, traversing the tablelands south to Bogota, following the Andes to Quito, and crossing the equator and Chimborazo, at last reaching the Pacific at Guayaquil. From Guayaquil they were able to take steamers to Panama, but the railroad across the isthmus was but partly built; for the rest of the crossing they had again to resort to mules. This would be a difficult and toilsome journey even now, and it was far more so forty years ago. But it had memorable results, for it was at this time that Mr. Church made the sketches for his most famous tropical landscapes.[2]

Mrs. Judson quoted an Aspinwall (now Colón, Panama) newspaper of October 1853, in which some comments by Church and Field were recorded: "They say that the scenery in some parts of the Andes is grand and beautiful beyond description . . . and that they have been so much pleased with their journey that they intend soon to return to the land of beautiful flowers and birds, and to the continent for which the Almighty has done so much and man so little."[3] On this adventuresome trip, Church, for the first time, saw and sketched places that were to become the subjects forming the backbone of his oeuvre both preceding and succeeding *Heart of the Andes*, among them the Magdalena River, the Falls of Tequendama, and the volcanic mountains Cotopaxi and Chimborazo. It should also be noted that Church and Field, both of an entrepreneurial bent, did not fail to visit a number of gold, silver, and emerald mines along their route. For over a year after his return to New York, Church worked up his sketches into a series of finished canvases. At the spring exhibition of 1855, the galleries of the National Academy of Design echoed with praise for his South American views, particularly *The Cordilleras: Sunrise*; *La Magdalena*; and *Tequendama Falls, near Bogotá, New Granada*, the last one painted for Cyrus Field. In 1857, Church pursued further success (as well as his intellectual and artistic interests) with a second, nine-week visit to South America, that time accompanied by the little-known painter Louis Rémy Mignot (see p. 298) and concentrating on Ecuador and its three most daunting mountains: Chimborazo, Sangay, and Cotopaxi.

The trip was apparently strictly for business; after a passage highlighted by "a good tearing fit of seasickness,"[4] Church and his party headed off toward Quito, "trailing along with eight or nine mules in Indian file zig-zagging up the mountains."[5] The tour must have gone well: in late June, a month sooner than he had expected, Church was able to prepare to "leave for the states . . . owing to the fact that we shall be able to accomplish all of our journey which we had planned out, in time for the steamer which leaves Guayaquil on the 30th of July for Panama."[6] Church had worked extremely hard and under difficult conditions in Ecuador, assembling a battery of sketchbooks and numerous individual sketches in pencil, watercolor, gouache, and oil, all of which went into the compiling of his great finished pictures.[7]

Church's diary for the expedition contains a passage thought to describe the scene that subsequently became *Heart of the Andes*:

> During the first part of the journey, behind us at the West, towered the distant Chimborazo which, like all these mountains, seem to increase in magnitude as we recede from them. Surrounding us were lower snow peaks, some of which are not clad in perpetual snow. Among the most conspicuous was the Tuna range exactly in front of a very irregular sierra but comparatively not very high. The lack of trees gives a singularly lonely effect which was increased by the absence of birds; the river contains no fish.[8]

Relying on individual sketches, his memory, and his mind's eye, Church created a preliminary oil study (ill.) measuring only ten by eighteen inches that contains all the major factual elements of *Heart of the Andes*—a river foreground, flanked by jungle flora and fauna, receding to a flashing waterfall and, behind, a series of diminishing and rising tablelands that end in the right middle ground in a large ridge of mountains, with the gleaming, conical mass of Chimborazo looming in the left distance. Because of its small size and the absence of the artistic enhancement found in the finished work, the sketch lacks the astounding sense of massiveness and rarefied atmosphere, combined with almost endless natural foreground detail, that are the unforgettable hallmarks of the completed *Heart of the Andes*. Only three-quarters of an inch narrower than ten feet, the painting is an extravaganza that celebrates at once nature, landscape, distance, and the artist's own heroic effort. During the more than one-year course of its painting, Church's

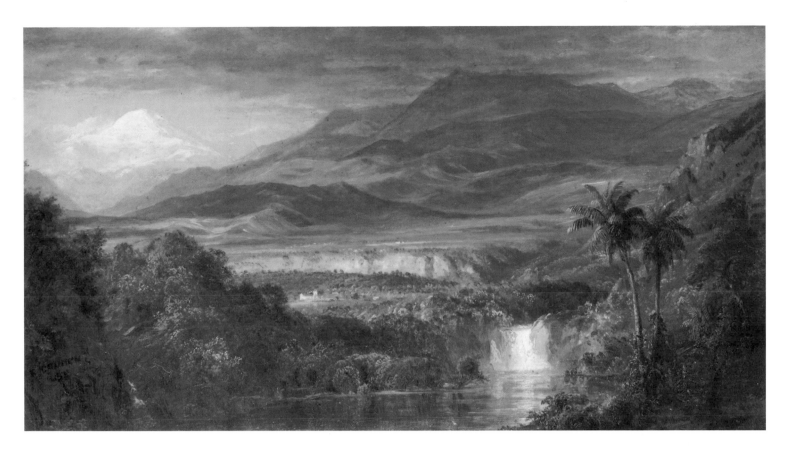

Frederic E. Church, Study for *Heart of the Andes*, 1858, oil on canvas, 10 x 18 in. (25.4 x 45.7 cm.). New York State Office of Parks, Recreation and Historic Preservation, Olana State Historic Site (OL.1981.47)

picture had been mentioned often in the art columns of New York periodicals; by March 1859, it had become known as "his great canvas."[9]

By itself, the painting is a wonder of Church's artistic showmanship, and the dramatic and most effective manner in which he mounted it proved that as a producer of public displays he had few peers. In conjunction with a Mr. Whitlaw,[10] an English decorator, he contrived of dark walnut wood an immense, freestanding, neo-Renaissance-style architectural frame, estimated to have measured almost thirteen feet high by nearly fourteen feet wide, with the intention that his masterpiece be seen as though through "a palatial window or castle terrace upon an actual scene of picturesque mountains, tropical vegetation, light and loveliness."[11] The picture's first public showing, on 27 April 1859, in a rented gallery in Lyric Hall on Broadway, resulted in an outpouring of lavish praise tempered only by objections to the murky gaslight by which it was displayed. By 29 April, presumably following the advice of a *New York Times* critic, the painting, with its accoutrements of drapery and palm trees, had been moved to the main gallery of the Tenth Street Studio Building (in which Church had recently rented work space), where a skylight provided natural illumination for its display.[12] The welling-up of publicity surrounding the exhibition was immense, encouraged by Church's astuteness in arranging for the concurrent publication of descriptive appreciations in pamphlet form by two of his intimate friends, the Reverend Louis LeGrand Noble and Theodore Winthrop. Noble's "appreciation" assessed Church's artistic endowments: "Gifted, as Cole declared, with an eye of unrivaled excellence for lines and forms . . . of singular fidelity to color, light and shade, with the capacity, feeling and skill to reproduce on the canvas the scenery of nature with consummate truthfulness and splendor."[13] Noble's review of the picture and the nature seen in it ended with this pronouncement: "A splendid triumph. A masterpiece among the masterpieces of the world. And the painter stands out in line with those whose presence has passed from the earth, but whose great names in art never perish."[14]

As for Winthrop, his effusive and wordy *Companion to the Heart of the Andes* undertook to guide the visitor around and through the painting just as a Baedeker *Handbook for Travellers* would pilot him through a distant European region. Containing forty-three pages—almost twice the length of Noble's pamphlet—Winthrop's *Companion* attempts "to analyse [the picture's] subject and manner of treatment . . . the subject is new, the scenes are strange, the facts are amazing."[15] While Winthrop goes on at great length, he does provide at one point a useful and welcomely compact listing of what we see:

The picture may be roughly divided into different regions, as follows:
The Sky.

The Snow Dome.
The Llano, or central plain.
The Cordillera.
The Clouds, their shadows and the atmosphere.
The Hamlet.
The Montaña, or central forest.
The Cataract and its Basin.
The Glade on the right foreground.
The Road and left foreground. . . .
The Scene is an elevated valley in the Andes, six thousand feet above the sea; the Time, an hour or two before sunset.[16]

Winthrop's pamphlet, though obviously influential in publicizing the picture, did not escape the scathing private notice of George Templeton Strong, who wrote in his diary for 5 May 1859: "Theodore Winthrop has been writing the most polysyllabic pamphlets about Church's picture, like the ravings of Ruskin in delirium tremens."[17] The sardonic Strong thought well enough of the painting itself, calling it a "very splendid picture; it beats any landscape I ever saw." He added, "But I don't believe it merits all people say about it."[18] Nonetheless, the outpouring of written praise for the canvas was immense, establishing it once and for all as Church's most famous work.

There is a touching and illuminating footnote to the story. Just as the concert of praise was rising, Church wrote to his friend Bayard Taylor, the famous poet, world traveler, and travel writer, who was an acquaintance of the aged Baron von Humboldt:

> The picture "draws" famously—an artist is amply rewarded when he finds his pictures giving so much pleasure to cultivated people— As the "Andes" will be on its way to Europe before you return to the City—I take the liberty of asking you to bear in mind your kind promise to give Mr. McClure [Church's European agent] a note to your Noble Correspondent Baron Humboldt. Mr. McClure's principal motive in taking the picture to Berlin is to have the satisfaction of placing before Humboldt a transcript of the scenery which delighted his eyes sixty years ago and which he has pronounced to be the finest in the world.[19]

Although the picture was shown successfully in London, it never made the trip to Berlin, possibly for the unhappy reason made clear in Church's next letter to Taylor, written just over a month after the previous one: "I had scarcely finished reading it [a letter from Taylor] when a friend communicated the sad intelligence of Humboldt's death—I knew him only by his great works and noble character but the news touched me as if I had lost a friend—how much more must be your sorrow who could call him a friend."[20] Humboldt had died in Berlin on 6 May, three days before Church's first letter to Taylor.

<div align="right">J.K.H.</div>

Notes

1. Douglas Botting, *Humboldt and the Cosmos* (New York and London: Harper and Row, 1973), p. 285.
2. Isabella F. Judson, *Cyrus W. Field, His Life and Work* (New York, 1896), pp. 51–52.
3. Ibid., p. 54. For a full description of the trip, see Huntington 1960, pp. 97–114.
4. Church, in Guayaquil, to A. C. Goodman, in New York, 27 May 1857, Church Archives.
5. Ibid.
6. Church, in Quito, to A. C. Goodman, in New York, 24 June 1857, Church Archives.
7. Spassky 1985, pp. 269–75, provides a detailed entry on the painting and lists related sketches.
8. Ibid., p. 269, quotes diary in Church Archives.
9. *Cosmopolitan Art Journal* 3 (March 1859), p. 87. Cited in Huntington 1960, p. 106.
10. Kevin J. Avery, "*The Heart of the Andes* Exhibited: Frederic E. Church's Window on the Equatorial World," *The American Art Journal* 18 (1986), pp. 52–72, provides new and complete information on the exhibition of *Heart of the Andes* in New York and elsewhere. For mention of Whitlaw in 27 April 1859 *New York Post*, see p. 58; p. 70, n. 42.
11. Ibid., p. 58; p. 70, n. 41.
12. Ibid., p. 54, quotes *New York Times*, 28 April 1859, p. 4.
13. Rev. Louis L. Noble, *The Heart of the Andes* (New York, 1859), pp. 6–7.
14. Ibid., p. 24.
15. Winthrop, *Companion* (New York, 1859), p. 6.
16. Ibid., p. 13.
17. Nevins and Thomas 1952, 2, p. 450.
18. Ibid., p. 451.
19. Church to Taylor, 9 May 1859. Cornell University Regional Archives, Bayard Taylor correspondence, Letter no. 1.
20. Church to Taylor, 13 June 1859. Ibid., Letter no. 2.

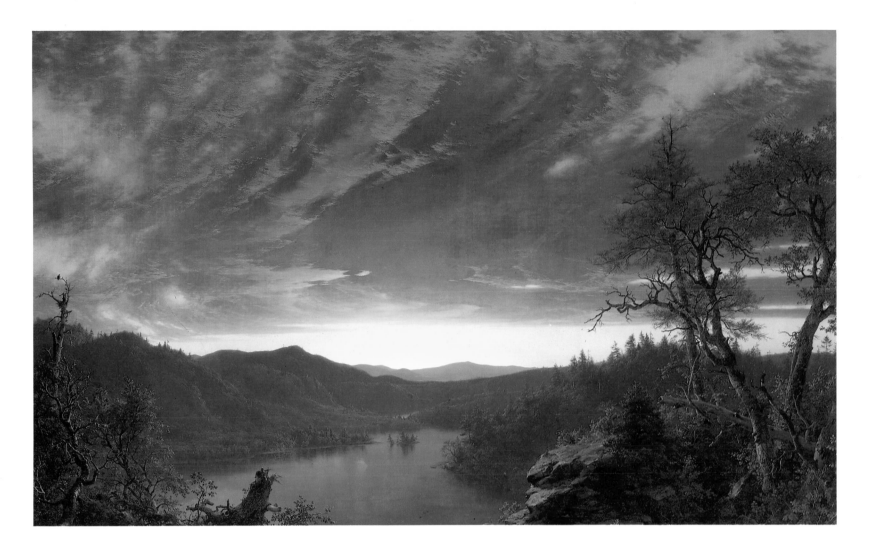

Twilight in the Wilderness, 1860

Oil on canvas, 40 × 64 in. (101.6 × 162.6 cm.)
Signed and dated at lower right: F.E. Church . 60.
The Cleveland Museum of Art, Mr. and Mrs. William H. Marlatt Fund
 (CMA 65.233)

Americans have been for at least a hundred and fifty years a nation fascinated and often intoxicated with the alluring and haunting beauties of unspoiled nature. That was not always so intensely the case when the arduous work of establishing coastal farms, settlements, villages, and cities took precedence over relishing the aesthetics of nature and pondering the meaning of the land that lay beyond the sunset. By the mid-nineteenth century, however, with easier times, attitudes changed. Americans were secure enough to be able to indulge themselves in their love of the land, as they demonstrated by eagerly welcoming the novels of James Fenimore Cooper, the exploration records of Lewis and Clark, Benjamin

Silliman's influential publications and his lectures on science and natural history at Yale, the topographical descriptions of N. P. Willis, the idyllic Catskill views by Thomas Cole, and Thoreau's *Walden*, which they devoured when it appeared in 1854. Those persuasive products of the eastern, mostly urban milieu prepared the ground for the work of almost countless followers of Cole's— painters who traveled on foot, by stagecoach, boat, and train into the woods, pencil in hand, to capture nature undefiled. The best of them, who included Durand, Church, Cropsey, Kensett, Gifford, and Whittredge, produced scenes of the virgin forests and of the land undergoing sometimes violent transformation through timbering, settlement, farming, the laying of railroad lines and roads, and the establishment of villages and towns. The homestead in the wilderness became a regular theme in the hands of Cole and his followers, a familiar and predictable one for landscape painters working in a society torn between love of land and nature and the need to dominate them both in an almost heedless quest for more land and greater wealth. Such pictures could be, probably should be, accepted as corrective object lessons.

 Twilight in the Wilderness, the single most impressive exam-

ple of Church's depictions of unsullied North American woodlands and their most famous representation in nineteenth-century painting, is the culmination of his production of many such theme pictures. With fortuitous timing, Church completed and exhibited the picture in New York in June 1860 to a nature-loving public that was deeply apprehensive about the future of the nation, and, by extension, their beloved landscape. *The Albion* greeted the painting with an appreciative and precise description:

> Mr. Church has finished yet another landscape of some importance, which is now exhibiting at Goupil's rooms in Broadway on the corner of Ninth Street. The new picture is very appropriately called *Twilight in the Wilderness*. We look up a valley in a wild and mountainous country, down which flows a broad and placid stream. There are high hills on either side, and the horizon is bounded by a mountain range which runs directly across the course of the little river. The time is about ten minutes after the disappearance of the sun behind the hill-tops. The air is clear and cool; the whole landscape below the horizon lies in transparent shadow; but the heavens are a-blaze. A-blaze, except a luminous belt stretching round the horizon of gradually varying tint, which passes from silvery white to the faintest blue to the tenderest apple-green, and into which the distant mountains thrust their broad, rich purple wedges. From this clear zone of tender light the clouds sweep up in flaming arcs, broadening and breaking toward the zenith, where they fret the deep azure with dark golden glory. The pines here and there show their sharp black points against the sky; the stream gives back a softened, vague reflection of the splendour which glows above it: the stillness of twilight and the solemnity of undisturbed primeval nature brood upon the scene; and that is all the picture. It is not one of Mr. Church's largest works; but one of his very best.[1]

The critical reception of the picture, though overwhelmingly favorable, was not unmixed. The *Cosmopolitan Art Journal* (organ of the commercially interested Cosmopolitan Art Association) issued the tart and purblind comment that the painting was "unworthy of the artist, being a mere piece of scene painting, which it was a vanity to exhibit."[2]

Whether the picture, so magnificent in its presentation of nature in its purity, quivering between light and dark, was meant as a religious statement or political comment, whether triumphantly celebrating a godly aurora or sadly presaging an impending conflagration, is a moot point, since Church is not known to have prepared a written program of meaning for this picture.

Because of its vividness and strong composition—indeed, its gripping theatricality and expressiveness—*Twilight in the Wilderness* stands as an early signpost central to the landscape preservation movement in this country and anticipating the extraordinary popularity of outdoorsmanship, as well as the establishment of our system of national forests and parks. Based upon many sketches made during the 1840s and 1850s, the scene is almost surely a composite of northeastern locations, but most particularly in the state of Maine, where Church traveled often in the role of hiker, camper, tourist, and outdoors artist. As early as 1844, Church visited Mount Desert Island, particularly the neighborhood of Bar Harbor (then called Eden), in company with his mentor, Thomas

Cole. That trip and its artistic results have been credited with establishing Bar Harbor as an artists' haven and a summer resort.[3] Church subsequently revisited Mount Desert in 1850, 1851, 1854, 1855, 1856, 1860, and perhaps more often, before completing *Twilight in the Wilderness*.[4] During those same years, when Church was busily discovering and recording the beauties of Mount Desert, he also made even more arduous explorations of remote north central Maine, especially the environs of Mount Katahdin, the state's highest mountain, which rises commandingly, like a lonely sentinel standing over the region. Church may have been the first artist to visit and paint Mount Katahdin.[5] Prior to executing *Twilight*, Church made the difficult pilgrimage to Mount Katahdin during at least five summers between 1850 and 1856.[6] A major result of those trips was his *Sunset* of 1856 (ill.). The collections of both Olana and the Cooper-Hewitt Museum in New York City contain numerous pencil, wash, and oil sketches of the Mount Desert and Mount Katahdin regions, and the records of exhibitions at the National Academy of Design show a generous number of Maine canvases. (Long afterward, in 1880, Church purchased a camp near Katahdin on Millinocket Lake, and was a regular vacationer there.)

In 1848, Church, not long removed from Cole's studio and yet only twenty-two years old, took William James Stillman as his first student in painting. Stillman, later co-founder of *The Crayon*, a friend of Ruskin's, and a staunch defender of the Pre-Raphaelite movement in America,[7] was a dedicated outdoorsman and camping enthusiast; on one well-known occasion, he was with, and painted a view of, a party numbering among its members Ralph Waldo Emerson that in 1858 went camping in a distant and unspoiled part of the Adirondacks.[8] The almost cathedral solemnity of *Twilight in the Wilderness* is evidence of the seriousness and intensity of Church's love for remote forest tracts, but it was a devotion that was mixed with pleasure, fun-seeking, and amusement. Witness a letter, making preparations for a lark in the woods, that he wrote to his good friend John F. Kensett on 23 June 1855:

> I think my best course will be to join you at Conway whither I will turn my face next Tuesday . . . can't you induce Suydam & Champney to join us? Regarding maps—I have a fine one of New Hampshire and a *hugeous* one of Maine, with all the lakes, mountains, rivers, brooks, towns, villages, hamlets, houses, sheds and pig styes all portrayed a *leetle* under the size of the originals. We have nothing more to desire in the map way.
>
> I propose that we strike East-ward from Conway taking as direct a course as possible for Ktaadn. What say you? At any rate I hope to see you next Wednesday when we will give the matter a brief discussion.[9]

Later that summer, Church and his two sisters joined a sizable group that included Theodore Winthrop and Charles Tracy, a lawyer from New York, for a delightful exploratory holiday on Mount Desert. Mount Desert is one of the most beautiful and varied landscapes in America, combining mountains, glacial fjords, forests, lakes, and streams, bounded entirely by rocky shores and the bracing Atlantic Ocean. Church reveled in every aspect of wea-

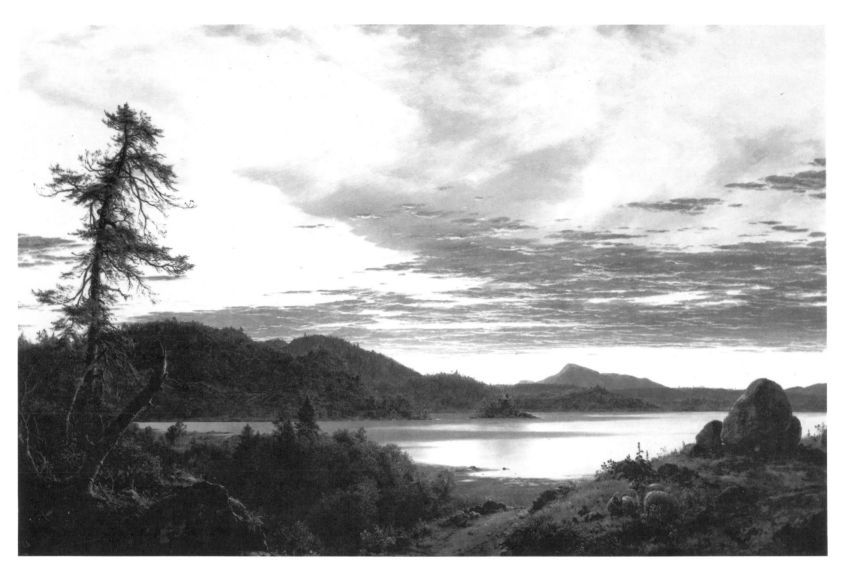

Frederic E. Church, *Sunset*, 1856, oil on canvas, 24 x 36 in. (61 x 91.4 cm.). Collection of Munson-Williams-Proctor Institute, Museum of Art, Utica, New York

ther, topography, vegetation, and animal life, setting them all down perfectly in his sketches. Tracy's surviving logbook is the other record of the trip, which was filled with serious work in the field for Church and music, games, fishing, hiking, and high jinks for all.[10] In the summer of 1856, Church and Winthrop returned to the Maine woods for a trip by train, wagon, steamboat, canoe, horse, and foot back to Katahdin. Winthrop's posthumously published account of the trip, *Life in the Open Air*,[11] is an extended hymn of praise to the aspect, pleasures, and underlying meanings of the North American forest tracts still undisturbed by the hand of man. As Winthrop wrote:

> [Church and I] both needed to be somewhere near the heart of New England's wildest wilderness . . . that was the great object of our voyage—Katahdin and a breathless dash down the Penobscot. And

while we flashed along the gleam of the river, Iglesias [Church] fancied he might see the visible, and hear the musical, and be stirred by the beautiful. These, truly, are not far from the daily life of any seer, listener, and perceiver; but there, perhaps, up in the strong wilderness, we might be recreated to a more sensitive vitality.[12]

The trip was clearly essential to Church's careful process of arriving at the finished *Twilight in the Wilderness*.

The blazing sky, comprising subtly graded tones from deep purple through oranges to dazzling yellow, is the most impressive element in this attention-demanding picture. Many commentators have noted the influence of works by J. M. W. Turner and John Martin on Church; they, and possibly other visionary English painters such as Francis Danby, helped Church on his own visionary route. It is important to add as a technical note that just as he was working on *Twilight in the Wilderness*, Church purchased paints particularly suited to his current purpose. In a letter to Thomas B. Lawson of Boston, an artists' supplier, Church wrote: "I have just received from Boston the madder lake which you was

[*sic*] kind enough to put up for me—also the stone yellow which looks finely—I have not tried it yet—I expect to do a great deal with your incomparable lakes—I don't use much Indian red, yet should like to see a superior article and thank you for the suggestion."[13] Church took what seem to have been ordinary paints and transformed them into an unforgettable vision.

<div align="right">J.K.H.</div>

Notes

1. "Fine Arts," *The Albion*, 9 June 1860, p. 273. The quoted passage was found by Franklin Kelly during the course of his research for "Frederic Edwin Church and the North American Landscape, 1845–60," Ph.D. diss., University of Delaware, 1985.
2. *Cosmopolitan Art Journal* 4 (1860), p. 126.
3. Richard Walden Hale, Jr., *The Story of Bar Harbor* (New York: Ives Washburn, 1949), p. 126.
4. For listings of visits, see Huntington 1960; Huntington 1966.
5. Huntington 1966, pp. 29–30.
6. Ibid., pp. 29, 128–29.
7. Ferber and Gerdts 1985, pp. 277–78.
8. See William James Stillman, *Autobiography of a Journalist*, 2 vols. (Boston: Houghton Mifflin Co., 1901), 1, pp. 199–216, 236–47, 249–66, 285–87. Stillman's painting, *The Philosopher's Camp*, is in the Concord (Mass.) Free Library.
9. Letter from Church, in Hartford, Conn., to Kensett, in Conway, N. H., 23 June 1855. Edwin D. Morgan Collection, New York State Library, Albany.
10. Charles Tracy, Logbook (Mount Desert Island, Maine, 1855). Original ms. in J. Pierpont Morgan Library, New York; copy in Jesup Library, Bar Harbor, Maine. See Huntington 1960, pp. 50–54, for a discussion of the outing.
11. Theodore Winthrop, *Life In the Open Air* (Boston: Ticknor and Fields, 1863).
12. Quoted in Huntington 1960, p. 58, where illuminating and extensive quotes from Winthrop and commentary on the trip are provided.
13. Letter from Church, at No. 15 .10th Street, New York City, to Thomas B. Lawson, in Boston, 11 January 1860, Church Archives. The Cleveland Museum of Art kindly provided a copy of the letter, as well as technical reports from the Research Laboratory of the Museum of Fine Arts, Boston, that confirm the presence of lead white, vermilion, red lead, red lake, strontium yellow, chrome yellow, cadmium yellow, chrome green, green earth, earth colors, umber, artificial ultramarine, and Prussian blue on the canvas.

Cotopaxi, 1862

Oil on canvas, 48 × 85 in. (121.9 × 215.9 cm.)
Signed and dated at lower right: F. E. CHURCH/1862
The Detroit Institute of Arts, Detroit, Michigan. Founders Society Purchase, with funds from Mr. and Mrs. Richard A. Manoogian, Robert H. Tannahill Foundation Fund, Gibbs-Williams Fund, Dexter M. Ferry, Jr., Fund, Merrill Fund, and Beatrice W. Rogers Fund

In a manner surely more careful, thoughtful, and artistically punctilious than that of any of his landscapist colleagues, Church traveled extensively, took down voluminous, annotated visual records, and cogitated long and thoroughly before arriving at final determinations of subjects, compositions, and details for his finished paintings. With the aid of sketches he had brought back from his trips through the Ecuadorian Andes in 1853 and 1857, Church created his great series of Andean pictures, especially the arresting *Heart of the Andes* of 1859 (see p. 246), which established him as the painter par excellence of the genre, and the imposing *Chimborazo* of 1864 (see p. 259), which completed the group.

From near the beginning of his 1853 trip until well after the completion of *Heart of the Andes*, the artist had clearly been held in an almost hypnotic trance by the idea for a grand view of Cotopaxi, that seething, 19,347-foot-high volcanic mass.[1] When confronting the reality of Cotopaxi, one of the world's most imposing mountains, one can understand why. Exceeded in height among the Ecuadorian Andes only by Chimborazo (20,561 feet) and rivaled in volcanic activity only by Sangay (17,159 feet), Cotopaxi is remarkable for its isolated grandeur, symmetry of form, and boisterous volcanic life within a seemingly motionless and water-clear atmosphere, all done full justice in Church's depiction.[2]

An early oil sketch of the mountain completed by Church in 1853 was succeeded by a host of sketches and finished views taken from different aspects. In 1855, he produced a *Cotopaxi* (Fig. 1), which was executed for his friend and traveling companion Cyrus Field. It was to be followed over the next twelve years by a series of sketches and completed versions—including this *Cotopaxi* of 1862—of varying dimensions, all presenting the mountain, often hissing forth a great sulfurous plume, and its neighbors flanking the elevated rift valley of Ecuador.

In reviewing his letters home and the diary he kept during the 1853 trip,[3] it becomes obvious that Church found his pictorial goal in the Andean highlands after progressing southward and upward from the steamy, relatively populated lowlands around the Rio Magdalena. Calm but interested comments about the Magdalena's "luxuriance of vegetation, magnificent trees which spread out their immense branches to a prodigious extent,"[4] are replaced by more excited remarks about the "marvellously beautiful and picturesque"[5] scenery around Popayán in New Granada [Colombia], leading to an outburst of enthusiasm at the country encoun-

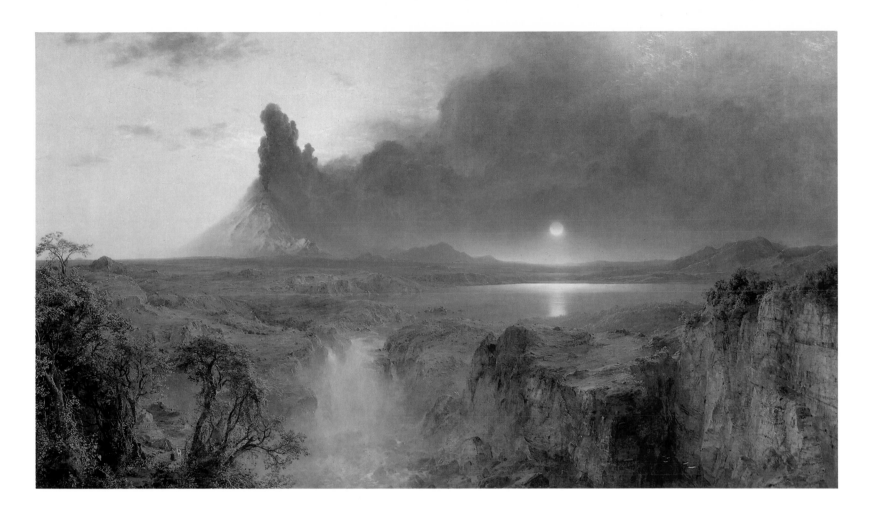

tered just below the border between New Granada and Ecuador, looking south toward the Quito valley:

> After a disagreeable journey across an elevated plain with a cold piercing wind and a sprinkling of rain we finally came to the edge of an eminence which overlooks the valley of the Chota. And a view of such unparalleled magnificence presented itself that I must pronounce it one of the great wonders of Nature. I made a couple of feeble sketches this evening in recollection of the scene. My ideal of the Cordilleras is realized.[6]

From that memorable spot south to Quito and beyond to Cotopaxi is less than a hundred miles through a mountainous avenue in which Church roamed delightedly for the next several weeks. He spent a week in and about Quito, where he was "more and more pleased with the picturesque views,"[7] one of which he took down in a small sketch, called "A view of Cotopaxi from the Hacienda San Antonio," on 30 August.[8] By 9 September, he had moved to Machachi, between Quito and Cotopaxi, encountering there "fine and near views of several snow peaks including Cotopaxi."[9] The next day, he arrived at the village of San Juan that is west of Cotopaxi. As he wrote, "After a pleasant journey we reached this place [the hacienda of one Señor Larrea] which has a commanding view of Cotopaxi. Our journey today was over the

base of the mountain but unfortunately it was obscure with clouds."[10] It is evident from Church's diary that throughout the trip clouds were a regular interrupter of good views and, hence, of sketching. Not until two days later was he rewarded: "Waited patiently all day for the clouds to disappear from the summit of Cotopaxi and about sunset had the satisfaction of a partial view which was magnificent. Took a slight sketch."[11] Church's path then took him south to Riobamba and about for views of Chimborazo, then to Guayaquil on the coast and the return voyage to New York.

Between 1853 and his second trip to Ecuador, in 1857, Church produced several fine, accomplished depictions of Cotopaxi, which present a relatively quiescent cone set in calm landscape compositions that reflect in some cases the more closed arrangement (Fig. 2) of *Heart of the Andes*; in others (Fig. 3), the more spacious composition of this, the mature *Cotopaxi* of 1862. None of them, however, suggests the agitation and high drama that are crucial to the 1862 masterpiece.

Church's return in the summer of 1857 with Louis Rémy Mignot was a brief visit, allowing less than two months of travel and work concentrated in the Quito–Riobamba region.[12] Church found Cotopaxi to be in a stridently different mood from before:

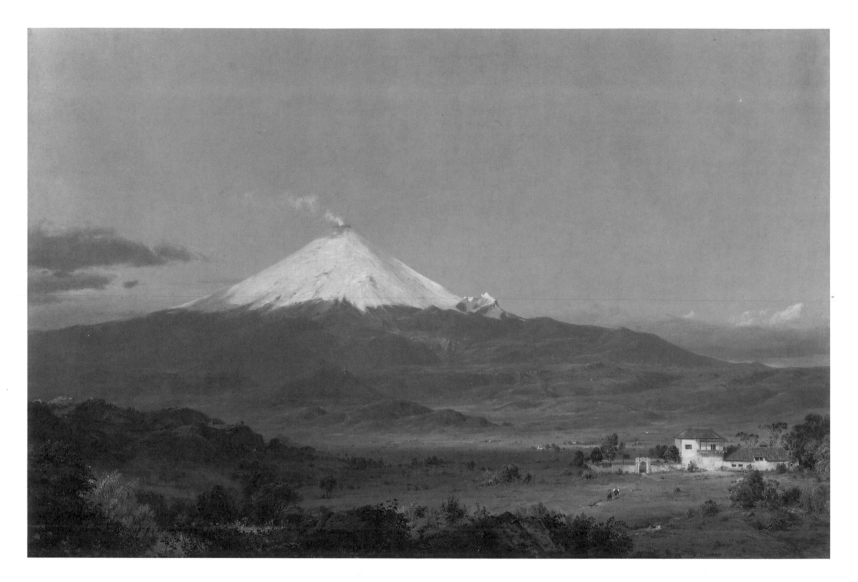

Figure 1. Frederic E. Church, *Cotopaxi*, 1855, oil on canvas, 28 x 42⅛ in. (71.1 x 107 cm.). National Museum of American Art, Smithsonian Institution, Gift of Mrs. Frank R. McCoy (1965.12)

it was in continuous eruption, producing immense belches of smoke and debris that caught and held the artist's attention. To a friend in New York, he wrote: "Cotopaxi has got to be a confirmed old smoker. Three years ago there was a grand eruption and since then it has done nothing but smoke and spit—fire and stones. Cotopaxi is but a few leagues from Quito and we have the benefit of its respectable presence."[13] Church had heard descriptions of how frightened the natives had been after a three-day eruption of the volcano the previous December, which doubtless added to his sense of excited involvement with the mountain.[14] The new experience of Cotopaxi transformed Church's perception of it, as exemplified in a bold view (Fig. 4) dated 1857, which shows the fulminating orange and brown plume of smoke streaming in high contrast before a brilliant, crystalline sky. Together, the apex and

its great smoke dominate the landscape, and, with them, a new visual drama enters the Cotopaxi paintings,[15] setting them apart from the restrained presentation of *Heart of the Andes*.

In 1861, Church painted an oil study of Cotopaxi (Fig. 5) that established a revised composition and content for the superb picture of the following year: a wide horizontal format, evenly divided into two zones of sky and earth, with mountain and smoke at left, hazy sun rising over the lake at right, and a deep chasm in the foreground separating the viewer from the distant scene.[16] This, the greatest of the *Cotopaxi*s, commissioned by the New York benefactor James Lenox, has been recognized ever since its completion as one of Church's finest works and certainly the most apocalyptic in mood. Church's friend the Reverend Louis LeGrand Noble prepared a manuscript for a pamphlet, apparently never published, similar to that he produced for *Heart of the Andes* and meant to accompany public exhibition of the picture.[17] The words therein are certainly a close rendering of Church's feelings and intentions. Noble locates the scene:

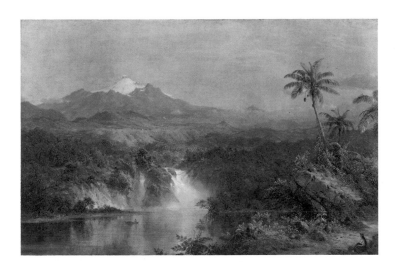

Figure 2. Frederic E. Church, *View of Cotopaxi*, 1857, oil on canvas, 24½ x 36¼ in. (62.2 x 92.1 cm.). The Art Institute of Chicago, Gift of Mrs. M. J. Hamlin (1919.753)

3. Church Archives contain original letters and copies of Church correspondence in other collections.

4. Church, on the Rio Magdalena, to Joseph Church, in Hartford, Conn., 16 May 1853. Courtesy, Henry Francis du Pont Winterthur Museum, Joseph Downs Manuscript Collection, No. 57X 18.33.

5. Church, at Popayán, New Granada, to his sister Charlotte Church, 8 August 1853. Courtesy, Henry Francis du Pont Winterthur Museum, Joseph Downs Manuscript Collection, No. 57X 18.39.

6. Diary entry, Friday, 26 August 1853, Church Archives.

7. Ibid., Monday, 5 September 1853.

8. Sketch in the Cooper-Hewitt Museum, 1917-4-94. Illustrated and discussed in Manthorne 1985, no. 25.

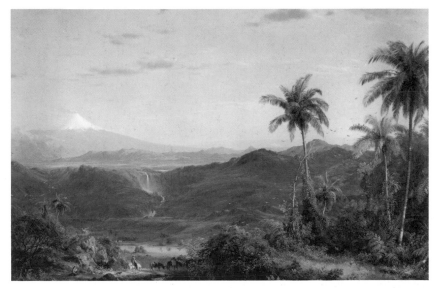

Figure 3. Frederic E. Church, *Cotopaxi*, 1855, oil on canvas, 30 x 46⁷⁄₁₆ in. (76.2 x 118 cm.). The Museum of Fine Arts, Houston, The Hogg Brothers Collection, Museum Purchase by exchange (74.58)

The neighboring valleys of La Tapia & Quito, in the former of which . . . are the finest of the Andes, & among them the most extraordinary in the world. . . . In the present aspect & condition of these high valleys, so magnificently cradled, we view the manifold results of those gigantic, last upheavals, accomplished by the vast central forces—forces which still continue to manifest their existence below by frequent agitations of the surface, & volcanic eruptions. Earthquakes convulse, lavas overwhelm, waters wash and excavate, gather in . . . the hollows & abysses, rush through fissures & over precipices, clouds & electricity storm the summits, tropical sunshine touches all with warmth & brightness. Hence that marvellous mingling of the Seasons—Spring, Summer & Autumn, below & all around—above, the arctic Snows. Hence that picturesque variety of wild Steeps & Cliffs, & hill & dale, broad plains & broken tracts, torrents, lakes & rivers, gorges, rocks & cataracts. And hence those shocks & thunders that alarm, & those sheards of flame that redden the night, & the black, smoky columns that pillar the blue vault of heaven.[18]

When *Cotopaxi* was exhibited in London in 1865, W. P. Bayley, a sensitive critic and an admirer of Church's work, expressed his interpretation of the painting: "The scene impresses the mind as one of those rocky solitudes that have maintained their present aspect since the last disruption of the surface, when the world was many thousands of years younger than it now is."[19] That was the image Church hoped to have his canvas convey.

J.K.H.

Notes

1. See Manthorne 1985, in which the picture is fully discussed and which includes an essay by Richard S. Fiske and Elizabeth Nielson, "Church's *Cotopaxi*: A Modern Volcanological Perspective."

2. Altitudes given for Cotopaxi, Chimborazo, and Sangay come from *Webster's New Geographical Dictionary*.

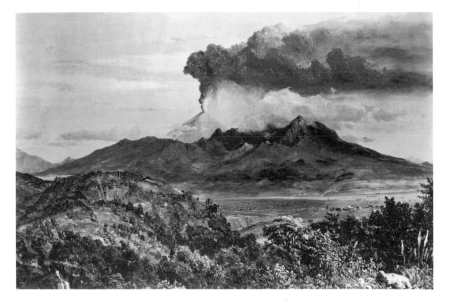

Figure 4. Frederic E. Church, Study for *Cotopaxi*, 1857, oil on academy board, 13½ x 22 in. (34.3 x 55.9 cm.). Collection of Mr. and Mrs. Stuart P. Feld

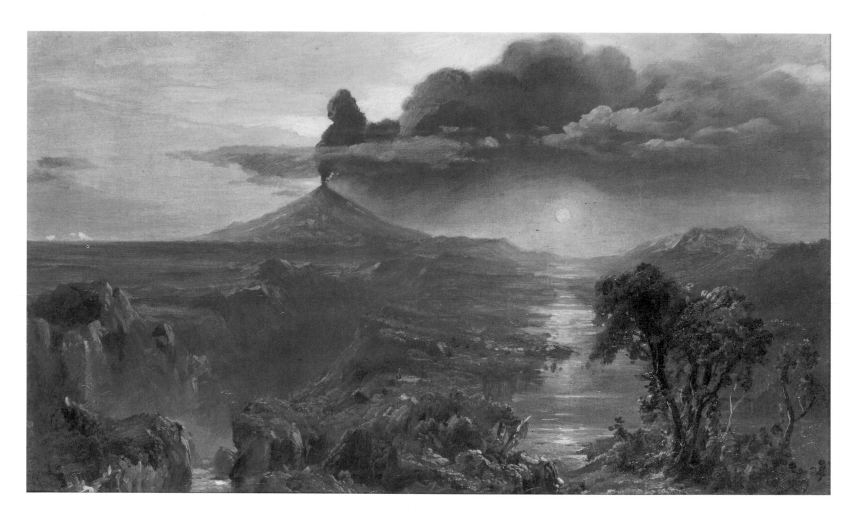

Figure 5. Frederic E. Church, Oil sketch for *Cotopaxi*, 1861, oil on canvas, 9 x 13 in. (22.9 x 33 cm.). Collection of Nelson Holbrook White

14. Manthorne 1985, p. 45, quotes Church's letter.

15. *Cotopaxi*, 1857, oil on academy board, 13½ × 22 in. (34.3 × 55.9 cm.). Collection of Stuart P. Feld, New York City. See Manthorne 1985, no. 7; pl. IV.

16. *Oil Study for Cotopaxi*, 1861, oil on canvas, 7¼ × 12 in. (18.4 × 30.5 cm.). Collection of Nelson Holbrook White, Waterford, Conn. See Manthorne 1985, no. 9; fig. 25.

9. Diary entry, Church Archives.

10. Ibid., Saturday, 10 September 1853.

11. Ibid., Monday, 12 September 1853.

12. Huntington 1960, pp. 97–105, gives the Church–Mignot itinerary.

13. Church, in Quito, to A. C. Goodman, in New York City, 24 June 1857, Church Archives.

17. Louis LeGrand Noble, "Cotopaxi, A Picture By Frederic E. Church, Painted from Studies made in the summer of 1857." Ms. in Church Archives. Printed in its entirety in Manthorne 1985, pp. 60–64.

18. Ibid., p. 61.

19. W. P. Bayley, *Art-Journal* 26 (August 1865), p. 257.

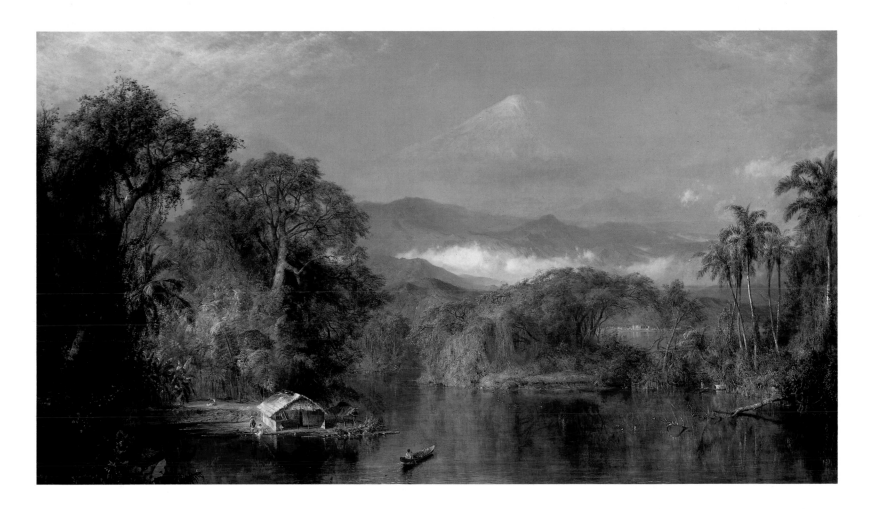

Chimborazo, 1864

Oil on canvas, 48 × 84 in. (121.9 × 213.4 cm.)
Signed and dated at lower right: F.E. CHURCH/1864
Museum of Fine Arts, Boston. On loan from a private collection

Church was fascinated, even spellbound, by the bold juxtaposition of the dominating peaks of the Andes and the throbbing density of the lowland tropical jungles he traversed going to and from the Ecuadorian highlands. *Chimborazo* was the artist's ultimate presentation of these dramatic and, for North American and European viewers, exotic relationships that were noted by the English critic W. P. Bayley, who wrote about the painting when, more than a year after its completion, it was shown in London in company with *Cotopaxi* (see p. 254) and the recently finished *Aurora Borealis* (Fig. 2.26, p. 43):

> Here are trees, gigantic, yet of a light grace, garlanded to the top with drooping parasites; old aristocrats of the woods overrun and borne down by a whole democracy of climbing plants; an infinite entanglement and confused embracement of sylvan greatness and loveliness. . . . It is a scene of wild, weird, Indian loveliness. The river flows by, all fresh and lively with mountain floods and rains, playing filmily with the reflections of these astonishing growths. . . . Yet we should scarcely like to remain there long; for all looks humid and hot, as if the place would, very likely, soon sweetly insinuate an ague, or marsh fever. A spur of the Cordilleras, immediately above, shines forth, one low long ridge of golden light too splendid for this moist air below; but around it is a wide diffusion of transparent vapour, within which some higher peaks, flushed with rose tints, appear, or lose themselves in a delicate mystery of aerial colours of surpassing loveliness. . . . But where is Chimborazo? Oh, it is far above, islanded in the soft blue of the upper heavens, above an expanse of this sky-like vapour, like a dome of tender sunny cloud, a thing entirely pertaining to heaven, and having nothing whatever to do with earth, but to present it with an image of heavenly peace, an object to inspire heavenly fancies, and yearnings.[1]

The same writer took great occasion to lavish praise on Church as being "the very painter Humboldt so longs for in his writings; the artist who, studying, not in our little hot-houses, but in Nature's great hot-house bounded by the tropics, with labour and large-thoughted particularity parallel to his own, should add

Figure 1. Map of Ecuador, 1858, paper, 32⅜ x 43¾ in. (82.2 x 111.1 cm.). New York State Office of Parks, Recreation and Historic Preservation, Olana State Historic Site (OL.1984.369)

a new and more magnificent kingdom of Nature to art, and to our distincter knowledge." In commenting that some important English artists condemned Church's "minute precision" of handling, he hotly responded, "Our present painters, having little perception of beauty of form, but more observance of general effects of light and shadow, probably see nothing but obscure intricacy, where an eye like Mr. Church's would trace out distinct and orderly shapes of loveliness, and systems of lines." According to Bayley, Church had "taken up the pencil of our great Raphael of landscape, Turner," and was "adding to the beauty and magnificence of the whole, greater precision and completeness of detail."[2]

With its preceding *Heart of the Andes* and *Cotopaxi* (see pp. 246; 254), *Chimborazo* forms the grand coda to what was recognized by contemporaries as a consciously constituted trilogy. In early April 1863, even as *Chimborazo* was still on the easel, a critic so grouped the pictures: "The three are a series. They are parts of a whole in the painter's design, which is evidently nothing less than an epic of the Tropics in color."[3] That tropic-epic theme has been reiterated by students of Church's work, most persuasively by David Huntington, who characterized and contrasted the three compositions: *Heart of the Andes*, as a great summation of the book of nature; *Cotopaxi*, as a presentation of "the natural Armageddon"; *Chimborazo*, as "Church's ultimate in cosmic pastoral landscape."[4]

Church's encounters with the great domed mountain that became the centerpiece of *Heart of the Andes* began in September of 1853 as he journeyed south from Quito to see the greatest concentration of Ecuador's mountains (Figs. 1; 1a). On 10 Sep-

tember, though he was preoccupied by the nearer presence of Cotopaxi, Chimborazo was well within his line of vision. Church and his traveling companion, Cyrus Field, continued their journey south and east of Chimborazo and, on 14 September, "arrived here [Riobamba] this afternoon after a long ride of 12 or 13 leagues but the latter part of the journey had a fine and near view of Chimborazo from the base up. Riobamba is magnificently situated being surrounded with snow peaks and high mountains."[5] The next few days afforded Church the opportunity to make a variety of studies, including a "slight sketch of Chimborazo,"[6] before he moved to the village of San Juan that lies almost directly beneath Chimborazo, where he commented that "the views near Riobamba are much better."[7] Church and Field then made their landward way via Guaranda to the river-braided plains and embarked on the placid Rio Yaguachi for the sail down to the coastal city of Guayaquil, the end of their first Ecuadorian visit. Church's second trip to Ecuador, in 1857, which focused on the high peak region south of Quito, began with his return to Guayaquil in late May. A trip upriver brought him directly to Mount Chimborazo for two weeks of intensive sketching in the neighborhoods of Guaranda, southwest of the mountain, and Mocho, to its northeast. In the

Figure 1a. Map of Ecuador, 1858 (detail)

Figure 2. Frederic E. Church, Sketch for *Mount Chimborazo, Ecuador,* ca. 1857, pencil on paper, 10⅛ x 6¹⁵⁄₁₆ in. (25.7 x 17.6 cm.). Cooper-Hewitt Museum, Smithsonian Institution's National Museum of Design (1917-4-827)

next few weeks, which were occupied in voluminous sketching, Church proceeded north to Cotopaxi and Quito. He then returned south to Riobamba for further arduous work around Mount Chimborazo, a very trying and dangerous side trip to the rumbling Sangay, and, late in July, the final trip back to Guayaquil and thence home.

The collection of Church sketches at the Cooper-Hewitt Museum in New York City includes numerous dated and undated views of Mount Chimborazo, the region around it, and tropical river locations, all of which were preliminary necessities for the completion of the large *Chimborazo,* whose vantage point has been located as ". . . the banks of the River Guayaquil [Guayas], near the city of that name, and at the distance of a hundred miles from the mountain itself."[8] One undated sketch (Fig. 2) exemplifies the comprehensive care and precision Church consistently exercised in his work. It is a general plan of the mountain with coherent

areas neatly numbered and annotated and specific areas of color and texture listed.[9]

The problems of selling the canvas to a banker named Hallett were a plague to Church, who was not accustomed to dunning his patrons. His letters tell the tale. In one of March 1863 to his father, Church requested a loan to pay off the mortgage on his farm, saying, "I ought to have had the money myself and should if the man for whom I am painting Chimborazo (my new picture) had kept his agreement about payment. If he does not very soon come up to the mark I shall give the picture to someone else."[10] The senior Church quickly sent the requested funds.[11] Church continued work on *Chimborazo,* noting on 28 February 1864 that it was "all but finished and I have another large picture in progress and two or three small ones commenced."[12] Problems with his buyer continued, as Church later complained to his father:

The person for whom I painted my last picture — "Chimborazo" — has failed to meet his engagement. I have waited six weeks for him and get nothing satisfactory from him. I think that I shall be compelled to give the picture to someone else. As $3000 has been paid on the picture — I should be obliged just to repay that . . . I am

unusually short of funds—I have taken legal advice [from his Mount Desert and New York friend Charles Tracy] and am informed that the picture is really forfeited by the person for whom I painted it. I can probably get a much larger sum from others but that is nothing compared with the disappointment and annoyance of dealing with unprincipled people.[13]

Nevertheless, Church's financial problems must have been relatively minor, since in the same letter he cited plans to buy more land, lay out a new road, and do further building at Hudson. His problems with the sale of *Chimborazo* then began to move to a final resolution. As he wrote to his father:

I called on Mr. Osborn [William H. Osborn, Massachusetts-born railroad entrepreneur, philanthropist, and humanitarian then living in New York] who advises to pay off the $3000 paid on the picture with interest and then leave the whole thing to him—he has some friends in England who want some of my pictures and he is confident that I can sell the picture for pounds which will be very much better for me in every respect. At any rate Mr. Osborn is anxious to have me leave the matter to him and as he is one of my best friends I have concluded to do so.[14]

For Church, the sturdy English pound had a stronger appeal than the war-battered American dollar.

Within a month, however, Church sent word to Osborn:

I promised to let you know when the matter was settled between Hallett and myself relative to the picture. I failed to see Mr. Tracy when I was in New York as he was out of town; but communicated with him, with the request that he would bring the matter to a prompt decision. The consequence is that Mr. Hallett has finally paid the amount due and therefore the picture has gone into his possession. I should have liked to have had the picture go to England for various reasons, but it can't be helped. Of course, the way Hallett has managed, rather mismanaged the affair has made it cost me a good deal. If he had paid promptly according to agreement the money would then have been nearly as good as gold and I should have made some improvements in the building way on my place which I cannot now afford to do.[15]

By some avenue yet to be documented, *Chimborazo* shortly found its way into the welcoming hands of the ever-supportive Osborn. Because it was a treasured part of a private collection, *Chimborazo* was not prominently exhibited to the public after the London display of 1865 until the Centennial Exposition in Philadelphia in 1876. The official government report on that exhibition, published in 1880, criticized the picture in condescending terms that make it painfully evident that Church's work was considered decidedly out of fashion:

Mr. Church contributed his "Chimborazo," which, while it is representative of his peculiar style, is not one of his best works: it is not equal to his "Niagara" or "Heart of the Andes." . . . Mr. Church views the landscape with the cool deliberation of the scientist rather than with the intensity of the artist. . . . "Chimborazo" is one of a series of pictures the materials for which were sought in another continent; and the extraordinary enterprise manifested by this artist in visiting remote latitudes in search of subjects for his pencil was

a feature of his art that has since found numerous imitators. But Mr. Church is not insensible to the fact that all the materials requisite for great art may be found always near at hand, and even among what is termed mere commonplace.[16]

Church, of course, reveled in the "mere commonplace" of nature, as his extremely beautiful late oil sketches amply demonstrate. Further, he would not have objected to being credited with "the cool deliberation of the scientist." He understood surely, as contemporary and later critics often did not, that the selection of natural elements and the arrangement of them in intricate yet lucid compositions such as *Chimborazo* was artistry. In Church's hands, it was a monumental artistry of a kind rarely equaled by any of his contemporaries, whether American or European.

J.K.H.

Notes

1. Huntington 1960, pp. 110–11, quoting W. P. Bayley, "Mr. Church's Pictures: Cotopaxi, Chimborazo, and the Aurora Borealis," *Art-Journal* 27 (September 1865), p. 265.
2. Ibid., pp. 265–66.
3. *Harpers Weekly* 7 (4 April 1863), p. 210. Quoted in Huntington 1960, p. 114.
4. Huntington 1966, pp. 52–54.
5. Diary entry for 14 September 1853, Church Archives.
6. Diary entry for 15 September 1853, Church Archives.
7. Diary entry for 16 September 1853, Church Archives.
8. W. P. Bayley, *Art-Journal* 26 (August 1865), p. 257.
9. *Chimborazo* sketch, 1917-4-827, Cooper-Hewitt Museum.
10. Church, in New York City, to Joseph Church, in Hartford, Conn., March [n.d.] 1863, Church Archives.
11. Church to Joseph Church, 6 April 1863, Church Archives.
12. Church to Joseph Church, 28 February 1864, Church Archives.
13. Church to Joseph Church, 13 May 1864, Church Archives.
14. Church, in Hudson, N.Y., to Joseph Church, in Hartford, Conn., 11 June 1864, Church Archives.
15. Church, in Hudson, N.Y., to Osborn, in New York City, 7 July 1864, Church Archives.
16. *United States Centennial Commission: International Exhibition, 1876*, 9 vols., Francis A. Walker, ed., *Reports and Awards*, vols. 3–8 (Washington, D.C.: Government Printing Office, 1880), 7, p. 26.

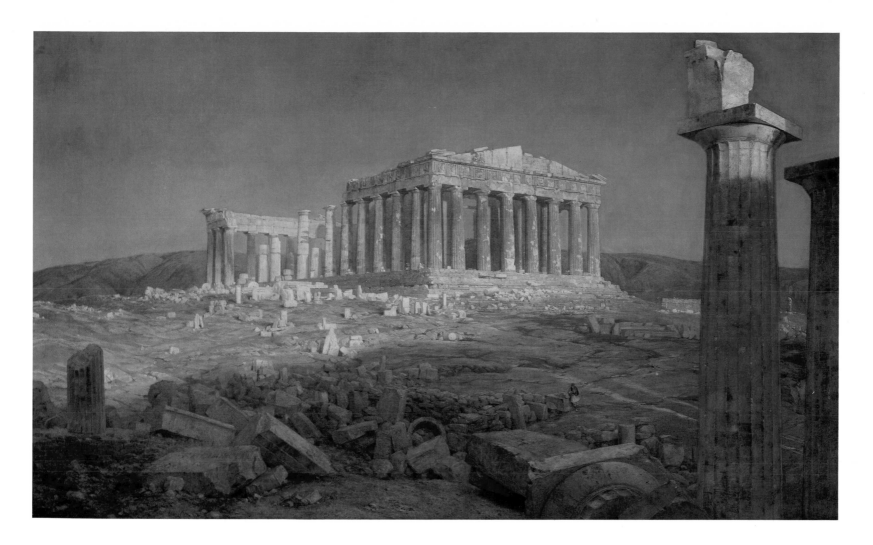

The Parthenon, 1871

Oil on canvas, 44½ × 72⅝ in. (113 × 184.5 cm.)
Signed and dated at lower left: F.E. CHURCH/1871
*The Metropolitan Museum of Art, New York City. Bequest of
Maria DeWitt Jesup, from the collection of her husband,
Morris K. Jesup, 1914 (15.30.67)*

Late in 1867, Church and his family began an extended, year and
a half Grand Tour that took them to England, France, Egypt,
Lebanon, Jerusalem, Syria, Turkey, Austria, Switzerland, and, fi-
nally, Rome, where they spent the fall and winter of 1868–69.
Church found Rome little to his taste. In April, after a sketching
trip south of the city, he left his family behind and sailed to Athens,
where he spent several weeks. As with many of the antiquities he
had seen in the Near East, Church was deeply impressed by the
ruins of Athens, especially the Parthenon, that architectural master-
piece built under Pericles during the fifth century B.C. From Athens,

in a letter to his intimate friend William H. Osborn, Church wrote
enthusiastically:

> The Parthenon is certainly the culmination of the genius of man in
> architecture. Every column, every ornament, every moulding asserts
> the superiority which is claimed for even the shattered remains of
> the once proud temple over all other buildings by man.
>
> I have made architectural drawings of the Parthenon and
> fancied before I came to Athens that I had a good idea of its merits.
> But in reality I knew it not. Daily I study its stones and feel its
> inexpressible charm of beauty growing upon my senses. I am glad—
> and shall try and secure as much material as possible. I think a great
> picture could be made of the ruins. They are very picturesque as
> well as imposing and the color is superb.[1]

In May, now in Paris but still in a state of excitement, he wrote to
his friend the sculptor Erastus Dow Palmer:

> I recently visited Greece—Athens—I was delighted—the Parthenon
> is a wonderful work of the human intellect—but it must be seen—no
> photograph can convey even a faint impression of its majesty and
> beauty—fragments of sculpture are strewn all about—and let me
> say that I think Athens is the place for a sculptor—To be sure in

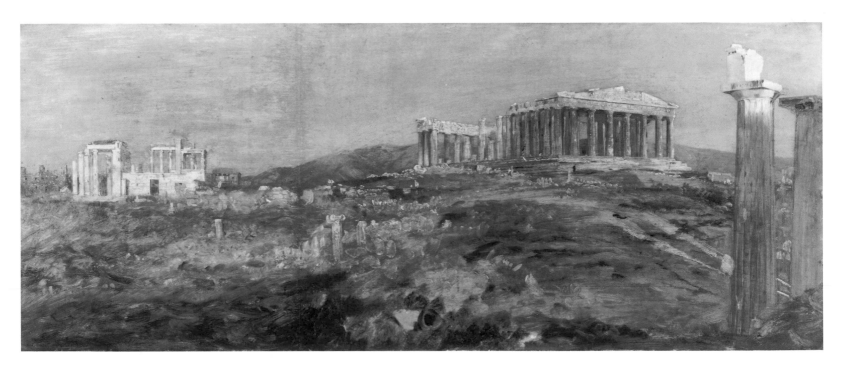

Frederic E. Church, Study for *The Parthenon*, ca. 1870, oil on paper (two pieces joined), 12¼ x 20¼ in. (31.1 x 51.4 cm.). Private collection

Rome they have famous things—mostly brought from Greece but on the classic ground itself everything is in its place. The Greeks had noble conceptions. They gave a large-godlike air to all they did and the fragments and bits are full of merit. I spent over two weeks there with immense pleasure and profit—and when I returned—Rome with its gross architecture looked cheap and vulgar.[2]

After returning to the United States and to his country retreat at Hudson, north of New York City, Church's idea of a painting of the subject continued to ripen. Early in January 1870, he wrote again to Osborn: "I shall commence a large picture of the Parthenon soon, probably."[3] Church subsequently received a commission for the picture, at a price of five thousand dollars, from the railroad financier Morris K. Jesup. In late April 1871, he was able to write Palmer, "The Parthenon is finished."[4] Shortly afterward, the picture was in Jesup's house where, without the shadow box Jesup thought it should have, it proved difficult to install to his satisfaction. Church, writing from Hudson in response to a letter from his friend Martin Johnson Heade, who often performed small services for him in New York, said: "I can't give any advice about reflections without reflection and indeed must be present to judge from observation—I haven't mind enough nor memory enough to be able to decide—100 miles from Jesup's house—what he needs to put the shine on the Parthenon."[5] Nonetheless, Jesup was delighted, and wrote: "'The Parthenon' is up, improves all the time, in fact, is a glorious picture."[6]

To compose and complete this large canvas—one of Church's last major undertakings—was complicated, requiring his usual dil-

igent research. Ten preliminary and related sketches have been recorded.[7] Also, in the collections at Olana is a stereographic photograph of the Parthenon that surely provided Church with the exact point of view he used in the painting. Here, however, he widened and altered the perspective of the photograph to include foreground detail and the *repoussoir* of columns in the near right foreground.[8] In the sketches, Church depicted the Parthenon from different viewpoints and at different times of day and night, and also recorded close-ups of fallen architectural fragments. One large oil sketch (ill.), a part of which contains the finally realized composition, shows that Church contemplated a much wider view that would have included the Erechtheum. The finished canvas is all that Church wanted, a striking presentation of the form, color, texture, character, and essence of the Parthenon, which seems to shimmer in its shattered, crystalline glory. As in all Church's major works, the dramatic composition, meticulous detail, sense of immense scale, and highly resolved light effects come together to endow the subject with undeniable iconic importance.

The Parthenon met with a mixed reception at its first public exhibition, one critic praising it as "full of subtle art";[9] another denigrating it as "the Parthenon without a soul."[10] In general, however, despite its departure from the artist's more highly regarded canon of naturalistic landscape, the picture has been perceived as one of Church's best. Seldom again did he paint a canvas of this importance and quality.

Church's fascination with the glories of antiquity coincided with a number of changing influences and interests that led him by degrees away from painting in his usual heroic mode: he had begun to develop a painful and crippling rheumatic condition that made the execution of large canvases an ordeal. Also, he had determined to build a great house on his extensive lands at Hudson, a

project that thenceforth occupied most of his attention. His high sense of the artistic and dramatic, combined with an enhanced preoccupation with historicism, found expression in the construction of Olana, his romantic, rambling Persian villa, and in the accumulation of an extremely eclectic booty of paintings and artifacts to fill its rooms. In effect, Church transferred his passion for building landscape paintings to building a beloved country retreat for himself and his family. His withdrawal from the world of art became virtually complete.

Increasingly in the 1870s, the changing tastes of critics and the public alike meant lessened esteem for Church as a painter: by the time of his death, in 1900, he was essentially disregarded, if not forgotten. The crux of that altered estimate of Church's work is touched upon in the critical, possibly jealous account by his former pupil William James Stillman—more memorable as co-editor of *The Crayon*—in Stillman's autobiography, published the year after Church's death. It would be well for the reader to remember that Stillman, as both artist and critic, was an ardent supporter of Pre-Raphaelitism, a style commonly criticized for lack of breadth and over-attention to detail.

> Church in many respects was the most remarkable painter of the phenomena of nature I have ever known, and had he been trained in a school of wider scope, he might have taken a place amongst the great individualities of his art. But he had little imagination, and his technical training had not emancipated him from an exaggerated insistence on detail, which so completely controlled his treatment of his subject that breadth and repose were entirely lost sight of. A graceful composition, and most happy command of all the actual effects of the landscape which he had seen, were his highest qualities; his retention of the minutest details of the generic or specific characteristics of tree, rock, or cloud was unsurpassed by the work of any other landscape painter whose work I know, and everything he knew he rendered with a rapidity and precision which were simply inconceivable by one who had not seen him at work. I think that his vision and retention of even the most transitory facts of nature passing before him must have been at the maximum of which human mind is capable, but he had no comprehension of the higher and broader qualities of art.[11]

Breadth of handling, as opposed to Church's almost photographic command of detail, was the pictorial preference of late nineteenth-century taste in landscape painting, and Church's reputation suffered thereby. However, the hand, eye, and mind that could successfully marshal the elements of those great masterworks of the 1850s and early 1860s speak indeed of "a comprehension of the higher and broader qualities of art" and have, in the long run, regained for Church one of the highest standings among all American artists.

J.K.H.

Notes

1. Church, in Athens, to Osborn, in New York City, 14 April 1869, typescript copy, Church Archives.

2. Church, in Paris, to Palmer, in Albany, N.Y., 14 May 1869, Albany Institute of History and Art, N.Y.

3. Church, in Hudson, N.Y., to Osborn, in New York City, 2 January 1870, typescript copy, Church Archives.

4. Church, in Hudson, N.Y., to Palmer, in Albany, N.Y., 8 April 1871, Church Archives.

5. Church, in Hudson, N.Y., to Heade, in New York City, 13 May 1871, Heade Papers, Archives of American Art.

6. Jesup, in New York City, to Church, in Hudson, N.Y., 1 May 1871, Church Archives.

7. Spassky 1985, pp. 275–79. All but one of the sketches are at the Cooper-Hewitt Museum.

8. Elizabeth Lindquist-Cock, "Frederic Church's Stereographic Vision," *Art in America* 61 (September–October 1973), p. 72.

9. *New York Commercial Advertiser*, 29 March 1872, p. 1.

10. *New York Evening Mail*, 3 April 1872, p. 1.

11. William James Stillman, *Autobiography of a Journalist*, 2 vols. (Boston and New York: Houghton Mifflin Co., 1901), 1, pp. 114–15.

GEORGE HETZEL
(1826–1899)

Hetzel, the most popular and best-known of nineteenth-century Pittsburgh artists, was born in Alsace, but was brought at the age of two to the United States, where his family settled in Allegheny City, now part of Pittsburgh. The boy showed a natural artistic ability that his father, a tailor who later established a vineyard in the region, encouraged in him. At twenty, after serving a four-year apprenticeship to a house- and sign-painter, Hetzel departed for Düsseldorf and enrolled at its Art Academy from 1846 to 1848.

Hetzel returned to Pittsburgh in 1849. Though he preferred painting the still lifes and landscapes that were later to occupy him completely, he supported himself by executing portraits in the tight, academic manner he had been taught. Relatively few of his still lifes have been located, but exhibition catalogues show that they represented a large part of his oeuvre. According to a tradition in the Hetzel family, the artist's first important sale was a small canvas purchased by Mrs. Abraham Lincoln, which hung in the White House during the Civil War years.

By the late 1850s, Hetzel was concentrating on landscapes based on western Pennsylvania scenery and painted in a manner heavily indebted to the Hudson River School. In 1866, on one of the sketching trips he had begun to make in the Allegheny Mountains, he came upon the region known as Scalp Level, not far from Johnstown, which he found so attractive that he persuaded a group of artists and friends to join him there the following summer. The congenial group of Pittsburgh artists scouted the area so thoroughly that they became known as the Scalp Level painters.

Hetzel's own style of painting continued to evolve throughout his career as the influence of the French Barbizon style and, later, that of French Impressionism replaced his Düsseldorf and Hudson River School beginnings. In Pittsburgh, he showed his work at the J. J. Gillespie and Wunderly Galleries and at almost all the local exhibitions, including the 1864 Sanitary Fair, to which he sent twenty-five canvases. The following year, when the Pittsburgh School of Design for Women opened, he gave painting classes. From then on, he never lacked for patrons; he is said to have been able to sell a landscape as quickly as he could paint one.

The artist exhibited outside Pittsburgh as well: at the National Academy of Design, in New York; at the Brooklyn Art Association; and at the Pennsylvania Academy of the Fine Arts, in Philadelphia. He also sent his work to exhibitions in Saint Louis, Cincinnati, and Cleveland. In 1876, he was the only Pittsburgh artist invited to participate in the Philadelphia Centennial Exposition; his entry, *Forest Scene in Pennsylvania*, was awarded a medal. Two of his works were displayed at the Chicago World's Columbian Exposition of 1893, and three years later he was represented at the first annual International Exhibition sponsored by Pittsburgh's newly founded Carnegie Institute. Ten years after his death at the age of seventy-three, the institute honored him with a retrospective exhibition of thirty-six of his works.

Select Bibliography

Dorothy Kantner. "George Hetzel, Mountain Artist." In *Journal of the Alleghenies* 8 (1972), pp. 14–16.

Donald A. Winer. "George Hetzel, landscape painter of western Pennsylvania." In *The Magazine Antiques* 108 (November 1975), pp. 982–85.

Art in Nineteenth-Century Pittsburgh. Exhibition catalogue. Hetzel entries by Gillian Hirth Bennett. Pittsburgh, Pa.: University Art Gallery, University of Pittsburgh, 1977.

Paul Chew and John A. Sakal. *Southwestern Pennsylvania Painters: 1800–1945*. Exhibition catalogue. Greensburg, Pa.: Westmoreland Museum of Art, 1981.

Rocky Gorge, 1869

Oil on canvas, 42 × 29 in. (106.7 × 73.7 cm.)
Signed and dated at lower right: Geo Hetzel 1869
Westmoreland Museum of Art, Greensburg, Pennsylvania

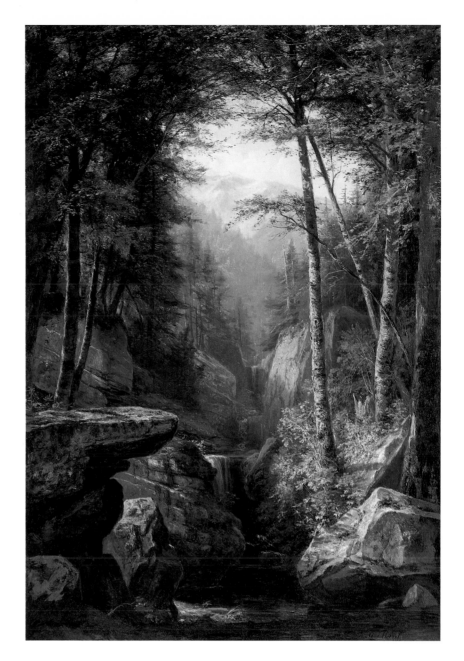

Rocky Gorge, painted by a Pittsburgh artist twenty years after Asher B. Durand's *Kindred Spirits* (see p. 108), to which it bears a striking resemblance, illustrates the far-reaching and enduring effect of the Hudson River School, whose style sent out ripples from its center in New York that were still being felt in provincial areas well after the influence of the School had begun to decline.

Pittsburgh, an industrial center known in the 1850s as the Iron City but already referred to as "Smoky City,"[1] was surprisingly hospitable to artists: a community of painters, some of them Düsseldorf-trained,[2] were active there by mid-century. Hetzel, who had himself studied in Düsseldorf, taking classes with Carl Ferdinand Sohn in 1846–47 and with Rudolf Wiegman in 1847–48,[3] returned to Pittsburgh in 1849 and immediately began to make his living as a professional artist. Although he first supported himself as a portrait painter, he was referred to in an 1856 article on Pittsburgh artists as "a painter of game . . . perhaps the first in the country."[4] He went on to become the most famous of all Pittsburgh painters, particularly well known for his landscapes and represented in the Philadelphia Centennial Exposition of 1876 and the Chicago World's Columbian Exposition of 1893, the most illustrious exhibitions in the United States.

Hetzel is perhaps best known today as founder of the group now known as the Scalp Level painters. While sketching in the Alleghenies near Pittsburgh in 1866, he discovered the scenic charm of that Cambria County area, and over the years took a number of artists and friends (including the mother of Andrew Carnegie, who served as chaperone on one occasion),[5] his own private pupils, and his students from the Pittsburgh School of Design for Women on summer sketching excursions there. The Scalp Level artists have been compared to the French Barbizon painters, who also sought a retreat from an industrialized city. In a review of the Carnegie Institute's retrospective exhibition of his work in 1909, Hetzel was recalled as the leader of the Scalp Level sketching trips:

> Hetzel was a silent man while his brush was busy. He invariably built a small fire of sticks and dry leaves close to his seat. "To keep away the punks," George said, in response to inquiries why he painted amid smoke. Punkies are villainous sandflies, or gnats, which infested Clear-Shade Creek, and were particularly fond of Hetzel blood.
>
> A German song would occasionally break from the artist's lips, if the light was good and the punks kept away. A shower would still the song, but George would often paint in the midst of rain. . . . A tent in the forest and close to the stream was Hetzel's choice.[6]

Rocky Gorge, painted in 1869, soon after Hetzel had become enthralled with Scalp Level, may not be a depiction of that site: that the work may represent scenery in either the Poconos or the Catskills, ranges Hetzel had visited by that time, has been suggested.[7] Whatever the mountains, it seems likely that the scene portrayed is a composite view, based upon several sketches from nature combined in one pleasing, idealized landscape.

The most striking feature of the work is its similarity to *Kindred Spirits* in composition, style, and a color palette closely related to Durand's, but its closed-in view is a characteristic of the Hudson River School that is particularly visible in paintings by Worthington Whittredge (see p. 180). In *Rocky Gorge*, however,

the pinks and lavenders in the portrayal of the distant mountains and the light greens of some of the foliage, which bear a marked resemblance to colors Frederic Church used in his canvases (see p. 246), show that the work belongs unmistakably with second-generation Hudson River School paintings. Those colors would not have been acceptable to the public at mid-century, but any objections to them would have been dispelled after 1859, when Church first exhibited his great South American masterpiece to unprecedented success.

Hetzel, who had exhibited regularly at the Pennsylvania Academy of the Fine Arts from 1855, may have lived for a year in Philadelphia about 1869,[8] when he exhibited two paintings at the academy's annual, one of them called *A Glimpse of the Ravine.*[9] Its title suggests that it and *Rocky Gorge,*[10] which Hetzel signed and dated the same year, were one and the same work.

L.D.

Notes

1. "Art at Home," *Cosmopolitan Art Journal* 1 (1856), p. 16.

2. At least two other Pittsburgh artists studied in Düsseldorf: Trevor McClurg (1816–1903) in 1841–43 and Emil Bott (1827–1908), though Bott's exact period of study there is not known. For McClurg, see *The Hudson and the Rhine: Die amerikanische Malerkolonie in Düsseldorf im 19.Jahrhundert*, exh. cat. (Düsseldorf, Germany: Kunstmuseum Düsseldorf, 1975), p. 99; for Bott, see Chew and Sakal 1981, p. 22.

3. *The Hudson and the Rhine*, p. 98.

4. *Cosmopolitan Art Journal* 1 (1856), p. 15.

5. Helen Scully, "George Hetzel and American Still Life Painting," ms., University of Pittsburgh, 1978, p. 11.

6. "With George Hetzel in 1865," *The Index*, 22 May 1909, in Artists' File, Westmoreland Museum of Art. I am grateful to Jeffrey P. Rouse, the museum's registrar, for providing me with this and other material pertaining to Hetzel.

7. Paul Chew, Director, Westmoreland Museum of Art, conversation with author, 17 June 1986.

8. Hetzel's whereabouts in 1869 is not completely known, but, according to Pittsburgh art dealer Gary Grimes, the artist may have been in Philadelphia for at least part of the year (conversation with author, 23 June 1986).

9. "#126. *A Glimpse of the Ravine*," Rutledge 1955, p. 98.

10. In 1981, prior to its exhibition in *Southwestern Pennsylvania Painters, 1800–1945* (see Chew and Sakal 1981), the painting was given this title by a group that included Paul Chew and Gary Grimes (Grimes, conversation with author, 23 June 1986).

DAVID JOHNSON
(1827–1908)

David Johnson, born and reared in New York City, was a self-taught artist. His earliest known paintings are landscapes of scenery in the Catskill Mountains and the Genesee region of New York state. A painting he made of Haines Falls in 1849 (private collection) is inscribed, "My first study from nature—made in company with J. F. Kensett and J. W. Casilear." In 1850, for a brief period, the artist took painting lessons with Jasper Cropsey; the two men did a number of views of the same subjects in rural New Jersey. Since Johnson had already achieved such a level of artistic achievement that he had begun exhibiting at the American Art Union and at the National Academy of Design, the "lessons" with Cropsey must have been for the purpose of refining his skills.

In 1859, Johnson became an Associate of the National Academy of Design and within two years was elected a full Academician. In common with most of the other landscapists of the era, he spent summers at the popular painting locales of the Northeast: the White Mountains, Lake George, and the Catskills. In addition to his views of those often-recorded sites, Johnson also executed more pastoral, river landscapes of central New York state, an area not frequented by any other prominent artist of the day. Johnson is believed to have traveled also to the western United States and to Europe, but there is no evidence of those trips in any of his works or in his letters. Later in his career, he began to paint in West Cornwall and elsewhere in western Connecticut.

Johnson reached the height of his popularity in the mid-1870s. He was awarded a first-class medal for art in 1876 at the Centennial Exposition in Philadelphia, and in 1878 he received an award from the Massachusetts Charitable Mechanics Association of Boston. He also exhibited at the Paris Salon of 1877, showing a painting titled *Housatonic River* (date and location unknown). After that his style began to show the marked influence of French Barbizon painting. Johnson's later works, more tonal in nature than those of his earlier years, were sharply criticized by other artists (and by twentieth-century art historians), though they were popular with late-nineteenth-century writers on art. The change in Johnson's style did not prevent him from sinking into relative obscurity by the end of his life. In 1890, Ortgies and Company held a two-day public sale of Johnson's work, suggesting that the artist had a substantial number of unsold paintings and needed to raise money. In 1904, Johnson moved from New York City to Walden, New York. He died there four years later.

Select Bibliography

Lamb's Biographical Dictionary of the United States, s.v. "Johnson, David."

John I. H. Baur. "'. . . the exact brushwork of Mr. David Johnson,' An American Landscape Painter, 1827–1908." In *The American Art Journal* 12 (Autumn 1980), pp. 32–65.

Forest Rocks, 1851

Oil on canvas, 17 × 21 in. (43.2 × 53.3 cm.)

Signed and dated at lower left: D. J. 1851; at lower right:
 D. Johnson/1851

Inscribed (on back of canvas): Study. North Conway, N.H./
 David Johnson. 1851.

The Cleveland Museum of Art, Mr. and Mrs. William H. Marlatt Fund
 (CMA 67.125)

Throughout Johnson's career, rocks held a particular fascination for him. In addition to views of the boulder-strewn Haines, Bash-Bish, and Trenton waterfalls, he painted a number of compositions in which the rock formations themselves are the subjects. *Forest*

Rocks, among the earliest of the artist's paintings of New Hampshire, is one of them.

After the artistic discovery of the area around North Conway in 1849, it became a popular summer sketching place for landscape painters.[1] They were attracted by the dramatic contrasts in the New Hampshire landscape—high mountains, wide valleys, and deep ravines. It was the valleys that most of those mid-century artists depicted, often with Mount Washington in the background. Johnson composed many views of New Hampshire after his first trip to the state in 1851, among them *North Conway, New Hampshire* (1852; Museum of Fine Arts, Boston), a canvas that shows the village with Mount Washington looming in the distance. In addition, he painted *Moat Mountain* (1851; private collection) and *Mount Chocorua* (1851; private collection). He also made

studies for such other works as *View at Jackson, New Hampshire* (1852; location unknown), which he exhibited, along with *North Conway, New Hampshire*, at the National Academy of Design in 1852. All his early paintings, even his mountain views, are generally on a more intimate scale than are those of his contemporaries. He never overwhelms his viewers with the majesty of the landscape; he provides instead a glimpse into a pastoral world far removed from the city.

Though *Forest Rocks* is executed with a sketchy brush technique that might be mistaken for the uncertain stroke of a young painter, Johnson's contemporaneous canvases, more finished in appearance, make it apparent that he was able to paint precisely, but here elected not to. In this, Johnson's earliest known work in which the rocks themselves are the subject, the artist limited himself to their detailed portrayal. As in all his later rock pictures, the rough terrain of the composition is made to look inviting, not hostile. Johnson used various means to create that effect: warm and appealing colors; rocks that are smooth, not jagged; and smaller rocks at the lower edge of the picture to facilitate the eye's entrance into the scene. It is the artist's clear intention to portray these subjects as hospitable, private spots in the woods rather than impenetrable or frightening places.

In some of Johnson's other rock paintings, his scale is confusing. Where that occurs, the proportions have been defined in some manner: in *Highland Falls, West Point* (Fig. 1), for example, Johnson added a small, seated figure at the upper left side of the canvas. Another characteristic of Johnson's rock pictures is the overall impression they convey of an untouched place, a natural landscape undisturbed by man. On close examination, however, each of them contains some small evidence of man's presence. In *Forest Rocks*, it is the unmistakable marks of an ax on the tree at the left edge. The same detail—one lone stump, confirming man's interference with the landscape—is found in *Brook Study at War-*

Figure 2. David Johnson, *Brook Study at Warwick*, 1873, oil on canvas, 25⅞ x 39⅞ in. (65.7 x 101.3 cm.). Collection of Munson-Williams-Proctor Institute, Museum of Art, Utica, New York

Figure 3. Asher B. Durand, *Landscape: Creek and Rocks*, ca. 1850s, oil on canvas, 17 x 26 in. (43.2 x 66 cm.). Courtesy, The Pennsylvania Academy of the Fine Arts

Figure 1. David Johnson, *Highland Falls, West Point*, 1869, oil on canvas, 16 x 24 in. (40.6 x 61 cm.). Phoenix Art Museum, Gift of Dr. Ronald M. Lawrence (65/177)

wick (Fig. 2). Whether Johnson meant to make a philosophical or political statement by the use of that detail is not certain. In a letter to G. W. Adams, president of the Utica Art Association and organizer of an exhibition that included *Brook Study at Warwick*, he merely commented: "The Brook Study . . . is an out door study, painted entirely upon the spot and is, as far as I was able to make it so, a literal portrait of the place. I placed my easel there and went to work earnestly to find out how Dame Nature made things, divesting myself of all thoughts of picture or Studio effects."[2]

For Johnson, the idea of a "portrait of the place" was an important one. Close study of his work reveals that the concept did not impel him to draw every tree and branch exactly as it appeared; to portray the general mood or feeling of a locale was to him a matter of more serious concern. Johnson attempted in his rock pictures to make a natural form, one he himself enjoyed, inviting to others. When compared with Asher B. Durand's more exacting depictions of the same subject, Johnson's compositions emerge not as mere studies of rocks in a forest setting but as finished pictures imbued with a life of their own. By contrast, in Durand's *Landscape: Creek and Rocks* (Fig. 3) and in other of his forest studies from the 1850s, the rocks are so precisely painted that the picture could be used as an illustration in a geology textbook. Johnson's desire was to present a rocky environment not only as an unusual place in a forest but also as a locale that welcomed acquaintance and exploration.

<div align="right">G.O.</div>

Notes

1. Catherine H. Campbell with Marcia Schmidt Blaine, *New Hampshire Scenery* (Canaan, N. H.: Published for the New Hampshire Historical Society by Phoenix Publishing, 1985), Robert McGrath, Foreword, p. ix.
2. David Johnson to G. W. Adams, 18 March 1878. Letter in Munson-Williams-Proctor Autograph Collection, Utica, N. Y.

Natural Bridge, 1860

Oil on canvas, 14½ × 22¼ in. (36.8 × 56.5 cm.)
Signed and dated at lower right: D.J. 1860
Reynolda House, Museum of American Art, Winston-Salem, North Carolina

It is not surprising that Johnson, who was fascinated by rock formations, would be interested in using the Natural Bridge of Virginia as the subject of a painting. The bridge, which is near Lexington, is more than two hundred feet in height. Created through the aeons by the wearing-down action of the creek on the surrounding horizontal limestone strata, it has captured the imagination of travelers since the eighteenth century; for European visitors, it was an attraction on a par with Niagara Falls. Though early tourists were not generally aware of how it had come to be carved through the rock, their lack of knowledge only made the structure more fascinating and mysterious to them. It was certainly a worthwhile side trip for travelers who hoped to experience the sublime quality of the American landscape.

Americans were also fascinated by the Natural Bridge.

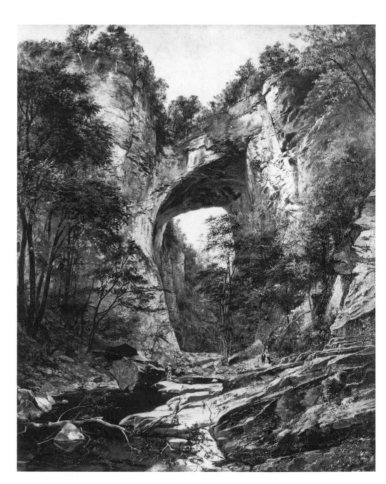

Figure 1. David Johnson, *The Natural Bridge of Virginia*, 1860, oil on canvas, 24 x 20 in. (61 x 50.8 cm.). Collection of Jo Ann and Julian Ganz, Jr.

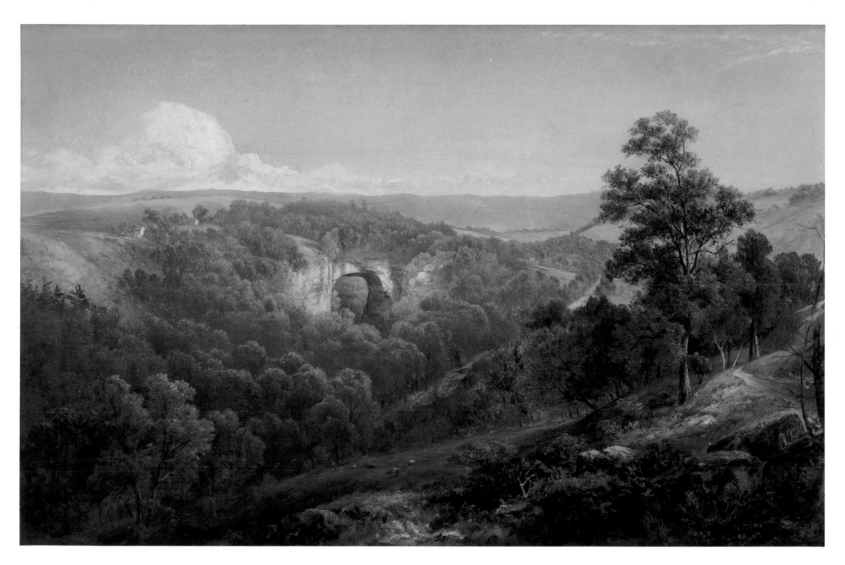

George Washington worked for a short time surveying it before he began his career in public service. In 1774, by a royal grant, King George III gave the bridge and the land around it to Thomas Jefferson.[1] The earliest paintings and engravings of the site, however, were made by Europeans. From the time of its first representations, in the eighteenth century, a standard view of the bridge seemed to develop, taken from a spot on Cedar Creek, which passes under its arch. Seen from that vantage point, the bridge looms large: to show how great was the height of its towering arch, a number of the early prints and drawings included human figures in the foreground.

Natural Bridge is not known to have been painted by an American artist until the early nineteenth century. Folk artist Edward Hicks included it in the background of at least six versions of the *Peaceable Kingdom* he did in the 1820s, but the view he used was probably based on an earlier, European print.[2] Jacob C. Ward is the first American artist documented as having made an original bridge depiction; his canvas, exhibited in New York City at the American Academy of Fine Arts in 1835, was the basis for

a lithograph by William James Bennett.[3] Despite the interest in the site and the growing number of prints available—W. H. Bartlett's engraving of 1839, an illustration for Nathaniel P. Willis's *American Scenery*,[4] for example—the bridge never became a popular painting locale for American landscapists.

Among the American artists who did paint the subject was Frederic Church. His view, executed from the usual vantage point on Cedar Creek, was made in 1852 and sold to his friend Cyrus Field, with whom he had traveled to Virginia to see this wonder of the American landscape.[5] Johnson certainly knew Church's painting, for it was exhibited at the National Academy of Design in 1853. It is also likely that Johnson read *Virginia Illustrated . . .*, a book by Porte Crayon, published in 1857, in which the author recommended that the arch be viewed from closely below, but also "from a hillside about half a mile below the bridge." He added, "From this point the perfection of the arch is more remarkable."[6] An engraving, drawn from a spot very close to the vantage point Johnson selected three years later, is included in Crayon's book along with the description.

Figure 2. David Johnson, *Natural Bridge, Virginia*, 1860, pencil and Chinese white on pale green paper, 11½ x 16⅞ in. (29.2 x 42.9 cm.). Private collection

2. Pamela H. Simpson, *So Beautiful an Arch: Images of the Natural Bridge 1787–1890*, exh. cat. (Lexington, Va.: Washington and Lee University, 1982), p. 17.
3. Ibid., p. 20. Ward's painting of the Natural Bridge is now in the Nelson-Atkins Museum.
4. Ibid., p. 24.
5. Ibid., p. 27.
6. David Hunter Strother [Porte Crayon], *Virginia Illustrated: Containing a Visit to the Virginian Canaan and the Adventures of Porte Crayon and His Cousins* (New York: Harper Brothers, Publishers, 1857), p. 195.
7. The large version is in the collection of Jo Ann and Julian Ganz, Jr.; the smaller painting, which was probably the source for an engraving of the Natural Bridge, is in the collection of Mr. and Mrs. Wilbur L. Ross, Jr. See Barbara Dayer Gallati, "David Johnson," Ferber and Gerdts 1985, p. 270.

Johnson did at least two other paintings of the bridge in addition to the present picture. Both are the standard Cedar Creek view taken from below the arch (Fig. 1);[7] in both, to show the scale, he added small figures below to play up its height. His three Natural Bridge paintings are all dated 1860; in 1862, he exhibited one at the National Academy.

Natural Bridge, in keeping with Johnson's usual approach, does not seek to invoke the sublime aspects of the formation but shows it merely as an integral part of the landscape. A small painting, the work has great detail in the trees in the foreground and the middle ground. As is true of many of Johnson's subjects, it could have been realized in a much larger format. Here, however, the small size serves to emphasize Johnson's concept of the structure—that it was not a startling phenomenon but simply an occurrence in the Virginia landscape. One of his more finished landscape drawings is a preliminary work (Fig. 2), heightened with Chinese white, in which the emphasis is on the detailed rendering of the bridge itself.

A viewer who did not know that the subject of this painting was a natural form in the Virginia landscape could easily mistake the arch for the ruin of a Roman aqueduct overgrown with vegetation. *Natural Bridge*, conveying as it does the impression of an arcadian vision, is not unlike views executed in Europe by such artists as Johnson's friend and teacher Jasper Cropsey. Whether seen as a ruin or a natural wonder, this distant view of the bridge shows a world of old and new elements—an ancient form depicted in the agrarian context of the nineteenth century.

G.O.

Notes
1. *Encyclopedia Britannica*, 11th ed., s.v. "Natural bridge."

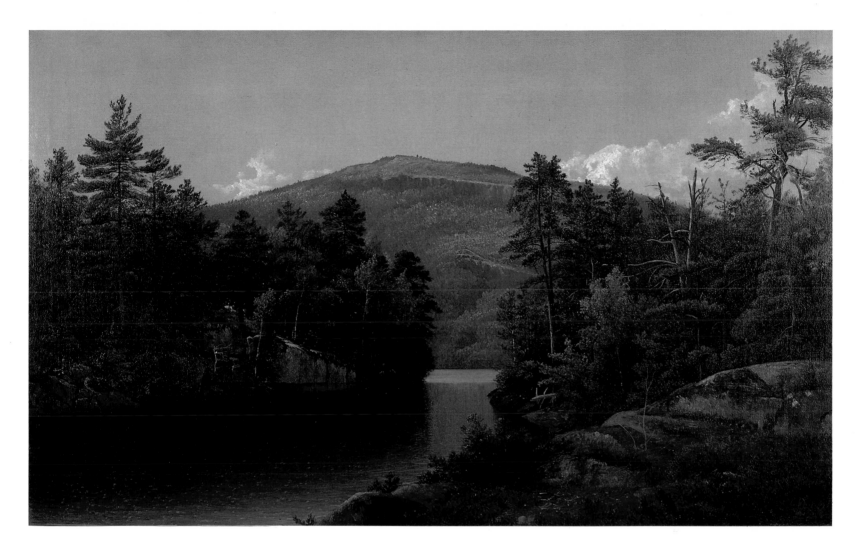

Harbor Island, Lake George, 1871

Oil on canvas, 16⅜ × 26¼ in. (41.6 × 66.7 cm.)
Signed and dated at lower right: DJ (monogram) 1871
Inscribed (on back of canvas): Study Harbor Island / Lake George /
 David Johnson 1871
Collection of Henry Melville Fuller

Lake George has a colorful history. Situated just south of the Adirondack Mountains in New York state, the lake has over two hundred islands[1] and is surrounded by high hills. Until the American Revolution, the Iroquois Indians controlled the region, in 1609 repulsing a challenge by the Frenchman Samuel de Champlain that was the first of many attempts to displace them. In the next century, the lake shoreline was the site of a series of crucial revolutionary-war battles in which a number of memorable individuals, such as Benedict Arnold and Ethan Allen, played a major role. The Iroquois, still living in the region and known to be excellent warriors, were sought as allies by both sides. After the war, when permanent white settlements were established along the lake, the increasing demand for timber caused the area to be logged. Development of an industrial center along the shoreline, however, proved difficult, not any longer because of the Indians but because the hilly terrain limited the growth of villages and towns.

When commercial steamboats began plying the lake in 1817 to transport the lumber from the region, it soon became clear that their main cargo was not timber but vacationers. Lake George's growing popularity was caused in part by its picturesque surroundings and in part by its being the setting for James Fenimore Cooper's novel *The Last of the Mohicans* (1826). To accommodate the growing numbers of summer visitors, a railroad line from Glens Falls north to Caldwell, a town on the lake's southern tip, began operating in 1849.[2] (Caldwell was later renamed Lake George.) Those factors—good transportation and the appeal to the popular imagination fostered by Cooper's novel—made Lake George at mid-century ripe for development as a fashionable resort. By 1876, there were twenty hotels and numerous private camps there. The visitors generally came up the Hudson River from New York by boat or train and completed their journey by rail.[3] For landscape

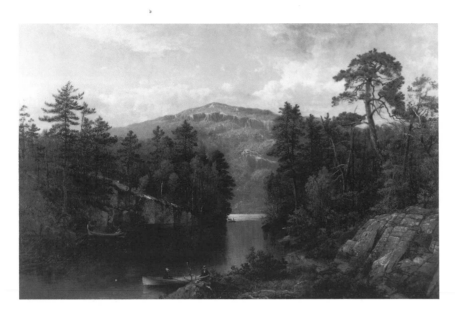

David Johnson, *A View on Lake George (Paradise Bay)*, 1876, oil on canvas, 26½ x 40½ in. (67.3 x 102.9 cm.). Manufacturers Hanover

for the greatest possible artistic effect. Neither version of this view, therefore, can be accepted as an accurate portrayal of the actual shore; Johnson is likely to have altered the scenery in both works.

<div style="text-align: right">G.O.</div>

Notes

1. William Chapman White, *Adirondack Country* (New York: Duell, Sloan and Pearce, 1954), p. 15.
2. Frederic F. van de Water, *Lake Champlain and Lake George*, The American Lake Series, ed. by Milo M. Quaife (New York: Bobbs-Merrill Co., 1946), p. 328.
3. White, *Adirondack Country*, p. 124.

painters, the area now offered a ready market in tourists, who would be eager to buy works that would remind them of their charming summer excursion.

Johnson's method of painting had evolved into a tight, controlled technique by the 1870s. Using a fine brush and minute, almost invisible strokes, he created delicately detailed compositions that are among his finest paintings. The superb handling, richness of color, and realistic effect of those works, which include *Harbor Island, Lake George*, make them exquisite examples of the style that is now called Luminism. While the majority of the pictures are small, they give the illusion of much greater size, an effect that probably derives from Johnson's choice of subjects—large mountains and broad lakes—usually painted in larger formats by other artists.

Johnson did many views of Lake George in the late 1860s and early 1870s. Two versions of this particular painting exist: the second is *A View on Lake George (Paradise Bay)* (ill.), which was obviously sketched from the same vantage point, though the trees and the shoreline on the right side have been altered and three boating parties on the lake added. *Harbor Island, Lake George*, an intimate view of a narrow passage between two islands with a mountain in the background, is much smaller both in scale and in concept. Nothing about the subject is threatening—like all Johnson's paintings, it presents an inviting view of the natural world. The artist executed the trees on the shoreline with great precision, taking pains to convey the differences among the species growing there. Apparently very concerned about the accuracy of his depictions, Johnson made many drawings as preliminary studies of individual specimens. He also painted the leaves and bark with scrupulous fidelity, portraying the correct angle of each of the branches and the actual shape of the canopy they created. Nonetheless, he was a painter skilled in arranging his compositions

JERVIS McENTEE
(1828–1891)

McEntee was born in the Hudson River town of Rondout, New York. Apparently without the benefit of formal artistic training, he began to paint landscapes; in 1850, one of them was exhibited at the National Academy of Design and four others were bought by the American Art-Union. That winter, McEntee received instruction in New York City from Frederic Church. In 1851, he returned to Rondout, where he worked in the flour-and-feed industry and simultaneously prepared paintings to send to the Academy's annual exhibitions.

In 1854, McEntee married Gertrude Sawyer, the daughter of the principal of his former school, the Liberal Institute in Clinton, New York. By 1859, he had abandoned his job in Rondout and had moved with his wife to New York, where he rented space in the Tenth Street Studio Building. In 1860, he was elected an Associate of the National Academy on the strength of his *Melancholy Days* (location unknown); he became a full Academician the following year. During the 1860s, the McEntees generally spent their summers and autumns at Rondout and returned to New York City in the winter. In 1868, they made a trip abroad that was to last a year. They traveled in England in July and in France in August. By the beginning of September, they had met Church and his wife in Switzerland; as the couples traveled south, the two men sketched together. In Rome, on 1 October, they met Sanford Gifford. Gifford and McEntee frequently wandered and sketched around Rome and in the Campagna until Gifford's departure on 1 January. The Churches and the McEntees stayed on in Rome for the rest of the winter, the painters occupying adjacent studios in the Hotel de Russie. The McEntees probably headed north in March 1869. By the beginning of June, they were in Great Britain; by the beginning of July, they were on their way home.

After his return, McEntee resumed his seasonal cycle of travel between New York City and Rondout, producing pictures every year especially for exhibition at the National Academy and occasionally showing at the American Society of Painters in Water Colors. In 1872, he began to keep a diary in which he recorded his various concerns regarding art, money, and social life. That pursuit, which eventually produced five volumes, provides an invaluable view of the New York artistic community during the 1870s and 1880s.

Select Bibliography

T[homas] B[ailey] Aldrich. "Among the Studios. V." In *Our Young Folks: An Illustrated Magazine for Boys and Girls* 2 (October 1866), pp. 622–25.

"American Painter—Jervis McEntee, N. A." In *Art Journal* 2 (1876), pp. 178–79.

G[eorge] W. Sheldon. *American Painters: With Eighty-three Examples of Their Work Engraved on Wood.* New York: D. Appleton and Co., 1879, pp. 51–56.

Executor's Sale Catalogue of Paintings by the Late Jervis McEntee, N. A. New York: Ortgies and Co., 1892.

"The Jervis McEntee Diary." In *Journal of the Archives of American Art* 8 (July–October 1968), pp. 1–29.

Sandra Kay Feldman. *A Selection of Drawings by Jervis McEntee from the Lockwood DeForest Collection.* Exhibition catalogue. New York: Hirschl & Adler Galleries, 1976.

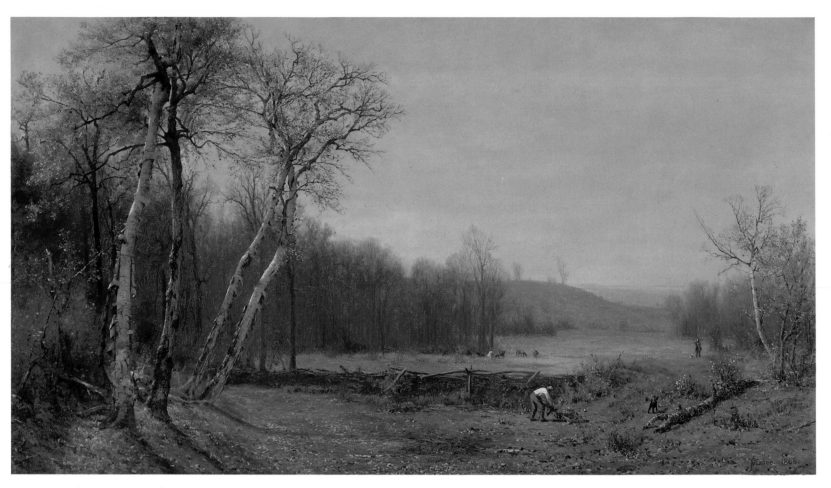

Autumn, Landscape, 1868
Oil on canvas, 24 × 42 in. (61 × 106.7 cm.)
Signed and dated at lower right: McEntee. 1868.
Private collection

As long as he lived, McEntee maintained a great attachment to the land in and around his hometown of Rondout, New York. Wintering in New York City each year, he often painted recollections of his native scenery, apparently without the aid of topographical sketches. *Autumn, Landscape*, probably just such a landscape of memory, records the appearance of the land at a characteristic, if short-lived, phase in its seasonal cycle. The autumnal canvases of Thomas Cole and Jasper Cropsey, "riant in the luxury of color,"[1] contrast markedly with McEntee's restrained interpretation of a later time in the season. McEntee worked with the visual vocabulary of the late autumn landscape throughout much of his career. In a summary of his accomplishments as he saw them, he wrote to a friend: "Perhaps what would mark my work among that of my brother artists is a preference for the soberer phases of Nature,

the gray days of November and its leafless trees as well as the Winter landscape."[2]

McEntee's success in this field is demonstrated by the 1867 *New York Times* review of the annual National Academy of Design exhibition. Of an autumn landscape McEntee exhibited that year, the critic wrote:

> The cheerless, chilly breath of late November is felt in every part of this admirable painting. Frost has touched all the leaves and dulled the thousand hues of October into one monotonous brown. The gray clouds that overhang this sunless landscape seem ready to fall in snow. A wreath of blue smoke, curling from the chimney of a little cottage that stands in the shelter of a low hill, is the only sign of warmth and comfort in the whole picture, and by suggesting the cheerful fire within, adds to the sense of dreariness without, and makes one feel that the saddest and most melancholy days of all the year have come.[3]

The reviewer, probably familiar with McEntee's earlier work, recognized the area of aesthetic sensibility the artist considered his métier, for his conclusion derives from William Cullen Bryant's *Death of the Flowers*, the poem that had provided McEntee with the title of another autumn painting, *The Melancholy Days* (1860; location unknown). McEntee had the first four lines of the poem printed under the painting's entry in the exhibition catalogue:

The melancholy days are come, the saddest of the year,
Of wailing winds and naked woods and meadows brown and sere,
Heaped in the hollows of the groves the withered leaves lie dead,
They rustle to the eddying gust and to the rabbits tread.[4]

This poem and others of Bryant's follow in the English tradition of melancholic verse, with its projection of the narrator's mood onto the description of an autumnal landscape.[5] McEntee, of a melancholy temperament, read Bryant in his youth and later in life considered himself to have been greatly influenced by the poet;[6] Bryant's ruminative work appears to have inspired the painter to channel his own depressed thoughts into avenues of aesthetic expression.

McEntee found the autumn landscape the most appropriate theater for his dark moods. In a midsummer entry in his diary, he confessed, "It saddens me to find that I am looking forward to the Autumn. Some spirit of unrest and melancholy has hold of me and controls me against my will." When autumn finally arrived, his response was ambivalent: "I get so lonely and melancholy when I walk alone that I dread to go but today I resisted the feeling and enjoyed my walk."[7] Often anxious at any time of year, McEntee relished the opportunity to combine emotional pain and aesthetic joy in projecting his innermost thoughts into the autumn landscape of his artistic wanderings. Such pleasures could be shared by viewers possessed of a similar sensibility—the previously cited *Times* reviewer, for instance—who enjoyed pondering the somber thoughts evoked by McEntee's spare landscape paintings.

In his topographical tastes, McEntee recognized his departure from many of his Hudson River School contemporaries: " . . . I don't care for what is known as 'a fine view.' From my home in the Catskills I can look down a vista of forty miles, a magnificent and commanding sight. But I have never painted it; nor should I care to paint it. What I do like to paint is my impression of a simple scene in Nature."[8] The direct relationship recognized to exist between stimulus and emotional response in earlier but still potent Associationist theory informs our understanding of McEntee's preference. Whereas the dramatic topography of Cole's paintings was associated with the tumultuous emotions that constituted the avidly sought experience of the Sublime, McEntee, who chose to express the subtler sentiments he was attuned to, tended to paint restrained landscape forms.

From the beginning of his career, McEntee concentrated his energies on settings defined by the effects of light, climate, and season rather than those emphasizing topography. As Henry T. Tuckerman put it, "McEntee is fond of rendering landscape subservient to, or identical with, a special sentiment or general fact of interest."[9] The titles of McEntee's canvases, such as *Winter on the Ice*, *Indian Summer*, *Sunshine*, and *Rainy Day*, attest to the wide variety of landscape moods the artist painted. From as early as 1860, however, his modest yet consistent reputation came to rest upon the late autumnal landscape, which he chose increasingly often for a subject.

D.S.

Notes
1. Words used by Cole to describe the autumn landscape in his "Essay on American Scenery," reprinted in Thomas Cole, *The Collected Essays and Prose Sketches*, ed. by Marshall Tymn (Saint Paul, Minn.: The John Colet Press, 1980), p. 14.
2. McEntee, in Rondout, New York, to the writer George Ripley, 28 October 1874. Archives of American Art, microfilm roll no. DDUl, frames 382–83.
3. "The National Academy of Design," *New York Times*, 24 April 1867, p. 4.
4. *The Death of the Flowers* was first published in *The New-York Review and Atheneum Magazine* 1 (November 1825), pp. 485–86.
5. For a review of this literary tradition, see Eleanor M. Sickels, *The Gloomy Egoist: Moods and Themes of Melancholy from Gray to Keats* (New York: Columbia University Press, 1932).
6. McEntee, after Bryant's death, in a letter of condolence to his daughter, wrote from Rondout on 16 June 1878, "Now that I have the occasion to reflect upon it, I think my life has been strongly influenced by his verse, which I always read with pleasure and with which I have been familiar from my childhood. . . . What little I have been enabled to accomplish in Art has been largely due to him." Bryant-Godwin collection, New York Public Library.
7. McEntee diary entries for 8 July and 31 October 1872. Archives of American Art, microfilm roll no. D180, frames 6, 13.
8. McEntee, cited in Sheldon 1879, p. 52.
9. Tuckerman 1867, p. 543.

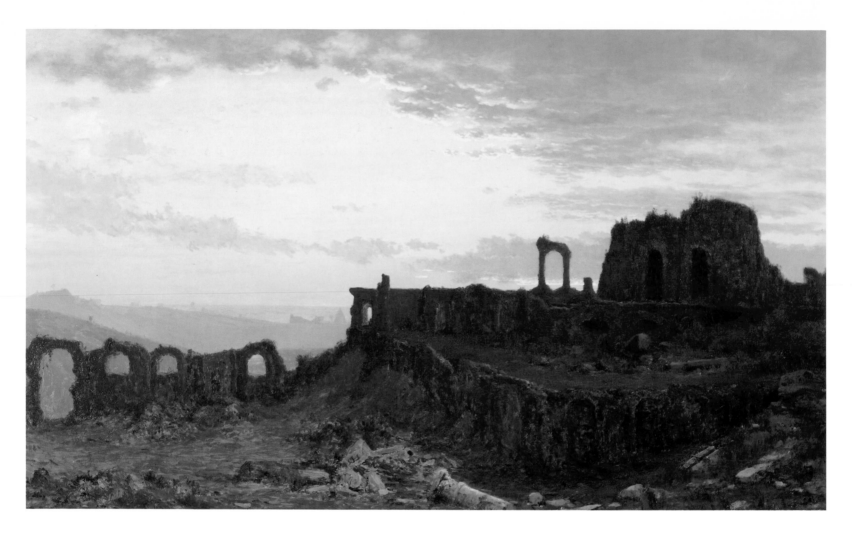

The Ruins of Caesar's Palace, ca. 1869

Oil on canvas, 24¼ × 40⅛ in. (61.6 × 101.9 cm.)
Unsigned
*The Pennsylvania Academy of the Fine Arts, Philadelphia. Purchased
with funds from the Fine Arts Ball and Discothèque, courtesy of The
Pennsylvania Academy of the Fine Arts Women's Committee (1978.9)*

In this landscape, McEntee wed two traditional symbols of mutability—classical ruins and the sunset. While Frederic Church and Sanford Gifford, his companions in Rome in the autumn of 1868, depicted well-known ruins seen on their European trips,[1] McEntee probably based *The Ruins of Caesar's Palace* on obscure architectural remains. The platform at the right, with its diagonally oriented building, suggests the Temple of Jupiter Anxur, at Terracina, south of Rome, but it is difficult to document the site's mid-nineteenth-century appearance.[2] Neither the work's current title, under which it was sold at auction in 1892, nor the title *Ruins*

of Claudian Aqueducts, under which McEntee exhibited a picture in Chicago in 1871, helps to identify the subject.[3] When designing a canvas meant to inspire thoughts on the passage of days and civilizations, the artist may well have considered an identifiable site a distraction.

The writings of the American poet Henry Pickering, who boarded at the McEntee home when Jervis was a child, probably offered the future painter his first exposure to this imagery. Though McEntee would have been a very small boy in 1831, when Pickering died, the extent of Pickering's influence on the painter's childhood and subsequent artistic development seems to have increased with each passing year. In 1866, speaking of Pickering, McEntee recalled: "He was very fond of children; and I became a favorite, accompanied him in his rambles, spending my happiest days in his society among the treasures of his room, and, I dare say, drew from him and his surroundings my first ideas of art."[4] While McEntee may have exaggerated the artistic conditioning that stemmed from their relationship, it seems likely that as he grew up, he would have become thoroughly familiar with Pickering's poems. One of them, invoking images of both sunlight and ruins, seems to anticipate *The Ruins of Caesar's Palace*:

But lo! what domes and places are those?
What mouldering arches those, and tottering walls?
Which, in the distance seen, and wrapt in shade,
(Save that a gleam of light now steals along
Their tops) seem in repose oblivious sunk?
Say, is it Rome, once mistress of the world,
Imperial Rome I there behold! where Time,
Thron'd on the ruins of two thousand years,
Her gilded places and pillar'd fanes
Sees unreluctant crumbled in the dust![5]

Judging from such titles in McEntee's estate sale as *Evening on the Campagna, Paestum, Twilight,* and *The Temple of Sybil, Sunrise,* the painter continued to demonstrate a concern for the dramatic effects of sunlight in a number of his Italian subjects.[6] In 1872, he exhibited an Italian picture at the Century Association that "was greatly admired for its atmospheric effect."[7] He and Gifford both painted a sunset subject they had observed during their travels together,[8] one Gifford described in a letter home:

> It was near sunset. A Cardinal's carriage (black, red and gold) stopped on a little rise of the road, bringing carriage and figures in strong relief against the warm gray of the Alban hills. A scarlet Cardinal descended from the carriage. A Carthusian monk in black and white, and two lackeys in purple, gold and white stood bowing. Horses black, with trappings of scarlet and gold. Imagine this color and light and dark relieved on a gray ground and illuminated by the richest horizontal light of sunset.[9]

The high-key palette and dramatic accents on individual clouds in McEntee's canvas bespeak not so much an exchange of ideas with Gifford as the influence of Church, whose Rome studio in 1868/69 was adjacent to McEntee's. *The Ruins of Caesar's Palace,* possibly one of four paintings McEntee sent to New York from Rome[10] or possibly a picture composed after his return,[11] is a notable example of his employing a theatrical pictorial approach learned from Church, with whom he had studied and, eighteen years later, spent time with in Europe. An article on McEntee's autumn pictures pointed out that the painter had been "educated in the studio of the most popular artist of the country, who sets him no example."[12] *The Ruins of Caesar's Palace* is the exception to an otherwise apt generalization.

<div align="right">D.S.</div>

Notes

1. For Gifford's paintings from that trip abroad, see Ila Weiss, "Sanford R. Gifford in Europe: A Sketchbook of 1868," *The American Art Journal* 9 (November 1977), pp. 83–103; for one of Church's, see p. 263.

2. I thank Elizabeth Bartman, Ann Blair Brownlee, and Elizabeth Milleker for discussing with me the possible identification of these ruins.

3. The painting, no. 75 in McEntee Sale Catalogue, brought $305. Gifford, on 19 October 1868, in a letter to his father from Rome, used the phrase "Palace of the Caesars" to describe Domitian's Palace on the Palatine Hill. Archives of American Art, microfilm roll no. D21, p. 47. The ruins depicted by McEntee are not Domitian's Palace. "Claudian aqueducts" might refer either to any of numerous aqueduct ruins surrounding Rome or to a specific group that stretched to the Alban Hills, a section of which was often depicted by American artists.

4. T. B. Aldrich, "Among the Studios. V," *Our Young Folks* 2 (October 1866), p. 624.

5. Henry Pickering, "Reflections on Viewing the Beautiful Moonlight Picture . . ." in his *Ruins of Paestum and Other Compositions in Verse* (Salem, Mass.: Cushing and Appleton, 1822), pp. 92–93.

6. Nos. 86, 99, and 125 in McEntee Sale Catalogue.

7. "American Painter—Jervis McEntee, N. A.," *Art Journal* 2 (1876), p. 179, gives the title of the picture as *Scene on the Via Appia, near Rome,* but the Century Association's catalogue for its exhibition of January 1872 lists *Paestum* as McEntee's entry, no. 30. I am grateful to Mark Davis and Roger Friedman for the latter information.

8. McEntee exhibited *Roman Cardinal Taking an Airing* in 1872 in Pittsburgh. In his diary entry for 15 April 1873, he wrote that he had sold his "little picture of the Cardinal on the Campagna for $100." Gifford, in a letter of 2 November 1868 from Rome to his father, said that he had made "a note of the sunset on a Cardinal," describing an event of 21 October. Archives of American Art, microfilm roll no. D21, p. 51.

9. Gifford to his father, 2 November 1868, describing an event of 20 October. Archives of American Art, microfilm roll no. D21, p. 51.

10. McEntee, in Florence, to "My dear Stoddard" [Richard Henry Stoddard], 24 March 1869. A. W. Anthony Collection, New York Public Library.

11. After Church and McEntee returned to the United States, they collaborated with George Peter Alexander Healy on *The Arch of Titus* (ca. 1874; Newark Museum). In the monumental canvas, the arch was painted by Church; the Colosseum, by McEntee; the figure groups, by Healy. William H. Gerdts, "Four Significant Paintings: Acquisitions and Reattributions," Newark Museum of Art, *The Museum* 10 (Winter 1958), pp. 18–20.

12. T. B. Thorpe, "Painters of the Century. No. VII. Our Successful Artists—Jervis McEntee," *Baldwin's Monthly* 13 (July 1876), p. 1.

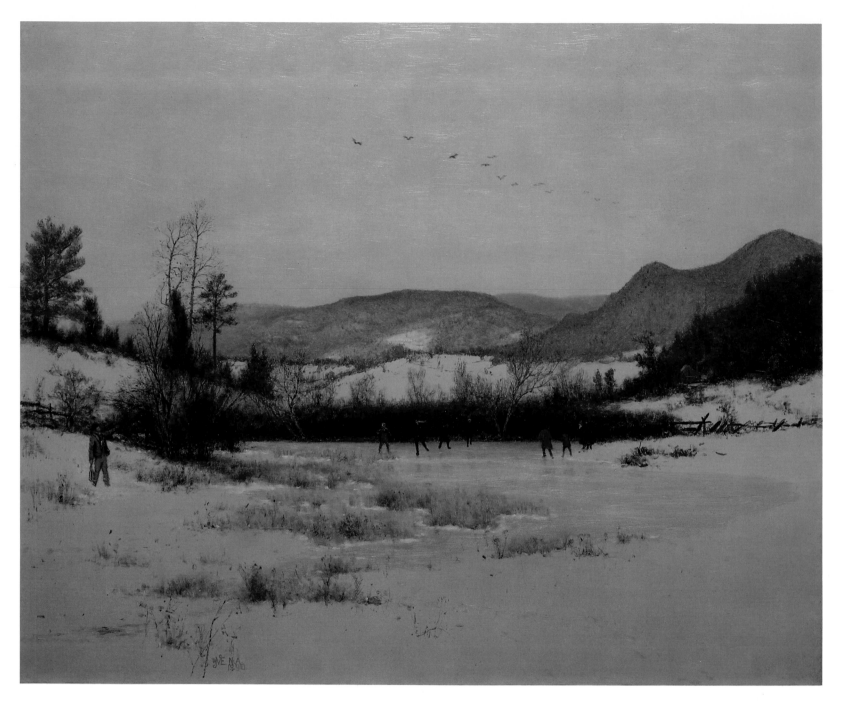

Winter in the Country, 1890
Oil on canvas, 30 × 36 in. (76.2 × 91.4 cm.)
Signed and dated at lower left: JMcE (monogram). N.A./1890
Collection of Robert C. Vose, Jr., Boston, Massachusetts

McEntee began early in his career to paint landscapes set in winter, the season least conducive to plein-air rendering. Because he nor-

mally based his work on recollections of land, the limitations imposed by inclement weather did not cause any departure from his usual mode of production. After returning to New York City from Rondout at the beginning of 1873, he wrote, "I am full of Winter pictures and the city is tame compared with the magnificence of the snowy country."[1] As a reminiscence of upstate New York, painted by McEntee in his Tenth Street studio during the last week of December 1889, *Winter in the Country* may be considered the product of a similar enthusiasm.

In his diary entry for 27 December 1889, McEntee wrote,

"I began a winter picture today on a canvas 30 × 36 and painted in the objects leaving the canvas to represent the snow which seems the exact trick. I am much interested and hope to make a good picture."[2] He devised a novel compositional procedure for the work, reading much of the flat white canvas as a prolonged and gradual recession into pictorial space. He organized the middle ground into a dense band of foliage flanked on either side by a fence, a bilateral symmetry reinforced by the high forms of trees at the left and hills at the right. The center of the canvas he translated into a sheet of ice, its movement into space marked with patches of grass arranged in a zigzag formation. Here, McEntee employed one of his favorite landscape forms, a ground plane inscribed with surface patterns:

> I especially like to walk when in the country in pasture-fields, where the beautiful greensward has been cut into and broken up by the teeth of the cattle. Side by side you see traces of what they have eaten and the beauty of what they have not eaten. . . . The detail, the variety, the beauty, in a piece of pasture-land destitute of any striking object, are always very interesting to me.[3]

Applying this taste to *Winter in the Country*, McEntee sought to engender visual interest by means of subtle, carefully crafted landscape elements.

He worked all day on 28 and 30 December, and seems to have finished the canvas by 31 December. In his diary entry for the last day of the year, he wrote, "Stopped in at a photograph place and bought one of some skaters in the Park from which to get suggestions for figures in my winter picture, and after I came to my studio painted in a number of figures."[4] McEntee's matter-of-fact statement that he bought a photograph of skaters implies that he had decided early in his compositional planning to represent them in his canvas, and had devised his landscape forms, especially the strongly articulated far border of the ice, to create a suitable space for their activity.

Photographic-supply stores in the mid- and late nineteenth century normally carried stocks of prints that provided artists with models. McEntee's mentioning his purchase in his diary, however, suggests that the procedure was a novel one for him. He had often featured skaters in earlier winter subjects, but this painting was perhaps a unique instance of his using photographs to aid him in depicting figures in motion. Though the relatively lasting features of landscape remained impressed on his mind, he does not seem to have been able to conjure up transient forms. He could just as easily have gone to Central Park to sketch the movements of real skaters, but still photographs would have provided naturalistic images of suspended action that he could easily transcribe onto his canvas.

After autumn landscapes, winter scenes were the subjects that McEntee thought most characteristic of his oeuvre.[5] His introduction of a new method of production demonstrates that he continued to rethink the compositional problems inherent in a seasonally defined landscape genre. In the days following his completion of this canvas, he set to work on a watercolor of the same

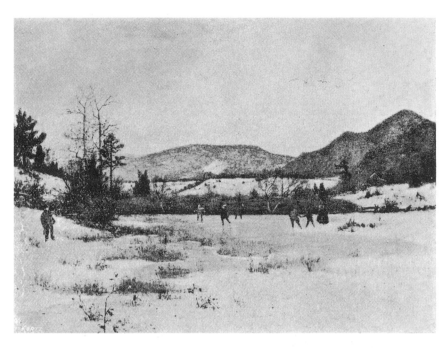

Jervis McEntee, *Northern Winter*, ca. 1890, watercolor, 14½ x 17½ in. (36.8 x 44.5 cm.). No. 467 in *Illustrated Catalogue of the Twenty-Third Annual Exhibition of the American Water Color Society* (New York, 1890)

subject, titled *Northern Winter* (ill.), which he sold at the American Water Color Society for a hundred and fifty dollars.[6] When he showed *Winter in the Country* at the National Academy of Design exhibition in spring 1890, his asking price was a thousand dollars.[7] The picture apparently did not sell, and was probably the work of identical size that appeared in his executor's sale two years later under the title *Snow Scene*.[8]

D.S.

Notes

1. Diary entry, 5 January 1873. Archives of American Art, microfilm roll no. D180, frame 19.

2. Ibid., 27 December 1889, frame 794.

3. Sheldon 1879, p. 52.

4. Diary entry, 31 December 1889. Archives of American Art, microfilm roll no. D180, frame 794.

5. McEntee, in Rondout, to George Ripley, 28 October 1874. Archives of American Art, microfilm roll no. DDUl, frames 382–83.

6. The painting was no. 467 in the 1890 exhibition of the American Water Color Society.

7. No. 555 in the Academy exhibition catalogue.

8. No. 161 in McEntee Sale Catalogue.

ALBERT BIERSTADT
(1830–1902)

Bierstadt was among the most energetic, industrious, and internationally honored American artists of the nineteenth century. Born in humble circumstances in Soligen, Germany, he emigrated at age two to America with his parents and his two brothers. The family settled in New Bedford, Massachusetts, where his father became established as a barrelmaker. Little is known about Bierstadt's rearing or early artistic training, but he was advertising himself as an instructor in monochromatic painting in New Bedford in 1850, the same year he exhibited thirteen of those works and one drawing in Boston. His collaboration during the next three years with a daguerreotypist who produced theatrical presentations of American scenery laid the foundation for his lifelong interests in photography and North American topography.

In 1853, Bierstadt returned to Europe to study at the Düsseldorf Art Academy in Germany and to travel extensively on the Continent. Although he had entered that period of formal training with only rudimentary capabilities, he emerged from it an ambitious, technically proficient master whose tastes for European scenery and society had been considerably enhanced in the process. On his return to New Bedford, he quickly became the city's most prominent artist, organizing in 1858 a large exhibition of paintings—including fifteen of his own works—that brought him to national attention. His career decisively expanded in 1859, when he traveled to the territories of Colorado and Wyoming, for a time in the company of a United States government survey expedition headed by Colonel Frederick W. Lander. The purpose of Bierstadt's trip was to procure sketches for a series of large-scale landscape paintings of the American West. After he moved to the Tenth Street Studio Building in New York, he painted a sequence of canvases that secured his renown as a "western" artist and as the foremost competitor of Frederic E. Church in the field of monumental New World landscapes.

Bierstadt rode the crest of success for the next decade. He made two additional western journeys, one in 1863, the other from 1871 to 1873. In the interval between, he married Rosalie Ludlow, built Malkasten, a magnificent mansion overlooking the river at Irvington-on-Hudson, New York, and undertook a two-year tour of Europe, where he and his wife mingled with the crème de la crème of British and Continental society. At the same time, he was painting spectacular pictures of western scenery, which were widely exhibited in the United States and abroad and which commanded the highest prices in American art at the time. Bierstadt balanced that wealth by his selfless participation in numerous charitable organizations and events.

Bierstadt's paintings began to attract adverse criticism in the mid-1860s. After 1880, his reputation substantially declined in the face of changing tastes, and he experienced a series of personal misfortunes that included the destruction by fire of Malkasten in 1882 and the death of his wife in 1893. Yet neither his public demeanor nor the plenitude of his artistic creativity was seriously hampered until the last years of his life. The sometimes uneven quality of his work, the stagey compositional effects to which he frequently resorted, and his sheer productivity tempted late-nineteenth-century writers and some twentieth-century observers to criticize him harshly. The temptation should be steadfastly resisted. Bierstadt's theatrical art, fervent sociability, international outlook, and unquenchable personal energy reflected the epic expansion in every facet of western civilization during the second half of the nineteenth century.

Select Bibliography

Gordon Hendricks. "The First Three Western Journeys of Albert Bierstadt." In *Art Bulletin* 46 (September 1964), pp. 333–65.

——. *Albert Bierstadt: Painter of the American West*. New York: Harry N. Abrams, 1974.

Matthew Baigell. *Albert Bierstadt*. New York: Watson-Guptill, 1981.

Patricia Trenton and Peter H. Hassrick. *The Rocky Mountains: A Vision for Artists in the Nineteenth Century*. Norman, Okla.: University of Oklahoma Press, 1983.

Allan Pringle. "Albert Bierstadt in Canada." In *The American Art Journal* 17 (Winter 1985), pp. 2–27.

Gerald L. Carr. "Albert Bierstadt, Big Trees and the British: A Log of Many Anglo-American Ties." In *Arts Magazine* 60 (Summer 1986), pp. 60–71.

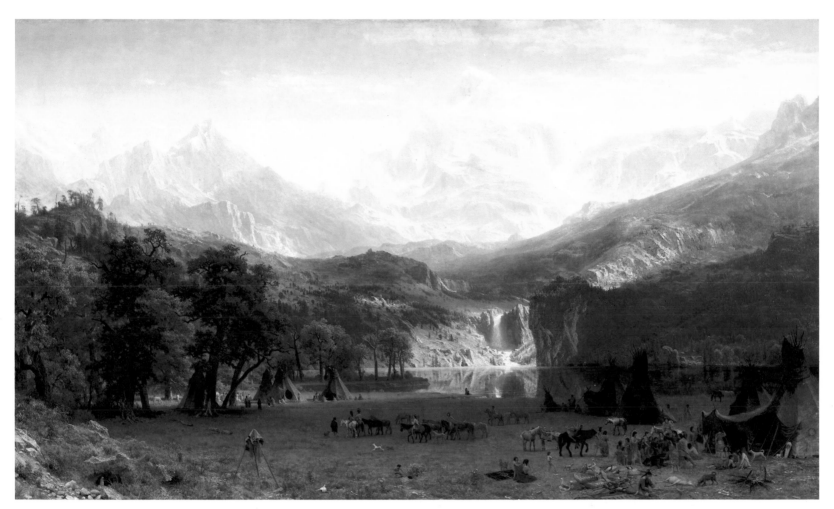

The Rocky Mountains, Lander's Peak, 1863
Oil on canvas, 73½ × 120¾ in. (186.7 × 306.7 cm.)
Signed and dated at lower right: ABierstadt/1863.
The Metropolitan Museum of Art, New York City. Rogers Fund, 1907
 (07.123)

The Rocky Mountains, Lander's Peak was the pivotal painting of Bierstadt's career. Completed and first exhibited in New York City early in 1863, it subsequently was sent on a domestic tour of at least a half-dozen cities (including two showings in Boston and three in Manhattan) and was then exhibited in London, Paris, and London again through early 1868. The romantic allure of the subject matter, coupled with the panoramic proportions of the canvas, the artist's astute marketing of the composition through exhibitions and the publication of high-quality color and black-and-white reproductions, and the sale of the painting in 1865 for a record price, established Bierstadt's international reputation as a painter of grandiose landscapes of the American West.

He had observed his subjects firsthand. After announcing in

January 1859[1] his intention to tour western territories in order to study "the manners and customs of the Indians" and to paint "a series of large pictures" of the scenery, he traveled from New Bedford, Massachusetts, through the present states of Kansas, Nebraska, Wyoming, and Colorado between April and October 1859. For the portion of the journey outbound from Saint Louis, he joined a government survey expedition headed by Colonel Frederick W. Lander. The outlines of the artist's movements during his first trip West are now reasonably clear, thanks to Gordon Hendricks, in 1964,[2] Patricia Trenton and Peter Hassrick, in 1983,[3] several published accounts from the period, among them two letters from Bierstadt himself, in 1859,[4] and Lander's official report, submitted in 1860.[5] The painter's oft-quoted letter to *The Crayon*, dated "Rocky Mountains, July 1859," foretells the major theme and many details of the present picture. In the letter, Bierstadt enthusiastically introduced his readers to the snow-capped Rockies by likening them to "the Bernese Alps, one of the foremost ranges of mountains in Europe, if not the world." He continued, "[The Rockies'] jagged summits, covered with snow and mingling with the clouds, present a scene which every lover of landscape would gaze upon with unqualified delight." Lesser elements, such as the "great variety of trees" blanketing lower ridges, a wide assortment

of colorful rocks, and multitudes of "silvery streams" bursting with fish, enchanted him. After devoting a substantial part of his communication to the local Indians, "whose manners and customs . . . are still as they were hundreds of years ago," he concluded, "Now is the time to paint them, for they are rapidly passing away; and soon will be known only in history." By the end of the journey, Bierstadt had amassed a sizable portfolio of drawings and oil sketches, a large quantity of stereopticon photographs of Indians and landscape views, as well as a formidable collection of Indian artifacts. He displayed the anthropological specimens in his quarters in the Tenth Street Studio Building in New York for years afterward.[6]

Two lesser-known facets of his trip also have a bearing on *The Rocky Mountains, Lander's Peak*. The first—which may have become exaggerated in the retelling—is the danger that Bierstadt, his companion artist Francis S. Frost, and an attendant experienced after they separated from Lander's party in July 1859. Although Bierstadt had ended his letter to *The Crayon* with a picturesque description of "camp-life" in the wilderness, a report published six months later revealed that the three men subsequently had "lived on bread and water—not daring to fire a gun, for fear of betraying their retreat to hostile Indians, tribes of whom had murdered three white travellers."[7]

The second factor is Lander himself, whose talents embraced a gamut of professions. Besides being a capable engineer, explorer, and soldier (he had already traveled in the West and later would die a Civil War hero), he was also a man of letters and a charismatic proponent of the visual arts. In March 1857, at the newly organized Washington, D.C., Art Association, Lander delivered a stirring lecture on "The Aptitude of the American Mind for the Cultivation of the Fine Arts."[8] Observing that his countrymen were an energetic, practical, yet "inspired" people, for whom poetry was "acted rather than written," he singled out the recently deceased explorer, soldier, writer, and orator Elisha Kent Kane for special mention. Kane's truly American character, Lander said, exemplified the "working revelation" of the nation as a whole; "poet of heart, and inspiration, [he] was one of the bards who should stand upon the sea of glass mingled with fire, with those having the harps of God." From this kind of "inspired faith—this trust in Divine apprehension," Lander argued, the greatest artists ever to walk the earth might arise, if their art were directed "to the patriotic sentiments of the people, which underlie and vivify all others." With apposite encouragement in the nation's capital, he concluded, great artistic "productions of the national history and the elaboration of themes of the soil" would be assured. While one may wonder if Lander and Bierstadt sometimes regarded one another as rival rather than allied partisans of American nationalism, one cannot doubt that the painter genuinely admired the expedition leader. Until the end of his life, Bierstadt associated not only his own expertise on the West but also the mountain that rises majestically in the center of *The Rocky Mountains*—his first epic canvas of the West—with Frederick Lander.

After his return to the east coast in late 1859, Bierstadt im-

mediately set to work developing his myriad observations, sketches and photographs, and anthropological souvenirs into studio pictures. The most ambitious of these, *The Base of the Rocky Mountains, Laramie Peak* (location unknown) was completed in time for the annual exhibition of the National Academy of Design in spring 1860. Published descriptions report that the composition consisted of an Indian encampment in the foreground; a fertile valley roamed by herds of buffalo and "thickly studded with cottonwood trees," through which a river, "being near its mountain source," flowed as "blue and crystal as the lake of Geneva," in the middle ground; and a "towering" snow-capped range of the Rockies in the background.[9] In the next eighteen months, Bierstadt painted another Rocky Mountain scene (location unknown), which was described as a view composed of a foreground river, a verdant meadow on which an Indian pursued "an infuriated buffalo," and a backdrop of snow-capped mountains.[10] In 1861, he also produced a picture now titled *Sunset Light, Wind River Range of the Rocky Mountains* (ill.), a five-foot-wide canvas that has been astutely assessed as a trial run for *The Rocky Mountains*.[11] Although compositionally less expansive throughout, and lacking the waterfall and the reflecting pool of the present picture, *Sunset Light* is more dramatically lighted and boldly colored.

That the illumination effects of *The Rocky Mountains* are less emphatic than those of its immediate predecessor is a symptom of the artist's conscious emulation of the work of Frederic Church, in particular *Heart of the Andes* (see p. 246). Other indications of Church's influence on Bierstadt are the ten-foot width of the canvas—the same as that of *Heart of the Andes*—and the fact that Bierstadt chose to exhibit it as a "Great Picture," that is, as a touring, single-picture attraction. At first, he sidestepped direct competition with his slightly older compatriot. He surely knew of Church's plans to exhibit *Cotopaxi* (see p. 254) at Goupil's Gallery in New York early in 1863.[12] It was therefore no accident that *The Rocky Mountains*, surrounded by Bierstadt's collection of Indian artifacts, was accorded its first public exposure, on 3 February 1863, at a reception held in New York at the Tenth Street Studio Building. Though it was displayed only briefly, the painting attracted immediate attention in the press.[13] It garnered more notice from a prolonged exhibition that took place in Boston's Studio Building on the eve of Bierstadt's second trip to the West, followed by a showing in his adoptive hometown of New Bedford, Massachusetts, and a second exhibition in Boston (that time at the gallery of Williams and Everett) before returning to Manhattan for display at the Seitz and Noelle gallery in February and March 1864. In April, at the Metropolitan Fair of the United States Sanitary Commission, *The Rocky Mountains* at last confronted its epic antecedent, *Heart of the Andes*, face to face, much as it does in its modern installation at The American Wing of the Metropolitan Museum. In the minds of most observers, there was little to choose between the two paintings.

Bierstadt's painting proved compelling for several reasons. First, despite their preoccupation with the Civil War, Americans remained keenly interested in the West and its magnificent scenery,

the more so because they sensed that the transcontinental railroad projects postponed by the war would be resumed when peace returned. *The Rocky Mountains* bespoke prewar aspirations and daring expeditions to remarkable, far-off places, which were regarded by Americans as part of their hegemony. Second, although many American and some foreign artists had preceded him to the West, Bierstadt was the first to re-create convincingly its scenic grandeur. That he did so partly through attractive artistic devices derived from his Düsseldorf training and from his remembrances of the Alps (for decades a source of subject matter for European artists) bothered some critics, but not members of the public at large. They were understandably enthralled. Third, Bierstadt introduced audiences to new dimensions in landscape painting: the towering peaks of *The Rocky Mountains* seemed much taller, and therefore more awe-inspiring, than the mountains in Church's paintings. Fourth, he claimed that the work was topographically accurate. In the opening sentences of a leaflet he wrote and had printed for gallery customers,[14] Bierstadt stated that the picture was the product of firsthand observations and on-the-spot sketches. The central peak he christened Mount Lander, after his compatriot and traveling companion, who had died in 1862 of wounds suffered in the Civil War.[15] Though the configurations of the waterfall and its basin were composed primarily for pictorial needs, Bierstadt was essentially correct in asserting that they represented the headwaters of the "Rio Colorado." And fifth, he made certain that the anthropological as well as the geologic details of the work were diverting. As though to verify the credibility of that part of the scene, he organized a tableau vivant of an Indian village, using real-life Indians, in another section of the Metropolitan Sanitary Fair of 1864.[16]

Bierstadt may not have been unduly dismayed when *The Rocky Mountains* remained unpurchased until the end of the Civil War. His resolute confidence in the artistic and monetary values of his achievement (it was rumored that he turned down an offer of ten thousand dollars in 1863)[17] was confirmed in October 1865, when James McHenry, an American-born railway financier residing in London, acquired the picture for a reported twenty-five thousand dollars, a price at least equaling any ever paid for a work by a living American artist. The sale enabled Bierstadt to ask fifteen thousand dollars or more for his largest paintings, and provided entrée to a quarter-century-long relationship between Bierstadt and Britain in terms of travel, exhibitions, publications, and patronage.[18] Among the highlights of that association were an exhibition of *The Rocky Mountains* at Thomas McLean's Gallery in London in 1866; Bierstadt's personal presentation to Queen Victoria of the painting, together with *A Storm in the Rocky Mountains—Mount Rosalie* (see p. 290), in December 1867; and a second showing at the McLean gallery in January 1868, in tandem again with *A Storm in the Rocky Mountains*. (Two years later, in 1869, McLean published companion chromolithographs of the two works.) In 1867, the painting also went to France, where it occupied a prominent position at the Paris Exposition Universelle.

G.L.C.

Albert Bierstadt, *Sunset Light, Wind River Range of the Rocky Mountains*, 1861, oil on canvas, 38½ x 59½ in. (97.8 x 151.1 cm.). New Bedford Free Public Library, Gift of Mrs. Eliza Dana

Notes

1. *The Crayon* 6 (January 1859), p. 26. Cited in Spassky 1985, p. 321. See also the *New York Evening Post*, 5 January 1859, p. 2.
2. Hendricks 1964, pp. 333–39.
3. Trenton and Hassrick 1983, pp. 120–39.
4. Letters from Bierstadt were printed in *The Crayon* 6 (September 1859), p. 287, and in the *New Bedford Daily Mercury*, 14 September 1859, p. 2, the latter cited in Trenton and Hassrick 1983, p. 121; p. 362, n. 55.
5. Cited in Hendricks 1964, p. 334.
6. In 1865, for example, T. B. Aldrich, "Among the Studios. No. 1," *Our Young Folks* 1 (September 1865), p. 597, characterized Bierstadt's quarters as a "perfect museum of Indian curiosities,—deerskin leggings, wampum-belts, war-clubs, pipe-bowls, and scalping-knives. The latter articles look so cruel and savage that you don't feel like prolonging your visit, for fear the artist might get out of patience with you!"
7. *Boston Daily Evening Transcript*, 29 March 1860, p. 4. The reporter, who was describing Bierstadt's *Base of the Rocky Mountains, Laramie Peak*, obviously had talked with the artist in his studio. Six months earlier, Bierstadt, in his letter to the *New Bedford Daily Mercury*, had referred to his and his comrades' subsisting on bread and water, explaining that they had run out of provisions and were too captivated by the scenery to hunt for game.
8. A summary of the lecture was printed in all the major Washington, D.C., newspapers at the time. The quotations used here are taken from the *Evening Star*, 23 March 1857, p. 3, and the *National Intelligencer*, 23 March 1857, p. 1.
9. This particular description comes from the *Boston Daily Evening Transcript*, 29 March 1860, p. 4.
10. According to published reports, the work, shown at the Tiffany Exhibition of November 1861–January 1862 in New York, was a different picture from that called *Base of the Rocky Mountains*. The painting displayed at the Tiffany Exhibition (reviewed in the *New-York Times*, 17 November 1861, p. 6, and in the *New York Evening Post*, 9 January 1862, p. 1) was said to represent "Pikes Peak," which Bierstadt did not see for himself until 1863.
11. Hendricks 1974, pp. 140–41; Trenton and Hassrick 1983, pp. 126, 128; Spassky 1985, p. 322.
12. Hendricks 1974, p. 140, plausibly suggests that Church's exhibition of *Cotopaxi* had a direct bearing on Bierstadt's plans for *The Rocky Mountains*. Church's *Heart of the Andes* also had been shown at Goupil's Gallery in April–May 1862, to assist sales of William Forrest's engraving of the composition. Church's

Under Niagara (location unknown) was displayed at Goupil's in December 1862–January 1863.

13. For example, the *New York Evening Post*, 5 February 1863, p. 2, *New York Tribune*, 4 February 1863, p. 8, and *Boston Daily Evening Transcript*, 7 February 1863, p. 1, discussed the picture at some length; the *Tribune*'s critic also mentioned the artist's Indian "trophies." Robert Barry Coffin [Barry Gray] wrote a long poem titled *The Rocky Mountains* for the *Boston Daily Evening Transcript* (9 February 1863, p. 1), as well as a second poem of comparable length after the painting arrived in Boston (*Boston Daily Evening Transcript*, 14 April 1863, p. 1). Bierstadt again placed *The Rocky Mountains* on view at New York's Tenth Street Studio Building at a reception on 3 April 1863 (*New York Tribune*, 4 April 1863, p. 2).

14. A copy of the leaflet is in the Gordon Hendricks Papers, Archives of American Art.

15. Trenton and Hassrick 1983, p. 128, have identified "Mount Lander" as the summit now called Temple Peak, in the Wind River Range in Wyoming.

16. Cited in Hendricks 1974, p. 149; Spassky 1985, p. 324.

17. *New York Tribune*, 4 April 1863, p. 2. A short time later, a correspondent for the *Boston Daily Evening Transcript* (14 May 1863, p. 4) wrote that Bierstadt recently had refused six thousand dollars for one of his pictures—presumably, *The Rocky Mountains*.

18. On this subject, see Gerald L. Carr, "Albert Bierstadt, Big Trees and the British: A Log of Many Anglo-American Ties," *Arts Magazine* 60 (Summer 1986), pp. 60–71.

Looking Up the Yosemite Valley, ca. 1865–67

Oil on canvas, 36 × 58½ in. (91.4 × 148.6 cm.)
Signed at lower right: ABierstadt
Haggin Collection, The Haggin Museum, Stockton, California

Bierstadt's first encounter with the Yosemite Valley, in August 1863, exceeded all his expectations. After leaving the Mariposa Grove, he and his companions endured an arduous climb, then effected easier passages through verdant meadows and thick forest until suddenly the valley opened before them at Inspiration Point. Fitz Hugh Ludlow, the designated chronicler of the journey, recalled the wonder of that first prospect:

> We did not so much seem to be seeing from that crag of vision a new scene on the old familiar globe as a new heaven and a new earth into which the creative spirit had just been breathed. I hesitate now, as I did then, at the attempt to give my vision utterance. Never were words so beggared for an abridged translation of any Scripture of Nature.[1]

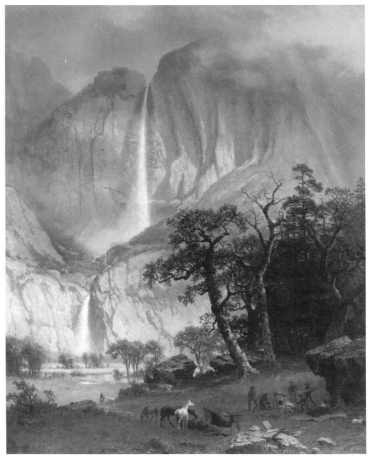

Albert Bierstadt, *Cho-looke, The Yosemite Fall*, 1864, oil on canvas, 34½ x 27⅛ in. (87.6 x 68.9 cm.). Courtesy, Putnam Foundation, Timken Art Gallery, San Diego, California

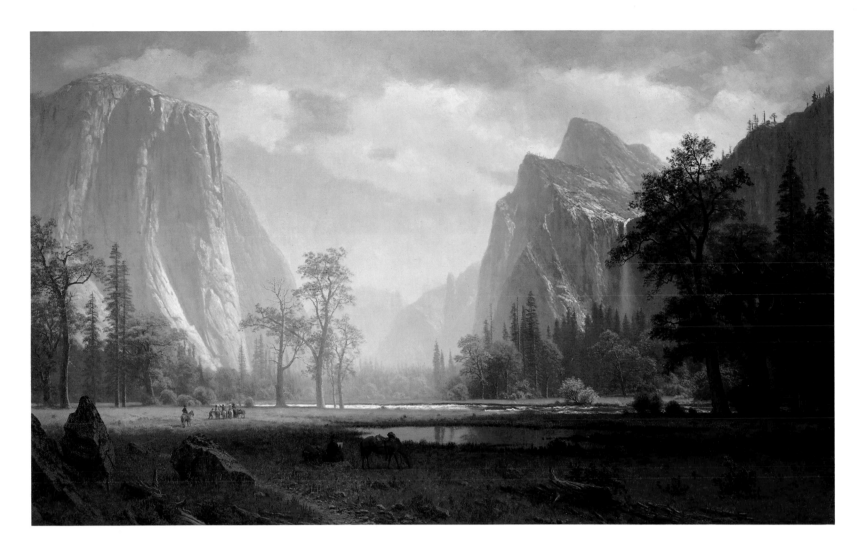

The spellbinding view set the tone for the entire seven-week stay.[2] Ludlow rhapsodized about the stupendous sheer cliffs, out-size precipices, and, as it was then believed, the world's tallest waterfall. Commingled with Indian legends, which conferred an aura of the human spirit in inanimate geology, the valley became a terrestrial Paradise, a Mount Olympus, and a scientific model of the earth's inner workings, rolled into one. The artists in the party busied themselves with sketching excursions that began shortly after sunup each day. In the evenings, they would reassemble at camp for gossip, a "private view" of the day's accomplishments, a hearty meal, and sleep on a bed of pine boughs.

Looking Up the Yosemite Valley commemorates that in-vigorating, visually full life. Beneath a benign, partly cloudy sky, the valley walls shimmer in the summer sunlight, the foreground meadow is bathed in transparent shadow, and the Merced River runs lazily through the middle distance. El Capitan rises at left, opposite Bridal Veil Falls, its volume of water reduced to a seasonal ebb as it tumbles in front of Cathedral Rocks, at right. Seated near his grazing horse in the middle distance, an artist records the scene while a party of men and their horses gathers farther away at left.

When the picture was acquired by the Haggin Museum, in 1930, it was accompanied by two assumptions: that it had been painted in 1863 and that the artist himself is shown sketching in the middle distance. The second is probably correct, but the first requires some modification. Published reports of Bierstadt's and Ludlow's return to New York on 14 December 1863 and of the painter's activities during the following few weeks specify that his portfolio bulged with oil studies of "large size, and in finish and elaboration almost equal to a completed picture," but that no studio works were very far advanced.[3] By mid-1864, however, Bierstadt had completed at least two Yosemite scenes, plus several other western subjects. The larger of the two Yosemite views, a vertical canvas dated 1864 and titled *Cho-looke, The Yosemite Fall* (ill.), focuses on a campsite at the edge of a wood. At the close of day, the camp and its occupants are covered in deepening shadow beneath a brightly lighted backdrop of Yosemite Falls emerging from mists. One may assume that Bierstadt is among the men seated around the fire: an engraving of the composition was used to illustrate *The Heart of the Continent* (1870), Ludlow's belated word-portrait of the 1863 journey.[4]

Although the restricted range of Bierstadt's handling of paint in the 1860s and 1870s makes generalization difficult, *Looking Up the Yosemite Valley* appears thematically similar to *Cho-looke, The Yosemite Fall* and stylistically consonant with other Bierstadt canvases of Yosemite that can be dated to the 1860s. Between executing *Looking Down Yo Semite Valley*, his major contribution to the National Academy of Design exhibition of 1865,[5] and *The Domes of Yosemite* (1867; St. Johnsbury Athenaeum), a leviathan, fifteen-foot-wide painting reportedly commissioned in 1864 and completed three years later, Bierstadt would have had ample opportunity to channel his boundless creative energy into several satellite canvases of the subject. It is also conceivable that the present picture originated in the aftermath of Bierstadt's second visit to California, from 1871 to 1873, though most of his Yosemite paintings that can be securely linked to the later decade contain animal rather than human anecdotal details or are devoid of such elements.

<div align="right">G.L.C.</div>

Notes

1. Fitz Hugh Ludlow, "Seven Weeks in the Great Yo-Semite," *The Atlantic Monthly* 13 (June 1864), p. 746; quoted in Hendricks 1974, p. 130.
2. Hendricks 1964, p. 345, speculates that the Yosemite sojourn actually lasted less than seven weeks, but Ludlow, in the fifth "Letter from Sundown" he wrote to the *New York Evening Post* (24 October 1863, p. 1), reported that he and his party had been in or near the Yosemite Valley for six weeks before the letter was written.
3. *New York Evening Post*, 15 December 1863, p. 2; 7 January 1864, p. 1.
4. *Cho-looke, The Yosemite Fall* was described in-progress in the *New York Evening Post*, 9 June 1864, p. 1. Its function as the frontispiece for one of the editions of Ludlow's book is mentioned in Hendricks 1964, p. 345, n. 68. A third Bierstadt painting of 1864, showing a camp in Yosemite at night (Hendricks 1974, p. 157, ill.), is now in the Yosemite National Park Museum. For a thorough discussion of the Timken Art Gallery picture and its historical content, see Nancy K. Anderson, *Focus II: Albert Bierstadt: Cho-looke, The Yosemite Fall* (San Diego, Cal.: Timken Art Gallery, 1986).
5. On this picture, see p. 290.

A Storm in the Rocky Mountains — Mount Rosalie, 1866

Oil on canvas, 83 × 142¼ in. (210.8 × 361.3 cm.)
Signed and dated at lower right: ABierstadt/N.Y. 1866
The Brooklyn Museum, Brooklyn, New York. Dick S. Ramsay Fund, A. Augustus Healy Fund B, Frank L. Babbott Fund, A. Augustus Healy Fund, Ella C. Woodward Memorial Funds, Gift of Daniel M. Kelly, Gift of Charles Simon, Charles Smith Memorial Fund, Caroline Pratt Fund, Frederick Loeser Fund, Augustus Graham School of Design Fund, Bequest of Mrs. William T. Brewster, Gift of Mrs. W. Woodward Phelps, Gift of Seymour Barnard, Charles Stuart Smith Fund, Bequest of Laura L. Barnes, Gift of J. A. H. Bell, John B. Woodward Memorial Fund, Bequest of Mark Finley (76.79)

Bierstadt's second journey to the Far West was better organized and more ambitious than his first. In 1859, he had affiliated himself with a government expedition and an experienced explorer, and had ventured forth on his own only after the halfway point. Before setting out four years later, in 1863, he joined forces with the popular lecturer and author Fitz Hugh Ludlow. The joint purpose of the two men was to imbibe deeply of the West and to commemorate their exploits in artistic form — Bierstadt through provocative painted images; Ludlow through verbal imagery culminating in a book, *The Heart of the Continent*, published in 1870. The collaboration between artist and author recalls the partnership of Frederic Church and Louis LeGrand Noble, whose voyage to the Labrador coast in 1859 resulted in Church's painting *The Icebergs* (1861; Dallas Museum) and Noble's book-length narrative *After Icebergs with a Painter* (1861).[1]

The Bierstadt–Ludlow expedition was announced in New York after Bierstadt had launched *The Rocky Mountains, Lander's Peak* (see p. 285) on a national exhibition itinerary lasting two and a half years.[2] Between May and December 1863, the two men, joined at times by other artists and writers, traversed thousands of miles of wilderness in Colorado, Wyoming, Utah, Nevada, California, Oregon, and Washington state, and sampled the cosmopolitan delights of San Francisco before going on to Panama and returning to New York by ship. Ludlow had kept eastern readers abreast of most of their doings through a series of "Letters from Sundown," printed in the *New York Evening Post*.[3]

Once he had resettled in New York, Bierstadt lost no time in resuming studio productivity in a series of large-scale compositions having western subjects. The first was *Mount Hood* (ca. 1864; Southwest Museum), shown extensively as a "Great Picture" from 1865 until the end of 1869, when it reached London.[4] The second was *Looking Down Yo Semite Valley* (perhaps the picture now owned by the Birmingham Public Library, Alabama, and on loan to the Birmingham Museum of Art),[5] which in 1865 represented Bierstadt in the inaugural exhibition at the new National Academy of Design headquarters in New York. Only with a third painting of panoramic proportions did he return to the more familiar terrain

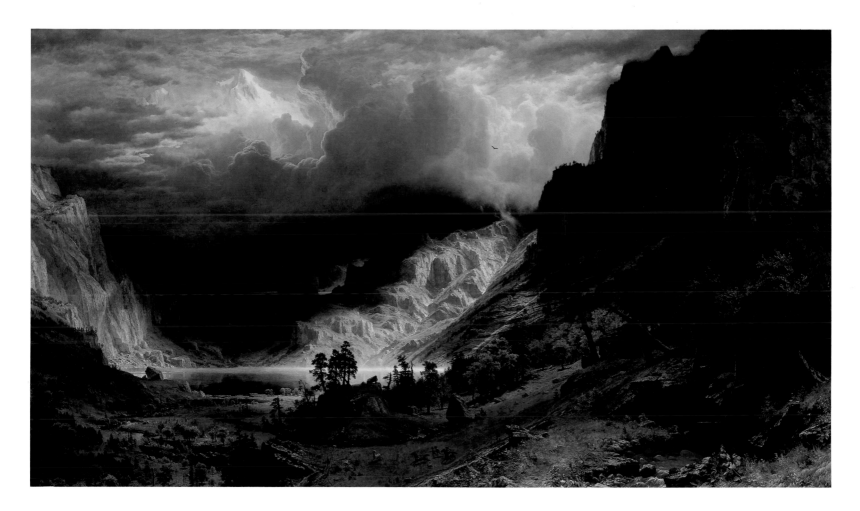

of the Rocky Mountains, in a work intended at least in part as a complement to his earlier masterpiece (see p. 285).

Begun in early 1865 and completed and unveiled in New York a year later, *A Storm in the Rocky Mountains—Mount Rosalie* is a startling contrast to its predecessor of 1863 and, for that matter, to *Mount Hood* and *Looking Down Yo Semite Valley.* The quiescent moods of the three previous works are confounded as geology and meteorology erupt in a cataclysm of shapes and strong oppositions of light and dark. The deep opening into space at middle left discloses two lakes connected by a waterfall, a half-dozen cascades of varying verticality in addition to the small waterfall at near right, and, eventually, the twin snow-capped summits of Mount Rosalie. Although long since redesignated Mount Evans, the mountain originally was named by Bierstadt in honor of Rosalie Ludlow, whom he married in 1866, after her divorce from the writer. Mingling with and seemingly threatened by the clouds surrounding them, the peaks hover above the gathering storm with no apparent geologic support. Across the foreground and the middle ground, a variety of animal, vegetable, and mineral incidents vie for the viewer's attention. A printed leaflet (its author evidently Bierstadt himself), available to visitors in exhibition galleries in 1866–67,[6] helps clarify the details. They include the stream-fed

pool at near right, "through which the rounded stones on the bottom are plainly seen, and in whose depths wily trout find a resting place"; the encircling "bright-colored flowers and ferns"; a verdant forest above, composed of "pines, hemlocks, spruce, cottonwood and aspens," mixed with "blue bells, wild sun-flowers, golden-rods, butter-cups, and violets"; and a flight of startled ptarmigan seeking shelter in the woods above the right-hand edge of the pool. Also described are the dying embers of a campfire, a slain deer, a saddle and blankets, all abandoned as a trio of Indians and horses at lower middle flee in advance of the storm, and a settlement of wigwams near a stream in which horses are being watered, at lower left. Not mentioned in the handout is the black bear running in the woods, just beyond the flock of ptarmigan.

The text also calls attention to the rugged hills at right, which "loom frowningly." The phrasing is indeed appropriate. The nearer of two immense, upright rocks at upper right resembles a glowering stone idol, though its shape, that of a human head, has been carved not by primitive man but by nature. Much the same can be said of the isolated boulder atop the small precipice at lower middle left. Propped up on one side by a smaller rock and silhouetted against the nearer of the two lakes, it forms an analogy to prehistoric dolmens that is probably intentional. A giant, uprooted tree,

Frederic E. Church, *Rainy Season in the Tropics*, 1866, oil on canvas,
56¼ x 84³/₁₆ in. (142.9 x 213.8 cm.). The Fine Arts Museums of San Francisco,
Mildred Anna Williams Collection (1970.9)

paintings often were encouraged to do, he or she will hardly believe that it belongs with the rest of the picture. In the larger context, however, the calm of the quiet pool complements the pristine, light-filled surfaces of the lake in the middle distance.[10]

The strength of Bierstadt's imagery in this painting derives principally from four factors: the painter's powerful emotional response to the actual scene; the escalating romanticism apparent as early as February 1864 in another of his Rocky Mountain pictures;[11] the admixture of California landscape features—the Yosemite-like cliffs and wind-blown cascade at left and the Sierra-Nevada-like swirl of serrated snow peaks and clouds above—with those of Colorado; and, by no means least, the art of his older compatriot Frederic Church. The close-up, almost touchable botanical details at lower right recall Church's *Heart of the Andes* (see p. 246), while the covey of ptarmigan amplifies a flight of birds occupying a similar position in Church's *Cotopaxi* (see p. 254). Bierstadt must have been influenced to an even greater extent by Church's *Chimborazo* (see p. 259), in which the distant, snow-covered Ecuadorian mountain floats above visible underpinnings, and by Church's *Rainy Season in the Tropics* (ill.), begun in 1863 but not completed until 1866 and representing in his work an unprecedented outpouring of exuberant atmospheric energy. For Church's part, elements in his *Rainy Season in the Tropics*—the towering snow mountain and the rock formations resembling those of Yosemite—suggest an appreciation of Bierstadt's work. Rivals though the two artists may have been, they were favorably impressed with one another's creations.

Although admission fees from the picture's maiden exhibition at the Miner and Sommerville Gallery in New York during February 1866 were donated to a local children's hospital, art reviewers did not necessarily respond charitably to the work. One critic termed it merely "large and showy," predicting that it would add nothing to the artist's reputation.[12] Another writer blasted the defective, "petty" painting, citing "insignificant, frittered and mean" mountain forms, misshapen trees already familiar in the artist's repertoire, and distracting, weakly painted details. By "pandering to the popular love of excitement," Bierstadt had succumbed to the hyperbole of his own press notices, the critic concluded.[13] A greater number of commentators reacted favorably. One characterized the work as the artist's masterpiece; another assessed the "grand and impressive" picture as "better even than his *Rocky Mountains*"; others questioned the credentials of those who voiced negative opinions.[14] Further showings of the painting in Washington, D.C., Baltimore, Philadelphia, Boston, and Buffalo enhanced its public popularity.[15]

In the fall of 1865, while it was underway in Bierstadt's studio, *A Storm in the Rocky Mountains—Mount Rosalie* was sold to Thomas William Kennard, a visiting English railroad magnate, for around twenty thousand dollars. Because it took place in the wake of James McHenry's purchase of *The Rocky Mountains, Lander's Peak* for twenty-five thousand dollars, the sale was an unprecedented coup: no American artist had ever received so great a financial reward in so short a time. The windfall enabled Bierstadt

another tree leaning sharply to the left, a whirlwind of treetops at right, several bounding deer, a soaring American eagle, and a tall cascade blown into mist before it reaches the ground at left, heighten the effect of impending meteorologic violence.

As Patricia Trenton and Peter Hassrick have demonstrated,[7] the scene is set in the Chicago Lakes region of Colorado, some forty miles southwest of Denver. Since Ludlow did not accompany Bierstadt on his four-day expedition to that locale in June 1863, no account of it appears among the author's narratives. William Newton Byers, editor of Denver's *Rocky Mountain News*, who acted as the artist's guide in this instance, did record the experience for his newspaper and, much later, for the *Magazine of Western History*.[8] Byers's words effectively convey the enthusiasm and fervor of the artist's sketching activity when, with little forewarning, he encountered a vista of "sublime" scenic splendor. Byers's accounts and Trenton's and Hassrick's research confirm in principle the painter's claim, made in his leaflet of 1866–67, that the scene portrayed in the painting is faithful to actual topography. The atmospheric drama generally accords with a storm described by Byers as well.[9] Yet the essence of Bierstadt's studio composition is an overpowering, unfathomable potency and an apparent improbability of forms, colors, and distances—that is, effect rather than accuracy, multiplicity instead of unity. In 1864, *The Rocky Mountains* had caused some critics to complain of spatial disruption between the foreground Indian settlement and the background mountains. In *A Storm in the Rocky Mountains—Mount Rosalie*, the dissonances are much stronger, yet the composition is capacious enough to absorb them. For example: if a spectator isolates the pool at right, perhaps by looking at it through opera glasses, as nineteenth-century viewers of American panoramic landscape

in 1866 to complete Malkasten, his mansion overlooking the river at Irvington-on-Hudson, New York, and to marry Rosalie Ludlow, and must also have helped underwrite the couple's two-year European tour of 1867–69.

After shipment to England, the painting was shown twice at Thomas McLean's Gallery in London within a seven-month period between June 1867 and January 1868. At its second showing, it was paired with *The Rocky Mountains*, as it had been during a private viewing arranged for Queen Victoria at Osborne House, on the Isle of Wight, in December 1867. On that occasion, the Queen reportedly "sat down beside him [Bierstadt] and conversed most affably and intelligently on art and artists—subjects with which she is wonderfully well acquainted."[16] The picture, through showings in 1869 at the Paris Salon and at the Munich International Exposition and in 1887 at the American Exhibition in London, helped sustain Bierstadt's European reputation over the next two decades. After 1887, it dropped from sight, leaving behind only the chromolithograph published by Thomas McLean in 1869, after the painting's second exhibition in his gallery, to hint at the glories of the original. The rediscovery of *A Storm in the Rocky Mountains—Mount Rosalie* in Britain by James Maroney in 1974 was a major event in the history of American art.

<div align="right">G.L.C.</div>

Notes

1. Noble had published an extract of his book in *The Atlantic Monthly* in 1860; in 1864, Ludlow wrote five articles on the western journey for the same periodical. Ludlow also read a series of lectures on the subject in New York in January 1865.

2. The announcement was made in the *Boston Daily Evening Transcript*, 4 May 1863, p. 2, and reiterated in the *New York Evening Post*, 7 May 1863, p. 2.

3. Ludlow's "Letters from Sundown" were printed on p. 1 of the newspaper on 26 May, 5 June, 24 July, 30 July, 24 October, and 28 October 1863.

4. *Mount Hood* was given its premier showing at the YMCA in New York in January 1865 and its first extended exhibition at the Derby Gallery, also in New York, in February 1865.

5. The Birmingham painting is smaller than the reported dimensions of *Looking Down Yo Semite Valley*, but conforms to published descriptions of it. I thank Nancy Anderson, whose research promises to resolve many aspects of Bierstadt's oeuvre, for assistance on this point.

6. No copies of the leaflet have come to light, but the major part of its text was reprinted verbatim in the *London Morning Post*, 10 June 1867, p. 2.

7. Trenton and Hassrick 1983, pp. 141–42.

8. Ibid.; Hendricks 1974, pp. 124, 126, 128.

9. As noted in Trenton and Hassrick 1983, p. 142.

10. One London reviewer perceptively asked, "If the foreground trees in the 'Storm' are so tossed by the first blast of the coming tempest, how is it that the lake in the middle distance lies unruffled by a breath?" *Morning Post*, 16 January 1868, p. 2.

11. At a reception at the New York Tenth Street Studio Building in February 1864, Bierstadt exhibited a picture of "Rocky Mountain scenery, with frowning rocks, dashing waterfalls and flying clouds." *New York Evening Post*, 5 February 1864, p. 2. It is not clear if that was a new painting or one dating from before Bierstadt's western expedition of 1863.

12. *New York Albion*, 17 February 1866, p. 81.

13. *New York Tribune*, 8 February 1866, p. 4.

14. *New York Evening Express*, 3 February 1866, p. 3; *New York Evening Post*, 23 February 1866, p. 2; *Rocky Mountain News* (Denver), 27 February 1866, p. 2; cited in Trenton and Hassrick 1983, p. 143. The *New York Herald*, 7 February 1866, p. 5, and the *New York Weekly Review*, 17 February 1866, p. 4, also gave the painting favorable notices.

15. In Philadelphia, the painting was exhibited at Wenderoth, Taylor, and Brown's on behalf of the "Lincoln Institution, or Soldiers' and Sailors' Orphan Boys' Home," a charitable organization. I thank Merl M. Moore, Jr., for data about the Boston and Buffalo exhibitions of the picture.

16. *New York Herald*, 13 January 1868, p. 8.

The Great Trees, Mariposa Grove, California, 1876

Oil on canvas, 118⅜ × 59¼ in. (300.7 × 150.5 cm.)
Signed at lower left: ABierstadt
Private collection

Concentrated in seventy-five groves in the central part of the state, the "Big Trees"—genus *Sequoiadendron giganteum*, an unusually large species of sequoia—are among the premier natural wonders of California. White men encountered them as early as 1833, but widespread knowledge of their existence had to await the discovery of the Calaveras Grove in 1852 and the Mariposa Grove, outside the Yosemite Valley, in 1857, during the late stages of the California Gold Rush. Reports of the trees' immensity at first were disbelieved, and doubts persisted for years afterward. Gradually, however, the fame of the great trees spread to the east coast and across the Atlantic. American visitors patriotically christened them *Washingtonia gigantea*; British explorers passing through the region designated them *Wellingtonia gigantea* (after the Duke of Wellington, who died in 1852) and singled out a specimen to send to London's rebuilt Crystal Palace in 1854; and various travelers bestowed on individual trees a plethora of names that ranged from those of statesmen, soldiers, and adventurers to those of family friends, relatives, heroic animals, and states of the Union. Under legislation passed by the Lincoln Administration in 1864, the Mariposa Grove and Yosemite Valley were set aside as a state preserve, although some of the legal ramifications were not settled for another decade. An important advocate of preservation status for the trees and the valley and the foremost member of the first commission set up for the purpose was Frederick Law Olmsted, co-designer of New York's Central Park.

Bierstadt personally inspected the Mariposa Grove on his first trip to California, in 1863, and returned there for a more thorough survey during his second visit to the state, from 1871 to 1873. The present picture is a product of his second stay. Although not dated and lacking a detailed provenance, it can almost certainly be identified as the work titled *The Great Trees, Mariposa Grove, California*, painted for and exhibited at the Philadelphia Centennial Exposition in 1876. It is the artist's most ambitious and successful attempt to re-create the physical presence of these monarchs of the American forest.

Thanks to Fitz Hugh Ludlow's recollections, published in 1864 and reprinted in 1870,[1] Bierstadt's initial encounter with the trees is well documented. The two men, accompanied by Enoch Wood Perry and Virgil Williams, painters then residing in San Francisco who had known Bierstadt in Europe, stopped at the Mariposa Grove around 1 August 1863 before going on to the Yosemite Valley. Nearby, they encountered Galen Clark, discoverer of the Mariposa Grove, who was then running a modest tourist accommodation and was destined to become guardian of the woodland preserve the next year. Although the party's members were aware of previous travelers' descriptions, Ludlow confessed that he was neither intellectually nor emotionally prepared for the prodigious size of the Big Trees. He began his own account of them by listing, in reverse order of magnitude, the circumferences of the 132 specimens that had been measured. With a controlled sense of awe, he reported that the grandest of these exceeded a hundred feet in girth, were sheathed in bark well over a foot thick, and grew to a height of more than three hundred and fifty feet. Efforts by members of the expedition to throw rocks to the tops of living trees met "with ludicrous unsuccess." Several horses and their attendants could stand within trunk cavities in the largest upright examples, while "through another tree, lying prostrate . . . and hollow from end to end, our whole cavalcade charged at full trot for a distance of one hundred fifty feet." Finally, they came upon "*the* tree," a stupendous prostrate hulk known as the Fallen Monarch, which is still very much in evidence today. Though it was scarred by fire and stripped of much of its bark, Ludlow estimated that as a living tree it would have measured as much as a hundred and twenty feet around.

Equally impressive were the great ages of the trees. As did many commentators of the period, Ludlow mused that they had sprouted in biblical times. His judgment that their beginnings were contemporaneous with the fall of Troy represented one category of guesses. Other visitors associated the trees' earliest years with the time of Christ.

Ludlow and his companions remained half a day at the Mariposa Grove, as "the artists painted color sketches" and the other members of the party marveled at the trees. The artists found they were unable to capture the amplitude of their subjects (Ludlow considered that such a task would require gargantuan canvases), but they did succeed in transcribing a "typical figure, which is a very lofty, straight, and branchless trunk, crowned almost at the summit by a mass of colossal gnarled boughs, slender plumy fronds, delicate thin leaves, and small cones scarce larger than a plover's egg."

Despite Ludlow's—and, it may be therefore assumed, Bierstadt's—vivid responses to the Big Trees, the artist evidently did not paint easel pictures of them until after his second sojourn in California. One reason for the delay might have been Ludlow's caveat that the Big Trees were virtually unpaintable. Further, such great geologic sights as the Yosemite Valley, which Bierstadt also observed in 1863, understandably took precedence on the painter's agenda. In addition, during the next decade, the completion of the transcontinental railroad, the ascendant prosperity of California, and the increasing number of visitors to Yosemite and the Big Trees generated competing artistic activity, notably on the part of painter Thomas Hill and of photographers whose images of the trees were disseminated across the country.[2] For a time, the Big Trees became national news,[3] as controversial settlements of white men near the Mariposa Grove seemed to threaten despoilage of the trees and the region as a whole.

Bierstadt could not have been unaware of those developments, all of which may have rekindled his interest in painting the

trees. While his second round of encounters with the Big Trees is thinly documented,[4] there can be no doubt of its results. In the spring of 1874, he exhibited a moderately large picture titled *California Forest* (probably the painting in the Berkshire Museum)[5] at the National Academy of Design in New York, and sent another of the same subject (location unknown) to the Royal Academy in London. Toward the end of 1875, he was reported to be preparing a huge, vertical canvas depicting "one of the great trees" in California for the Centennial Exposition. The work was described in a New York newspaper:

> [The] most salient feature is the Grizzly Giant, which is to say, one of the great trees of Calaveras County [*sic*], Cal., a cedar, and it is to be presumed in all essential features a portrait, so that the artistic value of the painting will not be the only element of interest in the work. Its size is, of course, emphasized by many details. In the cavernous opening at its base a man stands, and coming up from behind it are two horsemen, tourists evidently. Near it is another great tree, though young compared with the cedar, and in the background are such trees as command our forests, but whose lives are as a span compared with the Methusaleh of Calaveras.[6]

When the painting was finished, by February 1876, some observers judged it to be the artist's masterpiece.[7]

Thought to be the oldest living *Sequoiadendron giganteum*, and still a major attraction at the Mariposa Grove today, the Grizzly Giant is a fitting focus for such a picture. And as Bierstadt portrays it, the Grizzly Giant lives up to its name as easily the most massive, most strikingly colored, and craggiest specimen of the group. Four horses and five men, including a bearded, bareheaded figure said to represent Galen Clark standing at its base,[8] are dwarfed beneath it. Towering above the men, the animals, and its own progeny, the tree stretches through shade and dappled sunlight and breaks into clear blue sky above. About halfway up the elevation, the tilted trunk extends brawny, twisted branches in all directions. (Incidentally, the diameter of the largest branch, at left, has been measured at six feet—sufficient for the *trunks* of all but the grandest trees east of the Mississippi.) Two additional, lilliputian horsemen are visible in the right middle distance. Beyond them, rising to an unbelievable height, stands a second *Sequoiadendron giganteum*.

While Bierstadt's image has its origins in earlier nineteenth-century verbal and visual evocations of venerable trees by such Americans as author William Cullen Bryant and painter Asher B. Durand (see pp. 105; 113), it supersedes them much in the manner that the *Sequoiadendron giganteum* overwhelms all previous standards of arboreal monumentality. In Bierstadt's hands, the Grizzly Giant takes on aspects of dinosaur, mountain, cathedral, cenotaph, and time capsule, offering a glimpse into past ages at the same time that it provides—in the man-size seedlings near its base—a continuum far into the future. Visitors to the Big Trees in Bierstadt's day often found themselves spiritually uplifted by the experience. Although situated in a remote district of the New World, thousands of miles from the Mediterranean, the trees were perceived as silent witnesses to the life of Christ, the lives of other biblical personages,

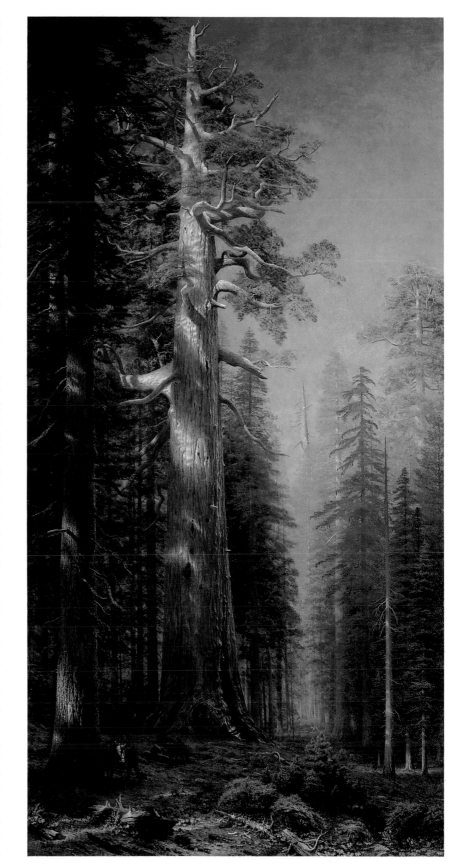

Figure 1. Albert Bierstadt, *Settlement of California, Bay of Monterey, 1770,* 1878, oil on canvas, 72 x 120 in. (182.9 x 304.8 cm.). United States Capitol Art Collection, purchased 1878 for the House Chamber

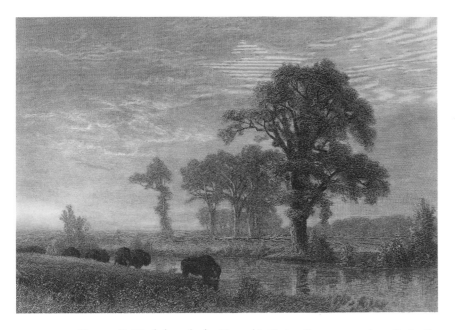

Figure 2. R. Hinshelwood, after Bierstadt's *Western Kansas,* engraving, 1876, 4⅞ x 7⅛ in. (12.4 x 18.1 cm.). In Edward Strahan, *The Masterpieces of the Centennial International Exhibition* (Philadelphia: Gebbie & Barrie, 1876), vol. 1

and all civilized history. The Grizzly Giant was especially susceptible to such associations. As one beholder put it in 1869:

> . . . What lengths of days are his! His years are the years of the Christian era; perhaps in the hour when the angels saw the Star of Bethlehem standing in the East this germ broke through the tender sod, and came out into the air of the upper world![9]

The flourishing life of Galen Clark, who had come to the region apparently near death, seemed an example of the miraculous re-

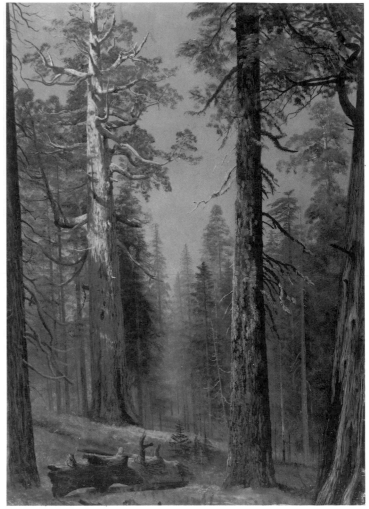

Figure 3. Albert Bierstadt, *The Grizzly Giant Sequoia, Mariposa Grove, Cal.,* ca. 1872–73, oil on paper mounted on cardboard, 30 x 21½ in. (76.2 x 54.6 cm.). Los Angeles County Museum of Art, Gift of Dr. Robert G. Majer (53.30)

storative powers of the Yosemite district and the bounty of the state of California.

Bierstadt hoped that visitors to the Philadelphia Centennial Exposition would comprehend the picture in a nationalist-spiritual context. Elsewhere in the Exposition Art Gallery, he displayed a painting of the Yosemite Valley and two further canvases that underscore the symbolic content of the present picture. The larger of those, the ten-foot-wide *Settlement of California, Bay of Monterey, 1770* (Fig. 1),[10] depicts an outdoor worship service held beneath an umbrageous oak tree in which hang two bells. Occupying the center of the scene, and the largest object in it, the tree is a natural analogue to a pilgrimage church. The smaller work, titled *Western Kansas,* is now unlocated, but its appearance is preserved in a high-quality engraving (Fig. 2). A scene of bison crossing a stream at sunset, its foremost element is again an imposing tree, the apparent objective of the leisurely animal migration.[11]

The Great Trees, Mariposa Grove, California was received with indifference at the 1876 exposition. Few reviewers of the art exhibits referred to it. A reporter from the *New York Times*, author of the longest published critique, devoted most of his comment to an analysis of Bierstadt's reputation, which he found excessive and undeserved.[12] The writer for the *Philadelphia Bulletin*, however, was more generous:

> . . . [It is] a striking work, full of rich, warm color, and rendered peculiarly pleasing by the admirably managed sunlight effect. The distinctively American character of the subject gives to the picture a value above its mere technical excellence, and particularly adapts it to a place in the present Exhibition.[13]

The picture evidently remained in Bierstadt's possession for many years. It was exhibited in London in 1879 and perhaps again in 1887, and a painting (or paintings) of its general description attracted notice from visitors to Bierstadt's studio in the 1880s and early 1890s.[14] An undated oil study of the Grizzly Giant (Fig. 3), presumably taken from life,[15] probably served as a model for the large painting.

<div align="right">G.L.C.</div>

Notes

1. Fitz Hugh Ludlow, "Seven Weeks in the Great Yo-Semite," *The Atlantic Monthly* 13 (June 1864), pp. 744–45; idem, *The Heart of the Continent* (New York: Hurd and Houghton, 1870), pp. 421–24.

2. One theatrical presentation of stereopticon photographs of the Yosemite Valley and the Big Trees was accompanied by a lecture and piano music; see, for example, *Albany Evening Journal*, 23 March 1868.

3. The controversy revolved around settlers who had come to the region before 1864 and their right to remain there after enactment of the state preservation law. The settlers, headed by James Mason Hutchings, vocally defended their position. Hutchings, an interesting figure, published a magazine between 1856 and 1861, lectured, and wrote two books on California, the earlier of which, *Scenes of Wonder and Curiosity in California . . . A Tourist's Guide to the Yosemite Valley*, was printed first in California about 1860, in London in 1865, and in New York in 1870. The New York edition contains an engraving of the "Grizzled Giant."

4. A stereoscope photograph by Eadweard Muybridge of Bierstadt sketching in the Mariposa Grove is preserved in the California Historical Society and is reproduced in Hendricks 1974, p. 209. In September 1874, a visitor to Bierstadt's studio saw sketches of "groups and single specimens of the famous *Sequoia gigantea*, and of many other trees of that wonderful country." Quoted in Hendricks 1974, p. 240.

5. Recent technical examination of the undated painting has uncovered an old label and a pencil inscription on the stretcher. The label is dated 1876. The inscription, dated 1875, reads: "'King's River Big Tree Grove.' 'Lafayette Place/A. Bierstadt'/ King's River/Big Tree Grove/ [illegible]/Jan 8/75." The inscription could refer to a prospective sale or to the painting's original completion date. The printed label more conclusively refers to a prospective sale, since it lists two of the artist's honors in addition to the King's River title. Debra Balken, Curator of Art at The Berkshire Museum, kindly provided this material.

6. *New York World*, 26 November 1875, p. 5. The writer confused Calaveras County with Mariposa Grove, the actual site of the Grizzly Giant. The picture also was briefly described in the *New York Herald*, 25 November 1875, p. 4.

7. *Boston Daily Evening Transcript*, 15 February 1876, p. 6. I thank Merl M. Moore, Jr., for this reference.

8. Hendricks 1974, pp. 129–31, states that Clark is the man shown standing at the base of the tree. He is doubtless correct. Photographs of Clark resemble the bearded figure in the painting and, according to Ludlow, Clark never wore a hat

"since he recovered from a fever which left his head intolerant of even a slouch." Ludlow, "Seven Weeks," p. 744.

9. "The Big Trees," *Boston Daily Advertiser*, 3 November 1869, p. 2. The author of the article, one of the best on the subject of this period, signed himself "Dixon."

10. The picture was exhibited under the title *Settlement of California, Bay of Monterey, 1770*, not under the title currently on the frame, *Expedition under Vizcaino Landing at Monterey, 1601*. The confusion of two events separated by a century and three quarters is understandable, since a Mass was actually said for Vizcaino's expedition under the same oak tree. Bierstadt's painting, however, depicts a Mass, one of three offered by Father Junipero Serra (1713–1784) to celebrate the founding of the missions of San Carlos (Monterey), San Diego, and San Antonio, in 1770. Descriptions of Serra's Mass mention bells hung in the tree and a cross erected on the altar. I thank Florian M. Thayn, Office of the Architect of the Capitol, Washington, D.C., for kindly permitting me access to the painting and for providing information on it and on Father Serra.

11. *Western Kansas* was similar to another work, probably painted in 1875 and now in the Karolik Collection, Museum of Fine Arts, Boston. In that picture, however, Bierstadt did not emphasize one particular tree.

12. *New York Times*, 13 June 1876, p. 1.

13. *Philadelphia Evening Bulletin*, 6 July 1876, p. 1.

14. The exhibition of 1879 took place at Agnew's Gallery, London. The painting was paired with a large, horizontal "Sierra Nevada" composition (possibly the one now titled *Mount Whitney*, in the collection of the Rockwell Foundation, Corning, New York) and complemented by four smaller works by Bierstadt. Some reports of visitors to Bierstadt's studio in 1884 and around 1891 are quoted in Hendricks 1974, pp. 279, 303–6.

15. The study is illustrated in Hendricks 1974, p. 325. The tree at left is clearly the Grizzly Giant seen from almost the same viewpoint as in the large painting.

LOUIS RÉMY MIGNOT
(1831–1870)

Mignot was born in Charleston, South Carolina, of Huguenot extraction. Although his family background still remains something of a mystery (at least one early biographer identifies him as a Creole), he was probably the son and namesake of a confectioner of that city. His boyhood, during which he exhibited a precocious talent for art, seems to have been spent in his grandfather's home, near Charleston. In 1851, he left for Holland and studied for four years with Andreas Schelfhout at The Hague. He also traveled around Europe before returning to the United States to settle in New York City, where he received the praise and support of numerous critics, patrons, and fellow artists. In the summer of 1857, he accompanied Frederic Church to Ecuador and there found scenery that provided a major subject for his subsequent work. One of a number of collaborative efforts Mignot was engaged in during the years 1855 to 1862 was a painting titled *The Home of Washington after the War* (Metropolitan Museum), which he and Thomas P. Rossiter completed in 1859. In that same year, Mignot's work was included in John W. Ehninger's *Autograph Etchings by American Artists*, the first and most important example of the cliché verre, a photographic etching process, published in the United States. Mignot was elected an Associate of the National Academy of Design in 1859 and an Academician the following year. In 1862, shortly after the outbreak of the Civil War, with anti-Confederate feelings prevailing in New York, Mignot held a sale of his paintings and on 26 June, aboard the *Great Eastern*, departed the United States. Originally bound for India, a destination reported by Henry Tuckerman and others, he went only as far as England. A resident of London for the remainder of his life, he exhibited regularly at the Royal Academy and elsewhere. Trips he took to Switzerland in 1868 and 1869 resulted in a number of Alpine scenes. In 1870, he went to Paris, where he showed two works at the Salon. He died of smallpox in Brighton, England, on 22 September 1870. An important exhibition of his collected works, organized by his widow, was held in London and in Brighton in 1876.

Circumstances seem to have conspired against Mignot's taking his rightful place in the history of American landscape art. After studying abroad, he returned to the United States for a period of just seven years before the Civil War and his southern sympathies forced him again to leave, that time permanently. Consequently, little of his artistic career was spent on his native shores. His peripatetic life scattered his paintings and effects and made the piecing together of his personal history all the more difficult. Too, he was an artist always a little out of step with his time and place: one sympathetic London critic postulated that the English were unable to appreciate Mignot's art fully because of their unfamiliarity with his subjects; more than one American reviewer indicated that Mignot's style was too vague, too refined, for a people who appreciated straightforward rendering of fact. Nevertheless, his pictures, which have endured on the strength of their own merit, confirm the opinion put forth over a century ago (*Harper's New Monthly Magazine* 59 [1879], p. 256) that Mignot was "one of the most remarkable artists of our country."

Select Bibliography

Catalogue of a Choice Collection of Paintings, and Studies from Nature, Painted by Louis R. Mignot. . . . New York: Henry H. Leeds & Co., 1862.

Catalogue. Special Sale of Fine Oil Paintings Including the Collection of the Well-Known American Artist, Mr. L. R. Mignot, Now in London, Comprising Some of his Latest and Best Works. . . . New York: Henry H. Leeds & Miner, 1868.

Catalogue of the Mignot Pictures with Sketch of the Artist's Life by Tom Taylor, Esq., and Opinions of the Press. Galleries: 25, Old Bond Street, London, and The Pavilion, Brighton, 1876.

Graham Hood. "American Paintings Acquired During the Last Decade." In *Bulletin of the Detroit Institute of Arts* 55 (1977), pp. 94–95.

Katherine Manthorne. "Louis Rémy Mignot's *Sources of the Susquehanna.*" In Barbara Novak and Annette Blaugrund, eds. *Next to Nature: Landscape Paintings from the National Academy of Design.* Exhibition catalogue. New York: National Academy of Design, 1980.

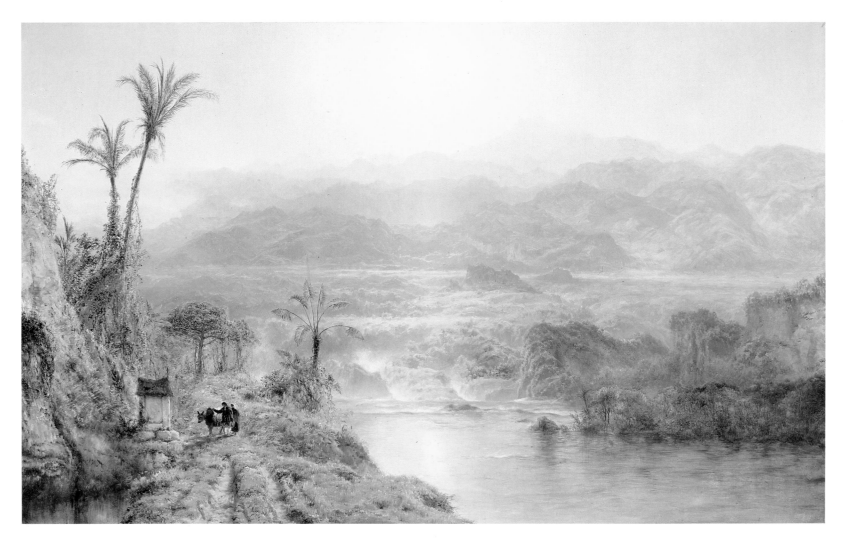

Lagoon of the Guayaquil River, Ecuador, 1863

Oil on canvas, 24¼ × 38 in. (61.6 × 96.5 cm.)
Signed and dated at lower left: L M (monogram) 1863
The Detroit Institute of Arts, Detroit, Michigan. Founders Society
Purchase, Beatrice W. Rogers Bequest Fund and contributions from
Robert H. Tannahill and Al [Abraham] Borman (68.345)

Quite diverse from the exactitude and vivid forest tints of many of
our Eastern painters, are the southern effects so remarkably ren-
dered by Louis R. Mignot, whose nativity, temperament, and taste
combine to make him the efficient delineator of tropical atmosphere
and vegetation.[1]

That perceptive assessment of Louis Rémy Mignot appeared in
Tuckerman's *Book of the Artists* (1867). The single statement re-
veals a good deal about the richly talented and highly respected
landscapist in antebellum America: that his Charleston origins and
European affinities contributed to a style distinct from that of the
majority of Hudson River School painters; that he had a special
flair with effects of atmosphere and vegetation; and that he was
particularly adept at the depiction of Latin-American scenery.

Mignot had his first and only exposure to the tropics in the
summer of 1857, when he traveled to Ecuador in the company of
Frederic Church. To reach their destination, the two men sailed
from New York to Aspinwall (present-day Colón), on the Atlantic
coast of Panama. They crossed the isthmus, probably by way of
the newly constructed Panama Railroad, and caught a steamer at
Panama City that landed them in Ecuador's port city of Guayaquil
on May 23. They apparently spent several days in Guayaquil,
sketching the city's colonnaded architecture and the surrounding
marshy lowlands before starting their journey up the Guayas (in-
correctly referred to often as the Guayaquil) River. Mignot particu-
larly delighted in the plant life and steamy heat of the coast, which
perhaps reminded him of his native Charleston. The painters' ulti-
mate destination, however, was the Andean range of the interior,
the site of mounts Cotopaxi, Chimborazo, and Cayambe, made
famous in the writings of the great German naturalist Baron Alex-
ander von Humboldt. By the end of May, they were in the capital

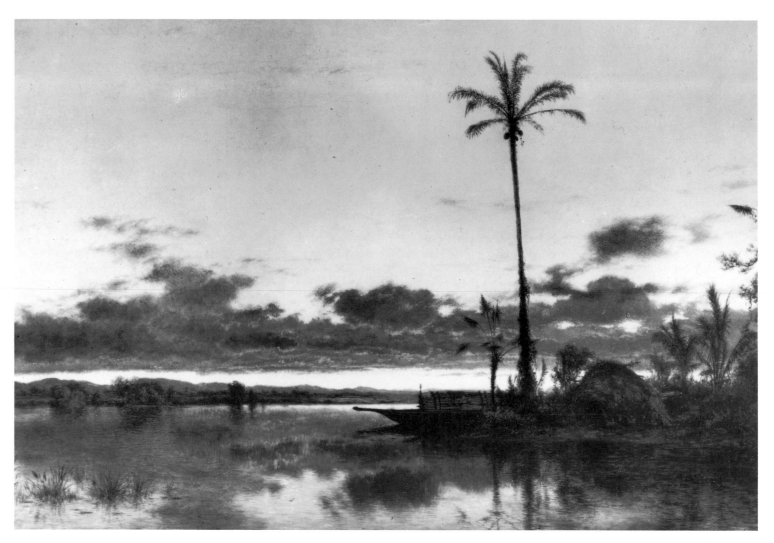

Louis Rémy Mignot, *Lagoon on the Guayaquil*, ca. 1863, oil on canvas,
17 x 25⅛ in. (43.2 x 63.8 cm.). Private collection

city of Quito, which they made their base of operations as they explored the surrounding peaks for the next two months, both artists gathering the impressions and drawings that formed the basis for some of the finest works of their careers.[2]

Mignot's South American oeuvre encompassed the full range of Ecuador's varied geography, from the coastal lowlands to the high sierras, a circumstance that has perhaps led to some confusion in assigning titles to his works. He rendered the flat, marshy lagoons along the Guayas River often, their open expanses filled with the melancholy of the evening sky (ill.). The present canvas, although currently known as *Lagoon of the Guayaquil River*, clearly represents not the same coastal lowlands but, rather, a broad sweep of the Cordilleras that also inspired Church's *Heart of the Andes* (see p. 246). The scenery pictured by Mignot, with its lush backdrop of massive mountain forms, is more readily associated with the central Andean region of Riobamba: a subject better described by the painting's former title, *Morning in the Andes*.[3] Similar

though it is to Church's work in choice of mountain theme, the painting reveals the distinct character of Mignot's style and approach. Whereas Church viewed the Andean panorama by the clear light of midday and rendered each rock and plant with almost brittle clarity, Mignot captured its appearance at sunrise, when its contours were slightly obscured by the dissipating haze. Such effects were admired by a contemporary critic: "His treatment of his subject displays peculiar delicacy of handling, and in his distances the aerial effects are masterly in the extreme; they are soft and melting, if that term may be used, without being marred by unnatural indistinctness and mistiness."[4] With its softly blurred edges and breadth of stroke, Mignot's picture seems to reveal the essence of the place at the same time that it maintains an air of tropical mystery.

Mignot's sensitivity to color is apparent here in the sure yet subtle application of a wide spectrum of high-keyed tones. The foreground vegetation rendered in strident greens and the distant mountains bathed in a pinkish purple haze demonstrate a chromatic audacity all but unmatched in American landscape imagery of that period. Through the emotive power of color, Mignot reinforces

the notion of the variety and fecundity of tropical nature without having to delineate precisely each species of flora and fauna. Given his ability to exploit the expressive potential of color and paint, the artist aligns himself not with the native Realist tradition but with European Romanticism.[5]

Mignot enjoyed an early and prolonged exposure to European art, the usual source of painterly technique in America. Arriving at The Hague at the age of twenty, he immersed himself in the work of his teacher, Andreas Schelfhout; in that of the great Dutch landscapists of the seventeenth century; and in that of other artists, past and contemporary, he would have seen during his travels on the Continent. He undoubtedly acquainted himself as well with the work of Turner and others of the English school, to which he would have had access after moving to London in 1862. Always, however, his study of art was put to the service of his observation of nature. That combination was emphasized by every critic who wrote about Mignot, including his friend and patron Tom Taylor, who described the artist's early years in Holland: "After acquiring from [Schelfhout] the rudiments of technical knowledge, he threw himself with all the ardour of an intense and enthusiastic character into the practise of landscape, and returned to America after five years spent partly in studio-work, but more out of doors in direct study from nature."[6]

That complementary study of nature and art led Mignot to forge his unique pictorial imagery. He sought out uncommon landscape motifs and unusual atmospheric effects of particular seasons and times of the day best suited to his poetic temperament. He had, as a reviewer for the *Cosmopolitan Art Journal* put it, "a great fancy for nature's exceptional aspects."[7] Thus, in South America, he painted flat lagoons more frequently than the more popular mountain themes, and preferred to view his subjects at dusk or in the early morning. In those transitory moments of twilight or, as here, dawn, the details of reality are rendered indistinct. Radiating light transfigures the natural scene into a still and beautiful dream in which the imagination floats freely.

The images of the Ecuadorian landscape created by Mignot might best be characterized according to the remarks of travel writer John Esaias Warren on the dual appeal of tropical nature: "If you are a *naturalist*, your reveries will be of birds and plants and flowers, of strange animals and curious shells; if a *poet*, your soul will expand with delight in contemplation of the beauties of nature around you . . . where all is poetry, and beauty, and love."[8] If the mind of a naturalist can be detected behind Church's work, then surely in Mignot's canvas can be perceived the heart of a poet who makes apparent to the viewer — as it was to the painted figures standing by the roadside shrine — the picturesque beauty and magic of the southern continent. But however different the sources and methods of their art may have been, both men partook of the quest for the edenic garden, for that unspoiled corner of the world left untouched since the Creation. That Mignot found it is indicated by the prominent palm trees, representative of the tree of life and signpost to the tropical paradise.[9]

K.E.M.

Notes

1. Tuckerman 1867, p. 563.
2. In the absence of Mignot's own documentation of the trip, it is here assumed that Mignot and Church traveled together. The itinerary is gleaned from Church's dated drawings from the expedition, in the Cooper-Hewitt Museum.
3. Information from Curatorial Files, Detroit Institute of Arts.
4. Excerpt from the *Morning Post* (London), quoted in *Catalogue of the Mignot Pictures with Sketch of the Artist's Life by Tom Taylor, Esq. . . . Galleries: 25, Old Bond Street, London, and The Pavilion, Brighton, 1876*, p. 20.
5. While a full treatment of Mignot's ties to Romantic art is beyond the scope of this entry, a few points should be mentioned. Though Romanticism has never had as continuous a tradition in America as has Realism, it emerged more frequently in artists' responses to faraway or exotic places. Mignot's South Carolina background too contributed to that outlook, for pictures of his with titles taken from Tennyson, Byron, and Coleridge testify that he, in common with southern writers and intellectuals of his day, looked to the English Romantics for models and inspiration. See Drew Faust, *A Sacred Circle: The Dilemma of the Intellectual in the Old South, 1840–1860* (Baltimore, Md.: Johns Hopkins University Press, 1977), pp. 19–20.
6. Taylor, quoted in *Catalogue of the Mignot Pictures*, p. 2.
7. *Cosmopolitan Art Journal* 3 (December 1859), p. 233.
8. John Esaias Warren, "The Romance of the Tropics," *Knickerbocker Magazine* 33 (June 1849), p. 500. The italics have been added for emphasis.
9. For the importance of the palm tree as a symbol, see Katherine Manthorne, "The Quest for a Tropical Paradise: Palm Tree as Fact and Symbol in Latin American Landscape Imagery, 1850–1875," *Art Journal* 44 (Winter 1984), pp. 380–81.

SAMUEL COLMAN

(1832–1920)

Samuel Colman was born in Portland, Maine, but grew up in New York City, where his father, Samuel senior, ran a successful publishing business. The family bookstore on Broadway, an excellent source of contemporary prints and a popular meeting place for prominent artists and writers, provided young Colman with an ideal introduction to the art world. It was probably there that he was introduced to Asher B. Durand, with whom he is said to have studied briefly around 1850. In 1851, Colman began exhibiting at the National Academy of Design, where his paintings of the White Mountains, Lake George, and other popular Hudson River School haunts won him early recognition and, in 1854, his election to Associate of the Academy.

In 1860, Colman embarked on a two-year European tour. He visited France, Italy, and Switzerland, and was one of the first American artists to travel to the more exotic locales of southern Spain and Morocco. During the 1860s, he exhibited numerous paintings that were based on his sketches of romantic Spanish sites. He became a full member of the Academy in 1862 and, two years later, was asked to join a group of Hudson River School artists, including, among others, Durand, Albert Bierstadt, and John F. Kensett, in contributing to a portfolio of sketches to be presented to the poet and editor William Cullen Bryant.

In 1866, Colman was co-founder and the first president of the American Society of Painters in Water Colors, an office he held until 1870, when he made his first trip to California, an experience that inspired a series of paintings of wagon trains carrying pioneers to the American West. In 1871, he began a four-year overseas trip, that time to Egypt, Algeria, Morocco, Italy, France, Holland, and England.

On his return to the United States in 1875, Colman resumed his extensive activities in the New York art world. In 1877, he was one of the founders of the Society of American Artists; by the following year, he had joined the New York Etching Club. Admired throughout his career for his broad range of artistic interests and his openness to the influence of new and exotic cultures, he began in the late 1870s to form a large and impressive collection of oriental art and artifacts. During that period, he expressed his strong interest in the decorative arts through his collaborations with Louis Comfort Tiffany and with Tiffany's Associated Artists firm on a number of interior-design projects.

Colman made several more trips to the American West and to Europe before 1906. He had ceased to exhibit at the Academy by 1897, and, after the beginning of the new century, he curtailed most of his artistic activities, preferring to devote his attention to esoteric writings on his theories of art. His first book, *Nature's Harmonic Unity*, was published in 1912, followed eight years later by *Proportional Form*, which was issued just five days before his death.

Select Bibliography

"American Painters.—Samuel Colman, N.A." In *The Art-Journal* 2 (1876), pp. 264–66.

G[eorge] W. Sheldon. *American Painters: With Eighty-three Examples of Their Work Engraved on Wood*. New York: D. Appleton and Co., 1879, pp. 72–76.

Wayne Craven. "Samuel Colman (1832–1920): Rediscovered Painter of Far-Away Places." In *The American Art Journal* 8 (May 1976), pp. 16–37.

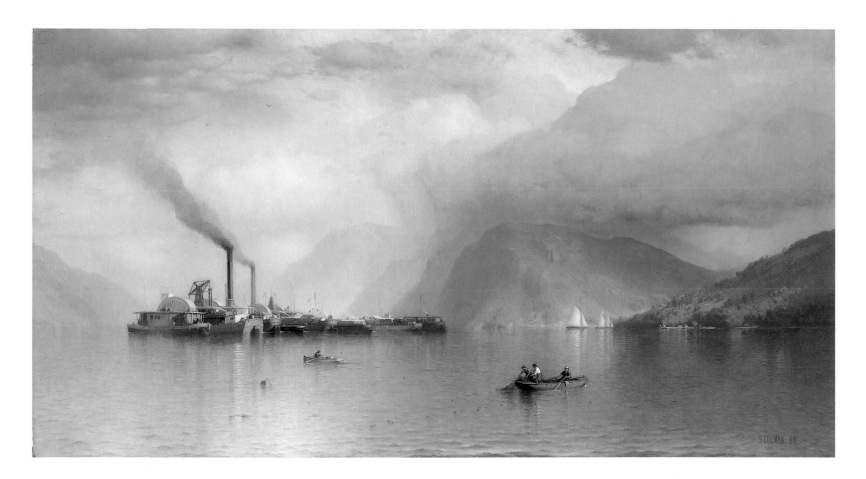

Storm King on the Hudson, 1866

Oil on canvas, 32⅛ × 59⅞ in. (81.6 × 152.1 cm.)
Signed and dated at lower right: S. Colman. 66.
National Museum of American Art, Smithsonian Institution, Gift of
John Gellatly

Around the time Colman painted *Storm King on the Hudson*, he was living at Irvington-on-Hudson, "where he could not fail to be impressed by the effects of clouds, Highlands and gleaming river; by the veils of fog and smoke and by the singular aspect of the long masses of canal and other boats which are slowly propelled along by queerly shaped tugs and show strange and solid against river, hills and sky."[1] The passage of river craft through the Highland region held a special appeal for artists and writers in the mid-nineteenth century. As early as 1838, the Englishman James Silk Buckingham offered this description of the river activity at the gateway into the Hudson Highlands: "The entrance into this channel is strikingly picturesque; and, with the full-green foliage of the month of June, and the countless sailing and steam vessels going up and down the river, some of the latter like floating warehouses . . . few prospects can be imagined more romantic, more stirring, or more beautiful."[2]

Colman's *Storm King on the Hudson* is a portrayal of the beauty and grandeur of the area described by Buckingham more than twenty years earlier. Dark, voluminous clouds hover over the crown of Storm King, a mountain that owes its name to "the poetic fancy of [N. P.] Willis, from the fact that for years it . . . served as a weather-signal to the inhabitants of the immediate district."[3] To its left, a curious array of towboats, barges, and steam-powered side-wheelers forms a dramatic counterpoint to the Highlands. Long trails of black smoke rising from the tall stacks of the two side-wheelers gently merge into the stormy clouds above; filtering through cracks in the billowy mass, light from directly overhead casts the reflection of the river craft onto the still water. The tranquillity of the scene notwithstanding, an air of nervous anticipation, a sense of silence about to be broken, is created by the movement of the clouds against the stillness of the water.

The delicate, translucent atmospheric effects of *Storm King on the Hudson*, characteristic features of Colman's work of the period, are found also in his *Becalmed in the Highlands* (ill.), a smaller river scene invoking the transitory effect of light on the water at sunset. Colman's interest in recording subtle changes in atmosphere coincided with his growing enthusiasm for working in watercolor. In 1866, the same year he painted *Storm King*, he co-founded the American Society of Painters in Water Colors. The suitability of watercolor to the depiction of light and atmosphere

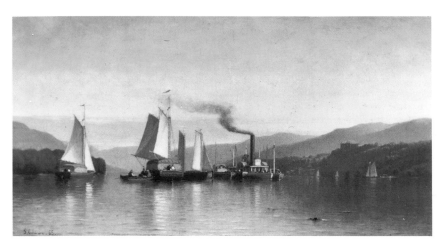

Samuel Colman, *Becalmed in the Highlands*, 1865, oil on canvas, 12 x 21½ in. (30.5 x 54.6 cm.). Collection of Mrs. Charles C. Shoemaker

was described in a pamphlet the society published in 1867, shortly after its first exhibition at the National Academy of Design:

> Of the advantages that water color painting in some respects possesses over oil, it may be well here to say a few words. No artist pretends that it can ever take the place of oil painting. The masters of water color, however, maintain, with some reason, that for certain luminous qualities, for purity of tint and tone, for delicate gradation especially in skies and distance, their favorite style of painting has decided advantages over oil.[4]

Colman's watercolor paintings won him warm critical praise.[5] According to a critic reviewing the society's exhibition: "[Colman] has never done any thing in oil equal to them in force of color and depth and purity of tone. If the New York public understand their own interests, they will never permit Mr. Colman to paint in oils again. His own inclination is to work in watercolors, and his remarkable success shows this to be his true sphere."[6]

While Colman's loose and more fluid surface treatment in *Storm King* can be attributed to his experiments in watercolor, his striking integration of coal smoke into the stormy sky suggests a familiarity with the work of the English landscape painter Joseph Mallord William Turner. How much of Turner's work Colman knew before he produced *Storm King*, however, is difficult to determine. In April 1861, writing from France to his sister, Colman said he intended to "go home by way of England."[7] That would have afforded him the opportunity to see any number of Turner oils, but there is little evidence to suggest that he carried out his plans.[8] His introduction to Turner's work, therefore, was probably through the engravings that in mid-nineteenth-century America were far more accessible than Turner's paintings.[9] Four watercolors Colman did after Turner engravings are perhaps the most direct proof of his admiration for the English master.[10]

From the 1840s, a wealth of literary material about Turner was available to stimulate an American artist's interest in his work; Colman is known to have been acquainted with the immensely popular writings of Turner's most avid supporter, John Ruskin.[11]

Moreover, the venerable Asher B. Durand, who is said to have taught Colman briefly, praised Turner especially for his treatment of the sky: ". . . Turner, who has gathered from the previously unexplored sky alone, transcripts of Nature, whose mingled beauty of form and chiaroscuro have immortalized him . . . has therein approached nearer to the representation of the infinity of Nature than all that have gone before him."[12]

Colman may possibly have seen Turner's *Staffa, Fingal's Cave* (1832; private collection), purchased by Colonel James Lenox of New York in 1845,[13] which also depicts a smoke-belching steamship dwarfed by an awesome, turbulent sky and a stormy sea. Colman, in his interpretation of a similar subject, only hints at an impending and far less threatening encounter between an object of man's creating and the forces of nature, a treatment that typifies his individual approach to landscape painting. The noted art critic James Jackson Jarves, in enthusiastically praising a painting Colman exhibited at the Academy in 1863, offered this opinion:

> Neither Turner nor Pyne, in our view, has painted a picture more replete with breatheable atmosphere, breezy water, translucent distances, and general harmonious effect, truer to the qualities of the Mediterranean than his Gibraltar of this year's Academy Exhibition. His rendering of smoke would delight Ruskin; coal-smoke heavily but gracefully uncoiling itself before a light breeze, as it slowly mounts the sky, letting the eye through its dark masses into the clear light beyond.[14]

Storm King on the Hudson, now recognized as one of Colman's most impressive oils, does not appear in any exhibition records of his day. Around the time that he would have completed the painting, however, a work of his was reviewed in *The American Art Journal*: "Colman has just finished a fine landscape which he calls 'Tow Boats on the Hudson,' full of rich color and great truthfulness. The 'noble Hudson' is represented in its best aspect, a stormy sky is covering the tops of the Highlands, while here and there a gleam of sunlight shines out and is reflected on the surface of the stream, the tow boats are coming down, heavily burdened. . . ."[15] That description, which could apply just as well to *Storm King on the Hudson*, is the first reason to suppose that the two paintings were one and the same.

Critical appreciation of what was called "Tow Boats on the Hudson" is exemplified by a *New York Times* review of the National Academy of Design exhibition of 1867: "Pictures of very great merit are frequently exhibited at the artists' studios, at the galleries of the 'Century,' the Atheneum and other clubs, and in salesrooms, instead of being sent to the Academy. Colman's splendid painting of 'Towboats on the Hudson'—one of the finest works ever produced in America—was thus exhibited. It ought to have been at the Academy, but it isn't."[16] The critic may have seen the painting earlier in the year, for an article in *The American Art Journal* of 2 March 1867 mentioned that Colman's "Tow Boats" was on view at a gallery "just opened by Mr. Snedecor at 768 Broadway."[17]

In 1867, Henry T. Tuckerman also discussed the Colman painting: "'Tow-Boats on the Hudson' is fine in color; the water

is admirably represented; so are the mountains: whoever has watched the tow-boats from the shore at Newburgh on a summer morning, will recognize with delight the delicacy and truth of this work in local details and natural effects."[18]

Of a painting at the 1868 spring exhibition of the Brooklyn Art Association,[19] a review in the *Brooklyn Daily Eagle* had this to say:

> One of the largest as well as one of the most noteworthy of the pictures on exhibition is from the brush of S. Colman, called Towboats in the Highlands, Hudson River. This painting deserves a long and critical notice, but space will not allow of it. The sky effect is very beautiful, and the lights and shades are very effectively managed. The filling in is of the minutest character, challenging the closest inspection. . . . Last night [Towboats in the Highlands, Hudson River] was always thronged by a large number of connoisseurs who seemed to think it one of the most effective pictures on the walls.[20]

The beautiful "sky effect," certainly the most impressive feature of Colman's *Storm King on the Hudson*, supports the theory that more than one title was assigned to the same canvas. In common with many painters of the Hudson River School, Colman not infrequently executed more than one version of the same scene and gave his paintings similar titles. The "Tow Boats" canvas, however, is his only known painting of that particular subject.

The first reference to the present title is in a notice that appeared in the 1915 issue of *American Art News*. The painting was then on view at the Arlington Gallery in New York, and the illustration caption read: " 'Storm King' on the Hudson."[21] Two years later, a black-and-white photograph in the July 1917 edition of *Art World* was named "Towboats in the Highlands, Hudson River."[22] The work illustrated is unmistakably the subject of this entry. In 1929, when John Gellatly presented the painting to the National Gallery of Art, it bore the title *The Storm King on the Hudson*.[23]

M-A.H.

Notes

1. "Samuel Colman, N. A., Veteran Painter," *Art World* 2 (July 1917), p. 315.
2. James Silk Buckingham, "America, Historical, Statistic, and Descriptive" (London, 1841), Van Zandt 1971, p. 225. Cited in Kenneth W. Maddox, *In Search of the Picturesque: Nineteenth Century Images of Industry Along the Hudson River Valley*, exh. cat. (Annandale-on-Hudson, N.Y.: Bard College, 1983), p. 66.
3. E. M. Ruttenber and L. H. Clark, comps., *History of Orange County, New York* (Philadelphia, 1881), p. 32.
4. Ralph Fabri, *History of the American Watercolor Society: The First Hundred Years* (New York: American Watercolor Society, 1969), unpaged [p. 14]. Cited in Wayne Craven, "Samuel Colman (1832–1920): Rediscovered Painter of Far-Away Places," *The American Art Journal* 8 (May 1976), p. 25.
5. Craven, "Samuel Colman," pp. 25–26.
6. "Fine Arts," *Putnam's Magazine* 1 (February 1868), p. 258.
7. Colman to "Mela" (Pamela, his sister), 21 April 1861, Archives of American Art, microfilm roll no. 832.
8. Only one biographical reference records that Colman went to England in 1871. See *Who Was Who in America* (Chicago: A. N. Marquis Co., 1942), 1, p. 246.
9. See Kathleen A. Foster, "The Pre-Raphaelite Medium: Ruskin, Turner, and American Watercolor," in Ferber and Gerdts 1985, p. 83.
10. See *19th and 20th Century European and American Paintings, Drawings, Watercolors and Sculpture*, sale cat. (Sotheby Parke Bernet, New York, 18 September 1980), lot 113, "The Building of Carthage; Apollo Slaying The Python; Dartmouth Cove and A Mountain Stream: Four Watercolors [by Samuel Colman] after Joseph Mallord Turner." I am grateful to Marcia Briggs Wallace for bringing these watercolors to my attention. Ms. Wallace is completing a Ph.D. dissertation at the Graduate Center of the City University of New York on the subject of Turner's influence on American landscape painting in the first half of the nineteenth century.
11. *Gallery of American Landscape Painters* (New York, 1872), unpaged. I am indebted to Marcia Briggs Wallace for pointing out this source to me.
12. Durand 1855, VII, p. 275.
13. Martin Butlin and Evelyn Joll, *The Paintings of J. M. W. Turner* (New Haven: Yale University Press, 1977), p. 180.
14. J. J. Jarves, "Art in America, Its Condition and Prospects: I," *The Fine Arts Quarterly Review* 1 (1863), p. 399. I am grateful to Marcia Briggs Wallace for bringing this source to my attention.
15. Paletta, "Art Matters," *The American Art Journal* 5 (5 January 1867), p. 165, transcript in the files of the Department of American Paintings and Sculpture, Metropolitan Museum.
16. "National Academy of Design," *New York Times*, 23 May 1867, p. 5, col. 2.
17. Paletta, "Art Matters," *The American Art Journal* 6 (2 March 1867), p. 293, transcript in the files of the Department of American Paintings and Sculpture, Metropolitan Museum.
18. Tuckerman 1867, p. 559.
19. Marlor 1970, p. 154.
20. "Artists' Reception. The Pictures and the People—Second Report of the Work of the Art Association," *Brooklyn Daily Eagle*, 18 March 1868, p. 2, col. 3.
21. "At the Arlington Gallery," *American Art News* 14 (20 November 1915), p. 7.
22. "Samuel Colman, N. A., Veteran Painter," p. 313.
23. Andrew Connors, Curatorial Assistant, Permanent Collection, National Museum of American Art, letter to author, 12 May 1986.

AARON DRAPER SHATTUCK
(1832–1928)

The seventh of nine children, Shattuck moved with his family in 1844 from Francestown, New Hampshire, to Lowell, Massachusetts, where he attended public school. In 1851, he took lessons in portrait painting at the Boston studio of Alexander Ransom, whom he accompanied to New York City the following year. While in New York, Shattuck developed his drawing skills in the Antique and Life classes at the National Academy of Design. During the summer of 1854, he took his first painting trip to the White Mountains. His only exhibitions were of portraits in New York and Boston the following year. It was about then that he discontinued his studies with Ransom. In 1856, at the National Academy, he exhibited landscapes for the first time. He was elected an Associate of the Academy in 1858 and an Academician three years later.

Shattuck visited the White Mountains of New Hampshire every summer from 1854 to 1860. In his first season there, he boarded in an old farmhouse with Samuel Colman, Sanford R. Gifford, and Richard Hubbard. Other years, he stayed in the town of Jackson, where Colman had established a studio that served as a gathering point for artists. Toward the end of the 1850s, Shattuck

also traveled in the mountains of West Virginia and New York and visited the Maine coast. He had changed his studio frequently over the course of the decade, using Ransom's, at New York University, in 1854 and 1855, renting his own, in the Mercantile Library in 1855–56, and moving back to the university in 1856. In 1859, he established himself in the Tenth Street Studio Building, where he continued to lease space until 1896.

Each year after Shattuck's marriage in 1860 to Marian Colman (Samuel's sister), the couple wintered in New York and traveled in the Northeast during the summer. In 1870, they moved with their children to Granby, Connecticut. In that decade, Shattuck began to feature livestock in pastoral landscapes with increasing frequency. In 1883, he patented a painting-stretcher key that soon became a standard device. He stopped exhibiting in 1884, and in 1888, after an illness, he gave up painting almost entirely, turning his attention instead to animal husbandry. In the year of his death, Shattuck was the National Academy's oldest living member.

Select Bibliography

Nettie Wright Adams. "A. D. Shattuck, Artist, Granby, Connecticut." In *The Lure of the Litchfield Hills* 27 (Summer 1967), pp. 4–7, 31–35; 27 (Winter 1967), pp. 20–21, 45–46; 28 (Summer 1968), pp. 12–15, 37–39; 28 (Winter 1968), pp. 23, 34, 40, 44; 29 (Summer 1969), pp. 22–23; 39, 41.

Charles B. Ferguson. *Aaron Draper Shattuck, N. A., 1832–1928: A Retrospective Exhibition.* Exhibition catalogue. New Britain, Conn.: New Britain Museum of American Art, 1970.

Charles B. Ferguson. "Aaron Draper Shattuck, White Mountain School Painter." In *American Art Review* 3 (May–June 1976), pp. 68–81.

John Walker Myers. "Aaron Draper Shattuck, 1832–1928, Painter of Landscapes and Student of Nature's Charms." Ph.D. diss., University of Delaware, 1981.

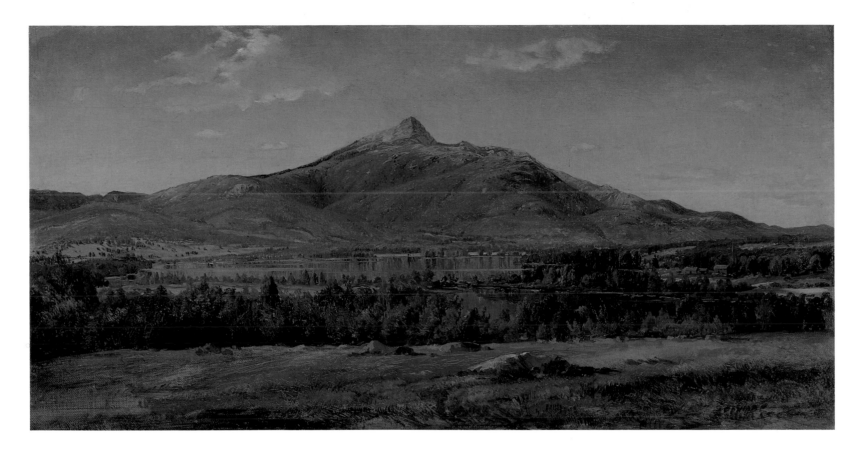

Chocorua Lake and Mountain, 1855

Oil on canvas, 10⅛ × 19⅝ in. (25.7 × 49.9 cm.)
Signed and dated at lower left: A. D. Shattuck 1855
Vassar College Art Gallery, Poughkeepsie, New York. Gift of
Matthew Vassar (864.1.64)

The number of artists traveling each summer to paint in the White Mountains of New Hampshire increased dramatically during the early 1850s.[1] Shattuck produced this canvas in 1855, having visited Mount Chocorua the previous year, during his first summer as a landscapist.[2] The painting was probably among the many works seen in his studio that fall by a journalist for *The Crayon*. After discussing White Mountain subjects executed by Asher B. Durand, John F. Kensett, and John Casilear, the writer noted, "Mr. Shattuck, a new name to us, contributes a large number of sketches to the 'White Mountain' collection. They indicate a fine feeling for Nature, and many of them are beautifully executed."[3]

Chocorua Lake and Mountain was one of six Shattuck works acquired between 1856 and 1863 by the Reverend Elias L. Magoon for his personal art collection. It has been persuasively argued that Magoon formed his collection as a dual statement of religiosity and nationalism, intending to illustrate with the American landscape God's handiwork in all its diversity.[4] In 1864, Matthew

Vassar acquired Magoon's entire collection for the Art Gallery of Vassar Female College.

Thomas Starr King, in his famous tribute to the White Mountains, tried to capture some of Chocorua's visual effects in prose. In one passage, he said:

> It is everything that a New Hampshire mountain should be. . . . In form it is massive and symmetrical. The forests of its lower slopes are crowned with rock that is sculptured into a peak with lines full of haughty energy, in whose gorges huge shadows are entrapped, and whose cliffs blaze with morning gold. And it has the fortune to be set in connection with lovely water scenery,—with Squam, and Winnipiseogee, and the little lake directly at its base.[5]

The mountain's symmetry relates Chocorua to the aesthetic of the Beautiful, but King's description draws for the most part on the vocabulary of the Sublime; his observation about the lakes suggests that the site would also appeal to a sensibility attuned to the Picturesque. Though his passage locates the landscape within long-established, conventional categories, Shattuck himself was concentrating on the topographical and atmospheric aspects common to much Hudson River School painting. His relatively undifferentiated, gently curving foreground hillock sets off an intricate rendering of Chocorua Lake, visible beyond the tree line. On the lake, two projections jut out from either shore, touch just right of the center of the composition, and then separate in graceful curves.[6] Because Shattuck was painting on the hillock, not very far above the lake, his line of vision formed a small angle with the plane of

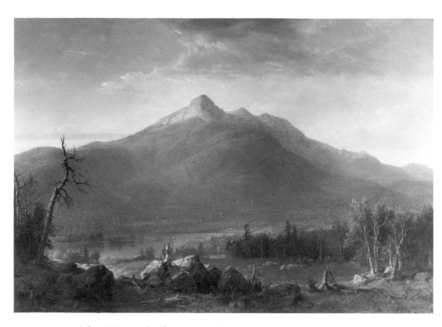

Asher B. Durand, *Chocorua Peak*, 1855, oil on canvas, 41 x 60 in. (104.1 x 152.4 cm.). Museum of Art, Rhode Island School of Design, Gift of the Rhode Island Art Association (52.104)

ings in popular modes. The following year, he abandoned those preconceived notions and began to paint the landscape with precise delineations of its topographical integrity. That different orientation, recognizable in *Chocorua Lake and Mountain*, may be attributable to contact with Durand, who lived next to Shattuck's friend Samuel Colman and who probably gave informal critiques.[7] If the two men were in touch, the elder artist might have attempted to dissuade the tyro from the practice of his first summer, advising him to "go first to Nature to learn to paint landscape, and when you shall have learnt to imitate her, you may then study the pictures of great artists with benefit."[8]

Durand granted more liberties to the experienced artist: "He may approach [Nature] on more familiar terms, even venturing to choose and reject some portions of her unbounded wealth."[9] That philosophy on landscape, echoing Thomas Cole's sentiments on composition, may be seen at work in Durand's own painting of Chocorua (ill.), executed in the fall of 1855 from sketches done that summer.[10] In his interpretation, he conveyed a sense of the mountain's immensity through the great size (forty-one by sixty inches) of the canvas it occupies, and he subordinated the region's topography to a system of zigzags that guide the viewer into the pictorial space and up the mountain's cropped right-hand slope. The monumental mountain and the gnarled and broken trees in the foreground, evoking the uncontrollable forces of wild nature, identify the mountain as Sublime, as had King in the passage from *White Hills* quoted above.

Shattuck and Durand thus imposed different demands on the picturemaking process. Whether Shattuck deliberately or inadvertently followed Durand's advice cannot account for the accomplishment of his second season as a landscapist. The evidence provided by the two artists' 1855 paintings of Chocorua discloses that they must be considered not as leader and follower but as independent creative intelligences.

D.S.

the lake's surface; his representation of that whole expanse of water is therefore realized in a section of canvas less than two inches high. Except for a stretch of Chocorua's base at the right, the rhythmic swellings and depressions of land that constitute the mountain can be followed from the lake to the peak without interruption. Beyond, the sky's lower reaches gradually lighten, accenting the mountain's profile.

This small plein-air painting demonstrates Shattuck's dedication to recording an extremely complex interplay of land and water as a convincing space. Chocorua itself fills a band of canvas comparable in size to a band representing the foreground and another representing the trees and the lake. The mountain's scale must be gauged in relation to the great distance the eye traverses in order to reach it. Shattuck does not employ any standard compositional punctuation to create a movement that the eye will readily follow. Once he decided to center the mountain on his canvas, the only vestiges of a conventional process of composing a landscape painting he observed were in the positioning of the tallest tree at the left edge of the canvas and the prominent rock off-center to the right. There, the rock begins a diagonal progression that leads to the meeting point of the banks and on to the mountain's peak. By selecting a wide format, Shattuck facilitated his scrupulous recording of low-lying land masses as they lead to the dominant presence of the mountain.

On Shattuck's first visit to the White Mountains, in 1854, he produced studies of specific plant and rock forms, as well as broadly conceived landscapes of distant objects that he rendered in terms of compositional formulas. In one, *A View of Conway*, inherited by the artist's granddaughter Katherine Emigh, he selected an oval format, demonstrating his eagerness to cast his paint-

Notes

1. See Benjamin Champney's recollection that "every year brought fresh visitors to North Conway as the news of its attractions spread, until in 1853 and 1854 the meadows and the banks of the Saco were dotted all about with white umbrellas in great numbers." Champney 1869, pp. 105–6.

2. Shattuck's account book of 1854, quoted by Nettie Wright Adams in "A. D. Shattuck, Artist, Granby, Connecticut," *The Lure of the Litchfield Hills* 27 (Summer 1967), p. 31, records a trip to Chocorua after 30 June. Shattuck includes this version of Chocorua among the "principal pictures" he lists in a letter of April 1857 to Charles Lanman. The New-York Historical Society.

3. "Domestic Art Gossip," *The Crayon* 2 (21 November 1855), p. 330. The conclusion of the notice on Shattuck, "The studies of rocks, grasses, and field flowers, are truthful as well as earnestly painted," refers to other works of 1855 such as *Flowers and Grasses by a Stream* (Collection of Katherine S. and Eugene D. Emigh, New Britain, Conn.).

4. Ella M. Foshay and Sally Mills, *All Seasons and Every Light: Nineteenth Century American Landscapes from the Collection of Elias Lyman Magoon*, exh. cat. (Poughkeepsie, N. Y.: Vassar College Art Gallery, 1983).

5. Thomas Starr King, *The White Hills: Their Legends, Landscape, and Poetry* (Boston: Crosby, Nichols, and Co., 1860), p. 141. As King also reported (p. 12),

"Many of the most competent artists, who have made faithful studies during summer vacations in New Hampshire, award superiority to Chocorua for picturesqueness over any view that they have found of Mount Washington."

6. A drawing of Thomas Cole's of the same site, executed from a higher spot, offers a different perspective on the lake (*Chocorua Peak and Pond*, Detroit Institute of Arts, 39.196. 9B). Reproduced in *To Walk with Nature: The Drawings of Thomas Cole*, exh. cat. (Yonkers, N. Y.: The Hudson River Museum, 1981), no. 47, fig. 20.

7. John Walker Myers, "Aaron Draper Shattuck, 1832–1928, Painter of Landscapes and Student of Nature's Charms," Ph.D. diss., University of Delaware, 1981, p. 164, n. 28, suggests that Shattuck and Durand knew one another, citing a letter dated 25 July 1855 (New-York Historical Society), in which Durand reports to Edward Nelson that "young Colman occupies the house next to me." Durand's "Letters on Landscape Painting" suggest the tutorial role he probably assumed with younger artists, while a letter from Flake White [Daniel Huntington], *The Crayon* 2 (October 1855), p. 217, suggests that Durand was often approached for advice. See Wendy Greenhouse, "The Crayon's 'Flake White' Identified," *The American Art Journal* 18 (1986), pp. 77–78.

8. Durand 1855, I, p. 2.

9. Ibid.

10. *The Crayon* 2 (21 November 1855), p. 330, also reported that Durand had made "several studies of scenery in the neighborhood of the White Mountains," of which "A study of Chocorua Mountain is the most remarkable." Lawall 1978, pp. 112–13, includes that painting as no. 200. See also Mandel 1977, pp. 31–34.

The Cascades, Pinkham Notch, Mt. Washington, ca. 1859

Oil on canvas, 15⅝ × 19⅛ in. (39.7 × 48.6 cm.)
Signed at lower left: ADS
Collection of Dr. Arthur Quart, Riverdale, New York

This scene[1] is one of several rock portraits that Shattuck produced in the course of his travels in the White Mountains in the late 1850s, years during which he also painted gatherings of rocks along the coasts of Maine and Lake Champlain. Works such as these grew out of the American tradition of close observation and depiction of specific landscape forms that began in the 1820s with Thomas Cole, who selected highly idiosyncratic and dramatic subjects for the sketches that informed his composed views. In the 1840s, Asher B. Durand and John F. Kensett also devoted their attention to bits of nature, and, in their preference for humbler forest elements as the subjects of finished paintings, transformed the genre. Shattuck's *Cascades, Pinkham Notch, Mt. Washington*, a highly detailed presentation of a carefully defined and coherent system of rocks and plants, may be considered a sophisticated contribution to that class of landscape painting. During the first six days of the vernal melting of snow, mountain streams swollen with half of all the water they will carry for the entire year occasion the downward movement of large and small rocks. Shattuck, however, has chosen to depict a moment late in the summer, when the system conducts very little water and the location of rocks is relatively stable. Here, he offers an upward view of a deposit of tabular rocks set along a channel that extends from the lower right diagonally back into the upper left quadrant, an ordered space that serves as the course of a small stream. White birches, growing from decaying organic matter in the depressions of near and far rocks on both sides of the stream, almost fill the top section of the canvas.

Carefully delineated pictures such as this one have led modern art historians to group Shattuck with the American Pre-Raphaelites.[2] While it is true that those artists subjected geological and floral forms to intense scrutiny, and painstakingly studied the means of reproducing their appearance in paint, a tradition of close observation was already established in this country by the time the first volume of the American edition of John Ruskin's *Modern Painters* appeared in 1847. Shattuck, who drew and painted rock formations in 1854, during his first season as a landscapist, made many pictures that coincided with Ruskinian ideas of truth to nature, and may have been encouraged to do so by Ruskin's eloquent advocacy of the truth-to-nature approach. Nevertheless, Shattuck's landscape paintings are not so much pictorial responses to Ruskin's verbal prescriptions or to any English Pre-Raphaelite works he might have seen by that time as they are expressions of an element deeply rooted in the American landscape tradition.

D.S.

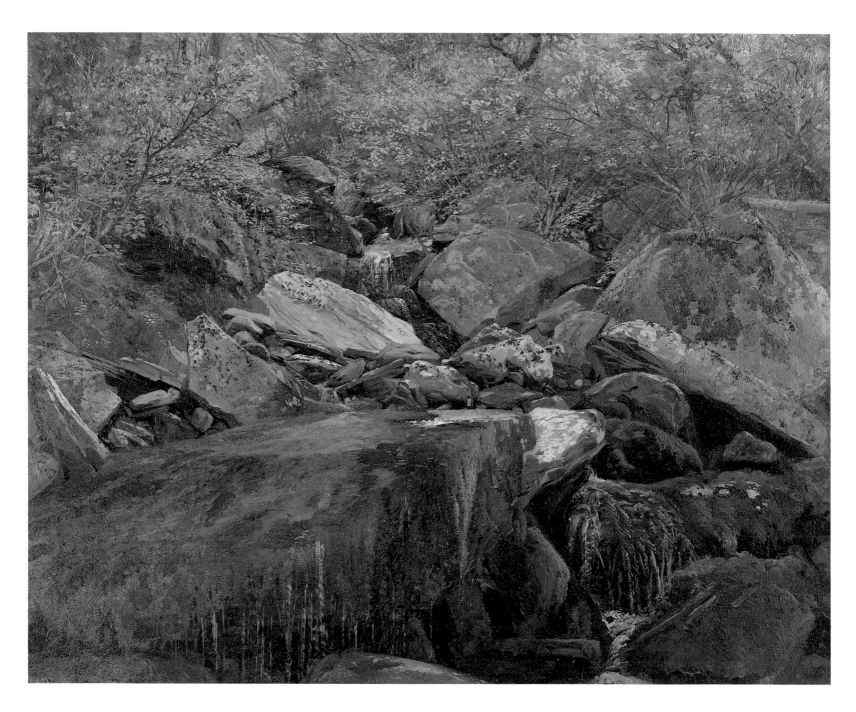

Notes
1. The painting was exhibited as no. 21, under the title *Trickling Water*, in *Aaron Draper Shattuck, N. A., 1832–1928: A Retrospective Exhibition*, mounted in 1970 by the New Britain Museum of American Art. It was retitled in 1976, when it appeared as no. 143 in the bicentennial exhibition *America as Art*. See Joshua Taylor, *America as Art* (Washington, D.C.: The Smithsonian Institution Press, 1976), p. 121.
2. Ferber and Gerdts 1985, pp. 275–76.

WILLIAM TROST RICHARDS
(1833–1905)

Richards grew up in his native Philadelphia, where in the early 1850s he studied art with the German painter Paul Weber and worked for the firm of Archer, Warner, and Miskey, makers of gas fixtures and ornamental metalwork. Richards's early admiration for Thomas Cole was manifested by a pilgrimage he made in 1853 to Cole's house and grave at Catskill, New York. In 1854, with fellow artist Alexander Lawrie, Richards opened his first studio in Philadelphia and in the same year made the acquaintance of the painters John F. Kensett, Frederic E. Church, Samuel Colman, and Jasper Cropsey.

Before his marriage in 1856, Richards traveled to Europe and visited many cities, including Paris, Florence, and Düsseldorf. When he returned to the United States, he made sketches for his romantic, often literary landscapes during numerous trips to the Adirondack and Catskill mountains and along the Hudson River. In the late 1850s, he became interested in the English Pre-Raphaelite Brotherhood and in the writings of their evangelist, John Ruskin; in 1863, he joined The Association for the Advancement of Truth in Art.

Richards soon attracted such important patrons as George Whitney and Samuel P. Avery. He was an Academician of both the National Academy of Design and the Pennsylvania Academy of the Fine Arts. In the second half of his career, his focus shifted from landscape to marine painting, primarily coastal scenes. Beginning around 1870, he worked frequently in watercolor and contributed regularly to the exhibitions of the American Society of Painters in Water Colors. For many years, the Richards family spent summers in Newport, Rhode Island, and winters in Germantown, Pennsylvania. They also traveled often to Europe. Although Richards continued to tour the Continent, he devoted increasing periods of time to England, where he exhibited at the Royal Academy and at the Grosvenor Gallery. His love of the sea drew him in England to the Cornish coast; in the United States, to the shores of Rhode Island. He died in Newport, Rhode Island, in 1905.

The eighty-five watercolors by Richards that the Reverend Elias L. Magoon donated to The Metropolitan Museum of Art in 1880 became the foundation of the Museum's collection in that medium. Richards was honored by exhibitions of his work at The Brooklyn Museum in 1973 and at the Metropolitan Museum in 1982.

Select Bibliography

Harrison S. Morris. *William T. Richards: Masterpieces of the Sea; a Brief Outline of Richards' Life and Art*. Philadelphia: J. B. Lippincott Co., 1912.

Linda S. Ferber. *William Trost Richards: American Landscape and Marine Painter, 1833–1905*. Exhibition catalogue. New York: The Brooklyn Museum, 1973.

Linda S. Ferber. *William Trost Richards (1833–1905): American Landscape and Marine Painter*. New York: Garland Publishing, 1980.

———. *Tokens of a Friendship: Miniature Watercolors by William T. Richards from the Richard and Gloria Manney Collection*. Exhibition catalogue. New York: The Metropolitan Museum of Art, 1982.

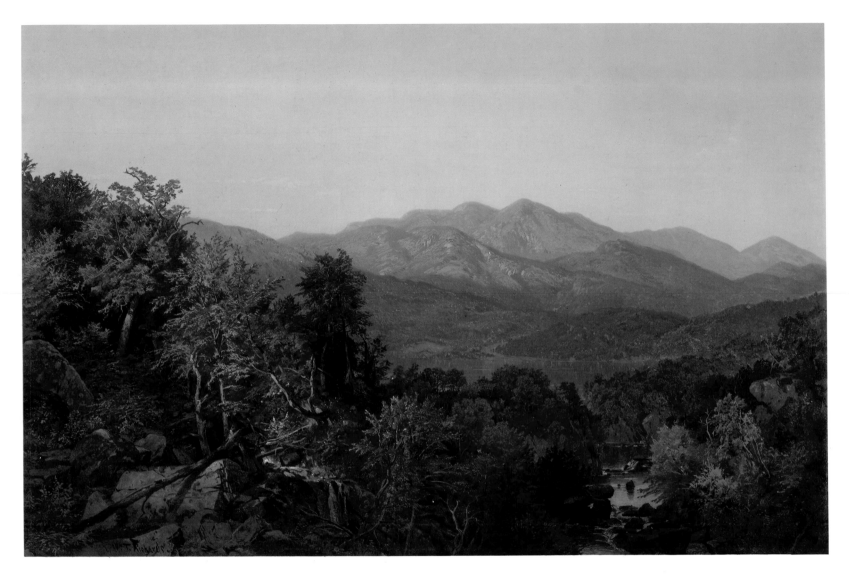

The Adirondacks, ca. 1857
Oil on canvas, 24⅛ × 36½ in. (61.3 × 92.7 cm.)
Signed at lower left: Wm T. Richards
Private collection

William Trost Richards is best known today as a marine painter, but in the mid-1850s, at the beginning of his career, he was very much the model of an aspiring landscape painter. Largely self-taught, and at work by the age of seventeen as a commercial draftsman, he was nevertheless steeped in the nature worship of the period and longed to devote himself to American scenery. Richards was of a literary bent. His essays and letters of the early 1850s show him familiar with the romantic landscape rhetoric, delighting in long and elaborate descriptions and relishing appropriate emotional and poetic associations. By 1854, although he

was living in Philadelphia rather than in New York City, the Hudson River School's center, Richards had become personally acquainted with several major figures: Jasper Cropsey and John F. Kensett, as well as Frederic Church, whose star was then ascending. While some influence of Richards's early mentor, German expatriate Paul Weber,[1] can be detected in the landscapes of those early years, there is little doubt that Richards's principal exemplars during that crucial decade were the works of the contemporaneous American landscape school whose vision had its roots in that of Thomas Cole.

To consider *The Adirondacks* and *A View in the Adirondacks* (see p. 314) together is useful. Each was painted about the same time, and each is a prime example of Richards's enthusiasm for the program and ideals of what was then the dominant landscape vocabulary. While not a pair, the two works are complementary in theme: this one embodying the wilderness vision; the other, that of the cultivated landscape. That duality of vision, whether explored in two separate canvases such as these or in a single paint-

ing—Cole's great work, *The Oxbow* (see p. 125), for instance—was a primary preoccupation of the American landscape school for over half a century. Though undated, the Richards paintings can be assigned with some confidence to 1857, for each relates closely to a similar work dated that year.[2] All are of Adirondack subjects. Richards first visited the Adirondacks in the summer of 1855, just before his departure for a year's sojourn in Europe. He returned to the region in 1857 and possibly again in 1859, and is known to have been there in 1862, 1863, 1865, and 1868.[3] He exhibited views of the area, along with others of the Catskill and White mountains, regularly from 1857 through 1866, after which the marine and coastal scenes for which he is now better known appeared with increasing frequency. For the subjects of the first decade of his career, however, Richards drew heavily on those areas that had long been traditional sketching ground for American artists—up the Hudson River into the Catskills and the Adirondacks, as well as the White Mountains of New Hampshire. Those are the locales of the wildness Cole had found earlier in the century and described in 1835 in his "Essay on American Scenery"[4] as "perhaps the most impressive characteristic" of the native landscape.

In the summer of 1853, while still working full time as a draftsman, Richards traveled up the Hudson as far as Catskill and described his artist's itinerary in an amusing self-parody:

> I am happy to inform you that after occasioning much anxiety to all his friends, the 'William T. Richards,' who used to live in our neighborhood . . . has returned to his home after 3 weeks of insane wanderings. From his rambling and incoherent discourse it has been gathered,—that on the 4th of August 1853, he left Philadelphia, journeyed north, that he visited N.Y.—Crystal Palace,—West Point, Catskill, Cauterskill Falls, Catskill Mountain Clove. He was seen at the last named places by gentlemen of New York—with what seemed a Portfolio—Some thought he was an itinerant agent, Preacher, or News Paper Carrier—and some more shrewdly guessed he was sketching.[5]

On his trip, Richards explicitly acknowledged Cole's role as primary interpreter of the region by making what he termed "a pilgrimage to the home & Grave of Cole" at Catskill. "There are pictures upon the walls of the study where he once painted, that place at once landscape Art among the foremost of the means for teaching and elevating human nature," he wrote.[6]

By the next spring, Richards had left his occupation as an "ornamental copyist," as he put it, and opened a studio in Philadelphia. In a letter to a friend, he said, "Now I am an Artist in good earnest . . . painting away for dear life . . . in the vain endeavor to eclipse some other of our landscape suns." In the same letter is a "declaration of principles" that reveals the seriousness and the conscious dedication with which Richards regarded his new role:

> You know . . . something of the desire that will not rest satisfied till landscape can tell stories to the human heart and be a medium of noble and powerful expression even as the human countenance. I believe that Cole and Turner have each in their way developed purposes and principles of landscape expression that will yet in their further and higher application place their department of art, even

in the world's estimation, on the same standard with Raphael's and Angelo's.[7]

Those contemporaneous figures (Cole had been dead six years; Joseph Mallord William Turner, only three) replaced the traditional landscape idols Claude Lorrain and Salvator Rosa, whose styles had provided models of excellence for earlier generations of artists, including Cole and Turner themselves. Richards's admiration for Turner, like that of most Americans, was inspired primarily by *Modern Painters*, in which English critic John Ruskin had designated Turner the greatest landscape painter the world had yet known, replacing both Claude and Rosa in the pantheon of landscapists. Richards knew Turner's work through the medium of reproductive engravings—the *Liber Studiorum* and topographical vignettes prepared as book illustrations. In common with Cole, Cropsey, and Church, Richards toyed briefly in his early career with literary and historical themes and with such landscapes as *The Delectable Mountains* (ca. 1854; location unknown) and *The Children of the Mist* (1854; location unknown), all of them inviting interpretation as Turnerian fantasies.[8]

Richards, however, then turned to the tradition of Cole and Cole's followers for the principles of landscape expression appropriate to depictions of native scenery. In *The Adirondacks*, he delineated the forest scenery that Cole had described as one remarkable aspect of American landscape, adding that in its primitive state "it differs widely from the European," and continuing:

> In the American forest we find trees in every stage of vegetable life and decay—the slender sapling rises in the shadow of the lofty tree, and the giant in his prime stands by the hoary patriarch of the wood—on the ground lie prostrate decaying ranks that once waved their verdant heads in the sun and wind. These are circumstances productive of great variety and picturesqueness—green umbrageous masses—lofty and scathed trunks—contorted branches thrust athwart the sky—the mouldering dead below, shrouded in most of every hue and texture, from richer combinations than can be found in the trimmed and planted grove.[9]

The Adirondacks, with its heavy deciduous woods in every phase of the life cycle, offers a virtual exegesis of Cole's characterization of the unique, primitive quality of American forest scenery. Richards also celebrated another New World phenomenon in this work: the American autumn. In his "Essay on American Scenery," Cole had established that particular season as one of the components of scenery that made the American landscape singular:

> There is one season when the American forest surpasses all the world in gorgeousness—that is the autumnal;—then every hill and dale is riant in the luxury of color—every hue is there, from the liveliest green to deepest purple—from the most golden yellow to the intensest crimson. The artist looks despairingly upon the glowing landscape, and in the old world his truest imitations of the American forest, at this season, are called falsely bright, and scenes in Fairy Land.[10]

Cole acclaimed the fall season in a number of his paintings, including his great *Schroon Mountain, Adirondacks* (see p. 134).

It was Cropsey, however, who, in the 1850s, began to develop autumn as a particular specialty, drawing upon a concept of chromatic "gorgeousness" unique to the New World. Cropsey's understanding of that identification is demonstrated by a set of seasons he painted in 1860 (private collection), in which four different nations embodied the four seasons: Switzerland, winter; England, spring; Italy, summer; and the United States, fall. Richards was certainly working within that same tradition in *The Adirondacks*, but the rich crimson, russet, and golden hues used by Cole and Cropsey are no preparation for the giddy brilliance of this painting. Richards was stimulated not only by his subject but also by constant plein-air study, as well as by a growing interest in the intense colors of the English Pre-Raphaelites. Their practice of working in an extraordinarily high key was one Richards adopted here but duplicated nowhere else in his autumn subjects. Although strong in formal composition and confidently painted with a brisk and energetic brushwork in keeping with the chromatic excitement of the picture, *The Adirondacks* may well have been considered extreme even by an audience attuned to the autumnal vividness of paintings by Cole and Cropsey, and hence a virtuoso performance Richards chose not to repeat.

L.S.F.

Notes

1. For Weber, see Ferber 1980, pp. 12–15.
2. *In the Adirondack Mountains* (1857; St. Louis Museum) explores the wilderness theme; *In the Adirondacks* (1857; Adirondack Museum) depicts the same view as *The Adirondacks*, but under different conditions.
3. Ferber 1980, pp. 103–26.
4. McCoubrey 1965, pp. 98–110.
5. Richards to James Mitchell, 28 August 1853, quoted in Linda S. Ferber, *"Never at Fault": The Drawings of William Trost Richards*, exh. cat. (Yonkers, N. Y.: The Hudson River Museum, 1986), p. 9.
6. Ibid., p. 20.
7. Richards to Mitchell, 27 April 1854, quoted in Ferber 1980, p. 19.
8. Long descriptions of these lost paintings in Richards's letters indicate the strong influence of Turner's (and Cole's) visionary manner. Richards to W. H. Willcox, 18 January 1854; Richards to Mitchell, 24 May 1854; both quoted in Ferber 1980, pp. 28, 29.
9. "Essay on American Scenery," quoted in McCoubrey 1965, p. 106.
10. Ibid., p. 107.

A View in the Adirondacks, ca. 1857

Oil on canvas, 30¼ × 44¼ in. (76.8 × 112.4 cm.)
Signed at lower right: W^m T. Richards/PHILA.
Henry Art Gallery, University of Washington, Gift of J. W. Clise

Whereas *The Adirondacks* (see p. 312) is cast in the wilderness mode, *A View in the Adirondacks* depicts a mountainous vista whose rolling foreground and middle ground are both cultivated and populated—a native pastoral vision evocative of precedents in the work of Thomas Cole, Jasper Cropsey, and, in its pristine atmosphere and sharply defined patterns of sunlight and cloud shadow on the earth, especially reminiscent of that of Frederic Church, whom Richards called one of the "great men" he had met in New York in 1854. Annotated drawings place the scene in the Essex County region of the Adirondacks known as Pleasant Valley; the peak at the left has been tentatively identified as Mount McIntyre. A drawing dated 9 July 1855 (private collection) records this very view, as do an undated, larger, and more unfinished drawing and, in a sketchbook, a schematic profile vista of the peaks, dated June 1863 (both, Brooklyn Museum). The view offers a pleasing blend of comfortable, inhabited foreground and middle ground in combination with remote and distant mountain peaks. That these sketches provided the subject for three paintings demonstrates Richards's attraction to the site. *In the Adirondacks* (1857; Adirondack Museum), proposed as a pendant to *A View in the Adirondacks*, presents the same terrain under a rosy, even light and a clear sky that contrast with this fitfully lit landscape presided over by dramatic clouds.[1]

The two paintings, while based on the same studies, do take liberties with Richards's on-the-spot pencil records by the introduction into the foreground of the broad surface of a lake, mirroring the sky, whose shores offer grazing for cattle and provide the site of a mill. Beyond the distant bank, fields are harvested right up to the foot of the peaks that rise in the left distance. The close parallels between the two paintings—both depicting the same scene under totally different atmospheric conditions—suggest that Richards may have consciously set himself the pedagogic task and painterly challenge of interpreting the same study as a pair of landscapes under varying effects of weather. That exercise in creating contrasting moods was in keeping with the young artist's determination not only to acquire the technical competence with which to record landscape accurately but also to master those principles of expression he considered necessary for the interpretation of nature. In 1854, Richards had concluded a declaration of his principles with these words: "I care not to be a painter of trees and water and houses if they can be all, not only shall I endeavor to do even the commonest incident in art well and unexceptionally but I shall seek also to be—a Poet."[2]

Asher B. Durand had urged close attention to the fine points of weather in his "Letters on Landscape Painting," published in *The Crayon* in 1855. Those famous articles, instructing the neophyte landscapist in method and approach, were surely known to Richards. In the fifth letter, Durand, who had assumed leadership

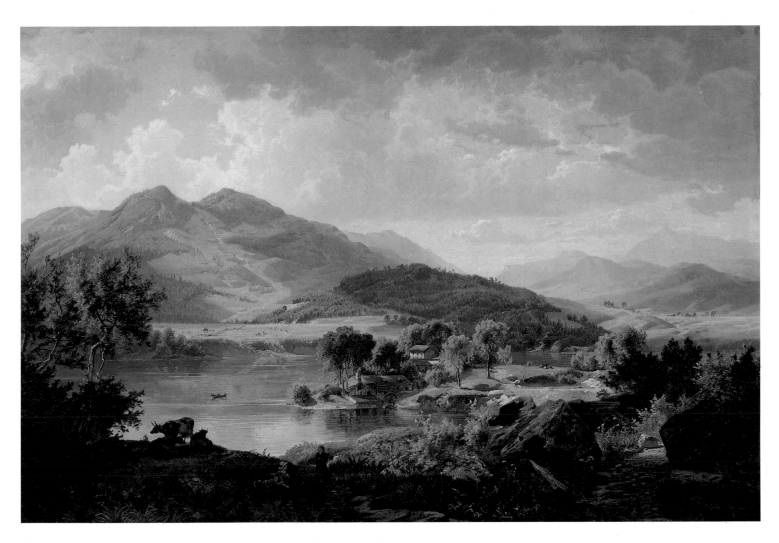

of the native school after Cole's tragically early death, wrote of atmosphere:

> I can do little more than urge on you the constant study of its magic power, daily and hourly, in all its changes, at times shortening, at others lengthening, the space before you; now permitting to be defined, in all its ruggedness, the precipice on the mountain side— and now transforming it to a fairy palace, and the solid mountain itself to a film of opal.[3]

In the clear, defining light of *A View in the Adirondacks*, the mountain face is easily read from base to summit. The areas of open country and forest can be determined with some precision, and a path of ascent from the fields below to the peaks above can be visually plotted. The pendant version, *In the Adirondacks*, permits no such definition. Rather, it presents the same peaks generalized into a picturesque shape under a transforming, rosy light; a ruddy glow suggesting to a degree Durand's "film of opal." In his deliberate manipulation of the magic power of light and air, Richards sought to provoke a variety of emotional or poetic responses.

In those last years of the 1850s, Richards actively explored and, on the evidence of these works, mastered the approach to landscape associated with the Hudson River School. By 1857, with a draftsmanship honed by the discipline of illustration and commercial work and with a painterly technique refined by a year's study abroad and a growing interest in John Ruskin's insistence on faithful accuracy, Richards was fully prepared to realize his self-proclaimed program of poetic landscape—that blend of the real and the ideal that informs the best work of the native school. Richards's moment would be brief. Within a year, he would be drawn increasingly into the compulsive literalism characteristic of the American Pre-Raphaelites. Nevertheless, the works he painted under the impulse of his earlier vision represent the finest productions of a precocious maturity.

L.S.F.

Notes

1. A third version, incorrectly titled *Wyoming Valley, Adirondacks* (1863; Armand du Vannes Gallery, Los Angeles, in 1975), depicts a view much closer to the twin peaks and may be based on a different study: painted in the precise, slightly finicky manner Richards sometimes adopted in the 1860s, it lacks the robust energy of the earlier versions.
2. Richards to Mitchell, 27 April 1854, Richards Papers, Archives of American Art.
3. Durand 1855, V, p. 146.

FRANCIS A. SILVA
(1835–1886)

Francis Augustus Silva was born in New York City to an immigrant barber purportedly descended from a French painter at the Portuguese court. After trying his hand at several occupations, Silva became a sign-painter's apprentice, advancing rapidly in the trade and also practicing the art of embellishing the wooden panels of stage coaches and other vehicles with landscape and historical subjects. In 1861, at the outbreak of the Civil War, he enlisted in the Seventh Regiment of the New York State Militia. He was quickly appointed to the rank of captain, but, owing to illness and a misunderstanding with his superior officer, he was accused of desertion and was dishonorably discharged in 1862. Three years later, the circumstances of the incident were resolved, and Silva rejoined the army as a hospital steward.

In 1868, Silva married Margaret A. Watts in Keyport, New Jersey. The couple moved to New York, where Silva, without formal training, began his career as an artist. His first paintings, shown at the National Academy of Design in 1868, reflected a preference for marine subjects. Throughout the 1870s, he made frequent excursions to Cape Ann, Massachusetts; Narragansett Bay, Rhode Island; Nyack, New York, on the Hudson; and other northeastern coastal areas. He also visited Venice, Italy, around 1879, the only trip abroad he is known to have made.

Silva was a regular contributor to the annual exhibitions at the National Academy of Design and at the Brooklyn Art Association from the late 1860s until the end of his life. He was elected a member of the American Society of Painters in Water Colors in 1872 and joined the Artists' Fund Society a year later.

Silva and his family moved to Long Branch, New Jersey, in 1880, but the painter maintained quarters in New York in the famous Tenth Street Studio Building from 1882 until his death. He devoted most of the last six years of his life to quiet recordings of the New Jersey coastline. He died of pneumonia in New York City.

During his lifetime, Silva never received the critical praise accorded many of his peers. Only in recent years has interest in this somewhat ingenuous painter of luminous, atmospheric sea- and landscapes been rekindled.

Select Bibliography

Charles Jolly Werner. "F. A. Silva." Biographical sketch, ca. 1949. Manuscript Collection, New-York Historical Society.

William De Costa. "F. A. Silva: Painter of the Shore." August 1975. William De Costa Papers, Archives of American Art, Smithsonian Institution, Washington, D.C.

John I. H. Baur. "Francis A. Silva: Beyond luminism." In *The Magazine Antiques* 118 (November 1980), pp. 1018–31.

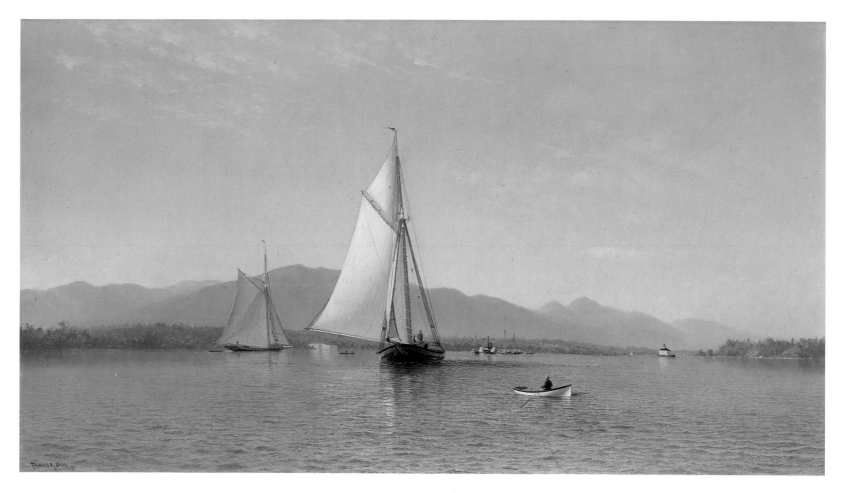

The Hudson at the Tappan Zee, 1876

Oil on canvas, 24¹⁄₁₆ × 42³⁄₁₆ in. (61.1 × 107.2 cm.)
Signed and dated at lower left: Francis A. Silva./–'76
*The Brooklyn Museum, Brooklyn, New York. Dick S. Ramsay Fund
(65.10)*

In the 1870s, Silva traveled extensively up and down the north-eastern seaboard in search of tranquil coastal scenes. Many of the areas he frequented were popular haunts of other marine painters: his serene paintings of the first years of the decade were inspired by the shores of Cape Ann, Massachusetts, immortalized in the earlier canvases of the Gloucester marine artist Fitz Hugh Lane. Silva made several sketching trips to the Newport shore and to the Narragansett Bay area of Rhode Island, as did his contemporaries Alfred Thompson Bricher and William Trost Richards, and he also sketched often on the well-known banks of the Hudson River.[1] Along with Sanford Gifford, Albert Bierstadt, and Samuel Colman, he was especially drawn to the broad reaches of the river at Tappan Zee. *The Hudson at the Tappan Zee* is one of a number of paintings that reflect his interest in that four-mile width of water, which offered him an attractive prospect for executing broad panoramic

views of the Hudson that are akin to his views of the ocean. Large sloops cruising under full sail are a familiar subject of those paintings. Silva perhaps viewed their presence with a growing sense of nostalgia, for their number had begun to decline rapidly—at the height of the sailing era, more than a hundred sloops would have been seen at the Tappan Zee on a summer day.[2]

The quietude and spaciousness of *The Hudson at the Tappan Zee* are notable attributes of Silva's style. The off-shore view, a typical vantage point in his Tappan Zee paintings,[3] and the unde-fined boundaries amplifying the river's breadth contribute to a sense of unenclosed space. Silva was fond of including a rowboat carrying a small figure in the foreground of his compositions, where it functioned as a stepping-stone into the perspective. Here, it di-rects the eye to the large, majestic sloop in the middle distance. The rowboat, the principal sloop, and another sloop at the left, all aligned on the same diagonal, create the sort of regular, stepped-back progression into the distance that is a principal characteristic of Silva's work.

The painter's carefully controlled approach to composition is even more emphatic in such earlier canvases as *On the Hudson, Nyack* (ill.), which shows three sloops of diminishing size evenly arranged along a gently receding diagonal. The ordered design so evident in Silva's compositions invites comparison with similar, if

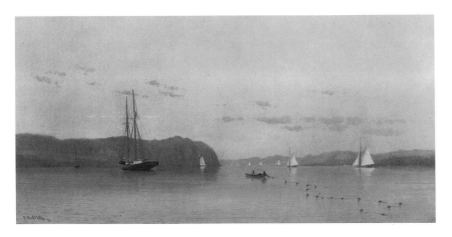

Francis A. Silva, *On the Hudson, Nyack*, 1871, oil on canvas, 12 x 24 in. (30.5 x 61 cm.). Private collection

The author of an 1877 review offered this assessment of the special attributes of what he referred to as colored air: "Different conditions of air produce different impressions upon the mind, making us feel sad, or glad, or awed, or what not. Hence the condition—that is, the colour—of the air is the one essential thing to be attended to in landscape-painting. If the painter misses that, he misses everything."[7] He was speaking of works by Sanford Gifford, but his remarks could be used to describe Silva's artistic quest as well. For Silva, the challenge was not to transcribe nature exactly as he saw her, but to endow her with a sense of poetry uniquely his own.

M-A.H.

subtler, designs in paintings by Lane and Martin Johnson Heade. Silva, who shared those artists' preference for balancing factual recording with individual interpretation, explained his rationale in an article he wrote for *The Art Union*:

> Some men can never paint from memory or feeling—they give us only cold facts in the most mannered way.
>
> I hold it impossible to paint a large and important work entirely out-of-doors, for light and effect change so rapidly that the mind becomes confused and involved in difficulty from which there is no escape except to take the picture into the studio to finish it.[4]

Silva's belief in the advantages of relying on memory to finish a picture is very much in the tradition of his Hudson River School predecessors, including Thomas Cole, who once said, "By looking intently on an object for twenty minutes I can go into my room and paint it with much more truth than I could if I employed several hours on the spot. By this means I become more intimately acquainted with the characteristic spirit of nature than I could otherwise do."[5]

Silva constantly sought a poetic effect, which he achieved primarily through his sensitive handling of light and atmosphere. In *The Hudson at the Tappan Zee*, delicate variations of golden brown and brownish green tones create a warm, glowing, and almost palpable atmosphere that unifies the elements of the picture. The hills in the background are enveloped in a soft haze, but the light focused on the water heightens the details of the river craft and brightens the white of the sails. This was a painter who tended to favor intensely colorful times of day, such as sunrise and sunset, and who often used the cadmium-based pinks, yellows, and oranges to heighten the atmospheric drama. Here, however, he has depicted a less vivid time—perhaps the early afternoon—and has accordingly altered his palette to more subdued tones.

Silva was one of a number of landscape painters who in the 1870s shared an interest in capturing the effects of light and atmosphere on the landscape,[6] phenomena whose expressive possibilities were the subject of discussion in contemporary articles.

Notes

1. Baur 1980, pp. 1022–25, where Silva's travels in the 1870s are documented on the basis of his dated sketches, watercolors, and paintings.
2. Van Zandt 1971, p. 127.
3. For example, see Silva's *Sunrise at Tappan Zee*, 1874, Baur 1980, fig. 8.
4. F. A. Silva, "American vs. Foreign-American Art," *The Art Union* (June–July 1884), p. 130.
5. Undated letter from Thomas Cole to person unknown, quoted in Novak 1969, p. 70.
6. Talbot 1973, p. 9.
7. Sheldon 1877, p. 284, cited in Talbot 1973, p. 13.

ALEXANDER H. WYANT
(1836–1892)

Born to a farmer and carpenter in the village of Evans Creek, Ohio, Alexander Helwig Wyant did not seem destined for a distinguished artistic career. With very little formal art education, he was nevertheless to achieve a notable reputation as a landscape painter that continued to grow for some thirty years after his death. By the time he was apprenticed to an Ohio harness- and saddlemaker, the youth had already developed an interest in art; before he was out of his teens, he had begun to paint signs for a living in Ohio and Kentucky. On a visit to Cincinnati in 1857, he saw works by George Inness that so impressed him that he went to New York to meet the artist. Inness arranged to have Wyant introduced to Nicholas Longworth, Cincinnati's leading art patron, whose financial support enabled Wyant to spend about a year in New York. By 1861, Wyant was working in and around Cincinnati, where he remained until Longworth's death in 1863. Wyant returned to New York and in 1865 exhibited at the National Academy of Design for the first time. The old guard of the Hudson River School, who still governed the New York art world, believed that the Düsseldorf Academy offered the best art instruction in the world, and Wyant, having seen an exhibition in New York of the work of Düsseldorf artists, arranged to study with the Norwegian Hans Fredrik Gude, a former Düsseldorf student then teaching at Karlsruhe. Wyant arrived in Germany in 1865, but departed within the year for home, stopping briefly in Paris and proceeding to London, where he became acquainted with the work of J. M. W.

Turner and John Constable. By 1866, after spending some time in Ireland, he was back in New York and in a studio on West 57th Street. He joined the American Society of Painters in Water Colors in 1867. The following year, he was elected an Associate of the National Academy of Design; he was made an Academician in 1869. Wyant resumed his friendship with Inness, which deepened over the years. He exhibited in New York, Brooklyn, Boston, and Philadelphia; he also began to sketch in upstate New York and as far as New Jersey, West Virginia, Ohio, Pennsylvania, New Hampshire, and Connecticut.

In 1873, Wyant joined a government expedition to Arizona and New Mexico, on which he endured much hardship. As a result, he suffered a stroke that left him paralyzed on the right side. Showing admirable spirit, he learned to paint with his left hand under the instruction of Joseph Eaton, an Ohio portrait painter. About 1874, Wyant rented a studio and living quarters at the YMCA, on Fourth Avenue at 23rd Street in New York, and began to teach art to a few students, including Arabella Locke, whom he married in 1880. In the late 1870s, he was elected to the Society of American Artists and also joined the Century Association. He began spending more time away from New York City, preferring to be in Keene Valley in the Adirondack Mountains and, later, in Arkville, in the Catskills. After a long period of increasing pain and debilitation, Wyant died in his Fourth Avenue studio.

Select Bibliography

Eliot Clark. *Alexander Wyant*. New York: Privately printed, 1916.

———. *Sixty Paintings by Alexander H. Wyant*. New York: Privately printed, 1920.

Robert S. Olpin. *Alexander Helwig Wyant, 1836–1892*. Exhibition catalogue. Salt Lake City: Utah Museum of Fine Arts, University of Utah, 1968.

Robert S. Olpin. *Alexander Helwig Wyant (1836–1892) American Landscape Painter: An Investigation of His Life and Fame and a Critical Analysis of His Work with a Catalogue Raisonné of Wyant Paintings*. Ann Arbor, Mich.: University Microfilms, 1971.

Tennessee, 1866

Oil on canvas, 34¾ × 53¾ in. (88.3 × 136.5 cm.)
Signed and dated at lower left (on rock): A. H. Wyant/1866
The Metropolitan Museum of Art, New York City. Gift of
Mrs. George E. Schanck, in memory of her brother,
Arthur Hoppock Hearn, 1913 (13.53)

Intimate, soft-focused, tonal landscapes painted in his later career
were what won Alexander Wyant the great critical and popular
acclaim that only continued to increase after his death. In 1919,
as an article in *Arts & Decoration* proclaimed:

> If one were to ask the average person who were the three greatest
> American landscape painters, the answer would probably be:
> Inness, first; Wyant, second; and after that any one of a dozen
> others, no two persons agreeing on the third. . . .
>
> If there is a Gallery of American art anywhere that does not
> contain a Wyant, it is doubtless because they could not get one—not
> because they did not want one. Inness has become a household
> word . . . and the name of Wyant is rapidly becoming a rival in
> popularity.
>
> It is probably safe to say that the average person . . . has never
> heard of West, Cropsey, Cole, Church, Martin, Ranger, Minor,
> Homer, and the like. But who has not heard of Inness and Wyant?
> The answer is: Only those who have not heard of Rosa Bonheur,
> Raphael, Leonardo da Vinci, Whistler, and so on. . . .[1]

Though the article reveals how far the reputation of the Hudson
River School had declined by the early years of the twentieth cen-
tury, Wyant himself had served an apprenticeship to the School
before developing a personal style that drew on the Barbizon paint-
ers and on the later works of George Inness.

When Wyant arrived in New York City in the early 1860s,
the prevailing taste in landscape painting still favored the Hudson
River School, even though it had already reached its zenith and
would soon be superseded in popularity by a new French style. For
Wyant and others of his generation, however, the grand view was
still thought to be the best view of nature. Wyant, eager to establish
himself as a professional artist, emulated the works he saw in New
York at the National Academy of Design and at the Düsseldorf
Gallery. In 1865, when he went abroad for art instruction, he chose
to study with the Norwegian Hans Fredrik Gude, a former student
of the Düsseldorf Academy then teaching at Karlsruhe.[2] Wyant
was the last major American painter to seek such training, for the
influence of the Düsseldorf Academy too had begun to wane.

The instruction Wyant received from Gude stressed the same
essentials adhered to by the Hudson River School painters: an
almost photographic realism in the portrayal of nature; the use of
thin paint and tight, controlled brushwork; an overall brown tonal-
ity; and a panoramic format. As Wyant wrote from Düsseldorf of
his training: "I can, in this country see things clearing up which I
only groped after in America. I always knew there was much to
learn without knowing what it was. Now I begin to understand
what must be learnt. It is much like science thus far. . . . This
training of the mind is only intended to teach me to study nature
in the right manner."[3]

Wyant painted *Tennessee*[4] in 1866, while under Gude's in-

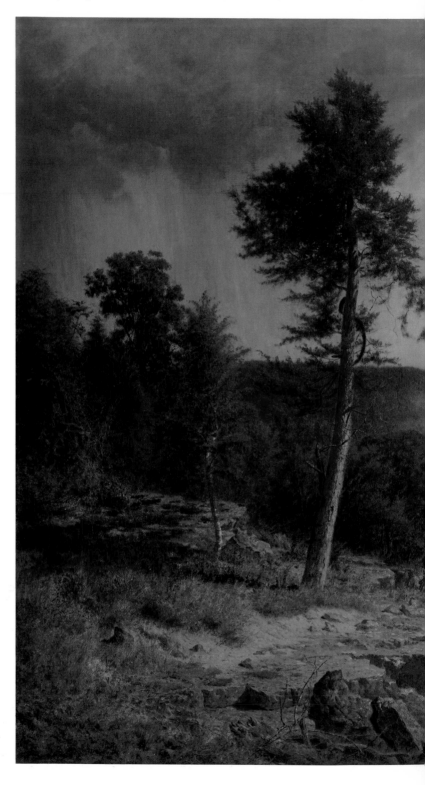

struction, probably from sketches he had brought from America. Apparently, he had made a trip to the area depicted, which is just outside of Chattanooga, in the 1850s or 1860s, when he was spending most of his time in Frankfort, Kentucky,[5] and had sketched the untouched natural scenery where the Tennessee River

cuts through the Cumberland Mountains.[6] In 1865, he had painted a view similar but smaller in size and less dramatic in treatment of nature (*Mohawk Valley*, Los Angeles County Museum).[7] Both works show the "Grand Canyon of Tennessee"—the gorge produced by the river's passage through the Cumberland range—with

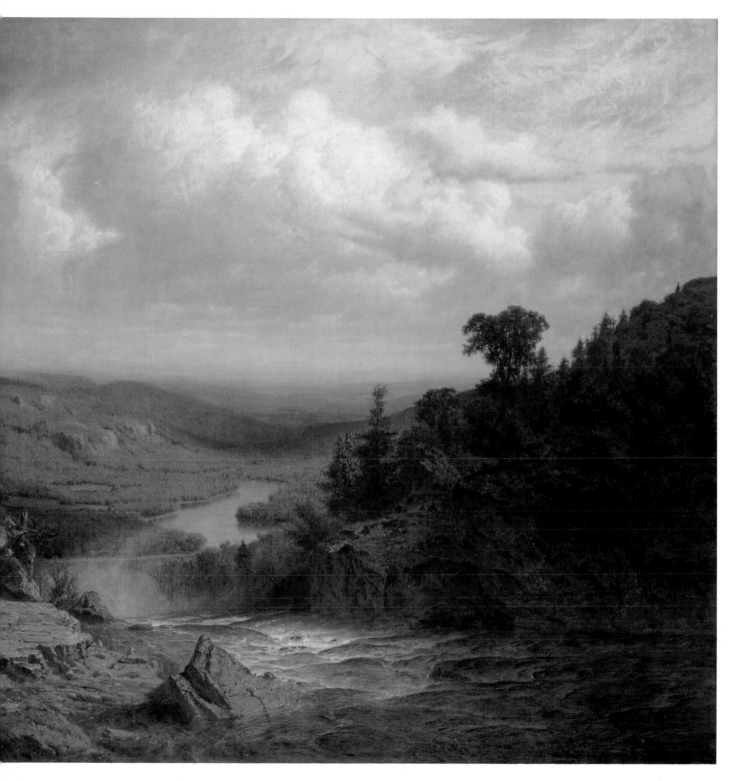

Elder Mountain to the right of the river gap and Signal Mountain to the left.[8]

Wyant's letters make it clear that he hoped to show *Tennessee* at a London exhibition. It was rejected, and he sent it instead to the 1866 spring annual at New York's National Academy of Design.[9] A review of the exhibition reveals that study in Düsseldorf was not as esteemed as it had been only a few years earlier:

> Mr. Wyant has . . . gone to Germany to pursue his studies under distinguished artists of the Dusseldorf school. We hardly know whether to felicitate him on this step or not, and incline to believe that an artist, after he has acquired the first principles of drawing, will receive the best schooling, in no *dorf* of Europe or America, but in the wide fields of nature. . . . His "Tennessee" is full of truthful painting—full of natural characteristic—but it greatly lacks vitality of color, and displays throughout something of that hardness which is associated with the German school. The general impressiveness of the picture as a unit, is hurt by the obtrusion of a solitary unsupported tree in the left foreground.[10]

What the critic, no doubt accustomed to looking at transcripts of nature painted by the leading Hudson River School artists, probably found disconcerting was Wyant's predilection for a gray green palette, already evident in this painting and to become a feature of his mature work. Years later, Wyant spoke of painting *Tennessee* in Germany and of his relationship with Gude. His recollections were recorded in *Harper's Weekly*:

> Now Gude had undoubtedly done some creditable work, but at the time of Wyant's advent he had tricked himself down to a manner. His representations of Norwegian scenery . . . were often forcible and admirable; but the young American . . . did not fall into veneration of his master. Sympathy was lacking, to begin with; and then one day, soon after his arrival, he began to paint a picture of Lookout Mountain [*Tennessee*] from studies brought with him, and Gude said, impatiently, "I can't help you on American subjects, but if you will scratch out that composition, and draw a coast scene, I think I can be of assistance to you." . . . Wyant refused absolutely. . . . [Gude's] suggestion to Wyant to scratch off his "Lookout Mountain," Tennessee, and put a Norwegian coast scene in its place, is one of those gems of conventional academic teaching that the world of art ought not willingly to let pale.[11]

Tennessee, called the "most important and representative work" of Wyant's early period,[12] is a fortuitous survival, for Wyant's widow destroyed many of her husband's early paintings in the belief that their quality was inferior to that of his mature work.[13] In a sense, it represents one of the final statements of the Hudson River School, for soon after the Civil War, under the influence of French models then flooding the art world, tastes changed. With the war, America had lost her innocence; never again could the country be perceived as a new Garden of Eden. No longer applicable was an iconography that stressed America's unsullied landscape: with its loss, the Hudson River School style was undermined and outmoded. Ironically, the area depicted in Wyant's painting was the scene of more than one Civil War battle. Signal

Mountain, seen at the left of the canvas, was so named for the signal stations that had been set up on it during the war.[14]

L.D.

Notes

1. Eugene V. Brewster, "Wyant—the Nature-Painter," *Arts & Decoration* 10 (February 1919), p. 197.
2. Olpin 1971, pp. 87–89. See also *American Artists in Düsseldorf: 1840–1865*, exh. cat. (Framingham, Mass.: Danforth Museum, 1982), p. 46. For a contemporary account of the academy, see "The Dusseldorf School of Art," *Cosmopolitan Art Journal* 1 (September 1857), pp. 154–55.
3. Wyant to Thomas Turlay, 26 January 1866. Within a few months, the lonely and homesick Wyant was disillusioned by his training, which he found cold and scientific. For his own account, in his letters, see Bermingham 1972.
4. Though this is the name Wyant gave his painting, the work acquired the erroneous title "Mohawk Valley" sometime in the 19th century. For information on the proper name and dating of *Tennessee*, see Spassky 1985, pp. 412–15.
5. Olpin 1971, pp. 79, 85. Dr. Olpin is currently doing research as to when Wyant might have sketched in Tennessee (conversation with author, 25 April 1986). Other American painters who discovered the rugged natural beauty of Tennessee include Ralph E. W. Earl and Emil Bott, who painted scenes of the Cumberland River in 1823 and in the 1850s, respectively. James Cameron painted *Moccasin Bend* in Chattanooga in 1857 (see Kelly 1985, pp. 9–10).
6. While researching *Tennessee* for his exhibition of Tennessee paintings (see Kelly 1985), James C. Kelly believed that Wyant had exercised artistic license in depicting the waterfall in the foreground, but when Graham Hawks, Jr., Director of the Tennessee River Nature Conservancy, visited the exhibition, he recognized the view Wyant portrayed: he knew a ravine on a plateau similar to those in Wyant's painting and established that the type of waterfall shown in *Tennessee* occurs intermittently in the area, usually in the spring and the fall. He also confirmed that the features of the site—from the kind of soil to the indigenous sandstone—were precisely portrayed. I am grateful to Mr. Kelly for sharing his information on the painting with me and for putting me in touch with Mr. Hawks, who graciously discussed his findings with me (conversation, 5 May 1986).
7. The title of the Los Angeles painting is a modern one, based on the former, erroneous titling of *Tennessee* (see n. 4).
8. Kelly 1985, p. 68, identifies the mountain on the right as Lookout Mountain, but Mr. Hawks confirms that its correct name is Elder Mountain.
9. Letters from Wyant to Thomas Turlay, 17 and 21 February 1866, quoted in Bermingham 1972, pp. 4, 5.
10. "National Academy of Design. Third Article," *The American Art Journal* 5 (16 May 1866), p. 52.
11. "Alexander H. Wyant," *Harper's Weekly* 24 (23 October 1880), p. 678. I am grateful to Doreen Bolger Burke for bringing this article to my attention.
12. Eliot Clark, *Alexander Wyant* (New York: Privately printed, 1916), p. 26. See also Olpin 1968, unpaged [p. 4]; Olpin 1971, pp. 22, 115, 140–42; Bermingham 1975, p. 56.
13. John C. Van Dyke, *American Painting and Its Tradition* (New York: Charles Scribner's Sons, 1919), p. 52.
14. Kelly 1985, p. 44.

ALFRED T. BRICHER
(1837–1908)

Alfred Thompson Bricher, born in Portsmouth, New Hampshire, grew up in Newburyport, Massachusetts, where he attended the Putnam Free School and the Newbury High School. In 1851, he took a position as a dry-goods clerk in Boston, and probably studied at the Lowell Institute in that city. Deciding by 1858 to paint professionally, he set himself up in a studio in Newburyport. The next year, he moved back to Boston, where he and Martin Johnson Heade had their studios in the same building. During the summers of the late 1850s through the mid-1860s, Bricher ventured forth on many sketching trips, working in the Catskills of New York, in New Hampshire and its White Mountains, in the upper Mississippi River region, and on Mount Desert Island in Maine, sketching there with Charles Temple Dix and William Stanley Haseltine. In 1866, Bricher began to do landscape paintings for L. Prang and Company, a Boston lithographic firm that bought and published his work throughout the remainder of his career.

In 1868, the same year that Bricher married Susan Wildes and moved to New York City, he exhibited his first painting at the National Academy of Design, *The Millstream at Newburyport.*

Working in his studio in the YMCA building in New York, he branched out from the landscapes of his early career and began to produce marine scenes. In the late 1860s, he started to exhibit regularly in New York at the National Academy, the Brooklyn Art Association, and the American Society of Painters in Water Colors; in Springfield, Massachusetts, at Gill's Art Galleries. In 1873, he was chosen to be a member of the American Society of Painters in Water Colors; in 1879, he was elected an Associate of the National Academy.

Bricher continued to make sketching trips up the New England shore and to the islands off the coasts of Massachusetts and Maine. Probably in 1874, he began to visit Grand Manan Island, New Brunswick, a site he depicted on numerous occasions. After a second marriage, in 1881, Bricher spent a great deal of time in Southampton, Long Island, though he kept his New York studio. He made frequent sketching trips to the Casco Bay area of Maine until 1908, when he died at the home he had built for his family eighteen years earlier in New Dorp, Staten Island.

Select Bibliography
"Alfred T. Bricher." In *The Art Journal* 39 (1877), pp. 174–75.
John D. Preston. "Alfred Thompson Bricher, 1837–1908." In *The Art Quarterly* 25 (Summer 1962), pp. 149–57.

Jeffrey R. Brown and Ellen W. Lee. *Alfred Thompson Bricher, 1837–1908.* Exhibition catalogue. Indianapolis, Indiana: Indianapolis Museum of Art, 1973.

Time and Tide, ca. 1873

Oil on canvas, 25⅛ × 50¼ in. (63.8 × 127.6 cm.)
Signed at lower right: ABricher
Dallas Museum of Art, Foundation for the Arts Collection, Gift of
 Mr. and Mrs. Frederick F. Mayer

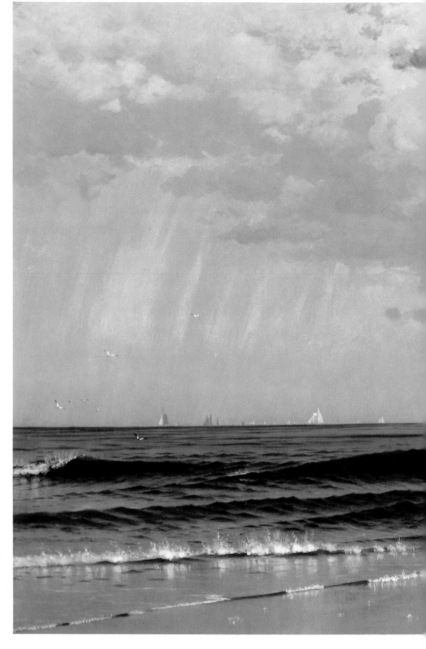

Although this tranquil scene of an unidentified spot probably along the New England coast is today thought to be Bricher's finest work, at its initial exhibition, at the National Academy of Design in 1874, it elicited a mixed response from the critics. The reviewer for the *New York Times* of 13 April said that it "merely re-echoes Mr. W. T. Richards' style," but the article in the *Evening Post* was more favorable, praising *Time and Tide* for its "careful observation of quiet waves rolling in and breaking gently on the shore."[1]

At the exhibition, these lines by Bricher were inscribed above his name on the painting's brass label:

<div align="center">

TIME & TIDE.
TIME, A September Afternoon, the [approach of] the Equinoctial.
TIDE, Turning, the long swell before the storm.[2]

</div>

They describe the moment he has chosen to represent and explain the nearly flat water and the still atmosphere of an approaching storm. A deeper interpretation can refer to such well-known nineteenth-century sayings as Sir Walter Scott's "Time and tide tarry for no man"[3] and Charles Dickens's "Time and tide will wait for no man . . . but all men have to wait for time and tide."[4]

By the time Bricher made this painting in 1873, his sketching trips to the favorite spots of earlier Hudson River painters—the Adirondacks, the Catskills, the White Mountains, Lake George, and Lake Champlain—had all but ceased, and he was giving more and more attention to paintings devoted to the seashore and ocean, a natural development for a man who had grown up in old coastal towns in New England. In *Time and Tide*, to stress the eternal elements inherent in the title, he reduced the boats to tiny shapes on the horizon and emphasized the calm appearance of a sea that here foretokens an impending storm. The sky's soft clouds and the light drenching the boats, the sea, and the land are trademarks of his. In contrasting the flatness of the water with the bold ruggedness of the upthrusting headland, he used the lines of the gently breaking waves to convey the eye of the viewer up to the land mass, a technique he frequently employed in his work.

The canvas is outstanding in Bricher's oeuvre for its crispness of handling and clarity of detail. He depicted the water superbly, showing depth, shallowness, and the varied shapes of the waves as they crest and curl, break into foam, and eventually roll into nothingness on the sand. The more generalized textural quality of the headland is treated to variations of light and shadow; the sea itself is at once brilliant and translucent. By placing the boats a great distance away and by eliminating foreground figures, as well as the rocks and mounds of seaweed whose obsessive, Pre-Raphaelite realism often dominates other canvases of his, Bricher focuses the viewer's attention on the pure interaction of waves and sandy shore that are the heart of the work. Stripped of extraneous details, the painting is an evocation of the inexorable ebb and flow of the tide; the timelessness of the sea.

In 1890, Bricher built a permanent home on Staten Island, but continued his travels to seaside spots up and down the New England coast and on the New Jersey and Long Island shores until almost the last years of his life. It has been suggested, though never established, that Bricher may have known Fitz Hugh Lane, the

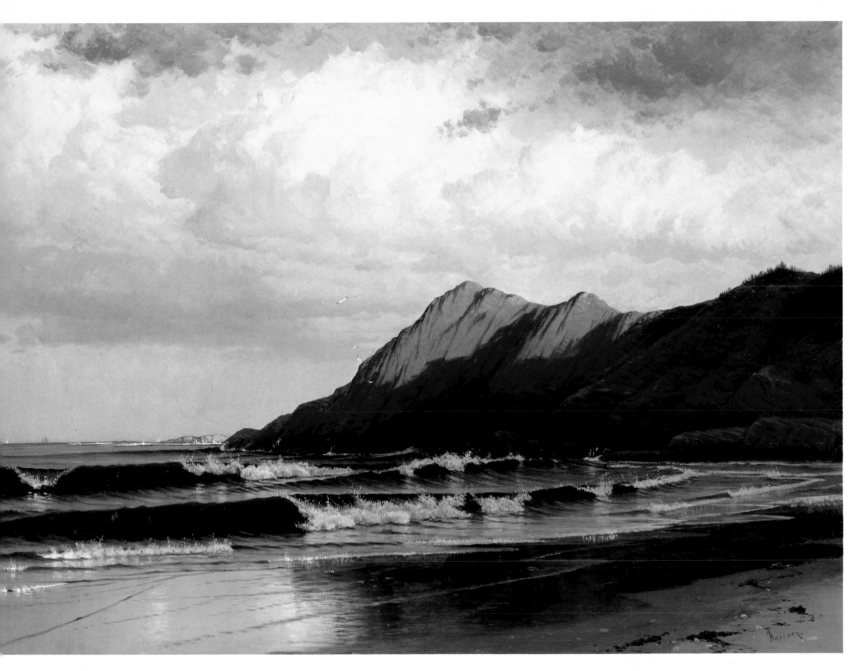

New England seascapist said to have been the first artist "to use stilled time as a means of expressing moods" in his work rather than the explicitness of standard features, such as storms and wrecks.[5] Whether or not the two actually met, Bricher would certainly have known the older man's work and have been influenced by his ability to express "stilled time," as well as by his selectivity of detail, which helped Bricher to open up his own compositions.

On a piece of his own letterhead attached to the stretcher of *Time and Tide*, Bricher noted his asking price for the canvas—six hundred dollars, a sizable amount for that period. The painting was purchased by the Osborne family of Auburn, New York, and was sold by Mrs. Agnes G. Timingham, an Osborne daughter, to Mr. and Mrs. Robert C. Vose, Jr., of Boston, from whom the Dallas Museum bought it in 1976.

B.B.B.

Notes
1. *Evening Post*, 25 April 1874.
2. Quoted in Brown and Lee 1973, p. 19.
3. Ibid., quoting Scott's *Antiquary* (1816).
4. Ibid., quoting Dickens's *Martin Chuzzlewit* (1843).
5. John Wilmerding, *A History of American Marine Painting* (Boston: The Peabody Museum of Salem, Massachusetts, and Little, Brown and Co., 1968), p. 158.

ARTHUR PARTON
(1842–1914)

Born and reared in Hudson, New York, Parton moved in 1859 to Philadelphia, where he studied landscape painting with William Trost Richards over the next few years. The first works that Parton exhibited—in 1861 at the Pennsylvania Academy of the Fine Arts—were Hudson River subjects. In 1862, having moved back to Hudson, he exhibited landscapes at both the Pennsylvania Academy and at the National Academy of Design in New York City. In 1863, he returned to Philadelphia for a year; in 1864, he moved to Manhattan and lived at different addresses in that borough over the next decade. During travels abroad in 1869 and 1870, Parton visited Paris briefly but spent most of his time in England and Scotland. The mainstays of his career were subjects based on upstate New York scenery, though throughout the 1880s he also produced landscapes of Scottish subjects.

Parton rented space in the Tenth Street Studio Building in 1874 and settled into the routine of spending winters in the city and summers in the Adirondacks. He retained his Manhattan studio when he moved to Yonkers sometime after his marriage to Anna Taylor in 1877. Around 1880, Parton shifted his summer retreat from the Adirondacks to the Catskills, where he bought a cottage in Arkville, living near his friends Alexander Wyant, Charles Warren Eaton, and J. Francis Murphy. Elected an Associate of the National Academy in 1872 and an Academician in 1884, he continued to exhibit at the Academy until 1900.

Select Bibliography

Clara Erskine Clement and Laurence Hutton. *Artists of the Nineteenth Century and Their Works. A Handbook.* 2 vols. Boston: Houghton, Mifflin and Co., 1880, 2, pp. 164–65.

Gilbert Cranmer. "An American Landscape Painter—Arthur Parton." In *Monthly Illustrator* 12 (1896), pp. 329–33.

Dumas Malone, ed. *Dictionary of American Biography.* 11 vols. New York: Charles Scribner's Sons, 1927–1957, 7, pp. 278–79.

A Mountain Brook, 1875

Oil on canvas, 52½ × 40½ in. (133.4 × 102.9 cm.)
Signed and dated at lower right: Arthur Parton 1875
*Museum of Fine Arts, Springfield, Massachusetts, Gift of
 Judge and Mrs. Ernest S. Fuller*

The character of Parton's work prior to this painting remains obscure because of the paucity of extant paintings, but he seems to have demonstrated an interest in the detailed execution associated with Pre-Raphaelitism, perhaps attributable to his early training under William Trost Richards. A review of Parton's *Spring Leaves* (1863; location unknown), complimenting the "growth and grace and good drawing in the large weed in the centre of this little study," noted "positive evidence of the influence of W. T. Richards."[1] In *A Mountain Brook*, painted twelve years later, Parton continued to express interest in the highly specific renderings of natural forms advocated by the Pre-Raphaelites, though here the deliberately monumental composition owes a great deal to the forest interior scenes of Asher B. Durand. A contemporary writer brought to the work his personal associations of nature's power and significance when he wrote: "The very name—'Mountain Brook'—suggests to the imagination just what it is, a quiet, lonely, retired spot, among the recesses of a wooded pass where Nature in her wildest mood has spread out her giant trees, etc. The artist has imparted to the scene the 'still quiet' which seems to reign over all, and the 'weirdness' which ever attaches itself to Nature's forest scenes."[2]

A more analytic view of Parton's accomplishment was offered in a review of the National Academy of Design exhibition of 1875:

> Arthur Parton has a large, bright study of the weeds and undergrowth of an American forest in a picture called the "Mountain Brook." It is by far the most elaborate study of foreground in the collection. Mr. Parton has depicted every fern leaf, each blackberry twig and spray of birch in the vivid brightness of summer. Every one is a study minute enough to have been painted for itself alone. . . . Mr. Parton seems to have done just what he attempted, in the best way. With fresh eyes, looking at nature freshly, he has, so far as he was possibly able, rendered all her forms.[3]

The so-called fresh look referred to by the writer emerges from a conventional core, for the picture's composition derives from a common landscape formula, used by Richards in 1870 and by Parton in the next decade,[4] consisting of a distant bank at the left separated by water from a near bank dominated by a tall tree at the right (ill.). *A Mountain Brook* is nevertheless distinguished by Parton's novel interpretation: he recorded what appears to have been an actual site that not only conformed to the formula but was also possessed of a highly individual assembly of nooks and crannies and highly individual patterns of light and shade.

The composition of a landscape flanked by near and far elements generally escorts a viewer's eye along a diagonal sweep of space that opens up into a deep vista at the center of the picture. In *A Mountain Brook*, however, the dense foliage on the far bank blocks any recession into what could be called a background. Instead, a diagonal space forks off into two unfollowable avenues: the first, a bend in the brook implied by the strong silhouette of a shadowed rock on the near bank against a brightly lighted rock on the far bank; the second, a path of receding space that burrows into the far reaches of the opposite bank. The fork of the two trajectories is marked by a strategically placed white bird that follows the brook upstream.

The sun illuminates the scene from its position behind, above, and to the right of the picture plane. Aligned with the course of the visible part of the brook, it directly irradiates only those trees adjacent to the open space. The brightest greens of Parton's pigments, highlighted against the dark recesses of the far bank, record the busily photosynthesizing, translucent leaves of the tall tree's lower branches and a two-branched young tree aglow to the right

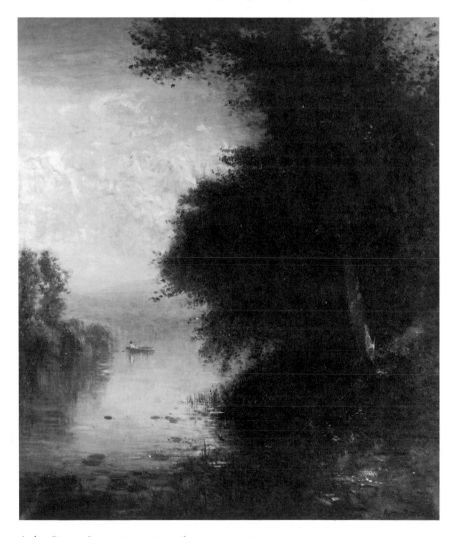

Arthur Parton, *Summertime*, 1884, oil on canvas, 37½ x 31½ in. (95.3 x 80 cm.).
Collection of Mr. and Mrs. Roger Eisinger

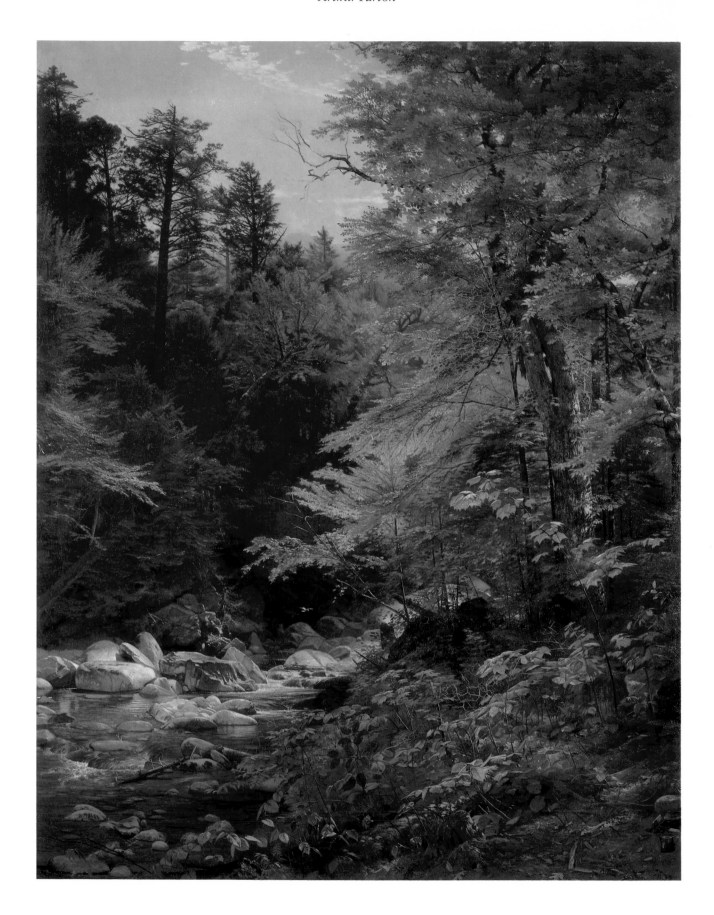

of the canvas's center. With less saturated greens Parton reproduces a different optical effect, this one manifested by the light-reflecting leaves of the tree at the left edge of the canvas. The ambient light that glances off the top of the leaves of the foreground flora adds to Parton's variegated scene yet another characterization of the interaction between light and leaf.

The clearing in the foreground, with a pot and charred wood, indicates a makeshift campsite, presumably that of Parton, who must have spent a good deal of time observing the intricacies of the site and who has left his signature painted in the lower right as testimony. Considering the documentary character of the artist's presence at the scene, the question arises as to whether Parton executed the painting on the spot, especially in view of his closely observed rendering of nature's particulars. A report that "Mr. Arthur Parton . . . is finishing a large study from Nature on an Adirondack brook"[5] in April 1875 provides part of the answer. The mention of "finishing" demonstrates that Parton worked on the canvas in his quarters in New York's Tenth Street Studio Building. Complementing that information and strongly suggesting that *A Mountain Brook* was entirely a studio production is the painting's size, too large to have been readily transported from a site as densely wooded as the one represented. In tandem with the paint-ing's detailed, life-size foreground objects, its representation of a limited amount of space on a canvas of considerable dimension facilitates its successful evocation of the out-of-doors.

The partly cleared area, while suggesting Parton's presence, also doubles as the sole means by which a viewer could enter the scene. That conceit, which locates the viewer on the brook's bank, creates a fictive unity between him and the artist. With content as well as with form, Parton uses the viewer's act of looking at the painting to seduce him into recollecting some personal experience of the land.

D.S.

Notes
1. "Good Work in the Academy Exhibition," *New Path* 1 (1863), p. 22.
2. Clement and Hutton 1880, 2, p. 165, citing an unidentified newspaper review mistakenly attributed to the *New York Express* of June 1875.
3. S. N. C. [Susan N. Carter], "The Academy Exhibition. II. The Landscapes," *Evening Post*, 24 April 1875, p. 1. The painting was bought by the New York department store magnate A. T. Stewart. One of his last acquisitions, it fetched $625 at his estate sale in 1887.
4. See Richards's seasonal series discussed in Ferber 1980, pp. 213–14.
5. "New-York Studio Notes," *Art Journal* 5 (April 1875), p. 125.

SHORT TITLES AND ABBREVIATIONS

Adamson 1981
Jeremy Elwell Adamson. "Frederic Church's 'Niagara': The Sublime as Tran-scendence." 2 vols. Ph.D. dissertation, University of Michigan, 1981.

Adirondack Museum
Adirondack Museum, Blue Mountain Lake, New York

Albany Institute
Albany Institute of History and Art, Albany, New York

Alexander Gallery
Alexander Gallery, New York City

Allen Museum
Allen Memorial Art Museum, Oberlin College, Oberlin, Ohio

Amon Carter Museum
Amon Carter Museum, Fort Worth, Texas

Archives of American Art
Smithsonian Institution, Washington, D.C. Some Archives material also available on microfilm

Arnot Art Museum
Arnot Art Museum, Elmira, New York

Art Institute of Chicago
The Art Institute of Chicago, Chicago, Illinois

Austin Arts Center
Austin Arts Center, Trinity College, Hartford, Connecticut

Baigell 1981
Matthew Baigell. *Thomas Cole*. New York: Watson-Guptill, 1981.

Baur 1942
John I. H. Baur, ed. "The Autobiography of Worthington Whittredge, 1820–1910." In *The Brooklyn Museum Journal* 1 (1942), pp. 5–68.

Baur 1948
John I. H. Baur. "Early Studies in Light and Air by American Landscape Painters." In *Bulletin of The Brooklyn Museum* 9 (Winter 1948), pp. 1–9.

Baur 1949
John I. H. Baur. "Trends in American Painting, 1815–1865." In W. G. Constable, ed. *M. and M. Karolik Collection of American Paintings, 1815–1865*. Cam-bridge: Harvard University Press, 1949, pp. xv–lvii.

Baur 1954
John I. H. Baur. "American Luminism: A Neglected Aspect of the Realist Move-ment in Nineteenth-Century American Painting." In *Perspectives USA* 9 (Autumn 1954), pp. 90–98.

Baur 1980
John I. H. Baur. "Francis A. Silva: Beyond luminism." In *The Magazine Antiques* 118 (November 1980), pp. 1018–31.

Benjamin 1879
S[amuel] G[reene] W[heeler] Benjamin. *Our American Artists*. Boston: D. Lo-throp & Co., 1879.

Benjamin 1879a
S[amuel] G[reene] W[heeler] Benjamin. "Present Tendencies in American Art." In *Harper's New Monthly Magazine* 58 (March 1879), pp. 481–96.

Benjamin 1880

S[amuel] G[reene] W[heeler] Benjamin. *Art in America: A Critical and Historical Sketch*. New York: Harper & Bros., 1880.

Berkshire Museum
The Berkshire Museum, Pittsfield, Massachusetts

Bermingham 1972
Peter Bermingham. "Alexander H. Wyant: Some Letters from Abroad." In *Archives of American Art Journal* 12 (1972), pp. 1–8.

Bermingham 1972a
Peter Bermingham. "Barbizon Art in America: A Study of the Role of The Barbizon School in the Development of American Painting, 1850–1895." Ph.D. dissertation, University of Michigan, 1972.

Bermingham 1975
Peter Bermingham. *American Art in the Barbizon Mood*. Exhibition catalogue. Washington, D.C.: National Collection of Fine Arts, 1975.

Boime 1971
Albert Boime. *The Academy and French Painting in the Nineteenth Century*. London: Phaidon, 1971.

Born 1948
Wolfgang Born. *American Landscape Painting: An Interpretation*. New Haven, Conn.: Yale University Press, 1948.

Brooklyn Museum
The Brooklyn Museum, Brooklyn, New York

Brown and Lee 1973
Jeffrey R. Brown and Ellen W. Lee. *Alfred Thompson Bricher, 1837–1908*. Exhibition catalogue. Indianapolis, Ind.: Indianapolis Museum of Art, 1973.

Burroughs 1917
B[ryson] B[urroughs]. *The Metropolitan Museum of Art: Paintings of the Hudson River School Brought Together in Commemoration of the Completion of the Catskill Aqueduct. Supplement to the Bulletin of The Metropolitan Museum of Art*, October 1917.

Caffin 1907
Charles H. Caffin. *The Story of American Painting: The Evolution of Painting in America from Colonial Times to the Present*. New York: Frederick A. Stokes Co., 1907.

Carr 1980
Gerald L. Carr. *Frederic Edwin Church: The Icebergs*. Dallas, Tex.: Dallas Mu-seum of Fine Arts, 1980.

Carr 1987
Gerald L. Carr. *Olana Landscapes: The World of Frederic E. Church*. Corte Madera, Cal.: Pomegranate Artbooks, 1987.

Century Association
The Century Association, New York City

Century 1880
Gifford Memorial Meeting of the Century, Century Rooms, Friday Evening, November 19, 1880. New York: The Century Association, 1880.

Champney 1869
Benjamin Champney. *Sixty Years' Memories of Art and Artists*. 1869. Reprint. Woburn, Mass.: Wallace and Andrews, 1900.

Chew and Sakal 1981
 Paul Chew and John A. Sakal. *Southwestern Pennsylvania Painters, 1800–1945.* Exhibition catalogue. Greensburg, Pa.: Westmoreland County Museum of Art, 1981.

Church Archives
 Frederic Church. Olana State Historic Site, Hudson, New York, the repository of many of Church's papers.

Cikovsky 1970
 Nicolai Cikovsky, Jr. *Sanford Robinson Gifford (1823–1880).* Exhibition catalogue. Austin: University of Texas, 1970.

Cikovsky 1970a
 Nicolai Cikovsky, Jr. "George Inness and the Hudson River School: *The Lackawanna Valley.*" In *The American Art Journal* 2 (Fall 1970), pp. 36–57.

Cikovsky 1971
 Nicolai Cikovsky, Jr. *George Inness.* New York: Praeger Publishers, 1971.

Cikovsky 1977
 Nicolai Cikovsky, Jr. *The Life and Work of George Inness.* New York and London: Garland Publishing, 1977. Ph.D. dissertation, Harvard University, 1965.

Cikovsky and Quick 1985
 Nicolai Cikovsky, Jr., and Michael Quick. *George Inness.* Exhibition catalogue. Los Angeles, Cal.: Los Angeles County Museum of Art, 1985.

Clark 1954
 Eliot Clark. *History of the National Academy of Design, 1825–1953.* New York: Columbia University Press, 1954.

Clement and Hutton 1880
 Clara Erskine Clement and Laurence Hutton. *Artists of the Nineteenth Century and Their Works: A Handbook.* 2 vols. 1880. Reprint. New York: Arno Press, 1969.

Cleveland Museum
 The Cleveland Museum of Art, Cleveland, Ohio

Cole Papers
 Thomas Cole. New York State Library, Albany, New York

Cook 1883
 Clarence Cook. "Art in America in 1883." In *Princeton Review* 11 (May 1883), pp. 311–20.

Cooper-Hewitt Museum
 Cooper-Hewitt Museum, Smithsonian Institution's National Museum of Design, New York City

Corcoran Gallery
 The Corcoran Gallery of Art, Washington, D.C.

Corn 1972
 Wanda M. Corn. *The Color of Mood: American Tonalism, 1880–1910.* Exhibition catalogue. San Francisco, Cal.: M. H. de Young Memorial Museum and the California Palace of the Legion of Honor, 1972.

Cortissoz 1923
 Royal Cortissoz. *American Artists.* New York: Charles Scribner's Sons, 1923.

Cowdrey 1943
 [Mary] Bartlett Cowdrey, comp. *National Academy of Design Exhibition Record, 1826–1860.* 2 vols. New York: The New-York Historical Society, 1943.

Cowdry and Sizer 1953
 Mary Bartlett Cowdrey and Theodore Sizer. *American Academy of Fine Arts and American Art Union.* Vol. 1, *Introduction: 1816–1852.* Vol. 2, *Exhibition Record: 1816–1852.* New York: The New-York Historical Society, 1953.

Cropsey Papers
 Certain of Jasper Cropsey's papers, works of art, and personal possessions are housed in his former residence, now the Newington-Cropsey Foundation, Hastings-on-Hudson, New York. That repository has been designated "Cropsey Papers" in this book.

Cummings 1865
 Thomas S[eir] Cummings, N. A. *Historic Annals of the National Academy of Design.* Philadelphia: George W. Childs, 1865.

Dallas Museum
 Dallas Museum of Art, Dallas, Texas

Davidson, Hattis, and Stebbins 1966
 Gail Davidson, Phyllis Hattis, and Theodore E. Stebbins, Jr. *Luminous Landscape: The American Study of Light, 1860–1875.* Exhibition catalogue. Cambridge, Mass.: The Fogg Art Museum, Harvard University, 1966.

Denver Museum
 Denver Art Museum, Denver, Colorado

Detroit Institute of Arts
 The Detroit Institute of Arts, Detroit, Michigan

Driscoll and Howat 1985
 John Paul Driscoll and John K. Howat. *John Frederick Kensett: An American Master.* Exhibition catalogue. Worcester, Mass., and New York: Worcester Art Museum in association with W. W. Norton & Co., 1985.

Dunlap 1834
 William Dunlap. *A History of the Rise and Progress of the Arts of Design in the United States.* 2 vols. 1834. Reprint. New York: Dover Publications, 1969.

Durand 1855
 A[sher] B. Durand. "Letters on Landscape Painting." In *The Crayon.* Letter I, 1 (3 January 1855), pp. 1–2; Letter II, 1 (17 January 1855), pp. 34–35; Letter III, 1 (31 January 1855), pp. 66–67; Letter IV, 1 (14 February 1855), pp. 97–98; Letter V, 1 (7 March 1855), pp. 145–46; Letter VI, 1 (4 April 1855), pp. 209–11; Letter VII, 1 (2 May 1855), pp. 273–75; Letter VIII, 1 (6 June 1855), pp. 354–55; Letter IX, 2 (11 July 1855), pp. 16–17.

Durand 1894
 John Durand. *The Life and Times of A. B. Durand.* New York: Charles Scribner's Sons, 1894.

Durand Papers
 Asher B. Durand. New York Public Library, New York City

Dwight 1969
 Edward H. Dwight. *Worthington Whittredge (1820–1910): A Retrospective Exhibition of an American Artist.* Exhibition catalogue. Utica, N.Y.: Munson-Williams-Proctor Institute, 1969.

Edwards 1982
 Lee M. Edwards. "The Life and Career of Jerome Thompson." In *The American Art Journal* 14 (Autumn 1982), pp. 5–30.

Evers 1972
 Alf Evers. *The Catskills: From Wilderness to Woodstock.* 1972. Reprint. Woodstock, N.Y.: The Overlook Press, 1982.

Ferber 1980
 Linda S. Ferber. *William Trost Richards (1833–1905): American Landscape and Marine Painter.* New York: Garland Publishing, 1980. Ph.D. dissertation, Columbia University, 1980.

Ferber and Gerdts 1985
 Linda S. Ferber and William H. Gerdts. *The New Path: Ruskin and the American Pre-Raphaelites.* Exhibition catalogue. New York: The Brooklyn Museum and Schocken Books, 1985.

Ferguson 1970
 Charles B. Ferguson. *Aaron Draper Shattuck, N.A. 1832–1928: A Retrospective Exhibition.* Exhibition catalogue. New Britain, Conn.: New Britain Museum of American Art, 1970.

Fine Arts Museums of San Francisco
 The Fine Arts Museums of San Francisco, California

Fink 1978
 Lois Marie Fink. "French Art in the United States, 1850–1870: Three Dealers and Collectors." In *Gazette des Beaux-Arts* 92 (September 1978), pp. 87–100.

Fink and Taylor 1975
 Lois Marie Fink and Joshua C. Taylor. *Academy: The Academic Tradition in American Art.* Exhibition catalogue. Washington, D.C.: National Collection of Fine Arts, 1975.

Flagler Museum
 The Henry Morrison Flagler Museum, Whitehall Mansion, Palm Beach, Florida

Flexner 1962
 James Thomas Flexner. *That Wilder Image: The Paintings of America's Native School from Thomas Cole to Winslow Homer.* Boston and Toronto: Little, Brown and Co., 1962.

Gerdts 1978
William H. Gerdts. "On the Nature of Luminism." In *American Luminism*. Exhibition catalogue. New York: Coe Kerr Gallery, 1978.

Gerdts 1980
William H. Gerdts. *American Impressionism*. Exhibition catalogue. Seattle, Wash.: The Henry Art Gallery, 1980.

Gerdts 1984
William H. Gerdts. *American Impressionism*. New York: Abbeville Press, 1984.

Gerdts and Weber 1987
William H. Gerdts and Bruce Weber. *In Nature's Ways: American Landscape Painting of the Later Nineteenth Century*. Exhibition catalogue. West Palm Beach, Fla.: Norton Gallery and School of Art, 1987.

Gifford Memorial Catalogue
A Memorial Catalogue of the Paintings of Sanford Robinson Gifford, N.A. Biographical and critical essay by John F. Weir. New York: The Metropolitan Museum of Art, 1881.

Goodrich 1925
Lloyd Goodrich. "George Inness and American Landscape Painting." In *The Arts* 7 (February 1925), pp. 106–10.

Goodrich 1925a
Lloyd Goodrich. "The Hudson River School." In *The Arts* 8 (November 1925), pp. 246–54.

Goodrich 1938
Lloyd Goodrich. *A Century of American Landscape Painting, 1800–1900*. Exhibition catalogue. New York: Whitney Museum of American Art, 1938.

Haggin Museum
The Haggin Museum, Stockton, California

Hartmann 1902
Sadakichi Hartmann. *A History of American Art*. Boston: L. C. Page and Co., 1902.

Hendricks 1964
Gordon Hendricks. "The First Three Western Journeys of Albert Bierstadt." In *Art Bulletin* 46 (September 1964), pp. 333–65.

Hendricks 1974
Gordon Hendricks. *Albert Bierstadt: Painter of the American West*. New York: Harry N. Abrams, 1974.

Henry Art Gallery
Henry Art Gallery, University of Washington, Seattle, Washington

Herbert 1962
Robert L. Herbert. *Barbizon Revisited*. Exhibition catalogue. Boston: Museum of Fine Arts, 1962.

High Museum
The High Museum of Art, Atlanta, Georgia

Hoopes 1978
Donelson F. Hoopes. "Jerome B. Thompson's Pastoral America." In *Art and Antiques* 1 (July–August 1978), pp. 92–99.

Howat 1968
John K. Howat. *John Frederick Kensett, 1816–1872*. Exhibition catalogue. New York: American Federation of Arts, 1968.

Howat 1972
John K. Howat. *The Hudson River and Its Painters*. 1972. Reprint. New York: American Legacy Press, 1983.

Hudson River Museum
The Hudson River Museum, Yonkers, New York

Huntington 1960
David C. Huntington. "Frederic Edwin Church, 1826–1900: Painter of the Adamic New World Myth." Ph.D. dissertation, Yale University, 1960.

Huntington 1966
David C. Huntington. *The Landscapes of Frederic Edwin Church: Vision of an American Era*. New York: George Braziller, 1966.

Huth 1946
Hans Huth. "Impressionism Comes to America." In *Gazette des Beaux-Arts* 29 (April 1946), pp. 225–52.

Huth 1957
Hans Huth. *Nature and the American: Three Centuries of Changing Attitudes*. Berkeley and Los Angeles: University of California Press, 1957.

Indiana University Art Museum
Indiana University Art Museum, Indiana University, Bloomington, Indiana

Inness 1878
[George Inness.] "A Painter on Painting." In *Harper's New Monthly Magazine* 56 (February 1878), pp. 458–61.

Inness 1917
George Inness, Jr. *Life, Art, and Letters of George Inness*. New York: The Century Co., 1917.

Ireland 1965
LeRoy Ireland. *The Works of George Inness: An Illustrated Catalogue Raisonné*. Austin: University of Texas Press, 1965.

Isham 1905
Samuel Isham. *The History of American Painting*. 1905. Reprint. New York: Macmillan, 1942.

Janson 1979
Anthony F. Janson. "Worthington Whittredge: The Development of a Hudson River Painter, 1860–1868." In *The American Art Journal* 11 (April 1979), pp. 71–84.

Jarves 1864
James Jackson Jarves. *The Art-Idea*. 1864. Reprint. Edited by Benjamin Rowland, Jr. Cambridge: The Belknap Press of Harvard University Press, 1960.

Jones 1968
Agnes Halsey Jones. *Hudson River School*. Exhibition catalogue. Geneseo, N.Y.: Exhibition Gallery of the Fine Arts Center, State University of New York at Geneseo, 1968.

Joslyn Museum
Joslyn Art Museum, Omaha, Nebraska

Kelly 1985
James C. Kelly. "Landscape and Genre Painting in Tennessee, 1810–1985." In *Tennessee Historical Quarterly* 44 (Summer 1985). The issue, which was devoted solely to Mr. Kelly's article, served as the catalogue of the similarly titled exhibition.

Kilgo 1982
Dolores Ann Kilgo. "The Sharp-Focus Vision: The Daguerreotype and the American Painter." Ph.D. dissertation, University of Illinois at Urbana-Champaign, 1982.

Koke 1982
Richard J. Koke. *American Landscape and Genre Painting in the New-York Historical Society*. 3 vols. New York: New-York Historical Society, 1982.

LaFollette 1929
Suzanne LaFollette. *Art in America*. New York: Harper & Brothers, 1929.

Lawall 1971
David B. Lawall. *A. B. Durand, 1796–1886*. Exhibition catalogue. Montclair, N.J.: Montclair Art Museum, 1971.

Lawall 1977
David B. Lawall. *Asher Brown Durand: His Art and Art Theory in Relation to His Times*. New York and London: Garland Publishing, 1977. Ph.D. dissertation, Princeton University, 1966.

Lawall 1978
David B. Lawall. *Asher B. Durand: A Documentary Catalogue of the Narrative and Landscape Paintings*. New York and London: Garland Publishing, 1978.

Lindquist-Cock 1977
Elizabeth Lindquist-Cock. *The Influence of Photography on American Landscape Painting, 1839–1880*. New York and London: Garland Publishing, 1977. Ph.D. dissertation, New York University, 1967.

Los Angeles County Museum
Los Angeles County Museum of Art, Los Angeles, California

Lyman Allyn Museum
Lyman Allyn Museum, New London, Connecticut

McCoubrey 1965
John W. McCoubrey. *American Art, 1700–1960: Sources and Documents*. Englewood Cliffs, N.J.: Prentice-Hall Publications, 1965.

McEntee diary
 Jervis McEntee Diary, 1872–1890. Archives of American Art, Smithsonian Institution, Washington, D.C. Available on microfilm, roll no. D180.

McEntee Sale Catalogue
 Executor's Sale. Catalogue of Paintings by the Late Jervis McEntee, N.A. New York: Ortgies and Co., 1892.

McNulty 1983
 J. Bard McNulty, ed. *The Correspondence of Thomas Cole and Daniel Wadsworth.* Hartford, Conn.: The Connecticut Historical Society, 1983.

McShine 1976
 Kynaston McShine, ed. *The Natural Paradise: Painting in America.* Exhibition catalogue. New York: Museum of Modern Art, 1976.

Maddox 1981
 Kenneth W. Maddox. *The Railroad in the American Landscape: 1850–1950.* Exhibition catalogue. Wellesley, Mass.: Wellesley College Museum, 1981.

Mandel 1977
 Patricia C. F. Mandel. "Selection VII: American Paintings from the Museum's Collection, c. 1800–1930." In *Bulletin of Rhode Island School of Design: Museum Notes* 63 (April 1977).

Manthorne 1985
 Katherine Manthorne. *Creation and Renewal: Views of Cotopaxi by Frederic Edwin Church.* Exhibition catalogue. Washington, D.C.: Smithsonian Institution Press, 1985.

Marlor 1970
 Clark S. Marlor. *A History of the Brooklyn Art Association with an Index of Exhibitions.* New York: James F. Carr, 1970.

Matthews 1946
 Mildred Byars Matthews. "The Painters of the Hudson River School in the Philadelphia Centennial of 1876." In *Art in America* 34 (July 1946), pp. 143–60.

Mead Art Museum
 Mead Art Museum, Amherst College, Amherst, Massachusetts

Merritt 1967
 Howard S. Merritt, ed. "Appendix 1: Correspondence Between Thomas Cole and Robert Gilmor, Jr." In *Annual II: Studies on Thomas Cole, An American Romanticist.* Baltimore, Md.: Baltimore Museum of Art, 1967, pp. 41–81.

Merritt 1969
 Howard S. Merritt. *Thomas Cole.* Exhibition catalogue. Rochester, N.Y.: Memorial Art Gallery of the University of Rochester, 1969.

Metropolitan Museum
 The Metropolitan Museum of Art, New York City

Miller 1969
 Jo Miller. *Drawings of the Hudson River School: 1825–1875.* Exhibition catalogue. Brooklyn, N.Y.: The Brooklyn Museum, 1969.

Mobile Gallery
 Mobile Gallery, MacMurray College, Jacksonville, Illinois

Montclair Art Museum
 Montclair Art Museum, Montclair, New Jersey

Moure 1973
 Nancy Dustin Wall Moure. "Five Eastern Artists Out West." In *The American Art Journal* 5 (November 1973), pp. 15–31.

Moure 1980
 Nancy Dustin Wall Moure. *William Louis Sonntag: Artist of the Ideal, 1822–1900.* Los Angeles: Goldfield Galleries, 1980.

Munson-Williams-Proctor Institute
 Munson-Williams-Proctor Institute, Museum of Art, Utica, New York

Murdoch 1846
 Rev. David Murdoch, comp. *The Scenery of the Catskill Mountains as Described by Irving, Cooper, Bryant, Willis Gaylord Clark, N. P. Willis, Miss Martineau, Tyrone Power, Park Benjamin, Thomas Cole, and Other Eminent Writers.* 184[6]. Reprint, with essay by Bayard Taylor. New York: D. Fanshaw, 1864.

Murphy 1979
 Alexandra R. Murphy. "French Paintings in Boston: 1800–1900." In Anne L. Poulet. *Corot to Braque: French Paintings from the Museum of Fine Arts, Boston.* Exhibition catalogue. Boston: Museum of Fine Arts, 1979.

National Academy of Design
 National Academy of Design, New York City

National Cowboy Hall of Fame
 National Cowboy Hall of Fame and Western Heritage Center, Oklahoma City, Oklahoma

National Gallery of Art
 National Gallery of Art, Washington, D.C.

National Gallery, Edinburgh
 National Galleries of Scotland, Edinburgh, Scotland

National Gallery, London
 The National Gallery, London, England

National Museum of American Art
 National Museum of American Art, Smithsonian Institution, Washington, D.C.

Naylor 1973
 Maria Naylor, ed. and comp. *The National Academy of Design Exhibition Record 1861–1900.* 2 vols. New York: Kennedy Galleries, 1973.

Nelson-Atkins Museum
 The Nelson-Atkins Museum of Art, Kansas City, Missouri

Nevins and Thomas 1952
 Allan Nevins and Milton Halsey Thomas, eds. *The Diary of George Templeton Strong.* 4 vols. New York: Macmillan, 1952.

Newark Museum
 The Newark Museum, Newark, New Jersey

Newington-Cropsey Foundation
 The Newington-Cropsey Foundation, Hastings-on-Hudson, New York

New-York Historical Society
 The New-York Historical Society, New York City

Noble 1853
 Louis L. Noble. *The Course of Empire, Voyage of Life, and Other Pictures of Thomas Cole, N. A.* New York: Cornish, Lamport & Co., 1853.

Novak 1969
 Barbara Novak. *American Painting of the Nineteenth Century: Realism, Idealism, and the American Experience.* 1969. Rev. ed. New York: Harper & Row, 1979.

Novak 1980
 Barbara Novak. *Nature and Culture: American Landscape Painting 1825–1875.* New York: Oxford University Press, 1980.

Novak and Blaugrund 1980
 Barbara Novak and Annette Blaugrund, eds. *Next to Nature: Landscape Paintings from the National Academy of Design.* Exhibition catalogue. New York: National Academy of Design, 1980.

Nygren 1986
 Edward J. Nygren. *Views and Visions: American Landscape before 1830.* Exhibition catalogue. Washington, D.C.: The Corcoran Gallery of Art, 1986.

O'Brien 1986
 Maureen C. O'Brien. *In Support of Liberty: European Paintings at the 1883 Pedestal Fund Art Loan Exhibition.* Exhibition catalogue. Southampton, N.Y.: The Parrish Art Museum, 1986.

Olana
 Olana State Historic Site, Hudson, New York. Olana, the house built by Frederic E. Church, is now the repository of many of the artist's papers.

Olpin 1968
 Robert S. Olpin. *Alexander Helwig Wyant, 1836–1892.* Exhibition catalogue. Salt Lake City: Utah Museum of Fine Arts, University of Utah, 1968.

Olpin 1971
 Robert S. Olpin. *Alexander Helwig Wyant (1836–1892) American Landscape Painter: An Investigation of His Life and Fame and a Critical Analysis of His Work with a Catalogue Raisonné of Wyant Paintings.* Ann Arbor, Mich.: University Microfilms, 1971. Ph.D. dissertation, Boston University, 1971.

Pennsylvania Academy
 The Pennsylvania Academy of the Fine Arts, Philadelphia, Pennsylvania

Philadelphia Museum
 Philadelphia Museum of Art, Philadelphia, Pennsylvania

Phoenix Art Museum

Phoenix Art Museum, Phoenix, Arizona

Porter 1951
James A. Porter. "Robert S. Duncanson: Midwestern Romantic-Realist." In *Art in America* 39 (October 1951), pp. 98–154.

Powell 1980
Earl A. Powell. "Luminism and the American Sublime." In John Wilmerding, ed. *American Light: The Luminist Movement, 1850–1875*. Exhibition catalogue. Washington, D.C.: National Gallery of Art, 1980, pp. 69–94.

Princeton University Art Museum
The Art Museum, Princeton University, Princeton, New Jersey

Quick 1976
Michael Quick. *American Expatriate Painters of the Late Nineteenth Century*. Exhibition catalogue. Dayton, Ohio: Dayton Art Institute, 1976.

Reynolda House
Reynolda House, Museum of American Art, Winston-Salem, North Carolina

Rice 1877
The Editor. [A. T. Rice.] "Art[icle] VIII.—The Progress of Painting in America." In *North American Review* 124 (May 1877), pp. 451–64.

Richards 1854
T. Addison Richards. "The Catskills." In *Harper's New Monthly Magazine* 9 (July 1854), pp. 145–58.

Richardson 1956
E[dgar] P. Richardson. *Painting in America*. New York: Thomas Y. Crowell, 1956.

Rodriguez Roque 1985
Oswaldo Rodriguez Roque. "The Last Summer's Work." In John Paul Driscoll and John K. Howat. *John Frederick Kensett: An American Master*. Exhibition catalogue. Worcester, Mass., and New York: Worcester Art Museum in association with W. W. Norton & Co., 1985, pp. 137–61.

Rosenfeld and Workman 1986
Daniel Rosenfeld and Robert C. Workman. *The Spirit of Barbizon: France and America*. Exhibition catalogue. San Francisco, Cal.: The Art Museum Association of America, 1986.

Ruland 1976
Richard Ruland, ed. *The Native Muse: Theories of American Literature*. Vol. 1. New York: E. P. Dutton, 1976.

Rutledge 1955
Anna Wells Rutledge, ed. *Cumulative Record of Exhibition Catalogues: The Pennsylvania Academy of the Fine Arts, 1807–1870. . . .* Philadelphia: The American Philosophical Society, 1955.

St. Johnsbury Athenaeum
Saint Johnsbury Athenaeum, Saint Johnsbury, Vermont

St. Louis Museum
The Saint Louis Art Museum, Saint Louis, Missouri

Santa Barbara Museum of Art
The Santa Barbara Museum of Art, Santa Barbara, California

Schuyler 1894
Montgomery Schuyler. "George Inness: The Man and His Work." In *Forum* 18 (November 1894), pp. 301–13.

Shelburne Museum
Shelburne Museum, Shelburne, Vermont

Sheldon 1877
[George William Sheldon.] "How One Landscape-Painter Paints." In *Art Journal* (New York) n.s. 3 (September 1877), pp. 284–85.

Sheldon 1879
G[eorge] W[illiam] Sheldon. *American Painters: With Eighty-three Examples of Their Work Engraved on Wood*. New York: D. Appleton and Co., 1879.

Sheldon 1882
G[eorge] W[illiam] Sheldon. *Hours with Art and Artists*. New York: D. Appleton and Co., [1882].

Sherman 1912
Frederick Fairchild Sherman. *Homer Martin: Poet in Landscape*. New York: Privately printed, 1912.

Sizer 1957
Theodore Sizer, ed. *The Recollections of John Ferguson Weir: Director of the Yale School of the Fine Arts 1869–1913*. New York and New Haven: The New-York Historical Society and The Associates in Fine Arts at Yale University, 1957.

Soby and Miller 1943
James Thrall Soby and Dorothy C. Miller. *Romantic Painting in America*. Exhibition catalogue. New York: Museum of Modern Art, 1943.

Solkin 1982
David H. Solkin. *Richard Wilson: The Landscape of Reaction*. London: The Tate Gallery, 1982.

Sordoni Art Gallery
Sordoni Art Gallery, Wilkes College, Wilkes-Barre, Pennsylvania

Southwest Museum
Southwest Museum, Los Angeles, California

Spassky 1985
Natalie Spassky. *American Paintings in The Metropolitan Museum of Art*. Volume II. Edited by Kathleen Luhrs. New York: The Metropolitan Museum of Art, 1985.

Stebbins 1969
Theodore E. Stebbins, Jr. *Martin Johnson Heade*. Exhibition catalogue. College Park, Md.: University of Maryland Art Gallery, 1969.

Stebbins 1975
Theodore E. Stebbins, Jr. *The Life and Works of Martin Johnson Heade*. New Haven, Conn.: Yale University Press, 1975. Revised edition forthcoming.

Stebbins 1976
Theodore E. Stebbins, Jr. *The Hudson River School: 19th Century American Landscapes in the Wadsworth Atheneum*. Exhibition catalogue. Hartford, Conn.: Wadsworth Atheneum, 1976.

Stein 1981
Roger Stein. *Susquehanna: Images of the Settled Landscape*. Exhibition catalogue. Binghamton, N.Y.: Roberson Center for the Arts and Sciences, 1981.

Strahan 1876
Edward Strahan [Earl Shinn]. *The Masterpieces of the Centennial International Exhibition: Illustrated*. 3 vols. Vol. I. *Fine Art*. Philadelphia: Gebbie and Barrie, [1876].

Strahan 1879
Edward Strahan [Earl Shinn]. "The Art Gallery: The National Academy of Design. First Notice." In *Art Amateur* 1 (June 1879), pp. 4–5.

Sweet 1945
Frederick A. Sweet. *The Hudson River School and the Early American Landscape Tradition*. Exhibition catalogue. Chicago, Ill.: Art Institute of Chicago, 1945.

Talbot 1970
William S. Talbot. *Jasper F. Cropsey: 1823–1900*. Exhibition catalogue. Washington, D.C.: The Smithsonian Institution Press, 1970.

Talbot 1973
William S. Talbot. "Landscape and Light." In *The Bulletin of the Cleveland Museum of Art* 60 (January 1973), pp. 9–20.

Talbot 1977
William S. Talbot. *Jasper F. Cropsey: 1823–1900*. New York and London: Garland Publishing, 1977. Ph.D. dissertation, New York University, 1972.

Terra Museum
Terra Museum of American Art, Chicago, Illinois

Trenton and Hassrick 1983
Patricia Trenton and Peter H. Hassrick. *The Rocky Mountains: A Vision for Artists in the Nineteenth Century*. Norman, Okla.: University of Oklahoma Press, 1983.

Tuckerman 1849
Henry T. Tuckerman. *Sketches of Eminent American Painters*. New York: D. Appleton and Co., 1849.

Tuckerman 1867
Henry T. Tuckerman. *Book of the Artists: American Artist Life*. 1867. Reprint. New York: James F. Carr, 1966.

Van Dyke 1919
John C. Van Dyke. *American Painting and Its Tradition*. New York: Charles

Scribner's Sons, 1919.

Van Rensselaer 1882
M[ariana] G[riswold] Van Rensselaer. "Sanford Robinson Gifford." In *The American Architect and Building News* 11 (11 February 1882), pp. 63–64.

Van Rensselaer 1886
M[ariana] G[riswold] Van Rensselaer. *Book of American Figure Painters*. Philadelphia: J. B. Lippincott Co., 1886.

Van Zandt 1966
Roland Van Zandt. *The Catskill Mountain House*. New Brunswick, N.J.: Rutgers University Press, 1966.

Van Zandt 1971
Roland Van Zandt. *Chronicles of the Hudson: Three Centuries of Travelers' Accounts*. New Brunswick, N.J.: Rutgers University Press, 1971.

Vassar College Art Gallery
Vassar College Art Gallery, Poughkeepsie, New York

Wadsworth Atheneum
Wadsworth Atheneum, Hartford, Connecticut

Washington University Art Gallery
The Washington University Gallery of Art, Saint Louis, Missouri

Weir 1873
J[ohn] F. Weir. "Article VIII.—American Landscape Painters." In *New Englander Magazine* 32 (January 1873), pp. 140–51.

Weiss 1977
Ila S. Weiss. *Sanford Robinson Gifford, 1823–1880*. New York and London: Garland Publishing, 1977. Ph.D. dissertation, Columbia University, 1968.

Weiss 1986
Steven Weiss. *Sanford R. Gifford, 1823–1880*. Exhibition catalogue. Essay and chronology by Ila S. Weiss. New York: Alexander Gallery, 1986.

Westmoreland Museum
Westmoreland Museum of Art, Greensburg, Pennsylvania

Willis 1840
N[athaniel] P. Willis. *American Scenery: Or, Land, Lake and River: Illustrations of Transatlantic Nature*. 2 vols. London: George Virtue, 1840.

Wilmerding 1976
John Wilmerding. *American Art*. Harmondsworth, England: Penguin Books, 1976.

Wilmerding 1980
John Wilmerding, ed. *American Light: The Luminist Movement, 1850–1875*. Exhibition catalogue. Washington, D.C.: National Gallery of Art, 1980.

Worcester Art Museum
Worcester Art Museum, Worcester, Massachusetts

Yale University Art Gallery
Yale University Art Gallery, New Haven, Connecticut

Yarnall 1981
James Leo Yarnall. "The Role of Landscape in the Art of John La Farge." Ph.D. dissertation, University of Chicago, 1981.

INDEX

PHOTOGRAPH CREDITS

Photographs are credited to the individuals, institutions, or firms cited in the captions, except in the following cases: p. 4, Fig. 1.1, Scott Hyde; p. 10, Fig. 1.8, Meredith Long & Company; p. 17, Fig. 1.11, Sotheby's; p. 18, Christie's; p. 19, Figs. 1.13, 1.14, Sotheby's; p. 48, O. E. Nelson; pp. 58, 59, 65, Albert L. Mozell; p. 80, Rudolph Burckhardt; p. 84, Jack Meyer; p. 85, Fig. 4.17, Hirschl & Adler Galleries; p. 117, Geoffrey Clements; p. 127, Fig. 4, Helga Photo Studios; p. 144, Robert Linthout; p. 147, Alexander Gallery; p. 180, Thomas Colville; p. 186, Geoffrey Clements; p. 193, Kennedy Galleries; p. 216, Fig. 1, Sotheby's; p. 225, Rick Stafford; p. 226, E. Irving Blomstrann; p. 257, Fig. 4, Helga Photo Studios; p. 287, John Robson; p. 291, Gamma One Conversions; p. 295, Jeffrey Nintzel; p. 296, Fig. 1, The Capitol, Office of the Architect; p. 300, Richard York Gallery; p. 318, Herbert P. Vose; p. 327, Mr. and Mrs. Harry Farr, The Dent Collection, Washington, D.C., photograph by Brooks Photographers.